W9-CRC-669

THE ROUTE 66 ENCYCLOPEDIA

JIM HINCKLEY

Voyageur Press

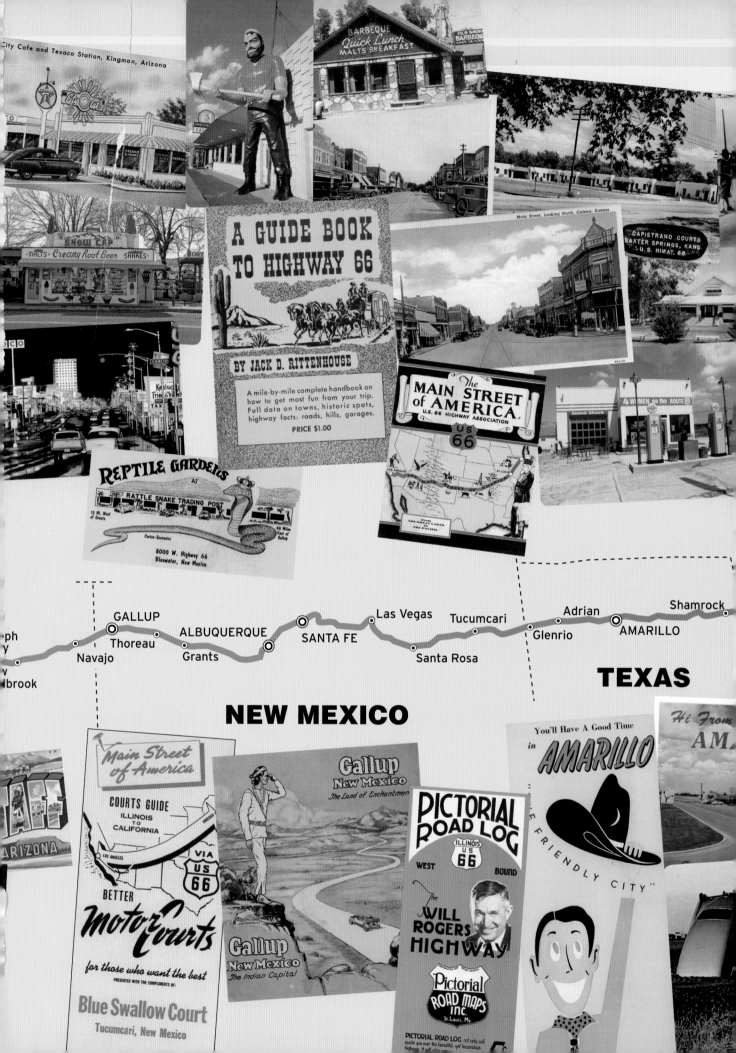

City Cafe and Texaco Station, Kingman, Arizona

BARBEQUE
Quick Lunch
MALTS BREAKFAST

OLD SMOK
BARBEQUE

SNOW CAP
MALTS • Creamy Root Beer • SHAKES

Main Street, Looking North, Galena, Kansas

CAPISTRANO COURTS
BAXTER SPRINGS, KANS.
U.S. HIWAY 66

A GUIDE BOOK
TO HIGHWAY 66

BY JACK D. RITTENHOUSE

A mile-by-mile complete handbook on
how to get most fun from your trip.
Full data on towns, historic spots,
highway facts: roads, hills, garages.

PRICE $1.00

The
MAIN STREET
of AMERICA
U.S. 66 HIGHWAY ASSOCIATION

US
66

From THE GREAT LAKES
to THE PACIFIC

Snack Shack

4 WOMEN on the ROUTE

AMARILLO

REPTILE GARDENS
AT
RATTLE SNAKE TRADING POST

12 Mi. West
of Grants

48 Miles
East of Gallup

Curios-Souvenirs

8000 W. Highway 66
Bluewater, New Mexico

Shamrock

Adrian

Las Vegas Tucumcari

GALLUP

ALBUQUERQUE SANTA FE Glenrio AMARILLO

Thoreau

Navajo Grants Santa Rosa

ph
y
lbrook

TEXAS

NEW MEXICO

Main Street
of America

COURTS GUIDE
ILLINOIS
TO
CALIFORNIA

VIA
US
66

BETTER
Motor Courts

for those who want the best

PRESENTED WITH THE COMPLIMENTS OF:

Blue Swallow Court
Tucumcari, New Mexico

Gallup
New Mexico
The Land of Enchantment

Gallup
New Mexico
The Indian Capital

ARIZONA

PICTORIAL
ROAD LOG

ILLINOIS US
66
WEST BOUND

WILL
ROGERS
HIGHWAY

Pictorial
ROAD MAPS
INC.
St. Louis, Mo.

PICTORIAL ROAD LOG not only will
guide you over this beautiful, yet hazardous
highway. It will also save...

You'll Have A Good Time
in
AMARILLO

FRIENDLY CITY"

Hi From
AMA

ROUTE 66

Based on a 1930s alignment

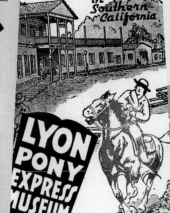

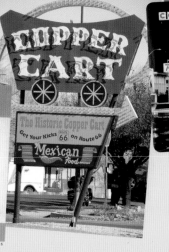

CALIFORNIA

LOS ANGELES
Santa Monica
Pasadena
San Bernardino
Victorville
Barstow
Ludlow
Bagdad Amboy
Needles
Goldroad
Kingman
Williams
FLAGSTAFF
Winona
Twin Arrows
Two Guns
Jos... Ci...
Winslow
H...

ARIZONA

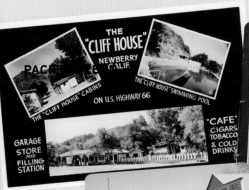

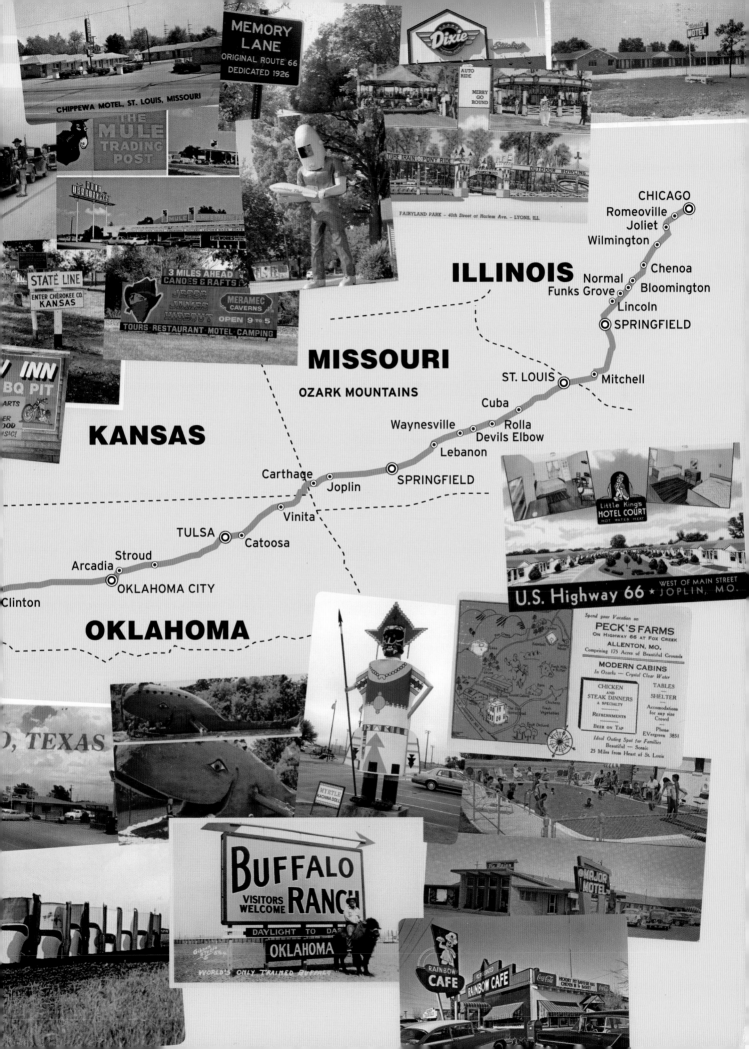

CHIPPEWA MOTEL, ST. LOUIS, MISSOURI

MEMORY
LANE
ORIGINAL ROUTE 66
DEDICATED 1926

THE
MULE
TRADING
POST

3 MILES AHEAD
CANOES & RAFTS
JESSE
JAMES
HIDEOUT
MERAMEC
CAVERNS
OPEN 9 to 5
TOURS · RESTAURANT · MOTEL · CAMPING

STATE LINE
ENTER CHEROKEE CO.
KANSAS

Dixie

AUTO
RIDE
MERRY
GO
ROUND

OUTDOOR BOWLING

FAIRYLAND PARK – 40th Street at Harlem Ave. – LYONS, ILL.

ILLINOIS

CHICAGO
Romeoville
Joliet
Wilmington
Chenoa
Normal
Funks Grove
Bloomington
Lincoln
SPRINGFIELD

MISSOURI

OZARK MOUNTAINS

ST. LOUIS
Mitchell

Cuba
Waynesville
Rolla
Devils Elbow
Lebanon

KANSAS

Carthage
Joplin
SPRINGFIELD

INN
BQ PIT

Vinita

TULSA
Catoosa
Stroud
Arcadia
OKLAHOMA CITY
Clinton

Little Kings
HOTEL COURT
HOT WATER HEAT

U.S. Highway 66 ★ WEST OF MAIN STREET
JOPLIN, MO.

OKLAHOMA

D, TEXAS

MYRTLE
KACHINA DOLL

Spend your Vacation on
PECK'S FARMS
ON HIGHWAY 66 AT FOX CREEK
ALLENTON, MO.
Comprising 175 Acres of Beautiful Grounds

MODERN CABINS
In Ozarks — Crystal Clear Water

CHICKEN
AND
STEAK DINNERS
A SPECIALTY

TABLES

SHELTER

REFRESHMENTS

Accommodations
for any size
Crowd

BEER ON TAP

Phone
EVergreen 3851

Ideal Outing Spot for Families
Beautiful — Scenic
25 Miles from Heart of St. Louis

MAJOR
MOTEL

BUFFALO
RANCH
VISITORS
WELCOME
DAYLIGHT TO DARK
OKLAHOMA
WORLD'S ONLY TRAINED BUFFALO

RAINBOW
CAFE
RAINBOW CAFE

First published in 2012 by MBI Publishing Company and Voyageur Press,
an imprint of MBI Publishing Company, 400 First Avenue North, Suite 300, Minneapolis, MN 55401 USA

Voyageur Press titles are also available at discounts in bulk quantity for industrial or sales-promotional
use. For details write to Special Sales Manager at MBI Publishing Company, 400 First Avenue North,
Suite 300, Minneapolis, MN 55401 USA.

To find out more about our books, visit us online at www.voyageurpress.com.

ISBN-13: 978-0-7603-4041-7

 Library of Congress Cataloging-in-Publication Data

Hinckley, James, 1958-
 Route 66 encylopedia / by Jim Hinckley.
 p. cm.
 Includes index.
 ISBN 978-0-7603-4041-7 (hbk.)
 1. United States Highway 66--Encyclopedias. 2.
United States Highway 66--History--Encyclopedias. 3.
United States--Description and travel--Encyclopedias.
4. Automobile travel--United States--Encyclopedias.
I. Title.
 HE356.U55H56 2012
 388.10973--dc23
 2012027539

Editors: Melinda Keefe, Jordan Wiklund
Design Manager: Cindy Samargia Laun
Design: Pauline Molinari

Printed in China

10 9 8 7 6 5 4 3 2 1

DEDICATION

This book is dedicated to my dearest
friend, Judy Ann, who serves as my rudder
to keep me on course, the beacon that
prevents crashing on rocky shoals, and the
safe harbor that shelters me during the
storms of life.

CONTENTS

ACKNOWLEDGMENTS

My name may be on the cover, but I cannot take sole credit for this multifaceted time capsule. The Route 66 community past and present has been my partner in this endeavor.

Some lived the stories I chronicled, others became entrusted guardians of its history and legacy, but each contributed greatly. Special thanks go to Mike Ward, Joe Sonderman, and Steve Rider who made their vast collections available to me and who lent their knowledge and expertise to ensure accuracy and to provide the book with color, and with life.

Likewise, without the assistance and contributions of historians, and authors, such as Michael Wallis, Jim Ross, Rich Dinkella, Scott Piotrowski, David Clark, Mark Spangler, and Jerry McClanahan, this book would have most likely been little more than a litany of dry facts. Their contributions ensured it contained the vibrancy of Route 66 itself.

Of course, without the hard work of the editors and the design staff at the publishing company, an idea such as this could never be more than that. To them, I am deeply indebted.

I would be quite remiss if acknowledgment was not given to the greatest contributor of all, my dearest friend and wife, Judy. Without her patient support, prayers, assistance, companionship on the road, and the occasional plate of food slipped under my nose when I become too engrossed in the work to remember dinnertime, it would be an impossibility to create a work such as this.

INTRODUCTION

To describe this book as an encyclopedia is like referring to Route 66 as a road. Single-word descriptors cannot measure the depth, the scope, or the importance of either one.

As with the highway itself, this work does not fit within the traditional confines of generalities or terminology. Yes, this is an encyclopedia, a reference book for all things Route 66. However, it is also a time capsule, a travel guide, a history book, a memorial, a testimonial, and a chronicle of almost a century of societal evolution.

The shortcomings of an encyclopedia have always been its relevance. The *Route 66 Encyclopedia* is no different.

The primary subject matter within these pages is the history of this road, the communities along its course, and the people who played a role in its transformation from highway to icon between the periods of 1926 to 2011. However, this highway is as a chameleon. Its significance and meaning have been different for each generation and all indications are that this will continue for years to come.

As a result, there are countless chapters, yet unwritten, to be chronicled. Judging by the rising popularity of this iconic highway, these will be as colorful, as exciting, and as inspirational as the ones documented in the *Route 66 Encyclopedia*.

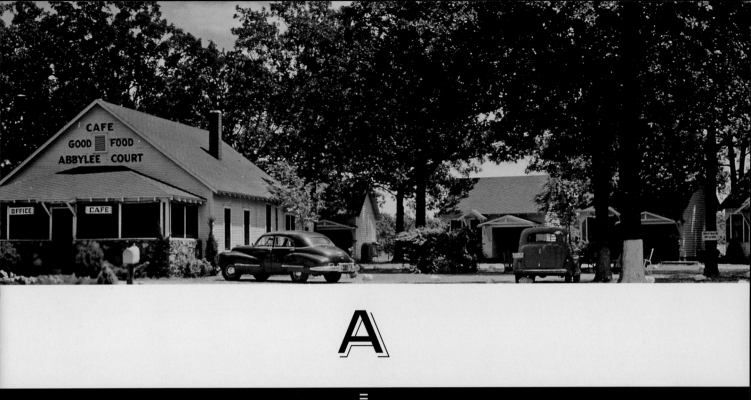

A

ABBYLEE MOTEL

Promoted as "the prettiest location on Route 66 in Missouri," the Abbylee Court opened in 1940 thirty-two miles east of Springfield. The complex consisted of a café and eight clapboard cabins and warranted mention in *A Guide Book to Highway 66*, written by Jack Rittenhouse in 1946. In 1950, the café burned, but the motel remained operational. The remaining cabins, rented by the month as of 2010, stand at the intersection of two county highways, CC (formerly U.S. Highway 66) and M.

Above: **The Abbylee Motel, originally the Abbylee Modern Court, opened in 1940. The café burned in 1950, but the cabins still stand among the trees near the intersection of County Route CC.** *Joe Sonderman*

ADAMANA, ARIZONA

Established as a station on the main line of the AT&SF (Atchison, Topeka & Santa Fe) Railroad in 1896 (also the year of the local post office's establishment) as a departure point for tourists visiting the Petrified Forest, Adamana is located twenty-five miles east of Holbrook on the north bank of the Rio Puerco River. The name is a derivative combining the first and last names of Adam Hanna, a partner with Jim Cart in a large sheep ranch that operated in the area.

An article in the *Oakland Tribune* dated July 12, 1914, indicates this was a flag station on the main line of the Santa Fe Railroad. This article describes the community as consisting of a "station house, water tank, store, hotel, and a half dozen other buildings."

The little oasis had an association with the National Old Trails Highway, at least during the teens and possibly into the early 1920s,

and as a result may have served the needs of motorists on the first incarnation of Route 66 that followed that highway. However, there is no evidence to indicate it had a direct association.

A great deal of the confusion pertaining to the link between Route 66 and Adamana stems from highway maps produced around 1928. These maps indicate that Adamana was located on that highway, but in actuality, the town was located several miles to the south.

The most likely explanation for the discrepancy is that a station or other services were available at the junction of U.S. 66 and the road to Adamana, which resulted in the notation. Modern references to the small community are at exit 303 on Interstate 40, Adamana Road, and a railroad siding to the south with the same name.

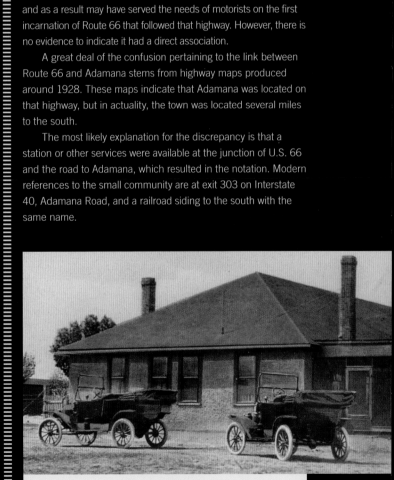

The Campbell Store and Campbell Hotel in Adamana, Arizona, was a welcome oasis for pioneering motorists traveling the vast desert wilderness on the National Old Trails Highway. *Steve Rider*

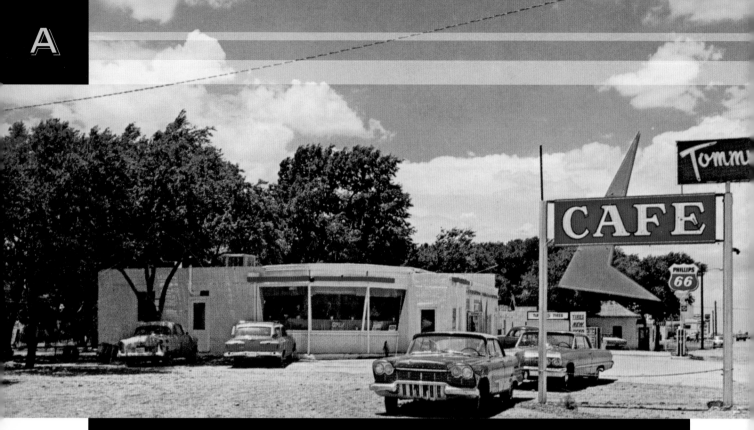

The cantilevered doors and windows from a cannibalized military airfield control tower provided this little café in Adrian, Texas, with notoriety all along the length of Route 66. *Steve Rider*

ADRIAN, TEXAS

Adrian is located near the geographic midpoint of Route 66. Named for Adrian Cullen, a pioneering farmer in the area, the town began as the surveyed site for a station on the Rock Island Railroad in 1900. The official founding date is set as 1909, the year the Chicago, Rock Island & Gulf Railway completed the rail line through Oldham County. Marketing of the town site and area by the American-Canadian Land & Townsite Company, an Iowa-based firm, attracted prospective residents, business owners, and farmers. Within one year, the business district included a post office, lumberyard, general store, bank, brick factory, pool hall, blacksmith shop, and newspaper, the *Adrian Eagle*, established by J. P. Collier. A drought stifled projected growth, however, and in 1915, the official population was fifty.

After 1926, meeting the needs of travelers on Route 66 became an integral part of the community's economy, even though traffic on the Ozark Trails served as the initial catalyst for development of a service industry. In 1929, the establishment of a grain elevator bolstered this as Adrian became an important shipping point for area wheat growers.

For Route 66 enthusiasts, Adrian is famous for its sign proclaiming the town as the halfway point between Chicago and Santa Monica and for its Midpoint Café, which opened in late 1956 as Jesse's Café. The Midpoint Café was the inspiration for Flo's V8 Café in Pixar's animated film *Cars*. The original café, a joint effort between Dub Edmonds and Jesse Fincher, utilized a rough building of indefinite origin for the launch of the roadside enterprise. The addition of a service station next door (formerly Zella's Café) ensured a steady flow of customers.

As with many businesses along Route 66, the café and service station evolved in direct correlation to the increase of traffic. By 1965, renovations included an A-framed second-story addition to the café that housed an apartment and the construction of a large canopy over the pump island at the station. The café proved so successful that the partners opened a second Jesse's in Wilderado, east of Adrian on Route 66. Damage to the original café from two fires resulted in removal of the second-story apartment, giving the property its current appearance. The *Route 66 Dining & Lodging Guide*, fifteenth edition, published by the National Historic Route 66 Federation, highly rates the Midpoint Café on atmosphere, value, and service.

Another landmark of note in Adrian is Tommy's Café, located east of the Midpoint Café. Initially, this was the site of the Kozy Cottage Camp, a roadside complex consisting of cabins, a service station, and a café. A fire in December 1947 destroyed the original café and service station, but the cabins still provided lodging under the name Adrian Court. Shortly after this date, Bob Harris, a former employee of Kozy Cottage Camp, acquired the property as the site for a new café. A limited budget and the urge to create a business that would stand out led to the acquisition of an Army Air Corps control tower at a military surplus auction. The uniquely cantilevered doors and windows resulted in the nickname Bent Door Café, a moniker that quickly became more recognizable than the business's actual name.

In the mid-1970s, the café closed. Harris announced plans to restore and reopen the property in 1995, but as of this writing, it remains closed.

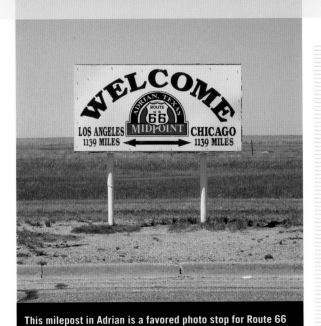

This milepost in Adrian is a favored photo stop for Route 66 enthusiasts. Directly across the highway is the aptly named Midpoint Café. *Judy Hinckley*

AFTON, OKLAHOMA

According to Oklahoma historian George Shirk, Anton Aires, a Scottish railroad surveyor, bestowed the name Afton on this town in commemoration of his daughter, Afton Aires, who was named after the Afton River in Scotland. The post office initially opened in 1886, and as a railroad and farming supply center, Afton became a community of red brick buildings that reflected the town's solid nature and prosperity.

Major employers during the first thirty years included the railroad, with a roundhouse and turntable, and the Pierce & Harvey Buggy Company, its building later utilized by Leo's Grocery until 2009. In 1910, the Kansas City, Fort Scott &

This 1950s view of Afton is looking east toward Afton Station. The Palmer Hotel, built in 1911, and Bassett's Food Store, housed in the former buggy manufacturing building, are on the left.

Memphis Railroad established a second main line through town. By the mid-teens, the town supported a large waterworks, a brick and tile plant, a creamery, several mills and grain elevators, two banks, two hotels, and a newspaper. The post–World War I collapse of wheat, corn, and beef prices, however, served as the catalyst for a period of sharp decline. Between 1920 and 1930, the population dropped by almost 20 percent.

The commissioning of Route 66 in 1926 stabilized the economic slide with a resulting establishment of service-related industries, including motels, gas stations, and garages. This trend continued with tourism fueled by construction of the nearby Pensacola Dam, the creation of the Lake O' Cherokees in 1940, and postwar prosperity leading to the development of tourism attractions like the Buffalo Ranch.

With the suspension of railroad repair in Afton, the demolition of the roundhouse and turntable, the completion of Interstate 44 that resulted in the closure of motels and cafés, and the closure of the Buffalo Ranch in 1997, Afton entered a period of severe economic decline. As of the summer of 2011, the majority of existing structures in the historic district are abandoned.

Attractions of particular interest to Route 66 enthusiasts include the Horse Creek Bridge, built in 1929, with a pedestrian walkway on both sides, the stark ruins of Avon Court, and Afton Station, voted best new business on Route 66 in 2009.

AFTON STATION

The building known today as Afton Station dates to 1930. Initially, it served as a DX station and was purportedly the first twenty-four-hour station in Afton. Expansion during the 1930s included the addition of a building that allowed for the operation of several service bays. Additionally, extension of the canopy to the edge of the Route 66 right of way, allowing for three gasoline pump islands, occurred during this period.

The brand of fuel and related oil products changed over the years, but the facility continued to operate as a gasoline station until the mid-1980s. After this date, a succession of owners found various uses for the property, including a flower shop, beauty shop, and Western Auto store.

In the year 2000, David and Laurel Kane purchased the property and initiated restoration. It officially opened as Afton Station and Route 66 Packard's, a name indicative of the Kanes' proclivity toward collecting automobiles built by the Packard Company. Representatives from other automotive manufacturers on display include Studebaker, Citroën, DeSoto, Graham, and Chevrolet. A prized exhibit added in the summer of 2011 is a one-of-a-kind 1917 motorhome built on a Packard truck chassis.

The facility has grown to include a Route 66 museum and visitor center displaying remnants from the area's rich history as well as souvenirs representing eighty-five years of Route 66 being America's favorite highway. In 2009, Afton Station was selected the best new business on Route 66.

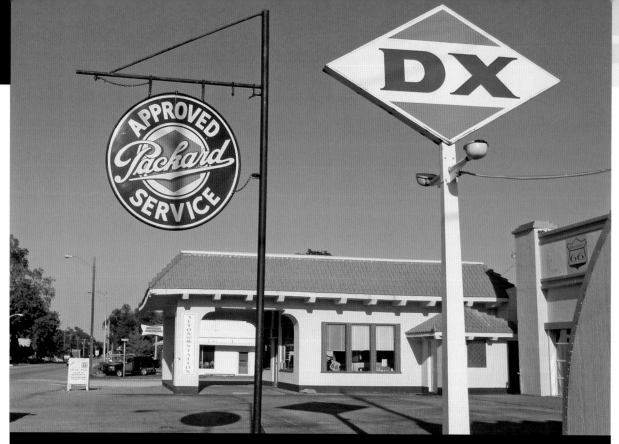

Housed in a classic DX service station, Afton Station preserves the finest automobiles from Detroit and a delightful array of vestiges from the glory days of Route 66. *Judy Hinckley*

ALAMEDA, NEW MEXICO

Alameda is a Spanish term referring to a grove. In the desert Southwest, a grove of cottonwood tress would indicate a dependable water source. The records of the Coronado expedition along the Rio Grande in 1540 indicate a Tiwa pueblo existed at the location of present-day Alameda. With the relocation of the Tiwa to Isletta, Spanish settlers settled on the site after 1696. The Americanization of the area culminated with the establishment of a post office in 1866, which was discontinued in 1868 and reestablished in 1890. In 1960, it became a branch of the Albuquerque post office.

ALANREED, TEXAS

Alanreed, located less than a dozen miles west of McLean, was another victim of changing times. Purportedly, the name is a derivative of the contracting company, Alan & Reed.

The original town site is in the basin of McClellan Creek six miles north of present-day Alanreed. The site, selected in 1881, was centrally located on the busy stage and freight road that connected Mobeetie to Clarendon. Oddly enough, it would be another three years before the Clarendon Land & Cattle Company began selling lots.

When surveys in 1900 made it apparent that the Choctaw, Oklahoma & Texas Railroad would miss the little village, the platting of a new community along the course of the proposed rail line commenced. The following year, the school opened at this location, and the year after, the post office transferred to the new location. G. E. Castleberry Land Company sold parcels in the burgeoning community for $2.25 per acre during this period. By 1904, Alanreed was the largest community in Gray County, and tax records from 1907 indicate a business district that included a bank, a hotel, a depot, churches, saloons, grocery and hardware stores, and a livery stable and blacksmith shop.

During the 1910s, farming (particularly watermelon farming) became a major cash crop, and with five hundred railroad cars being shipped annually, Alanreed was at the center of one of the largest areas of production for this crop in the United States. Built during this period was a new two-story school, and a telephone exchange was also established. The population surpassed 250.

The initial decline commenced with the postwar recession and the resultant collapse of agricultural prices during the 1920s. A brief boom fueled by oil discoveries led to additional unsuccessful bids for Alanreed to become the Gray County seat.

In 1928, the bank and hotel closed. The following year, the school consolidated with three others in the area, and the population, estimated at 150, represented a decline of more than 30 percent from the peak in 1927.

Resurgence in farming coupled with service industries related to the traffic on Route 66 stabilized the decline for most of the 1930s and even resulted in substantial growth. Jack Rittenhouse, quoting 1940 population figures, listed Alanreed's population as 1,489, but this seems unlikely. He also noted available services as the Ranch House Court as well as gas stations, cafés, and a few stores.

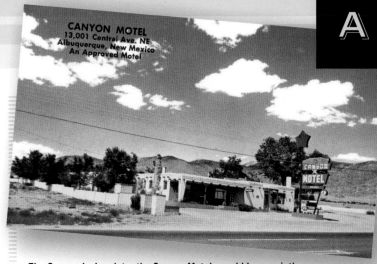

By 1947, county records indicate fifteen operating businesses, including the Ranch House Auto Court. Thirty years later, there were an estimated sixty residents and no operating businesses.

Of primary interest to Route 66 enthusiasts today is the Spanish Mission–styled service station signed as 66 Super Service. The two-carport station with adjacent double-bay garage dating to 1932 is currently closed.

As of 2001, the population of Alanreed hovered at fifty. This number has remained consistent through the first decade of the twenty-first century.

In March 1935, Alanreed and Route 66 garnered statewide attention in a tragedy that linked them. Ralph Inman, a fireman at the plant of the American Natural Gas Company in Shamrock, was returning home from a special church service with his family when the car he was driving drifted across the center line into the path of a westbound truck. Four members of the family died instantly; three friends of the Inmans in the vehicle were severely injured. The truck driver, unnamed in the article by the Corsicana paper, rendered assistance.

ALBATROSS, MISSOURI

Established in 1926 as a stop for the Albatross Bus Line, the town of Albatross continued to grow in direct correlation to the increase of traffic on Route 66 through the early 1950s. Existing structures as of the summer of 2010 include the ruins of Carvers Cabins, several buildings from the Welcome Inn complex that included a tavern and cabins, a former body shop housed in the original Albatross Store, and a former DX service station.

ALBUQUERQUE, NEW MEXICO

The modern incarnation of Albuquerque dates to a settlement feasibility study authorized by Don Francisco Cuervo y Valdes, governor of New Mexico, in 1706. However, initial Spanish exploration in 1540 noted remnants of a village on the site.

The Spanish colonial outpost built here—named San Francisco de Albuquerque, the third established in New Mexico—was named in honor of Don Francisco Fernandez de la Cueva Enriquez, Duke of Alburquerque, thirty-fourth Viceroy of New Spain. English-speaking travelers and cartographers arriving in the early nineteenth century often dropped the first "r."

In late 1879, the New Mexico Townsite Company, a subsidiary of the AT&SF Railroad, established a town east of Albuquerque at the site of a planned station. The new station opened in April 1880, and in 1886, a post office opened as New Albuquerque. Following this was the designation of the original town as Old Albuquerque. Urban sprawl, however, eliminated the need for a qualifying adjective by 1900.

The Canyon Lodge, later the Canyon Motel, would have quietly faded into obscurity if it had not been for the property's association with the heinous murder of Linda Lee Daniels in 1986. *Mike Ward*

Surprisingly, in *By Motor to the Golden Gate*, published in 1916, Emily Post confined most of her Albuquerque observations to the Harvey House there. She did note, "Two Indian shepherds in fact were the only human beings we saw until our road ran into the surprisingly modern city of Albuquerque."

By the date of the designation of U.S. Highway 66 (1926), the population of Albuquerque had surpassed fifteen thousand, but with the exception of the Alvarado Hotel (the Fred Harvey enterprise noted by Emily Post), lodging recommendations in guidebooks were sparse. The *Hotel, Garage, Service Station, and AAA Directory* of 1927 lists the Alvarado and Franciscan at $2.00 per night.

Before 1937, Route 66 entered the city from the north following Fourth Street and, for a brief time, Second Street. After this date, the highway followed Central Avenue.

The Barelas–South Fourth Street Historic District is a linear corridor preserving elements of the earlier alignment of Route

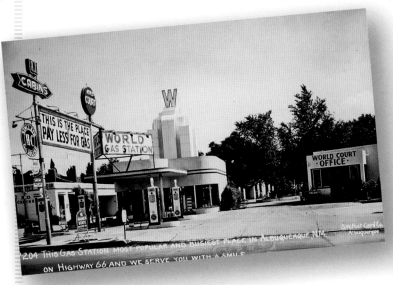

Initially owned and operated by Ralph Branson and Glenn Hoefgen, World Gas Station and World Courts were located at 1717 West Central Avenue directly across from the Hedges Oil Company station. *Steve Rider*

ALBUQUERQUE, NEW MEXICO *continued*

66 as well as the Barelas neighborhood, among the city's earliest. The area represents a distinctive historical crossroads: the Hispanic farming community of the early nineteenth century, the transition that resulted from the arrival of the railroad in 1880 and the establishment of repair facilities and roundhouse, and the automotive era that includes the Trail to Sunset, National Old Trails Highway, and Route 66 before 1937.

The designation of Route 66 in 1926 sparked a period of extensive commercial development in the area that peaked in the mid-1950s. After decades of decline, the district, listed in the National Register of Historic Places in 1997, received renewed interest with the appropriation of $12 million from the New Mexico Legislature for the construction of the National Hispanic Cultural Center at the south end. Representatives attended the 1999 groundbreaking ceremonies from Spain, Mexico, and the United States. This proved the catalyst for extensive renovation.

A number of buildings with historic connections to Route 66 remain along the early alignment. Among these are the former Hudson dealership garage at 714 Fourth Street, the Magnolia Service Station at 1100 Fourth Street, the Red Ball Café at 1303 Fourth Street, and Durand Motor Company at 929 Fourth Street.

Along the later Route 66 corridor, urbanization has erased numerous vestiges of the city's association with this highway, but there still remains a wide array of structures with particular interest and historic value. Among these are the Hiland Theater and Shopping Center dating to 1952, a former Pig Stand at 2106 Central, the restored KiMo Theater built in 1927, and El Vado Motel near the Rio Grande River that dates to 1937. As of this writing, intervention has stayed scheduled demolition of El Vado Motel, but the future of this authentic auto court is still in question.

A partial listing of additional historic motels, from east to west along Central Avenue, includes the La Puerta Motor Lodge (1949), Luna Lodge (1949), Urban Motor Lodge (1941), Pinon Lodge (1946), La Mesa Court (1938), Tewa Lodge (1946), Zia Lodge (1940), El Oriente Auto Court (1935), Aztec Motel (1931), Modern Auto Court (1937), Tower Court (1946), Cibola Court (1947), and El Campo Tourist Court (1939). Other surviving structures with direct association to Route 66 include Enchanted Mesa Trading Post (1948), Ace Café (1948), Jones Motor Company (1939), Horn Oil Company and Lodge (1946), and Last Chance Gas Station (1936).

The *Directory of Motor Courts and Cottages* (1940) lists several AAA-recommended Route 66 auto courts in Albuquerque, including Monterrey Court, one mile west of the city on U.S. 66, Country Club Auto Court on west U.S. 66, and De Anza Motor Lodge at 4391 East Central.

The 1954–55 *AAA Western Accommodations Directory* reflects the increasingly important role of Route 66 and tourism

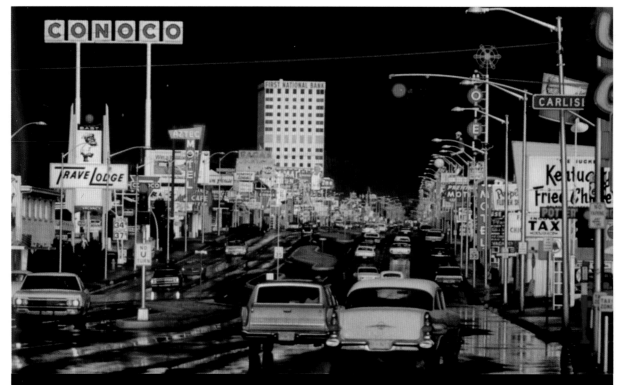

By the mid-1960s, Central Avenue in Albuquerque was a cacophony of signage representing the present, the past, and the future along Route 66. *Steve Rider*

to the economy in Albuquerque. In this directory are listed two hotels, the Alvarado and Hilton, and thirteen auto courts on Route 66 and Central Avenue: Zia Lodge (4611 Central Avenue), Tropicana Lodge (8814 Central Avenue), Tewa Lodge (5715 Central Avenue), Premiere Motel (3820 Central Avenue), Ambassador Lodge (4501 Central Avenue), Bel Air Motel (4222 Central Avenue), Bow and Arrow (8300 Central Avenue), Casa Grande Lodge (2625 Central Avenue), Comfort Lodge (4020 Central Avenue), De Anza Motor Lodge (4301 Central Avenue), Desert Inn (918 Central Avenue), El Don Motel (2222 Central Avenue), Luna Lodge (9019 Central Avenue), and Monterrey Court (2402 Central Avenue). Restaurants recommended include the Airport Restaurant, Hacienda Dining Room, Hoyt's Dinner Bell, Leonard's, and Wayside Inn Restaurant.

The Albuquerque Army Air Base, established in 1940, became the Air Forces Advanced Flying School on December 24, 1941. This bombardier training school served as the primary filming location for the 1943 film *Bombardier* starring Eddie Albert, Pat O'Brien, and Randolph Scott. In 1942, Jimmy Stewart accepted an assignment to serve as an instructor for pilots of AT-6, AT-9, and B-17 aircraft. The school consistently received commendations for its record of achievement.

By the late 1950s, traffic on Route 66 along Central Avenue had reached unsustainable levels, further fueling the need to complete the interstate highway system. An article in the *Albuquerque Journal* dated October 18, 1961, reports, "The narrow underpass at the Santa Fe Railway line on Central was blasted Tuesday by the New Mexico Highway 66 Association as 'the greatest traffic slowdown in the entire 2,000 mile length' of US 66, and the group called on the city of Albuquerque to eliminate the bottleneck."

An obscure footnote in the city's development of tourism-related businesses is Little Beaver Town, a small theme park with an Old West theme that opened in the summer of 1961. The odd naming of the attraction was due to the investors' hope of capitalizing on the fame of the *Red Ryder–Little Beaver* comic strip, the creation of Fred Harmon Jr., a primary investor. Bankruptcy in 1964 led to the park's closure, followed by reorganization of the corporation and reopening under the Sage City name. Under this guise, the park primarily served as a set for local commercials and promotional films. The venture was short-lived, and vandalism and fire necessitated demolition.

A resurgent interest in Route 66, as well as a deepening understanding about the potential for economic development based on this resurgence, has made Albuquerque a leading proponent in the revitalization of historic properties associated with that highway, manifested in the city's effort to restore vintage neon signage along the Route 66 corridor and to prevent demolition of El Vado Motel.

Exemplifying the modern era on Route 66 is the former Enchanted Trails Trading Post, located immediately west of the city, near the top of Nine Mile Hill. This property, now an RV park, offers a unique experience for the Route 66 traveler,

utilizing the original building for offices, a laundry, and a gift shop. The owner, Vickie Ashcraft, has restored a wide array of vintage travel trailers, which are rented as motel rooms.

ALGODONES, NEW MEXICO

There are historical indications that a small village existed at this point on the Rio Grande floodplain as early as the first decades of the eighteenth century. The establishment of a post office in 1855 provides a date for the origins of the modern village. Further chronicling the town's evolution are the closure of this post office in 1881, its reestablishment in 1898, and a second closure in 1966.

The town's association with Route 66 was relatively brief, eleven years between 1926 and 1937. In the second edition of *EZ 66 Guide for Travelers*, published in 2008, author Jerry McClanahan notes, "From Algodones thru Bernallio, HWY 313 is a nice, scenic drive along the railroad, also signed 'El Camino Real.'" This signage indicates that this section of highway predates the era of American association.

A. LINCOLN TOURIST COURT

The 1954 edition of the *Western Accommodations Directory* published by AAA contains a listing for the A. Lincoln Tourist Court, located at 2927 South Sixth Street, Springfield, Illinois. "South edge on U.S. 66 city route. A brick court and rooms in house. Air conditioning or fans, radios, tiled combination or shower baths and central heat; 9 car ports. Playground." Rates listed range from $5.00 to $8.50.

The twenty-four-unit auto court—plus guest rooms in the large two-story home of the proprietors, Mr. and Mrs. W. D. Posegate—opened in 1947 with promotion heralding the accommodations as "ultra modern" and providing "year round comfort." Near-constant renovation transformed the property and kept it competitive with facilities that were more modern.

By the late 1950s, the property bore little resemblance to the original facility. A large modern office and residence had replaced the two-story home, a swimming pool and an additional eighteen units were added, and the grounds were landscaped. Demolition of the complex occurred in the mid-1990s. In the summer of 1996, the new Cozy Dog Drive In opened on the site.

ALLANTOWN, ARIZONA

Established as a siding, the town was named after Allan Johnson, a construction superintendent with the Atlantic & Pacific Railroad, predecessor to the AT&SF Railroad. The primary function of the siding was to ship cattle from the ranch of A. G. Johnson.

With establishment of the National Old Trails Highway, and later Route 66, the site became an oasis for motorists. In 1946,

according to Jack Rittenhouse, businesses included a gas station, a grocery store, a curio shop, and Stafford's Café.

In the preinterstate highway era, travelers on Route 66 associated Allantown with a large geodesic dome structure that housed Indian City. This facility, however, no longer exists. Another unique structure here was the Indian City Exon office. Photographed in December 1970 as part of the EPA Documerica program, the structure looked like a teepee with doors and windows.

ALLENTON, MISSOURI

The site of Allenton was named for Thomas R. Allen, senator and president of the Pacific Railroad Company, who platted the town site in 1852. The community's association with the post-1932 alignment of Route 66 is negligible.

A 1946 route guide indicated it was a small town of 301 people across the railroad tracks from the highway. This guide also noted, "It offers no tourist facilities on U.S. 66."

Establishment of the limited-access, four-lane alignment of Route 66 in 1956 initiated a period of dramatic transition in Allenton, as it did with nearby Eureka, which escalated into the building boom that coincided with the opening of the Six Flags over Mid-America amusement park.

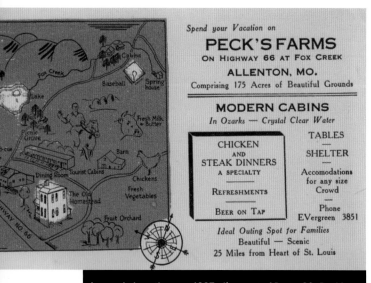

Located along the post-1937 alignment of Route 66, Peck's Farms exemplifies the profitability derived from a location along that highway that prompted many farmers to turn from agriculture to providing services to travelers. *Steve Rider*

AMARILLO, TEXAS

The initial name for the community at this site was Oneida. The current name is derived from the Spanish word for yellow, describing the color of the soil as well as the native flowers that dominated these plains.

Ranching (commencing with the establishment of ranches in the Palo Duro Canyon area by Charles Goodnight in late 1876), the railroad, oil and gas wells beginning in 1918, and automotive tourism that began in earnest with the establishment of the Ozark Trails Highway System in the early teens were the catalysts for initial development. The Route 66 chapter for the city commenced in 1926 with the highway's commissioning and the adaptation of sections of the Ozark Trails System, including Sixth Street, Amarillo's first paved roadway.

There are two primary alignments of Route 66 in Amarillo. The initial alignment was Eighth Avenue, later signed as Amarillo Boulevard, south on Fillmore Street, west on Sixth Street, and then Bushland Avenue. The second alignment exclusively followed Amarillo Boulevard, bypassing large sections of the downtown district.

Indicative of the role Route 66 played in the economic development of the city's tourism industry is the growth of the lodging industry from 1927 to 1955. The 1927 AAA directory lists three hotels (the Blackstone, Herring, and Lewis) and two repair facilities (Ballew-Satterfield Garage and the Buick-Cadillac Garage at 219 Polk Street). The AAA directory from 1940 lists three recommended properties, all motels: Bungalow Courts at 1004 North Fillmore Street, Grande Tourist Court at the junction of U.S. 60 and U.S. 66, and the Pueblo Court just east of the city limits. A 1946 guide lists eight hotels, thirty-six "auto courts," and numerous garages.

The 1954 edition of the *AAA Western Accommodations Directory* lists two hotels, Capitol Hotel, Herring Hotel, and seventeen motels. Of these, one (the Ranch 66 Motel) capitalized on its location to ensure its promotions were memorable.

In the *Western Accommodations Guide* for 1955, the display ad appears as a weathered wooden sign emblazoned with "Amarillo's Beautiful New Motel—Air Conditioned—Swimming Pool—Radio—Television." Accompanying this is "Ranch 66 Motel—6666 Hwy. 66 West, Amarillo, Texas—Ken Bourland, Manager." This guide also lists four recommended restaurants on Route 66: Dell's Ranch House Restaurant (48800 Northeast Eighth Street), Neal's Charcoal Broiler (900 Northeast Eighth Street), Rice's Dining Salon (705 Northeast Eighth Street), and Silver Grill Cafeteria (704 Tyler, two blocks south of Route 66).

The Negro Motorist Green Book for 1949 has extensive listings for this city as well. There are three hotels, Mayfair at 119 Van Buren Street, Watley at 112 Van Buren Street, and the Tennessee at 206 Van Buren Street. Restaurants listed are Tom's Place (322 West Third Street), New Harlem (114 Harrison Street), and Blue Bonnet (400 West Third Street). Other available services were M & M Garage at 202 Mississippi Street, the

Workingman's Club, listed as a roadhouse, at 2020 Harrison, and Carter Brothers Service Station on West Third Street.

The city has been relatively slow in capitalizing on the resurgent interest in Route 66. Notable exceptions would include the ongoing renovation of the Triangle Motel that resulted in designation on the National Register of Historic Places and an award presented by Kaisa Barthull of the Route 66 Corridor Preservation Program to the owners, Alan McNeil, and his mother, Marianne, at the 2011 International Route 66 Festival.

Primary attractions of interest to Route 66 enthusiasts include the thirteen-story Santa Fe Railroad Building, constructed between 1928 and 1930 at a cost of $1.5 million, and the Big Texan Steak Ranch. Because of its relocation to its current spot along Interstate 40 in 1972, it is not technically a Route 66 restaurant.

Between Western and Georgia Streets along Southwest Sixth Avenue, a former alignment of Route 66, in an area known as the San Jacinto Heights Addition, are numerous historic structures of particular note. Among these would be the Bussey Buildings dating to the 1920s, the first commercial buildings in this district, the Cazzell Buildings, one of which housed a general store and post office shortly after its opening in 1918, and the Carolina

Building, a strip commercial building built in the Spanish Colonial architecture style in 1926.

Buildings in this district directly associated with Route 66 are numerous. Listed among these are the Adkinson/Baker Tire Company building (a service station built in 1939), the Dutch Mill service station and café (1932), Taylor's Texaco Station (1937),

Promotion for the Ranch 66 Motel located at 6666 West Sixty-Sixth Street in Amarillo, Texas, published by AAA in 1954, proclaimed this was "a first class court with spacious, tastefully decorated one and two room units." *Mike Ward*

Amarillo, as with most every community along Route 66 in the 1950s, turned to colorful, eye-catching brochures to capitalize on the dramatic surge in tourism during the postwar era. *Steve Rider*

AMARILLO, TEXAS *continued*

and Martin's Phillips 66 Station (built in 1963 to replace an older circa-1934 structure).

Though it is located just south of Route 66 on South Georgia Street, the "Natorium" (Nat Ballroom) has long been associated with that highway. Built in 1922 as an indoor swimming pool and health club, extensive remodeling transformed it into a ballroom in 1926. Before its closure in the early 1960s, the Natorium was a central component in the city's cultural scene. Headliners that appeared here included Duke Ellington, Tommy Dorsey, and Harry James. Restoration is ongoing, and in January 2012, plans were initiated to transform it into an antique mall. During the 2011 International Route 66 Festival, Joe Loesch and the Road Crew, recipients of the Bobby Troup Award at that festival, performed at the Nat.

In June 2011, Amarillo served as the host city for the International Route 66 Festival with a theme of Deep in the Heart of Historic Route 66. Recognized at the awards banquet for having traveled the longest distance to attend were Akio Takeuchi of Japan, and Dale and Kristi Anne Butel, Richard and Robyn Hattrill, and John Mascali of Australia. The keynote speaker at the awards ceremony was Michael Wallis, author of *Route 66: The Mother Road*. Wallis, cofounder of the Route 66 Alliance, spoke on Route 66 as a highway of memories made and memories yet to be made.

In the 1940 edition of the *AAA Directory of Motor Courts and Cottages*, the listing for Grande Tourist Court proclaimed this to be "one of Texas' finest motor courts with 68 ultra modern units." *Mike Ward*

AMARILLO ARMY AIRFIELD

Initially, the U.S. Army Air Corps utilized English Field, the primary commercial airfield serving the Texas Panhandle, but official activation of the Amarillo Army Airfield on adjacent grounds occurred in April 1942. By September of that year, with the base still unfinished, classes for the training of aircrews and ground mechanics for the B-17 commenced. Institution of additional courses from 1943 to 1945 included instruction for flight engineers and technicians. During this period, flying operations commenced, and Edwin Waldmire Jr., the father of famous Route 66 artist Bob Waldmire, was stationed here. It was at this PX that he developed the recipe for his deep-fried, breaded hot dog on a stick that became the iconic Cozy Dog.

In September 1945, with the cessation of hostilities, Amarillo Army Airfield received designation as a permanent base assigned to the Technical Training Command. Postwar budget cuts resulted in the closure of the base in September 1946, but through the War Assets Administration, the base became a civilian facility. During this period, many buildings were converted or relocated, and others were dismantled for use at other locations. The base, reactivated as Amarillo Air Force Base in March 1951, became the first school for jet mechanic training.

Under the Air Training Command, activation of the 3320th Technical Training Wing added to the base's importance with the training of airmen from various allied nations. In 1954, the base again received permanent installation designation, and more classes were added.

In the same year, the Air Defense Command established a mobile radar station here in support of the permanent ADC radar network. Evolution of this aspect of the base resulted in the designation of the unit as NORAD ID Z-88 in July 1963.

Deactivation of the airfield became official on December 31, 1968. A portion of the base reopened as the Amarillo Air Terminal, now the Rick Husband Amarillo International Airport, on May 17, 1971.

The long runway built by the air force bisected the original alignment of Route 66. As a result, this remains one of the few portions of that highway not accessible in Texas.

AMBASSADOR LODGE

Built by Louis Bartot, a retired miner, in a style that blended Spanish influences with art deco touches, such as the use of rounded glass bricks at the corners, the Ambassador Lodge opened at 1601 West Highway 66 in Gallup, New Mexico, in 1946. With the exception of signage reflecting the name change to Ambassador Motel in 1959, the property retains most of its original architectural attributes. As of late 2010, it remained in operation, though its primary business consisted of long-term rather than nightly rentals.

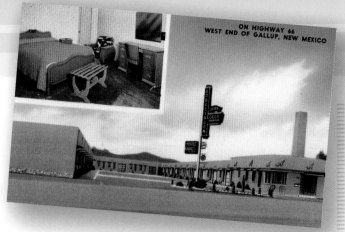

The *Western Accommodations Directory*, published by AAA in 1954, listed the Ambassador Lodge as a facility with a wide array of amenities, including radios, alarm clocks, and glass-door showers. *Mike Ward*

AMBLER'S TEXACO

Built in the domestic style developed by Standard Oil Company in 1916, Ambler's Texaco in Dwight, Illinois, dates to 1933 when Jack Schore, with assistance from his son, built the facility at the intersection of Illinois Route 17 and U.S. 66. Three years later, Schore leased the property to Vernon Von Qualon, who operated it for two years before turning it over Basil "Tubby" Ambler. Ambler operated the station from 1938 to 1965, and during his tenure, numerous modifications, including construction of two service bays allowing for the repair of vehicles year-round, ensured profitability.

In the late 1960s, the property changed hands several times before its acquisition by Phil Becker in March 1970. He operated the facility as a Marathon station for more than twenty-six years.

Added to the National Register of Historic Places on November 29, 2001, the restored facility now serves as a Route 66 interpretive and visitor center with free brochures detailing historic sites in Dwight. In addition, the complex includes period gasoline pumps, displays, and an automated audio information kiosk.

The refurbished Ambler Becker Texaco station in Dwight, Illinois, is a living time capsule as it now serves as a visitor center and tangible link to the era of "We Like Ike" buttons.

AMBOY, CALIFORNIA

Attributed to Lewis Kingman, a survey engineer for the Atlantic & Pacific Railroad (later the Atchison, Topeka & Santa Fe Railroad), is the system of alphabetical designations for station names between Amboy and the Colorado River. In addition to supplying water for the railroad, this siding served as a supply and distribution point for area mines and the salt harvesting operations that commenced about 1858.

For travelers on the National Old Trails Highway, the sparse services that included basic lodging, fuel, and automotive service available at Amboy made it a literal oasis. Indicative of the importance of Amboy to early motorists in the desert is the listing of the J. M. Bender Garage, a complex that dated to the late teens, in the *Hotel, Garage, Service Station, and AAA Club Directory* of 1927, the only approved service facility between Barstow and Needles.

The *AAA Directory of Motor Courts and Cottages* published in 1940 indicates the original Bender facility had expanded during the 1930s to include an improved café and motel, Bender's De Luxe Cabins. Between 1930 and 1950, expansion of the facilities in

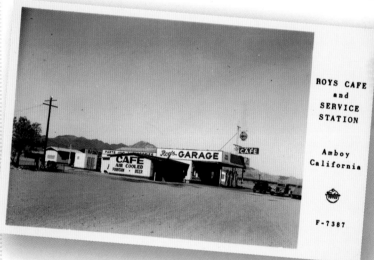

By the 1950s, the desert oasis of Amboy was largely a family-owned empire with the Roy's complex of motel, service station, garage, and café dominating. *Steve Rider*

Amboy included another garage, a motel, and Roy's Café, endeavors initiated by Roy Howard, namesake for the famous café and father-in-law of Buster Burris. Listed in the 1954–55 *AAA Western Accommodations Directory* is only one facility, Roy's Motel, with rates of $4.00 to $6.00.

In the seminal work by Michael Wallis, *Route 66: The Mother Road*, Buster Burris, owner of the motel, café, and service station and later most of the town of Amboy, recounted the importance of Route 66 to the community: "The heavy highway business started about forty-eight. After the war, my cabins were busy. We kept

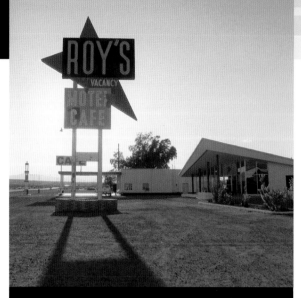

The towering sign for Roy's Motel and Café has cast its shade across this dusty parking lot and Route 66 since 1959.

AMBOY, CALIFORNIA *continued*

them rented night and day. Folks pulled over and slept in their cars when they couldn't get a room. That's how busy it was in Amboy.

"From the late 1940s into the early seventies this place was a madhouse. We kept everything open twenty-four hours a day. I had ninety people working for me full time. During the summer, the numbers of workers could get as high as a hundred and twenty.

"Then everything changed. The interstate was completed. It was just like somebody put up a gate across Route 66. The traffic just plain stopped. That very first day it went from being almost bumper to bumper to about a half dozen cars."

Shortly after the bypass of this section of Route 66 in 1973, Burris bulldozed many structures to avoid tax liabilities. The service station, café, and motel (currently under renovation) and the school, several houses, and the church (currently closed) are the primary existing structures. Restoration efforts commenced with acquisition of the property by Albert Okura, a California restaurant entrepreneur. Plans are to reopen the café, motel, and cabins.

The towering Roy's Motel–Café sign has cast its shadow across Route 66 since 1959. This sign is now one of the most widely recognized Route 66 landmarks in the world.

ANDY'S STREET CAR GRILL

Located at the corner of Elm Street and Jackson Avenue in Lebanon, Missouri, Andy's Street Car Grill, opened by Andy Liebel in 1946, exemplified the entrepreneurial creativity fueled by the potential for business resulting from traffic on Route 66. Linking two former street cars from Springfield, Missouri, Liebel created the grill and promoted it heavily with signs that proclaimed the finest food in the Ozarks and fried domestic rabbit.

Demolished in 1961, shortly after realignment of Route 66, the grill only survives in vintage postcards sought by collectors.

ARCADIA, CALIFORNIA

Archaeological evidence indicates settlement in the area of Arcadia, California, for at least the last three thousand years. The historic association with the site commences with a land grant given by the Spanish government to Hugo Reid.

A succession of owners improved on and expanded Reid's initial development. In 1875, Elias J. "Lucky" Baldwin purchased a large tract of land that include the present town of Arcadia for $200,000. Baldwin developed the land as orchards, as well as for farm and ranch use.

Initial platting, and naming, of this community in the San Gabriel Valley was the work of Herman A. Unruh of the San Gabriel Valley Railroad. The name selection was inspired by popular poetry that portrayed the Arcadia district of Greece as a place of natural beauty and rural simplicity.

On July 27, 1903, with a population of five hundred, the city of Arcadia incorporated. During the same election, Baldwin was elected president of the board of trustees and Elmer Anderson the city marshal. A fire that devastated the White Horse Saloon on North Santa Anita Avenue in the spring of 1909 resulted in the board of trustees allocating money to purchase firefighting equipment and expanding the duties of the city marshal to include the position of fire chief as well as responsibility for the collection of city fees and taxes. In July 1926, the title of chief of police replaced the title of city marshal, and in 1936, fire chief and police chief became two separate positions.

Even though Arcadia was largely a rural community during the prewar period, several violent crimes ensured that this community would feature in national headlines. In the early morning hours of July 19, 1927, officer Albert E. Matthies stopped to investigate three suspicious men sitting in a car in the area of Northview and Laurel. Without warning, a man in the back seat opened fire, killing the officer instantly. The suspects fled the scene. When later arrested in the stolen car that prompted the hasty shooting, they

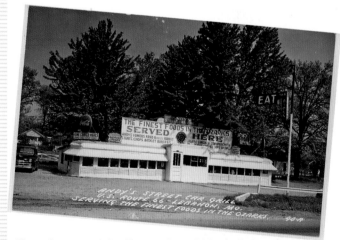

The endless stream of traffic along Route 66 inspired all manner of creative enterprise. In 1946, Andy Liebel transformed two former Springfield street cars into Andy's Street Car Grill. *Steve Rider*

told investigators that the officer had stopped them moments before they initiated the robbery of the Wigwam Barbeque on Foothill Boulevard, Route 66.

A second Route 66–related shooting involving Arcadia police officers occurred on February 25, 1959, when Bill Mitter and Jack Renner received a call that a robbery was in progress at a market on the corner of Santa Anita and Foothill Boulevard. Upon their arrival, both officers were wounded by heavy gunfire, which riddled their patrol car. The assailants, never identified or apprehended, fled on Route 66.

The initial transition from agricultural to residential bedroom community for the greater metropolitan area commenced in the late

Lyon's Pony Express Museum, with its staggering collection of authentic memorabilia from the era of the western frontier, remained a major attraction until its closure in the 1950s. *Steve Rider*

The Westerner Hotel in Pasadena, California, in 1954, was promoted as "one of the state's finest motor hotels" by AAA. Rates ranged from $5.00 to $20.00. *Mike Ward*

1930s with the Rancho Anita subdivision carved from the former Baldwin Ranch. Also carved from this ranch was the world-famous Santa Anita Race Track, established in 1904 by Elias Jackson "Lucky" Baldwin.

During World War II, the racetrack underwent extensive modification for its transformation into a military facility. In this configuration, the property served as an internment camp for Japanese Americans.

Indicative of the increasingly urban landscape in Arcadia during the postwar era is the lack of AAA-recommended lodging until publication of the 1954–55 *AAA Western Accommodations Directory*. In this edition, the Westerner Hotel (161 Colorado Place) is listed as, "One of the state's finest motor hotels A beautiful, new motor hotel close to everything but out of city traffic." Amenities listed include a restaurant, shuffleboard, free television in all rooms, a swimming pool, and lanai rooms.

From 1935 to 1955, a primary attraction was Lyon's Pony Express Museum, a stunning collection of more than one million items from the Western frontier period. The museum derived a portion of its income by leasing items for use as props in movies.

Jack Rittenhouse, in his 1946 guidebook, ran most communities between Rialto and Los Angeles into a single entry. However, for Arcadia he noted, "Just west of Arcadia, you pass the Pony Express Museum, containing a historic collection of stagecoaches and old western relics."

Along the Route 66 corridor in Arcadia are a number of historic structures and businesses. Of particular interest is the Derby restaurant, the 100-to-1 (a bar), and Rod's Grill.

ARCADIA COURT

Initial promotion billed the Arcadia Court, opened in late 1938, as having the "finest appointments for the fastidious guest." The 1940 edition of the *AAA Directory of Motor Courts and Cottages* listed the property, noting that rates were $3.00 to $3.50 and available amenities included air conditioning and private baths.

Numerous expansion projects through the 1960s transformed the property with the addition of a swimming pool and a second story, resulting in a forty-seven-unit complex. During this period, the name changed to Arcadia Motel after a short period of promotion as Arcadia Lodge.

The *Western Accommodations Directory* for 1954, also published by AAA, features an expansive advertisement: "An attractive Spanish style court on landscaped grounds. Air cooled units have one or two rooms, central heat and tiled shower or combination baths. Baby beds. Restaurant adjacent. Pets allowed."

Plans for renovation of the property, located at 909 East Andy Devine Avenue in Kingman, Arizona, during the 1990s never fully materialized. Instead, it received minor upgrades and is now a complex of apartments rented by the week or the month.

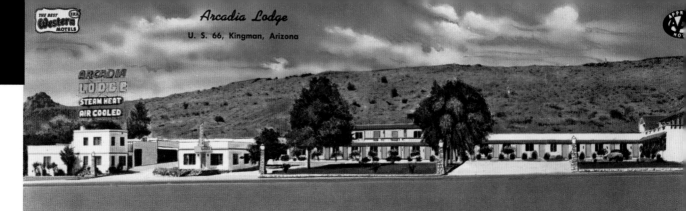

THE BEST Western MOTELS

Arcadia Lodge
U. S. 66, Kingman, Arizona

ARCADIA
LODGE
STEAM HEAT
AIR COOLED

The Arcadia Lodge was fifteen years old in 1954, but it still garnered approval with AAA that promoted the property as being "an attractive Spanish style court on landscaped grounds." *Mike Ward*

ARCADIA, OKLAHOMA

Purportedly a contingent of U.S. Rangers, including Washington Irving, author of *Rip Van Winkle*, encamped at this location in the fall of 1832. A 1946 route guide notes that a historical marker located on the east side of town attested to this.

The 1890 establishment of the post office in Arcadia is the general reference point for the community's date of origin. Farming, particularly cotton, was the foundation for the local economy until the advent of automotive tourism led to the development of a service industry that expanded with certification of Route 66 in 1926.

Highway traffic served as a catalyst for reconstruction after a devastating fire swept through the business district in 1924. A 1946 route guide lists an auto court, café, gas station, grocery store, and general store as the primary businesses.

Lyons Park near Arcadia served as a recreational center for the African American community in Oklahoma City. Amenities at the park included a swimming pool and dance pavilion. Additionally, traveling circuses, carnivals, and Vaudeville-type shows stopped at the park.

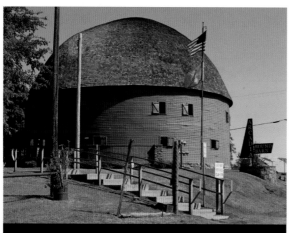

Built in 1898, and refurbished in 1989, the round barn in Arcadia, Oklahoma, is a treasured landmark that doubles as a visitor center. *Jim Hinckley*

Today, Route 66 enthusiasts associate Arcadia with its round barn, a unique structure listed on the National Register of Historic Places in 1977 that serves the community as a location for special functions and as the offices of the Arcadia Historical and Preservation Society. The barn, sixty feet in diameter and forty-three feet in height, built by William F. Odor in 1899, was in a state of near collapse in the 1980s before its refurbishment by Luke Robison and area volunteers.

Pops, located immediately to the west of Arcadia, is indicative of a new era on Route 66. Futuristic design of all aspects of the facility, including the gasoline pumps, seems to serve as a cocoon for a soda pop shop and small restaurant lifted from the 1950s, and an illuminated sixty-six-foot-tall pop bottle offers a modern incarnation of the neon once common along the highway.

Pops served as the venue for the introduction of *Route 66 Sightings* in October of 2011. This book, featuring the best photography and select writings by Jerry McClanahan, Shellee Graham, and Jim Ross, received critical acclaim upon its release.

ARISTON CAFÉ

The original Ariston Café opened in Carlinville, Illinois, in 1924, but with the highway realigned to the east in late 1929, founder Pete Adam relocated the business to Litchfield.

Construction of the current building, directly across the street from the original Litchfield restaurant, commenced in late 1934, and the doors opened for business on July 5, 1935. With the exception of two major modifications—the addition of a banquet wing and the modern front doors with awnings in 1973—the interior, with numerous original components, remains much as it was in 1935.

In 1940, a four-lane bypass of Route 66 completed at the rear of the restaurant prompted owner Pete Adam to adorn the back of the restaurant with neon signage to ensure continued business. Listed on the National Register of Historic Places in May 2006 and inducted into the Route 66 Association of Illinois Hall of Fame in 1992, the Ariston Café is (as of this writing) managed by Nick Adam, son of Pete Adam.

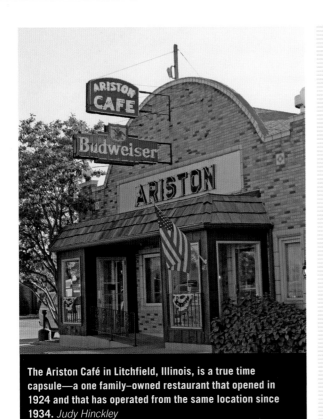

The Ariston Café in Litchfield, Illinois, is a true time capsule—a one family–owned restaurant that opened in 1924 and that has operated from the same location since 1934. *Judy Hinckley*

ARKANSAS RIVER BRIDGE

Built by the Missouri Valley Bridge & Iron Company in 1916 and 1917 for a cost of $180,000, the 11th Street Arkansas River Bridge in Tulsa, Oklahoma, was a determining factor in the route U.S. 66 initially followed through that city. The bridge is of the multispan, arch type with eighteen spans set on piers sunk into bedrock. Completed in 1917, the bridge represented the most modern of engineering and architectural designs. At 1,470 feet in length, it was one of the longest concrete spans in the Midwest. It supported a railroad line as well two lanes for vehicular traffic and a sidewalk along each edge. Initially, it also featured classic-styled balustrades and Victorian-type lighting. Modernization in 1929 resulted in the replacement of these design features with art deco–styled guardrails and modern lights.

A major renovation occurred in 1934 when the roadbed was widened from thirty-four feet to fifty-two feet, eight inches. This allowed for the accommodation of four lanes of traffic. The bridge remained in service until 1980.

Listed on the National Register of Historic Places in 1996, the bridge became an integral component in the Vision 2025 initiative approved by Tulsa County voters in 2003. In 2004, the bridge was designated the Cyrus Avery Route 66 Memorial Bridge, and as of winter 2010, plans for renovation, including a visitor center near the site, were still pending.

ARLINGTON, MISSOURI

Arlington has an interesting history that begins with indefinite origins. However, the consensus is that as a settlement, it dates to at least the 1860s. With the redrawing of county lines as Missouri evolved, Arlington appears on various maps of the past century as being in St. Louis, Gasconade, Crawford, Pulaski, and Phelps Counties.

This community was at the original crossing site of Route 66 over the Little Piney River. Stoneydell, another footnote to the community's association with the highway and a once-popular resort, is now only ruins, old cabins, and foundations located by taking exit 176 off of I-44 and driving about one mile. The Stonydell Resort originally opened in 1932 to great acclaim. Amenities included a one hundred–foot-long swimming pool, a hotel, cabins, a restaurant, and a large goldfish pond. With the construction of I-44 in 1967, however, demolition erased much of the complex.

An interesting footnote in its history is found in *A Guide Book to Highway 66*, written by Jack Rittenhouse in 1946: " . . . no gas or other facilities. Arlington is a small, old-style village whose main street was cut off by a new highway. In 1946, the buildings of the town were sold for $10,000 to Rowe Carney, of Rolla, who intends to develop it as a resort." This is in contrast to a listing in the 1940 *AAA Directory of Motor Courts and Cottages*: "Powellville Service Cottages. $1.50. Public Showers. Café."

Among its numerous associations with Route 66, Arlington has the distinction of being on the last segment of that highway to be paved in the state of Missouri. Highway workers celebrated this achievement on January 5, 1931, by tossing coins into the wet concrete.

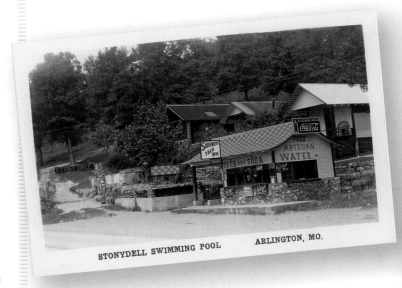

STONYDELL SWIMMING POOL ARLINGTON, MO.

The Stonydell Resort remained a popular destination until the construction of I-44 erased a large swath of the complex in 1967. *Steve Rider*

ARMIJO, NEW MEXICO

Jose de Armijo, the namesake for this community, now a suburb of Albuquerque, immigrated to the area in 1695. In the 1880s, a descendant, Policarpio Armijo, was instrumental in renaming the community from Ranchos de Atrisco to Armijo. It was under this name that the post office opened in 1883 and operated until 1886 before it closed and reopened in 1906 under the name of Old Albuquerque. In 1909, it became a branch of the Albuquerque post office.

The original alignment of Route 66 ran south from Albuquerque on Isletta Boulevard, through Armijo, Parajito, and Los Padillas, to Isletta Pueblo. The realignment of 1936 and 1937 bypassed this section to continue west on Central Avenue.

Jerry McClanhan, in *EZ 66 Guide for Travelers* (second edition), published in 2008, says of this section of the original alignment of Route 66: "The towns south of Albuquerque blend together, a succession of walled adobe houses among the trees, small farms, and a few old roadside remnants."

ARROWHEAD CAMP

Located on the pre-1937 alignment of Route 66, approximately twenty-two miles east of Santa Fe, New Mexico, Arrowhead Camp opened shortly before certification of U.S. 66 in 1926. The facility was quite sophisticated for such a remote location. In addition to the campground, there was a store, a service station, and some cabins. The business survived the bypass, and travel guides from the 1940s list the property as Arrowhead Lodge with amenities that included showers, a trailer camp, and a café.

During the 1950s, the facility opened and closed through a succession of owners. The property as of 2011 consisted of the heavily overgrown ruins of the log cabin–type main building. Russell A. Olsen's book, *The Complete Route 66 Lost & Found*, features photos of the camp in the 1920s and in 2005.

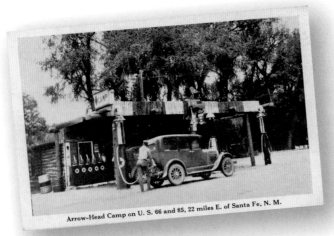

Arrow-Head Camp on U. S. 66 and 85, 22 miles E. of Santa Fe, N. M.

A promotional advertisement published by AAA in 1940 noted that Arrowhead Camp offered cabins, public showers, café, and trailer parking. Rates ranged from fifty cents to $5.00. *Steve Rider*

ARROWHEAD LIQUORS

Arrowhead Liquors, 318 East 2nd Street, eastbound Route 66 in Winslow, Arizona, opened in 1933. As of the summer of 2011, it remained operational as a liquor store and bar.

ARROWHEAD LODGE

Rex E. Goble established his auto court at 2010 East Santa Fe Avenue in Flagstaff, Arizona, in about 1936. In 1939, new owners put up a sign that called it the Arrowhead Lodge.

The *Directory of Motor Courts and Cottages*, published by AAA in 1940, gives the property a cursory entry: "Arrowhead Lodge, 1 mile east on U.S. 66. 10 cottages with baths, $3.50 to $5.00." The property also received recognition in the Jack Rittenhouse guide published in 1946.

A series of renovations through the 1950s transformed the complex, and in June 1959, new signage promoted it as the Gaslite Motel, advertised as the motel "with a friendly glow that's difficult to leave—impossible to forget." Additional changes occurred in the 1960s when it became the Twilite Motel. As of late 2010, the property still existed as the Arrowhead Lodge and Apartments.

ARROWHEAD TRAIL

The Arrowhead Trail, also referred to in early guidebooks as the Arrowhead Highway, was the first all-weather, regularly maintained automotive road connecting Salt Lake City with Los Angeles. Built in the early to mid-teens, the road saw several major realignments in its short history, but the sections incorporated into the portion of the federal highway system designated U.S. 66 were those that went through Goffs, Daggett, Barstow, Victorville, Oro Grande, and Helendale.

ARROYO SECO PARKWAY

The nine-mile-long Arroyo Seco Parkway (renamed the Pasadena Freeway in 1954) connecting Arroyo Parkway and Sunset Boulevard is considered California's first modern, limited-access freeway. It is the only National Scenic Byway fully encompassed by a metropolitan area.

Its opening on December 1, 1940, represented the culmination of a cooperative venture between the cities of Los Angeles, Pasadena, and South Pasadena to relieve congestion in the foothills area. The opening ceremony was a gala affair that included Culbert Olson, governor of California. Almost immediately after its designation, signage made it official that this was part of U.S. 66.

From January 1, 1964, through December 31, 1974, the intersection of Colorado Street and Arroyo Parkway served as the official western terminus of Route 66. With decertification of Route 66 in California on January 1, 1975, the official western terminus became the Colorado River crossing at the Arizona state line.

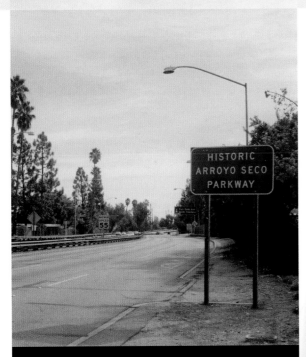

When the Arroyo Seco Parkway was incorporated into the U.S. 66 highway system in 1940, it remained a parkway designed for maximum speeds of forty miles per hour.

ART'S MOTEL

Purportedly, Art McAnarney entered into partnership with Marty Gorman in 1932 and for the next five years operated a wide array of businesses in the area of Farmersville, Illinois. Most of these, including gas stations and dance halls, were legitimate enterprises, but local legend has it there were others, including casinos and speakeasies.

In 1937, McAnarney sold his share of the various enterprises to Gorman and leased the building that had housed the Hendricks Brothers Café and adjoining gas station. In addition to the restaurant and gas station, McAnarney added a six-cabin motel complex. After a fire in 1952 extensively damaged the main building, evaluation determined the second floor was not salvageable, so McAnarney took this as an opportunity to modify and expand the first floor dining facilities. Upon his death in 1957, Elmer and Joe, his sons, inherited the business. In 1960, they expanded the complex to include a traditional thirteen-room motel in an "L" configuration.

The completion of Interstate 55 in the early 1970s, with inclusion of an exit for Farmersville almost directly in front of Art's Motel and Restaurant, allowed the place to avoid the fate of many establishments along Route 66 that were adversely affected by the construction of the interstate highway system and the resultant bypass. After a brief period of closure in the 1980s and induction into the Illinois Route 66 Hall of Fame in 1995, refurbishment transformed the property into a favorite stop for travelers rediscovering Route 66.

The fifteenth edition of the *Route 66 Dining & Lodging Guide*, published by the National Historic Route 66 Federation in 2011, lists the facility as "good." It also notes that the Route 66 Association of Illinois provided funding to restore the vintage signage and that concessions to the modern era include nonsmoking rooms, as well as Internet connections.

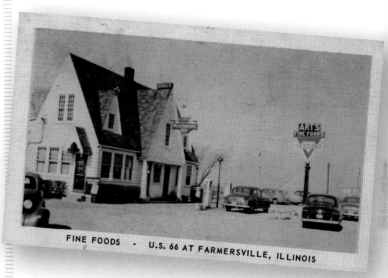

FINE FOODS - U.S. 66 AT FARMERSVILLE, ILLINOIS

Art McAnarney opened Art's Fine Foods, a complex consisting of a service station, restaurant, and six cabins, in 1937. The restaurant burned in 1952. *Steve Rider*

ASH FORK, ARIZONA

The confluence of the three tributaries of Ash Creek served as an important place of rest for travelers during the pre–Spanish colonial era; for early American trappers and explorers, including Kit Carson, Ewing Young, Antoine Leroux, and Bill Williams; and for the initial survey parties of the Army Corps of Topographical Engineers during the 1850s. The current manifestation of Ash Fork near this site dates to 1893 after a devastating fire led to relocation of the business district along the south side of the railroad tracks. The initial community dates to the 1882 establishment of a siding for the Atlantic & Pacific Railroad (later the Atchison, Topeka & Santa Fe Railroad) and the establishment of a post office the following year. As a result of the market accessibility made possible by the railroad siding, large ranches like the Ash Fork Livestock Company were established. Stockyards at both ends of town and saloons that lined the main street of the fledgling community were manifestations of the town's economic foundations.

Many historians consider the completion of a 136-mile rail line from Ash Fork to Phoenix, through Prescott, in March 1895 to be the end of the frontier era in Arizona. The importance of this junction led to the establishment of a station and elegant

ASH FORK, ARIZONA *continued*

Harvey House, the Escalante, in Ash Fork in 1907 to replace the original one that burned in 1905. Fueling additional growth was the establishment of the National Old Trails Highway, Route 66, after 1926. A 1946 traveler's guide lists three hotels, the Escalante, the Arizona, and the White House, still existing; three auto courts, Hi-Line, Copper State (operational as of late 2011), and McCoy's; a garage; and several cafés.

The Copper State Modern Cottages, later renamed Copper State Court, built by Ezell Nelson opened for business in 1928 and was operated by this family until 1975. The Hi-Line Modern Auto

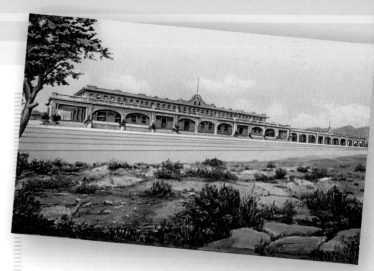

Named for explorer Silvestre Escalante, the stylish Escalante Hotel closed in 1951, the restaurant closed two years later, and in 1968, the building was razed in spite of valiant efforts by preservationists. *Joe Sonderman*

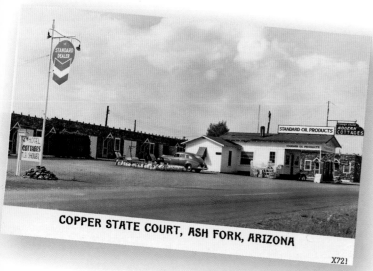

COPPER STATE COURT, ASH FORK, ARIZONA

X721

Ezell and Zelma Nelson opened the Copper State Modern Cottages, latter Copper State Court, in Ash Fork, Arizona, in 1928 and managed it through 1975. *Joe Sonderman*

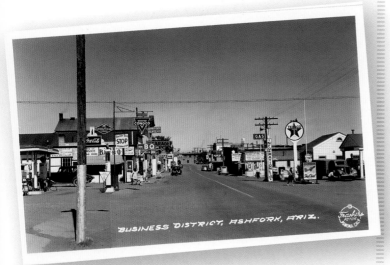

BUSINESS DISTRICT, ASHFORK, ARIZ.

This is the view Jack Rittenhouse had of Ash Fork, Arizona, in 1946 during his research tour for the now classic *A Guide Book to Highway 66*. *Steve Rider*

Court, later renamed Hi-Line Motel, opened for business in 1936 and originally included a Shell station at the center of the complex.

Shortly after the publication of this 1946 guidebook by Jack Rittenhouse, a series of disasters devastated Ash Fork. In the early 1950s, the railroad relocated operations and realigned the main line ten miles to the north of town, resulting in the closure of the Escalante Hotel in 1951 and the restaurant in 1953.

The next thirty years were particularly harsh decades for the community with the razing of the Escalante in 1968 and fires in 1977 and 1987 that erased a large swath of historic structures. The completion of I-40 in 1979, negating the need for traffic to drive through town, further fueled the decline.

Ash Fork has been slow to capitalize on the resurgent interest in Route 66. Two remaining sites of note are Desoto's Beauty and Barber Shop, housed in an old gas station with a purple and white De Soto perched on the roof (closed as of this writing), and the Route 66 Grill in the former Green Door Bar.

ATLANTA, ILLINOIS

Founded as Xenia, this community became known as New Castle in November 1847 after the establishment of its post office. The name changed again to Atalanta in 1853 and then the current spelling of Atlanta in 1861. Indications are that classical Greek mythology was the inspiration for the Atalanta name.

A 1946 guidebook indicates services at that time included a garage, a gas station, and cafés but no lodging. This guide also hints at the antiquated state of the business district: "US 66 goes down one of the main business streets, past some very old store buildings, some dating back to the 1850s."

Vestiges from the town's early history remain prevalent. Additionally, the community has capitalized on its association with Route 66 with dramatic effect. Atlanta is now a favored destination and stop for Route 66 enthusiasts.

Among the numerous attractions is the Bunyon Giant, a towering fiberglass statue cradling an equally giant hot dog built

In Atlanta, Illinois, the clock dating to 1909 that is wound every eight days by hand behind a viewing window is housed in a somewhat more modern forty-foot tower.

by the same company that manufactured the Gemini Giant, relocated from Berwyn, Illinois. Providing a more historic but colorful context to the business district are a wide array of murals and restored signs painted on the century-old brick structures by the world-famous Letterheads. Other unique attractions include an octagonal public library and museum built in 1908 of white granite that received recognition with inclusion in the National Register of Historic Places, the J. H. Hawes Grain Elevator Museum housed in a building dating to 1903, and a circa-1909 Seth Thomas clock in a forty-foot tower that is wound by hand every eight days.

Of particular note is the recently refurbished Palm's Grill Café at 110 Southwest Arch Street in the historic Downey Building. After more than a decade of closure, the resurgent interest in the highway made it economically viable to refurbish the café to its original 1935 appearance. A specialty is the blue ribbon homemade pie that received international exposure with inclusion of the café in the 2011 television special *Billy Connolly's Route 66.*

AUBRY, FRANCOIS XAVIER

On November 16, 1852, Francois Xavier Aubry left Santa Fe, New Mexico, to map a shorter route to Los Angeles, California, than the Old Spanish Trail, a trade route of more than 1,200 miles established in the late eighteenth century that looped through present-day Colorado, Utah, and Nevada. His expedition consisted of ten large freight wagons, 100 mules and horses, and a herd of 3,500 sheep that he planned to sell in California.

The following March he arrived in Los Angeles, sold the sheep near San Francisco, and immediately began organizing and outfitting an exploratory team to further map a feasible route along the thirty-fifth parallel. Utilizing information garnered from his previous trip, and interviews with Native American guides as well as trappers, he crossed the Sierra Nevada Mountains in the area of present-day Kern County, California, crossed the Mojave Desert, and continued explorations across northern Arizona into New Mexico. Upon completion of the trek, he proposed a road connecting Albuquerque with Los Angeles along his route.

Lieutenant Amiel Whipple, before commencing his survey along the thirty-fifth parallel for a proposed cross-country railroad, met with Aubry in Albuquerque. Lieutenant Edward Beale later incorporated numerous segments of his proposed road into the Beale Wagon Road, as did survey crews for the Atlantic & Pacific Railroad (later the Atchison, Topeka & Santa Fe Railroad) from Albuquerque to present-day Barstow, California. Additionally, segments of the National Old Trails Highway, and then Route 66, also followed portions of his proposed route.

On August 18, 1854, a saloon altercation resulted in Aubry's death, but his extensive journals provided a wealth of valuable information about northern Arizona and the crossing of the Mojave Desert from the Colorado River to Newberry Springs. Numerous western landmarks bear his name as mute testimony to his contributions to westward expansion. The most notable of these along the path of Route 66 is the oft-misspelled Aubry Valley to the west of Seligman (the site selected for reestablishment of the black-footed ferret in northern Arizona) and Aubry Wash in northwestern Arizona.

AUBURN, ILLINOIS

The initial settlement of Auburn, established in 1835, was located approximately one mile northwest of the current town. A post office established on the current site in 1838 was designated Sugar Creek but was subsequently changed to Auburn in March 1839, which resulted in the former community becoming Old Auburn. As a stop on the Alton & Sangamon Railroad, after 1853 the town quickly eclipsed its namesake, resulting in that community's abandonment.

The *Hotel, Garage, Service Station, and AAA Club Directory* of 1927 lists one recommended service facility in Auburn, Pierce & Ramsey Garage. An additional note indicates that after-hour service is available.

Auburn is located on a pre-1931 alignment of Route 66, State Highway 4. Between Auburn and Chatham is a very rare, hand-laid, red brick section of the original roadway, now Snell and Curan Road, listed on the National Register of Historic Places.

Epitomizing the modern era of Route 66 is Becky's Barn. The eclectic display of merchandise—ranging from antiques to hand-crafted birdhouses—as well as creative marketing, has made this a Route 66 destination for a new generation.

AVERY, CYRUS STEVENS (1871–1963)

Born in Stevensville, Pennsylvania, on August 31, 1871, Cyrus Stevens Avery relocated to Oklahoma in 1901 and established the Avery Oil and Gas Company of Tulsa in 1907. Additionally, he was instrumental in numerous residential developments through the Woodland Park Development Company, served as a Tulsa County commissioner, and was an early proponent of good roads.

In the latter capacity, Avery joined numerous transcontinental road associations and became active in their promotion, including the Oklahoma Good Roads Association. He served as the vice president of the Ozark Trails Association and was instrumental in bringing the national convention for this organization to Tulsa in 1916. Portions of this trail system were incorporated into the initial alignment of U.S. 66 after 1926.

From his position with this association, he successfully lobbied the Oklahoma State Legislature for passage of a law that stated, in part, "County commissioners shall make contracts with

persons resident along the road for regular dragging of all roads which have been graded to a roadway not exceeding twenty feet in width, sandy roads being properly clayed, the cost not exceeding five dollars per mile per year to be paid from funds raised by taxation of all the property in the county."

In addressing the Ozark Trails convention on May 27, 1914, he called attention to efforts in Oklahoma to utilize crude oil on roads in an effort to make them suitable for all weather and to lessen the need for maintenance: "Our twenty-five Independent Refiners are making the best of road oil, and when the proper methods are applied to our dirt roads, we can have a system of highways that will rival California."

From 1917 to 1927, he served as president of the Albert Pike Highway Association, an organization he helped found. This automotive trail system connected Colorado Springs, Colorado, with Arkansas via Tulsa, largely a result of Avery's efforts.

According to the *Muskogee Times Democrat* on September 19, 1917: "Tulsa people are taking a most active interest in the plans for building the Albert Pike Highway running from Arkansas through Tulsa to Colorado Springs. Recently, Mr. Cyrus Avery, president of the association, and E. Bee Guthrey, secretary, completed a trip over the proposed route from Tulsa to Arkansas."

In an article about the Albert Pike Highway published in the *Sequoyah County Democrat* on May 9, 1919, these efforts received extensive praise: "Too much credit cannot be given to Cyrus Avery, president of the association, and E. Bee Guthrey, secretary, for their friendship and loyalty to Sallisaw and Sequoayah County. These men have been the prime movers in this great work and have held their respective offices since the first convention in 1917. They have been true to our county and have favored us upon every occasion and this fact was never more clearly emphasized than at the Enid meeting."

In 1921, Avery was elected president of the group Associated Highways of America. In 1922, he accepted an appointment from Oklahoma Governor Martin E. Trapp to the position of state highway commissioner, a position that led to his appointment by the U.S. Department of Agriculture to the Joint Board of Interstate Highways in 1925. The primary purposes of this board were to develop and coordinate an interstate highway system that would utilize a uniform system of markers and signs. Initial highway designation as approved by this committee placed U.S. 60 as the highway from Chicago to Los Angles through Oklahoma. However, the change to U.S. 66 was the result of a compromise with the governor of Kentucky negotiated by Avery.

As the keynote speaker, Avery, representing the Tulsa Chamber of Commerce at a meeting of representatives of cities along "Federal Highway 66" in Tulsa on February 4, 1927, inspired attendees with ideas for promoting the highway as well as ensuring proper routing. Many of his ideas, including how to raise revenue for completion of portions of the road between St. Louis and Tucumcari, were critical components in the development of U.S. 66.

Additionally, Avery utilized the gathering of delegates and interested parties to establish the U.S. 66 Highway Association,

Often credited as the father of Route 66 for his pivotal role in the highway's numerical designation, as well as establishment of the U.S. 66 Highway Association, is Cyrus Avery. *Joe Sonderman*

From
THE GREAT LAKES
TO
THE PACIFIC

MISSOURI SCENE ON U. S. 66

The U. S. 66 Highway Association maintains headquarters and a full time secretary at 15 West Seventh Street, Tulsa, Oklahoma, on the marked route through that city, where the public is invited to call either in person or by letter for free information regarding any point on the route.

From its inception in February of 1927, the U.S. 66 Highway Association initiated promotion of Route 66 as the Main Street of America. *Steve Rider*

an organization that Avery would assume the presidency of in March 1929. According to the *Joplin Globe* on February 5, 1927: "A permanent organization, which will be known as U.S. 66 Highway Association, the Main Street of America, was perfected at a meeting of delegates from various towns along national highway No. 66 here [Tulsa] today. The association will launch a campaign to encourage the use of the highway, which is the most direct all-weather road from Chicago to Los Angeles."

In addition to this work, Avery was instrumental in the development of numerous aspects of the modern highway system. Among these was the implementation of a gasoline tax to finance highway construction and maintenance in Oklahoma, the beautification of roadsides with the planting of clover and other native plants, and the development of grading systems as well as the equipment needed for this grading.

AVILLA, MISSOURI

Nestled in a rich agricultural district, the town of Avilla began as a business and trade center established on the western fringe of the Ozarks in 1858. Historian and author C. H. Curtis in *The Missouri U.S. 66 Tour Book* claims that D. S. Holman and A. L. Love established the town site and that the name is derived from Avilla, Indiana, their hometown.

On October 28, 1861, Governor Claiborne Jackson met with the Missouri General Assembly in Neosho and declared Missouri the twelfth state to join the Confederate States of America, but leading businessmen in Avilla defied the decree by flying the American flag in the park. To defend their homes and farms from Confederate raiders and guerillas, Dr. J. M. Stemmons organized a militia company.

On March 8, 1862, this militia engaged in its first military skirmish when a group of Confederate raiders under the leadership of William T. "Bloody Bill" Anderson moved on Avilla. Killed in the ensuing action were Dr. Stemmons, three of his sons, and at least two Avilla militiamen. In the late summer of 1862, the Union Army took possession of the area, headquartered in Avilla in 1863, and authorized the local militia to patrol portions of Jasper and Lawrence Counties.

Spared much of the destruction neighboring communities experienced during the war, Avilla became a boomtown during the period of postwar reconstruction. By the early 1870s, the town supported boot stores and a cobbler, several dry goods stores, grocers, livery stables, a drug store, doctor's offices, and several attorneys. There was also a school, three churches, an Odd Fellows Lodge, and a Freemasons Lodge.

The railroad that connected Springfield with Carthage and Joplin bypassed Avilla, however, and the town began a slide only briefly interrupted with the flow of traffic on Route 66 that sparked a resurgent growth in new businesses.

The 1940 *AAA Directory of Motor Courts and Cottages* lists Log City Camp, a complex consisting of cabins, a service station, and a café, three-and–one half miles east of Avilla. Rates listed are $1.50 to $3.00 per day for two persons, $2.00 to $3.50 for four persons, and spaces for trailers were fifty cents per night. The entry also notes the "dining room and coffee shop air conditioned by washed air."

Jack Rittenhouse noted, in 1946, that the population was 178 and that available services consisted of "Gas, café, stores. The lumber yard and farm implement stores here indicates its importance as agricultural trading and supply center."

By the 1970s, a decade after I-44 replaced Route 66, Avilla was a ghost town with few businesses remaining in operation. The population today numbers around 120.

Numerous historic structures remain. Perhaps the most notable is the bank built of red brick in 1915 that now houses the post office. In 2011, proposed as a cost-saving measure by the U.S. Postal Service, this post office was included in a list of possible closures.

Housed in a bank building built in 1915, the post office in Avilla, Missouri, was one of many rural facilities slated for closure in a 2011 cost-cutting proposal by the U.S. Postal Department.

AVON COURT

Built in 1936 by John Foley, the Avon Court in Afton, Oklahoma, was a small motel consisting of seven cabins connected with covered carports. Amenities promoted in prewar advertisements included panel ray heat and a modern trailer park. The property changed hands numerous times before the bypass of this section of Route 66 in 1957. At that point, the business entered a period of precipitous decline, and today, the shells of three units and the weathered sign are all that remain, providing an interesting photo stop for Route 66 enthusiasts.

AZTEC AUTO COURT

Added to the National Register of Historic Places in 1993, the Aztec Court at 3821 Central Avenue in Albuquerque, built in late 1931 by Guy and May Fargo, was the first motel constructed on East Central Avenue. In 1995 this property, then designated by its sign as the Aztec Motel, was partially renovated and was purportedly the oldest continuously operated motel on Route 66 in New Mexico.

In spite of renovations dating to the 1950s that transformed the carports into additional motel rooms (and that replaced the original signage with modern neon), the Aztec Court remained historically significant as one of the best-preserved examples of a

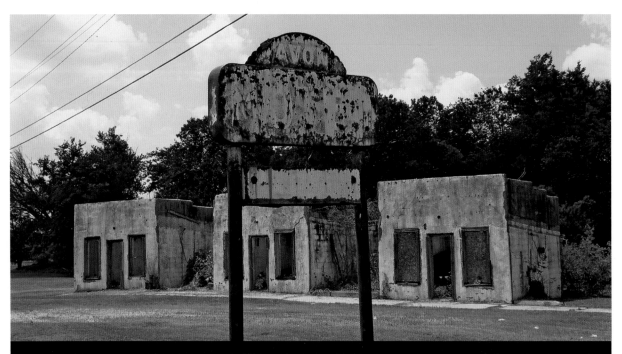

In Afton, Oklahoma, the Avon Motel that opened in 1936 as Avon Court with John Foley as the proprietor survives only as a photo stop for Route 66 enthusiasts.

prewar auto court in Albuquerque. In 2003, a cost share grant from the National Park Service Route 66 Corridor Preservation Program provided the needed finances for restoration of the neon sign. This was part of a nine-sign restoration program supported by the New Mexico State Historic Preservation Office and the New Mexico Route 66 Association. This project served as the catalyst for extensive restoration of neon signage along Route 66 in Albuquerque and throughout New Mexico.

In spite of its historical significance, and previous efforts to renovate portions of the complex, Jerry Landgraf, who purchased the property in 2006, deemed it cost prohibitive to restore the facility. In June 2011, the structure was razed.

AZTEC HOTEL

Located at 311 West Foothill in Monrovia, California, the Aztec Hotel opened in 1925 to great fanfare as an outstanding example of the newest trends in architectural styling coupled with the most modern construction techniques and extensive use of Mayan-inspired trim work. It remains as one of a few examples of this type of building and is one of the most unique buildings in Monrovia.

Architect Robert Stacy-Judd received inspiration for the design work from a popular book, *Travel in Central America*, written by a leading archaeologist of the period, John L. Stephens. Although the structure utilized Mayan details, Stacy-Judd selected the name Aztec because he felt the name would be more recognizable. The interior featured additional elements of the Mayan theme, including mosaics, reliefs, murals, and custom electrical fixtures. The furniture in the lobby further mirrored the motif drawing on Toltec, Aztec, and Inca designs.

The critical acclaim associated with the hotel's completion and opening spawned an architectural movement that manifested in the Beach & Yacht Club in La Jolla, California, the Mayan Hotel in Kansas City, and the Mayan Theater in Los Angeles, to name a few of the more notable examples. In addition, several small companies formed to produce Mayan-styled fixtures, tiles, and furniture.

In 1931, realignment of Route 66 bypassed the hotel, but it remained popular with the Hollywood elite and with other travelers through the 1930s. Listed in the National Register of Historic Places in 1978, renovation of the Aztec Hotel commenced in 2000 with grant assistance from the National Park Service Route 66 Corridor Preservation Program.

Numerous factors hindered full renovation and reopening, however. A new management team initiated endeavors to restore profitability to the historic hotel in the spring of 2011. As of January 2012, it remained open even though foreclosure proceedings were still pending.

AZUSA, CALIFORNIA

Erroneously, common folklore claims this town's name Azusa is derived from an early store that "sold everything from A to Z in the USA." In actuality, the town derives its name from a report written by Father Juan Crespi with the Portola Expedition of 1769 in which he noted the Native American village of Asuka-gna in this valley.

The European development of the site began as an 1841 land grant to Luis Arenas. In 1844, Arenas sold the properties to Henry Dalton, an Englishman, who named the ranch Azusa Rancho de Dalton.

Dalton planted a vineyard and built a winery, distillery, and vinegar house as well as a smokehouse and flour mill. In 1860, the U.S. government initiated surveying and validity studies of early Spanish and Mexican land grants, which resulted in the seizure of large sections of Dalton's property and the opening of the valley to homesteading. This initiated a land rush as well as a twenty-four-year legal battle. Loans from and land sales to Jonathon S. Slauson, an early Los Angeles banker, funded the litigation. In 1887, Slauson platted the town site of Azusa and incorporation followed in 1898.

Notable events associated with Route 66 in Azusa include the opening of one of the pre–Ray Croc McDonald's on Foothill Boulevard, Route 66, in 1954. This was the first establishment to utilize the golden arches that later became a trademark of the burger chain.

The Foothill Drive-In Theater, designated a California historic resource in 2002, was the last original drive-in on Route 66 west of Oklahoma. Jerry McClanahan, in the second edition of *EZ 66 Guide for Traveler*, published in 2008, notes, "The walls surrounding this former fresh air cinema are down, the land destined to house facilities of Azusa Pacific University. The neon marquee, however, is reportedly slated for preservation."

Additional points of interest include Corky's Coffee Shop and Wimpy's Pawn Shop. The city hall and auditorium is an architectural masterpiece built in 1932.

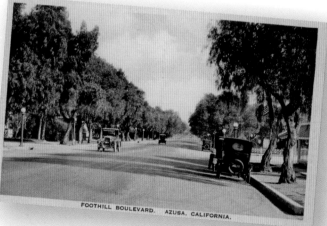

FOOTHILL BOULEVARD, AZUSA, CALIFORNIA.

Well into the postwar era, much of the Route 66 corridor from San Bernardino to Pasadena was through a vast landscape of tree-lined streets, orchards, farms, and vineyards. *Steve Rider*

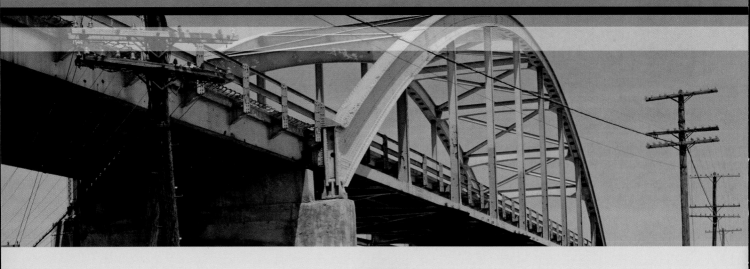

B

BAGDAD, CALIFORNIA

Initially established as a water stop by the Southern Pacific Railroad in 1883, Bagdad served as a supply and shipping point for mines in the nearby Bristol and Bullion Mountains. Shortly after the turn of the century, there was enough activity to warrant the establishment of a small Harvey House restaurant and the population peaked at nearly six hundred before 1920.

In 1923, the population had plummeted to a point where the community no longer warranted a post office. A 1946 traveler's guide to the region indicates a population of twenty-five and several businesses, including a café, tourist cabins, a gas station, and a garage. These facilities continued in operation until 1972.

Inspiration for the 1988 motion picture *Bagdad Cafe* was derived from the town and its café, owned by Alice Lawrence,

but the setting used was actually Newberry Springs. The café used for the film location in that community changed its name to Bagdad Café and is still operational.

With the adaptation of diesel locomotives by the railroad in the early 1950s, Route 66 remained the only viable source of business for the remote community. With the completion of Interstate 40 in 1973, however, and the bypass of Route 66, the café, gas station, small store, and cabins closed.

Utilization of the town site for a natural gas storage project decimated most remnants. Today there are no existing structures, and only foundations, a solitary tree, and a cemetery on the north side of the tracks remain.

As a historic footnote, Bagdad holds the unofficial record for lack of precipitation in the continental United States. Between October 3, 1912, and November 8, 1914, measurable rainfall was zero.

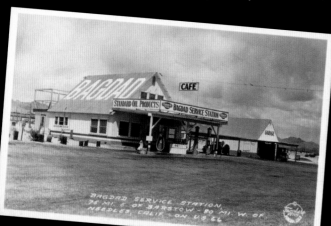

The desert oasis of Bagdad and this café served as inspiration for the 1988 film *Bagdad Cafe*. The actual filming took place in nearby Newberry Springs. *Steve Rider*

BALES PIONEER MOTEL

The 1955 edition of the *Western Accommodations Directory* published by AAA lists Bales Pioneer Motel, Springfield, Illinois, as "located 4 1/4 miles north on U.S. 66 at By-pass. . . . Rooms have shower baths, central heat, and radios; some rooms air conditioned." Rates listed range from $4.00 to $9.00. As of late 2010, the motel at 4321 North Peoria Road remained operational. Its towering neon sign is a landmark for Route 66 enthusiasts.

BALLWIN, MISSOURI

In 1837, the namesake for Ballwin, Missouri, John Ball platted the town site on his farm near Fish Pot Creek along the Manchester Road and recorded it as Ballshow. Two days later, an amendment filing changed the name to Ballwin.

Route 66 had an effect on every town through which it passed regardless of size, and Ballwin was no exception. The *Service Station Directory*, published by the American Automobile Association in 1946, lists Ballwin Motor Company for approved service.

It remained a small community even after incorporation in 1950, although the widening of Manchester Road in 1963 and suburban development served as catalysts for growth and transition, mirrored in the town's status as a major retail area.

BARD, NEW MEXICO

Initial settlement in Bard dates to 1906, and population became sufficient to warrant a post office in 1908. The following year, acceptance of an amended post office application changed the name to Bard City, and another amendment in 1913 changed it back to Bard.

Numerous sources claim the name comes from the association a pioneering family had with a railroad siding named Bard in Texas. However, the most probable namesake is the Bar-D Ranch operating in the area at the time of the town's establishment.

On three different occasions, the entire town relocated to capitalize on the change in traffic patterns from predominately railroad to automotive. A 1946 highway guide indicates a population of twenty-six and a sparse business district consisting of a gas station, garage, and post office. Today Bard is a ghost town.

Russell's Truck Stop opened near the site in late 2009. The unique complex blends the modern, all-purpose travel center with an automotive museum and Route 66 gift shop.

BARNEY'S BEANERY

Unofficially the third-oldest eatery in continuous operation in Los Angeles County is Barney's Beanery, established by John "Barney" Anthony in 1927 at its current location, 8447 Santa Monica Boulevard in West Hollywood. The Beanery is a major landmark on Route 66 and an icon among aficionados of movie and music history.

Excellent but simple food, the charitable nature of the owner, and a down-to-earth atmosphere transformed the Beanery into a destination for thousands of travelers and those relocating to the Los Angeles area. At some point in the 1930s, the tradition of donating the license plate from the customers' home state began and today the ceiling above the bar is festooned with a wide array

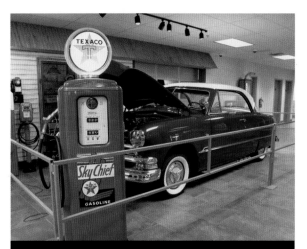

A small automotive museum is only one of the things that makes Russell's Travel Center unique in the modern era of sterile, one-stop travel centers clustered along the interstate highway. *Judy Hinckley*

of license plates. However, some were in actuality collateral for dinner bills.

It was also during this period the owner began developing a reputation for lending a hand to writers in need of finances between checks. In 1945, *Hollywood Nightlife* magazine featured a profile of the Beanery that noted, "Barney Anthony is a name known to most writers who at one time or another have been broke in this town. Barney has always made sure they had food and a little cash to tide them over."

The *Route 66 Dining & Lodging Guide* (fifteenth edition), published by the National Historic Route 66 Federation, lists the restaurant as "a very special must stop."

BARSTOW, CALIFORNIA

The earliest community at the current site of Barstow on the Mojave River was a stop on the Mojave Road labeled Fishpond in the 1860s. In 1882, with the completion of the Southern Pacific Railroad past the site and establishment of a switchyard, the name became Waterman Junction in honor of Robert W. Waterman, who served as governor of California from 1887 to 1891. The change to Barstow came in 1886, shortly after acquisition of the railroad by the Atchison, Topeka & Santa Fe Railroad. The name change was in deference to William Barstow Strong, president of the railroad at that time.

In addition to the rail yard, the community profited as a supply center for area mines and ranches. With the establishment of the Arrowhead Trail and the National Old Trails Highway in 1913 (Route 66 after 1926), Barstow became an important service center for motorists traveling the high desert.

A book published in 1914 by the Arizona Good Roads Association, *Los Angeles Phoenix Route Map*, lists the Central

Garage and Machine Works, with hotel attached. Surprisingly, as evidenced by the *Hotel, Garage, Service Station, and AAA Club Directory* of 1927, there was little improvement concerning services for travelers by the advent of Route 66, since this directory does not list recommended lodging for Barstow. However, it does list the Barstow Garage as an approved service facility.

This is in stark contrast to the 1940 *AAA Directory of Motor Courts and Cottages* that lists the Casa Loma Motel, Hollon Motel, Kail Court, Rio Grande Cottages, and Tom Tyler Motor Inn. The Jack Rittenhouse guide of 1946 is a little less restrictive. It lists five hotels, seventeen auto courts and motels, and five repair facilities.

The 1954–55 *AAA Western Accommodations Directory* lists nine recommended motels, all on Main Street, Route 66. The motels listed are Brant's Motel, Cactus Motel, Desert Lodge Motel, the Dunes Motel, El Carlos Motel, El Rancho Motel, Hollon Motel, Sage Motel, Sands Motel, and Skyview Motel. The three recommended restaurants (the Broiler, the Cliff House, and El Rancho Café) are also on Main Street.

Of particular note is El Rancho Motel. Cliff Chase built the facility in 1947 almost entirely from discarded railroad ties. This property today serves as a senior housing facility, but its future is uncertain as a series of fires, including one that destroyed the former restaurant in the spring of 2011, may make the cost of repairs and renovation not economically feasible.

Much of the historic section of Barstow dates to 1925. This was the year the expansion of the rail yard by the Atchison, Topeka & Santa Fe Railroad necessitated the relocation of almost the entire town to its current location on Main Street to the south. The most notable exception to the relocation was the Casa Del Desierto (house of the desert), a Harvey House and railroad office complex completed in 1911. Recently restored, this facility currently houses a railroad museum as well as the Route 66 Mother Road Museum that opened on July 4, 2000.

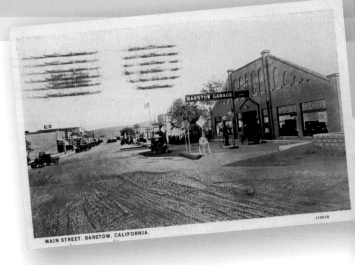

MAIN STREET. BARSTOW, CALIFORNIA.

The *AAA Hotel, Garage, Service Station and AAA Club Directory*, 1927 edition, lists the Barstow Garage as one of two authorized facilities between Barstow and Needles. *Steve Rider*

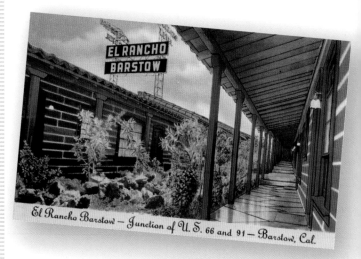

Built in 1947 by Cliff Chase, the El Rancho in Barstow discarded ties from the defunct Tonopah & Tidewater Railroad as its primary component of construction. *Mike Ward*

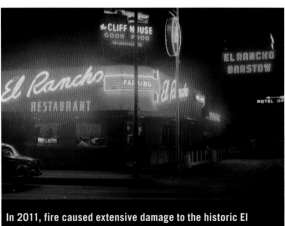

In 2011, fire caused extensive damage to the historic El Rancho Restaurant in Barstow, California, resulting in consideration of demolition. *Mike Ward*

BARTON, NEW MEXICO

A post office under the name Barton, established in 1908, continued in operation through 1936. Settlement of the site predated the post office by several years. The book *A Guide Book to Highway 66*, published by Jack Rittenhouse in 1946, notes that services in the remote New Mexico hamlet included "a gas station, grocery, and a few cabins." Scattered ruins and foundations mark the site today.

BAXTER SPRINGS, KANSAS

It was the perception of healing powers in the waters of the mineral springs at this site that made it a favored summer campsite for the Osage Indians. These springs were included as

part of the initial 160-acre homestead of John J. Baxter, who built an inn and general store on the property near the military road in about 1853.

Fort Blaire, established near the inn, was the target of an unsuccessful raid by a band of Confederate guerillas known as Quantrill's Raiders in 1863. The repulsed raiders then decimated a military convoy under the command of Major General James Blunt near the springs in a battle known as the Baxter Springs Massacre. A monument erected in the city remembers this dark chapter in the community's history. According to the *Post Tribune*, March 31, 1961: "A marker commemorating the massacre is to be renovated and relocated. It will be removed from its location in the city to the site of the massacre north of town on a new section of U.S. 66, now under construction."

John Baxter's inn and general store served as the nucleus for the establishment of a community initially known as Baxter's Place, changed to Baxter Springs after incorporation in 1868. During this period, Baxter Springs became a primary shipping point for Texas cattle herds as the city government issued $150,000 in bonds as incentives for the Missouri River, Fort Scott & Gulf Railroad to build a line into Baxter Springs. However, with relocation of major livestock shipping centers farther to the west and realignment of the railroad that then bypassed Baxter Springs, the town entered a period of steep decline. The development of the mineral springs into a resort helped to reverse this trend, though, as the town became a vacation destination and host for the annual Grand Army of the Republic and the Old Soldiers and Sailors reunions.

The discovery of extensive deposits of lead and zinc, initially along the Missouri and Kansas border and then later along the Kansas and Oklahoma border, transformed the economic structure of the community. During the teens, the mines in this tri-state area were the largest producers of lead ore in the world.

The *Hotel, Garage, Service Station, and AAA Club Directory* of 1927 indicates a population of 3,700 and lists the Baxter, at $1.00 per night, as approved lodging. Approved service facilities do not appear in this directory. Jack Rittenhouse, in 1946, noted a slight improvement with regard to available services for travelers. In his route guide published that year, he highlighted one hotel (Merry Bales), two garages (Pruitt Motor Company and Talley's), and three "cabin camps."

Mining continued to be an important part of the economy well into the early 1960s. Additionally, as a result of the town's location on Route 66, five major transcontinental trucking companies and one freight company operated terminals and repair facilities here. With a population of more than 4,500, Baxter Springs is too large to be considered a ghost town. However, this is less than half the population from its peak.

Historical association of note includes the initiation of Mickey Mantle's professional baseball career (three years with the Baxter Springs Whiz Kids) and the building that houses the Café on the Route. In 1876, this building was a bank that was robbed by Jesse James and Cole Younger.

Capistrano Courts was but one manifestation of the dramatic rise in tourism evidenced by the quadrupling of the number of motels and auto courts along Route 66 during the immediate postwar era. *Steve Rider*

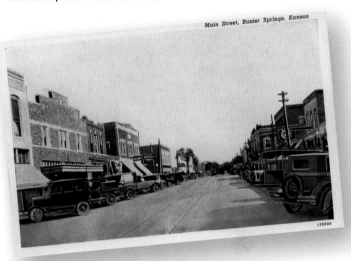

Baxter Springs, at the center of a tristate lead mining boom, was a modern, prosperous community in the early 1920s. *Steve Rider*

Scattered throughout the community are nondescript structures that have a lengthy historic association with Route 66. For example, the Independent Oil and Gas service station, listed in the National Register of Historic Places in 2003, dates to 1930 and stands at the north end of the business district.

BAZELL MODERN CAMP

Before establishing Bazell Modern Camp in Winslow, Arizona, in about 1928, Grover Cleveland Bazell was a lawyer and newspaper publisher who had established a Buick dealership and garage in this city in 1921. AAA lists this facility as an approved garage in the 1927 edition of the *Hotel, Garage, and Service Station Directory*.

After the sale of the property to Mr. and Mrs. Robert Powell in about 1938, the facility underwent extensive renovation and addition that included connecting the cabins to create additional

rooms. In this configuration, the name changed to Bazell Auto Court. The *Directory of Motor Courts and Cottages*, published by AAA in 1940, gave the facility a cursory entry: "Bazell Auto Court. 75¢ to $2.00. Public showers. Trailers 50¢ to $1."

The property no longer serves as a motel. However, as of summer 2011, some of the original structures remain as private residences.

BEALE, EDWARD FITZGERALD

On March 3, 1853, Edward Fitzgerald Beale, a former naval officer, accepted a commission as superintendent of Indian affairs for California and Nevada from President Millard Fillmore. In 1857, he accepted an assignment from President James Buchanan to lead a survey party from Fort Defiance in the territory of New Mexico to Fort Mohave on the Colorado River.

The primary purpose of this expedition was to survey a road that roughly followed the thirty-fifth parallel from Fort Defiance near present-day Window Rock, Arizona, to the Colorado River. A secondary mission, authorized by Secretary of War Jefferson Davis, future president of the Confederate States of America, was to evaluate the feasibility of camels for military transport in the desert Southwest.

It was on this expedition that Beale camped at the springs near the head of Crozier Canyon. In his journal, he indicated the springs area was a "beautiful one; the water pouring over a rock is received in a basin of some 20 feet in diameter and 8 to 10 feet deep." He bestowed the name Truxton on the springs to honor his brother Truxton and his mother, Emily Truxton Beale.

Beale led an additional expedition and survey in 1858 and 1859 from Fort Smith in Arkansas to the Colorado River at the border with California. The subsequent Beale Road became an important trade corridor for the development of northern Arizona. With its connection to the Mojave Road at the Colorado River, it also became a favored route to southern California. The railroad and later the National Old Trails Highway, predecessor to Route 66, followed large sections of this road across northern Arizona.

The Beale Hotel and Beale Street in Kingman, Arizona, refer to Beale's association with the railroad that served as the cornerstone for the town's founding. Another would be Beale Springs, site of Fort Beale, to the west of Kingman, which served as headquarters for the first Hualapai Indian reservation and as an important station on the Beale Wagon Road and the Mohave–Prescott Toll Road that connected Hardyville on the Colorado River with Fort Whipple at Prescott.

BECKY'S BARN

Becky's Barn, located along the brick-surfaced early alignment of Route 66 near Auburn, Illinois, is a recent addition to attractions on the highway. Still, it perfectly exemplifies the very essence of that iconic highway. It started as a home utilizing a nontraditional floor plan derived through a compromise to ensure marital bliss. The result was a house the couple, Rick and Becky, jokingly began referring to as Becky's Barn.

Shortly after retiring in 2002, the couple began frequenting auctions and selling miscellaneous antique items and memorabilia. It was during this period that Route 66 signs were installed along the old brick road, Route 4. Rick and Becky were surprised to discover the old road was formerly U.S. 66. In talking with some of the people who stopped along the road to take pictures, they learned the iconic old highway had an international appeal.

Recognizing an opportunity, and hoping to educate travelers about the history of the brick-surfaced segment of Route 66, Becky and Rick converted two metal outbuildings and began selling actual antiques as well as Route 66 souvenirs, gas pumps, and other collectibles. Becky's Barn is now a favored stop for travelers following the pre-1930 alignment of Route 66 from Springfield to Staunton.

BELLEFONTAINE NEIGHBORS, MISSOURI

Bellefontaine Neighbors in Missouri is a suburb in north St. Louis County where Bellefontaine Road, the post-1936 alignment of U.S. 66, and Riverview, the former City 66 that connects with the Chain of Rocks Bridge, intersect. The namesake is Bellefontaine Springs, French for "beautiful fountain," on Coldwater Creek. Established in 1806 at the mouth of this creek, on a bluff above the Missouri River, was Fort Bellefontaine. The fort remained a military installation through 1827. The community remained rural in nature into the 1940s, but the explosive growth of suburban development following World War II resulted in extensive transformation.

During the Chillin' on Beale event on the third Saturday evening of the month from April until October, Beale Street in Kingman, Arizona, is transformed into a sea of vintage cars.

BELLEMONT, ARIZONA

Volunteer Springs derived its name from a militia encampment at the site in 1863. In 1876, Walter J. Hill moved a small flock of sheep to the area of the springs, and by 1882, the year the Atlantic & Pacific Railroad completed the railroad to this point, his sheep ranch was reputed to be the largest in the territory of Arizona.

Hill later served in a variety of law enforcement capacities in northern Arizona. While pursuing a gang wanted for robbery and rustling west along the Beale Wagon Road, Hill was severely wounded in a gun battle near the Colorado River. Upon recovery, he relocated to California.

With the building of a railroad siding at the springs and completion of a sawmill and lumber operation, a small community developed under the name Bellemont, named after Belle Smith, daughter of F. W. Smith, general superintendent of the Atlantic & Pacific Railroad. A post office established at the site in 1887 made the name official.

Establishment of the Navajo Ordinance Depot, one of the nation's largest munitions storage depots for use in the Pacific Theater during World War II, transformed the isolated mountain community. In spite of the military presence, however, it remained a small town dependant on Route 66 traffic for survival. In 1946, a tour guide noted there were a store, a post office, and two gas stations. After the rerouting of Route 66 in New Mexico in 1936, which bypassed Glorieta Pass, Bellemont became the community with the highest elevation (at 7,130 feet) at any point along Route 66.

Bellemont now is at the center of extensive residential development, and as a result, the original character of Route 66 is difficult to discern. Primary attractions for travelers on that highway are the Route 66 Roadhouse and Grand Canyon Harley Davidson, a full-service repair and rental dealership with gift shop.

BELLVUE, OKLAHOMA

A small ranching/farming community named by P. T. Fry, Creek County superintendent, for its view in 1909, the town was large enough to warrant establishment of a post office in February of 1913, but the era of prosperity was relatively short, as evidenced by its closure in 1916. Its association with Route 66 spanned the period from 1926 to 1965. With the exception of a few homes, little remains.

BELVIDERE CAFÉ AND MOTEL

Albina and Vincenzo Cerolla, immigrants from Europe, launched their version of the American dream in 1929 by acquiring property along Route 66 in Litchfield, Illinois, and establishing a small, wood-framed service station consisting of a single visible register pump. In addition to gasoline, they offered basic automotive services like replacement of fan belts and lube jobs.

By late 1937, through frugal management and attention to detail with regard to customer service, the Cerollas were able to expand the facility to include a modern brick service station, the Belvidere Café, a four-room motel complex, and a small home for themselves and two children. The café, with daughter Edith and her husband Lester Kranich assisting with daily operations, was a show piece of art deco styling with black lacquer counter tops trimmed in chrome and chrome-based bar stools. With additional expansion during the 1940s, the Belvidere also served as a dance hall. The specialties of the house—fried chicken, roast beef, and pork—made it popular with locals as well as travelers.

With the passing of Albina and Vincenzo in the 1940s, Edith and her husband assumed full control of the business. During the 1950s, they built a new home on the property and greatly expanded the motel. The enterprise remained prosperous until the early 1970s and the opening of the Interstate 55 bypass. Shortly after completion of the interstate highway, the complex closed.

Today most of the facility, located at 817 Old Route 66, is utilized for storage, but as of 2010, a few motel rooms were still being rented. A listing in the National Register of Historic Places in 2007 is indicative of the complex's historic significance.

BENLD, ILLINOIS

Founded and named for Ben L. Dorsey in 1903, this community was given a sense of legitimacy by the establishment of a post office in March 1904. Until the summer of 2011, the primary attraction of note associated with Route 66 was the Coliseum Ball Room Antique Mall at 520 South Hard Road. Persistent local legend has it that the Tarro brothers built the facility with a $50,000 loan from Al Capone. Shortly after its opening in 1924, promotion heralded the facility as having the largest dance floor between St. Louis and Chicago. Before the ballroom's destruction by fire in July 2011, a portion of the ten thousand–square-foot dance floor was utilized for the display of fine antiques.

Another unique attraction in Benld is the Holy Dormition of the Theotokos, part of the Patriarchal Russian Orthodox Catholic Church and established in 1907. It is the only Russian Orthodox parish under the Moscow Patriarchate in the state of Illinois. After being rebuilt after a devastating fire in 1915, the church was renovated in 1989.

BENSON'S TOURIST CITY

The entry for Benson's Tourist City in the *Directory of Motor Courts and Cottages*, published by AAA in early 1940, notes, "Three miles east of Stanton, on U.S. 66, and seven miles west of St. Clair. One of the newer tourist sites in Missouri. Located on a high elevation of over 1,000 feet. Convenient to Meramec and Bourbeuse Rivers and Meramec State Park. 16 nicely furnished cottages all with tile

showers, automatic hot water, thermostatically controlled gas heat; well ventilated. Cottages are set back from the noisy highway with plenty of fine grounds for children to play. All cottages have modern lavatories and are well insulated against heat and cold. Rates $1.25 to $2 per day for two persons. 2 public baths and flush toilets. Good café. Filling station. Laundry facilities. Accommodations, with electrical connections, for 15 trailers. Rate, 50¢ daily. A refined place for refined people, at moderate cost."

Proprietors Mr. and Mrs. Lewis J. Benson opened the facility in late 1938 with the slogan "Clean, Respectable, Your Home Away from Home" emblazoned on promotional material. With a succession of owners, the property underwent numerous name changes: under Mr. and Mrs. R. McGinnis, the name was McGinnis Sho-Me Courts before it later became the Del Crest.

As of the fall of 2010, portions of the complex still existed; however, it no longer operated as a full-service tourist center.

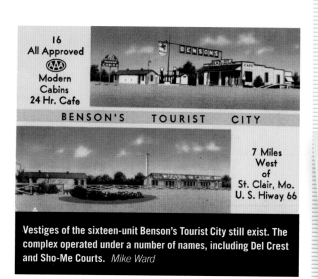

16
All Approved
AAA
Modern
Cabins
24 Hr. Cafe

BENSONS

BENSON'S TOURIST CITY

7 Miles
West
of
St. Clair, Mo.
U. S. Hiway 66

Vestiges of the sixteen-unit Benson's Tourist City still exist. The complex operated under a number of names, including Del Crest and Sho-Me Courts. *Mike Ward*

BERGHOFF RESTAURANT

Still operated by its namesake family, the Berghoff Restaurant at 17 West Adams (Route 66) in Chicago, Illinois, opened in 1898 as a saloon that offered free sandwiches for lunch with the purchase of a nickel beer. During Prohibition, the family relocated the restaurant to its current spot, less than a block east of the original, and upon repeal of the Volstad Act in 1933, Herman Berghoff was the recipient of liquor license number one.

The building that houses the restaurant is among the oldest in the Loop district. It dates to 1871, the year following the great fire that leveled most of the city. With great fanfare, the restaurant celebrated its centennial in 1998. Prized among collectors is the commemorative menu created for the event featuring images from the restaurant's history.

BERNAL, NEW MEXICO

This is the site of the first stage stop east of Las Vegas on the Santa Fe Trail. According to most sources, the name comes from a familial association with Pascuala Bernal, who arrived in what would become the state of New Mexico with her husband, Juan Griego, a member of the Don Juan Onate expedition of 1598.

The town is located on the pre-1937 alignment of Route 66, and a truncated segment of this original alignment continues east of town for a short distance. Jerry McClanahan, in his second edition of *EZ 66 Guide for Travelers*, notes that an old store stands along this segment of road, indicating its importance to the small community.

BERNALILLO, NEW MEXICO

Bernalillo is located on the colonial Spanish road the El Camino Real and the pre-1937 alignment of Route 66 north of Albuquerque. Historic records indicate the original settlement on this site, a pueblo of the Tiwa Indians, served as the winter camp for the Coronado expedition of 1540. This was also one of the earliest areas settled by Spanish colonists in the New Mexico territory, with Juan Griego and his wife, Pascuala Bernal, among the first families to establish a ranchero here.

JOE I. GROS -- Hiway 66 and 85 -- Produce Ranch and Trading Post
Gardens, Orchards, General Merchandise, Auto Camp, Service Station and Cafe
BERNALILLO, N. M.

This complex along the pre-1937 alignment of Route 66 bridged the gap between the modern era of motorists and automobiles and preterritorial New Mexico, as the store dated to about 1903. *Steve Rider*

The earliest reference to Bernalillo is a 1696 record that notes a "Real de Bernalillo" at this location. Las Cocinitas (the little kitchens neighborhood) has been listed as one of the oldest residential sections in the United States with buildings that date to 1690.

BERWYN, ILLINOIS

The namesake for Berwyn, Illinois, is Berwyn, Pennsylvania, a town named for the Berwyn Mountains of Wales. Legend has it the selection of the name came from a timetable for the Pennsylvania Railroad. The post office opened under this name in April 1891.

Ogden Avenue, the town's 1.5-mile main street, is the course followed by U.S. Highway 66. This corridor, lined with vintage streetlights and adorned with historic Route 66 signs and a wide array of family-owned businesses, is also the location for the city's Route 66 museum.

Among these family-run businesses is Ogden Top and Trim at 6609 West Ogden Avenue. Managed by the original family that established the company in 1919 for the manufacture of carriage harnesses, it is now a leading specialist in the restoration of vintage automobile interiors.

The city is quite active in development and promotion associated with Route 66, including the annual Historic Route 66 Car Show hosted by the Berwyn Route 66 Committee of the Berwyn Development Corporation. *Chicago Magazine* proclaimed the event, celebrating its twenty-first year in 2011, one of the five best things to do in the Chicago area.

BETHANY, OKLAHOMA

Founded in 1906 by the Nazarene Church and named for the Biblically referenced village near Jerusalem, the town's post office was established in March 1913. A 1946 travel guides notes the unique characteristics of the town: "The Nazarene Church . . . established a college here and laid down certain community regulations which still stand. No cigarettes, tobacco or alcoholic drinks are sold in the town, and there are no theaters." This guide also lists a number of service-related businesses, including garages, stores, and a café, but no auto courts.

Bethany is unique among communities along Route 66 in that its founding by the Nazarene Church resulted in ordinances that forbid the sale or advertising of tobacco or alcohol. *Steve Rider*

BEVERLY HILLS, CALIFORNIA

The name for the original land grant, El Rancho Rodeo de las Aguas, brings to mind the principal landscape features of the area during the period of colonization. The *aguas*, or waters, were Canada de los Encinos and Canada de las Aguas Frias, two streams that flowed to the southern edge of the ranch (*rancho*) through Coldwater Canyon and Benedict Canyon. Here, a number of springs added their flow to that of the streams during the rainy season, and swamps (or ciengas) formed, hence La Cienga, a north–south street.

In about 1900, large portions of the original land grant came into the possession of the Amalgamated Oil Company. After several years of unproductive drilling, the Rodeo Land and Water Company formed to acquire the property and develop it into a subdivision, where an association with wealth would become a foundational element of Beverly Hills. In 1907, while searching for a suitable name for his new development, Burton Green, the company's president, read a newspaper story that reported President William Howard Taft was vacationing at Beverly Farms. Beverly Farms became Beverly Hills, and the wealth followed.

As an interesting note, the *Hotel, Garage, Service Station, and AAA Directory* for 1927 does not list a recommended facility for this community. Neither does the *Directory of Motor Courts and Cottages* for 1940. The *Western Accommodations Directory*, published by AAA in 1954, lists a wide array of hotels and restaurants, but none has a location on Route 66

The city's association with Route 66 dates to 1936. In this year, the extension of the western terminus for the highway from the intersection of Seventh Street and Broadway Avenue in Los Angeles to the intersection of Lincoln and Olympic Boulevards (U.S. 101A) in Santa Monica received certification.

BIG CHIEF HOTEL

Opened in early 1929, the Big Chief Hotel in Wildwood, Missouri (then called Pond, according to its sign), was actually a cabin court. Some period literature called this type of complex a cabin hotel, but this particular venue featured sixty-two cabins with attached garages and a restaurant. The facility represented another link in the Pierce Pennant Petroleum chain of establishments built along Route 66 during this period. Similar to the relationship between the railroad and the Harvey House chain, Henry K. Pierce proposed to build full-service establishments at 125-mile intervals through the Ozarks and into Oklahoma. The Big Chief encapsulated his vision.

Promotional material from the period notes that the facility featured cabins with shower baths, a fine dining restaurant, a playground, a gas station, a small grocery store, and other "modern Amenities." The rerouting of Route 66 in the early 1930s resulted in a precipitous decline in cabin rentals only stemmed by the advent of World War II and renting to employees of the Weldon Spring Ordinance Works.

BIG CHIEF HOTEL *continued*

In 1949, the facility closed. Renovation in the mid-1950s razed the cabins, removed the false bell tower, and got rid of the pumps from the service station. As a restaurant, the Big Chief in Wildwood survived as a popular local eatery. In 1993, after extensive renovation, it reopened as Big Chief Dakota, a grill that specialized in unique meats like bison or elk burgers. Listed in the National Register of Historic Places in 2003, the restaurant, under new ownership, became B. Donovan's Restaurant in 2006. As of 2011, it remained operational under the name Big Chief Roadhouse.

The Big Chief Hotel, established by the Pierce Pennant Petroleum Company, represented a revolutionary idea that applied the concepts of the Harvey Houses for railroad travelers to the modern era of the motorist. *Steve Rider*

BIG TEXAN STEAK RANCH

The original Big Texan Steak Ranch opened on Route 66 in Amarillo, Texas, in 1960. The catalyst for its creation was the desire of the owner, R. J. "Bob" Lee, to create an ambiance that captured the romanticized image of the Old West where people could enjoy an excellent steak dinner.

Building on the Texas reputation for being the biggest, he commissioned a towering, illuminated sign that featured a lanky cowboy with hat pushed back on his head. Expanding on this theme, Lee launched a promotional campaign that would make the restaurant world famous to this day.

Posted along Route 66 in both directions were billboards featuring the cowboy and proclaiming a "Free seventy-two-ounce steak." The gimmick was that the customer had only one hour to eat the steak and accompanying dinner to avoid payment.

In the early 1970s, as plans to bypass Route 66 with Interstate 40 neared fruition, Lee purchased property along the new highway and built a larger Big Texan Steak Ranch. To relocate the now iconic cowboy sign, Lee used a helicopter.

A fire in 1976 devastated the new facility, but Lee immediately rebuilt and expanded the property to include a larger restaurant, a gift shop, and a motel with a Texas-shaped swimming pool. Even though the restaurant is no longer located on Route 66, its association with that highway, and the seventy-two ounce steak dinner, has made it an internationally recognized symbol.

The use of the steak dinner as a draw has kept pace with the changing times. Today, a live cam connected to the Internet provides front-row viewing for an international audience.

BESSIE'S PLACE

Bill and Beatrice "Bessie" Bayless built a roadhouse and six small log cabins along Route 66 eight miles west of Rolla, Missouri, in 1931. In October 1935, Eugene Duncan shot and killed his estranged wife, Billie, at the roadhouse, an event that led to its closure.

John Dausch, in late 1950, purchased the property and renamed it John's Modern Cabins the following year. The property entered a period of decline in the 1960s, and since Dausch's death in 1971, abandonment of the cabins has resulted in almost complete collapse. Today the ruins of the cabins remain a very popular photo stop for Route 66 enthusiasts.

The rustic cabins at Bessie's Place began their slow slide to oblivion in 1971 with the death of the owner, John Dausch. *Judy Hinckley*

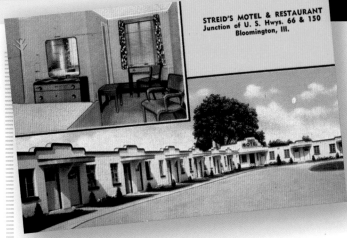

STREID'S MOTEL & RESTAURANT
Junction of U. S. Hwys. 66 & 150
Bloomington, Ill.

BLOOMINGTON, ILLINOIS

The origins of the name and the initial date of settlement are unknown for Bloomington, Illinois. However, in January 1829 the population was large enough to warrant establishment of a post office under the name Blooming Grove. In 1831, an amended application submitted under the name Bloomington received approval.

The 1927 edition of the *Hotel, Garage, Service Station, and AAA Club Directory* lists one recommended service station, with Fred G. Taylor as proprietor, at 110 South Madison Street (Route 66). The lodging recommendations include the Illinois (185 rooms, 100

With rates that ranged from $5.00 to $6.00, Streid's Motel, in 1954, was heralded as "a centrally heated brick motel with tiled shower baths and televisions available." *Mike Ward*

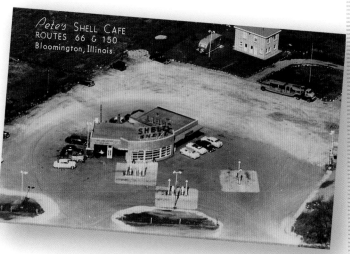

Pete's SHELL CAFE
ROUTES 66 & 150
Bloomington, Illinois.

The Six Points Oil Station in Bloomington, Illinois, represented the high point in roadside service facilities in 1930 with a service station, cabins, soda fountain, showers, and store in one complex. *Steve Rider*

baths, $1.50–$3.50 for a single, $2.50–$5.50 for a double), as well as the Rogers and Arlington.

A 1946 guide to Route 66 notes numerous businesses of interest to travelers. Among these were Wannemacher's and Cherry Street Garage, and the hotels Illinois, Hamilton, Rogers, Tilden Hall, Commercial, and Phoenix.

At 1219 South Main Street was the first Steak 'n Shake, later an area chain, that opened in 1934. This restaurant was the culmination of an endeavor begun in 1920 when Gus and Edith Bell opened a Shell gas station and later expanded the facility to include a dining room, Shell's Chicken.

The 1954 edition of the *AAA Western Accommodations Directory* lists two recommended motels in Bloomington: Streid's Motel at the junction of U.S. 66 and Highway 150, and the Rusk

In 1954, AAA described the Rusk Haven Motel in Bloomington, Illinois, as being located at the junction of U.S. 51 and U.S. 66. Interestingly, the lodging guide also noted the availability at the motel of "a variety of accommodations." *Joe Sonderman*

B

BLOOMINGTON, ILLINOIS *continued*

Haven Motel at the overpass junction with U.S. 51. Streid's Motel offered television in select rooms, as well as the services of a dining room, cocktail lounge, and service station.

Attractions of interest today include the David Davis Mansion State Historic Site (an architectural masterpiece built in 1872 by David Davis, an appointee to the Supreme Court by Abraham Lincoln), the Nestlé candy factory, and the Beer Nut factory, the only one of its kind in the world. The McLean County Museum, at 200 North Main Street in the 1903 courthouse, holds an extensive, well-displayed collection of materials chronicling the area's unique history.

The *Route 66 Dining & Lodging Guide* (fifteenth edition), published by the National Historic Route 66 Federation, features several listings for Bloomington, the most notable being Lucca Grill (116 East Market Street), which dates to 1936.

BLUE DOME STATION

The Blue Dome Station, located at the corner of Second Street and Elgin in Tulsa, Oklahoma, dates to 1925. Built by T. J. Chastain, it marked the first endeavor to diversify the business of Chastain Oil Company, a manufacturer and distributor of petroleum products in Tulsa. Initially the station, with its distinctive blue dome that served as living quarters for the manager, was the first retail outlet for Superoil products, a division of the Chastain Oil Company. Expansion of the product line in 1928 was a result of Chastain's acquisition of the Tulsa County rights to distribute Tydol products.

The station was one of the first in Oklahoma to offer a car wash as well as free pressurized air. In the *Service Station Directory*, published by AAA in 1946, this facility warranted recommendation for service as well as repair.

The overwhelming success of the station prompted the construction of a second, identical building at the corner of Fourth Street and Detroit. Because of their rarity, postcards promoting either station rate quite highly among collectors of Route 66 memorabilia and often sell for more than one hundred dollars.

Most recently, the original facility served as offices. The unique structure is the centerpiece for the eastern downtown section of the city known as the Blue Dome District that received recognition with designation to the National Register of Historic Places on December 13, 2011. The district is bound by Kenosha, Detroit, and Eighth Streets, as well as the tracks of the Frisco Railroad. It includes portions of Second Street, an alignment of Route 66 from 1926 to 1932. The district has been experiencing a renaissance with the establishment of restaurants and shops, and it is the venue for the Blue Dome Arts Festival.

THE BLUE DOME, "BEST IN WEST", 2ND AND ELGIN, TULSA, OKLA.

Built in 1925, the Blue Dome Station is now at the center of the Blue Dome District of Tulsa, a fast-developing collection of historic buildings at the heart of the city's cultural nightlife. *Steve Rider*

BLUE SPRUCE LODGE

The Blue Spruce Lodge in Gallup, New Mexico, an existing property as of late 2011, opened in 1949. John Milosovich built the motel, with financing from John Novak. The endeavor proved so successful Milosovich repaid the loan in less than half the time stipulated.

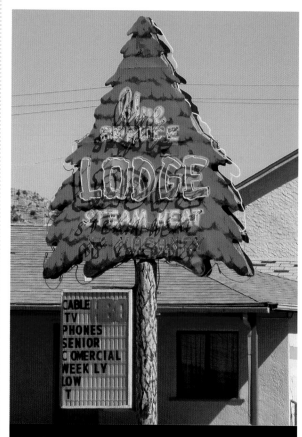

The Blue Spruce Lodge opened in 1949 as a twenty-unit complex, and as 2011 it remained in business with original signage.

In the 1954 edition of the *Western Accommodations Directory* published by AAA, it is noted that "One and two room units have air cooling, central heat and shower or combination baths; 2 closed garages. Baby beds, radios, and alarm clocks available. Special day rates to tourists who plan to drive across the desert at night. Free ice." As a historic footnote, John Milosvich won the mayoral election in Gallup in 1935. He was twenty-one years old, which made him the youngest elected mayor in the United States.

Unique original signage makes this a favored photo location for Route 66 enthusiasts.

BLUE SWALLOW MOTEL

Construction of Tucumcari, New Mexico's Blue Swallow Motel, listed in the National Register of Historic Places in 1993, commenced in 1939. Ted Jones, a prominent area rancher, purchased the property from W. A. Huggins in 1942.

The 1954 *AAA Directory of Western Accommodations* promoted the Blue Swallow Motel as "One of New Mexico's Most Popular Motels." The list of amenities available included "air conditioning by refrigeration," automatic heat, tiled baths, heated and locking garages, connecting units, and the availability of baby beds.

After the death of Jones and his wife in a plane crash in the late 1950s, the manager of the Bonanza Motel, Floyd Redman, acquired the Blue Swallow Motel and presented it to his future wife, Lillian, as an engagement present in 1958. The Redmans operated the motel as a team through 1973, the year Floyd died, and then Lillian ran it on her own until early 1998.

The historic Blue Swallow Motel in Tucumcari with its refurbished signage is one of the most photographed sites on Route 66.

Main Street of America

COURTS GUIDE

ILLINOIS TO CALIFORNIA

CHICAGO

LOS ANGELES

VIA US 66

BETTER

Motor Courts

for those who want the best

PRESENTED WITH THE COMPLIMENTS OF:

Blue Swallow Court

Tucumcari, New Mexico

TO BE SURE YOU HAVE A PLACE TO STAY TONIGHT

Reservations may be made at our office for courts listed herein.

COPYRIGHT BY MAINSTREET OF AMERICA COURTS GUIDE
LITHO BY JOPLIN PRINTING CO.

As crude auto camps and cabin complexes evolved into more sophisticated motels and auto courts, a wide array of organizations formed to provide independent owners with advertising built upon pooled resources. *Steve Rider*

BLUE SWALLOW MOTEL *continued*

Under the stewardship of new owners, Hilda and Dale Bakke, renovation commenced in 1998 and continued with the next owners, Bill Kinder and Terri Johnson, who relocated to Tucumcari from Bullhead City, Arizona. The motel, with the sign installed by the Redmans in 1960 and refurbished with money from a cost-share grant received from the National Park Service Route 66 Corridor Preservation Program, is now a favored stop for Route 66 photographers and travelers alike.

In July 2011, a new chapter for the historic property commenced with its acquisition by Nancy and Kevin Mueller. The restored neon signage is one of the most photographed sites on Route 66, and in the fall of 2011, the Muellers commenced repainting the facility in its original colors.

BLUEWATER, NEW MEXICO

Spanish colonists called the area north of the Zuni Mountains *Agua Azul*, or Bluewater. In 1819, the creek by this name was designated the southern boundary of Navajo country in the Navajo/Spanish Treaty.

The first establishment of a community on the site dates to the creation of a railroad camp on the Atlantic & Pacific Railroad in late 1880. Mormon settlers built a dam at the confluence of Bluewater and Cottonwood Creeks three miles to the west shortly after this date.

After 1890, records indicate a farming community near the dam named Mormontown. With abandonment of the railroad camp and the establishment of a post office, the name officially became Bluewater.

Jerry McClanahan, in the second edition of the *EZ 66 Guide For Travelers*, notes, "Numerous remnants of old motels, garages and trading posts line the west side of old 66 (4-lane much of the way) thru Bluewater to Prewitt."

With Jake and Maxine Atkinson as proprietors, the Rattlesnake Trading Post and Reptile Gardens in Bluewater, New Mexico, opened in the former Bluewater Trading Post in 1945.
Steve Rider

BOBCAT BITE

Bobcat Bite, located at 420 Old Las Vegas Highway (Route 66 before 1937) in Santa Fe, New Mexico, opened in 1953 and, as a result, is not technically associated with that highway. However, it remains a very popular local restaurant and is a favorite stop for those traveling on this segment of Route 66 because of its period atmosphere. *Hamburger America* included it in its top 100 list for best burgers, and in the *Route 66 Dining & Lodging Guide* (fifteenth edition), it is listed as a "very special must stop."

BOISE, TEXAS

Located between Adrian and Vega, the exact date of origination for Boise, a community that offered minimal services to travelers on the Ozark Trails Highway System and Route 66, is unknown. Because its settlement is associated with a siding established by the Chicago, Rock Island & Pacific Railway, the date would most likely be between 1901 and 1906. The population never warranted establishment of a post office, however, and as of this writing, it is a total ghost with little to mark the site along the old rail bed on the Bridwell Ranch.

BOSQUE FARMS, NEW MEXICO

There are references to a farming community named Bosque de los Pinos on or near this site as early as the mid-eighteenth century. The first concrete documentation of occupation at the present site, however, dates to an 1848 reference to a farming community named Bosque Redondo.

In the late nineteenth century, Solomon Luna operated a large ranch and sheep farm from this location. His son, Eduardo Otero, played a key role in the establishment of the Middle Rio Grande Conservancy District, a foundational component of a government resettlement project during the 1930s.

The Bosque Farms name dates to this resettlement project for families displaced by the Dust Bowl in 1934 and 1935. The association with Route 66 terminated with the realignment of 1937.

BOURBON, MISSOURI

In about 1852, the store owned by Richard Turner became a favorite watering hole for local railroad construction workers, since he was among the first importers of bourbon whiskey to the area. As a result, the establishment known locally as Bourbon Store became a cornerstone for a fledgling community developing at this location.

The *Hotel, Garage, Service Station, and AAA Club Directory* for 1927 lists the only available services as Bourbon Garage. By the mid-1940s, travelers on Route 66 had far more options for services, however, including the Roedemeier Garage (a facility

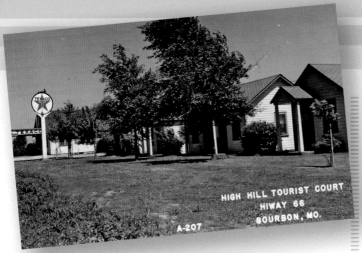

After selling the Bourbon Lodge, Alex and Edith Mortenson established the High Hill Tourist Court immediately to the west with cabins renting for $3.00 to $5.00 per night. *Joe Sonderman*

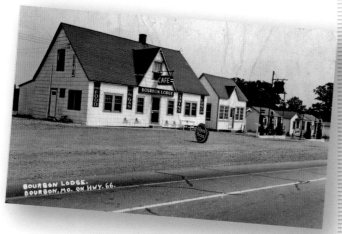

Now a private home with the cabins in ruins, the Bourbon Lodge opened in 1932. The complex run by Alex and Edith Mortenson included a café, service station, and cabins. *Joe Sonderman*

attractive accommodations. . . . Delightful tree shaded patio—air cooled rooms—automatic heat—tile tub and shower baths—baby cribs—convenient to Sandia Base—good restaurant nearby."

Author Joe Sonderman in *Route 66 in New Mexico* (Arcadia Publishing, 2010) provides a succinct list of owners.

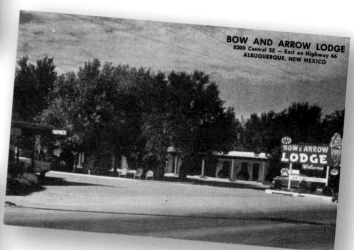

Among the many motels and auto courts that lined Central Avenue in Albuquerque, the Bow and Arrow Lodge (originally Urban Motor Lodge) that opened in 1941 with Mr. and Mrs. L. F. Morgan as proprietors is a rare survivor. *Mike Ward*

listed in the *Service Station Directory*, published by AAA in 1947), cabins, gas stations, and cafés.

Water towers emblazoned with "Bourbon" on the sides have long been the primary landmarks of note. Existing structures associated with Route 66 include the Bourbon Lodge, opened in 1932, now a private home, and the High Hill Tourist Court, opened in 1947, with the house and one cabin still standing.

The *Route 66 Dining & Lodging Guide* (fifteenth edition) lists two recommended businesses in Bourbon: the Circle Inn Malt Shop at 171 South Old Route 66 and the Budget Inn Motel.

BOW AND ARROW LODGE

The Bow and Arrow Lodge, an existing property as of 2011, opened in 1941 at 8300 East Central Avenue in Albuquerque, New Mexico, as a "modern, twenty-five unit Urban Motor Lodge." The 1954 *Western Accommodations Directory* published by AAA featured a display advertisement as well as a succinct text overview entry for this motel: "A hospitable atmosphere with

BOWDEN, OKLAHOMA

Rolandus A. Bowden, a Sapulpa merchant who relocated to the area in about 1907, is the namesake for Bowden. A post office operated here from the summer of 1909 to the fall of 1957. The period of Route 66 association spans the years 1926 to 1951. The Turner Turnpike, now I-44, supplanted the realignment of that highway in 1953.

BRACEVILLE, ILLINOIS

Founded shortly before the advent of the American Civil War, Braceville was named for the hometown of B. R. Down (some records indicate Dowd), the first township supervisor. Initially the designation was Braysville, but with the establishment of a post office in March 1865, it officially became Braceville.

The discovery of large coal deposits shortly after this date sparked a boom that transformed the sedate farming community. By 1880, estimates place the population at more than three thousand, and the business district included two banks, six general stores, a hotel, several restaurants, and more than a dozen other businesses.

The boom lasted until 1910 when a miners strike proved to be the proverbial straw that broke the camel's back for the

Braceville Coal Company. Within six months of the mine's closure, the population dropped by more than 80 percent.

A 1946 guidebook for Route 66 claimed that the population was 321 at that point and notes: "This town is but a remnant of a once thriving coal town." The book also notes there were a few gas stations, several cafés, and a small garage.

Removal of a vintage bridge southwest of town in 2001 truncated Route 66. To a large degree, the town remains as described by Rittenhouse with the exception of existing businesses.

Enhancing the sense of carefree whimsy at the Polk-A-Dot Drive In in Braidwood, Illinois, is this vintage clock with cast-iron base that predates establishment of the restaurant. *Judy Hinckley*

Built in 1939, the bridge at Braceville represented the initial stages of Route 66 modernization that would culminate with the construction of a limited access, bypass alignment in the 1940s.

BRAIDWOOD, ILLINOIS

The town of Braidwood was named for James Braidwood, a steamship engineer who immigrated to the United States from Scotland in 1863 and who was instrumental in the development of the coal mines in Will County. The initial coal discovery came with the digging of a well on a farm owned by Thomas Byron in 1865.

Establishment of a town, and a post office in 1867, followed the development of the mine, and Braidwood quickly gained a reputation for lawlessness. The election of town officials in April

1876 culminated in a fight at the polls, the disarming of the town marshal, a riotous crowd, the stealing of all records, and the severe beating of the ballot counter. A mining strike in 1877 in which mine owners brought in trainloads of African Americans from the South resulted in the governor sending 1,300 troops to Braidwood to restore order.

On February 16, 1883, a massive cave-in at the Diamond Mine, owned by the Wilmington Coal Mining and Manufacturing Company, resulted in the deaths of almost fifty miners; forty-six of whose bodies were never recovered. Since two were age thirteen, and one was fourteen, the event became a national sensation fueling the growing cry for child labor laws.

A devastating fire swept through the business district in the spring of 1879 leveling the hotel, several saloons, the railroad depot, a gristmill, a blacksmith shop, and numerous homes. Among the men who helped rebuild Braidwood was a recent immigrant from Italy, Peter Rossi.

Rather than turn to mining, Rossi began manufacturing macaroni, an enterprise that led to his purchase of the Broadbent Hotel and its conversion into a factory in 1898. A 1946 guide notes the business was still in operation at that time. The establishment of a bakery and a saloon opened by his son, Stephen, soon followed. With the coming of Route 66, the members of the Rossi family expanded their operations to include a grocery store, a service station, a pair of auto courts, and a restaurant.

The *AAA Western Accommodations Directory* for 1954–55 indicates the family was still actively involved with development in the community at this time. "Rossi Motel—center on U.S. 66 &

Rossi's Motel in Braidwood, Illinois, represents almost a century of family-owned businesses in this community that commenced with the establishment of a macaroni factory by Peter Rossi in 1898. *Mike Ward*

State 113S – A modern brick motel on spacious grounds, 1/2 block west of U.S. 66A." This facility located at 120 North Washington Street is now the Braidwood Motel.

The primary Route 66–related attraction in Braidwood today is the Polk-A-Dot Drive In, established in 1956 by Chester Fife and a restaurant designated a "very special must stop" by the National Historic Route 66 Federation in the fifteenth edition of the *Route 66 Dining & Lodging Guide*. The first incarnation of this classic drive-in was a school bus covered with rainbow colored polka dots from which the owner took fast food orders.

Fife relocated the business to its current building in 1962. Enhancing the time capsule feel are life-sized fiberglass figures of Elvis Presley, the Blues Brothers, James Dean, Marilyn Monroe, and Betty Boop displayed along the outside wall.

Another historic structure of note with a Route 66 connection would be the Lucenta Tire store housed in a service station built in 1939. This facility is located on Highway 113 across the railroad tracks.

BRAIDWOOD INN

The Braidwood Inn, now the Sun Motel, in Braidwood, Illinois, at 140 South Hickory was featured in a 1987 film produced by Paramount, *Planes, Trains, and Automobiles*. In this film, Neal Page, played by Steve Martin, and Del Griffith, played by John Candy, share a room at this motel after a flight delay reroutes their airplane to Wichita.

BRANDIN IRON MOTOR HOTEL

Located at the top of El Trovatore Hill in Kingman, Arizona, the Brandin Iron Motor Hotel, later the Brandin Iron Motel, opened in 1953. The original owners, Mr. and Mrs. R. A. Bewley, promoted the property as "Kingman's Newest and Finest."

The *Western Accommodations Directory*, published by AAA in 1955, gave the property a concise review: "An attractive air conditioned court. Some rooms are connecting, all have vented heat and tiled shower or combination baths; 1 two room unit. Restaurant opposite $6.50—$10.00."

The widening of Route 66 in the early 1960s restricted entry and exit, and in the mid-1990s, the motel closed. In 2001, renovation transformed the property into an apartment complex.

BRENTWOOD, MISSOURI

Located along Manchester Road (U.S. 66) west of St. Louis, Brentwood, Missouri, developed a reputation as a speed trap in the 1950s. This was a result of a city ordinance that allowed the ticket-writing officer and the judge to share in money derived from fines.

Prior to this, according to author and historian Joe Sonderman, the small community had a local reputation for ignoring the operation of speakeasies and illicit casinos. A number of these establishments operated openly in the area of North and South Road, the current Brentwood Boulevard.

BRIDGEHEAD INN

Opened in 1935, the Bridgehead Inn quickly developed a local reputation for illicit and possibly illegal activities. Edward Steinberg purchased the property in 1947, updated and expanded the facility, and renamed it Steiny's. It remained in business until 1972.

The inn's restaurant, Galley West, became the EPA headquarters during dioxin cleanup operations at Times Beach, Missouri. As of 2011, it housed the visitor center for Route 66 State Park.

BRIDGEPORT, OKLAHOMA

The town began as the site of a stage crossing of the Canadian River, and with the establishment of farming in the area—and a work camp on the South Canadian River while the Rock Island Railroad built a bridge here in 1891—it quickly morphed into a respectable little town. The post office dates to February 20, 1895.

A postal road established through Bridgeport after 1900 became a primary roadway for early motorists traversing Oklahoma. In 1917, this route was absorbed into the Ozark Trails network.

Spearheading this important development were business owners in nearby Geary who assembled their own road crew and improved the road to the river. They then negotiated a contract with George Key of the Postal Bridge Company in Oklahoma City and a powerful politician who was serving as the chair of the state Democratic Party committee for the construction of a permanent

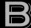

bridge at Bridgeport. The suspension toll bridge built across the river about a mile north of town in 1921 furthered growth.

An article in the *Ada Weekly News* of Ada, Oklahoma, on July 28, 1921, detailed a meeting of delegates from four states who were gathering in Oklahoma City to celebrate completion of the "road from California, said to be the first continuous direct highway from coast to coast thru the south. . . . " Incorporated into the U.S. highway system in 1926, the Key Bridge became the crossing of the Canadian River for traffic on Route 66. With the purchase of the bridge by the state of Oklahoma in 1930, tolls were suspended.

With the completion and opening of a bridge on a realignment of the highway that eliminated the loop through Calumet, Geary, and Bridgeport in 1934, the community began a precipitous slide, though the Key Bridge survived for another twelve years, meeting the needs of local traffic before a fire in 1946 rendered it unusable. A salvage firm from Kansas City purchased the bridge and dismantled it in 1952.

Considered a ghost town, Bridgeport still holds a small population. Primary attractions consist of abandoned homes and business that provide interesting photo opportunities and the rusty supports for Key Bridge.

BRIDGETON, MISSOURI

Bridgeton, Missouri, on the post-1936 alignment of Route 66, has distinctly international origins. Initial settlement by the French commenced with the platting of a town site utilizing the name Marais de Liards, roughly translated as Cottonwood Swamp, in 1794. A short period of association with the Spanish resulted in a name change to Vila a Robert. American settlement here led to the town's renaming to Owen's Station. As early as 1842, historical documents refer to the community as Bridgeton, the site of a ferry crossing and later a bridge on the Missouri River.

The town remained a small rural community into the postwar era. In 1950, it had a population of 276. However, because of postwar suburban development, the city's boundaries have expanded to seventeen square miles as of late 2010. Bordering the Lambert–St. Louis International Airport, the community further transformed when the construction a new runway resulted in the razing of two thousand homes.

BRISTOW, OKLAHOMA

Bristow began as a Creek trading post in Indian Territory. As the trading post morphed into a small community named for Joseph L. Bristow, a senator from Kansas and assistant postmaster general, a post office opened in the spring of 1898.

The prosperity that followed the railroad, the development of oil- and gas-related industries, the establishment of the Ozark Trails, and the certification of Route 66 manifested as a town built of substantive red brick. Bristow weathered the Great Depression and in the immediate postwar era was a prosperous farming community with Route 66-related services proving key components to the local economy.

A postwar traveler's guide notes the town featured "all accommodations." These were catalogued as "garages: 66 Motor Company and Bristow Motor Company; courts: Mac's, Brayton's, Thurman's, Rest-Well, and Bristow Court & Trailer Park; Roland Hotel; stores." The 1946 *Service Station Directory* published by AAA also lists the Bristow Motor Company as an approved service facility.

As of 2011, the community retained a wide array of historic structures reflecting unique architectural attributes, such as the plaster relief on the façade of the former Bristow Motor Company, now Bolin Ford. Dating to 1923, this building, listed on the National Register of Historic Places, was heavily damaged during a fire in December 2008. In December 2012, completion of renovations that preserved the historical integrity of the structure, and that included modern features such as a wind turbine on the Bolin Ford sign, were celebrated with an open house.

Another historic structure of note is the Bristow Firestone Service Station. Listed on the National Register of Historic Places in 2007, the building, refurbished to original appearance, reopened as Bristow Body Shop in November 2011.

For Route 66 enthusiasts, the Anchor Inn, a small café in operation since 1950, is a favorite stop that warranted a cursory recommendation in the *Route 66 Dining & Lodging Guide* (fifteenth edition), published by the National Historic Route 66 Federation in 2011.

BRITTON, OKLAHOMA

Britton, named for Alexander Britton, a Washington D.C.–based attorney for the Santa Fe Railroad, warranted a post office in 1889. Technically, the community was not officially on Route 66 but on the beltline route, designated U.S. 66 Alternate, from 1931 until 1953.

Counted among the primary attractions for Route 66 enthusiasts are the circa-1934 Owl Courts complex, currently undergoing restoration, and Western Trails Trading Post.

BROADWELL, ILLINOIS

The Tantivy Inn existed near the current municipality site of Broadwell in about 1840. The accepted date of origination for the town itself is 1856, the year William Broadwell and Jacob Eisiminger initiated platting of the town site in conjunction with the construction of the Chicago, Alton & St. Louis Railroad.

The town was centrally located in a richly diverse agricultural region, and as a result, its economic base was as a shipping point

for hogs, cattle, wheat, and corn. The certification of Route 66 fueled diversification.

According to the 1927 edition of the *Hotel, Garage, Service Station, and AAA Guide*, Rodemer & Sons Garage was the recommended service facility, day or night. The guidebook published by Jack Rittenhouse in 1946 notes that available services included a café, gas station, and grocery store. He also indicates that a garage was not available.

The most famous Route 66 site in Broadwell was the Pig Hip Restaurant, established in 1937 by Ernest L. Edwards, who continued in the position of proprietor until the establishment's closure in 1991. Edwards, with assistance from the Route 66 Preservation Volunteers, transformed the building into a museum in 2003 that became a prime attraction for Route 66 enthusiasts until a fire devastated it in 2007.

On August 5, 2007, Ernest "Ernie" Edwards unveiled a bronze and stone memorial on the site at 1010 West Oak Street. Incidentally, this was also his ninetieth birthday.

BROOKLYN HEIGHTS, MISSOURI

The origins for Brooklyn Heights are obscure, but apparently it served as a bedroom community for neighboring towns Carthage and Carterville. Its association with Route 66 appears to be equally negligible, since it does not receive recognition in the authoritative guidebooks, such as that written by Jack Rittenhouse in 1946.

BRUSH CREEK BRIDGE

The Brush Creek Bridge, listed in the National Register of Historic Places in 1983 and located three and a half miles north of Baxter Springs, Kansas, is the last bridge of this type still existing on Route 66 in Kansas. The dismantling of the other two examples, one spanning Willow Creek and another spanning Spring River, occurred in 1986 and 1991.

James Barney Marsh, a bridge designer from Iowa, devised this type of graceful arch bridge and patented the unique steel and concrete truss design in 1912. This particular example dates to 1923 and the construction of an all-weather road to link Galena and Baxter Springs.

In 1992, the Kansas Historic Route 66 Association initiated efforts to save the Brush Creek Bridge. During this period, a new bridge opened immediately to the east. Along with the Cherokee County Commission, the association pooled resources in 1994 to make needed repairs to the 130-foot span. Funded through cost-share grant money provided by the National Park Service Route 66 Corridor Preservation Program in 2005, repairs were completed on the concrete superstructure.

The new bridge serves as the primary crossing of Brush Creek. However, the Brush Creek Bridge still accommodates pedestrian and one-way traffic and is a favored photo stop for Route 66 enthusiasts.

BUCKAROO MOTEL

The Buckaroo Motel (1315 West Highway 66 in Tucumcari, New Mexico) opened in 1952 and survived a succession of owners through 2004. As of 2010, it was still intermittently open.

The *Western Accommodations Directory*, published by AAA in 1955, lists the property as an "attractive new air cooled motel. Large rooms have vented heat and combination baths. Radios and baby cribs available. Free newspaper." Listed rates range from $5.00 to $7.00 per night.

AAA in 1954 promoted the Buckaroo Motel in Tucumcari, New Mexico, as "an attractive new air cooled motel featuring large rooms with vented heat, combination baths, radios, free newspapers, and cribs on request." *Mike Ward*

BUCKHORN, MISSOURI

The popularity of the Buckhorn Tavern on the stage road between St. Louis and Springfield resulted in the renaming of the town of Pleasant Grove. Route 66–related businesses during the 1940s included D & D Café and Market (most recently a gift shop), Pleasant Grove Cabins & Café, and Hillcrest Groceries and Station.

BUCKINGHAM'S RESTAURANT

Buckingham's Restaurant (8945 Manchester Road in St. Louis, Missouri, formerly Route 66), built at the turn of the century, initially was a large sprawling residence. In the mid-1920s, extensive renovation transformed the lower level into a restaurant that advertised, "Table d'Hote where polite people assemble." *Table d'Hote* refers to a set menu at a fixed price.

The restaurant became a favorite of locals as well as travelers. The *Western Accommodations Directory*, published by AAA in 1954, provided an extended entry for the facility: "Air

BUCKINGHAM'S RESTAURANT *continued*

conditioned. Open noon to 8:30 p.m.; closed Monday and January 2 to February 1. Good family style meals featuring fried and baked chicken, chicken pies, steaks and homemade rolls and pastries. Luncheons $1.50, dinners $2 to $3.50. Ample parking available."

Buckingham's Restaurant closed a few years after the writing of this directory. The building still stands, however, west of Annalee Avenue.

BUDVILLE, NEW MEXICO

Budville began as an automobile service center established by H. N. "Bud" Rice and his wife, Flossie, in 1928. A trading post opened shortly after this date, but the community never amounted to more than a few houses and the Budville Trading Company. For a number of years, Rice operated the only towing service on Route 66 between the Rio Puerco River crossing west of Albuquerque and Grants. He was also a justice of the peace notorious for issuing steep fines.

Rice was shot and killed here during a robbery in November 1967. His wife continued to operate the facility until 1979. Even though it remains closed, as of the fall of 2011, the complex appeared as though it was receiving regular maintenance.

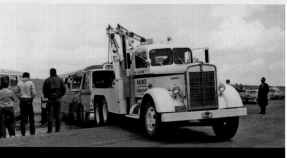

By the late 1950s, Bud Rice of Budville in New Mexico had towing equipment large enough to handle almost any size of vehicle and offered a transport service to surrounding states. *Steve Rider*

inception of their idea to establish a tourist-orientated trading post, the Kays had decided that the American bison, or buffalo, would be a foundational element.

An almost instantaneous popularity resulted in continual expansion through 1963, the year Russell Kay died. These transitional elements included the addition of a western goods store, the Chuck Wagon (a barbeque-buffet-styled restaurant), and the Dairy Ranch (an ice cream parlor); the sponsoring of annual Indian tribal dances; and expansion of the livestock displays to include llamas, elk, deer, sheep, rabbits, and goats.

Completion of the Will Rogers Turnpike (I-44) in 1957 resulted in the bypass of Route 66. However, the popularity of the Buffalo Ranch complex enabled it to remain a profitable and popular attraction until 1997, the year Aleene died. Liquidation of the livestock and furnishings at auction occurred the following year.

The Dairy Ranch, purchased by Betty Wheately in 1958, continued in operation until the end of the summer season in 2000. A modern travel center that utilizes the Buffalo Ranch name to evoke memories of Route 66 now stands on the site.

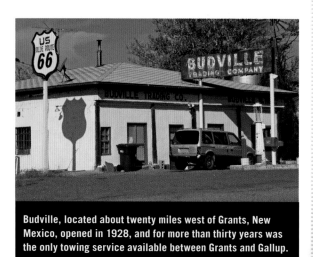

Budville, located about twenty miles west of Grants, New Mexico, opened in 1928, and for more than thirty years was the only towing service available between Grants and Gallup.

BUFFALO RANCH

After an extensive search for the ideal location, Aleene and Russell Kay purchased property immediately to the east of Afton, Oklahoma, at the intersections of U.S. 69, U.S. 66, and U.S. 60 and established the Buffalo Ranch in July 1953. From the

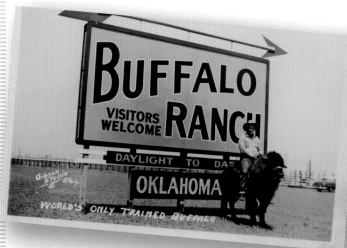

The Buffalo Ranch in Afton, Oklahoma, received international promotion when Larue Olson and his trained buffalo, Pat, rode in President John F. Kennedy's inaugural parade. *Steve Rider*

For promoter C. C. Pyle, the Second Annual International Trans-Continental Footrace proved to be an even bigger financial bust than the previous one. *Steve Rider*

fifty-five completed the entire course. Andy Payne ended up winning with a time of 573 hours, 4 minutes, 34 seconds.

Payne used the winnings to pay off the family farm and purchase a farm of his own. Signage in Foyil designates Route 66 as Andy Payne Boulevard, and at the east end of town, in a small park, is an Andy Payne statue. At the west end of town, near Fourth Street, is a Bunion Derby Marker.

Profits eluded Pyle, but he scheduled another race for the following year and utilized his reputation to garner a wide array of initial publicity. The *Decatur Review* on February 7, 1929, reported: "When the annual transcontinental 'bunion race' promoted by C. C. Pyle, internationally known sports promoter, takes place this spring, the route will pass from New York to Los Angeles. . . . " The grandiose plans and extensive promotion that accompanied the launch of the 1929 race that followed the Old National Trail from New York City to St. Louis and then Route 66 west did little to prevent an even larger financial bust, and Pyle was unable to pay expenses or provide the promised cash prizes for the first-tier finishers.

BUNION DERBY

C. C. Pyle, nicknamed "Cash and Carry," was a sports promoter and entrepreneur who devised a Los Angeles–to–New York City race billed as the First Annual International Trans-Continental Footrace. The race, conceived to expand Pyle's reputation as a promoter, was also supposed to be a profitable venture.

In fact, Payne's reputation for successful promotion of sporting events led the U.S. Highway 66 Association to become an early sponsor, since the projected publicity generated by the event would be a boon for the then two-year-old highway. Additionally, the race presented individual businesses along the highway with an opportunity for international exposure.

Cash prizes for the top ten finishers were to be given, with the first place prize being $25,000. Each participant was required to cover a predetermined distance daily, and the winner would be determined by the shortest elapsed time.

The entry fee for runners was $100, an exorbitant fee in 1928 that, when coupled with expenses, resulted in most participants needing a sponsor. The age of entrants ran from sixteen to sixty-four years old. Among the more than two hundred entries that included professional marathon and long-distance runners from throughout the world was nineteen-year-old Andy (Andrew) Payne, a Cherokee boy from Foyil, Oklahoma, on Route 66. The race, dubbed the Bunion Derby by some reporters, began March 4, 1928, at the Los Angeles Ascot Speedway. It culminated at Madison Square Gardens in New York City on May 26, 1928.

Payne, an unknown amateur, began dominating sports headlines as he became a consistent front-runner after leading the remaining eighty-two entrants across the Oklahoma state line at Texola. Subsequently, Route 66, and his hometown of Foyil, received international attention. Of the original entrants, only

BUSHLAND, TEXAS

Initially established as a station on the Chicago, Rock Island & Gulf Railway in 1898, Bushland, Texas, resulted from the transfer of the Frying Pan Ranch owned by Joseph Glidden to his son-in-law, William Henry Bush, who subsequently donated land for a town site and siding. Official dedication of the town took place on July 3, 1908. Approval of an application for a post office occurred in January 1909, shortly after establishment of a school district. The community remained small, though there was steady growth.

In 1940, the town consisted of four businesses and a population of 175. Jack Rittenhouse, in 1946, indicated the population was twenty-one and noted that, with the exception of a combination gas station and store, there were no services available. As of 2000, the *Handbook of Texas* listed the estimated population as 130.

Jerry McClanahan, in the *EZ 66 Guide for Travelers* (second edition), published by the National Historic Route 66 Federation, makes a very brief notation pertaining to Bushland: "After the thrill of roadside art, the frontage road past Bushland, marked by white concrete silos, is more sedate. Watch for rounded 'Quonset huts,' refugees from old military bases. . . . "

BUSHYHEAD, OKLAHOMA

The namesake for Bushyhead, a small farming community, was Dennis Bushyhead, principal chief of the Cherokee from 1879 to 1887. A post office opened on April 18, 1898, and operated until November 15, 1955.

A 1946 tour guide lists rudimentary services, including a gas station and grocery store. Today, the community remains the proverbial wide spot in the road.

CACTUS MOTOR LODGE

The Cactus Motor Lodge in Tucumcari, New Mexico, opened in 1941 with Pat and Edna Perry as proprietors. Norma and Irene Wegner renovated the Pueblo-styled court with stone facing over the stucco in 1952 after its acquisition.

The *Western Accommodations Directory*, published by AAA in 1954, noted that this was an "unusually attractive court facing a landscaped lawn." It also noted the following: "Nicely furnished one and two room units have radios, vented heat and tiled shower or combination baths; 17 closed garages. Baby cribs. Family rooms for five or six persons. Colorful lobby and gift shop. Playground. Restaurant convenient."

Shortly after the motel's closure in the early 1990s, the property underwent extensive modification, including conversion of the courtyard into a recreational vehicle park. Its historic signage, refurbished in 2008 with cost-share grants from the National Park Service Route 66 Corridor Preservation Program, is a favored photo opportunity for Route 66 enthusiasts.

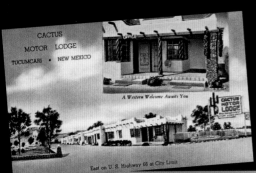

The Cactus Motor Lodge in Tucumcari opened in 1941. The AAA's 1954 *Western Accommodations Directory* describes the property as "an usually attractive court facing a landscaped lawn." *Mike Ward*

CADILLAC RANCH

The Cadillac Ranch consists of ten Cadillacs, each purchased for less than $1,000, buried to their windshields nose-first in a wheat field. Contrary to popular myth, the attraction was not located along Route 66 originally or after the relocation to the current site in 1997. Cadillac Ranch is located south of Interstate 40 along the south frontage road. Route 66 (Indian Hill Road) is north of I-40.

The creator of this modern art sculpture is Stanley Marsh 3, an oil industry heir who does not like to be called "the Third" or "III." The idea was resulted from discussions between Marsh 3 and the people at Ant Farm, a three-member group of eclectic and experimental architects who viewed buildings in a nontraditional manner and operated out of San Francisco from 1968 to 1977. Marsh 3 donated the land along Interstate 40 on the south edge of Amarillo and a $3,000 budget for the project, launched on Monday, May 28, 1974. The design called for burial of the cars at the same angle as that of the Great Pyramid of Giza in Egypt.

The choice of Cadillac models came from the association these vehicles had with success in America. The Cadillac styles selected for the project document the evolution of the tailfin from 1948 through 1964.

The Cadillac Ranch has morphed from eccentric modern art to icon. Thousands of people sign their names to the cars annually, and the site has served as the location for weddings and various commercial photo shoots. Rand McNally has given it legitimacy by adding the Cadillac Ranch to maps of Texas.

Marsh is also responsible for a series of mock road signs in Amarillo collectively known as the Dynamite Museum. The content runs the gamut from whimsical and silly to philosophical.

Opposite: **In a 1994 interview with** *Texas Monthly*, **Doug Michels, one of the Ant Farm artists, said, "Well, suddenly we imagined a dolphin fin sticking up out of the wheat. Then the dolphin fin became a Cadillac tail fin. That was it. There was Cadillac Ranch."** *Steve Rider*

CADIZ, CALIFORNIA

Cadiz, established as a small water station on the Atlantic & Pacific Railroad in 1883, was an important stop for motorists crossing the Mojave Desert on the National Old Trails Highway. A notation in a 1914 guidebook to the roads connecting Los Angles with Phoenix and the Grand Canyon reads, "Cadiz—Water—sandy road—railroad access."

Captured in the cover photo for *Route 66 Sightings*, **a compilation of more than three decades of writing and photography by Jim Ross, Shellee Graham, and Jerry McClanahan released in the fall of 2011, are the ruins of Cadiz Summit Service Station.** *Jim Ross*

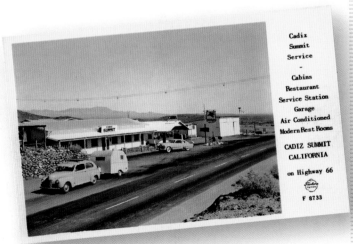

Some maps listed Cadiz Summit Service Station as in the town of Cadiz, but in actuality, the community was miles to the south along the railroad on the National Old Trails Highway. *Steve Rider*

A Route 66 alignment built in 1931 bypassed the small community to the north by three miles. This alignment crossed the Marble Mountains at Cadiz Summit, creating confusion, since some maps refer to this simply as Cadiz. In actuality, it was never a town. George and Minne Tienken relocated their business, Cadiz Service, to this location shortly after the realignment and named it Cadiz Summit Service.

Jack Rittenhouse, in 1946, referred to this as Summit and noted, "A handful of tourist cabins, a café, and gas station comprise this desert oasis." Abandonment, followed by vandalism and a fire, came soon after the opening of I-40 and the bypass of Route 66 in 1973. Nothing remains with the exception of extensive ruins covered in graffiti, a wide array of debris, and stunning desert vistas.

These ruins, photographed under stormy skies, served as the cover image for the book *Route 66 Sightings*, a joint endeavor between Jim Ross, Jerry McClanahan, and Shellee Graham.

CALIFORNIA ROUTE 66 MUSEUM

The California Route 66 Museum on D Street (between Fifth Street and Sixth Street) in Victorville, California, is housed in the former Red Rooster Café building that later became a grocery store. *The Jazz Singer*, starring Neil Diamond, features numerous scenes filmed in this building.

CAJON PASS [MEEKER'S CAFÉ]

As the primary pass between the San Gabriel Mountains and San Bernardino Mountains that connects the Mojave Desert with the coastal valleys now dominated by the urban sprawl of Los Angeles and its satellite communities, the Cajon Pass has served as a primary transportation corridor for centuries. Three key roads associated with the development of the Southwest (the Mojave Road, the Mormon Trail, and the Spanish Trail) all utilized the Cajon Pass, as did the modern equivalents (the railroad, the Arrowhead Highway, the National Old Trails Highway, U.S. Highway 66, and Interstate 15).

In 1914, the National Old Trails Highway became the first surveyed, graded automobile road over the pass, and some oiled sections served as an all-weather road. The November 1914 issue of *Touring Topics*, in an article about the Desert Classic Race, noted, "There will be a dash on a seven and one-half mile oiled straightaway for place in the narrow defile up Cajon Pass, where for twelve miles the road is in a narrow canyon with continuous heavy up-grades and sharp, dangerous turns with few opportunities for passing." The first generation of Route 66 utilized much of this roadway.

In 1919, Marion Meeker, the father of Ezra Meeker, built a café and service station near Camp Cajon, a popular rest stop and picnic area built by William Bristol. A few years later, with assistance from his brother, Marion purchased property nearby

CAJON PASS [MEEKER'S CAFÉ] *continued*

and established a garage, gas station, café, and auto court, Meeker's Sunrise Cabins. Camp Cajon, most of the Meeker complex, and the railroad and Route 66 infrastructure were erased with a massive flood in 1938.

A runaway truck destroyed most of the second Ezra Meeker's complex in 1946. In the mid-1950s, construction of the four-lane alignment of Route 66 erased his next endeavor with the exception of two surviving cabins that were relocated, combined, and converted into a house on the grounds of the next enterprise, a gas station and the Double D Ranch café.

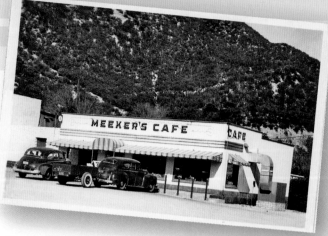

After the devastation of his gas station and café by a runaway truck in 1946, Ezra Meeker built this facility. The transformation of Route 66 into a four-lane highway in 1954 necessitated its demolition. *Steve Rider*

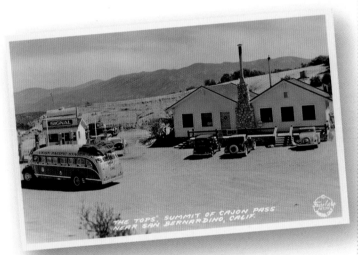

During the 1930s, this complex located at the summit of Cajon Pass was a welcome stop for eastbound travelers on Route 66 after the steep climb of more than six miles through the pass. *Steve Rider*

In 1952, Burton and Dorothy Riley built the Summit Inn. The facility survived the update of Route 66 to four lanes and the construction of Interstate 15 in 1970. With a resurgent interest in Route 66, the complex has again become a favorite stop and was included as a recommended stop during the 2012 International Route 66 Festival held in nearby Victorville.

The transformation of Route 66 to four lanes in the 1950s was but one in a series of adjustments made in the Cajon Pass portion of the highway during the postwar period. During this transition, a City 66 was built to run to San Bernardino while the regular U.S. 66 continued westward from the foot of the pass, and construction of various realignments to ease the climb through elimination of switchbacks was completed. Most of the earliest remnants of Route 66 in the Cajon Pass are now inaccessible, are under I-15, are truncated, or are on forest service lands that require a permit.

An exception to this would be the section between the Cleghorn Road exit and the Kenwood Avenue exit that includes a number of old bridges, the site of a former migrant workers camp

at Swathout Canyon Road, and views of earlier alignments in the flats bypassed or damaged because of floods. Additionally, on the east side of Cajon Junction (State Highway 138), a two-lane section of Route 66 serves as a frontage road and dead ends at a Mormon Trail marker.

CALUMET, OKLAHOMA

Located on the pre-1933 alignment of Route 66, Calumet was established in 1898 with Reuben G. Shirk's platting of a town site on ten acres of his farm bordering Willie Tyler's property, on which the Choctaw, Oklahoma & Gulf Railroad had built a depot. Selection of a name for the community was resolved when the post office was relocated under the Calumet name from the Anna Cowdrey homestead to the new town.

Agriculture served as the primary component for the community's economy and in 1911 supported three mills and elevators. The designation of Route 66 provided opportunity for diversification that continued after the 1933 bypass, since the new U.S. 270 followed the path of Route 66 through town.

CAMPBELL 66 EXPRESS

Campbell 66 Express, founded in 1926 by Frank Campbell in Springfield, Missouri, operated as a long-haul trucking company until 1986. The company's trailers—adorned with the words "Campbell "66" Express Inc.," the Snortin' Norton camel mascot, and the slogan "Humpin to Please"—were familiar sights on Route 66 and the highways of twenty-two states.

William Boyd, the mascot's creator, updated the image in about 1953. From this point on, Snortin' Norton became a galloping camel with a flopping tongue and a big red number sixty-six emblazoned on its side.

Original items pertaining to Campbell 66 Express are treasured mementos among Route 66 enthusiasts. Several original Campbell 66 Express trailers complete with vintage tractor, logo, and mascot, as well as other memorabilia from this pioneering company, are on display at Rich Henry's Rabbit Ranch in Staunton, Illinois.

Snortin' Norton, the mascot for Springfield, Missouri–based Cambell 66 Express, and the slogan "Humpin to Please" were once familiar sights all along Route 66 in the Midwest.

CAMP LOOKOUT

Located almost halfway between Springfield and Carthage in western Missouri, Camp Lookout epitomized the opportunities Route 66 presented to hardworking and industrious families during the 1930s and 1940s. Advertisements promoted the facility that included nine cabins, a gasoline station, and a café as "spotlessly clean" and "Your Home Away From Home." The foundations of the café and station remain, and prized among collectors of Route 66 memorabilia are postcards from Camp Lookout.

This view of a crash near Camp Lookout west of Springfield, Missouri, in 1952 provides insight into the character of traffic on Route 66 during this period; the wrecked vehicle is a 1946 Dodge, the other trucks are a 1941 Chevrolet and a Model A Ford. *Joe Sonderman*

CANUTE, OKLAHOMA

Named for Canute, King of Denmark, this town was initially named Oak. The post office established in February 1899 was listed under the current name.

A 1946 guidebook to Route 66 indicates services included a garage (Mahl Brothers) and a gas station, but no auto courts or cabins. For its array of vintage roadside architecture and faded signage, including the former Cotton Boll Motel and Washita Motel, Route 66 photographers favor the town.

Canute's association with Route 66 spanned the years 1926 to 1970, and the four-lane segments at the west and east ends of the town date to the period from 1956 to 1970. The Interstate 40 bypass opened in April 1970.

Woodrow and Viola Peck, former cotton farmers, opened the Cotton Boll Motel in Canute, Oklahoma, in 1960. With completion of I-40 in 1970, business plummeted and the facility closed in 1979.

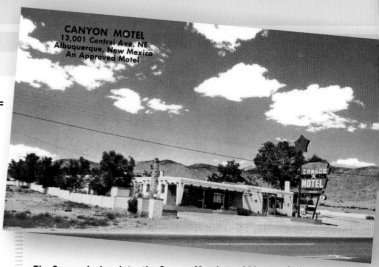

CANYON MOTEL

The Canyon Motel (at 13001 East Central Avenue in Albuquerque, New Mexico) was a typical eighteen-unit complex with Pueblo and Spanish architectural components built in the early 1950s. Promoted as the motel "Where comfort is assured year round," the property would have shared in the decline of neighboring motels into obscurity were it not for the brutal murder of Linda Lee Daniels. She was killed after being held at the motel by her kidnappers, and the subsequent trial with its shocking details rattled the community in 1986. Demolition occurred in 2002. As of 2010, the Value Place Central Hotel stood on the site.

The Canyon Lodge, later the Canyon Motel, would have quietly faded into obscurity if it had not been for the property's association with the heinous murder of Linda Lee Daniels in 1986. *Mike Ward*

CANYON PADRE TRADING POST

Built in either 1948 or 1949, the Canyon Padre Trading Post initially consisted of a store, a service station, and a small ten-stool café housed in a prefabricated diner built by Valentine Manufacturing Company. Purchase by William and Jean Troxell in late 1954 preceded renovations that included the addition of two giant arrows made from discarded telephone poles and renaming to Twin Arrows Trading Post, one of six trading posts between Winona and Winslow in Arizona.

The place remained in operation through the early 1990s. To date, numerous proposals for the property's renovation and reopening, including plans by the Hopi tribe to create an Indian marketplace, have not progressed beyond the planning stage and the renovation of the trademark arrows.

CARLINVILLE, ILLINOIS

The namesake for Carlinville, the Macoupin County seat on the pre-1930 alignment of Route 66, was Thomas Carlin, an Illinois senator instrumental in the creation of the county and governor of Illinois from 1838 to 1842. Platted as the county seat in 1829, the post office has been in continuous operation since February 1830.

Repair services available to Route 66 travelers in 1927, according to the *Hotel, Garage, Service Station, and AAA Club Directory*, were limited to the Mack Motor Company on West Main Street, a facility that offered after-hours repairs. The *Service Station Directory*, published by AAA in 1946, also noted one recommended repair facility, Marko Garage. Primary attractions of note are the courthouse, completed in 1870, and the jail built in 1869. Corruption and political favoritism resulted in the labeling of the former as the "million dollar courthouse," an ornate structure that was larger than the state capital and, at the time of its construction, the largest courthouse outside of New York City.

With acquisition of the Canyon Padre Trading Post by Jean and William Troxell in late 1954, the property underwent extensive refurbishment and renaming to Twin Arrows Trading Post. *Joe Sonderman*

In 1918, a mail-order record was established when Standard Oil of Indiana placed a $1 million order with Sears Roebuck & Company for 156 Honor Bilt homes to house their workers in Carlinville, Illinois. *Joe Sonderman*

Route 66 enthusiasts favor the Carlin Villa Motel, a facility listed in the *Route 66 Dining & Lodging Guide* (fifteenth edition), published by the National Historic Route 66 Federation in 2011. Jerry McClanahan also recommends this motel in the second edition of *EZ 66 Guide for Travelers*, published in 2008.

Additionally, the town has the largest existing collection of Sears & Roebuck Company mail-order houses. These complete homes, sold as kits that included pre-cut framing, date to 1918. In that year, the Standard Oil Company ordered 156 of these houses as homes for mine workers, and as of 2011, 152 remained in the Standard Addition of the city.

The association with Route 66 was relatively short, 1926 to 1930. State Highway 4 now follows this alignment.

CARNUEL, NEW MEXICO

The true origins and meaning of the name, as well as date of initial settlement, are unknown. Archaeological evidence indicates a pueblo near the present site of Carnuel predates the arrival of Spanish explorers. Modern history of the town is dated to February 1763 and the establishment of a small village, Miguel de Carnue, but Indian attacks forced its abandonment in 1771. Archaeological investigation just outside the mouth of Tijeras Canyon, originally indicated as Canon de Carnuel, in Singing Arrow Park has revealed ruins that may be those of the original village.

In 1819, Governor Facundo Melgares signed the application for the Canon de Carnuel grant to provide property to landless individuals in the village of Albuquerque. Carnuel is the resulting settlement.

Before 1951, Carnuel was infamous for its proximity to a sharp, blind turn at the top of a hill aptly referred to as "Dead Man's Curve." Completion of a four-lane divided highway through the canyon—the most expensive highway project in the state's history to that point—eliminated this curve in 1952, and the hill itself was removed during the construction of I-40 in 1965, which bypassed Route 66.

CAROTHERS AND MAUDLIN

The Carothers and Maudlin building, a stylish and modern complex consisting of a service station with garage, opened at 320 East Central Avenue in Albuquerque, New Mexico, in 1938. In the ensuing years after closure in 1957, it housed a variety of businesses before its acquisition by the brothers Vince, John, Mathew, and Chris DiGregory in the spring of 2006 and conversion into the Standard Diner.

The *Route 66 Dining & Lodging Guide* (fifteenth edition), published by the National Historic Route 66 Federation in 2011, gives the restaurant high recommendations: "eclectic upscale diner food—homemade breads and desserts—exceptional value—a very special 'must stop'—moderate atmosphere and service." Additional endorsement came when it was featured on the Food Channel program *Diners, Drive-Ins & Dives*.

CARS

Produced by John Lasseter and Joe Ranft, *Cars*, released in 2006, was the seventh animated Disney-Pixar feature film and the last film independently produced by Pixar before its purchase by Disney. John Lasseter claimed the idea for the film came from a cross-country vacation with his wife and five sons in 2000.

Upon his return, Lasseter contacted Michael Wallis, author and acclaimed Route 66 historian. Discussions with Wallis about the historical importance of Route 66, the international resurgent interest in this highway, and the effect the interstate highway system had on towns along U.S. 66 led to an agreement in which the acclaimed author would lead Pixar animators on a tour of that highway.

As a result of this tour, real people and places along the highway served as the inspiration for character development and scenery in the animated feature film. In an interview with Joe Williams, film critic for the *St. Louis Dispatch*, Lasseter said that a great deal of the story for Radiator Springs was derived from interviews with Angel Delgadillo of Seligman, Arizona.

The Cozy Cone Motel in the film is a composite of the Wigwam Motel in Holbrook, Arizona, and the Wigwam Motel in Rialto, California. The name for the mythical motel is a nod to the Cozy Dog Drive In of Springfield, Illinois. Bob Waldmire served as inspiration for the character Fillmore. Waldmire, a self-proclaimed "hippie," as well as an artist and muralist of great renown, was a fixture on Route 66 who preferred traveling the highway in his Volkswagen bus.

The iconic U-Drop Inn in Shamrock, Texas, served as inspiration for Ramone's House of Body Art. The yellow billboard proclaiming "Here It Is!" for Lizzie's Curio Shop is a reference to the Jack Rabbit Trading Post at Joseph City, Arizona, that is still promoted, as it has been for more than a half century, with a large billboard proclaiming the same slogan. The inspiration for Sally, portrayed in the film as a Porsche with a voice by Bonnie Hunt, is Dawn Welch, owner of the Rock Café in Stroud, Oklahoma. In addition to serving as a consultant for the film, Michael Wallis lent his signature voice to that of the sheriff.

Other locations along Route 66 incorporated into the film include Tucumcari Mountain, Cadillac Ranch, Hackberry General Store, the leaning water tower at Groom, the twisted course of pre-1952 Route 66 through the Black Mountains, the tunnels of the Arroyo Seco Parkway, La Bajada Hill, Glenrio, and the Wagon Wheel Motel. Additionally, individuals who lent unique attributes to the character development include Dean Walker, Harley Russell, and Fran Houser at the Midpoint Café in Adrian, Texas.

The popularity of the film mirrors that of Route 66. In its opening weekend, at 3,985 theaters, the film earned $60,119,509 and would eventually gross $461,981,604 with worldwide release. With international release of the DVD in the fall of 2006, Walt Disney Company claimed sales of five million copies in the first two days and more than six million copies in

CARS continued

the first week. Related merchandising, through 2009, resulted in $5 billion in sales.

A sequel, *Cars 2*, debuted on June 24, 2011, to mixed reviews, possibly as a result of its departure from the original Route 66 theme.

CARTERVILLE, MISSOURI

Carterville, platted in 1875 by J. L. Carter, was economically an agricultural community until late in the nineteenth century. The discovery of extensive lead and zinc deposits during this period sparked a mining boom that culminated in the late teens when the population neared twelve thousand.

In 1946, Jack Rittenhouse noted, "This former opulent mining center is now almost a ghost town, with its boarded up stores, empty buildings, and general air of desolation. Its decline began at the close of World War I when nearby lead and zinc mines were closed." *The Service Station Directory*, published by AAA in the same year, listed Spencer Garage as a recommended repair facility.

The two attractions of note are the SuperTam 66, an ice cream parlor with an extensive collection of Superman memorabilia and the welcome center at 401 West Main Street. The structure utilized by the welcome center dates to 1937 when it opened as a Sinclair service station.

CARTHAGE, MISSOURI

Initial settlement in the richly timbered and fertile bottomlands that would become Carthage commenced after relocation of Native American tribes to the Indian Territories to the west through treaties in the 1820s and 1830s. In 1837, members of the Osage tribe returned to the area in search of better grounds for hunting and farming. Governor Lilburn Boggs addressed the situation with orders for the state militia to utilize force in the relocation of the Indians back to Kansas. Commemorating this incident, known as the Osage War, is a marker in the Jasper County Courthouse Square. Jasper County, named for William Jasper, a Revolutionary War hero, was formed on January 29, 1841. Designation of Carthage as the county seat took place on March 28, 1842, and platting of the town site commenced shortly after this date.

For reasons unknown, the namesake of this community is Carthage, a city in the classical world known as a model for democracy. From a perspective of historical hindsight, this is rather ironic as numerous homes and businesses built during the period before 1860 utilized slave labor. By the advent of the Civil War, Carthage was a progressive, modern community at the center of a prosperous agricultural region. On July 4, 1861, the Battle of

Carthage, the first land battle of the American Civil War, commenced. This was the first of thirteen major military engagements that centered on Carthage, with the last occurring on September 22, 1864. During this engagement, Confederate forces burned most of the city.

An additional association with the Civil War has to do with Myra Belle Shirley, the Confederate spy who used the name Belle Star and who was born in Carthage. In the postwar era, Shirley embarked on a life of crime that earned her the moniker "Queen of the Outlaws." Within ten years of the cessation of hostilities, Carthage was again a prosperous, progressive community. The building of the Missouri & Western Railroad in 1872 fueled agricultural business as well as establishment of numerous industries including the Carthage Woolen Mill, a brickyard, and the Carthage Foundry & Machine Works. Further economic development and diversification occurred with establishment of the Missouri & Pacific Railroad. It was during this period that lead mines, first established in 1849, as well as marble and limestone quarries, became a foundational element in the town's economy.

Indicative of the progressive nature of the community was the election of Anna White Baxter as county clerk in 1890. This revolutionary event garnered national headlines. With the dawning of the twentieth century, Carthage continued to develop as a substantial community of brick and stone businesses as well as homes. The extensive number of surviving buildings from the late nineteenth and early twentieth century resulted in the entire courthouse square district's listing in the National Register of Historic Places in 1980. Dominating this district is the stunning Romanesque Revival courthouse built during the mid-1890s, designed by Maximilian Orlopp Jr. and faced with locally quarried limestone and marble. Missouri tourism officials list this structure as the most photographed in the state after the Saint Louis Gateway Arch.

As a historic footnote, marble from Carthage quarries, the only source for gray marble in the United States, was used to

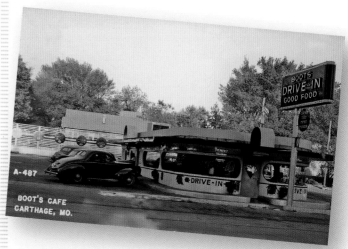

Arthur Boots opened the Boots Drive-In in 1946 across from Boots Court. The drive-in closed in 1970, and as of 2011, the building housed the Great Plains Credit Union. *Steve Rider*

The stunning courthouse in Carthage, Missouri, built in 1895, is the second-most photographed manmade site in the state after the St. Louis Gateway Arch.

face the Missouri State Capitol and the United States Capitol and in decorative features at the White House. These quarries continued in operation into the 1980s.

During the teens, mining and industry continued to play integral roles in the community's economic development. Additionally, establishment of the Southwest Missouri Electric Railway that connected Carthage with Webb City, Carterville, and Duenweg, and the city's location at the junction of the Ozark Trails Highway and Jefferson Highway, served as a catalyst for the development of a service industry that further diversified the economy.

The *Hotel, Garage, Service Station, and AAA Club Directory* of 1927 indicates the population was ten thousand. Recommended services included the Drake Hotel ($1.50 per night) and St. John's Garage. The Drake Hotel (at 406 Howard Street) also is listed in the 1954 edition of the *AAA Western Accommodations Directory*: "Near U.S. 66 and U.S. 71."

The 1946 guidebook published by Jack Rittenhouse contains an expanded entry that profiles the community's rich history. He also indicates that available services included hotels, motels, cabins, garages, and restaurants.

The 1949 edition of *The Negro Motorist Green Book* has one listing for lodging in Carthage. Under the heading "Tourist Home" is "Mrs. M. Webb—S. Fulton St."

The 1954–55 edition of the *AAA Western Accommodations Directory* lists two lodging recommendations in addition to the Drake Hotel: Dazy Court and Boots Court. The latter, established in 1939 by Arthur Boots, has survived into the modern era after a lengthy string of modifications necessitated by the drive to stay relevant. Initially the complex consisted of four, two-room structures, a restaurant across the highway, and a Mobil service station in front of the motel. The razing of the service station allowed for expansion of the motel. During the 1950s, existing structures were given a modern appearance through the addition of pitched roofs, and five more units were built to expand the complex. Amenities were updated to include television and air conditioning.

The Boots Drive-In and Gift Shop, located across the highway from Boots Court, most recently housed an insurance agency. As of 2011, the motel was purchased from a bank foreclosure sale, plans were initiated for restoration with a

Log City Camp near Carthage, Missouri, built of trees cut on the property, opened in 1926 and evolved into a full complex of sixteen cabins, café, and service station. *Mike Ward*

55

CARTHAGE, MISSOURI *continued*

projected date for a limited reopening of May 2012, and the Route 66 Chamber of Commerce established offices in one of the former motel rooms.

Attractions and historic sites related to the community's lengthy and colorful history are plentiful, but surprisingly, few associated with Route 66 remain. In addition to the extensive collection of preserved or restored Victorian homes, the Powers Museum, the ornate Jasper County Courthouse, and the Civil War Museum with detailed dioramas (at 205 Grant Street), Carthage historic sites with Route 66 association include C D's Pancake Hut and the recently renovated 66 Drive-In Theatre that initially opened in September 1946.

At the junction of U.S. 66 and U.S. 71, as of 2010, stands the Red Rocks Apartment Complex. This property dates to at least 1927 and the establishment of a café and gas station. Promoted as White's Court, the eight stone cabins were built shortly afterward. In 1957, the adjoining garages were enclosed and the cabins modernized. It continued in operation as a motel through 1987.

Often overlooked by Route 66 enthusiasts are the remnants of Dazy Court and those from the Murrell Courts at 830 Oak. An older Victorian home obscures them from the street.

CASA DEL DESIERTO

Initially the Harvey Houses were built to fulfill a utilitarian purpose with minimal capital outlay, and the one in Barstow (built in 1885) was no exception. After 1900, management of the Atchison, Topeka & Santa Fe Railroad initiated a program of modernism that coincided with the 1908 fire, which devastated the Barstow facility.

Designed by renowned architect Mary Colter in a blending of Spanish Colonial and Southwest styles, Casa del Desierto (House of the Desert) was built from 1909 to 1910 with an official opening in February 1911. The complex was one of the few buildings to the north of the railroad tracks that remained after expansion of the rail yard necessitated relocation of the Barstow business district to the south in the early 1920s. The hotel remained in operation until 1959, the restaurant until 1970. It was one of the last historic Harvey House facilities to close.

The National Old Trails Highway, and initially Route 66, ran adjacent to the Harvey House and railroad depot. That section of the original highway now provides access to the Casa del Desierto from the business district and the final alignment of Route 66.

The complex remained empty, with the exception of railroad offices, before its listing on the National Register of Historic Places in 1975. Through local contributions and grants from Federal Transportation Enhancement Funds, renovation commenced in the mid-1990s, and in 2000, the Route 66 Mother Road Museum opened its doors.

As a Harvey House establishment, the beautiful Casa Del Desierto in Barstow, California, met the needs of railroad travelers as well as those on the National Old Trails Highway and Route 66.

A railroad museum occupies the opposite end of the complex. As of winter 2011, the central portion of the complex had been renovated to accommodate nine businesses, the Barstow Chamber of Commerce had relocated its offices to the structure, and the former ballroom was being rented for special events.

CASTLE CAR WASH

Built by Louis Ehrenberer to serve as a gas station and garage, the Castle Car Wash, located at 3801 West Ogden Avenue in Chicago's North Lawndale district, dates to 1925. It continued to operate as a service station through the 1970s. Its storied history and unique architectural elements make it a favored photo stop for Route 66 enthusiasts. As of 2011, it remained closed in spite of numerous proposals for renovation.

CASTLE KOURT

At its zenith during the 1950s, the Castle Kourt (later Castle Motel) at 2403 West Seventh Street in Joplin, Missouri, consisted of thirty-five stone-faced cabins, the result of enclosure of the original garages between units. Jack Rittenhouse included the facility in his guidebook, published in 1946, and the 1954 edition of the *Western Accommodations Directory* published by AAA noted the complex offered one- or two-room units with air conditioning or fans, and radios upon request. The complex no longer exists.

CATOOSA, OKLAHOMA

The name "Catoosa" is derived from a Cherokee word purportedly meaning "new settlement place." Establishment of a post office under this name occurred on March 27, 1883, a year after expansion of the St. Louis & San Francisco Railroad to this point.

Transportation continues to be an integral component in the economy of Catoosa. As the head of the 445-mile McClellan–Kerr Arkansas Navigation System that links Tulsa to the Gulf of Mexico using the Arkansas and Mississippi Rivers, Catoosa is the farthest inland year-round seaport in the United States.

ARK in Catoosa, Oklahoma, was a manifestation of the fascination Hugh Davis (a renowned wildlife photographer and curator of the Mohawk Zoo in Tulsa) and his wife, Zelta, had for alligators and other reptiles. *Steve Rider*

The now iconic Blue Whale in Catoosa, Oklahoma, was the creation of Hugh Davis, who designed and built the whale as the centerpiece for a recreational park that included canoe rentals, picnic grounds, and a water slide. *Steve Rider*

The primary attraction for Route 66 enthusiasts is the Blue Whale, built between 1970 and 1972 as part of a recreational complex that was built by Hugh Davis for his wife, Zelta, and their family in the late 1960s. The whale, as well as the pond and park with small zoo that surrounded it, served the recreational needs of the community for almost twenty years.

After a decade of abandonment and subsequent vandalism, an informal group of Catoosa area residents commenced refurbishment of the landmark whale and the grounds. In the winter of 2010, a community celebration of Christmas culminated with the lighting of strings of colorful lights adorning the Blue Whale.

Additional points of interest in the area of Catoosa include bridges over the former channel of the Verdigris River: the original 1936 span (scheduled for demolition in late 2011) and the 1957 span built to accommodate the transformation of Route 66 from two to four lanes. On Rice Street southwest of the park that surrounds the Blue Whale is a bridge built in 1913 that served traffic of the Ozark Trails Highway System, now used as a footbridge.

CAWSTON OSTRICH FARM

Located at the intersection of Sycamore Avenue and Pasadena Avenue in Pasadena, California, the Cawston Ostrich Ranch opened in 1896. The plumes sold to hat makers were initially the primary profit source. However, the ranch soon began to capitalize on tourism to supplement income. Edwin Cawston, namesake business owner of the enterprise, sold the property for a reported $1.25 million in 1911.

By the advent of Route 66 in 1926, the ranch had developed a reputation as a tourist trap with the primary attraction being rides in carts pulled by ostriches. Interestingly, early promotion proclaimed the farm was open to "first class citizens," but in this age of segregation, the park proved quite popular with the African American community in Los Angeles.

The decrease in tourism revenue by 1930, the rising value of the property for development, and tax claims resulted in closure in 1934. Ostrich Farm Lofts stand on the site today.

CHAIN OF ROCKS AMUSEMENT PARK

In 1918, the city of St. Louis established the Chain of Rocks Park on the riverside bluff overlooking the city's new waterworks on the Mississippi River. The forty-acre park, the answer to New York's Central Park, featured landscaped grounds, fountains and goldfish ponds, and the words "Chain of Rocks" spelled out in large flowery beds.

Adjacent to the park, two years before the opening of the Chain of Rocks Bridge in 1929, the Chain of Rocks Amusement Park (later the Chain of Rocks Fun Fair) opened with Christian Hoffman as the president. The small park—with rides like the

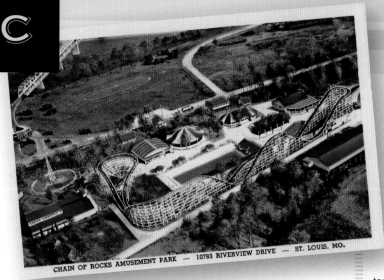

Located on a bluff overlooking the Mississippi River at the western terminus of the Chain of Rocks Bridge, the Chain of Rocks Amusement Park opened in 1927. *Steve Rider*

CHAIN OF ROCKS AMUSEMENT PARK *continued*

Whip, Dodgem Pavilion, Swooper, and carousel—became a popular weekend destination for residents of St. Louis.

In 1935, Carl Trippe, founder of the Ideal Novelty Company that provided the machines for the penny arcade at Chain of Rocks Amusement Park, obtained controlling interest in the park. Trippe moved the park from carnival-type fare to a more modern complex that included fine dining. The Sky Garden Bar and Restaurant, with sweeping views of the Mississippi River and original oil paintings depicting river scenes, became a popular dining establishment for local residents as well as travelers on Route 66. Trippe had his offices upstairs and an apartment for his family next door. Enhancing the park's popularity in the St. Louis area were Trippe's generous sponsorships and contributions. For example, he sponsored the annual Easter egg hunt and Ozark AAU Junior Swimming Meet.

Carl Trippe died instantly after suffering a major heart attack in the offices of the Ideal Novelty Company in 1955. Three years later, his wife, Margaret, initiated the sale or lease of the park.

The leasees, William Zimmerman and Ken Thone, owners of Holiday Hill Amusement Park and similar properties (including golf courses), undertook extensive remodeling and renovation. This included removing the wooden-framed Comet roller coaster; repairing some of the original rides, including the Swoop (one of only nineteen such rides ever manufactured); transforming the roller rink into a miniature golf course; and changing the name to Chain of Rocks Fun Fair. Zimmerman and Thone also expanded the park grounds and contracted with a carnival operator based in Florida to provide additional rides from mid-April through mid-June. Presented to schools during this period were special promotions that encouraged them to utilize the park for their picnics.

Creative marketing in tune with the times ensured the park would remain profitable through the 1960s. Among the more lucrative promotions, Splash Parties used the park's Olympic-sized swimming pool during the summer months, coinciding with

performances by live bands, some of which became quite famous, such as Paul Revere and the Raiders.

In 1971, Six Flags over Mid-America opened at nearby Eureka and there was an immediate slide in business. A secondary blow occurred in 1973 when a fire destroyed the Sky Garden Bar and Restaurant.

In 1975, with closure of the amusement park at Holiday Hill because of Lambert Field expansions, a number of the rides from that park were relocated to the Chain of Rocks Fun Fair Park, but this failed to stop the slide in attendance. Imposition of a 5 percent amusement tax in addition to the city's 4.5 percent sales tax in late 1976 further restricted attendance.

In June 1977, another fire destroyed several of the older rides, including the ornate 1922 carousel. The park was closed on Labor Day of 1977, and the rides and other components of the park were sold at auction in June 1978.

CHAIN OF ROCKS BRIDGE

Built in 1929 as a toll bridge (the toll being twenty-five cents in 1946), this cantilever through truss bridge across the Mississippi River is 5,353 feet long with a unique twenty-two-degree bend at the middle of the crossing to allow for uninterrupted river traffic. The U.S. 66 system absorbed it as a beltline alternative to a direct route through the municipality of St. Louis in 1936.

On the Missouri side of the river through the 1950s was the Chain of Rocks Amusement Park built in Riverview Park, a site once proposed for the 1904 St. Louis Exposition. The park consisted of rides, a skating rink, a dance hall, baseball fields, and picnic areas.

The narrow confines of the historic Chain of Rocks Bridge that led to its discontinuance as a river crossing for Route 66 in 1965 are ideally suited for a pedestrian and bicycle walkway. *Judy Hinckley*

With completion of a new bridge to carry Interstate 270 across the Mississippi River in 1967, the bridge closed. The prohibitive cost of demolition left its fate in limbo for more than thirty years. During this period, the bridge garnered major attention outside of the St. Louis area only twice, once with the murders of Julie and Robin Kerry in April 1991 and once in 1981, with the filming of *Escape from New York*.

In 1998, Trailnet leased the bridge, and it was renovated for pedestrian and bicycle usage at a cost of $4.5 million. Today the bridge is a favorite attraction for Route 66 enthusiasts and is the longest pedestrian/bicycle bridge in the country.

CHAIN OF ROCKS MOTEL

The Chain of Rocks Motel in Mitchell, Illinois, opened in 1957 at 3228 West Chain of Rocks Road. Expansion in 1958 doubled the size of the complex from six to twelve units. An additional eleven units in 1960 and another fifteen in 1977 transformed the property. The towering landmark sign remained until late 2006. As of 2010, the motel remained operational under the Economy Inn name.

CHAMBERS, ARIZONA

There are two conflicting stories pertaining to the namesake for Chambers, a town established as a railroad siding. One claim is that it was Edward Chambers, the vice president of the Atchison, Topeka & Santa Fe Railroad. Another is that it was Charles Chambers, who established a trading post at this location sometime before 1895.

Regardless, a post office opened under the Chambers name in 1907. Application for a name change to Halloysite, a type of Bentonite clay used in the manufacture of fine china mined

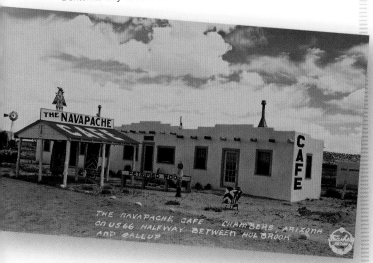

The Navapache Café was one of three roadside businesses in Chambers, Arizona, during the 1940s. The others were Chambers Trading Post and Cedar Point Trading Post. *Joe Sonderman*

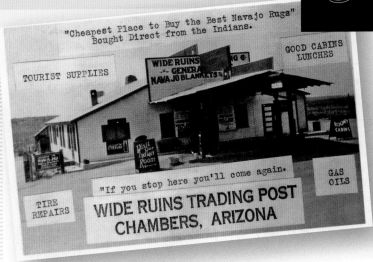

Promotion for the Wide Ruins Trading Post noted a Chambers, Arizona, location, but in actuality, it was two miles to the east. *Steve Rider*

nearby, received approval in 1926. The change was short-lived, however, and in 1930, another request restored the original name.

The building of the National Old Trails Highway (Route 66 after 1926) led to the development of a number of service-related businesses. In 1946, these consisted of a tourist court, two gas stations, Riggs Café, and the Navapache Café.

The dramatic increase in travel on Route 66 resulting from the postwar boom in tourism led to the establishment of other businesses. These included expansion of the Chambers Trading Post by Alice and Frank Young, who later built the Chieftain Motel along I-40 after completion of the Chambers bypass, and construction of the Cedar Point Trading Post. Charley Jacobs established a Navajo village near Chambers on Route 66 where Navajo families could live and sell handicrafts such as rugs and jewelry. It proved to be a lucrative endeavor for Jacobs.

In the first days of January 1962, a tragedy that occurred near Chambers briefly placed that small, obscure little community at the center of national media attention and underscored the need for completion of the interstate highway system. The seven-member family of Eugene Wildenstein was headed home to El Cerrito in California after spending the holidays with grandparents in Las Vegas, New Mexico, when family members were involved in a head-on collision with a truck. Six members of the family died instantly. Five-year-old Warren Wildenstein sustained severe injuries but recovered after numerous surgeries.

CHAMBLESS, CALIFORNIA

James Albert Chambless established his original store in the Mojave Desert along the National Old Trails Highway around 1920. The Automobile Club of Southern California noted his proprietorship of a small store at the junction of Cadiz Road and the National Old Trails Highway in 1922, but with the realignment of the highway, and its subsequent designation as U.S. 66, he relocated his business and reestablished it as Chambless Camp.

59

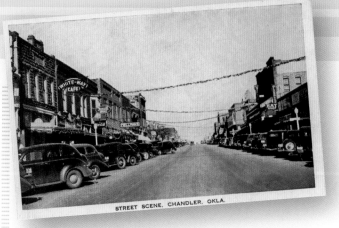

In Chandler, Oklahoma, Route 66 utilized Manvel Avenue to traverse the business district. For Route 66 enthusiasts today, Chandler is associated with the gallery of Jerry McClanahan at 306 Manvel. *Steve Rider*

CHAMBLESS, CALIFORNIA *continued*

By the 1930s, maps began indicating Chambless Camp as Chambless, but by this time James Chambless had sold the property. During the period between the late 1930s and 1960, Chambless mushroomed into a desert oasis that included a grove of trees and a post office, a gas station, motel cabins, a café, and a store.

For Jack Rittenhouse in 1946, Chambless mirrored nearby Danby in that it consisted of a "wide porched gas station, with a café and several tourist cabins." He also noted that, "Except for Ludlow, California, there are no 'towns' which merit the definition between Needles and Daggett, California, a stretch of about 150 miles."

Today the future of the remaining structures is uncertain, even though Gus Lizalde recently purchased them and fenced the property. A severe storm destroyed the wide porch over the service islands, but the store built of adobe bricks, now roofless, and the small stone cabins remained as of 2011.

The origins for Chambless Camp predate Route 66, as the facility initially met the needs of travelers on the National Old Trails Highway before its relocation to the current site. *Steve Rider*

CHANDLER, OKLAHOMA

The post office in Chandler, named for George Chandler, assistant secretary of the interior under President Benjamin Harrison, opened on September 21, 1891. In 1897, a tornado leveled the majority of structures in the community and killed fourteen citizens.

As an agricultural community, Chandler prospered well into the late 1920s. With the onslaught of the Great Depression fueled by the collapse of agricultural prices, constriction of credit, and drought, Route 66 became an important element in the town's economy.

The 1940 *AAA Directory of Motor Courts and Cottages* gave Gibson's Court in Chandler an excellent review: "five blocks south of the business district on U.S. 66, 10 apartments, completely furnished, all with private tub and shower baths and closed garages. All heated by gas. . . . Coil spring beds with inner spring mattresses; hardwood floors." Other amenities noted were a porter, a night watchman, a maid service, and a kitchenette in several units. Additionally, a restaurant was located next door.

The Rittenhouse guide from 1946 lists a hotel, the LaGere Garage, several auto courts, numerous cafés, and other services. In addition, the guide also notes, "In the cemetery here is the grave of Bill Tilghman, a famous frontier marshal in the days of the Territory."

Today, Chandler has a wide array of sites of historic importance as well as locations of particular interest to the Route 66 traveler. Counted among these are a circa-1930s cottage-style service station (undergoing restoration as of late 2011), the Lincoln Motel (dating to 1939), the armory (dating to 1937, now a Route 66 interpretive center), the Valentine Diner, the Steer Inn, and P. J.'s Bar-B-Que. One of the primary attractions for Route 66 enthusiasts is the gallery of Jerry McClanahan, an acclaimed Route 66 artist and the author of *EZ 66 Guide for Travelers*, one of the most popular guidebooks for Route 66 yet written, located at 306 Manvel.

The *Route 66 Dining & Lodging Guide* (fifteenth edition), published by the National Historic Route 66 Federation in 2011, indicates that the Lincoln Motel is "currently undergoing restoration." The second recommended business in Chandler is Marsha's Country Kitchen.

CHANDLER ARMORY

Built in two sections through the Works Progress Administration (WPA), the Chandler Armory's construction began in 1935. With completion of the complex in March 1937, the community celebrated with a parade, music, and a banquet.

The facility, designed by Major Bryan W. Nolan of the Oklahoma National Guard, featured offices, vehicle repair bays, an

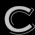

ammunition vault, classrooms, an auditorium that served as a drill hall, and locker rooms. It served as the home for the Battery F, Second Battalion of the 160th Field Artillery of the Oklahoma National Guard 45th Infantry Division, a unit that served with distinction in North Africa, Sicily, and in Italy. The armory served as a textbook project of the WPA, whose goal was to boost community economies with local labor for public works projects. The local quarry that supplied the sandstone for the walls employed more than 250 men. The hand-laid floor of the drill hall required more than 156,000 wooden blocks.

The building remained in use as designed through 1971, at which time the historic structure, listed in the National Register of Historic Places in 1992, was deeded to the city. Utilization of the building for an array of purposes, little maintenance, and long periods of abandonment resulted in extensive decay, and by the early 1990s debates about demolition dominated city council discussions.

The Old Armory Restorers, a volunteer organization formed in 1998, began plans for renovation. The initial work by this group, and a succession of grants, matching-funds grants, and endowments, resulted in refurbishment of the structure and its transformation into the Chandler Route 66 Interpretive Center and the Ben T. Walkingstick Conference Center and Exhibition Hall. As of 2010, the center averaged more than seven hundred visitors per month.

CHATHAM, ILLINOIS

There are indications the name of the town of Chatham, platted in 1836 by Luther Ransom, refers to the Chatham Presbyterian Church in Pittsylvania County, Virginia. The initial post office opened under the name Lick Creek in June 1840, and an amended application, approved on August 9, 1841, resulted in the name change to Chatham.

Chatham is located on the pre-1930 alignment of Route 66. Southwest of town is a rare 1.4-mile section of brick road surface. According to Illinois historian John Weiss, these bricks were laid in 1932 over the Portland cement roadway that predates Route 66, as indicated by the bridges dated to 1920 that were utilized by Illinois State Highway 4.

In the 1927 edition of the *Hotel, Garage, Service Station, and AAA Directory*, the only approved facility listed is Dean's Garage. The *Service Station Directory*, published by AAA in 1946, also lists one approved repair facility, Chatham Garage.

CHARLEY'S PIG STAND

Charley's Pig Stand opened at 2106 East Central Avenue (Route 66) in Albuquerque, New Mexico, in 1924. The popularity of the restaurant led to the construction of a new building at this location in 1930. Since its closure in 1954, the building has housed various businesses, including a laundry and, as of 2010, another

restaurant. In spite of these transformations, the embossed pigs still remain on the façade. Indicative of the significance of this structure is its listing in the National Register of Historic Places as well as in the State Register of Historic Places.

CHELSEA, OKLAHOMA

Credited with naming Chelsea for his hometown in England is Charles Peach, a railroad official. Initial settlement dates to at least 1872, but the population did not warrant establishment of a post office until the fall of 1882. Agriculture served as the primary economic foundation until the discovery of oil and drilling of a well by Edward Byrd in 1889, the first oil well in the territory. Chelsea also has some celebrity association. Gene Autry resided here for a short time while working for the Frisco Railroad, and Will Rogers often visited his sister, Sallie McSpadden, here.

The 1940 *Directory of Motor Courts and Cottages* lists one AAA-recommended lodging facility, Shady Grove Tourist Camp. The 1946 guide by Jack Rittenhouse was less restrictive and lists two auto courts, two garages, and several cafés, and in the same year, AAA listed Null Chevrolet as an approved repair facility in its *Service Station Directory.*

Attractions or sites of interest for the Route 66 enthusiast include a tunnel under Route 66, built to facilitate pedestrian traffic placed at risk by the highway's near-constant flow of traffic, and the Pryor Creek Bridge, built in 1926. Others include a home at the corner of Tenth and Olive ordered as a kit from the Sears & Roebuck catalog in 1913 and the Chelsea Motel. The Chelsea Motor Inn, an older property that warranted recommendation by the National Historic Route 66 Federation in its *Route 66 Dining & Lodging Guide* (fifteenth edition), published in 2011, has several features that are reminiscent of independent motels along Route 66 in the 1950s, including three pet donkeys and a teepee rented during the summer months.

CHENOA, ILLINOIS

Matthew T. Scott platted the site for this town on the proposed junction of the Chicago & Alton Railroad and the Peoria & Oquawka Railroad in 1856. Scott insisted the name, Chenowa, was the native name for his home state of Kentucky, but there was, and is, no substantive validation to the claim. Subsequently, he was incensed that the postal application recorded the name incorrectly, resulting in the establishment of the post office in 1856 under the name Chenoa. The post office continues in operation.

The home of Matthew Scott stands at 227 North First Street. Built in two stages—the rear in 1855 and the Georgian-styled front in 1863—the house, listed on the National Register of Historic Places, is open for tours on Sunday afternoons.

The H. C. Masso Garage at 408 Sheridan Street is the approved repair facility listed in the *Hotel, Garage, Service Station, and AAA Club Directory* of 1927. The *AAA Directory of*

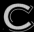

Motor Courts and Cottages for 1940 lists only Sweeney's Tourist Cabins, $1.50 to $2.00 per night. Stroller Farm Supply is the recommended repair facility in the 1946 edition of the *Service Station Directory* published by AAA.

Initially, Route 66 followed Morehead Street. Realignment resulted in severing the business district from traffic on Route 66. Jack Rittenhouse noted in 1946 that most businesses, including cafés, gas stations, cabins, and Burch & Downe's Garage, were located to the north of the railroad tracks off the highway.

Attractions of note are plentiful. These include the Chenoa Pharmacy with original cabinetry (209 Green Street), dating to 1889 and inducted into the Route 66 Hall of Fame in 2005, and the refurbished Selz Royal Blue Shoes advertisement at 224 Green Street.

The Sweaney station, left, would dominate this corner for years. By the 1930s, additions included a faux steeple, a second series of pumps, and a cottage-faced front. *Steve Rider*

CHICAGO, ILLINOIS

Native Americans resided by the rivers here centuries before initial exploration by the French and settlement by the Americans. However, the accepted date of origination is 1829, the year the Illinois State Legislature created the Illinois and Michigan Canal Commission to link the Chicago River with the Mississippi River and retained James Thompson, a civil engineer, to lay out the original town site. As a town, incorporation came in 1833. Incorporation as a city followed four years later.

The city's link to Route 66 predates that highway's designation by almost 100 years. Of two county roads commissioned in Cook County in 1831, one served as the course for Route 66 after 1926. Additionally, in 1834 this roadway became part of the first stagecoach line to connect Chicago with St. Louis.

Canals and the railroads negated this initial lead in the development of a roadway system in the state of Illinois when the funding for the former left little money for the construction or maintenance of roads. On March 4, 1902, nine auto clubs met in Chicago to create an organization that would address this shortcoming from a political standpoint as well as from an educational one and to add a voice to that of the Wheelman, an organization of bicycle enthusiasts that initiated the modern good roads movement. After the election of a board of directors, the first order of business for the new organization, the American Automobile Association, was to initiate plans for the creation and funding of a transcontinental highway designed specifically for the needs of the motorist that would link New York City with California.

During the next decade, various associations would form to campaign for the development of all-weather roads and to develop established highway corridors. Of particular note with regard to Route 66 history were the endeavors of A. L. Westgard who, in the employ of the Touring Club of America, mapped a route to California from Chicago designated as the Trail to Sunset in 1910. As was that of Route 66, the eastern terminus for this trail was at Jackson and Michigan Boulevards in Chicago. Emily Post would utilize this route west from Chicago to Iowa in her 1916 transcontinental adventure chronicled in *By Motor to the Golden Gate*.

In 1916, the Illinois General Assembly passed an act to construct hard-surfaced roads with special funding from $60 million in bonds. State Bond Issue Route 4 provided for the development and improvement of a roadway to connect Chicago with East St. Louis. By December 1926, with paving from Jackson and Michigan Boulevards in Chicago to the McKinley Bridge in Venice on the Mississippi River complete, the designation as U.S. 66 on January 15, 1927, resulted in Illinois being the first state in which the highway was fully paved.

The history of Chicago and Route 66 is full of iconic buildings, businesses, and people. For example, John Raklios was a pioneer in the chain restaurant business, and by 1930, there were more than twenty Raklios restaurants in the Chicago area offering standardized fare, service, and design. Four of these restaurants were located directly along the course of Route 66 in the city, and the remainder were located within two miles of that highway. The harsh economic climate of the Great Depression led to a reversal of fortune for Raklios, however, and by 1937, he was bankrupt and the restaurants were sold to competitors. His son, Hercules Raklios, opened a restaurant under the Raklios name on Clark Street in 1940.

Another pioneering business associated with Ogden Avenue (Route 66) was Warshawsky and Company, a wholesaler of rebuilt components for automobiles established in 1915. By 1930, the company had expanded to include four retail stores, with one at 3924 Ogden Avenue. In 1930, under the J. C. Whitney name, the company introduced a widely circulated mail-order catalog.

Located between Lake Shore and Columbus Drives (the eastern terminus of Route 66 from 1937 to 1977), the Buckingham Fountain that opened in 1927 remains as a major attraction in the city of Chicago.

The evolution of urban traffic needs necessitated changes to the path of Route 66 in Chicago. The most sweeping of these occurred in 1953 when Adams became the westbound one-way corridor to Ogden and Jackson became the east-bound one-way corridor from Ogden to Lake Shore Drive.

Route 66 in Chicago is a corridor bordered by historic structures representing more than a century of American architectural and societal evolution. *Route 66 in Chicago*, written and researched by David Clark, provides excellent detail about many of these buildings.

For the Route 66 enthusiast who will not consider a trip on this storied highway complete without driving it from end to end, the journey begins at Jackson Boulevard and Michigan Avenue, the eastern terminus of Route 66 until 1937. Historian and author John Weiss, in his book *Traveling the New, Historic Route 66 of Illinois*, notes, "As mentioned, Chicago is a worthwhile stop, but unfortunately, there is really nothing much worth noting after you leave downtown Chicago except heavy industrial [businesses] and traffic."

In the downtown section of the city, attractions of particular interest include one tied directly to Route 66 and another that predates the highway by more than a quarter century. The former is Lou Mitchell's at 565 West Jackson, established in 1923, and the latter, the Berghoff at State and Adams Streets, opened in 1898.

CHICKEN IN THE ROUGH

Chicken in the Rough, an early franchise, dates to 1936. Legend has it that the name derives from an incident on Route 66 in Oklahoma in which Beverly and Rubye Osborne spilled their chicken dinner because of the rough road and then quipped, "This is really chicken in the rough."

With money obtained from Rubye's pawned wedding ring, Beverly and his wife established a small eatery that specialized in

a one-meal menu based on the premise "fingers were made before forks." The meal consisted of fried chicken, shoestring potatoes, hot biscuits, and honey.

Rather than expand on this simple premise, the Osbornes chose to franchise the operation. *Time* magazine published a feature article profiling the company in 1950. By this time, the Osbornes were grossing almost two million dollars annually and had created more than 250 international franchised outlets, a number of which were located along Route 66.

The building on Andy Devine Avenue that housed the Lockwood Café affiliated with the Chicken in the Rough franchise currently is used as a Catholic church. *Joe Sonderman*

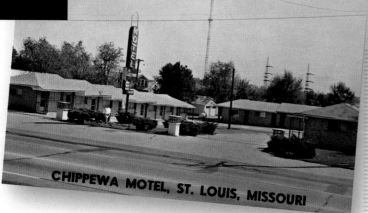

Currently utilized as apartments, the Chippewa Motel at 7880 Watson Road in St. Louis, Missouri, opened in 1937 as a thirteen-cottage complex. *Mike Ward*

CHIPPEWA MOTEL

Built in 1937, the Chippewa Motel, now used as apartments, is located at 7880 Watson Road (Route 66) in St. Louis. The original complex consisted of thirteen cottages. At some point after 1947, the cottages were joined together to create a twenty-unit complex.

CICERO, ILLINOIS

The town's initial post office application, approved on May 15, 1867, was under the name Hyman. An amendment on April 17, 1900, changed this to Hawthorne, and another amendment on January 28, 1910, settled the town's name finally on Cicero. The name is in reference to Marcus Tullius Cicero, a Roman orator and statesman. However, the consensus is that the selection was in deference to Cicero, New York, the hometown of Augustus Porter who platted the town site in 1857.

Of particular interest to Route 66 enthusiasts today is Henry's Drive-In, 6031 West Ogden Avenue, dating to the mid-1950s. This restaurant is a famous attraction known for its food and giant hot dog sign.

CIRCLE S MOTEL

Built in the early 1950s at 1010 East Highway 66 in Tucumcari, New Mexico, by John and Callie Sefcik, the Circle S Motel, as of 2010, operates as the Relax Inn. The *AAA Western Accommodations Directory* for 1954 featured the motel with a quarter-page advertisement that included a photograph of the motel as well as a lengthy description: "An attractive ranch style court. Nicely furnished units are air cooled or air conditioned and have one or two rooms, telephones, free radios, vented heat and tiled shower or combination baths; open garages. Connecting rooms. Restaurant next door."

CITY CAFÉ

The City Café stood on the eastern outskirts of Kingman, Arizona, in the unincorporated community of El Trovatore when it was opened by Roy Walker in 1943. The café survived a wide array of changes, including various owners, the widening of Route 66 that eliminated its highway-facing parking lot, and the creation of Stockton Hill Road that halved its east-side parking facility.

In 2005, new owners changed the name to Hot Rod Café and added painted panels over the 1960s sign to signify the change. In 2009, the café and the entire block to the west that included a warehouse, a Texaco station dated to 1939, and the Imperial Motel were razed for construction of a new Walgreen's.

The Route 66 Association of Kingman recovered the City Café and Imperial Motel signs. There are plans to refurbish them as part of a proposed neon park for that city's historic district along the Route 66 corridor.

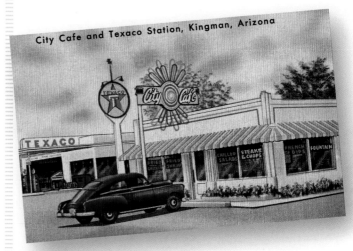

The City Café opened at the corner of what is now Stockton Hill Road and Andy Devine Avenue in 1943. Demolition occurred in 2009, but the Kingman Route 66 Association salvaged its historic sign. *Joe Sonderman*

The Circle S Ranch Court, later the Circle S Motel and currently the Relax Inn, in Tucumcari, New Mexico, was promoted in 1954 as a nicely furnished, attractive ranch style court with a restaurant next door. *Mike Ward*

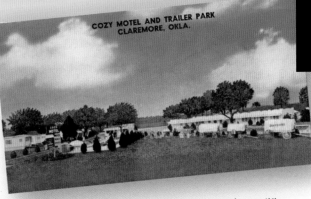

During the 1950s, the Cozy Court underwent extensive modification that included enclosure of the garages, addition of a trailer court, and landscaping that included covered wagons after its acquisition by R. E. Riley. *Mike Ward*

CLAREMONT, CALIFORNIA

The town site platted in 1887 was on property owned by H. A. Palmer. For this reason, the Pacific Land and Improvement Company, a development and survey company that was a subsidiary of the Santa Fe Railroad, offered to name the new community Palmer. H. A. Palmer instead suggested numerous Spanish descriptors that would be indicative of the mountainous views. The directors of the company headquartered in Boston, however, decided to name the town after Claremont, New Hampshire.

The community languished until the founding of Pomona College and then, in October 1907, incorporation. The primary economic foundation was agricultural, consisting of citrus and olive groves as well as vineyards.

All alignments of Route 66 entered Los Angeles County from San Bernardino County on Foothill Boulevard in Claremont. Found here are numerous sites of interest with a lengthy association to U.S. 66, including Wolfe's Market. Still operated by the family that initially opened the store in 1917, this business has operated from its current location since 1935.

Jack Rittenhouse in his guidebook published in 1946 lumped several communities together in his notations about Claremont. "Now you pass through vineyard country and orange groves, through Cucamonga, at 329 mi, (40 mi.), Upland, at 332 mi. (37 mi.), and Claremont. . . . "

The *AAA Western Accommodations Directory* for 1954 offers but one recommendation for lodging on U.S. 66 in the city: "Claremont Inn $2.50 to $6.00 per night, Claremont Restaurant, west edge of U.S. 66. Small attractive dining room serving buffet style luncheons and dinners."

CLAREMORE, OKLAHOMA

Chief Clermont of the Osage tribe is the generally accepted namesake for this community located near Claremore Mound, site of a battle between Osage settlers and a band of Cherokee. Contemporary history dates to the establishment of a post office in the summer of 1874.

In the search for oil, wildcat drillers tapped an underground pool of sulphur water in 1903. For centuries, these types of waters were deemed recuperative for a wide array of ailments, and numerous entrepreneurs established bathhouses to capitalize on this promoting them as radium baths.

With the establishment of Route 66 and the resulting ease of access to the resorts by tourists, some of these businesses expanded. The Mason Hotel ($1.00 per night) and the Sequoyah ($1.25 per night) were the approved lodging choices listed in the 1927 edition of the *Hotel, Garage, Service Station, and AAA Club Directory*. During the 1930s, the most lavish lodging was the seventy-eight room, six-story Hotel Will Rogers with an opulent Spanish décor. This structure still exists, serving as apartments for senior citizens. The namesake for the hotel was, of course,

the community's favorite son, American cowboy humorist Will Rogers. A museum and memorial dedicated to Rogers is located at 1720 West Will Rogers Boulevard.

As a historic footnote, in 1952 the U.S. 66 Highway Association dedicated the road as the Will Rogers Highway. A caravan organized that year to promote the designation culminated in Palisades Park, in Santa Monica, California, near the western terminus of U.S. 66. A monument commemorating the designation reads, "Will Rogers Highway—Dedicated in 1952 to Will Rogers—Humorist, World Traveler, Good Neighbor—This Main Street of America, Highway 66, Was the First Road He Traveled in a Career That Led Him Straight to the Hearts of His Countrymen."

The *AAA Directory of Motor Courts and Cottages* for 1940 lists two approved motels, both at $1.50 to $2.00 per night. Not given for either the Cozy Court or the El Sueno Court, however, are addresses. In the same year, the *AAA Service Station Directory* listed the Paulger-Johnson Garage as a recommended repair facility.

In 1946, Jack Rittenhouse noted that the lobby of the Mason Hotel housed the gun collection of J. M. Davis, the largest private collection in the world at that time. This collection served as the catalyst for the creation of the J. M. Davis Arms and Historical Museum located at 333 North Lynn Riggs that now includes more than twenty thousand firearms ranging from matchlock rifles to artillery pieces.

The 1954 edition of the *AAA Western Accommodations Directory* lists three facilities, but only one, De Ann Motel, received the AAA rating. The other listed properties are the Will Rogers Hotel and Ranch Motel.

The 2011 edition of the *Route 66 Dining & Lodging Guide* recommends two motels, the Claremore Motor Inn and Will Rogers Inn, as well as one restaurant, Cotton Eyed Joe's.

CLEMENTINE, MISSOURI

Establishment of a post office in 1891 is the general date of origination accepted for Clementine, Missouri, a ghost town in Phelps County, even though settlement in the immediate area predates this by several decades. The community's primary association with Route 66 came with its series of highway-fronting stores and stands specializing in homemade baskets and Ozark native crafts, as well as a Fisher's Filling Station.

CLINES CORNERS

Ray Cline established a service station at the junction of New Mexico Route 6 (the Santa Fe bypass) and New Mexico Route 2 in 1934. Shortly after the realignment of 1937 that resulted in the bypass receiving designation as U.S. 66, Cline relocated his facility to the junction of U.S. 66 and U.S. 285.

Jack Rittenhouse, in 1946, noted that one building housing a gas station and café constituted Clines Corners. He also noted that eleven miles to the west was a historic marker providing a brief history of Gregg's Trail that roughly paralleled the highway in this section of New Mexico. Overshadowed by the Santa Fe Trail, this trail, established by Josiah Gregg to connect Fort Smith, Arkansas, with Santa Fe, New Mexico, in 1839, saw little traffic until 1849. With the discovery of gold in California and the subsequent rush of immigrants westward, this and most established east–west trails became important corridors of transport.

Cline developed the property to include a café, motel, and garage and petitioned Rand McNally to include Clines Corners on maps and atlases. After the sale of the property in 1939, Cline opened the Flying C Ranch, a gas station, a garage, and a café about seventy-five miles east of Albuquerque that he operated until 1963.

Under the ownership of Lynn and Helen Smith, Clines Corners continued to expand after World War II. A post office established in 1964 continues to operate, and the facility has remained a popular stop even though Interstate 40 supplanted Route 66 in 1973.

Clines Corners in New Mexico is a rarity as it has survived for more than seventy years, first meeting the needs of travelers on Route 66 and today those who travel I-40. *Judy Hinckley*

CLINTON CABINS

Clinton Cabins opened in about 1930 one mile west of Devil's Elbow, Missouri. It remained in operation for only a few years before becoming a popular roadhouse.

Since the 1930s, the property has on occasion operated as a motel under various names, including Grandview Court and Ernie and Zada's Inn, as well as the Grandview Trailer Court. As

of 2010, the service island for the gas station was enclosed and the building served as a private residence. Several of the cabins remained standing.

A promotional postcard from the 1930s offers insight into the recreational opportunities offered at the complex when it operated as Ernie & Zelda's Inn: "Dancing, fishing, hunting, shady trailer camp, dinners, lunches, beer, modern cabins with in-spr. mattresses."

CLINTON, OKLAHOMA

The completion of the Frisco Railroad to the Washita River and establishment of a siding at that site in 1903—the year in which the post office application received approval—is the accredited date of establishment of Clinton. The namesake was Clinton F. Erwin, a leading jurist of the period.

The community has an extensive association with Route 66 that continues to this day. Jack and Gladys Cutberth—known as "Mr. and Mrs. 66" for their tireless promotion of Route 66 during a two-decade association with the U.S. Highway 66 Association (including Jack's position as executive secretary)—operated offices from their home here.

Famous sites include the Trade Winds Motel, reportedly a favorite stop for Elvis Presley, and the Mohawk Lodge Indian Store, established in 1892, one mile east of town. Most notable among modern attractions would be the Oklahoma Route 66 Museum at 2229 West Gary Boulevard.

The centerpiece for the museum (currently the only state-operated museum devoted entirely to Route 66 history) is a self-guided, narrated tour through detailed exhibits that chronicle the evolution of the highway. Additional exhibits include a small theater and restored Route 66 Diner.

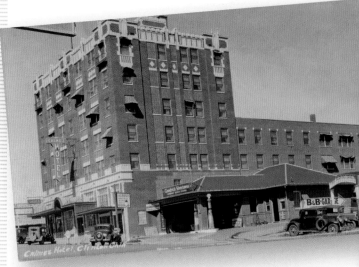

Next to the Calmez Hotel, a landmark demolished in 2007, is the service station belonging to D. C. Shamburg, who would later found Shamburg's Sporting Goods. *Steve Rider*

By 1930, even though Route 66 was fast transforming the urban and rural landscapes along its course, in most communities the city center remained the hub for lodging and service. *Steve Rider*

The 1940 edition of the *AAA Directory of Motor Courts and Cottages* lists only the Neptune Court, $1.50 to $2.00 per day. In addition, the directory notes there is a café on site as well as accommodations for trailers. The AAA service station directory for the same year lists Y Service Station as an approved service and repair facility.

In an unusual departure from brevity, Jack Rittenhouse notes in his guidebook that the "Hotel Calmez is good, so is Harry's café." He also lists the Neptune Court, Petty's, and other establishments.

The 1954–55 edition of the *AAA Western Accommodations Directory* lists two recommended motels, Glancy Downtown Motel and Glancy Suburban Court. It also lists Pop Hick's Restaurant as its recommendation for dining. This facility operated from 1936 until a fire in 1999 resulted in its demolition.

Construction on the McLain Rogers Park, a joint project between the Civil Works Administration and Works Progress Administration (WPA), began in 1934. Named for the mayor, the park (listed in the National Register of Historic Places in 2004) was accessed from Route 66 via an art deco–type gateway on the east side supported by brick pillars and was alluded to by Jack Ritttenhouse in his guidebook.

The twelve-acre park evolved to become a recreational center for area residents as well as a welcome respite for travelers. Amenities included a miniature golf course, tennis courts, a baseball field, a picnic area, a playground, a volleyball court, a bathhouse, and an amphitheater. Many structures in the park are of prewar origin, including the Oklahoma Highway Patrol Building near the entrance, built in 1941.

Numerous motels and restaurants, many built more recently, received recommendation in the *Route 66 Dining & Lodging Guide*, fifteenth edition (published by the National Historic Route 66 Federation in 2011). For the purist in search of Route 66 vestiges, the Dairy Best dating to 1960 is included in this listing.

CLUB CAFÉ

Newton Epps established the Club Café in Santa Rosa, New Mexico, along Route 66 in 1935. The café's acquisition by Phil Craig and Floyd Shaw in 1939 resulted in its transformation from a typical eatery into a landmark. Signage designed by Jim Hall used the simple caricature of a smiling chubby faced man with the simple verbiage of "Club Café since 1935" to create an identity. Purportedly, Craig served as the model.

Initially, the sign graced only the café, but with its inclusion on an extensive network of billboards along the highway, the restaurant became a favored stop for travelers in eastern New Mexico. Expansion of the facility that added a gift shop and the

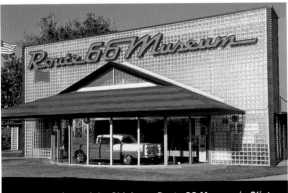

The centerpiece of the Oklahoma Route 66 Museum in Clinton is a self-guided tour written and narrated by acclaimed author and historian Michael Wallis. *Judy Hinckley*

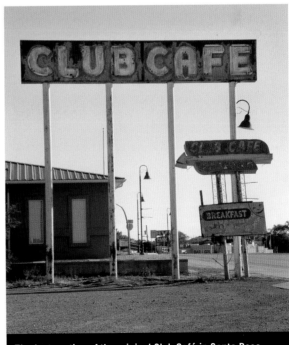

The last vestige of the original Club Café in Santa Rosa, New Mexico, is a faded sign that casts long shadows across Route 66.

67

CLUB CAFÉ *continued*

inclusion of the café as a regular stop on the Greyhound bus line during the 1950s further added to Club Café's fame.

In the late spring of 1973, Ron Chavez, a former dishwasher at the café, acquired the restaurant. He managed it until 1992 when the cost of needed repairs and upgrades, coupled with declining revenue, resulted in its closure. Joseph and Christina Campos evaluated the cost of refurbishment in 2002 but deemed it cost prohibitive. Demolition occurred in 2005, and the Camposes opened Joseph's, a restaurant listed in the *Route 66 Dining & Lodging Guide* (fifteenth edition), a half block away utilizing the widely recognized logo for the Club Café to ensure recognition and preservation of this Route 66 icon.

The Route 66 Auto Museum currently has the Club Café sign on display, as well as the large Riddles of Old Route 66 sign, a conversation piece in the original café. However, an independently standing Club Café sign remains at the original location.

COLLINSVILLE, ILLINOIS

Initial American settlement in the area dates to the arrival of the Collins brothers—Anson, Augustus, Frederick, Michael, and William—from Litchfield, Connecticut, in 1817. William Collins platted the town site in late 1836. However, as evidenced by the mounds at Cahokia Mounds State Historic Park, and extensive archaeological investigation, the area of Collinsville was once the center of a vast pre-Columbian enterprise. The existing remains are the best preserved of the Mississippian culture.

Downing's Station was the name utilized on the first post office application dated November 20, 1819; however, amended applications changed the name to Unionville in 1822 and Collinsville in 1825.

The community's association with Route 66 dates to a realignment in 1955 that placed the course of the highway on what is today State Highway 157 and Collinsville Road. The final realignment in 1963 placed that highway onto a shared roadway with Interstate 55/70.

The primary landmark, located just south of Route 66, is the 170-foot water tower built in the shape of a large ketchup bottle. Built in 1949 for the bottlers of Brooks Catsup, and restored in 1995, its addition to the National Register of Historic Places in August 2002 is indicative of its historic significance.

Since U.S. Highway 40 also traversed Collinsville, there were numerous motels and service stations here before the realignment of Route 66. However, with the addition of traffic on that highway, a major expansion of those types of facilities occurred during the 1950s. These included some of the earliest chain motels like Howard Johnson's Motor Lodge and Holiday Inn. Independent motels built during this period included the Rainbo Court Motel (5280 Collinsville Road) and the Round Table Lodge and Restaurant at the intersection of Mall Road and Bluff Road.

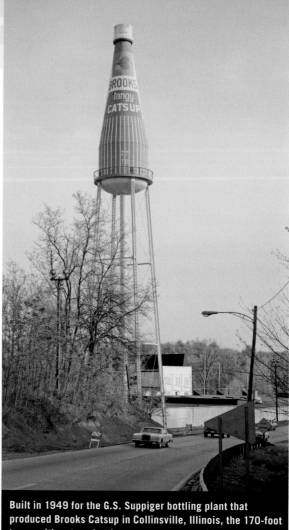

Built in 1949 for the G.S. Suppiger bottling plant that produced Brooks Catsup in Collinsville, Illinois, the 170-foot tower with catsup bottle water tower was added to the National Register of Historic Places in 2002.

COLEMAN THEATER

Built in 1929 at a cost of $590,000 by zinc mining magnate George L. Coleman Sr., the Coleman Theater is located on Main Street (formerly Route 66) in Miami, Oklahoma. The Coleman family donated the property, listed on the National Register of Historic Places in 1983, to the city of Miami in 1989.

The ornate Spanish Colonial exterior and opulent interior that mimics then-popular Louis XV design features was the work of the Boller Brothers, an architectural firm in Kansas City, Missouri. Towers, minarets, parapets, and intricate cornice work that includes hand-carved gargoyles and stucco and terra cotta trim dominate the exterior. The interior is richly appointed. Trim accented with gold leaf, carved mahogany moldings and railings, and stained-glass windows hint at the prosperity derived from mining in the area during the teens and twenties.

The theater opened with a lengthy vaudeville bill to a sold-out crowd on April 18, 1929. A number of celebrities from this period performed at the Coleman Theater, including Sally Rand, the legendary fan dancer, and Will Rogers. It remained an integral and vital component of the community for more than a half century.

The opulent Coleman Theater in Miami, Oklahoma, cost $590,000 to build, opened on April 19, 1929, and after its donation to the city by the Coleman family in 1989, was fully refurbished. *Steve Rider*

With completion of the restoration, the theater now serves as a venue for special events. As an example, in 2010 a special showing of the film *Bones of the Road* by Route 66 historian Jim Ross and legendary artist Jerry McClanahan attracted enthusiasts from throughout the United States and Europe.

COLONIAL MOTEL (GALLUP, NEW MEXICO)

With Mr. and Mrs. F. D. Bridges listed as proprietors, the Colonial Motel, promoted as Gallup, New Mexico's newest and most modern motel, opened in 1956. As of late 2011, the twenty-six room motel complex remained operational at 1007 West Coal Avenue (Route 66).

Still operational, the Colonial Motel at 1007 West Coal Avenue in Gallup, New Mexico, opened in 1956 with Mr. and Mrs. F. D. Bridges as proprietors. *Mike Ward*

COLONIAL MOTEL (SPRINGFIELD, ILLINOIS)

The 1954 edition of the *Western Accommodations Directory* published by AAA lists the Colonial Motel in Springfield, Illinois, as being located at 2900 South MacArthur Boulevard on U.S. 36, U.S. 54, and State Route 4, the original alignment of Route 66. Amenities included the following: "fans or air conditioning, shower baths and individually controlled electric heat."

COLONIAL TOURIST HOME

Located six miles south of Springfield, Illinois, near Lake Springfield, the Colonial Tourist Home consisted of a large home on spacious grounds converted into a lodging complex. It remained operational as such from approximately 1937 until the mid-1950s.

COLORADO STREET BRIDGE

Upon completion in 1913, the 150-foot-high Colorado Street Bridge spanning the Arroyo Seco at Pasadena, California, received international acclaim as the highest concrete bridge in the world. Designed by engineer John Drake Mercereau, the bridge's midspan fifty-degree curve to the south, graceful arch supports, and extensive use of decorative architectural features were primary features that led to its recognition as a Historic Civil Engineering Landmark and listing in the National Register of Historic Places in 1981.

Construction of the bridge required eighteen months, eleven thousand cubic yards of concrete, and six hundred tons of steel reinforcement. Completion of the bridge resulted in dramatic growth in the Pasadena area, since it negated the climb up the steep east bank of Eagle Rock Pass on the west bank of the Arroyo Seco.

By 1930, the traffic on Route 66, as well as the urban traffic to Los Angeles, resulted in the ornate bridge becoming a hazardous bottleneck. The bridge remained in use until the completion of the Arroyo Seco Parkway in 1940 that culminated in the realignment of Route 66. After this date, the bridge was still a key component in the flow of local traffic between Los Angeles and Pasadena, but concerns about its condition, compounded by the Loma Prieta earthquake in 1989, led to its closure. After extensive renovation that preserved much of the unique architectural details, funded by $27 million in federal, state, and local monies, the bridge reopened in 1993.

"America's Most Educational Tour!"

DON'T MISS

AT JUNCTION
66 69

NORTH OF MIAMI, OKLAHOMA

The UNDERGROUND TOUR

320 FT.

FREE MEDICAL

THE "NANCY JANE LEAD & ZINC MINE"

The Nancy Jane Mine was one of the many mines in the Commerce area that offered tours. The tristate area was the largest producer of lead and zinc in the years bracketing World War I. *Steve Rider*

COMMERCE, OKLAHOMA

The initial name utilized on the post office application for this community filed in 1913 was North Miami. With development of a community named Miami two miles to the south, an amended application filed in 1914 officially changed the name to Commerce. Lead and zinc mining during the teens served as the primary economic catalyst for growth, with the most notable mine being the Turkey Fat.

There are numerous sites associated with Route 66 on the early alignment that followed Main and Commerce Streets, as well as the latter alignment signed as Mickey Mantle Boulevard. Among these is the oft-overlooked park at Third and Main Streets with a small monument that commemorates the slaying of a constable by Bonnie and Clyde. Other sites of interest include Mutt Mantle Field, named for the father of Mickey Mantle and the former home of the baseball legend at 319 South Quincy. Mantle began his career with the Commerce Comet baseball team.

Jack Rittenhouse noted the only auto court was O'Brien's Camp. The *AAA Directory of Motor Courts and Cottages* for 1940 also lists this auto court with the notation that fourteen units had running water and four (for $1.00 per night) did not.

In the summer of 2011, a tangible link to that era in Commerce, the Star Cash Grocery, closed its doors. This store had opened in 1938.

After more than three decades of working as a miner, and injuries that included the loss of an eye, D.E. Dion established a service station and the Rock of Ages gift shop in Commerce, Oklahoma. *Steve Rider*

CONWAY, MISSOURI

The date of origination for Conway is 1869, when a railroad siding was established at this site. The namesake for the community is J. Conway.

In *A Guide Book to Highway 66*, published in 1946, Jack Rittenhouse noted, "Population 516; gas; garage; café; few cabins."

Located seven miles west of Conway and seven miles east of Marshfield stood one of the most uniquely named restaurants on Route 66. Signed with a large, dented garbage can and letters spelling out "café," the Garbage Can Café opened in 1952 with Kermit and Letha Lowery as owners.

Top O' Th' Ozarks Café opened in 1940 with John and Cassie Warren as owners. Demolition occurred in 1950 after a fire gutted the structure. *Steve Rider*

CONWAY, TEXAS

Conway, Texas, is unique in that its origins are rooted in education rather than economics. Established in 1892, the Lone Star School met the needs of area ranching families.

With completion of the Choctaw branch of the Chicago, Rock Island & Gulf Railway near this point, Delzell and P. H. Fisher platted a town site at a siding and relocated the school. The post office application approved in 1903 used the name Conway, in deference to H. B. Conway, a former county commissioner. Growth of the town remained relatively stagnant until the 1930s. In 1925, Conway was a community of twenty-five people, but by 1939, population had risen to 125. It hit its peak population of 175 in 1969, but a dramatic decline from this point resulted in closure of the post office in 1976.

Jack Rittenhouse, in 1946, noted that services available in Conway consisted of a gas station, small garage, café, store, and small auto court. Jerry McClanahan in *EZ 66 Guide for Travelers* (second edition), published by the National Historic Route 66

Federation, highlights Conway with the notation that, "A line of stucco, tile roofed cabins survive behind a chain link, junkyard fence. Next door, an old wooden building was once home to Buddy's Café."

COOLIDGE, NEW MEXICO

The original village of Coolidge was located approximately three miles northwest of the present community by this name. The initial settlement, referred to as Cranes, was the headquarters for a ranch on Bacon Creek owned by William Crane, a former teamster and scout for Kit Carson. Completion of the Atlantic & Pacific Railroad to this point and establishment of a siding and station led to the designation Cranes Station, and the post office application filed in 1881 resulted in an official name of Cranes for the community. In late 1882, however, an amendment changed the town's name to Coolidge in honor of Thomas Jefferson Coolidge, president of the Atlantic & Pacific Railroad. With the transfer of railroad operations to Gallup in 1894, Coolidge entered a period of decline.

The current community named Coolidge dates to 1926 and the establishment of a service station and trading post on Route 66. Oddly enough, the namesake founder was Dane Coolidge.

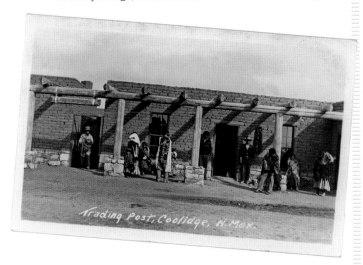

Merle and Daisy Muncy established the Navajo Lodge in about 1936, but sold it to Al and Melvina Lavasek during World War II. *Steve Rider*

COOL SPRINGS CAMP

Cool Springs Camp, on the eastern approach to Sitgreaves Pass in the Black Mountains of Arizona, dates to 1927. The extensive fields of stone that surround the site provided the primary construction material for N. R. Dunton, a property developer with a vision for Cool Springs. A pipeline connecting the remote camp to springs in Warm Springs Canyon, the site of Kings Dairy, ensured a steady supply of fresh water. In the summer of 1936, Dunton sold the property to

Established in 1926 as a simple gas station and a couple of cabins, the Cool Springs complex transformed into a full-service stop with improvements, renovations, and additions made during the 1930s. *Joe Sonderman*

James and Mary Walker. In January 1937, the addition of a restaurant and bar was completed. Shortly after this date, Mary acquired title to the property in a divorce settlement. Floyd Spidell, her second husband, added a full-service garage as well as cabins, completing the transition from primitive camp to full-service facility.

The realignment of Route 66 in 1952 bypassed the Sitgreaves Pass section of the highway, however. Cool Springs remained open until 1964, was gutted by fire in 1966, was partially rebuilt and destroyed as a set for the movie *Universal Soldier* in 1991, and then was partially resurrected again after purchase by Ned Leuchtner in 2002. Leuchtner, with general contractor Dennis De Chenne, utilized the existing pillars as well as original stones to re-create a portion of the complex and constructed a short hiking trail to the summit of the mesa on the south side of the highway from which there are stunning views of Route 66's course across the Sacramento Valley. Completion in December 2004 marked the first stage in a plan that calls for the addition of a museum. The property currently houses a gift shop and, with its location amid a stunning quintessentially western landscape, is a favored photo stop for Route 66 enthusiasts.

With the quintessential western landscapes as a background, Cool Springs Camp, is a rich tapestry where the past and present blend seamlessly.

COPPER CART

Ethel Rutherford, who established the Qumacho Café in Peach Springs, and who later became an Arizona state representative, opened the Copper Cart restaurant in Seligman in 1950. In February 1987, Angel Degadillo called the first meeting for what would become the Historic Route 66 Association of Arizona, the first association of its kind, at this restaurant. The property remained in operation until 2008. After extensive renovation, it reopened and, as of the summer of 2011, remains in operation.

Established in 1941 and razed in 1995, the Coral Court Motel came to symbolize the endangered commercial architecture that lined the Route 66 corridor from Chicago to Santa Monica. *Joe Sonderman*

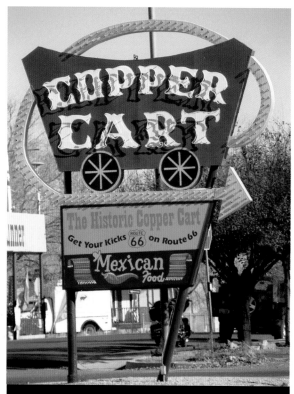

The first meeting of what would become the Historic Route 66 Association of Arizona was held in 1987 at the Copper Cart Restaurant in Seligman, Arizona.

CORAL COURT MOTEL

Built in 1941 on Watson Road in Marlborough by John Carr, the Coral Court was a masterpiece of art deco styling, designed by architect Adolph L. Stuebig. Situated in a parklike setting, the motel had exterior walls sheathed in buff-colored curved tiles that flowed into pyramids of glass blocks at the corners. All lintels were of red tile.

In 1946, expansion of the property included the addition of twenty-three units designed by architect Harold Tyre. The primary structural change from the original design was the addition of triangular glass block windows.

A third expansion occurred in 1953 with the addition of two-story units also designed by Tyre. The installation of a swimming pool followed in about 1961. Carr and his wife Jessie operated the facility until his death in 1984. Jessie continued to manage the property with her second husband, Robert Williams, until 1993.

The motel units, connected by adjoining garages, provided guests with near complete privacy. They also fueled talk about the motel's reputation—which had begun with the policy of renting rooms in four- or eight-hour increments for truck drivers—as a nonfamily-type of facility after the completion of Interstate 44 bypassed this portion of Route 66.

Despite the valiant efforts of preservationists and historical societies, the property was sold to developers who razed it in 1995. At the forefront of efforts to save the classic motel was Shellee Graham, professional photographer. Before demolition, Graham photographically documented every aspect of the architecture and structure. These photographs became the centerpiece of Graham's book, *Tales from the Coral Court*, as well as several international photo exhibitions. They were also crucial to the reconstruction of one unit from the complex at the Museum of Transportation in Saint Louis.

CORONADO HOTEL

Opened in 1925 at 3701 Lindell Boulevard in St. Louis, the Coronado Hotel became a part of the Sheraton Hotel chain. During the period of 1925 to 1950, the hotel was the lodging choice for celebrities and dignitaries visiting the city. The hotel closed in 1965, remained vacant for a number of years, and was considered for demolition. However in 2003, for a purported cost of $40 million, the property was renovated and modernized and again serves its original purpose.

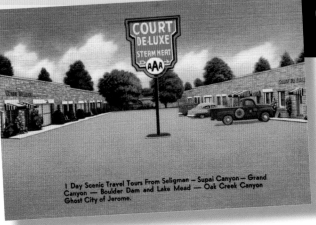

Built in 1932, and still operating as a motel, the Court De Luxe in Seligman, Arizona, remains as the oldest continuously operated motel in that community. *Mike Ward*

CORREO, NEW MEXICO

Between 1902 and the establishment of a post office under the name Correo in 1917, the community appears on maps under a number of names. These include San Jose, Rio San Jose, Suwanee, and Suanee. In 1920, the town located near the junction of the pre- and post-1937 alignment of Route 66 consisted of a post office, general store, and bar. With regard to Correo, Jack Rittenhouse noted in 1946, "Here there are two establishments, one on each side of a railroad which crosses U.S. 66. Correo offers gas, groceries, a small café, and a few cabins." As of this writing, only a scattering of houses and foundations remains.

COTTON HILL, ILLINOIS

The date of origin for Cotton Hill is unknown. However, there are records that indicate John Ebey established an enterprise for the production of "Illinois redware pottery" at the site of Cotton Hill between 1826 and 1828, and the U.S. Industrial Census of 1840 listed this business among twenty-three potters in Illinois. The post office established in 1862 continued in operation through 1908.

Because the original alignment of Route 66 followed the Illinois Central Railroad in this section of Illinois and Lake Springfield inundated the site in 1933, the community's association with the highway was relatively short. Today, overgrown sections of this early alignment of Route 66 run into the lake, and the only references to the community are signage for Cotton Hill Road and maps that indicate Cotton Hill Township.

COUNTRY CLUB COURT

Charles H. Stearn, the former New Mexico prohibition director, established the Country Club Court at 2411 West Central Avenue in Albuquerque, New Mexico, in 1937. The *Directory of Motor Courts and Cottages*, published by AAA in 1940, gave the court a cursory recommendation: "West on U.S. 66, 10 cottages with baths, $2 to $2.50, 5 housekeeping cottages." The motel survived a succession of owners, improvements, and name changes that included Prince Motel and Relax Motel. As of 2010, it remained as the 21 Motel.

COURT DE LUXE

Built in 1932, the Court De Luxe (now the De Luxe Inn) was, as of the winter of 2011, the oldest operational motel in Seligman, Arizona. It is listed as recommended lodging in the *Route 66 Dining & Lodging Guide* (fifteenth edition), published by the National Historic Route 66 Federation in 2011.

Initial promotion noted that the place was "new and fireproof" and "quiet, restful, attractively furnished," with "closed garages, steam heat, and with or without tub or shower baths." The 1940 *Directory of Motor Courts and Cottages* published by AAA noted, "12 cottages with baths, $2 to $3.50. 5 house keeping cottages." Surprisingly, the motel, also mentioned by Jack Rittenhouse in his 1946 guidebook, was still the recipient of AAA recommendation fifteen years later.

The *Western Accommodations Directory*, published by AAA in 1955, indicated that the property featured "air cooled rooms with tiled shower or tub baths and central heat; 9 garages. Baby bed. Restaurant near by." Rates were given as $6.50 to $8.00 per night.

COZY DOG DRIVE IN

The Cozy Dog, a hot dog on a stick dipped in batter and fried, was the creation of Edwin "Ed" Waldmire Jr., who was stationed at the airfield in Amarillo, Texas, during World War II. In an interview given on July 7, 1996, Edwin's son, Buzz, said, "My dad stopped at a roadside restaurant in Amarillo, Texas. They had corn dogs on the menu, but it took twenty minutes to get one because they baked them in an oven. Restaurants across the country were developing similar versions. One of the more successful was Pronto Pups "Weiner Dun in the Bun," available at a number of restaurants in the Maryland area during the mid-1940s.

Upon his return to the air base, Waldmire called his college roommate in Galesburg, Illinois, whose father owned a bakery, and asked, "Can you mix me up some batter that will stick to the side of a hot dog while we fry it in oil?" Waldmire sold the resultant "Crusty Curs" to the base PX, through the USO club, and on weekends to restaurants, diners, and cafés along U.S. 66 in Texas and Oklahoma. They proved to be so popular that upon his discharge he introduced the dogs to the people of his home state of Illinois in 1946 at the Illinois State Fair. The positive response inspired Waldmire to open a stand at the Lake Springfield beach house on June 16, 1946. With creative input from his wife, Virginia (Ginny), Waldmire changed the name to Cozy Dog (after considering naming them snuggle puppies) and opened a second stand on

COZY DOG DRIVE IN *continued*

the corner of Ash and MacArthur in Springfield. Virginia also served as the inspiration behind, and creator of, early promotional material. The Cozy Dog logo of two hotdogs bound in a loving embrace that continues to this day was her creation.

In 1950, Waldmire expanded his enterprise by relocating operations to a building shared with a Dairy Queen. This resulted in a rather tense partnership when the owner of the Dairy Queen adhered to the segregated seating rules and regularly posted signs proclaiming "We Reserve the Right to Seat Our Customers." Waldmire ignored the rules and served anyone, regardless of color.

Eventually the popularity of the Cozy Dog encouraged Waldmire to open three locations in Springfield. These enterprises were short-lived, however, and Waldwire focused instead on developing the one location along Route 66, which included the purchase of the Dairy Queen and a remodeling of the building.

The Cozy Dog relocated to its current location, the site of the former A. Lincoln Motel (at 2935 South Sixth Street) in 1996 and is now managed by Sue Waldmire, Ed's daughter-in-law. Demolition of the original building occurred on June 25, 1996, and a Walgreens is located on that site as of 2011.

CROZIER CANYON RANCH

Dating to the late 1870s, the Crozier Canyon Ranch remains one of the oldest existing ranches in northwestern Arizona. The main ranch house built in the late 1880s utilized redwood framing and hickory interior trim as well as red cedar, all brought in by rail. With the increase in traffic on the National Old Trails Highway and the growth of Kingman, Ed Carrow, retained by the Grounds family (the ranch owners), initiated transformation of the main ranch house and yard into a resort. This transformation commenced with completion of a spring-fed swimming pool in the 1910s and culminated with construction of a restaurant, gas station, garage, and cabins during the 1920s and early 1930s.

The Crozier Canyon Ranch is the oldest ranch in northwestern Arizona, and the ranch house at the old 7-V Ranch Resort predates certification of Route 66 by almost a half century. The bus station, café, and restaurant building at the 7-V Ranch Resort near Valentine, Arizona, were built from reclaimed cut stone railroad piers. *Steve Rider*

In addition to capitalizing on the traffic on the National Old Trails Highway, an arrangement made with the Santa Fe Railroad allowed for special Sunday excursion trains from Kingman to the point closest to the ranch, where visitors were picked up by wagons. During this period of early development, Andy Devine worked at the bathhouse.

During the late teens, the Grounds family reached an agreement with the railroad that included the use of lands for a new right of way in exchange for the exclusive right to dismantle the old trestles, bridges, and abutments. To dismantle the cut-stone abutments and build the restaurant, garage, and gas station, an itinerant Italian stonemason was hired.

Shortly after the designation of U.S. Highway 66 in 1926, eight two-unit cabins were built on the opposite side of Crozier Creek. Called the 7-V Ranch Resort, the complex also served as a designated bus stop. In 1937, torrential rains resulted in Crozier Creek overflowing its banks, washing out Route 66 and devastating a great deal of the complex. Construction of the current alignment of Route 66 that bypasses the ranch on the hill above is a result of the flood.

The cabins that continued to serve as bunkhouses into the 1980s now serve as storage sheds; the remaining section of the stone restaurant/garage/gas station complex is a private residence. The entire complex, as well as the concrete bridge at the east end of the canyon on the pre-1938 alignment of Rout 66, is fenced, gated, and signed as private property.

As a historic footnote, a section of Route 66 near the mouth of this canyon was the last segment paved in the state of Arizona. This occurred in 1937.

CRESTWOOD, MISSOURI

Crestwood, a suburb of St. Louis incorporated in 1949, is associated with several key Route 66–related sites. The Motel Royal, an ultra-modern facility at the time of its construction in 1941, used promotion that proclaimed it the "Traveler's Paradise." The 66 Park-In Theater, in continuous operation from 1948 to 1994 (the year it was demolished), was a favorite of travelers and area residents as well, especially before 1960. It was one of the largest drive-in theaters in the area with an eight hundred–car capacity. Ensuring a complete evening of family entertainment was a wide array of premovie shows and activities, including free pony rides and trained bears, as well as a playground complete with Ferris wheel and merry-go-round.

Numerous auto courts and motels lined Route 66 (Watson Road) in Crestview, including the Oaks Motel, Ahern Tourist Court, Lone Star Auto Court, Blue Haven Motel, and Colonial Motel.

Strip malls and urban developments have replaced a number of tangible vestiges of the Route 66 era here, but two notable exceptions are the Crestwood Bowl with original signage and the first McDonald's to open in the St. Louis area.

Location:
Highway 66 at Sappington Road in Crestwood, across from Crestwood Shopping Center, which contains all of the area's leading department stores.

Capacity:
1,200 cars

WEHRENBERG
THEATRES

The 66 Park-In Theater that opened in 1947 provided patrons with a wide array of preshow entertainment, including a Ferris wheel, pony rides, and trained animal acts. *Steve Rider*

CRYSTAL CITY

In the now classic guidebook to Route 66 published by Jack Rittenhouse in 1946, there is an entry after the one for Tulsa that reads, "At 2 mi. you pass Crystal City Amusement Park. Soon afterwards you enter the suburb of Red Fork."

Crystal City Amusement Park—located in the suburb of Tulsa that had been a separate entity, West Tulsa, before 1909—had its origins in the Park Addition Company that operated a dance hall, boat rides, and concessions on this site in the late teens. In 1921, Electric Amusement Park Company acquired the property and expanded the facility to include a variety of rides and a miniature train. Additional expansions made in 1922 were largely the result of subcontracting to Brodbeck Amusement Company of Miami, Florida, to operate a Ferris wheel and carousel and to J. W. Ely Company, Inc. for an Aeroplane Swing. The expense of expansions, coupled with the postwar economic slump, resulted in the owners assigning their share in the company to the mortgage holder, First National Bank of Sapulpa.

After the park's acquisition by a new management company, as well as the addition of rides such as the Zingo roller coaster, the park reopened as Crystal City in June 1928. The park, with occasional additions and renovations, operated profitably until

the early 1950s. After a period of declining revenues, fire struck in February 1956 and destroyed several of the older buildings in the complex. Two months later, the Casa Loma Dance Hall burned. The park closed shortly after, and the investors who purchased the property razed the remaining structures and liquidated the rides. Several of these rides sold to the Lakeview Amusement Park near the Mohawk Zoo in Tulsa.

In September 1958, construction commenced for the Crystal City Shopping Center on the site of the Crystal City Amusement Park. This facility included a large, state-of-the-art bowling alley, Crystal Bowl.

CUBA, MISSOURI

The reasons for naming this community after the Caribbean island are a matter of conjecture, but the town certainly was named after Cuba. The generally accepted explanation claims that two miners returning from the California gold fields via Cuba in 1857 selected the name as part of their praise for that island.

Unlike some communities along Route 66, Cuba has capitalized on resurgent interest in the highway to revitalize properties and to make that city a destination, with dramatic results. Cuba was the first site in the state of Missouri to take advantage of the Adopt-a-Highway Program and has created enterprise and industrial parks as well as undertook an extensive project called Viva Cuba's Outdoor Mural Project, which resulted in the Missouri legislature designating the community the "Route 66 Mural City." The initial beautification group commissioned twelve murals depicting historic scenes associated with Cuba. In turn, this served as a catalyst for local businesses to commission murals, both indoors and outdoors.

Numerous structures and businesses associated with the glory days of Route 66 remain. Refurbishment of many, including the historic Wagon Wheel Motel owned by Connie Echols (initially opened as Wagon Wheel Cabins in 1934), has also contributed to Cuba becoming a destination for Route 66 enthusiasts.

Further indication of how Cuba has embraced Route 66 is found in the *Route 66 Dining & Lodging Guide* (fifteenth edition). This guide lists two restaurants, Missouri Hick Bar-B-Q, damaged by fire in early 2011 and reopened that October, and the Route 66 Café, as well as two motels, including the Wagon Wheel Motel.

The *AAA Directory of Motor Courts and Cottages*, 1940 edition, has an extensive listing for the Wagon Wheel Cabins. Jack Rittenouse also notes this facility in his guidebook from 1946. Additionally, the AAA Western Accommodations Directory, published in 1954, also contains a listing.

Before the completion of Interstate 44 in 1965, the traffic on Route 66 supported a wide array of service-related businesses. Among these was Barnett Motor Company, listed in the 1927 *Service Station Directory* published by AAA. Others include Chester's Café and Cooke Service Station (which initially opened

CUBA, MISSOURI *continued*

in 1944 as part of the Wagon Wheel Annex), the Midway Café (scheduled for demolition in the winter of 2011), and the Red Horse Cabins (opened in 1938 and evolved with the addition of a service station and garage, before burning in 1953).

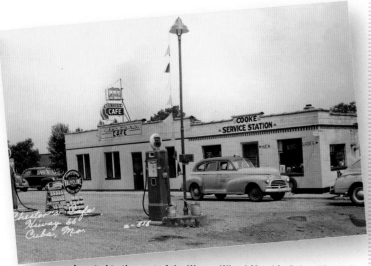

Located to the east of the Wagon Wheel Motel in Cuba, Missouri, Missouri Hick Bar-B-Q now stands on the site of Chester's Café that opened in 1944 as part of the Wagon Wheel Annex. *Steve Rider*

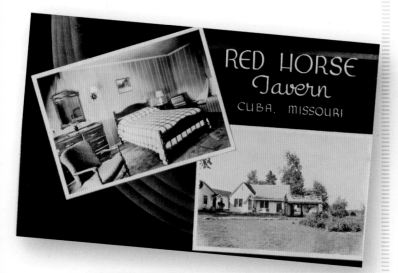

With Mr. and Mrs. C. C. Cox as proprietors, Red Horse Cabins opened in 1938. Shortly after this, additions to the complex included Red Horse Tavern, a service station, and a garage. As of 2011, a few of the cabins remained. *Steve Rider*

CUBERO, NEW MEXICO

Formerly an Indian pueblo, Cubero, bypassed in 1937, is located just a few miles north of Highway 124, the replacement designation of Route 66. Spanish expeditionary reports from the late seventeenth century and early eighteenth century signal this was an important crossroads on native trade routes.

The first indication of a European village at the site is a map drawn by Bernardo Miera y Pacheco, cartographer for the Dominguez-Escalante Expedition of 1776. For most of the next century, the village alternately served as an enclave for outlaws and renegades or as a military outpost, first for the Spanish, then the Mexicans, and, finally, the Americans.

The small village's association with U.S. 66 is a long one, and it is the site of one of the highway's most famous landmarks. During the teens and early twenties, tourists in automobiles flocked to the desert Southwest on the National Old Trails Highway to take in views of the wondrous lands and strange cultures. Old trading posts and new ones capitalized on this opportunity for profit.

In Cubero, Wallace and Mary Gunn operated one of these trading posts and did a thriving business by providing local Indians with a wide array of goods from flour to coal oil in exchange for pottery, sheep, cattle, and work created by Indian artisans. In turn, the artisan-produced goods were then sold to tourists.

Shortly after the realignment of Route 66 in 1937, the Gunns relocated their business to a new facility on the highway. By the summer of that year, in partnership with Sidney Gottieb, the new trading post had morphed into Villa De Cubero Trading Post, a complex that included the trading post, a service station, and a small motor court.

Hollywood discovered the charming village of Cubero, and the trading post, during this period, and soon the Villa De Cubero was a

Closed for decades but preserved in a state of arrested decay are the cabins at the historic Villa de Cubero complex where legend has it that Ernest Hemmingway wrote sections of *The Old Man and the Sea*. *Steve Rider*

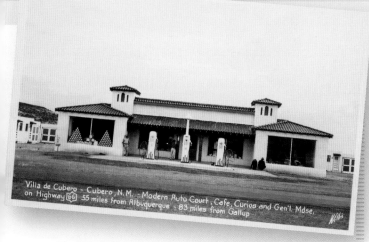

The Villa de Cubero complex served as a restful oasis for a surprising number of celebrities, including Ernest Hemmingway, Lucille Ball, and the Von Trapp family. *Steve Rider*

popular place for celebrities seeking a hidden hideaway or pleasant stay while filming in the area. The surprising guest list includes Gene Tierney, Bruce Cabot, the Von Trapp family, and Sylvia Sidney. Vivian Vance owned a ranch nearby, and Desi and Lucy Arnaz were regulars during the early 1950s. Purportedly, another brush with fame came with Ernest Hemmingway, who resided here for two weeks while working on *The Old Man and the Sea*.

The entry for Villa de Cubero in the 1940 *AAA Directory of Motor Courts and Cottages* indicates there were ten cottages with baths, as well as public showers, and a café. Nightly rates ranged

from $2.00 to $3.00; for trailers the fee was fifty cents per night. The complex does not appear in AAA directories after 1949.

Notes by Jack Rittenhouse in his 1946 guide indicate that Cubero was a "small community off U.S. 66." At the intersection of the road to the village, there was "a good café and tourist court at Villa de Cubero. Along the road here are gas stations, cafés, stores, a few cabins, but no other accommodations."

As of summer 2011, the store remained operational. The rest of the complex remains surprisingly intact.

CUERVO, NEW MEXICO

The establishment of a siding at the site of Cuervo, New Mexico, by the Chicago, Rock Island & Pacific Railroad in 1901 is the accepted date of this community's origination. The establishment of a post office under this name dates to 1902.

In the classic work by Jack Rittenhouse, *A Guide Book to Highway 66*, published in 1946, he notes a "few gas stations, groceries; no café, garage, or other tourist accommodations." He also notes, "A scant dozen dwellings comprise this small town. Cuervo is Spanish for small raven."

I-40 effectively bisected the town. The "modern" remnants from roughly post–World War II to the bypass of Route 66 in 1973 are located north of the interstate. The older section of town, including the church, school, and early homes, is located on the south side of the highway.

Construction of I-40 neatly bisected the old farming community of Cuervo, New Mexico, leaving the remnants associated with the town's earliest history isolated on the south side of the highway.

D

DAGGETT, CALIFORNIA

The namesake for this community was John Daggett, lieutenant governor of California from 1883 to 1887, who platted the town site. Designation of a siding by the Southern Pacific Railroad in 1884 was the initial reference to the town as Daggett, and settlement in the immediate area dates to the mid-1860s. Development of mines to exploit rich silver deposits approximately six miles to the north in the Calico Mountains, and completion of the Southern Pacific Railroad from Mojave to Daggett, then known as Calico Junction, in 1882 sparked explosive growth.

The discovery of extensive borax deposits to the north of the Calico Mountains, construction of a ten-stamp mill, and completion of the Daggett–Calico Railroad (a spur line) further added to the town's prominence. With exhaustion of profitable bodies of silver and the collapse of silver prices in the 1890s, borax and the railroad became the principal underpinnings for the town's economy.

In 1903, speculation based on the community's association with the railroad, fueled by media reports, added a new dynamic to the economy. The *Salt Lake Tribune* on April 19, 1903, reported, "Senator W.A. Clark states that he has purchased for San Pedro, Los Angeles, and Salt Lake Railroad company all lines and equipment of Oregon Short Line company lying south of Salt Lake in Utah and Nevada, including Leamington cut-off, and has obtained a ninety-nine year lease on terminal facilities in Salt Lake City in conjunction with Oregon Short Line. Grading and

Above: **The Stone Hotel in Daggett, California, dates to the late 1870s and has an association with John Muir as well as Death Valley Scotty, famous for Scotty's Castle in Death Valley.**

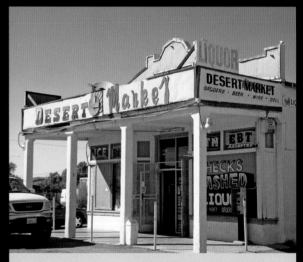

The Desert Market on Route 66 in Daggett, California, has operated without interruption since its opening in 1908 as Ryerson's General Store.

track laying will be commenced in Daggett, California, and the road will soon be extended from Calientes through Nevada. . . . He hopes to have the road completed within two years."

With discontinuance of borax mining and nearby Barstow's rise to prominence as the primary railroad junction, highway traffic on the National Old Trails Highway (Route 66 after 1926) and the Arrowhead Highway became increasingly important to the community.

Jack Rittenhouse, in 1946, notes that Daggett was "a tree shaded little old town that was formerly the location of smelters which handled the ore brought down from nearby mountains. Some of the old store buildings remain, but the town is now quiet.

There are two trailer camps but no cabins. Cafés, garage, and gas stations."

Vestiges from the long and colorful history of Daggett are numerous. These include Desert Market (in continuous operation since opening in 1908 as Ryerson's General Store) and Alf's Blacksmith Shop (built in 1894 and serving as a garage during the period of the National Old Trails Highway and Route 66).

The Stone Hotel (currently closed), a nondescript edifice with stone and adobe walls two-feet thick that fronts Route 66, dates to at least 1885. Originally a two-story structure with an iron-framed glass dome over the lobby and balcony facing the street and railroad depot, the hotel has association with Walter Scott (Death Valley Scotty), who used room seven as his offices in the early part of the twentieth century; Bill Curry; and naturalist John Muir, whose daughter resided in Daggett.

Persistent rumors associate the hotel, and Daggett itself, with Wyatt Earp. Even though his family had extensive land holdings in the area, there is no evidence to provide credence.

DAIRY BEST

Specializing in basic foods, including hamburgers, broasted chicken, and ice cream desserts, the Dairy Best opened at 301 South Nineteenth Street in Clinton, Oklahoma, in 1960. As of 2011, it remained operational.

DANBY, CALIFORNIA

Danby began life as a water stop for the railroad in the Mojave Desert. These stops—named, from west to east, in alphabetical order: Amboy, Bristol, Cadiz, Danby, Edison, Fenner, and Goffs—proved important oases for early motorists crossing the desert.

At some point, Danby morphed into a small community on the National Old Trails Highway (Route 66 after 1926). The 1914 edition of the Los Angeles/Phoenix Route Map of the "Desert Classic" Race Course indicates services offered here included repairs, oil, and gas, the same limited services Jack Rittenhouse noted in 1946.

Today, a high fence protects the sparse remnants from vandals. The elements are another matter, and the likely collapse of several structures is imminent.

DAVENPORT, OKLAHOMA

Nettie Davenport, the first postmistress in the area, inserted the family name for the community on the postal application filed in 1892. Initially, agriculture served as the primary economic foundation of this community. The traffic associated with the Ozark Trails road system, the discovery of oil in 1924, the subsequent development of wells and supportive infrastructure, and the

commissioning of Route 66 diversified the economy and spurred a steady growth that continued into the twenty-first century.

Jack Rittenhouse, in 1946, lists available services as cafés, garages, and gas stations. He also notes, "The many oil derricks which line both sides of U.S. 66 at the eastern edge of town testify to its importance as an Oklahoma oil center."

The primary attraction for Route 66 enthusiasts is Gar Wooley's Food-N-Fun. Vintage automotive and highway signs and early gas pumps are the backdrop for this unique emporium.

DAZY COURT

The Dazy Court on the northwest corner of Central and Garrison in Carthage, Missouri, dates to 1941. The motel still exists as a weekly or monthly apartment complex. The namesake was most likely Daisy Neese, wife of Tilden Neese, listed as proprietor in 1947. They lived in an adjacent house at 115 North Garrison, a home that, as of 2011, still served as a residence.

DE ANZA MOTOR LODGE

The De Anza Motor Lodge, listed in the National Register of Historic Places in 2004, dates to 1939. The ultra-modern facility was the result of a partnership between S. D. Hambaugh, a successful tourist court owner from Tucson, and C. G. Wallace, a pioneer trading post developer. Wallace came to New Mexico in 1919 in the employ of the Ilfield Company, operator of a chain of mercantile stores and trading posts on Indian reservations and in towns associated with the railroad. His first position was with the trading post at Zuni, where he obtained his trading license in 1920 and immediately immersed himself in the language and customs of the people. Wallace quickly became a leader in the marketing of Zuni-made goods.

Shortly after certification of Route 66, the Fred Harvey Company began offering very popular Indian detours to the Zuni Pueblo. To capitalize on this, Wallace expanded on an endeavor initiated in 1920, the introduction of new equipment for the manufacture of jewelry, materials provided to artisans, and the innovation of new designs using traditional motifs. He also collaborated in the establishment of six roadside ventures, which proved to be valuable outlets for products produced by the people of the Zuni Pueblo.

The De Anza Motor Lodge (4301 Central Avenue East in Albuquerque) represented a new type of venture. It was also the largest motel built to date on Central Avenue. Wallace chose the name in deference to Juan Bautista de Anza, a Spanish military officer and territorial governor. While serving as governor, he helped prevent the starvation of the Hopi pueblos.

The *Directory of Motor Courts and Cottages*, published by AAA in 1940, noted that the facility consisted of "thirty cottages with baths" and "four housekeeping cottages." In addition, the

DE ANZA MOTOR LODGE *continued*

Pueblo/Spanish-styled property featured a large jewelry counter in the lobby and a small silversmith's shop.

With the postwar increase in tourism, Wallace expanded the property to sixty-seven units, added a café (the Turquoise Room), and installed a covered carport at the front of the office. To ensure the property kept up with changing times with regard to amenities and promotion, Wallace became active in the U.S. Highway 66 Association and a group that actively worked with motel owners from Missouri to California. As the group expanded, it reorganized as Western Motels, Inc., which would be the foundational element for Best Western Motels.

Incredibly, the property evolved with the times and remained an AAA-recommended facility until 1991. In 1993, Wallace died, and the property entered a period of decline. Today the De Anza Motor Lodge with its unique triangular, thirty-five-foot high sign remains the only existing structure associated with Wallace. The City of Albuquerque, in recognition of the historic significance of the property, acquired the motel in 2002. As of the date of this writing, it remains closed.

DELGADILLO, ANGEL

Born to Angel and Juanita Delgadillo in Seligman, Arizona, Angel grew up in a home that fronted Route 66. In 1948, Angel and his siblings formed a band and began playing music in communities along Route 66 from Holbrook to Needles. In the same year, he attended the American Pacific Barber College in Pasadena, California, and he served his apprenticeship in Williams, Arizona, from 1948 to 1950. Both communities are located on Route 66. In

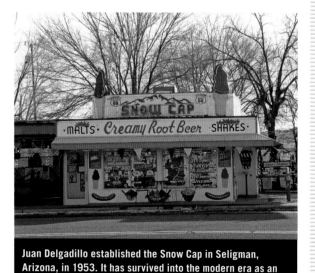

Juan Delgadillo established the Snow Cap in Seligman, Arizona, in 1953. It has survived into the modern era as an internationally recognized icon associated with the renewed interest in Route 66.

1950, he returned to Seligman and worked as a barber in the shop begun by his father before marrying Vilma Rampelotto in 1959.

With the completion of the I-40 bypass in 1978, Seligman began a period of precipitous decline. To curb the decline and capitalize on the nostalgic interest in Route 66, Delgadillo initiated the creation of the Historic Route 66 Association of Arizona in 1987, an organization that successfully lobbied the Arizona legislature to designate U.S. 66 in Arizona as a historic highway.

Associations emulating this model formed in the additional seven states through which Route 66 crossed. Angel continues to be an active participant in the revitalization of Route 66, is now an internationally recognized figure, still serves as a barber in the community in his original shop, and maintains a gift and information center with his wife and daughter.

DELL RHEA'S CHICKEN BASKET

According to stories told by Irv Kolarik, a promoter similar to P. T. Barnum as well as the founder of the business that became Dell Rhea's Chicken Basket in Willowbrook, Illinois, the origins for the business were his gas station and garage that included a small café with a limited menu of pie, coffee, and cold sandwiches. One day while he was publicly voicing an opinion that he would rather sell food than gasoline, two women who overhead him offered to teach him to fry chicken with a special recipe if he would buy all his chickens from them.

The resulting restaurant, variously signed as Club Roundup and Triangle Inn, proved to be so popular that Kolarik converted the garage into a dining room. In June 1946, the need for expansion resulted in relocation to the adjacent property (the current location) and construction of a restaurant designed by architect Eugene Stoyke.

In addition to excellent food, Kolarik utilized a wide array of publicity stunts to attract customers. Indicative of his creative talents with regard to promotion were modifications to the roof that allowed for its conversion to a skating rink in the winter where hired skaters performed.

The realignment of Route 66, and subsequent bypass of the restaurant, led to bankruptcy and closure in the early 1960s. In 1963, Dell Rhea and his wife, Grace, purchased the property and reopened under the name Dell Rhea's Chicken Basket.

The restaurant was inducted into the Illinois Route 66 Hall of Fame in the summer of 1992, and Rhea's son, Patrick, currently owns and manages the restaurant. As a result of the current resurgent interest in Route 66, the restaurant is now a popular stop. Listed in the National Register of Historic Places in 2006, Dell Rhea's retains a number of original features and components. Among these are the bar and paneling in the cocktail lounge that opened in 1956 and the original neon signage. The *Route 66 Dining & Lodging Guide* (fifteenth edition) lists the property as a "very special must stop."

DEL SUE MOTEL

Initially a tent camp in the mid-1920s on the National Old Trails Highway, the Del Sue Motel opened by Sue Delaney was listed on the National Register of Historic Places in 1996. Recently renovated, and now named the Grand Motel, the complex at 234 East Bill Williams Avenue is the oldest continuously operated motel in Williams, Arizona.

The *Directory of Motor Courts and Cottages*, published by AAA in 1940, contains a stark listing for the facility: "On U.S. 66 and 89. 15 cottages with baths, $2.50 to $3.50. 5 housekeeping cottages."

The 1954 edition of the *Western Accommodations Directory*, also published by AAA, provides just a little more information about the property: "One to three room units with central heat and combination baths; some open garages. Service Station. Restaurant near by. Pets allowed."

The *Directory of Motor Courts and Cottages*, 1940, and the *Western Accommodations Directory*, 1954, recommended the Del Sue Motor Inn, currently the Grand Motel. *Mike Ward*

DEPEW, OKLAHOMA

Initially, Halls was the name given the railroad siding for the St. Louis & Oklahoma City Railroad that would become Depew. For reasons unknown, the town's eventual namesake would be Chauncey Depew, a U.S. senator from the state of New York. Establishment of a post office under the name Depew took place in 1901. The post office remains operational today.

On May 29, 1909, a tornado devastated the community. The *Billings Daily Gazette* on May 30, 1909, reported: "Depew was destroyed by a double twister that formed from that striking Key West, and another coming from due east. The tornado wiped out Depew and then pushed northeast."

This vintage service station is but one of many time capsules that line the concrete pavement of the pre-1928 alignment of Route 66 in Depew, Oklahoma. *Jim Hinckley*

The first alignment of Route 66 made a loop through town via Land, Main, and Flynn Streets. After 1928, the highway followed the current alignment just north of the town at the bottom of the hill.

In *A Guide Book to Highway 66*, published in 1946, Jack Rittenhouse notes, "US 66 skirts the northern edge of Depew, but the only facilities along the highway are gas stations."

On February 8, 1960, Depew garnered headlines throughout Oklahoma when the State National Bank was robbed of $5,000. An alert patrolman, Glen Alt, apprehended the suspect at Bristow an hour later.

The majority of structures in the business district are of an architectural style associated with the period 1910 to 1930, including the mission-styled service station with portico that most recently served as a NAPA auto parts store. Most are currently empty, but an informed source says an investor is looking into purchasing these properties for development as an artist colony.

DESERT HILLS MOTEL

The Desert Hills Motel at 5220 East Eleventh Street in Tulsa, Oklahoma, and its intact and operational neon sign date to 1953. Rerouting traffic from the Eleventh Street corridor, which had served as the eastern entrance into Tulsa for Route 66 since 1933, and building an interstate highway transformed the motel into weekly or monthly rental units in the early 1970s.

Jack Patel purchased the property in 1996 and immediately commenced a full and complete restoration. With the exception of the removed swimming pool, the motel appears as it did during the late 1950s. The National Historic Route 66 Federation in the *Route 66 Dining & Lodging Guide* (fifteenth edition), published in 2011, gives the property a favorable review.

DESERT POWER AND WATER COMPANY

Built in 1907, the Desert Power and Water Company building remains the oldest reinforced concrete structure in the state of Arizona. The company supplied power for Kingman, surrounding communities, and numerous mines in the Cerbat and Black Mountains.

With completion of Boulder Dam, now Hoover Dam, electricity production ended in 1938. From this date to 1997, when it was restored and converted into a museum and visitor center, the building served as storage for Citizens Utilities transformers, city equipment, and similar purposes. In 1997, work commenced to transform and renovate the property rather than demolish it. Today, it houses the office of the Kingman Area Chamber of Commerce, the Powerhouse Visitor Center, the offices and a gift shop for the Route 66 Association of Arizona, and a Route 66 museum operated by the Mohave Museum of History and Arts.

The Grand Canyon West Resort, managed by the Hualapai tribe, also opened offices there during the spring of 2011, which further solidified the building's new role as a tourism center for the Kingman area.

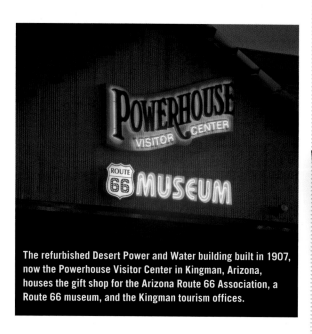

The refurbished Desert Power and Water building built in 1907, now the Powerhouse Visitor Center in Kingman, Arizona, houses the gift shop for the Arizona Route 66 Association, a Route 66 museum, and the Kingman tourism offices.

DESERT SANDS MOTOR HOTEL

The Desert Sands Motor Hotel (the Desert Sands Motel as of 2010) at 5000 East Central Avenue (Route 66) in Albuquerque, New Mexico, opened in October 1954. In the movie *No Country for Old Men*, the motel represented a complex in El Paso, Texas.

DESERT SKIES MOTEL

The thirty-four-unit Desert Skies Motel at 1703 West Highway 66 in Gallup, New Mexico, with Auro and Nellie Cattaneo as proprietors, opened to great fanfare in May 1959. Advertisements and promotional materials listed a wide array of modern amenities, including "hi-fi music" and twenty-one-inch televisions. As of 2010, it remained operational as a motel. Adding to the notable attributes of this property is the fact that it retains its original signage.

DESERT SUN MOTEL

Built in 1953 at 1000 East Third Street (Route 66) in Winslow, Arizona, the Desert Sun Motel remained operational as of 2010. Initial advertisement promoted thirty-three "comfortable and attractive air conditioned units with the finest furnishing. Free radio available and away from railroad noise."

DESERT VIEW LODGE

The Desert View Lodge (1009 West Hopi Drive in Holbrook, Arizona, Route 66) opened in the early 1950s with Jim and Ruby McDermott as proprietors. In 1956, after Norm and Adelyne Hormandl acquired the property, the twenty-three-unit complex underwent extensive renovation that included the addition of an eleven-unit upper floor and a swimming pool, the first at a motel in Holbrook. It later became the Star Inn.

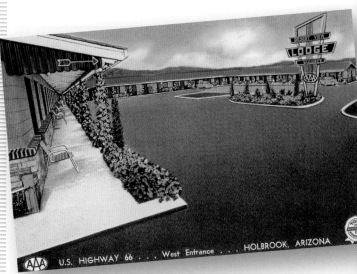

The first motel in Holbrook to offer a swimming pool, the Desert View Lodge at 1009 West Hopi Drive later became the Star Inn.
Joe Sonderman

DES PERES, MISSOURI

The date of initial settlement for Des Peres, Missouri, is unknown, but a post office opened here in 1848. The name refers to the River Des Peres that borders this community west of St. Louis. The Manchester Drive-In Theater opened on Manchester Road (the pre-1932 alignment of Route 66) as the first drive-in theater in the St. Louis area. The West County Shopping Mall now occupies the site.

DEVIL'S ELBOW, MISSOURI

The name of this town comes from a nearby bend in the Big Piney River that was so severe it caused massive logjams of railroad ties being floated downriver to Jerome. The town's association with Route 66 is a lengthy one.

The steel truss bridge built over the Big Piney River in 1923 served as a crossing for traffic on the Ozark Trails Highway System as well as Route 66 until late 1943. The Devil's Elbow received inclusion in the state planning commission's listing of Seven Beauty Spots of Missouri in 1941, and today, this bridge is a favored photographic location for fans of this highway.

Wartime necessity dictated an improved roadway to supply Fort Leonard Wood, and as a result, construction of the ninety-foot-deep Hooker Cut was initiated in 1941 to bypass the dated and narrow river crossing. When completed, this bypass became the deepest roadway cut in Missouri as well as the second four-lane section of U.S. 66 in the state. Additional points of interest include Allman's Market (opened in 1954 as Miller's Market and serving as the Devil's Elbow post office), a rock-walled pullout that provides a scenic overlook of the valley, Ernie and Zada's Inn (now a private residence), and the Elbow Inn & BBQ (the former Munger Moss sandwich shop that opened in 1936).

The Devil's Elbow Bridge over the Big Piney River opened in 1923 and served as the river crossing for Route 66 traffic from 1926 to 1943. *Steve Rider*

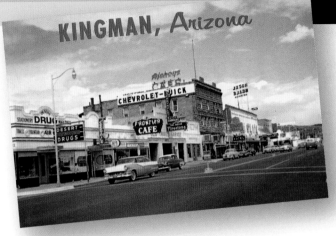

KINGMAN, Arizona

Since the late 1950s, Route 66 in Kingman, Arizona, has been signed as Andy Devine Avenue in honor of the city's favorite son, the character actor Andy Devine. *Joe Sonderman*

DEVINE, ANDREW

Andrew "Andy" Vabre Devine was born on October 7, 1905, in Flagstaff, Arizona, but the family relocated to Kingman, Arizona, shortly after this date. His father, Thomas Devine, became proprietor of the Beale Hotel in that city in 1916. Legend has it that Devine's trademark gravelly voice was a result of a childhood accident at the hotel. However, in an interview for the Encore Westerns Channel, his son, Tad, said that the accident was a fact, but that there was no evidence to support the claims it resulted in the distinct voice.

After completing some classes at the Northern Arizona State Teachers College, now Northern Arizona University, Devine transferred to Santa Clara University where he excelled as a football player. It was his football career and an ambition for acting that led to his first major screen role in *The Spirit of Notre Dame* released in 1931. His acting career included roles in more than four hundred feature films. Additionally, he played the role of Jingles in *The Adventures of Wild Bill Hickok*, served as the host of the children's television program *Andy's Gang*, and made numerous appearances on radio and television programs as diverse as the *Jack Benny Show*, *The Twilight Zone*, *The Barbara Stanwyck Show*, and *Batman and Robin*. He also provided voices for animated characters in full-length feature films as well as commercials.

In 1955, the television program *This Is Your Life* profiled Devine. During the program, it was announced that the city of Kingman had renamed Front Street (Route 66) Andy Devine Avenue, a designation that remained in place as of 2011. The Mohave Museum of History and Arts in Kingman also maintains an extensive Andy Devine exhibit. In addition to a wide array of movie memorabilia, it also contains Devine's prized, custom-made saddle.

The city of Kingman also pays homage to its most famous son with its Andy Devine Days celebration, a replacement for the Dig-N-Dogie Days event noted by Jack Rittenhouse in 1946. This weekend of festivities includes a parade and PRCA rodeo.

DEVORE, CALIFORNIA

Establishment of a siding and station at this location in 1885 by the California Southern Railroad coincided with completion of a rail line through Cajon Pass. The initial name was Kenwood but soon changed to Devore in deference to John Devore, a major landowner in the area.

Of primary note with regard to Route 66 is a narrow, short segment of concrete roadway about one mile south of the railroad overpass. The section of roadway predates Route 66 by several years and may be the only existing remnant of this type of pavement associated with the highway in California.

DILIA, NEW MEXICO

The initial community at this site, named Vado de Juan Paiz, has an unknown date of origination, but historic indications are that settlement here predates certification of Route 66 by almost a century. Development of the community commenced after the Anton Chico Land Grant of 1822 was issued. Modern origins can be pegged at 1911 and the establishment of a post office referencing the community as Dilia in the application. The post office remained operational through 1968.

The association with Route 66 terminated in 1937, the year the realignment resulted in a direct roadway from Santa Rosa to Albuquerque rather than the loop north through Santa Fe. Apparently, its location on U.S. 66 did little to promote economic diversity in the agricultural community. The town receives no mention or designation in the Rand McNally *Auto Road Atlas* published in 1929.

DILLON COURT

Built in 1941, the name for Dillon Court is derived from the Dillon School District. The court initially consisted of five unconnected cabins, later connected by a single roof with cabins built in the spaces. At this point, the name changed to Country Aire. The primary attraction that set the facility apart from others near Rolla in Missouri was the landscaped grounds. Fruit trees and a wide array of flowers created a parklike setting. The *Western Accommodations Directory*, published by AAA in 1955, contains a cursory entry: "Rooms have shower baths and central heat. Restaurant 1 mile." The rate given was $4.00 to $6.00 per day.

DIVERNON, ILLINOIS

Divernon is a small community located on the post-1930 alignment of Route 66 with an unknown date of origin. Establishment of a post office occurred on February 23, 1887. Jack Rittenhouse noted in 1946, "Divernon is a small, quiet town. Garage here." John Weiss, in *Traveling the New, Historic Route*

66 of Illinois, published in 2010, indicates little change: "The business district is located around a central park. Drive around it. It is a nicely maintained town area."

DIXIE TRUCKERS HOME

Considered the oldest truck stop on Route 66, the Dixie Truckers Home was built in 1928 at the junction of U.S. 66 and U.S. 138 in McLean, Illinois, by J.P. Walters and his son-in-law, John Geske. From its inception, the facility has undergone transition that mirrored the evolution of the highway. Initially, the restaurant consisted of a counter fronted by six stools, but by 1938, the restaurant had a seating capacity of sixty, there were six tourist cabins available, and there were fuel islands on two sides of the building.

In 1965, a fire destroyed the café and station with the exception of the pumps, which enabled the sale of fuel to continue by the following day. One of the cabins remodeled as a temporary café served in this capacity until completion of the new facility in 1967. Renamed the Dixie Travel Plaza after reconstruction and sale, the facility has consistently been rated among the top ten truck stops in the nation. With the resurgent interest in Route 66, the facility initially housed the collection of the Route 66 Hall of Fame and currently maintains a Route 66 exhibit. As of 2011, it remained a thriving business, affiliated with another roadside classic, Stuckey's.

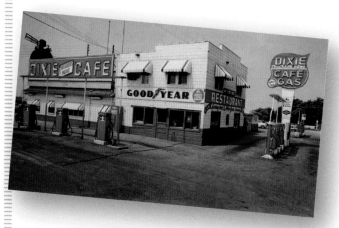

The Dixie Truckers Home in McLean, Illinois, opened in 1928, expanded through the 1960s, burned, and was rebuilt in 1967. It is purportedly the oldest continuously operated truck stop on Route 66. *Steve Rider*

DOMINGO, NEW MEXICO

Domingo, a faded community on the pre-1937 alignment of Route 66, is located three miles east of the historic Santo Domingo Pueblo that dates to about 1770. The pueblo was an amalgamation of older communities on the Atchison, Topeka & Santa Fe Railroad. From 1883 until the establishment of the post

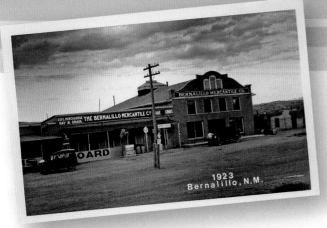

Established by Fred Thompson, the historic Bernalillo Trading Post suffered extensive fire damage in 2009. Plans are to rebuild the structure, but as of late 2011, work had yet to commence. *Steve Rider*

office in 1909, the community appears on maps as Wallace (a name selected in honor of territorial governor Lew Wallace, author of *Ben Hur*), Annville, and Thorton.

Census records indicate this was a thriving community in 1884 with a population of one thousand. The population declined precipitously after 1915 and by 1942 was no longer large enough to warrant a post office.

With roots that predated the initial Spanish explorations of 1598, the nearby Santo Domingo Pueblo—through promotion by railroad boosters and, later, material published to promote tourism on the National Old Trails Highway as well as Route 66—became a favored destination for tourists. The sale of traditional crafts proved an economic boon.

DOOLITTLE, MISSOURI

Before 1946, the cluster of service facilities at the junction of Route 66 and State Highway T appeared on maps as Centerville. In *A Guide Book to Highway 66* published that year, it was noted the population was 208 and businesses "loosely strung along about two miles of highway" consisted of gas stations, cabins,

In 1946, the wide spot in the road between Newburg and Rolla, Missouri, known as Centerville, was renamed Doolittle in honor of World War II flying ace and Medal of Honor winner General Jimmy Doolittle. *Steve Rider*

cafés, and Five Oaks Garage. Another of these businesses was Ramsey's Garage, the only facility listed in the 1946 edition of the *Service Station Directory* published by AAA.

Indicative of the volume of business that resulted from the traffic on Route 66 is the growth of Malone's Service Station, opened in 1941 as a two-pump facility. By 1952, the facility had expanded to include twelve gas pumps.

In 1946, with pomp and ceremony that included participation by General "Jimmy" Doolittle, the community name changed to Doolittle. General Doolittle was a World War II Medal of Honor recipient best known for his raid on Tokyo in 1942.

DREWES, TED

Ted Drewes, an award-winning tennis player during the late 1920s and early 1930s, opened his first small ice cream store in Florida in 1929. In 1930, sale of the first establishment after a season of anemic business allowed for the opening of a new, larger facility in St. Louis, Missouri, on Natural Bridge Road. In turn, the sale of this property allowed for construction of a new Ted Drewes Frozen Custard store on South Grand. The overwhelming success of the enterprise allowed for the opening of a second store at 6726 Chippewa in 1941. This store, managed by Ted Drewes Jr. and his family, remains operational.

A St. Louis favorite since 1929, Ted Drewes Frozen Custard at 6726 Chippewa is still a top desination on Route 66 for many enthusiasts. *Joe Sonderman*

A favorite of locals, the store is also known for its Christmas trees, a supplemental source of income during the winter. With the resurgent interest in Route 66, Ted Drewes Frozen Custard is now an internationally recognized destination.

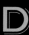

The *Directory of Motor Courts and Cottages*, published by AAA in 1940, noted that Drumm's Auto Court featured twenty cottages, all with bathrooms, and that rates ranged from $1.75 to $2.50.
Mike Ward

DRUMM'S AUTO COURT

John Drumm initiated his business enterprises in Winslow, Arizona, with a barbershop that opened in 1889, and he later owned a mortuary. (He also served seven terms as justice of the peace.) His wife, Frona Parr Drumm, was the city's first female insurance agent.

In 1937, John opened Drumm's Auto Court along Route 66 near the city center. The twenty-unit complex, noted in the route guide published by Jack Rittenhouse in 1946, received a favorable recommendation in the *Directory of Motor Courts and Cottages*, published by AAA in 1940: "Drumm's Auto Court, west side on U.S. 66. 20 cottages with baths, $1.75 to $2.50." (Note: Auto courts with bathrooms in the room, especially in the Southwest, were rather rare before the war.) In 1944, Drumm sold the complex, which no longer exists.

DUARTE, CALIFORNIA

The establishment of Rancho Azusa de Duarte, an almost seven thousand–acre land grant, by Don Andres Duarte in the summer of 1841 serves as the cornerstone date of origination for this community. The Americanization of the area and platting of the town site commenced with legal disputes pertaining to Mexican and Spanish land grants after cessation of hostilities during the Mexican–American War of 1846 to 1848 and the sale of one hundred acres to Michael Whistler in 1855.

Duarte remained a prosperous agricultural community with diversification from ranching to cultivating field crops and orchards. Additionally, a locally grown specialty crop, Chappelow avocados, became a highly sought-after commodity with the publication of the U.S. Department of Agriculture Yearbook in 1906, which described them in detail.

Recognition of Duarte as a unique community was a result of primary settlement by Methodists and Presbyterians and their focus on the development of educational facilities. The January 8, 1887, issue of the *Monrovia Planet* notes, "The settlement of Duarte is in every respect a model one without saloons or disreputable resorts of any kind, and any owner of any property

in the village who shall attempt to start a saloon will forfeit his rights to the property. It is a charming place for homes, and the rich and growing settlement will undoubtedly develop into a thrifty and prosperous village."

Facilitated by completion of the Southern Pacific Railroad's Duarte branch in 1891, packing houses became a major employer further solidifying agriculture as the primary economic element for the community. Completion of the Pacific Electric Railway through Duarte in 1908 and a sanatorium, the foundation for the City of Hope Medical Center, for tubercular patients (established by Jewish philanthropists in 1912) marked the initial stages of diversification.

The certification of Route 66 and the use of Huntington Drive for that highway through Duarte sparked further nonagricultural development. However, the largest period of transition occurred with the postwar population boom and the completion of the 210 freeway in 1968 that transformed the town from agricultural to suburban.

Even though this community is no longer rural or agricultural in nature, its association with Route 66 provides a tangible link with the past as evidenced by the annual Duarte Salute to Route 66 festival held each September.

DU BEAU'S MOTEL INN

Purportedly, Du Beau's Motel Inn, opened by Albert Du Beau in 1929, was the first motel in Arizona to offer garages, steam heat, and sheets with the room. Another unique aspect of the property was its consistently favorable rating by AAA.

The *AAA Directory of Motor Courts and Cottages* (1940) contains a sparse entry that reads, "28 cottages with baths, $2.50 up. Housekeeping facilities." The 1954 edition of the *AAA Western Accommodations Directory* entry for the facility is almost as sparse: "One and two room units with central heat and shower or tub baths; 20 open garages. Curio shop. Restaurant nearby."

The property located at the corner of Beaver and Phoenix Avenues in Flagstaff, Arizona, remains an existing business as of late 2011. It now operates under the name Du Beau International Hostel.

DUPLEX MOTEL

Built in 1937, the Duplex Motel at 7898 Watson Road (Route 66) in St Louis consisted of eleven cottages with private baths. Conversion to a motel complex and expansion resulted in a twenty-seven-unit motel utilized as apartments as of 2010. The *Directory of Motor Courts and Cottages*, published by AAA in 1940, notes that the property consisted of "27 modern, white granite cottages, all with shower baths, oil heat, fans and radio; nicely furnished. Convenient to garages, filling stations, and restaurants." The rates listed range from $2.00 to $4.00 per night.

The old Durlin Hotel in Oatman, Arizona, has operated under many names since it opened more than a century ago. It remains as the oldest and largest adobe structure in Mohave County. *Steve Rider*

DURLIN HOTEL

Dating to 1902, the Durlin Hotel, listed on the National Register of Historic Places in 1983, is the oldest commercial structure in Oatman, Arizona. It is also the oldest two-story adobe structure in Mohave County. Built by John Durlin, the hotel underwent numerous renovations after fires that decimated the business district of this

mining camp in 1921 and again in 1935, as well as part of a modernization effort. The eight-room hotel, with saloon and barbershop offset from the lobby, continued to rent rooms through 1952, and the name changed to the Oatman Hotel in about 1968.

In 1939, after marrying in Kingman, Clark Gable and Carol Lombard spent their first night as husband and wife here. Their room and the rest of the second floor serve as an intermittently opened museum while a portion of the first floor and an adjacent building house a restaurant and bar.

DWIGHT, ILLINOIS

Initial platting of the town site (whose namesake is Henry A. Dwight, principal financier for Chicago & Mississippi Railroad, as well as the Alton & Sangamon Railroad that became the Chicago & Alton Railroad) dates to 1853. Completion of the railroad to this point in 1854 resulted in the establishment of a station and siding with the name West New York, amended to Dwight in 1857.

Agriculture was the primary economic base initially, as evidenced by the early establishment of a large mill in 1859 by Richard Morgan, a railroad survey engineer. Morgan would be instrumental in the development of the community and donated the land for the construction of a Presbyterian church.

David McWilliams was also a pioneering developer in Dwight. His endeavors began with the acquisition of various properties within the township and continued with the establishment of a

Located on the grounds of the historic Country Mansion Restaurant, the Oughton Estate Windmill, listed on the National Register of Historic Places, looks like a cross between lighthouse and windmill. *Judy Hinckley*

successful general goods store, financial contributions for the construction of the first school, and the founding of the first bank in town.

Dr. Leslie Keeley established the Keeley Institute here in 1879. This was the first medical institution to offer treatment of alcoholism as a disease rather than incarcerating alcoholics because they had a mental disorder. By 1900, the success of the Keeley Institute resulted in establishment of others throughout the nation as well as internationally.

Located along the primary automobile route connecting Chicago and St. Louis, Dwight began developing supportive infrastructure before 1910. The certification of Route 66 allowed that sector of the economy to thrive. Jack Rittenhouse noted in 1946 that services included a few tourist cabins, stores, hotels, and the Boyer Brothers Garage, a facility also listed in the 1940 edition of the AAA service station directory.

Many attractions remain from the Route 66 period as well as the community's earlier history. Of particular note is Ambler's Texaco (1933) at the junction with State Highway 17. It closed in 1999 before it was recognized as one of the longest continuously operated stations on that highway. It found a place on the National Register of Historic Places in 2001. In May 2007, after extensive renovation, it reopened as a Route 66 visitor center.

Other points of interest include the Bank of Dwight, organized in 1855, at 132 East Main Street. The oldest bank still operating under its original charter, the current building dates to 1910. Frank Lloyd Wright designed the First National Bank of Dwight (122 West Main Street), built in 1905. This was one of three banks designed by Wright and the only one still that still exists.

At 119 West Main Street is the Chicago & Alton Railroad Depot that still serves its original purpose as an Amtrak stop and houses the Dwight Historical Society Museum. Dating to 1891, and placed on the National Register of Historic Places in 1982, this depot is representative of the work by renowned Chicago architect Henry Ives Cobb.

One of the unique, and often overlooked, attractions in town is the Dwight Windmill, built in 1896. An octagonal tower that resembles a lighthouse perched on a small cottage, the windmill is on the grounds of the Country Mansion Restaurant at the end of Prairie Avenue. The building that now holds the restaurant, listed in the national Register of Historic Places in 1980, dates to 1891. Initially constructed as a boarding house, it was relocated to its current site in 1895, expanded, and used as a private home until 1928 when it was donated to the Keeley Company. In 1977, the Ohlendorf family purchased the property, remodeled it, and opened it as the Country Mansion.

The former Keeley Institute building, built in 1891 and remodeled in 1902, is world famous for its stained-glass windows designed Louis J. Millet, a student of Lewis Tiffany. The windows portray the five senses affected by alcoholism.

Built in 1891, the railroad depot in Dwight, Illinois, still serves its original purpose and houses a community information office as well as museum. *Judy Hinckley*

E

EAGLE HOTEL

Built in 1836 as a stage station and inn by David Lizer, the Eagle Hotel (100 Water Street in Wilmington, Illinois) is one of the oldest commercial structures in existence on the Illinois alignment of Route 66. The building, damaged by fire several times, has served as a bank, a warehouse, a tavern, a storefront, apartments, and, most recently, a museum. As of December 2011, plans for the empty building's restoration were uncertain, and it remained for sale.

The Eagle Hotel building in Wilmington, Illinois, dates to 1836 and remains as the oldest commercial structure along the entire course of Route 66 in Illinois.

EARLE, HORATIO

Born in Mount Holly, Vermont, on February 14, 1855, Horatio Earle is generally regarded as the father of the good roads movement. His passion came from an intimate knowledge of the dismal quality of rural roads garnered as a traveling salesman, first of agricultural implements in Vermont and later for the North Wayne Tool Company of Detroit. The invention of an improved sickle and eventual ownership of the Wayne Tool Company provided Earle with adequate income, allowing him to indulge his passion for bicycling.

By 1899, his reputation as a vocal proponent of improving road conditions for cyclists resulted in appointment to the position of chief consul for the Michigan division of the League of American Wheelmen, an organization devoted to increasing public awareness of bicycling and providing a voice to enthusiasts. In this position, he energized and focused the attention of bicycling enthusiasts nationally and, in 1900, initiated the International Good Roads Congress with the first meeting held in Port Huron, Michigan. To garner publicity for the cause and congress, he organized a "good roads train," forty motorized vehicles that included dump wagons, a road roller, and a traction engine, and hundreds of bicyclists. The subsequent media coverage resulted in international attention for Earle and his organization, referring to him as the "father of Good Roads in Michigan."

Earle utilized the momentum generated by the event and its coverage to found the Michigan Good Roads Association and, in 1901, accepted the position of president of LAW (the League of American Wheelmen). In the same year, he accepted that organization's selection for candidate to the Michigan State Senate. While serving his first term in the state legislature, Earle introduced legislation to create a state highway commission. The bill that passed in both houses became law when signed by the

Realignment in 1929 routed Route 66 along State Highway 3 from Venice into East St. Louis. Tracing the course of the old road in East St. Louis today is a daunting task. *Steve Rider*

governor. Shortly after, in 1902, the Highway Educational Department, with Earle as the first commissioner of highways, initiated road improvement studies.

In late 1904, Earle drafted the State Reward Road Law. Passage in 1905 resulted in creation of the Michigan State Highway Department, precursor to the Michigan Department of Transportation, with Earle appointed as the constitutional state highway commissioner. In 1909, Earle oversaw a joint project undertaken by the state highway department and the Wayne County Road Commission that resulted in the paving of a one-mile section of road (Woodward Avenue) with concrete, a national first. The following year, Earle renamed the American Road Markers, an organization he established in 1902, and the subsequent American Road Builders Association, which, after 1907, took Earle's push for good roads national. Many historians deem this to be a foundational element in the creation of the U.S. highway system.

Erected in Mackinaw City and Cass, Michigan, were monuments to Earle and his work. In his autobiography, Earle wrote, "The monument I prize most is not measured by its height but its length in miles."

EARL'S PARK 'N' EAT

Earl Nelson established Earl's Park 'n' Eat at 1400 East Highway 66 in Gallup, New Mexico, in 1947. Sharon and Maurice Richards purchased the property in 1974 and operated it through 1990. They then transformed it into Earl's Family Restaurant. The fifteenth edition of the *Route 66 Dining & Lodging Guide*, published by the National Historic Route 66 Federation in 2011, recommends this restaurant for value, quality, and historic association.

EAST ST. LOUIS, ILLINOIS

This community is located on the eastern banks of the Mississippi River directly across from St. Louis, Missouri, on the site of a large pre-Columbian city complex. The first European settlement at this location was Cahokia, founded by French missionaries in 1799. In 1818, with establishment of a ferry service operated by James Piggott, the name change to Illinoistown provided an American association. The initial post office opened under this name in 1824. Subsequent changes occurred in 1826 to Wiggins Ferry and to East St. Louis in 1861. During the 1870s, the city became a center of industrial development, to a large degree a result of heavy tolls charged on the Eads Bridge across the Mississippi River.

The twentieth century was a period of dramatic change in East St. Louis. In 1917, a violent race riot garnered international attention. However, in 1958, the community received recognition as an All-America City. By the closing years of the century, as a result of industry relocation and an exodus of businesses from the central district to suburban and outlying areas, the city became symbolic of modern urban blight.

The city's association with Route 66 dates to a realignment in 1929 that resulted in the highway turning south at Venice to cross the river at East St. Louis on the Municipal Bridge constructed in 1916. Utilization of this bridge as the primary river crossing continued until 1935. From 1936 to 1955, it served as the river crossing for City 66.

The 1927 edition of the *Service Station Directory* published by AAA lists three recommended service facilities: Crescent Gas Company, Drury Garage, and Harding Motor Company with twenty-four-hour towing and repair. The lodging directory for the same year lists two hotels: the Illmo and National. The *Directory of Motor Courts and Cottages*, published by AAA in 1940, lists but one property: the Cabins. The entry provides few details: "6 miles east. $1.25 to $2.25. Public showers."

The 1949 edition of *The Negro Motorist Green Book* has two lodging recommendations, both tourist homes, none of which were on Route 66 or any major highway: one owned by P. B. Reeves at 1803 Bond Avenue and another owned by W. E. Officer at 2200 Missouri Avenue. The only other entry for this community is the Cotton Club at 1236 Mississippi Avenue.

The 1954 edition of the *Western Accommodations Directory* published by AAA lists the Hotel Broadview, at the intersection of Broadway and Fifth Street, for approved lodging. Services available included a AAA office located in the building, dining, and a garage.

Revitalization efforts of the past decade have manifested in symbols reflecting the city's hope for a brighter future. The most notable of these is Gateway Geyser, the tallest fountain in the United States, and the surrounding park on the riverfront facing the Gateway Arch in St. Louis.

EDGEWOOD, NEW MEXICO

Before establishment of a post office under the name Barton in 1908, this community appears on maps as Venus, Mountain View, and New Barton. In 1936, an amended post office application resulted in the designation Edgewood.

In 1946, Jack Rittenhouse noted cafés and a service station but no cabins or auto court. He also indicates the primary agricultural product grown in the area was pinto beans.

In 2011, Overnight Kamper Inn—which had opened in Edgewood in 1966—reopened as the Route 66 RV Park with Howard McCall as owner. The complex has operated under various names, including Red Arrow Campground.

EDMOND, OKLAHOMA

Settlement predates the establishment of the post office at this location in May 1889. In August of the same year, the first schoolhouse in the Oklahoma Territory opened here. This building, recently utilized as a camera store, is located at the corner of Second Street and South Boulevard.

The 1940 edition of the *AAA Directory of Motor Courts and Cottages* contains one listing with notations about the available units: "Martin's Court–4 units with bath–$1.50 to $2.00 per night." Extensive urban development commencing in the mid-1970s has eliminated most vestiges associated with Route 66.

Crawford and Gene Noe opened the Night and Day Café, later the Wide-A-Wake Café, in the fall of 1931 in Edmond, Oklahoma. It remained in business until 1979. *Steve Rider*

ED'S CAMP

Historical evidence in the form of archaeological investigations under the auspices of the Smithsonian Institution during the 1920s support the theory that the springs at Ed's Camp, as well as those in nearby Warm Springs Canyon, are those noted by Father Francisco Garcés in his expedition of 1776. The springs at this location appear on early territorial era maps as Little Meadows, a key stop for travelers utilizing the Sitgreaves route through the Black Mountains rather than Union Pass to the north (with its easier grades) during the late nineteenth century.

Little Meadow, the site of Ed's Camp in the Black Mountains of Arizona, served as a restful oasis for travelers from the expeditions of Father Garces in 1776 to realignment of Route 66 in 1952. *Joe Sonderman*

An iron gate topped with the letters "LM," erected in about 1960 when a section of the area was set aside for a trailer camp, still stands. The initials are in reference to the territorial name for the location.

Lowell "Ed" Edgerton came to western Arizona from Michigan around 1919 to alleviate health issues, and after prospecting in the area of Oatman, he settled at Little Meadows. Shortly after the designation of Route 66 in 1926, he established a tourist camp at this location, which was also a stop for the Pickwick Stages bus line, a pioneering company that merged with Greyhound bus lines in 1929. Though he purchased and developed the property in the early 1930s, the facility remained a primitive one consisting of a small café, store, gas station, and tourist camp with a screened porch available for those not inclined to sleep in their cars or tents. This later morphed into rustic cabins.

With the realignment of Route 66 that bypassed Ed's Camp in 1952, business plummeted. Edgerton lived on the property until his death in 1978. Ruins, a small trailer park, and a vast array of discarded materials, including the remnants of the Oldsmobile that Edgerton used to relocate from Michigan to Arizona, litter the grounds today. The site is private property.

Framed by stunning western landscapes, the time-worn remnants of Ed's Camp stand in silent testimony to an era when business was so brisk that the owner did not have time to finish construction. *Joe Sonderman*

In Edwardsville, Illinois, as in communities all along Route 66, the blacksmith shop morphed into an automotive service center as the automobile and its supportive infrastructure transformed America society. *Steve Rider*

EDWARDSVILLE, ILLINOIS

Founded in 1812, Edwardsville's namesake was Ninian Edwards, governor of the Illinois Territory at that time. From its inception, the town has served as the Madison County seat. The post office has operated continuously since its establishment in November 1822.

Immediately to the south of Edwardsville, industrialist N. O. Nelson selected a tract of land in 1890 to locate his plumbing supply manufacturing company, which would include a model community named Leclaire. Nelson's ideal was that all employees would be included in a profit-sharing program and that, in his planned community, there would be free access to schools, educational lectures, and recreation at the various parks.

Today, the Edwardsville Children's Museum, located in the former Leclaire Academy, and the Lewis and Clark Community College utilize the former factory buildings. Each October the village, placed on the National Register of Historic Places in 1979, serves as the site of the Friends of Leclaire Festival that includes book sales, tractor parades, live music, and a wide array of activities.

The 1940 *AAA Directory of Motor Courts and Cottages* lists one facility: Green Gables Camp. Amenities included facilities for trailers, public baths, and an on-site café. A 1946 *AAA Service Station Directory* lists two recommended repair facilities: Cassens & Sons, Inc. and Wells Tire Sales Company. No address for either garage is given.

There are a number of existing buildings in Edwardsville with a lengthy Route 66 association; some even predate that highway's certification. As an example, housed in the former Superior Cash and Carry Grocery building along Route 66 is Springers Creek Winery. After Thomas and Mayme Halley acquired the property in 1927, it became Halley's Cash Market, a store that remained operational until 1972.

Often overlooked by travelers on Route 66 are the historic structures of importance, including the courthouse (1915), Wildey Theater (1909), U.S. Post Office building with unique octagonal front (1915), and public library (1903). One of the more intriguing buildings found along Vandalia Street (Route 66) is the Narodni Sin, the Czechoslovakian "national hall" built in 1906. Interestingly enough, the oversight of this building was the subject of an editorial

pertaining to the development of tourism through promotion of the community's tangible historic assets that appeared in the *Edwardsville Intelligencer* on December 3, 1937.

EL CAPITAN MOTEL

Opened in late 1954 by Dino Ganzerla, the forty-unit El Capitan Motel at 1300 East Highway 66 in Gallup, New Mexico, still existed as a motel as of 2011. The 1955 edition of the *AAA Western Accommodations Directory* noted, "Spacious, tastefully furnished one and two room units, many air cooled. Central heat and tiled combination or shower baths. Radios, alarm clocks."

A 1954 AAA-published advertisement for the El Capitan Motel in Gallup lists the property as "spacious, tastefully furnished one and two room units, many air cooled." Rates ranged from $6.00 to $8.00 per night. *Mike Ward*

EL CORONADO MOTEL

Built in the early 1950s, the El Coronado Motel in Williams, Arizona, received a lengthy entry, including photo advertisement, in the 1954 edition of the *AAA Western Accommodations Directory*: "Very good accommodations in one- and two-room units on spacious grounds. Central or thermostatically controlled vented heat and tiled glass shower or combination baths. Radios available. Lower off season rates. Special day rates in summer to

In 1954, AAA noted that the El Coronado in Williams, Arizona, offered "very good accommodations in one- and two- room units on spacious grounds. Special day rates in summer to tourists planning to drive across the desert at night." *Joe Sonderman*

tourists planning to drive across the desert at night. Restaurant across the street."

The restaurant across the street was Rod's Steak House. Still utilized as a motel, the El Coronado operated under the EconoLodge name as of 2011.

EL DON MOTEL

El Don Motel (2222 West Central Avenue in Albuquerque, New Mexico) opened as a fifteen-unit complex in 1946 with Dan Eitzen as proprietor. Eitzen sold the complex to Rolly and Marian Pease in 1958 and built the Capri Motel on Central Avenue at Twelfth Street.

The 1954 edition of the *AAA Western Accommodations Directory* noted, "One and two room, air cooled units have TV, radios, telephones, tiled combination baths; twelve garages; five kitchen units $1.50 to $2.50 extra. Baby cribs. Free ice and newspaper."

The El Don Motel received a favorable review in *Route 66 New Mexico* published in 2003 and remained an existing facility as of 2011. Recently renovated, the neon sign with cowboy at the top provides a time capsule feel for the property.

ELK CITY, OKLAHOMA

Initial settlement at this location dates to the early 1890s. The post office application, accepted in 1901, indicated the community's name was Busch, a departure from the original name, Crowe. An amendment filed in July 1907 resulted in the current name, which refers to nearby Elk Creek.

The initial alignment of Route 66 followed the Old Postal Road south before turning west. This was also the route listed in the 1923 edition of the *Auto Bluebook*, an early annual guidebook for motorists. Later alignments intertwined with the current track of Interstate 40 and Business 40 in Elk City itself.

In 1931, Elk City hosted the annual U.S. Highway 66 Association convention in which Charles H. Tompkins, former mayor of El Reno, succeeded Cyrus Avery as president. The estimate of attendees was thirty thousand.

The 1940 edition of the *AAA Directory of Motor Courts and Cottages* contains an extended listing for Motor Inn Courts, a facility also noted by Jack Rittenhouse in 1946: "West edge of the city, on U.S. 66. Consisting of eleven units; one double and one single cabin with tub baths, balance with shower baths; each with toilet and lavatory, hot and cold running water, gas heat and large, private garage; Beautyrest mattresses. Nine with one double bed and steel spring cot; two with two double beds and steel spring cot. Double beds divided by folding panel. Open all year. Rates $2 per day for two persons, $2.50 for three persons, $3.50 to $4 for units with two beds and cot. Attendant on duty 24 hours. Ice water furnished each cottage. Café and filling station with registered rest rooms. Dr. and Mrs. B. O. McDaniel, owners. J. M. Luther, manager." Additionally Rittenhouse noted

In Elk City, and other communities along Route 66 in the late 1920s, the hotel rather than motel served as the primary lodging choice. *Steve Rider*

Johnny Grayfish, a Delaware Indian, created the giant Kachina standing guard at the entrance of the National Route 66 Museum in Elk City, Oklahoma, for the owner of the Queenan's Trading Post, Reese Queenan. *Judy Hinckley*

other hotels, Casa Grande and Story, as well as several auto courts, Bungalo, Elk, Royal, and Star. The 1954–55 edition of the *AAA Western Accommodations Directory* lists the Bungalow Courts and Star Courts as well. This directory also listed the Hereford Court, McCoy's Motel, and Westerner Court. Miraglio's

ELK CITY, OKLAHOMA *continued*

Restaurant at 313 East Third Street is the recommended restaurant. All businesses listed in the AAA directory were located on Route 66.

Queenan's Trading Post, established at the junction with State Highway 6 in 1948 by Reese and Wanda Queenan, became a primary attraction of note in the Elk City area during the 1950s. To differentiate their trading post from others along the highway, the owners constructed two towering kachinas from drums and pipe. The trading post closed in 1980, and the trademark kachinas, now fully refurbished, currently stand in front of the National Route 66 Museum, part of the Old Town Museum Complex that includes the National Transportation Museum, Farm & Ranch Museum, and Blacksmith Museum at the corner of Third Street (Route 66) and Pioneer.

To the west of town, between exits 32 and 26 south of I-40, an early alignment of Route 66 crosses Timber Creek Bridge, a favored photo stop for enthusiasts. This through truss bridge opened to traffic in 1928.

The National Route 66 Museum in Elk City, Oklahoma, is a part of the Old Town Museum complex that chronicles the area's rich history. *Steve Rider*

ELKHART, ILLINOIS

After John Shockey plotting of the town site in 1855, an amendment in May 1883 to the original Elkhart City post office application from 1856 resulted in the current name.

Agriculture remained the primary economic foundational element even after designation of Route 66 in 1926. The 1927 *Hotel, Garage, Service Station, and AAA Club Directory* indicates one approved repair facility: Wm. A. Johnson's Garage. The 1946 *AAA Service Station Directory* also lists only one service facility: Hind's Implement Company. *A Guide Book to Highway 66* by Jack Ritttenhouse, published in the same year, notes, "Pop. 436; garage; gas. The dozen ancient store buildings which comprise

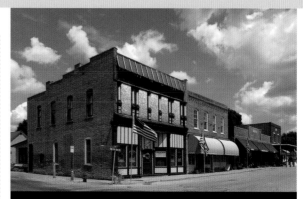

Lining the Route 66 corridor through Elkhart, Illinois, are a wide array of vestiges that reflect more than a century and a half of history.

the town are off to the left on the one main street which crosses U.S. 66. No courts here."

With the exception of the Wild Hare Café noted by historian and author John Weiss in *Traveling the New, Historic Route 66 of Illinois*, little has changed since the writing of the entry by Rittenhouse. Elkhart Cemetery, an unusual attraction of particular note, features unique headstones and historic markers as well as the Gillett Memorial Chapel, built of locally quarried stone. This is the final resting place of Richard Oglehurst, a friend of Abraham Lincoln's and the only governor of Illinois to be elected three times, and Captain Adam Bogardous, a world trap-shooting champion who traveled with the original Buffalo Bill Cody Wild West Show.

In late 2011, it was announced that construction of a 5.5-mile conveyor belt paralleling Route 66 was nearing completion here. The belt, built by the Arch Coal Company of St. Louis, is used to transport coal from mines near Williamsville to the processing plant in Elkhart.

ELLA'S FRONTIER TRADING POST

Frederick "San Diego" Rawson had earned his living in the territory of Arizona as a trapper, prospector, and (according to him) army scout. In 1927, he established San Diego's Old Frontier Trading Post along Route 66 west of Joseph City, Arizona. He sold the property in 1947 to Ray Meaney, a Hawaiian bandleader, and his wife, Ella Blackwell. In 1955, Ella Blackwell assumed possession of the trading post, and Ray received full ownership of the Hopi House, another trading post at Leupp Corner that he later traded for a motel in California as part of a court-awarded divorce settlement.

Ella was an eccentric and suffered from delusions. As a result, she often claimed a date of establishment for the trading post as early as 1873 and as late as 1940. In later years, she also developed a reputation for talking to imaginary people and animals. Ella's Frontier Trading Post remained operational until Ella's death in 1984. The facility remains today only as picturesque roadside ruins near the famous Jack Rabbit Trading Post.

El Oriente Court that opened in 1935 at 4101 East Central Avenue is a rare survivor, as in 2010 it was operating as the Town Lodge. *Mike Ward*

ELLIS, ALBERTA (ALBERTA'S HOTEL)

Shortly after World War II, Alberta Ellis decided to capitalize on the lack of dining and lodging options for African Americans on Route 66 in the Springfield, Missouri, area. With borrowed funds from other members of the family, she purchased the former city hospital on the 600 block of Benton Street, a few blocks north of City 66, and converted it into a hotel.

Initial advertisement for Alberta's Hotel was by word of mouth and small advertisements in "colored newspapers." By the early 1950s, the thriving business had grown to include a beauty salon, a dining room, a night club (the Rumpus Room), and a barbershop. It was largely a family-run enterprise. Rich, a grandfather who had served in the army as a cook during the Spanish–American War and World War I, oversaw operation of the dining room. A sister managed room service, and another sister handled the laundry.

In about 1953, Alberta Ellis purchased a ten-acre parcel of land to the west of Springfield and designated it as "The Farm." Here, produce for the hotel was grown, and as a bed and breakfast, it housed overflow from the hotel. Further expansion of Ellis's business interests occurred with the establishment of the Crystal Palace, a nightclub referred to as a "joot joint," on the southwest corner of West Chestnut (City 66). The celebrity association with Alberta's Hotel is also quite lengthy. Guests who frequented the establishment included Nat King Cole, Frankie Lymon, and the Harlem Globetrotters.

The passage of the Public Accommodations Act in 1960 eliminated the need for the niche market services offered by Ellis's various enterprises. By the time of her death in 1966, Alberta's Hotel had closed.

ELLISVILLE, MISSOURI

Settlement in the area of Ellisville, Missouri, located two miles west of Ballwin on the original alignment of Route 66, predates the date of origination for a post office in 1843. There are two variations of the story explaining the naming of the community.

One assumption is that William Hereford, the first postmaster, hailed from Ellisville, Virginia. However, it is more likely the namesake was Vespasian Ellis, a pioneer in the area and a St. Louis newspaper editor who purchased a portion of the plantation owned by Captain Harvey Ferris at this site. Ellis later became the U.S. consul to Venezuela.

The paving of Manchester Road in Ellisville (U.S. 66) commenced in 1917 with completion occurring in 1920, six years before certification of Route 66. With establishment of this highway, the community developed a certain reputation as a result of businesses like the Merry Inn (a speakeasy) and the Ellisville Hotel, referred to as a "Honeymoon hotel." Incorporation occurred in 1932. Through postwar annexation, the community has experienced tremendous growth.

EL ORIENTE COURT

The El Oriente Court (401 East Central Avenue in Albuquerque, New Mexico) opened in 1935 with James Evans as proprietor. With subsequent sales, the property became the Mecca Court and the Minton Lodge.

Extensive renovation in about 1954 resulted in AAA noting in 1955 that it was "one of the newer and finer lodges in Albuquerque with all rooms facing shaded, restful patio for the convenience of guests." The property, as of 2010, still existed as the Town Lodge.

EL PUEBLO MOTOR INN

Built in 1936 by E. B. Goble, a local contractor, El Pueblo Motor Inn still stands along U.S. 66 several miles east of downtown Flagstaff, Arizona, and serves as apartments rented by the month. Phillip Johnson, the son of missionaries to the Navajo Indians, was the original owner.

Johnson, best remembered as the man who developed the Navajo code talker program during World War II, utilized postcards with catchy slogans like "Modern Comfort in the Pines" and "Your Home Away from Home" to make his auto court a success. In the 1940 *Directory of Motor Courts and Cottages*, published by AAA, the auto court is listed as being "2 1/2 miles east of Flagstaff. Housekeeping facilities. $3 to $3.50."

Phillip Johnson, developer of the Navajo code talker program, established El Pueblo Motor Inn, listed in the 1940 edition of the *AAA Directory of Motor Courts and Cottages*. *Mike Ward*

EL RANCHO HOTEL

Billed as the "World's Largest Ranch House," El Rancho Hotel in Gallup, New Mexico, built by R. E. Griffith (a brother of the movie mogul D. W. Griffith), opened on December 17, 1937. Built with a western colonial–styled exterior and a frontier rustic interior, the hotel served as the primary residence for movie stars and film crews working in the area between 1940 and 1964 during the filming of eighteen major motion pictures.

Indicative of the hotel's prominence is its listing in the 1954 edition of the *AAA Western Accommodations Directory*, which notes, "Accommodations in a ranch style hotel and bungalows. Central heat and combination baths. Connecting rooms. Suites, $6.50 to $25. Air conditioned coffee shop, dining room, and cocktail lounge. Dancing nightly in the '49'er Room. Teletype service and Western Union."

The prestigious hotel entered a period of decline beginning in the late 1960s that culminated in its closure 1987. Scheduled for demolition, the historic property sold to Armand Ortega, proprietor of some of the largest and oldest Indian trading posts along Route 66, who renovated it.

The hotel is again a favorite for travelers on historic Route 66. The two-story lobby with its heavy, rough-hewn beams and circular staircase—and decorated with rustic Southwestern furniture, authentic Navajo rugs, and mounted animal heads—is a near perfect time capsule from the period of the 1940s and 1950s.

Renovation of the rooms kept the period atmosphere but with the limited intrusion of modern amenities. The primary change is that the rooms are now named for celebrities who frequented the hotel, such as John Wayne, Ronald Reagan, Kirk Douglas, and Katherine Hepburn.

Once a haven for the rich and famous of Hollywood, the historic El Rancho Hotel in Gallup, New Mexico, faced the wreckers ball before the resurgent interest in Route 66 served as a catalyst for its restoration. *Steve Rider*

EL RANCHO MOTEL, FLAGSTAFF

Andy Womack (a Phoenix, Arizona, land developer) opened El Rancho Motel—built in a unique "Spanish western frontier style" at the intersection of U.S. 66 and U.S. 89A in Flagstaff, Arizona—on December 9, 1947. The 1954 edition of the *AAA Western Accommodations Directory* listed the property as El Rancho Hotel Courts and noted that amenities included vented heat, tiled showers, telephones, and tub baths as well as "52 open or closed garages," ten housekeeping units, and radios or cribs upon request.

In 1959, renovation and new ownership resulted in a name change to Flamingo Motel. The property closed in 1986, demolition occurred in 1997, and the site is now occupied by a Barnes & Noble bookstore.

EL RANCHO MOTEL, WILLIAMS

The eighteen-unit El Rancho Motel in Williams, Arizona, opened in late 1956, and in 1958, AAA recognized the property as being "very attractive and well maintained." Several years later, renovation and expansion resulted in the addition of units to the two-story complex, and the facility at 617 East Bill Williams Avenue remained operational as of late 2011.

EL RENO, OKLAHOMA

To differentiate the community from another nearby town site (Reno City) and the fort (Fort Reno), the post office application approved on June 28, 1889, used the name El Reno. The town is the Canadian County seat and headquarters for the Cheyenne-Arapaho Tribe.

It was here that the western fork of the Chisholm Trail crossed the North Canadian River. The Chicago, Kansas & Nebraska Railroad, owned by the Chicago, Rock Island & Pacific Railroad (CRI&P) after 1891, also forded the river here. Completion of the Choctaw Coal and Railway (a subsidiary of the CRI&P) line connecting El Reno with Oklahoma City in 1892 led to the creation of a major railyard that, by the early 1950s, included repair facilities and a coach-building enterprise. The historic Rock Island Depot, listed on the National Register of Historic Places, now serves as an anchor for a museum complex operated by the Canadian County Historical Society.

In 1927, El Reno was still largely a progressive frontier-era railroad community. The *Hotel, Garage, Service Station, and AAA Club Directory* from that year lists the Southern Hotel for lodging and a population of eight thousand.

Route 66 played a key role in further diversification of the economy. A 1936 business directory lists thirty-eight filling stations, twenty-four restaurants, eight tourist camps, and ten hotels. Jack Rittenhouse, in the 1946 *A Guide Book to Highway*

66, showed the population as 10,078 and listed only two hotels, the Southern and Kerfoot. He also listed three auto courts, Eagle, Colonial Court, and Phillips, and two garages, El Reno and Rother. The 1946 *AAA Service Station Directory* lists a third garage, Messenger & Company. No address for any of the garages is given. The *AAA Western Accommodations Directory* of 1954–55 lists two auto courts: the Bunkhouse Motel (521 North Choctaw, five blocks north of U.S. 66) and the Phillips Court (on the west side of U.S. 66 and U.S. 270).

In recent years, numerous structures associated with Route 66 have been razed. One of the most notable is the Big 8 Motel, opened in the late 1940s and featured in the movie *Rainman* starring Dustin Hoffman. Still, a wide array of structures of historical significance from the preinterstate highway era remain along various alignments of Route 66. Exemplifying this are the former Avant's Cities Service Station (220 North Choctaw) and the former Jackson Conoco Service Station (121 West Wade). These stations are representatives of oil companies' initial endeavors to achieve brand recognition through architecture and design elements.

Avant's station, built in 1933, represents a blending of the art deco and Art Moderne architectural elements favored by Cities Service Oil Company during the late 1920s into the early 1930s. It also reflects period elements from expansion of the facility during the 1940s. The Jackson station, built in 1934, utilizes the "cottage" style favored by other companies like Phillips 66. Additionally, it contains elements dating to postwar expansion.

The stations, listed on the National Register of Historic Places in 2004, continued in operation after the bypass of Route 66 by Interstate 40. Refurbishment has allowed for utilization of the structures by nonautomotive businesses.

EL REY AUTO COURT

El Rey Auto Court, currently El Rey Inn, opened at 1862 Cerillos Road (the pre-1937 alignment of Route 66) in Santa Fe, New Mexico, in 1936. The architectural style reflects a blending of Spanish colonial and Pueblo influences popular in the 1930s and was designed, and built, by the same company that constructed the El Vado Motel in Albuquerque.

The initial facility consisting of twelve units with adjoining carports received an AAA recommendation in the *Directory of Motor Courts and Cottages*, published in 1940. In the early 1950s, enclosure of the carports created additional rooms.

The refurbished property is a favorite for Route 66 enthusiasts in the Santa Fe area. Renovations in 1973 and in 1994 carefully blended modern amenities with the original attributes of the 1936 property. The *Route 66 Dining & Lodging Guide* (fifteenth edition), published by the National Historic Route 66 Federation in 2011, lists the facility as "exceptional." Additionally, the guide states that the property is "vintage 66 at its best."

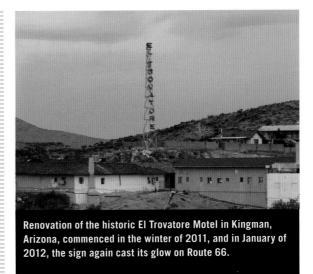

Renovation of the historic El Trovatore Motel in Kingman, Arizona, commenced in the winter of 2011, and in January of 2012, the sign again cast its glow on Route 66.

EL TROVATORE MOTEL

After the successful completion of numerous projects in Las Vegas, commencing with a land purchase at First Street and Fremont Street in 1905 and construction of the Nevada Hotel in 1906, John F. Miller turned his attentions to Kingman, Arizona, for its potential as an important highway crossroads after the completion of Boulder Dam. Acquisition of property on a bluff to the east of Kingman, in what was then the unincorporated community of El Trovatore, and construction of the ultra-modern El Trovatore Motel in 1939 were the results.

The expansive complex consisted of full laundry facilities and, after 1950, a swimming pool. The El Trovatore Motel tower on a knoll behind the motel, with name spelled out in large neon letters, was visible for miles.

In the late 1980s, the motel became a weekly or monthly apartment complex and closed in the fall of 2010. In the winter of 2011, renovation commenced, and in January 2012, for the first time in decades, the neon signage at the front of the complex was relit. In late December 2011, repair work commenced on the signature tower with neon lettering with a target of February 2012 for relighting.

EL VADO AUTO COURT MOTEL

To capitalize on the 1937 realignment of Route 66, and the increasing flow of traffic on Route 66, Daniel Murphy resigned from his position as manager at the Franciscan Hotel to establish the El Vado Auto Court Motel along Central Avenue near the Rio Grande, immediately to the south of Old Town Albuquerque. Built in a blending of Spanish and Pueblo Revival styles by the same company that built the El Rey Court in Santa Fe in 1936, the motel consisted of thirty-two units interspersed with enclosed

EL VADO AUTO COURT MOTE *continued*

carports arranged in two rows facing a central courtyard. The office with gasoline pumps fronted on Central Avenue.

The *Directory of Motor Courts and Cottages*, published by AAA in 1940, gave the facility an extensive review: "Five minute drive from downtown section, along the banks of the Rio Grande; adjoining golf course and bathing beach. 32 units of two, three, four, and five room apartments and hotel rooms, some with combination tub and shower bath, others with tile showers. Well insulated, with excellent ventilation for summer comfort. Automatically controlled steam radiators for winter. Soundproof and fireproof. Telephone in every room and apartment. Beauty-rest mattresses; beautiful Monterey furniture. Individual garages. One of the newest, completely modern and up to date courts in Albuquerque. Distinctive Spanish design, surrounded by well landscaped grounds with ample driveways. D. D. Murphy, manager. $2.50 to $5.00 per day."

In spite of a period of decline commencing in the late 1970s that culminated with closure in the fall of 2005, the property retains such a high degree of historic authenticity that historian David Kammer described it as "one of the best examples of a largely unaltered pre–World War II tourist court along Route 66 in New Mexico." This evaluation played a key role in the property's listing on the National Register of Historic Places in 1993 and intervention of the city to stop plans to raze the structure. As of this writing, the motel remains empty, but there are numerous plans for its resurrection.

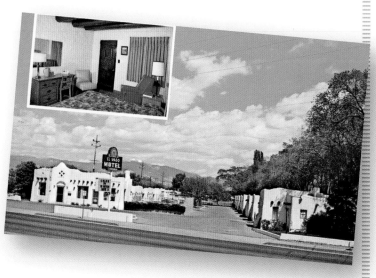

Built along the banks of the Rio Grande, the El Vado Auto Court was promoted as a "32 unit court with adjoining golf course and bathing beach" in 1940.

ELWOOD, ILLINOIS

With a name amended to Elwood on August 27, 1855, the town's initial post office application under the name Reed's Grove received approval on May 28, 1846. N. C. Elwood, a Joliet mayor, is the namesake. The establishment of the Chicago & Alton Railroad and platting in 1854 resulted in the area's transformation from a haphazard rural community into a town with streets laid out in a geometric pattern.

The *Hotel, Garage, Service Station, and AAA Directory* (1927) lists the Elwood Garage for recommended service. As a result of realignment shortly after this date, the original alignment of the Route 66 became Alternate 66.

The primary attractions in the Elwood area today are the Abraham Lincoln National Cemetery and Midewin National Tallgrass Prairie, carved from the former grounds of the Joliet Arsenal (a primary manufacturer of ammunition during World War II) and the site of a major explosion that left dozens of workers dead or injured. The cemetery is the second largest national cemetery in the country, and the tall grass prairie is a model for restoration of industrial properties.

EMMA JEAN'S HOLLAND BURGER CAFÉ

Located at 17143 D Street (Route 66) in Victorville, California, Emma Jean's Holland Burger Café opened in 1947. As of 2011, it remained operational with very little alteration and was featured on the television show *Diners, Drive-Ins & Dives*.

The *Route 66 Dining & Lodging Guide* (fifteenth edition), published by the National Historic Route 66 Federation in 2011, contains a lengthy entry: "A true mom & pop operation that has been serving Route 66 travelers since 1947—a very special 'must stop.'"

ENDEE, NEW MEXICO

The post office in Endee—founded as a supply center for area ranches, including the sprawling ND Ranch established by John and George Day in 1882—opened in 1886. The post office closed in 1955, three years after completion of a realignment of Route 66 that bypassed the community.

As a result of its remote location, Endee retained vestiges of the frontier era well into the early twentieth century. The *Santa Fe New Mexican* on May 2, 1906, reported that with the arrest of John Fife and Tom Darlington in Endee by mounted police, a major cattle-rustling ring had been "broken up." The *Evening Observer* on June 30, 1909, reported, "The anti saloon campaign at Endee, N.M. came to a close last night when a band of masked men, mounted and armed, rode their horses through the doors of a saloon and shot up the place until the mirrors and glassware were completely destroyed."

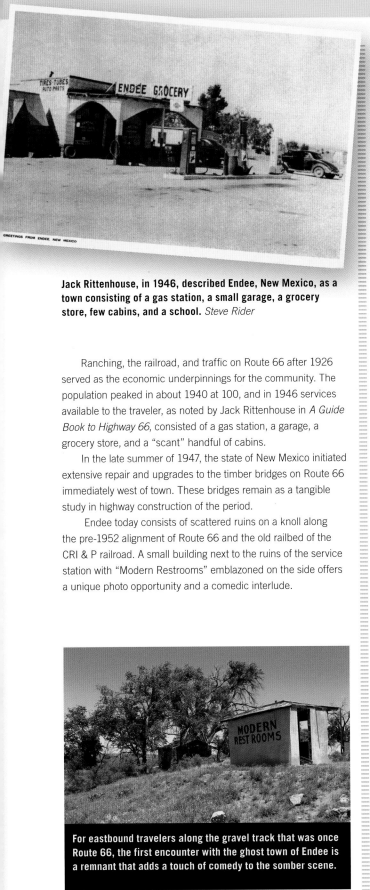

Jack Rittenhouse, in 1946, described Endee, New Mexico, as a town consisting of a gas station, a small garage, a grocery store, few cabins, and a school. *Steve Rider*

Ranching, the railroad, and traffic on Route 66 after 1926 served as the economic underpinnings for the community. The population peaked in about 1940 at 100, and in 1946 services available to the traveler, as noted by Jack Rittenhouse in *A Guide Book to Highway 66*, consisted of a gas station, a garage, a grocery store, and a "scant" handful of cabins.

In the late summer of 1947, the state of New Mexico initiated extensive repair and upgrades to the timber bridges on Route 66 immediately west of town. These bridges remain as a tangible study in highway construction of the period.

Endee today consists of scattered ruins on a knoll along the pre-1952 alignment of Route 66 and the old railbed of the CRI & P railroad. A small building next to the ruins of the service station with "Modern Restrooms" emblazoned on the side offers a unique photo opportunity and a comedic interlude.

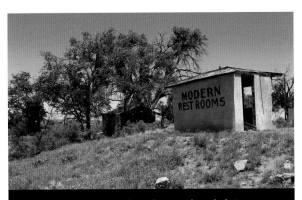

For eastbound travelers along the gravel track that was once Route 66, the first encounter with the ghost town of Endee is a remnant that adds a touch of comedy to the somber scene.

ERICK, OKLAHOMA

Erick, Oklahoma's town site developer was the Choctaw Townsite and Improvement Company, whose president was Beeks Erick. Initial settlement dates to 1900, and the post office opened November 16, 1901.

Agriculture, natural gas, and traffic on the Ozark Trails Highway (Route 66 after 1926) were the primary economic foundational elements of the town. Historic structures representing all stages of the community's development still exist.

In 1930, Erick garnered the attention of the national press when racial tensions exploded into violence. The *Frederick Post* of Frederick, Maryland, reported the following on July 14, 1930: "Reports received here [Shamrock, Texas] by Sheriff W. K. McLemore, Wheeler County, said negroes were driven out of Erick, Oklahoma, last night and from Texola, Oklahoma, today by a mob seeking reprisal for the death of Mrs. Harry Vaughn, wife of a farmer in a nearby county in Texas, who was beaten to death Friday by a Negro."

The DeLuxe Courts listed in the *AAA Directory of Motor Courts and Cottages* for 1940 is the only prewar court listed in these early directories. Jack Rittenhouse, in his less restrictive guidebook from 1946, lists this auto court as well as Erick Court and a trailer park. He also lists additional services as the Elms Garage, cafés, and gas stations and includes this interesting notation: "U.S. 66 crosses the one main street of the town, which is the first town you encounter, going west, which has any of the 'true' western look, with its wide, sun baked street, frequent horsemen, occasional sidewalk awning, and similar touches."

The most notable attractions are the 100th Meridian Museum (housed in a circa-1910 bank building), the now closed West Winds Motel, and the Sandhills Curiosity Shop (home of the Mediocre Music Makers and temporarily closed as of the summer of 2011). Roger Miller Boulevard (Route 66) and the former Main Street (signed as Sheb Wooley Avenue) are indicative of the town's most famous former residents.

In Erick, Oklahoma, the course followed by former U.S. 66 is signed as Roger Miller Boulevard, one of two celebrities associated with the community. *Steve Rider*

99

ESSEX, CALIFORNIA

Essex began life around 1883 as a water stop for the railroad, but as an oasis for the motorist, a small community a few miles north of the railroad siding by the same name mushroomed into a very busy wide spot in the road. Adding to its prominence in this capacity were efforts to promote automobile travel and the development of good roads in the Mojave Desert by the Automobile Club of Southern California, an organization that drilled a roadside well here to create an oasis with signs that proclaimed "Free Water" in the late teens.

By 1931, the traffic on Route 66 supported a market, garage, post office, and service station. The realignment of Route 66 that resulted in the bypass of Goffs in the same year greatly increased the town's importance to Route 66 travelers crossing the desert. Additionally, in 1937, the Goffs School closed, the Goffs School District was absorbed into the Needles Unified School District, and a new school was built in Essex.

During World War II, the establishment of Camp Essex Army Airfield three miles to the northeast, the installment of a small POW camp for the internment of Italian military personnel, and the vast war games that engulfed the Mojave Desert under the direction of General George S. Patton ensured that a decline in traffic as a result of wartime rationing would have negligible effect. Jack D. Rittenhouse noted in his *A Guide Book to Highway 66* (published in 1946) that Essex had a population of fifty-five, and businesses included a gas station, lunchroom, small grocery, and post office.

In 1977, after the bypass of U.S. Highway 66 by Interstate 40, worldwide attention focused on Essex when a feature in the *Los Angeles Times* proclaimed it was so remote that it was the last community in the continental forty-eight states without television service. As a result, all thirty-five residents appeared on

The Johnny Carson Show, and a manufacturer in Pennsylvania donated the necessary translator equipment to move the community into the modern era.

Numerous structures and the well house remain; however, the post office is the only business still operational.

EUREKA, MISSOURI

Eureka gained its name when, in 1853, a surveying engineer at a railroad construction camp on this site discovered that utilizing this valley would negate the need for numerous cuts and grades in the railroad's construction. Since its location was crucial to control of the railroad, the town played a role in the initial years of the Civil War that belied its size.

By the early 1950s, Route 66 in Eureka, Missouri, had been transformed into a modern roadway that would provide a template for development of the interstate highway system. *Joe Sonderman*

Even with the realignment of Route 66 that resulted in the community's association with that highway, the town remained very small. Jack Rittenhouse noted in 1946 that is was "a small community established just before the Civil War."

Gerwe's Log House Café, later Dot Hanephin's Log House Café, provided Eureka with a celebrity association. Bob Klinger, a major league baseball player, owned the café and leased it to Lou Gerwe.

Completion of a four-lane alignment of Route 66 in 1956 initiated a wave of modern development. The opening of Six Flags over Mid-America increased the transitional speed and transformed Eureka, as well as the surrounding area.

CHAMBER'S
WAYSIDE
INN

ESSEX

California

Highway 66

E-4226

The establishment of Essex as an oasis in the desert for motorists commenced with a well dug by the Automobile Club of Southern California several years before establishment of Route 66. *Steve Rider*

F

FAIRYLAND AMUSEMENT PARK

Fairyland Amusement Park in Lyons, Illinois, opened in 1938 on the site of a former low-key attraction, the Whoopee Coaster that opened in about 1928. The coaster was simply a series of modest hills and curves made of planks over wood framing, but the cars used on the course were the customers' automobiles.

The proprietors of Fairyland Amusement Park, Richard and Helen Miller, began their association with the business Miller Amusements of La Grange, Illinois, a traveling carnival operated by Richard's brother, Charles. Initially, the park was mostly a stationary version of the county-fair type carnivals with a Ferris wheel, various games, and pony rides. By 1955, the park had evolved into a five-acre complex with the majority of smaller

RIDE

MERRY GO ROUND

DES MINIATURE TRAIN PONY RIDE

FAIRYLAND PARK

OUTDOOR BOWLING

FAIRYLAND PARK - 40th Street at Harlem Ave. - LYONS, ILL.

Fairyland Amusement Park entertained generations of Chicago area children as it opened in 1938 and survived to 1977 before succumbing to the crush of urbanization. *Steve Rider*

attractions housed in a large, heated building. Another transition occurred with the Miller's son, Richard, and his family taking the helm of the prosperous enterprise in the same year.

The park remained operational until 1977. Rescued from Fairyland Amusement Park were various components of the vintage merry-go-round, including hand-carved horses, originally acquired from the sale of equipment after the closure of the White City park. They served as decorative features at the Barn of Barrington Restaurant in Barrington, Illinois, before its closure.

FALCON RESTAURANT

The Falcon Restaurant (1113 West Third Street, Winslow, Arizona) opened on July 9, 1955. Jim, George, and Pete Kretsedemas, Greek immigrants, ran the facility for forty-three years.

The restaurant remains operational, and the fifteenth edition of the *Route 66 Dining & Lodging Guide*, published by the National Historic Route 66 Federation in 2011, gave it a favorable rating.

FANNING, MISSOURI

The brothers Fanning, first names unknown, settled at this location in 1887. In 1930, Serafino and Mary Vitali established the Fanning Store fronting Route 66. Mary's brother, Joe, built the Speedway Garage, later converted to Joe's Place Tavern, and opened the Fanning Social Club shortly after the opening of the store.

In 1946, Jack Rittenhouse noted there was a gas station in town but no other facilities. Apparently, he overlooked the store as it remained in operation until 1972.

Demolition occurred in the early 1980s and built on the site was the Fanning Outpost General Store. For modern enthusiasts of Route 66, this store, with its indoor archery range and variety

of wines from area wineries, and the world's largest rocking chair (at forty-four feet tall), are the primary association with Fanning.

In 2008, promoters in nearby Cuba, Missouri, initiated a fund-raising Route 66 Race to the Rocker event. In January 2012, director Brad Austin noted in an interview that he had a goal of one thousand participants for the March 31 event. The 2012 beneficiaries were the Backpacks for Kids Program, scholarships for cross-country and track students, schools to make weight room equipment upgrades, and further development of the Rails to Trails program.

The forty-four-foot-tall rocking chair at the Fanning Outpost General Store in Fanning, Missouri, is purportedly the largest in the world and is the centerpiece for the annual fund-raising Race to the Rocker.

FARMERSVILLE, ILLINOIS

The date of origination for Farmersville is a matter of contention. However, the small village has a Route 66 attraction of particular note, Art's Motel and Restaurant at 101 Main Street.

The initial facility, opened by Art McAnamey in 1937, consisted of a gas station, restaurant, and six cabins. The current restaurant dates to 1952, the year fire destroyed the original.

After McAnamey's death in 1960, his sons replaced the cabins with a modern L-shaped complex consisting of thirteen rooms. The motel warranted recommendation in the fifteenth edition of the *Route 66 Dining & Lodging Guide*, published by the National Historic Route 66 Federation in 2011, and in 2007, the Route 66 Association of Illinois funded the restoration of the classic Art's motel sign.

FEDERAL AID ROAD ACT

The focus on development of a national all-weather road system as envisioned by President John Quincy Adams waned in importance with the development of the railroad. In the 1890s, the explosive growth of bicycle ownership, and the creation of political and lobbying organizations to place pressure on the government for road improvements, resulted in the development of a state-aid plan in New Jersey.

This 1891 resolution provided appropriated funds from the state to counties for road improvement and development. The initial success of this program, coupled with increasing pressure from lobbyists for better roads on a national level, led to the creation of the Office of Road Inquiry on the federal level in 1893.

The first administrator and engineer for this office was General Roy Stone. His primary duties were as an advisor to provide the latest engineering information on road construction to state and local road officials. His successor, Martin Dodge, with assistance from M. O. Eldridge, expanded the office from an advisory position by developing a federal-aid bill similar to that utilized in New Jersey for appropriation of federal funds for state improvement of roads.

Representative Walter P. Brownlow of Tennessee introduced the bill into Congress in December 1902. The foundational element of the bill was to create a Bureau of Public Roads to administer $20 million a year in federal aid given as 50-50 matching funds grants to the states. A secondary aspect of the bill had to do with standardization of roads through establishment of universal specifications.

Questions pertaining to the constitutional authority behind such a measure, as well as budgetary arguments, prevented passage of the Brownlow bill. The constitutional question was resolved in 1907 with the Supreme Court ruling in *Wilson v. Shaw*, in which Justice David Brewer wrote that Congress had the power to construct interstate highways under the constitutional right to regulate interstate commerce.

Coinciding with this ruling was growing pressure from agricultural lobbyists for the development of a rural free delivery road system for the transport of mail, the introduction of the Model T by Henry Ford in 1908 that resulted in a dramatic increase in automobile ownership, and the increasing influence of the American Automobile Association (AAA). Additionally, in 1914, the American Association of State Highway Officials (AASHO) gave the states an effective and unified voice for advocating federal assistance in the development of a national road improvement program.

Indicative of the changes wrought by this pressure was passage of a good roads bill, introduced by Representative Dorsey W. Shackleford of Missouri in 1912, by a vote of 240 to 86. The primary component of the bill was a $25 million allocation for the rental of county roads that would be developed and improved for rural mail delivery.

The bill died in the Senate, largely a result of lobbying efforts by the AAA and other organizations representing motorists, which felt a nationalized road program should emulate the development of the railroad by first building roads that connected major centers of commerce, essentially an interstate road system. This was in direct opposition to groups representing agricultural interests.

Through a rider to the Post Office Department Appropriations Bill for 1913, a compromise was reached. This experimental program allocated $500,000 to be utilized in a one-third/two-thirds funding program for state or local governments to improve post roads for mail delivery. A secondary aspect of this bill authorized creation of a joint congressional committee that would prepare a report on issues pertaining to the development of an interstate road system utilizing federal funds.

The postal service road project was plagued with problems, including lawsuits pertaining to federal statutes prohibiting the use of convict labor on federally funded projects and those stipulating an eight-hour workday for laborers. In spite of its shortcomings, road improvements were made in twenty-eight counties in seventeen states with some of these improved roadways incorporated into the federal highway system of 1926.

Serious debate on the issue of federal aid for the development of roads commenced in the House of Representatives in 1915 with submission of the joint committee report and culminated with debate on another federal aid road plan submitted by Representative Dorsey W. Shackleford. The resultant bill authorized $25 million to improve rural post roads with a minimum of 30 percent and a maximum of 50 percent allocated directly to states. The amount allocated to each state was based on a formula that considered population and the mileage of RFD (rural free delivery) and Star Mail (private carrier) delivery routes.

There were additional stipulations. Among these was a requirement for federal approval of all projects, including surveys, plans, and estimates.

The House approved the bill with a vote of 281 to 81 on January 25, 1916, and then referred it to the Senate Committee on Post Offices and Post Roads headed by Senator John H. Bankhead of Alabama, a long-standing and vocal proponent for federal aid for road improvements. Bankhead amended the House version by deleting everything after the enacting clause and substituting a bill developed by a group of AASHO members at the Pan American Road Congress headed by Thomas MacDonald, chief engineer of the Iowa State Highway Commission, in 1915.

This restructured bill proposed the appropriation of $75 million over a five-year period to be allocated to the states utilizing a formula of one-third for total area, one-third by population, and one-third by mileage of developed rural delivery and star routes. Additionally, the federal share would be 50 percent but with payments not exceeding $10,000 per mile. Each state would submit plans through its state highway agency to the secretary of agriculture for approval, the state would assume responsibility for road maintenance, and all funded roads would remain toll free.

With the exception of minor amendments, including an additional allocation for development of roads within national forests, approval of the Federal Aid Road Act of 1916 as proposed occurred on June 27. On July 11, 1916, President Woodrow Wilson signed it into law at a ceremony attended by members of Congress as well as representatives from AAA, AASHO, and various farm organizations.

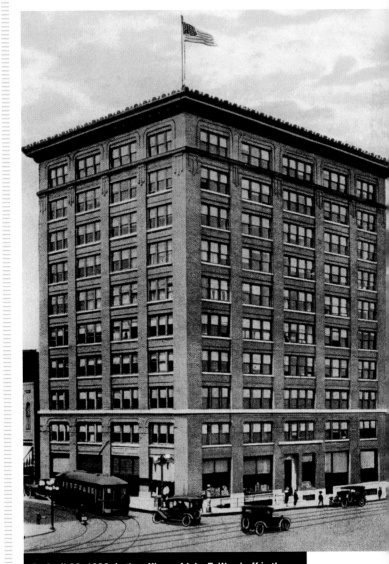

On April 30, 1926, in the offices of John T. Woodruff in the Woodruff Building, located at the northwest corner of St. Louis Street and Jefferson Avenue, in Springfield, Missouri, the number sixty-six was reportedly first proposed for the new U.S. highway connecting Chicago with Los Angeles. *Joe Sonderman*

From its inception, the Federal Aid Road Act had national defense implications with regard to the need for a modern road system. The military convoy of 1919 that required two months to travel from Washington, D.C., to San Francisco, California, magnified the importance of this road system and provided added incentive for congress to act.

An amendment in 1921, the Federal Aid Highway Act of 1921 (also known as the Phipps Act), clarified numerous aspects of the act and allowed the federal government to identify roads for inclusion in the federal aid highway system. This survey, under direction of General John Pershing, completed in late 1923, and appointment of a Joint Board on Interstate Highways to develop a system of uniform signage for the proposed highway system by Secretary of Agriculture Howard M. Gore, at the behest of AASHO, represented the first major challenge to the named trails system of highways. After completion of the survey, provision of monies to the states on a 50-50 basis to transform these roads into all-weather highways became available.

During meetings in April and August of 1925, coupled with numerous regional meetings, a proposal to identify the road network as U.S. highways with numerical designations on U.S. shields received approval. Immediately, numerous road associations initiated intense lobbying efforts to ensure that named trails received a single number for each route, leaving them intact.

The Joint Board instead chose to utilize numbers ending in zero for transcontinental, or major, east–west, alignments and odd numbers for the north-south routes. Additionally, there was a decision to use low numbers for northern routes with increasing numerical values placed on highways south from the northern border.

This also created issues as states vied for specific numbers, and some routes, such as the proposed route from Chicago to Los Angeles, ran north and south as well as east and west. Compromises of designation of routes— such as U.S. 60 in Kentucky, with north or east designators, and the proposal of marking the Chicago–Los Angeles route as 62—were the subject of heated debates for months.

By early spring of 1926, only the numbering of two routes remained unresolved. On April 30, 1926, Cyrus Avery and B. H. Piepmeier, both members of the numbering subcommittee, met in Springfield, Missouri, in the offices of John Woodruff in the Woodruff Building to discuss various highway-related issues, including the ongoing controversy over highway numbering.

During evaluation of maps that illustrated the proposed U.S. highway system, Avery's chief highway engineer, John Page, noted that number 66 had yet to be selected. After further discussion, Avery sent a brief telegram to Macdonald noting that, in regards to the Chicago–Los Angeles route, "we prefer sixty six to sixty two."

This simple proposal cleared the way for the state of Kentucky, led by Governor William J. Fields—previously insistent that U.S. 60 follow the National Roosevelt Midland Trail through the state, a route designated as U.S. 52, 62, and 150 with the new system—to be placated. On November 11, 1926, AASHO approved the national numbered system proposed as well as the unified system of signage.

Various amendments and riders added to the act in the next few years as the program developed and highway construction commenced reflected efforts to keep pace with the escalating evolution of automotive-related infrastructure needs. The dramatic increase in national traffic flow—coupled with the German development of a high-speed, limited-access highway system and the perceived need for improved roads to expedite military transport in cases of national emergency—led the administration of President Franklin Roosevelt to initiate studies for the construction of a toll-based superhighway system linking major population and industrial centers.

These studies culminated with the Federal Aid Highway Act of 1938 that guided the director for the Bureau of Public Roads to create a study for the construction of six routes that would compose a national limited-access, toll road system. On April 27, 1939, President Roosevelt submitted the report to congress that recommended a "special system of direct interregional highways, with all necessary connections through and around cities, designed to meet the requirements of the national defense and the needs of a growing peacetime traffic of longer range."

On April 14, 1941, the president appointed a committee to devise the initial routes. The ideal behind the project was to create a national highway system that would accommodate projected traffic patterns in 1961.

With passage of the Federal Aid Highway Act of 1944, and the Federal Aid Highway Act of 1952, the foundations for completion of the interstate highway system attributed to President Dwight Eisenhower were completed. Shortly before Eisenhower took office in January of 1953, a federal study concluded that only 24 percent of the U.S. highway system was adequate for current traffic conditions and that less than 2 percent met the original criteria for the projected needs of 1961.

With passage of the National Interstate and Defense Highways Act (the official title of the Federal Aid Highway Act of 1956), construction of the interstate highway system became a priority. Additionally, the act introduced a uniform standard of design and engineering for the construction of the interstate highway system.

Eisenhower later noted that passage of this bill, more than any single action of the federal government since World War II, resulted in the most dramatic change to the face of America. With regard to Route 66, the resulting changes would culminate with its complete replacement on October 13, 1984, when Williams, Arizona, became the last community on that highway bypassed by the interstate highway system. On June 26, 1985, AASHTO eliminated U.S. 66 from the log of U.S highways.

FENNER, CALIFORNIA

Fenner began as one of the alphabetical series of water stops and sidings for the Santa Fe Railroad in 1883. With establishment of the Arrowhead Highway and the National Old Trails Highway, a small service industry developed.

A 1914 guidebook to highways in the California desert contains a simple notation about Fenner: "Oil-Gas." This small oasis is unique in that it remains as it was in 1914, an island oasis in a sea of desert, albeit with a modern truck stop and travel plaza rather that a tin-roofed shanty with visible register pumps.

This modern facility is located where the pre-1931 alignment of Route 66 intersects with Interstate 40. Traces of the original complex were erased with completion of the modern facility.

FENTON, MISSOURI

William Lindsay Long, an English immigrant, established Fenton, Missouri, on the west bank of the Meramec River in St. Louis County in 1819. He selected the name based on his mother's claims of being a descendant of the Earl of Fenton. It remained a small rural community well into the 1950s, but with the annexation of property utilized as the site for a new Chrysler Corporation manufacturing plant that opened in 1959 along Route 66, the population and development surged.

Completion of a second facility for the production of light to medium-duty trucks immediately to the north further fueled economic growth in Fenton and the surrounding area. Closure of the original plant in 2008, and the north facility in 2009, devastated the local economy.

FIGUEROA STREET TUNNELS

The construction of the Figueroa Street Tunnels, an engineering marvel at the time, connected Figueroa Street with downtown Los Angeles and provided a key component in the evolving need for consistent traffic flow with limited-access highways. Completion of three of the four tunnels occurred in 1931, the fourth in 1935, and in 1936 this segment—officially dedicated in June 1936—received designation as Route 66.

In 1942, the increasing volume of traffic necessitated alteration of the traffic flow through the tunnels from two-way traffic to one-way, northbound traffic only. The listing of the Figueroa Street Tunnels as a National Scenic Byway provides them with a unique urban designation.

FLAGSTAFF, ARIZONA

Leroux and San Francisco springs at the site of modern Flagstaff provided an important camp for explorers and the crews of the Army Corps of Topographical Engineers commissioned by Secretary of War Jefferson Davis to survey the route of a possible transcontinental railroad along the thirty-fifth parallel in the early 1850s. The survey expeditions led by Captain Lorenzo Sitgreaves (1851), Lieutenant Amiel Whipple (1853), Lieutenant Joseph Ives (1858), and Lieutenant Edward Beale (1858) all utilized the springs.

Initial colonization at the springs commenced in the early summer of 1876 with the arrival of a contingent of fifty pioneers from Boston inspired by a book written by Samuel Cozzens, *Marvelous Country.* A town site platted near Leroux Springs served as the primary area of development, but abandonment occurred shortly after as the settlers determined the area was not suitable for farming.

In July, a second party arrived from Boston and commenced development of the site. According to legend, on July 4, 1876, these pioneers removed the limbs from a pine tree to utilize it as a flagstaff, leading to the community's current name.

Shortly after this date, the settlement was again abandoned, and only Thomas F. McMillan, with a cabin and corral at Antelope Spring near Mars Hill, remained. As a result of this, and the fact that he served as the first postmaster, McMillan is accredited as the first permanent resident.

With completion of the railroad to this point in 1881, a station built west of the springs became the focal development for the community. (As a footnote, McMillan built a large two-story cabin in the mid-1880s as the headquarters for the Flagstaff Ranch that the Museum of Northern Arizona utilizes for its staff at this time.)

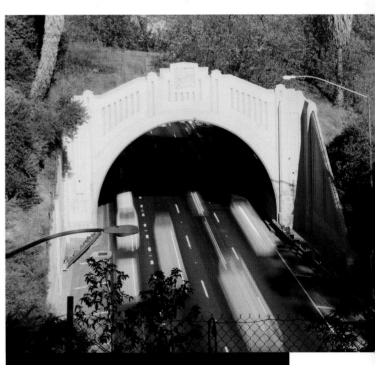

The official dedication for the Figueroa Street Tunnels occurred in 1936, the same year that Route 66 was rerouted to utilize them.

FLAGSTAFF, ARIZONA *continued*

By 1886, Flagstaff was the largest community on the main line of the Atlantic & Pacific Railroad between Albuquerque and the Pacific coast. Cattle, lumber, and tourism resulting from the community's proximity to the Grand Canyon continued to be the primary foundational elements of the economy well in to the early twentieth century.

(As another historic footnote, in 1911, Jesse Laskey and Cecil B. DeMille were scouting for a suitable location to relocate their New York City–based film studio. Initially, Flagstaff became their primary choice. However, an ice storm followed by heavy snow led to the selection of a site in southern California.)

The National Old Trails Highway, later Route 66, spurred development of the tourism industry and its related infrastructure. To a degree, the AAA directories serve as mileposts in this development.

The *Hotel, Garage, Service Station, and AAA Directory* for 1927 lists the Weatherford Hotel as recommended lodging. The *Directory of Motor Courts and Cottages* for 1940 lists five recommended facilities: Arrowhead Lodge, Du Beau's Motel Inn, Knox Motor Court, El Pueblo Motor Court, and Flagstaff Motor Village. For repairs, the only listing is Cheshire Motors.

The *Western Accommodations Directory* for 1955 indicates a dramatic increase in tourism-related business. The list of recommended lodging includes the Hotel Monte Vista, Amber Sky Motel, Arizonan Motel, Ben Franklin Motel, Du Beau's Motor Inn, El Rancho Hotel Courts, L Motel, Nackard Inn Motel, Park Plaza Motel, Vandevier Lodge, and Western Hills Motel.

The guidebook by Jack Rittenhouse published in 1946 expounds on this. His entry notes the Flagstaff Motor Village, Rock Plaza, Vandevier Lodge, Nickerson's, Mac's, Motor Inn, Cactus Gardens, Dixon, and Sunset. A surprising number of these postwar facilities still exist, as do a few from the prewar era.

Flagstaff remains a popular tourism destination. The resurgent interest in Route 66 is rapidly becoming a key component in this segment of the economy. Related landmarks of note include the

Since the death of Rex E. Goble in 1941, Goble's Auto Court has operated under numerous names—Arrowhead Lodge, Gaslite Motel, Twilite Motel, and, as of 2011, Arrowhead Lodge and Apartments. *Mike Ward*

Museum Club, built in 1931, the Pueblo and Western Hills Motels with functioning vintage neon, the Hotel Monte Vista and Hotel Virdon just north of Route 66, and the Downtowner. The *Route 66 Dining & Lodging Guide*, fifteenth edition, published by the National Historic Route 66 Federation lists a number of historic properties as recommended lodging, including the Weatherford Hotel (1897), Hotel Monte Vista (1927), and Dubeau Route 66 International Hostel, formerly Du Beau's Motel Inn (1929).

Of particular significance is Granny's Closet, formerly the Lumberjack Café, where the first of the large fiberglass muffler men statues manufactured by International Fiberglass stood in lumberjack guise. The statue now stands at the Walkup Skydome at Northern Arizona University in Flagstaff. These statues became a mainstay of roadside promotion, and though each featured different garb or accessories grasped in a one-palm-up and one-palm-down manner, the same company manufactured them all. Promotional statues manufactured by this company that appear on Route 66 include the Gemini Giant in Wilmington, Illinois, and the Bunyan giant with hot dog in Atlanta, Illinois, relocated from Berwyn, Illinois.

The Flagstaff lumberjack also inspired a book entitled *One Palm Up, One Palm Down*, written in 2009 by Gabriel Aldaz, which documents the history of these statues in various configurations and the company that built them. Aldaz also traces the relocation of several along Route 66, and their subsequent alterations.

A tangible link that bridged the era of Route 66 circa 1933 and the preterritorial era is the Commercial Hotel (center right). Novelist Zane Grey was a regular guest. The building burned in 1975. *Joe Sonderman*

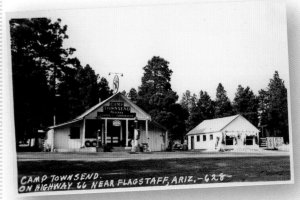

Camp Townsend, on the pre-1947 alignment of Route 66, was located between Flagstaff and Winona at the junction of U.S. 66 and U.S. 89. *Steve Rider*

FLAMINGO MOTOR HOTEL

Flamingo Hotels, an early motel chain in the Southwest, built the Flamingo Motor Hotel at 602 West Highway 66 in Flagstaff, Arizona, in 1954. With the sale of the property in 1959, it became a Ramada Inn. As of late 2010, it remained operational as a Super 8 motel.

FLORISSANT, MISSOURI

Florissant, Missouri, in North St. Louis County, has its origins in a small community of French pioneers who christened this area Un Valle Fleurissant, or Valley of the Flowers. Spanish settlers changed the name to St. Ferdinand, a name utilized by the state of Missouri and the state's highway department, even though area residents often called it Florissant. In 1939, however, official recognition of the Florrisant name occurred. The St. Ferdinand association still exists with the St. Ferdinand Shrine, a church established in 1821.

The city's attempt to annex the Ford Motor Company plant that had opened in 1948 resulted in the founding of Hazelwood in 1949. This factory closed in 2006.

FONTANA, CALIFORNIA

The initial town site platted by the Semi-Tropic Land and Water Company in 1887 failed to attract prospective property owners as envisioned, and as a result, abandonment soon followed. In about 1903, the Fontana Development Company purchased the property and the platting of a new town site under the name Rosena commenced in 1905. The name change to Fontana occurred in 1913. The town remained an agricultural community at the center of vast orange orchards until the late postwar era.

Looking East on Foothill Blvd. at Sierra Way Fontana 1943

Fifteen years before this photo was taken in 1944, this segment of Route 66 was lined with palm trees and orchards. *Steve Rider*

The Fontana Motor Court is the only recommended lodging noted in the 1940 *Directory of Motor Courts and Cottages* issued by AAA. The Redwing Motel, 1100 West Foothill Boulevard, is the only lodging listed in the *AAA Western Accommodations Directory* for 1954–55. Attractions of note include Bono's Historic Orange, one of the last thematic orange stands that once lined the highway in this area. Bono's Restaurant, at 15395 Foothill Boulevard and dating to 1935, would be another.

FORMOSA CAFÉ

The Formosa Café located at 7156 Santa Monica Boulevard in Hollywood, California, evolved from a small restaurant, the Red Post, housed in a former trolley car. Jimmy Bernstein, a prizefighter, opened the eatery in 1925. Expansion of the property occurred in direct correlation to the increase in business resulting from its location across from United Artist Studios and the traffic that increased when Route 66 was realigned in 1936.

In its current configuration, it appears as it did in the late 1940s. The fifteenth edition of *Route 66 Dining & Lodging Guide*, published in 2011 by the National Route 66 Federation, listed the restaurant as a "must stop."

FORT LEONARD WOOD

The groundbreaking ceremony for Fort Leonard Wood—named in honor of Major General Leonard E. Wood who fought in campaigns against Geronimo in the territory of Arizona and in the Spanish–American War, and served as chief of staff for the U.S. Army from 1910 to 1914—occurred on December 3, 1940. Construction of the camp, coupled with projected utilization of the facility and President Roosevelt's mandate to improve major roadways to meet the requirements of the envisioned traffic of 1960, resulted in numerous changes to Route 66 in the immediate area.

The roadside at the entrance to Fort Leonard Wood, an area originally known as Gospel Ridge, became a boomtown of service stations, cafés, and motels after completion of the complex. *Joe Sonderman*

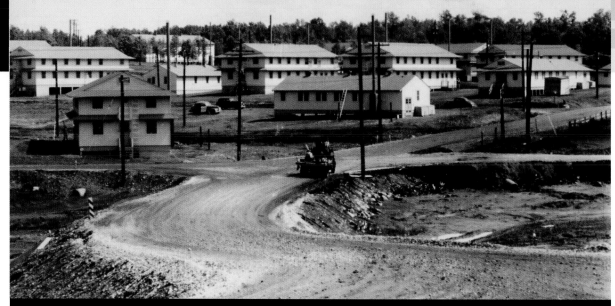

Since 1940, more than three million people have trained at Fort Leonard Wood, named for Leonard Wood, a Congressional Medal of Honor recipient and former U.S. Army chief of staff. *Joe Sonderman*

FORT LEONARD WOOD *continued*

This included the elimination of the bottleneck at Devil's Elbow with Hooker's Cut and the construction of a four-lane bridge over the Big Piney River in 1943 that now carries traffic for State Highway Z. Portions of this four-lane transition were later incorporated into Interstate 44.

The fort remained operational from 1941 to 1946. Reactivation occurred in August 1950. As of 2011, it remained an active military facility.

FORT RENO, OKLAHOMA

Major General Jesse L. Reno, killed at the battle of Antietam during the American Civil War, is the namesake for Fort Reno. Established in the summer of 1875 to protect the Darlington Indian Agency during the Cheyenne uprising that commenced in 1874, this military post served various functions through 1949. It had a brief period of closure in 1908. During World War II, the base served as a prisoner of war camp. The incarcerated included German and Italian soldiers captured during battles in North Africa and Sicily.

Postal service commenced in February 1877 and culminated with the post office closure in May 1907. A visitor center remains on site.

FOSS, OKLAHOMA

The first manifestation of Foss (named for J. M. Foss, former postmaster in Cordell, Oklahoma), on Turkey Creek north of the present site, vanished with a flood on May 2, 1902. Relocating to higher ground, the residents rebuilt the town at the heart of a vast area of rich farmland.

By 1912, Foss was a prosperous and substantial community of stone-constructed buildings with a business district that included two banks, cotton gins, several general merchandise stores, a newspaper, a wagon works, a machine shop, drug stores, a bakery, a broom factory, and an opera house. At its peak, the population purportedly was near one thousand residents.

The development of nearby Clinton and Elk City as rail and supply centers was the first blow to the town's economic stability. By 1920, the population plummeted to 348. Providing services to motorists on Route 66 partially stemmed the decline, but this was a short-lived reprieve as collapsing agricultural prices and the drought that fueled the Dust Bowl spurred an exodus.

Notes by Jack Rittenhouse, published in his 1946 guidebook, are brief, indicating a garage, café, and gas station at the junction. These businesses are no longer in operation.

For a brief moment in the early 1950s, with the establishment of an air force facility at nearby Burns Flat, it appeared Foss might experience a renaissance. However, the closure of the

The residents who call Foss, Oklahoma, home steadfastly deny it is a ghost town, even though ruins and broken sidewalks stand in silent testimony to livelier times.

108

base and the bypass of Route 66 by I-40 sent the old town into a downward spiral, and in 1977, the last bank closed.

Ruins, foundations in the brush, and broken sidewalks indicate that Foss was a larger, more prosperous community than it is today. However, there are a few surviving structures and a handful of residents who steadfastly deny that Foss is a ghost town.

Immediately south of Foss and I-40 is a graded gravel series of farm roads running east to west that were utilized initially as the postal road and the Ozark Trails Highway System. These roads served as the alignment of Route 66 from 1926 to 1931.

FOX CREEK, MISSOURI

Located at the headwaters of Wild Horse Creek, this settlement derived its name from the nearby Fox Creek. A post office operated here from 1833 to 1904. Fox Creek was located along the pre-1932 alignment of Route 66, now State Highway 100. The primary service available to motorists was the Fox Creek Garage that opened in 1922 as a Ford dealership. Recent modernization of this highway erased most surviving remnants of the community.

FOYIL, OKLAHOMA

Establishment of a post office here dates to June 5, 1890. The namesake for the community is Alfred Foyil, the first postmaster.

The advent of Route 66 did little to transform the small agricultural community. A 1946 guidebook lists services as a gas station, two garages, and a grocery store. However, Foyil has two notable associations with Route 66. It is the hometown of Andy Payne, winner of the 1928 First Annual International Trans-Continental Footrace, dubbed the Bunion Derby by the press. The main street (Route 66) in Foyil carries a sign designating it

Totem Pole Park near Foyil, Oklahoma, is the creation of Ed Galloway, a master wood carver and industrial arts teacher who built the totem pole and various park features like picnic tables, as well as carved more than four hundred fiddles. *Steve Rider*

as Andy Payne Boulevard. Found in a small park at the west end of town is a statue to Payne and at the east end is a historical marker commemorating the "Bunnion Derby."

The second landmark of note is located four miles east of town on State Highway 28A. Ed Galloway's Totem Pole Park, built between 1937 and 1961, remains one of the largest existing examples of folk art associated with Route 66. The centerpiece of the park is the ninety-foot-tall main totem pole made of red sandstone, framed with steel and wood, and a concrete skin mounted on a large turtle that took eleven years to complete. Galloway used the totem pole theme for the creation of picnic tables, gateposts, and a fireplace that doubled as a barbeque. His artistry also manifested in other aspects, such as the fish gate.

The creator, Nathan Edward Galloway, was a proficient blacksmith and woodworker who retired to this property in 1937. In addition to the totem poles, Galloway produced quality violins, decorative wall art, and various types of furniture. Today, the park also contains numerous examples of his work and a museum displaying his woodworking skills. After decades of abandonment, the Rogers County Historical Society in conjunction with the Kansas Grassroots Arts Association refurbished the monuments and grounds between 1988 and 1998.

In tiny Foyil, Oklahoma, Andy Payne, the winner of the 1928 "Bunion Derby," is the town's favorite son, as evidenced by this statue in this park along Andy Payne Boulevard. *Steve Rider*

Founded in 1933 by John Frank, Frankoma Pottery operated along Route 66 in Sapulpa, Oklahoma as a family-run business from 1938 to 1991 and closed in 2011. *Steve Rider*

FRANKOMA POTTERY

Upon graduation from the Chicago Art Institute in 1927, John Frank accepted a position at the University of Oklahoma to establish that school's first ceramic art department. However, Frank envisioned the creation of a commercial pottery studio that produced fine art ware at modest prices. In 1933, he established Frankoma Pottery, utilizing his last name and the last three letters in Oklahoma to derive the title. In 1938, he and his wife Grace Lee relocated the business to Sapulpa, Oklahoma.

In less than a year, the fledging company suffered a major setback as fire devastated the building and the master molds. By 1942, the year the company introduced a distinctive line of Southwestern dinnerware, Frankoma Pottery began garnering acclaim for its innovative design and use of color. In 1954, the Franks commissioned Bruce Goff, an architect of renown, to design a house for them. The construction utilized colorful ceramic bricks of Frank's design.

The Franks espoused deeply held Christian convictions that manifested in generous donations to service organizations, churches, people in need (including travelers on Route 66), and young adults for the furtherance of their education. In 1971, John Frank was selected outstanding small businessman in Oklahoma, and later, outstanding small businessman in America.

Upon the death of John Frank in 1973, his daughter, Joniece, an accomplished artist in her own right, assumed the role of president and CEO of Frankoma Pottery. In 1983, the company's most profitable year, a fire destroyed the property, but Joniece rebuilt and continued to operate until 1991. In that year, Richard Bernstein purchased the struggling company and maintained ownership until 2005 when he sold it to Det Merryman. In 2008, Joe Ragosta bought it.

After more than a year of closure, the remaining inventory, fixtures, and equipment sold at auction on May 18, 2011. The 1,800 molds, the Frankoma name, and the real estate were not included in the sale.

FRED HARVEY COMPANY

The cornerstone for the Fred Harvey Company was the establishment of two small restaurants in Wallace, Kansas, and Hugo, Colorado, to serve employees and passengers with the Kansas Pacific Railway in 1875. The arrangement between Fred Harvey and the railroad terminated within twelve months, but this was adequate time for Harvey to determine that there was profit in providing quality service and food at railroad stops, since the inclusion of dining cars with passenger trains was not a standardized offering.

His first proposal to provide these services to the Chicago, Burlington & Quincy Railroad—a company that Harvey had served as freight agent for—was met with rejection, but his second, submitted to the Atchison, Topeka & Santa Fe Railroad, was approved on a limited test basis. In 1876, the first restaurant opened in Topeka, Kansas, and in 1878, Harvey established the first restaurant/hotel at the railroad stop in Florence, Kansas.

Harvey's strict standards of quality in food and service proved popular with passengers. Subsequently, management of the railroad saw the potential for profit in extending the association with Harvey. By 1890, there was an eating house at almost every stop along the railroad's route and a hotel/restaurant combination at key locations. Among the many innovations introduced by Harvey were blue-plate specials, a low-priced meal served on blue-patterned china, and the exclusive hiring of female waitresses, known as the Harvey Girls.

The establishment of Harvey House facilities at other locations made this the first restaurant chain in the United States. Additionally, Fred Harvey became a pioneer in the promotion of tourism in the Southwest, and the Harvey Houses were a primary factor in the decision to route the National Old Trails Highway across northern Arizona rather than along the path of the Trail to Sunset between Santa Fe and Yuma.

Early travelers on the National Old Trails Highway, and Route 66, across Arizona, New Mexico, and California benefited from Harvey House restaurants and or hotels. These facilities were available in Santa Fe, Albuquerque, Gallup, Holbrook, Winslow, Flagstaff, Williams, Ash Fork, Seligman, Kingman, Needles, Baghdad, Barstow, and Los Angeles.

Of these, only the La Fonda, Santa Fe; La Posada, Winslow; and Fray Marcos in Williams remain operational as hotels. El Garces in Needles is currently under renovation, and the Casita Del Desierto in Barstow houses two museums as well as city offices. The others have been demolished.

FRONTIER MOTEL AND CAFÉ

The Frontier Motel and Café, in Truxton, Arizona, opened in 1952 and closed in 2012. In *Route 66: The Mother Road*, a book credited with igniting the modern resurgent interest in Route 66, author Michael Wallis said of the Frontier Café, "Ray, Mildred, and

their daughter Sue, keep the Frontier Café going by turning out some of the finest meals on the highway. From steak and veal cutlets to burgers and home fries, the food at the Frontier lives up to its reputation."

It is that reputation that has kept the old café going strong. Both facilities remain in operation, and the food—as well as refurbishment of the landmark sign, made possible with funds from the Route 66 Association of Arizona and grants from the Route 66 Corridor Management Program—gives the property a time capsule feel.

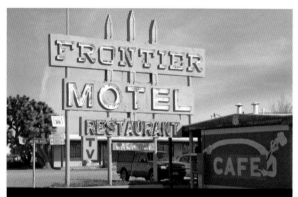

Alice Wright opened the Frontier Café and nine-unit Frontier Motel in Truxton, Arizona, in 1952. In 1955, Mildred Barker went to work in the café, and in 1970, she and her husband Raymond purchased the complex.

FRONTIER CITY, U.S.A.

Before the creation of Frontier City, U.S.A., near Oklahoma City, Jimmy Burge developed the skills needed to make it a success in California. His career in the entertainment industry began with the position of usher at the Criterion Theater in Oklahoma City. After relocating to California, he went to work as a press agent for Joan Crawford and Robert Taylor at MGM. His acceptance as manager of the municipal auditorium marked his return to Oklahoma City. In 1957, he assumed the director's position for the state of Oklahoma's semicentennial celebration.

Utilizing skills learned in studying Walt Disney's approach to the creation of Disneyland, and Walter Knott's park, Knott's Berry Farm, Burge oversaw construction of a key component in the celebration, a 1907-era Oklahoma boomtown. After closure of the fair, Burge acquired numerous components of the boomtown with the goal of creating an amusement park.

With four investors, Burge acquired properties along the westbound lanes of U.S. 66. Enlisting the aid of Russell Pearson, a designer with the semicentennial project, Burge initiated plans and construction for Frontier City, U.S.A.

The business model envisioned by Burge was unique. Frontier City, U.S.A. would be a corporation. There would be no charge for park admission; the primary revenue stream would be from businesses that opened subsidiaries in the park, as it was to be a city unto itself.

With the acceptance of R. F. "Jack" Williams, an owner of an Oklahoma City laundry chain, as partner, the project moved quickly from planning to reality. Williams would handle the linen concession at Frontier City, U.S.A., in a facility designed to appear as a frontier-era Chinese laundry.

On May 30, 1958, with tremendous fanfare and publicity, Frontier City, U.S.A. opened to the public. The ceremony commenced with Governor Raymond Gary shooting the rope across the entrance deigned as a stockade gate. The Oklahoma City mayor and select councilmen arrived via covered wagon.

The park had its own zip code with special postmark, newspaper, fire department, and a police force consisting of deputy and marshal. An Episcopal church provided regular services, and Frontier City, U.S.A. money featured the face of R. F. Williams.

During its first year, the park provided entertainment to 1.3 million people. This spurred an $800,000 expansion that included an additional twenty-six rides and numerous concessions.

Burge also transformed a failed investment into an opportunity that, at first, seemed oddly out of place at Frontier City, U.S.A. The investment was funding for creation of a vehicle that could fly to the moon. The only tangible asset derived from this was a large flying saucer that became the center of one of the parks most popular and profitable attractions.

In 1960, the year Burge sold his stock to Allen Dean of Ardmore, Oklahoma, the park garnered designation as one of the most photographed places in America. The park continued to prosper into the mid-1960s, in part because of abandonment of the original business model and the initiation of an admission fee.

A fire destroyed the OK Gunfight Corral and a large portion of Front Street. In 1968, the corporation declared bankruptcy and the Small Business Administration administered the sale of the property to Abe and Howard Slusky of Omaha, Nebraska.

During the next forty-eight months, an additional thirteen rides were added as well as arts and crafts displays, a picnic area, and a catering service. A 30 percent increase in ticket sales during the 1971 and 1972 seasons was indicative of a turnaround at the park. In 1975, another fire destroyed numerous rides and buildings. Many tenants, including Jack Williams, abandoned their business interests in the park.

In 1981, a property development corporation, the Tierco Group, acquired the property for a purported sale price of $1.2 million with the goal of utilizing the site for an office complex. A major recession in commercial real estate prevented the project from coming to fruition.

In 1983, Gary Story, who had successfully managed an amusement park in Sidney, Australia, moved to reopen and revitalize the park. After careful evaluation, the decision was made to blend the original low-tech concept with a modern high-tech one, including the contracting of West Texas Productions to manage the gunfights.

FRONTIER CITY, U.S.A. *continued*

The first roller coaster installation occurred in 1986, and in 1991, the second, a vintage coaster acquired from the former Fairyland Park in Kansas City, was put in. The formula proved to be correct, and the park remains a major attraction in the Oklahoma City area.

FUNKS GROVE, ILLINOIS

This natural stand of maple trees south of Bloomington is named for Isaac Funk, pioneering rancher, state representative, and Illinois state senator in the 1840s. After 1891, maple sirup, as those in Funks Grove spell it, became a mainstay of the family business.

The small community that developed here was never really a town but more a collection of service-related businesses that met the needs of travelers on Route 66 and provided residences for some workers. Jack Rittenhouse in 1946 indicated the population was forty-six.

Today, the roadside businesses noted by Rittenhouse are shuttered, but the Funk family still sells sirup and Route 66 items

The Funk family settled on this site in 1824, and in 1891, Arthur Funk initiated commercial production of maple sirup and related products.

from a small store. Nearby, accessed via Funk Grove Road, is the store made note of by Rittenhouse, and an old railroad depot relocated from the village of Shirley. The road continues a short distance to the Sugar Grove Nature Center, an historic shade-dappled cemetery, and the Funk's Grove church, built in 1845.

The old Funks Grove store (just off Route 66), the historic depot relocated from nearby Shirley, and the nature preserve that surrounds them are favorite stops for Route 66 enthusiasts.

G

GALAXY DINER

Located at 931 West Route 66 in Flagstaff, Arizona, the Galaxy Diner opened in 1952. As of 2011, it remained a near perfect time capsule of the local diner eclipsed by chain restaurants and franchises beginning in the late 1950s.

GALENA, KANSAS

The name for the community indicates the type of ore that spurred expansive development of mines in the tri-state area of Oklahoma, Kansas, and Missouri. (Galena is the primary ore mineral of lead.) During the World War I period, these mines were among the largest producers of lead and zinc in the world.

From the teens through the immediate postwar years of the 1940s, Galena remained a prosperous community with a population that neared fifteen thousand. The closure of the mines and the replacement of Route 66 with Interstate 44 that resulted in Kansas being the only state associated with Route 66 completely bypassed resulted in a downward spiral for Galena. In the census of 2000, the population was listed as less than four thousand.

Just to the east of Galena is the site of the Eagle Picher Company, a smelter that was the focus of one of the most violent labor disputes during the 1930s. In 1935, John L. Lewis, president of the United Mine Workers, called a labor strike against this facility, and the company responded by bringing in nonunion workers from Missouri, Kansas, and Oklahoma via

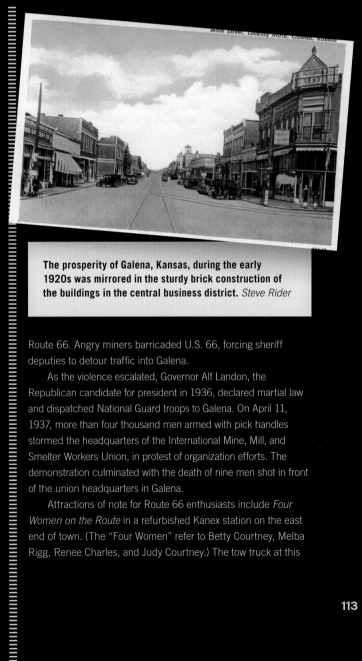

The prosperity of Galena, Kansas, during the early 1920s was mirrored in the sturdy brick construction of the buildings in the central business district. *Steve Rider*

Route 66. Angry miners barricaded U.S. 66, forcing sheriff deputies to detour traffic into Galena.

As the violence escalated, Governor Alf Landon, the Republican candidate for president in 1936, declared martial law and dispatched National Guard troops to Galena. On April 11, 1937, more than four thousand men armed with pick handles stormed the headquarters of the International Mine, Mill, and Smelter Workers Union, in protest of organization efforts. The demonstration culminated with the death of nine men shot in front of the union headquarters in Galena.

Attractions of note for Route 66 enthusiasts include *Four Women on the Route* in a refurbished Kanex station on the east end of town. (The "Four Women" refer to Betty Courtney, Melba Rigg, Renee Charles, and Judy Courtney.) The tow truck at this

Above: Four Women on the Route, with the battered old truck that served as the inspiration for the Tow Mater character in the animated film *Cars*, is one of the most popular attractions in Galena, Kansas.

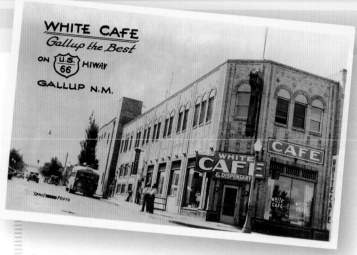

station served as the inspiration for the character Tow Mater in the 2006 animated film *Cars*.

Relocated to its present location on Seventh Street (Route 66) after its purchase by the city in 1978, the Katy depot that serves as the Galena Historical Museum originally sat near First Street. The museum is a primary attraction for visitors.

Galena, as the oldest mining town in Kansas, has a particularly interesting historic district, including the Main Street Deli built on the site of the Miners & Merchants Bank. The café used the last vestige of that business, the vault, as a pantry, and as of 2010, it still offered friendly service and good food.

Located on the corner of First Street and Railroad Avenue in Gallup, the White Café—established by Jimmy Blatsios in December of 1919—currently houses a Native American handicraft store. *Steve Rider*

GALLUP, NEW MEXICO

The namesake for this community is David Gallup, the auditor and paymaster for the Atlantic & Pacific Railroad in 1880. He later served as comptroller for the company in the New York City headquarters.

The railroad construction camp established on this site sparked expansion of the existing stage station to include a saloon and store. With the railroad, access to goods and services, as well as a lowered cost for shipping, fueled settlement in the area and growth of the camp, including the establishment of a post office in 1882.

The remote location made it an important service center for early motorists. As a result, the economic base for the community diversified from trading center for the Navajo and supply center for area ranchers to tourism in the first decades of the twentieth century.

The *Hotel, Garage, Service Station, and AAA Directory* for 1927 lists numerous facilities for repair and lodging, including El Navajo ($2.50 per night), Manhattan Café, and White Garage. Evidence of the important role Route 66 played in the development of tourism and travel-related businesses in Gallup are the listings in the *AAA Directory of Motor Courts and Cottages* for 1940. From an historical perspective, the most notable facility listed was Log Cabin Lodge.

From its inception, Route 66 was a transitional highway, evolving with the increase in traffic flow and improvements necessitated by natural disasters—such as the floods of July 1929, which resulted in dramatic ramifications for communities in western New Mexico. A notable aspect of the highway's evolution in Gallup was approval of the long-fought battle to have an early alignment of Route 66 designated Business 66 rather than Alternate 66 in September 1962.

(As an interesting historical footnote, this relatively remote community remained a primary target during the Cold War. A steeply slanted, rocky ridge known as the Hogback has a natural breech at the site of Gallup, a primary reason for the construction of the railroad as well as Route 66 across this section of New

Mexico. Additionally, during the mid-twentieth century major pipelines and communication lines also utilized this natural passage. As a result, the town of Gallup sat in the middle of a proverbial bull's eye during the period of confrontation between the United States and Soviet Union.)

Found in Gallup are numerous landmarks from the territorial period as well as the entire history of Route 66, including the Heller Building (1919), El Rancho Hotel (1937), El Morrow Theater, a mural by acclaimed artist Jerry McClanahan atop the chamber of commerce building, and the Blue Spruce Motel that dates to 1949.

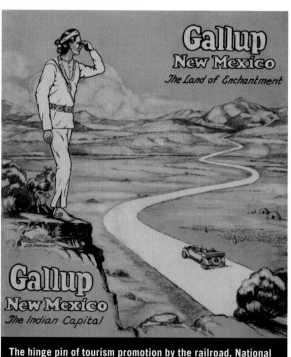

The hinge pin of tourism promotion by the railroad, National Old Trails Highway boosters, and various Route 66 associations in Gallup has been the community's association with the Navajo and Zuni tribes. *Steve Rider*

The Gacozark Café in Gascozark, Missouri, now abandoned, operated as a café, service station, and bus stop after 1939. In about 1952, new owners transformed it into the Spinning Wheel Tavern. *Steve Rider*

Other notable time capsules are Earl's Family Restaurant, the El Capitan Motel (1955), Arrowhead Lodge (1949), Lariat Lodge (1952), and Peter Kitchen's Opera House (1895).

There is also the Zia Motel, the White Café that reopened in the Heller Building in 1929 (now an American Indian art gallery), and the Colonial Motel (1956). Other vestiges of the influence Route 66 had on this community are the Ambassador Motel (opened in 1946 as the Ambassador Lodge) and the Desert Skies Motor Hotel (1959).

The Navajo Hotel, a Harvey House, was demolished in 1959, but the remaining sections of the complex that served as railroad administration offices now houses the Amtrak station, a cultural center, and Angela's Café. This café received favorable reviews in the *Route 66 Dining & Lodging Guide*, fifteenth edition, published by the National Historic Route 66 Federation in 2011.

GARDENWAY MOTEL

In late 1945, Louis B. Eckelkamp, co-owner of the Diamonds, built the Gardenway Motel at the western end of the Henry Shaw Gardenway segment of Route 66 in Gray Summit, Missouri. Since 1925, the Shaw Nature Preserve, originally the Shaw Arboretum—with 2,500 acres of trails, plant collections, and native Ozark flora—has ensured Gray Summit would be a destination, an additional reason Eckelkamp selected this location for his motel.

Built in a colonial style, featuring "Twenty Five modern cabins with tile baths," the property was expanded numerous times, culminating in a forty-one-unit complex. The motel remains a business as of this writing, and there are plans for renovation of its classic neon signage.

GARDNER, ILLINOIS

Platted in 1861 and named for John Gardner, one of three commissioners appointed to organize the county into townships, Gardner remained a community dependant on agriculture even after the commissioning of Route 66 in 1926. The 1946 publication *A Guide Book to Highway 66* noted, "There are gas stations and a café on US 66 at this intersection. This community now depends on the surrounding farms for its existence." The *AAA Service Station Directory* issued in the same year lists Hank's Garage. Given is a phone number but no address.

Until the summer of 2010, the primary attractions for Route 66 enthusiasts were the Riviera, a bar and restaurant that purportedly served as a speakeasy shortly after its construction in 1928, and the Street Car Diner, a diner built in a converted Kankakee street car after its relocation to Gardner in 1932. In the summer of 2010, fire destroyed the Riviera, and the diner, inducted into the Route 66 Hall of Fame in 2001, underwent refurbishment in 2011 after its relocation to a site next to the historic two-cell jail.

GASCOZARK

Frank Jones settled in the area of the Gasconade River, named in deference to the Gascony region of France, in the Ozark Mountains in the early 1920s. For reasons unknown, he combined the names to form Gascozark when establishing his café and service station on Route 66 in 1931.

Numerous additions made to the main building before Jones sold the property to Rudy and Clara Schuermann in about 1935 gave the business a patchwork appearance. In 1939, the new owners hired an itinerant stonemason to face the buildings to provide continuity to the structure and mask the disjointed appearance created by Jones's renovations.

During the 1940s, the establishment became a regular stop for the Greyhound bus line. An additional boost for business came with the establishment of the Spinning Wheel Tavern in 1952. Jack Rittenhouse noted in his guidebook published in 1946 that this was "a small community consisting of a store and two gas stations."

A precipitous decline in business during the early 1960s led to the sale of the property and its conversion into a private residence. As of late summer 2011, it remained vacant, heavily overgrown, and in a state of near collapse.

The distinctive rock-faced Gascozark Café, a bus stop in 1939 and the Spinning Wheel Tavern in the 1950s, is succumbing to the encroaching forest. *Steve Rider*

Caldwell's, later Caldwell-Salsman Truck Stop and Gascozark Trading Post, consisted of a small store, service station, café, and several cabins, of which three remain. *Joe Sonderman*

GATEWAY MOTEL

Postcard promotions noted that the Gateway Motel featured "clean units, all modern, four good restaurants within one half-block." Roy and Grace Gamble built the facility in 1936, in Williams, Arizona.

The motel, noted in the Route 66 guidebook published by Jack Rittenhouse in 1946, still exists. With renovation and conversion, the motel units now serve as an office complex, and as of late 2010, the former office served as a coffee shop.

GEARY, OKLAHOMA

Initial settlement in the area dates to the Cheyenne–Arapaho Opening of April 1892 that allowed for non-Indian occupation of lands. A town site company purchased land, approximately one and a half miles northwest of the present site, from Shubell Huff and his son, William, who had filed claims on the day of the opening.

The relocation of the community was the result of a railroad survey initiated by the Choctaw, Oklahoma, & Gulf Railroad that indicated the line to El Reno would bypass the town. The namesake for the community, with a post office established in 1892, was Edmund Charles F. C. Guerrir, who used the name Ed Geary.

By 1902, the population exceeded two thousand residents, and there was an extensive business district consisting of a dry goods store, bakeries, banks, saloons, lumberyards, and hardware stores. In addition to agriculture, the community also supported a flour mill, broom factory, cotton gin, and bottling company.

Officially, Geary was not on Route 66. However, it was on the postal road that also served as part of the Ozark Trails system, much of which became Route 66 from 1926 to 1933 and that followed a course immediately to the south of town.

Historian and author Jim Ross delicately noted the relationship between Route 66 and Geary in *Oklahoma Route 66*, published in 2001. "Although Route 66 never 'officially' passed through Geary's business district, the postal route did, and U.S. highway markers (whether authorized or not) may have been posted in a way that lured motorists right down Main Street."

GERONIMO TRADING POST

"Doc" Hatfield established the Geronimo Trading Post west of Holbrook, Arizona, in late 1949. He operated the property and made various upgrades until 1967 when the property sold to Carl Kempton.

The current trading post, built in 1974, remains as one of the few Route 66–era businesses in Arizona to have its own exit on the interstate highway. The primary promotional draw remains the "World's Largest Petrified Log" with an estimated weight of eighty-nine thousand pounds.

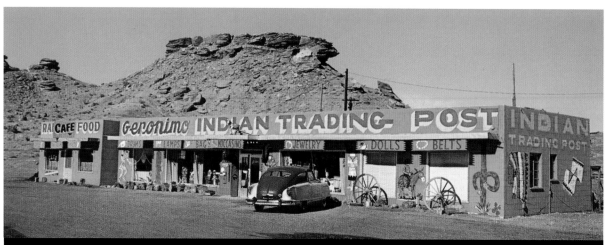

Established in 1950, the Geronimo Trading Post is unique among Route 66–era attractions, as it has survived into the modern era with its own exit off I-40. *Joe Sonderman*

GIDDINGS, JAMES

Hope and Harry Locke, owners of the property at the intersection of Route 66 and Meteor Crater Road (a place referred to as Meteor Junction), leased a small service station at this junction to James Giddings, known by the nickname of Rimmy Jim, in the mid-1920s. Giddings purchased the facility shortly after this date.

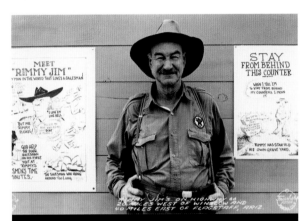

"Rimmy Jim" Giddings, arguably one of the more colorful characters along Route 66 in Arizona, leased Meteor Station in August of 1933 and proceeded to craft a unique roadside attraction. *Steve Rider*

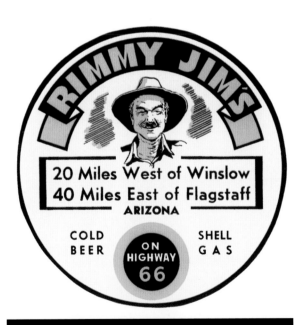

A rare and valued collector's item among Route 66 enthusiasts is this window decal for Rimmy Jims, an Arizona desert trading post that offered comedic relief with souvenirs and gas. *Steve Rider*

Giddings transformed the property into a small trading post that mirrored his colorful personality. Legend has it that intercoms were placed beneath the seats in the outhouse to startle travelers and signs hinting of a graveyard for salesmen to discourage peddlers were posted. On Thursday, June 24, 1943, Giddings—who was born on April 29, 1873, in Cleburne, Texas—died in Winslow, Arizona. The trading post remained operational with Ruth and Sid Griffin as proprietors until its closure as a result of the I-40 bypass of Route 66.

GILLESPIE, ILLINOIS

Located on the pre-1930 alignment of Route 66, the town of Gillespie was named for Joseph Gillespie, a jurist and Illinois state legislator, by vote of the board of directors for the Indianapolis & St. Louis Railroad. The community's origin dates to its platting in 1851 and the subsequent rectification of the erroneously filed post office application under the name Prairie Farm, which occurred in 1854.

Author John Weiss, in *Traveling the New, Historic Route 66 of Illinois*, published in 2010, said of Gillespie that it "has a friendly feel to it, nicely maintained, clean and pleasant."

GILLIOZ THEATER

M. E. Gillioz had planned for his theater to front the new federal highway designated U.S. 66 but was unable to find suitable property at a reasonable price on St. Louis Street in Springfield, Missouri. Instead, he purchased a site one block to the north and leased a frontage corridor on St. Louis Street that he linked to the theater.

Built in a Spanish Colonial Revival style, the theater was an architectural masterpiece that impressed the sold-out crowd on opening night, as well as attendees of the theater for decades after. The narrow façade featured terra cotta tiles with brick pilasters; a roofline that epitomized this architectural style; and a large, arched window above the marquee with the letter "G" in blue glass. Decorative touches in the lobby included extensive use of plaster friezes of flowers, birds, cherubs, and vines. The auditorium utilized a staggering array of medallions, wrought iron, columns, moldings, arches, and organ pipes. Since Maurice Earnest Gillioz was a pioneering builder and land developer in the area, the building's framework consisted of steel and concrete. Wood was reserved for door framing, handrails, and select trim.

Reportedly where Elvis Presley watched a film before his 1956 concert at the Abou Ben Adhem Shrine Mosque, the 1,100-seat theater closed in 1980. Evaluation of the property in 1990 determined its bridge-type construction would make demolition more costly than renovation. The Springfield Landmarks Preservation Trust restored the theater with attention to preservation of the historical attributes of the original theater design. It reopened in 2006.

GILMORE OIL COMPANY

It can be said with a degree of certainty that the Gilmore Oil Company, with corporate origins dating to late 1899, was a pioneer in the development and marketing of oil-based products for automotive application. It can also be said with equal certainty that by the mid-1920s this West Coast company, with its headquarters on East Twenty-Eighth Street in Los Angeles, California, dominated that market in the West.

In 1929, the company held more than two thousand acres of oil-producing properties under lease in California, operated four refineries, had partial interests in three others, and ran ten bulk plants distributing products through 875 independent dealers in California, Washington, and Oregon. Additionally, the company sold products in China and New Zealand, and it manufactured the asphalt sold to contractors paving Route 66 in western Arizona. By 1933, the company had expanded to include fifty bulk-distributing plants in three states that sold products through 3,500 independent dealers.

A great deal of this success was due to the creative, imaginative, and visionary promotional and marketing genius of Earl B. Gilmore, the company president. Beginning in the early 1920s, Gilmore began sponsoring all manner of races from airplanes to boats, cars, and motorcycles. In 1932, Gilmore sponsored its first cars at the Indianapolis 500 and, in the same period, built Gilmore Stadium in West Hollywood. He created the Gilmore Fun Circus and a radio program, and he devised a wide array of giveaways, including comic books, the Gilmore Club newspaper that featured the latest in racing news, candy lollipops in the shape of the Gilmore lion, and dishes.

There were exhibits that traveled to stations with lions, clowns, and the Gilmore Mystery Car, a special-bodied speedster. There was also a groundbreaking program, initiated in the 1920s, where company representatives visited each independent station on a monthly basis to recommend ideas for improving business, to provide the latest in company advertising and promotional material, and to ensure the facilities were clean and orderly.

Each year during the 1930s, Gilmore sponsored the Gilmore Grand Canyon Mileage Run, which departed from Gilmore stadium, picked up Route 66 in Los Angeles, and followed that highway to Flagstaff. There was also the Gilmore Economy Run to Yosemite National Park.

By 1940, through various manipulations, Socony-Vacuum Oil Company, Inc. acquired more than 75 percent of Gilmore Oil Company Stock, and Gilmore became a subsidiary under the trade name Mobiloil. In 1945, the Gilmore Oil Company merged with General Petroleum Corporation, a subsidiary of Socony-Vacuum Oil Company, Inc. since 1926.

Pieces of memorabilia in the form of the giveaways, racing programs, and petrolania are now highly sought-after commodities. A re-created Gilmore Station, with rare clock face pumps, stands at the entrance of the Farmer's Market in Los Angeles on Fairfax Avenue several blocks south of Santa Monica Boulevard (Route 66).

GIRARD, ILLINOIS

Initial platting of this town site by Barnaba Bogess and Charles Fink occurred in about 1852. Since the catalyst for the survey was establishment of a siding for the Chicago & North Western Railroad, it is assumed that the namesake for the community was Stephen Girard, a substantial stockholder in this railroad. A secondary assertion is that the name is in reference to Girard's Mills, which purportedly operated near this site in about 1830. The post office that opened in the summer of 1848 did so under the name Pleasant Grove, but an amendment changed this to Girard in 1885.

The community's association with Route 66 was relatively short, and it terminated with the realignment of 1930. Attractions are minimal in number but not in quality. A gazebo built in 1927 serves as the centerpiece for the town's park, and Doc's Soda Fountain houses an interesting drug store museum as well as serving traditional soda fountain treats.

GLENARM, ILLINOIS

The date of origination for Glenarm is unknown, but it remained a small community in spite of its association to Route 66.

In 1946, Jack Rittenhouse noted that the community consisted of "a dozen homes . . . a few gas stations, stores, café, and Atchison's Garage." Interestingly, Rittenhouse made no mention of a mirror located at the top of the steep railroad overpass. The theory behind its installation was that by allowing drivers to see oncoming traffic, accidents could be avoided on this dangerous portion of the highway.

GLENDORA, CALIFORNIA

George Whitcomb, a land developer, derived the name Glendora from his wife's name, Ledora. Founded in 1887 and incorporated in 1911, Glendora remained primarily a citrus-producing community into the early 1950s before succumbing to the postwar wave of urbanization.

In recognition of the resurgent interest in Route 66, and the role that highway played in the community's postwar development, the city renamed Alosta Avenue as Route 66 in the summer of 2001. Initially, Route 66 utilized Foothill Boulevard, but the latter alignment followed Alosta Avenue.

The 1955 *Western Accommodation Directory* published by AAA lists three motels and two restaurants, all located on Route 66. The motels were Palms Tropic Motel (19305 West Alosta Avenue); 20th Century Motor Hotel, listed as distinctive (1345 East Alosta Avenue); and Shamrock Motel (625 East Alosta Avenue). Dining recommendations are Old Hickory Inn (U.S. 66 at Grand Avenue) and Roma Villa Oaks Restaurant (745 East Highway 66).

In late 1953, AAA listed the 20th Century Motor Hotel at 1345 East Alosta Avenue (Route 66) as distinctive with rates that ranged from $4.00 to $6.00 per night. *Mike Ward*

GLENRIO, TEXAS

The origins of this community date to the surveying and division of the surrounding area into farms in 1905 and the establishment of a depot under the name Rock Island and siding by the Chicago, Rock Island & Gulf Railway in 1906.

The depot and rail yard were the initial cornerstones of economic development, as this allowed for the shipping of agricultural products at reasonable cost. However by the mid-teens, the development of service-related businesses catering to travelers on the Ozark Trails Highway (a precursor to U.S. 66) allowed for diversification of the economic base. By the late teens, the business district included the Glenrio Hotel, land office, hardware store, grocery store, several cafés, and service stations. The town even had a newspaper, the *Glenrio Tribune*, published from 1910 to 1934.

The droughts of the late 1920s and early 1930s, and the collapse of agricultural prices during this period, led to increased dependence on traffic from Route 66 for economic sustenance of the community. Its proximity to the state line led the state of Texas to build a welcome center here in the late 1930s, a facility that reportedly appeared in scenes of the 1940 movie *The Grapes of Wrath*.

An article in *The Amarillo Daily News* on November 15, 1946, about this welcome center provides a snapshot of the inception of the travel boom that began in the postwar era:

> The State Highway Department's information bureau located at the Texas-New Mexico line on U.S. 66 at Glenrio furnished 288 cars with maps of Texas and places of interest. Among the cars stopping for information were 65 from California, 25 from Illinois, 11 from Indiana, 24 from Michigan, and 13 from Missouri. Three cars from Canada and one from the Canal Zone also stopped for information."

Suspension of service and removal of rails led to the razing of the depot in 1955. With the completion of I-40 in 1975 that resulted in the bypass of Glenrio, the town entered a period of rapid decline. In 2000, the population was five.

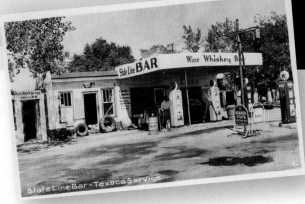

This is a unique view of Glenrio, Texas, as the sign on the building at the left indicates it serves as the post office for Glenrio, New Mexico. *Steve Rider*

The site most often photographed is the Texas Longhorn Motel and Café once promoted with a sign that read "First Stop in Texas" on one side and "Last Stop in Texas" on the other. These structures date to 1950.

Before establishing this facility, Homer and Margaret Ehresman opened the State Line Bar on the New Mexico side of the state line in 1934. (As an interesting historic curiosity, Margaret ran the post office from this location, and an early photo shows this building with "Post Office Glenrio N.M." over the door.) In 1946, for reasons unknown, the Ehresmans relocated their business five miles west to Endee, New Mexico. In 1950, they returned and opened the Longhorn.

Glenrio, now considered a ghost town, remains a popular photographic stop for travelers on Route 66. In 2007, seventeen buildings composing the entire business district of the town and the four-lane roadbed of Route 66 received recognition for their historic significance with inclusion in the National Register of Historic Places.

The majority of remaining structures are from the period 1930 to 1960. Of particular interest, in addition to the Texas Longhorn Café and Motel complex, are the Little Juarez Diner built to imitate the popular Valentine Diners of the period, the post office, and the adobe-constructed service station at the west end of town near the New Mexico state line.

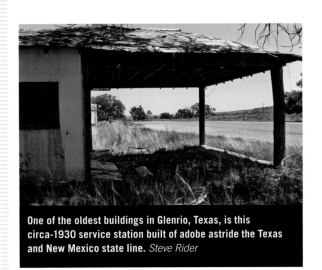

One of the oldest buildings in Glenrio, Texas, is this circa-1930 service station built of adobe astride the Texas and New Mexico state line. *Steve Rider*

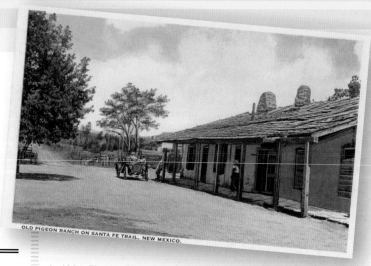

OLD PIGEON RANCH ON SANTA FE TRAIL, NEW MEXICO.

GLENSTONE COTTAGE COURT

The Glenstone Cottage Court at 2023 North Glenstone Avenue in Springfield, Missouri, opened in 1947 as the Greystone Cottage Court. The facility, still operating as a motel, promoted the availability of many modern amenities, including television, air conditioning, and thermostatically controlled heat in advertisements during the 1950s.

GLORIETA, NEW MEXICO

Located along the pre-1937 alignment of Route 66, to the east of Glorieta Pass, Glorieta first was established under the name La Glorieta with the establishment of a post office in 1875, but the modern name was in use by 1880. Its post office remains in operation.

Settlement here predates establishment of the post office by at least a decade. After 1879, the community became a stop for the Atchison Topeka & Santa Fe Railroad.

Headquartered here is the Glorieta Baptist Conference. The town also serves as a supply center for campers and hunters.

GLORIETA PASS, NEW MEXICO

Glorieta Pass, named by the Coronado expedition of 1542, was an important pass on the section of the Santa Fe Trail between Las Vegas and Santa Fe, New Mexico. Before the Mother Road's realignment in 1937, this 7,500-foot summit was the highest point on Route 66.

The pass figures prominently in the history of the Spanish Colonial era as well as the period of American expansion. In

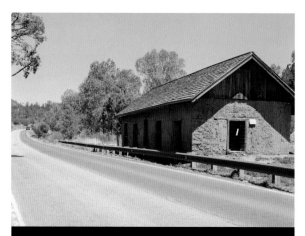

The Pigeon Ranch on the pre-1937 alignment of Route 66 in New Mexico served as a hostelry along the Santa Fe Trail and as a field hospital during the Battle of Glorieta Pass in 1862 during the Civil War. *Steve Rider*

In 1924, Thomas Greer transformed the historic Pigeon Ranch, originally a hostelry on the Santa Fe Trail, into a tourist attraction that capitalized on the history of the property.
Steve Rider

1841, the Mexican army detained the first wagon train of traders from Texas over the Santa Fe Trail here, after a pitched battle that left several men dead. This incident fueled the tensions that erupted as the Mexican–American war. On August 18, 1846, General Stephen H. Kearney overwhelmed the forces of General Manuel Armijo in the shadow of the pass. Kearney's victory here led to the proclamation that New Mexico was American territory.

One mile east of the present-day village of Glorieta, on March 26, 1862, Major John M. Chivington engaged Confederate troops in a battle that lasted for two days. The resulting Union victory represented a major turning point in the western theater of the American Civil War.

Playing a key role in this pivotal engagement was the Pigeon Ranch. The barn at this hostelry and stage station served as a field hospital during that conflict and later as the centerpiece for a roadside attraction before the realignment of Route 66 in 1937.

The stone-lined well on the south side of Route 66 also figured prominently in the transformation of the Pigeon Ranch into a tourist attraction. Historic evidence indicates the well's existence in the mid-1700s, but persistent local legend has it that the Spanish conquistador Francisco de Coronado utilized the waters in his expeditions during the sixteenth century.

GODLEY, ILLINOIS

Godley remained a small, rural agricultural community until the discovery of extensive coal deposits in the late nineteenth century. During the ensuing twenty years, the town mushroomed into a raucous mining camp that purportedly supported eighteen taverns and numerous houses of prostitution.

Closure of the mines resulted in the dismantling of many businesses and homes for use in other nearby communities. Illustrating the near complete decline of Godley is the notation made by Jack Rittenhouse in his 1946 guidebook: "Pop. 85; no facilities. Once a booming mining community. Now only a few homes remain. South of the town are more slag heaps."

In *Traveling the New, Historic Route 66 of Illinois* by John Weiss, published in 2010, the notation for Godley reads, "Before and during the early days of Route 66 this town was known for its red-light district. Now it is a small family oriented community." As to attractions, this guidebook suggests K Mine Park, "a huge, fantastic local area park. A very modern community center, jogging trails, ball park, gazebo, picnic areas." This entry provides more descriptors of the park before concluding with the following: "All of this in a town with a population of 500."

GOFFS, CALIFORNIA

The Southern Pacific Railroad selected the site for Goffs in 1883 for a siding, as well as a fuel and water stop, because of its location at the high point between the Colorado River Valley at Needles and the floor of the Mojave Desert to the west. The establishment of the siding served as a catalyst for the development of ranching and mining in the immediate area.

With the discovery of major silver and gold deposits at Searchlight, Nevada, which resulted in the creation of a Nevada Southern Railway short line that linked the mines there with the main line at Goffs in 1893, the community rose in prominence. The California Eastern Railroad and eventually the Santa Fe Railroad operated this line until its discontinuance in 1923.

Additionally, Goffs served as the junction for two primary automobile roads during the teens, the National Old Trails Highway and the Arrowhead Highway, the road that connected Los Angeles with Salt Lake City in Utah.

The transportation hub's mission-style school was built of lumber and stucco in 1914. In addition to the eight hundred–square-foot classroom that doubled as an auditorium for community dances and church services, the building featured a large library and two large covered porches.

The downturn began in the early 1920s, first with abandonment of the short line to Searchlight and then with consolidation of railroad service in Needles and Barstow. The commissioning of U.S. 66 that followed the path of the National Old Trails Highway provided the community with a supplemental source of economic viability until the realignment of the highway through South Pass bypassed Goffs in 1931.

By 1937, the population no longer warranted a school and most remaining businesses had closed, though a brief window of economic activity resumed during World War II. Large sections of the Mojave Desert, including the area surrounding Goffs, were used during this period for the largest war games training center in history as General George S. Patton prepared his troops for the invasion of North Africa. Indicative of the result in Goffs was the transformation of the school into a mess hall to feed thousands of troops.

After the war, the school remained as one of the largest structures in town, serving as a private residence until 1954. It remained abandoned from this date until 1982, when it was acquired by Jim and Bertha Wold, employees of the OX Ranch

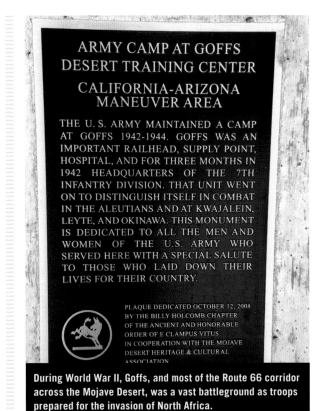

During World War II, Goffs, and most of the Route 66 corridor across the Mojave Desert, was a vast battleground as troops prepared for the invasion of North Africa.

Enthusiasts often overlook Goffs, California, a ghost town on the pre-1931 alignment of Route 66, even though it has one of the finest small museums on the highway.

north of Goffs. After purchasing the property, they stabilized the old school that was literally on the verge of collapse with most of the east wall gone and the roof sagging by several feet.

Illness prevented completion of the restoration, however, and the property was sold to Dennis and Jo Ann Casebier. Completion of the refurbishment under their direction was the first stage in the creation of a museum complex. The resulting Mojave Desert Heritage Cultural Association houses an eclectic collection of artifacts ranging from a ten-stamp mill and old trucks to World War II and railroad-related items. Additionally, the grounds are an educational botanical garden laced with trails.

GOLDEN DRAGON CHINESE RESTAURANT

The Golden Dragon Chinese Restaurant located at 1006 East Highway 66 in Tucumcari, New Mexico, opened in 1966 and as of 2011 continued to meet the needs of locals and travelers alike. The restaurant originally opened in the early 1950s as Hall's Restaurant with Lois and Ed Hall as proprietors.

GOLDEN LIGHT CAFÉ

Dating to 1946, the Golden Light Café at 209 West Sixth Street remains the oldest continuously operated café on Route 66 in Amarillo, Texas. This fact is noted in the listing for the restaurant contained in the *Route 66 Dining & Lodging Guide*, fifteenth edition, published by the National Historic Route 66 Federation in 2011.

GOLDROAD, ARIZONA

Reports filed by John Moss indicate gold was first found here in the mid-1860s. However, it was not until 1902, and a discovery by Joe Jerez, that the ore proved adequate for profitable mining.

Initially, the post office application utilized the name Acme, but three years later, in 1906, an amendment changed it to Goldroad. The narrow confines of the canyon in which the town was located proved prohibitive for support of a large population, a fact that further fueled the growth of Oatman a few miles to the southwest.

By late 1907, many of the easily accessed bodies of high-grade ore were exhausted. As a result, the primary mine closed, leaving only a scattering of independent miners to operate intermittently in the canyons around Goldroad.

The establishment of the National Old Trails Highway in 1913, Route 66 after 1926, ensured the continuation of business activity in Goldroad. However, by 1940 the majority of businesses had closed or relocated to Oatman.

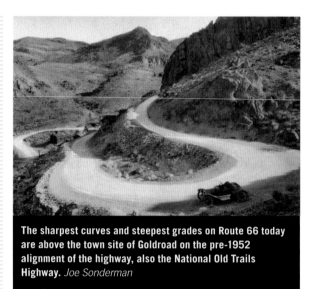

The sharpest curves and steepest grades on Route 66 today are above the town site of Goldroad on the pre-1952 alignment of the highway, also the National Old Trails Highway. *Joe Sonderman*

In 1946, the primary remaining business was a garage operated by N. R. Dunton, the man who had established Cool Springs on the eastern slope of the Black Mountains. A guidebook by Jack Rittenhouse published that year details his primary service: "For eastbound cars which cannot make the Gold Hill grade, a filling station in Goldroad offers a tow truck which will haul your car to the summit. At last inquiry their charge was $3.50, but may be higher."

In 1949, an Arizona law that required taxes to be paid on all existing structures led to the razing of most of the town. Extensive ruins, foundations and mine tailings, a section of an early alignment of the National Old Trails Highway with unique stone bridge abutments and intricate guardrails, and the sharpest curve and steepest grade on the existing Route 66 are the primary remaining features today.

Large sections of the town site are no longer accessible, as Adwest Minerals is developing and expanding one of the older mines and has acquired other mining properties here. Depending on mining activity, the company provides underground tours that culminate with a photo session at a sign that indicates you are under Route 66. As of the summer of 2011, however, the tours had been suspended.

GRAHAM, SHELLEE

Shellee Graham, recognized as one of the preeminent Route 66 photographers, has also written two books—*Return to Route 66* and *Tales from the Coral Court: Photos and Stories from a Lost Route 66 Landmark*, named book of the year in 2002 by *Route 66 Magazine*. Her initial work served as a foundational element in the resurgent interest in Route 66 and, in 2005, garnered the coveted John Steinbeck Award for historic preservation.

Her traveling Route 66 photo exhibition has played at venues as diverse as the Route 66 Fun Run in Kingman, Arizona, and a gallery in Samara, Russia. Indicative of the popularity of both the highway and Graham's photographic artistry is the fact that her exhibits are often booked many months in advance.

Graham is a passionate advocate for preservation and documentation of historic and endangered highways, as well as the structures associated with those roads, and in that capacity she has worked on numerous restoration projects and fund-raising endeavors. Before the razing of the Coral Court Motel, she photographically documented almost every aspect of that motel's unique architecture and coproduced the documentary film, *Built for Speed: The Coral Court Motel*, about it.

In conjunction with historian, author, and photographer Jim Ross and acclaimed artist and photographer Jerry McClanahan, Graham released *Route 66 Sightings* in October 2011. The book, a compilation of work by these artists, has garnered critical acclaim.

GRAND CANYON CAFÉ

The Grand Canyon Café, at 110 East Santa Fe (Route 66) in Flagstaff, Arizona, opened in 1938. In 1940, the founder, Eddie Wong, had his brother, Albert, join him in the venture, and in 1950 the façade of the restaurant underwent extensive modernization. This included the addition of brickwork, a stainless-steel canopy, and enlarged windows.

The café remains operational, and in the *Route 66 Dining & Lodging Guide*, fifteenth edition, published by the National Historic Route 66 Federation in 2011, it is listed as a recommended restaurant. The menu retains a number of the original offerings, including chicken fried steak (the restaurant's specialty) and Chinese food.

GRAND CANYON CAVERNS

Discovery of the caverns' entrance occurred in 1927 when, according to legend, Walter Peck nearly stumbled into the opening while on his way to a poker game. Initially, Peck utilized a winch to lower tourists into the cave promoted as Yampai Caverns.

In 1936, a wooden staircase was constructed down into the caverns, and the name changed to Coconino Caverns. Shortly after expansion of the property with a developed trail system— and after World War II designation as a fallout shelter and subsequent stocking with food stuffs and other materials by the civil defense department—an elevator provided easier access and the name became Dinosaur Caverns.

Another name change, this time to Grand Canyon Caverns, occurred in 1962, and expansion of the complex during this period included installation of a café and gift shop at the caverns' entrance, and a motel and service station at the highway junction.

After the bypass of this section of Route 66 in 1978, the property fell into disrepair. As of the winter of 2011, the facility

This iconic roadside attraction has operated under a wide array of names since its discovery in 1927: Yampai Caverns, Coconino Caverns, Dinosaur Caverns in 1957, and Grand Canyon Caverns after 1962. *Steve Rider*

had undergone a great deal of renovation as well as expansion that included development of the airstrip, riding stables, tours into undeveloped sections of the caverns, and Jeep tours along an early alignment of Route 66. One of the most unique developments is an in-cavern motel room. The room without walls represents a one-of-a-kind lodging experience on Route 66.

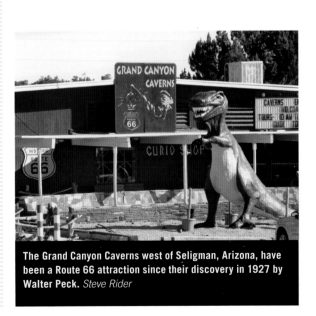

The Grand Canyon Caverns west of Seligman, Arizona, have been a Route 66 attraction since their discovery in 1927 by Walter Peck. *Steve Rider*

GRAND CANYON HOTEL

Built in 1891, the Grand Canyon Hotel located at 145 West Route 66 in Williams, Arizona, still remained as a lodging facility as of 2011. Refurbishment of the property preserved many original elements while adding modern amenities, such as Internet access.

In the 1946 guidebook published by Jack Rittenhouse, the hotel received a cursory notation. The fifteenth edition of the *Route 66 Dining & Lodging Guide*, published by the National Historic Route 66 Federation in 2011, gave the property a favorable review.

GRANDVIEW MOTEL

Located at 9700 West Central Avenue in Albuquerque, New Mexico, the Grandview Motel, with Russell H. Farber as proprietor, initially capitalized on its location as the first motel encountered by eastbound travelers on Route 66. As of winter 2010, it remained an existing business. The refurbished neon trim along the rooflines presents a colorful, period atmosphere.

GRANITE CITY, ILLINOIS

The date of origination for the first community on this site, Kinder, is unknown, but historical references predate establishment of a post office by at least twenty years. The first post office opened May 15, 1893, under the name Granite but through amendment changed to Granite City in November 1903.

The name is derived from the Granite Iron Rolling Mills, a company that manufactured cookware coated with enamel made with ground granite known as graniteware. Frederick and William Niedringhaus, St. Louis tinsmiths, developed the process about 1890.

Initially, the Niedringhaus brothers had established the St. Louis Stamping Company, for the manufacture of kitchen utensils, and the Granite Iron Rolling Mills in St. Louis. The high cost of property in that city prohibited expansion of their factories, however, and resulted in the purchase of 3,500 acres on the Illinois side of the Mississippi River in an area known as American Bottom. After platting the community, the brothers encouraged other factories to locate here in an effort to diversify the economic base. They also expanded their industrial empire with establishment of Commonwealth Steel Company.

The primary association with Route 66 and Granite City is between the years 1926 and 1930. This alignment of the highway followed Gonterman Boulevard, Nameoki Road, and Madison Avenue to cross the Mississippi River at Venice, Illinois, on the McKinley Bridge, named for Congressman William B. McKinley.

The *Hotel, Garage, Service Station, and AAA Club Directory*, published by AAA in 1927, lists two recommended repair facilities: Radcliff's Garage and Rall's Garage, no address given. The single lodging recommendation is Newman Hotel, $3.00 per night.

GRANT PARK

The eastern terminus for Route 66 is Grant Park in Chicago. The history of the park dates to 1835 and the efforts of a group of citizens hoping to preserve a tract of land along Lake Michigan from commercial development, which culminated in the designation of Lake Park on April 29, 1844.

In 1871, after the Great Chicago Fire, with debris pushed into Lake Michigan, the park increased to its present 319 acres. On October 9, 1901, the park name changed in honor of President Ulysses S. Grant.

From its inception, there were prohibitions against building construction in the park. Developers wanting to construct museums and related infrastructure in the park remained at odds with the city, as well as civic leaders such as Aaron Montgomery Ward, throughout the nineteenth century, a situation prohibitive to development.

The granting of an exception to the ordinance issued in 1892 resulted in the construction of the Art Institute of Chicago, the first major structure built in the park. In the years that followed, expansion of the park, such as the addition of Millennium Park to the north, as well as its development came as a result of further exceptions to the original ordinance.

The most famous feature of the park today is Buckingham Fountain, constructed in 1927. Modeled after Latona Fountain and reflective pool at the Palace of Versailles in France, the fountain in Grant Park is almost exactly double the size of the original.

A curious factoid about the park is that it is the site of a monument to Abraham Lincoln, not Grant. A memorial to President Grant, on the other hand, is located in nearby Lincoln Park.

GRANTS, NEW MEXICO

At some point between 1850 and the advent of the American Civil War in 1861, Antonio Chavez established a small homestead on the south side of the Rio San Jose at this site. Don Jesus Blea acquired the property in 1872 and called it Los Alamitos (the little cottonwoods).

In 1881, Lewis, John, and Angus Grant, railroad contractors with the Atlantic & Pacific Railroad, established a construction camp along the river at this point. As a point of reference, it received designation as Grants Camp—Grants Station after completion of a depot, coaling station, and siding. The initial post office application approved in 1882 shortened the name to Grant, and an amendment in 1935 changed this to the current name of Grants.

In spite of its importance as a freighting center for the area, and to travelers on the National Old Trails Highway after 1916, Grants remained a small isolated community as evidenced by the fact that the entire town was not electrified until 1929. The *Hotel, Garage, Service Station, and AAA Directory* for 1927 lists one recommended repair facility, St. Morris Garage, but no hotels or auto courts.

The California Hotel and Yucca Hotel were the two hotels listed as lodging choices by Jack Rittenhouse in his 1946 guidebook for Grants, New Mexico. *Steve Rider*

In 1954, AAA promotion of the Franciscan Lodge noted a long list of amenities, including alarm clocks, "air cooling," thermostatically controlled vented heat, and heated garages. *Mike Ward*

Improvement to Route 66 and the subsequent increase in traffic during the 1930s, coupled with development of mining in the immediate area, transformed the community and increased population from one hundred in 1927 to two thousand in 1946.

The neon is now dim at the Franciscan Lodge in Grants, New Mexico, a motel that opened in 1950 with advertisement that proclaimed "Your Home On The Road." *Judy Hinckley*

Jack Rittenhouse noted two hotels, California and Yucca, and five auto courts, Lakeside, Encanto, Kimo, Grants, and Zia.

The Zia is the only auto court recommended in the 1940 edition of the *AAA Directory of Motor Courts and Cottages*. The 1954–55 *AAA Western Accommodations Directory* lists the Franciscan Lodge and the Grants Motel, a facility noted by Jack Rittenhouse in 1946.

On March 22, 1958, Grants was thrust into the international spotlight with the crash of a light plane carrying film producer Mike Todd in a small valley about twenty miles from the CAA communications station. Todd, the husband of Elizabeth Taylor, was the producer of the award-winning film *Around the World in Eighty Days*.

Uranium mining, the railroad, and Route 66 ensured steady growth into the 1960s. The suspension of mining and completion of Interstate 40 precipitated an economic downturn that has yet to be reversed. Attractions of note for Route 66 enthusiasts include the New Mexico Mining Museum, the tarnished signs for the Franciscan Lodge dating to the 1950s, and the Lux Theater.

THE GRAPES OF WRATH—STEINBECK, JOHN, 1939

The Grapes of Wrath by John Steinbeck chronicled the story of the mythical Joad family and the trials faced as they became displaced farmers, refuges of the Dust Bowl, moving west toward California and hoping for opportunity. The book defined a generation and coined a term for Route 66 that became its slogan into the modern era of resurgent interest:

> 66 is the path of people in flight, refugees from dust and shrinking land, from the thunder of tractors and shrinking ownership, from the desert's slow northward invasion, from the twisting winds that howl up out of Texas, from the floods that bring no richness to the land and steal what little richness is there. From all of these, the people are in flight, and they come into 66 from the tributary side roads, from the wagon tracks and the rutted country roads. *66 is the mother road*, the road of flight (from Chapter 12, emphasis added).

In spite of the controversy created by the treatment these displaced people received (as portrayed in the story), especially in California, the book won critical acclaim as well as the Pulitzer Prize. In its first year of publication, the book sold nearly a half million copies, and Charles Poore wrote in his *New York Times* book review of it, "Mr. Steinbeck has created his best novel. It is far better than *Of Mice and Men*."

However, the book also received a great deal of criticism for its raw portrayal of social injustices deemed inflammatory. As a result, during the filming of *The Grapes of Wrath*, John Ford, the director, insisted on a closed set and took other precautions, including prohibiting cast members from having a complete script and banning still cameras on the set.

THE GRAPES OF WRATH *continued*

While the majority of filming was done at the main studio back lot, there were numerous scenes shot on location, including along Route 66. The latter included the Old Trails Arch Bridge on the Colorado River, the agricultural inspection station near Daggett, California, and various locations in Gallup, New Mexico, as well as Texas and Oklahoma.

On February 21, 1940, the film opened in a double premiere, with one showing in New York City and one in Los Angeles at the Four Star Theater on Wilshire Boulevard, a move Twentieth Century Fox hoped would allow for at least one showing to go forward if protestors closed the other.

The film, shot in only seven weeks, received critical acclaim for Nunnally Johnson's faithful adaptation of the original Steinbeck work. Additional accolades included nomination for seven Academy Awards, including Henry Fonda for Best Actor in his role of Tom Joad, Johnson for Best Screenplay, as well as Best Sound Recording and Best Film Editing. Jane Darwell received the award for Best Supporting Actress for her portrayal of Ma Joad, and John Ford received the Academy Award for Best Director.

GRAVES, RODNEY

Rodney Graves, a civic leader in Williams, Arizona, organized that city's first rodeo and played a key role in the formation of the Bill Williams Mountain Men, an organization created to commemorate the mountain men who were instrumental in the development of the American West. On August 23, 1946, he opened Rod's Steak House with a signature steer on the sign outlined in neon.

In 1967, Graves retired. The restaurant with original signage is considered a landmark on Route 66 to this day. It received favorable reviews in the 1954 edition of the *AAA Western Accommodations Directory* as well as in the fifteenth edition of the *Route 66 Dining & Lodging Guide*, published by the National Historic Route 66 Federation in 2011.

GRAY SUMMIT, MISSOURI

Initially known as Point Labadie, after the establishment of a hotel here by Daniel Gray in 1841, this community became known as Gray Summit when the railroad came to town. This was the highest point on the railroad between St. Louis and Jefferson City.

Since 1925, it is its association with Shaw Nature Reserve, originally the Shaw Arboretum, for which the community is well known. The connection to Route 66, now State Highway 100, ended in 1932 with completion of a realignment that moved the highway to the south.

GREEN SPOT MOTEL

In Victorville, California, an early alignment of Route 66 followed D Street, and then made a ninety-degree turn on to Seventh Street. At the corner of Seventh and C Streets sat the Green Spot

The Green Spot Motel, where the first draft of the *Citizen Kane* screenplay was penned, now clings to life as apartments rented by the week or month. *Steve Rider*

During the 1930s and 1940s, the Green Spot Motel and Green Spot Café in Victorville, California, were the haven of the rich and famous from Hollywood. *Steve Rider*

Café, which was part of the Green Spot Annex and almost directly across the street from this was the Green Spot Motel.

The motel and the café, during the mid-1930s and into the early 1950s, served as an oasis for movie stars filming in the area as well as celebrities seeking a respite from the rigors of Hollywood. Perhaps the motel's most notable association with film history is with the movie *Citizen Kane* as it was here that John Houseman and Herman J. Mankiewicz wrote the first drafts of the script.

For a short period of time, the motel, built in a U-shaped complex of twenty gable-roofed buildings containing two rows of guest units that faced an inner landscaped courtyard and swimming pool, was part of the United Auto Courts System. Advertisement from this chain lists the property as "Truly De Luxe."

The *Directory of Motor Courts and Cottages*, published by AAA in 1940, recommends the property but provides few details: "Green Spot Motel. 30-A, $2.50 to $3. Café."

After completion of the Victorville bypass in 1972, the motel quickly became a low-rent flophouse known locally for nefarious activity. In 1982, film star Kay Aldridge purchased the property intending to fully restore it and transform it into a premier facility.

Her plans never came to fruition, however, and the property sold to Benjamin Wu and Nancy Wei, who operated the facility until 1995 when Wei was sentenced to prison for the murder of her husband. The property sat dormant and became the target of vandals until its acquisition in 2001 by Hemant Patel.

The motel now caters to weekly and monthly rentals. However, the owner has indicated there are plans for restoration.

GREEN, VICTOR H.

Born on November 9, 1892, in New York City, Green worked as a postal carrier in Harlem and collected information on hotels, restaurants, and other businesses in the New York City area that served or catered to African Americans. In 1936, he published this information in a pamphlet entitled *The Negro Motorist Green Book*.

It proved so popular that for the 1937 edition he expanded coverage to include businesses throughout the United States. In the introduction, Green wrote, "There will be a day sometime in the future when this guide will not have to be published. That is when we as a race will have equal rights and privileges in the United States."

With each subsequent annual edition, demand exceeded the publication of fifteen thousand copies annually. This led Green, upon retirement from the post office, to establish a publishing office at 200 West 135th Street in Harlem, to hire a small staff, to expand coverage to international destinations that resulted in a name change to *The Negro Travelers Green Book* in 1952, and, in 1947, to establish a vacation reservation service.

Marketed to African American–owned businesses—such as Murray's Dude Ranch ("The World's Largest Negro Dude Ranch") near Apple Valley in California, and to carefully chosen Caucasian-owned businesses—the book continued to grow in popularity through the 1940s and 1950s. Among the primary outlets were the ESSO gas stations, one of the few franchises available to African Americans.

By 1949, the directory had expanded to more than eighty pages and included advertisements from major companies, such as Ford Motor Company, Esso, and resorts in Bermuda. Of particular interest in this issue is the advertisement from Esso: "As representatives of the Esso Standard Oil Co., we are pleased to recommend the Green Book for your travel convenience. Keep one on hand each year and when are planning your trips, let Esso Touring Service supply you with maps and complete routings, and for real 'Happy Motoring' – use Esso Products and Esso Service wherever you find the Esso sign."

With the postwar boom in travel, Green's publication gained in prominence and importance to the African American motorist. An article in *The Albuquerque Tribune*, dated August 16, 1955, quotes a spokesman for the NAACP who lays the blame of a fatigue-related accident near Clines Corners on the lack of available lodging for blacks in New Mexico. "Mr. Boyd said a recent survey by his committee showed that less than six percent of more than 100 motels and tourist courts on U.S. 66 in Albuquerque were accepting Negro tourists."

Shortly after passage of the Civil Rights Act of 1964, Green suspended publication. In the fall of 2010, the contributions made by Green and his guidebook were introduced to a new generation by Calvin Alexander Ramsey in a children's book entitled *Ruth and the Green Book*.

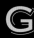

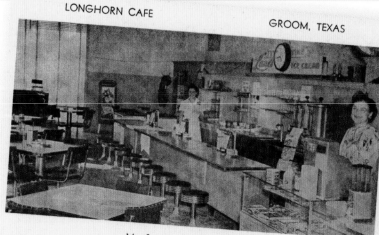

Mr. & Mrs. Jimmy McCasland

GROOM, TEXAS

The namesake for this community located two miles east of
Amarillo is B. B. Groom, the first general manager of the
Francklyn Ranch, later the White Deer Ranch. Platting of
the town site along the route of the Chicago, Rock Island,
& Gulf Railroad occurred in 1902. The post office under
this name opened in the general store owned by Frank S.
Dysart in the same year. Within four years, additional
businesses opened, including a bank, hotel, barbershop,
lumberyard, and second general store.

At the time of incorporation in 1911, the population
in Groom was in excess of 250. Fires in 1912 and in
1915 decimated the business district, but as a shipping
center for agricultural produce, the community
continued to prosper. The discovery of oil in the area during the
early 1920s spurred growth and development that included the
paving of streets and establishment of a city water system in
1928. Census figures indicate a population of 564 in 1931.

With the collapse of the oil boom, agriculture and Route 66
became the primary economic elements in the community. Jack
Rittenhouse noted in 1946 that services included a " . . . small
hotel, Wall's Café and several others; gas; garages; stores."

In June 1980, with the completion of I-40, the community
suffered a major blow to its economy as evidenced by the closure
of three of the four cafés in town. The lone survivor, the Golden
Spread Grill (the Grill as of 2010), opened in 1957.

The town's notoriety today is derived from a water tower
purposely built at an angle and the Cross of Our Savior Jesus
Christ. The latter, erected in 1995, is 190 feet tall and proclaimed
the tallest illuminated cross in the northern hemisphere, a
roadside shrine seen for miles on the Panhandle.

The leaning water tower is lettered "Britten USA." Never
intended for use as a water tower but as advertisement for the
now vanished truck stop at this location, the tower remains a
landmark near Groom.

GROVER, MISSOURI

Initial settlement here was under the name St. Frieding. The
current name is the result of approval of a post office application
filed in deference to the sitting president at that time, Grover
Cleveland. The community's association with Route 66
terminated with the realignment of 1932.

A GUIDE BOOK TO HIGHWAY 66

Self-published in 1946 by Jack Rittenhouse, *A Guide Book to
Highway 66* was conceived during Rittenhouse's extensive travels
on Route 66 from a sense that with cessation of hostilities in

**Before the completion of I-40 transformed Groom, Texas, into a
ghost town, the Longhorn Café, Wall's Café, as well as several
garages, stores, and the small hotel were a beehive of activity.**
Mike Ward

**The little pocket guide penned by Jack Rittenhouse in 1946
that sold in dismal numbers is now a valued treasure in the
era of resurgent interest in Route 66.** *Steve Rider*

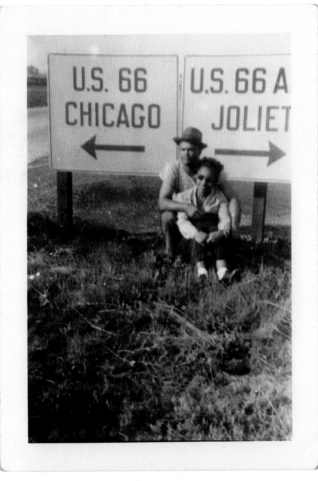

World War II, there would be a westward migration toward California that could make a detailed guidebook to the primary highway, Route 66, a profitable commodity. His wife, Charlotte, completed the foundational research for the book using maps to document elevations, historical records, and WPA Guidebooks.

In March 1946, Rittenhouse left his home in Los Angeles to compile a contemporary sense of the road, evaluate restaurants and auto courts, and log accurate directions utilizing mileage derived from set landmarks or locations. As an interesting historic footnote, on this trip he drove a 1939 American Bantam coupe manufactured by the American Bantam Car Company of Butler, Pennsylvania, the company that devised the initial Jeep prototype and that worked in conjunction with the Checker Cab Manufacturing Company of Kalamazoo, Michigan, to create a four-wheel-steering, four-wheel-drive Jeep prototype. The diminutive automobiles were extremely fuel efficient with guarantees of forty miles per gallon promoted in advertise-

ments. However, the car provided little room for luggage and at twenty horsepower proved quite anemic in the mountains of Arizona and New Mexico.

Rittenhouse sold the initial printing of three thousand copies of his book to auto courts, cafés, and bookshops and by mail order. In a 1988 interview, Rittenhouse quipped, "And I learned the hard way that a self-publishing author usually has a fool for a distributor. I never reached my full market."

In addition, hindering sales for the informative guide was Rittenhouse's inability to get it in the hands of reviewers. However, Jack Rittenhouse in a 1988 interview did note that Duncan Hines, best known during the 1940s for dining guides, wrote him a letter of praise for the book.

Original copies are now highly prized among Route 66 enthusiasts. In 1989, the University of New Mexico began reprinting exact facsimiles of the original book that proved surprisingly popular as part of a resurgent interest in Route 66.

H

HACKBERRY, ARIZONA

Indications are that the springs near present-day Hackberry were those utilized by the expedition of Father Francisco Garces in 1776 and were named Gardiner by Lieutenant Edward Beale during his expeditions in the 1850s. The discovery of a rich vein of silver and development of a mine to the west of the springs in the 1870s led to establishment of the community, and completion of the Atlantic & Pacific Railroad to this point in 1881 gave the town a prominence that led the territorial legislature to consider it for the Mohave County Seat.

The exhaustion of profitable ore bodies and the centralized location of Kingman to the mining districts of the Cerbat and Black Mountains, as well as ranching in the Hualapai and Sacramento Valley, led to near complete abandonment of Hackberry by 1890. Building of the National Old Trails Highway, and Route 66 after 1926, however, provided a tenuous continued existence.

Two structures make the town a major attraction for Route 66 enthusiasts. One is the Spanish mission-styled two-room schoolhouse that closed in 1990, the last two room school in Arizona. The second is the Hackberry General Store, built in the late 1930s to the north of the town and the railroad tracks on the post-1937 alignment of Route 66.

The Hackberry General Store, owned for several years by iconic Route 66 artist Bob Waldmire, is now a carefully crafted time capsule that captures the essence of a roadside business during the 1950s. It is a primary photographic stop for travelers on Route 66.

In the town itself, there is a picturesque hilltop cemetery dating to the late 1870s, and, in addition to the school, numerous structures of historic significance. Among them are a former boarding house near the post office and a large water tank once utilized by steam engines on the railroad.

It has been more than twenty years since the last two-room school in Arizona had students in its halls, but regular maintenance keeps this Hackberry landmark in good repair.

When viewed in the context of black and white, the Hackberry General Store in Hackberry, Arizona, appears as though it was transported into the modern era from that of the "Okie" migration.

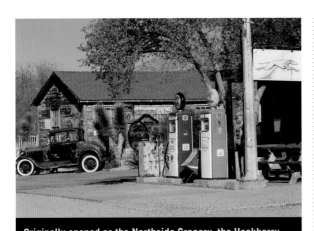

Originally opened as the Northside Grocery, the Hackberry General Store has an interesting history that includes cameos in *Easy Rider* and *Roadhouse 66* and was the home of iconic artist Bob Waldmire in the 1990s.

HALLTOWN, MISSOURI

A store opened here by George Hall in 1870 serves as the accepted date of this community's beginnings. The filing of a post application occurred in 1879.

By 1926, the year of designation for U.S. 66, the business district reflected a prosperous agricultural community. Businesses listed in a directory from that year include a drugstore, bank, variety store, blacksmith shop, garage, and grocery stores.

The bank figured prominently in the arrest of Basil Quilliam, a Wichita, Kansas, grocer purportedly associated with the Eddie Adams gang. On March 13, 1923, Quilliam pleaded guilty of conspiracy to rob the Rose Hill State Bank in Butler County, Kansas, in federal court. His arrest resulted from the discovery of $19,000 worth of marked liberty bonds that he admitted were from the robbery of the bank in Halltown.

Jack Rittenhouse noted in his 1946 guidebook that in Halltown "15 or 20 establishments line both sides of the highway here: gas stations, cafés, antique shops, stores."

In *The Missouri US 66 Tour Book* by Skip Curtis, 1994, the author noted that numerous historic structures remained. A former livery and meat packing company, then an antique store, Stone's Corner Station, a flea market housed in the former West's Grocery (1922), Las Vegas Hotel (1930), and Whitehall Mercantile, then an antique store, built in 1900. The Whitehall Mercantile closed in 2009 shortly after the death of its owner, Thelma White. White was also instrumental in the formation of the Missouri Route 66 Association.

HAMEL, ILLINOIS

The namesake for this community is A. J. Hamel who established a flour mill at this site, then known as Hamel's Corner, in about 1819. Establishment of a post office occurred on March 30, 1871.

In the 1946 publication *A Guide Book to Highway 66*, it was noted Hamel was " . . . a small

Hamel, Illinois, proudly proclaims its association with Route 66, first with an alignment that led to Mitchell, and later with an alignment that led to Collinsville.

farming community with several implement stores. Hamel Service Company, garage. No cabins or other accommodations, except gas."

There are two attractions of note in Hamel. One is the historic St. Paul Lutheran Church. The second is Weezy's, described by historian and author John Weiss as ". . . a nice original Roadhouse."

This view of Halltown, Missouri, looking west dates to 1954 and reflects the bucolic, rural nature of Lawrence County during this period. *Joe Sonderman*

HAVASU

The Havasu in Seligman was one of six Fred Harvey Hotels in Arizona. It opened in 1905 and drew its name from the Havasupai tribe that lived to the north of Seligman in canyons along the Colorado River.

The restaurant and hotel remained in operation until 1954. After this date, the Santa Fe Railroad utilized the complex as offices and as a maintenance yard. Demolition occurred in April 2008.

HAZELGREEN, MISSOURI

A post office operated under the Hazelgreen name from 1858 to 1958, but the cemetery indicates settlement dates to at least the 1840s. According to C. H. Curtis, historian and author, the name is indicative of the proliferation of hazel nut bushes early settlers found in the area.

Jack Rittenhouse noted in 1946 that "this town is typical of many throughout the Ozarks, drawing their livelihood from the fishermen and vacationists who throng the region." Route 66 provided additional support for motels and related service industries.

Construction of a new four-lane version of Route 66 through town in 1955 decimated the community. In the *EZ 66 Guide for Travelers*, Jerry McClanahan notes, " . . . several houses (some on stilts) and a charming Methodist Church perch on the edge of a steep drop."

Lee Walker took full advantage of his location along Route 66 and proximity to the Gasconade River in Hazelgreen to create a resort that met the needs of anglers and travelers. The post office here closed in 1958. *Steve Rider*

HAZELWOOD, MISSOURI

Missouri historian C. H. Curtis claims Hazelwood was "probably named after Hazelwood Farms. Senator Henry Clay of Kentucky, on a visit here in 1828, proclaimed a local orchard reminded him of his estate *Hazelwood*." The owner, Major Richard Graham, renamed his estate after Clay's visit.

The post-1936 alignment of Route 66 turned south in Hazelwood at the present-day intersection of Lindbergh and Interstate 270 passing the Airport Motel, still in operation as of 2011, and the St. Louis Ford Assembly Plant. The site of the Ford facility, in operation from 1949 to 2006, is under redevelopment as an industrial park.

HEATONVILLE, MISSOURI

Daniel Heaton platted a town site on his farm in 1868. A post office under the name Heaton operated from 1872 to 1881. Jack Rittenhouse noted in 1946 that services in Heatonville included the Castle Rock Cabins, garages, a grocery store, and gas stations.

Few businesses remain in operation. However, because many of the buildings' façades were made of stone, numerous structures remain.

HELENDALE, CALIFORNIA

Numerous historic trails, including the Mojave Trail, Spanish Trail, and Mormon Trail, utilized the waters of the Mojave River and springs at this site. A unique geological landmark resulted in the designation Point of Rocks.

Pioneering American explorers and military expeditions that utilized the site include Jedediah Smith in 1826, John Fremont and Kit Carson in 1844, and the Mormon Battalion during the Mexican–American War in late 1846 or early 1847. Point of Rocks Station built here in the early 1860s met the needs of early stage lines operating in the area.

The completion of the railroad to this point in 1882 resulted in establishment of a station to utilize the waters for the locomotives. The name change to Helen, in honor of Helen Wells, daughter of railroad executive Arthur G. Wells, occurred in December 1897. Adoption of the current name, Helendale, occurred in September 1918.

The National Old Trails Highway, Route 66 after 1926, became an integral component in the community's economy, based on the growing of alfalfa. In 1969, construction of two manmade lakes, North Lake and South Lake, created the foundational components of a resort community, Silver Lakes, which transformed the area.

As an historic side note, Jennie Lee, founder of the League of Exotic Dancers, established Exotic World in Helendale in the early 1980s. Exotic World, the only museum in the world

dedicated exclusively to preservation of artifacts pertaining to burlesque, remained operational under the direction of Dixie Evans after Lee's death in 1990. In late 2005, the search for a facility suitable for the museum and its collection commenced in Las Vegas, Nevada, and in 2010, it reopened in that city.

HENRY'S

Henry's, at 6031 West Ogden Avenue in Cicero, Illinois, with its unique signage dates to the mid-1950s and is now an institution for area residents as well as favored destination for travelers on Route 66. Initially, it was a simple food stand with walk-up window and no indoor seating.

The slogan, "Henry's—It's a Meal in Itself" is emblazoned in neon under a giant hotdog on the sign in front. A few years after opening, renovation and expansion included the addition of indoor seating as well as drive-up service.

HEXT, OKLAHOMA

Sources conflict pertaining to a date of origination for this community, but there is agreement on the namesake for the community: William Hext, a local farmer. A post office operated under this name at this location from 1901 to 1902.

Apparently the community never really developed. Jack Rittenhouse noted in 1946 that Hext was, "Not a community—just a gas station. . . . "

Ironically, this proverbial wide spot in the road is associated with a key point in the time line of Route 66 in the state of Oklahoma. This section of the highway, rebuilt as a four-lane road in the 1950s, was the last segment of Route 66 to lose its U.S. highway designation in the state.

HIGHLAND PARK, CALIFORNIA

Initially, Highland Park was a community separate from Los Angeles. Completion of the San Gabriel Valley Railroad, construction of a stop, and the opening of the Garvanza Hotel in 1886 sparked establishment and growth. Annexation by the City of Los Angeles occurred in 1895, and in 1898, Occidental College was established.

The area's first association with Route 66 dates to a realignment in 1931 that utilized Figueroa Street, signed as Pasadena Avenue, until 1936. On this route is the historic 1924 Highland Theater with towering roof-top signage that was restored in 2011.

HILAND THEATER

The Hiland Theater, at 4804 East Central Avenue (Route 66) in Albuquerque, New Mexico, opened as a modern, 875-seat showpiece in 1951. Built by the Frank Peloso family, the theater, as of 2010, served as the home of the National Dance Institute of New Mexico.

HILLCREST MOTEL

The Hillcrest Motel opened in about 1952 and the *AAA Western Accommodations Directory* for 1954 notes, "Air conditioned or air cooled rooms have electric or vented heat and tiled shower or combination baths. Some new units."

The motel, located at 2018 East Andy Devine Avenue, in Kingman, Arizona, is now an apartment complex. The former office, as of the winter of 2011, was a Pakistani restaurant, but the facility retained its original nonoperational signage.

HILLTOP MOTEL

Initially operated by Jack and Erma Horner, the Hilltop Motel opened in 1954 with promotion proclaiming the property had the "Best View in Kingman." The motel, located at 1901 East Andy Devine Avenue (Route 66) in Kingman, Arizona, and its landmark sign have changed little since that date, and the motel still serves its original purpose.

Addition of a swimming pool in about 1960 and landscaped grounds are the primary changes from its original configuration. Renovation of the neon sign occurred in 2002.

The Hilltop Motel at 1901 East Andy Devine Avenue in Kingman, Arizona, with its stunning views of the Hualapai Mountains opened in 1954 with advertisement that proclaimed, "Best View in Kingman."

HIWAY HOUSE

The Hiway House was an early motel chain established in 1956 in Phoenix, Arizona, by construction tycoon Del Webb, creator of the Sun City retirement communities. The initial success of the Ramada Inn chain in which Del Webb was a primary investor in 1954 served as the catalyst for the idea.

The Hiway House chain grew to include properties in numerous communities along Route 66, including Arcadia, California; Tulsa, Oklahoma; Albuquerque, New Mexico; and Flagstaff and Holbrook in Arizona. One of the last locations to operate under this name is the Hiway House in the 3200 block of Central Avenue Southeast, Route 66, in Albuquerque.

HODGE, CALIFORNIA

Established as a siding named Hicks by the Santa Fe Railroad, the name was changed to Hodge when Arthur Brisbane, a respected journalist and owner of a prominent ranch in the Mojave Desert, suggested that selection be in honor of Gilbert and Robert Hodge, owners of a ranch in the area since 1912.

Jack Rittenhouse noted in 1946 the following about Hodge: "The only business establishment is a gas station with café and a few cabins. Railroad maintenance crews live in this quiet little desert center."

HOLBROOK, ARIZONA

The initial settlement of the town site of Holbrook dates to the establishment of a railroad tie-cutting camp by John Young, a son of Brigham Young, several miles to the west of Horsehead Crossing near the junction of the Rio Puerco and Little Colorado

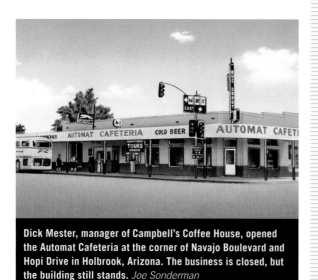

Dick Mester, manager of Campbell's Coffee House, opened the Automat Cafeteria at the corner of Navajo Boulevard and Hopi Drive in Holbrook, Arizona. The business is closed, but the building still stands. *Joe Sonderman*

River in 1881. The namesake for the railroad siding here is H. R. Holbrook, an engineer on the Atlantic & Pacific Railroad.

With the coming of the railroad, initiation of large-scale cattle and sheep ranching commenced, and Holbrook prospered as a shipping and supply center. One of these ranches, the Aztec Land & Cattle Company, using the Hashknife brand, became the largest in the territory of Arizona with control of more than one million acres. Until the sale and breakup of this ranch in 1902, it remained the second largest in the United States.

Holbrook quickly developed a reputation for frontier-era lawlessness and violence. Purportedly, Holbrook was the only county seat that did not have a church, and it remained this way until 1914. This town is also associated with the establishment of, as well as pivotal events in, the careers of two legendary lawmen of this frontier period, Commodore Perry Owens and Burt Mossman. Indicative of the atmosphere in Holbrook during the late territorial era is an ornate invitation to the hanging of George Smiley by order of Sheriff Frank Wattron that received a personal reprimand from President William McKinley: "George Smiley, Murderer—His soul will be swung into eternity on December 8, 1899 at 2 o'clock P.M., sharp. The latest improved methods of scientific strangulation will be employed and everything possible will be done to make the surroundings cheerful and the execution a success."

In spite of its reputation, Holbrook's proximity to the Painted Desert and Petrified Forest served as a catalyst for the development of tourism-related services, first via the railroad and later the National Old Trails Highway and Route 66. The *Hotel, Garage, Service Station, and AAA Directory* for 1927 lists the Commercial Hotel, $1.50 per night, and the Arizona Hotel, $1.00 per night. Listed as the recommended repair facility is the Taylor Garage.

The *Directory of Motor Courts and Cottages*, 1940, lists two AAA-recommended facilities, Forest Motel and café and White Auto Camp, consisting of nineteen cottages as well as trailer sites. In 1946, Jack Rittenhouse noted this about Holbrook: "Hotels: Arizona, Holbrook, Navajo; courts: Forest, Barth, Navajo, El Moderno, El Sereno, White, El Patio, Central, and El Rancho; garages: Mefford, Heward, and Guttery; good food at Green Lantern Café; stores; all facilities."

The 1955 edition of the *AAA Western Accommodations Directory* does not adequately portray the level of influence tourism had on the community, since it lists only four motels: Chief Motel, Exclusive Motel, Sea Shell Motel, and Western Motel. The most notable absence from this listing is Wigwam Village Number Six, a motel that is now an icon indicative of the resurgent interest in Route 66.

The Whiting Brothers, a gas station chain that later added motels in the Southwest, opened its second station in this city. Subsequently, two Whiting Brothers motels were later located here.

Since the bypass of Holbrook did not occur until 1981, existing buildings or businesses of particular note for their relationship to Route 66 are numerous. In addition to the Wigwam Motel, the building that housed Mester's Automat Cafeteria still

In Winslow and dusty communities all along Route 66 corridor in the Grand Canyon state, neon and modern façades masked vestiges from the territorial era. *Steve Rider*

stands. Young's Corral opened in 1948 and is still in business, as is Joe & Aggie's Café that opened at its current location in 1965.

Additionally there is the 66 Motel (1948), the Pow Wow Trading Post (1946), the Holbrook Motel (which is now an America's Best Value Inn, 1958), and the Woods Inn (which is now the Holbrook Inn, 1960). Others include the Western Motel (now a storage company), the Sea Shell Motel (now the Economy Inn), the Whiting Motor Hotel (which later became the Sun 'n' Sand Motel; now the Globetrotter Lodge), and the Desert View Lodge (purportedly the first motel in Holbrook with a swimming pool; it later became the Star Inn).

Indicative of the economic importance of Route 66 to Holbrook, and communities all along its length, is a report released by the Arizona Highway Department in December 1956. It stated: "During November 37,240 cars were counted going west on Route 66 at the station here bringing the total for 1956 to 540,562. The total for all 12 months of last year was only 503,322."

Further indication of the importance of Route 66 to the local economy is the number of business closures that occurred immediately after completion of the interstate highway bypass. Author Joe Sonderman notes in *Route 66 in Arizona*, published in 2010 by Arcadia Publishing, that within twelve months, forty-five businesses ceased operation in Holbrook.

HOLBROOK MOTEL

Promoted as being away from railroad noise with features that included wall-to-wall carpeting, air conditioning, and wall heaters in every room, the Holbrook Motel, built in late 1956, at 720 Navajo Boulevard in Holbrook, Arizona, is still in operation. As of the fall of 2010, it was a part of the America's Best Value Inn chain.

HOLLOW, MISSOURI

The community of Hollow, located on the pre-1932 alignment of Route 66, evolved from a relay station for the St. Louis & Jefferson City Stage Line. Initially the name was Dutch Hollow in deference to Charles "Charley" Pfaffath, who operated a popular tavern here. The association with Route 66 was negligible.

HOLLYWOOD, CALIFORNIA

Platted by Horace H. Wilcox in 1886, Hollywood purportedly derived its name from Wilcox's wife who became enamored with the name after discussions with a fellow passenger on a train trip that resulted in her importing two holly trees. The climate was not suitable for the plants, but the community flourished as a bedroom community for Los Angeles after several false starts.

From January 1936 until decertification of Route 66 in Los Angeles County in 1964, the highway followed Santa Monica Boulevard through Hollywood. A number of businesses having associations with Route 66 remain, but two, Formosa Café and Barney's Beanery, both dating to the 1920s, are of particular interest.

HOOKER, MISSOURI

Preceding the name Hooker, a reference to a popular camp for area sportsman owned by John Hooker, names for this community included Hooker Ford, Hooker Hollow, and Pine Bluff. A post office under the Hooker name operated from 1900 to 1955.

In 1929, a feature article in the *St. Louis Dispatch* noted that Hooker had the smallest high school in the state. According to Jack Rittenhouse, in *A Guide Book to Highway 66*, the population

HOOKER, MISSOURI *continued*

was 120 in 1946. This author also noted that gas was available but no other services.

Completion of Hooker Cut by the Fred Weber Construction Company of St. Louis, a bypass designed to accommodate a four-lane highway alignment necessitated by the expansive construction at Fort Leonard Wood and the dramatic increase in traffic between 1939 and 1941, occurred in 1943. At the time of its completion, the ninety-foot-deep cut was the largest of its kind in the United States. It also enabled the bypass of the sharp curves and narrow steel truss bridge over the Big Piney River at Devil's Elbow built in 1923.

The bypass of the constricted and curved segment of Route 66 through Devil's Elbow, Missouri, was made a priority with the construction of Fort Leonard Wood, resulting in the construction of Hooker Cut and a four-lane alignment.
Joe Sonderman

The ninety-foot deep Hooker Cut, completed by Fred Weber Construction of St. Louis, Missouri, represented the largest highway rock cut in the United States with completion of the project in 1943. *Joe Sonderman*

The historic Hotel Monte Vista in Flagstaff, Arizona, received recommendation in the 2011 edition of the National Historic Route 66 Federation's *Route 66 Dining & Lodging Guide*.
Joe Sonderman

HOTEL MONTE VISTA

Located one block north of Route 66 in Flagstaff, Arizona, the Hotel Monte Vista opened on January 1, 1927. Publicly owned until the early 1960s, the hotel remains as one of the oldest continuously operating hotels in that city.

The hotel received AAA recommendation and inclusion in the *Western Accommodations Directory*, published in 1954. The *Route 66 Dining & Lodging Guide*, fifteenth edition, published by the National Historic Route 66 Federation in 2011, also gave it favorable recommendation.

The Hotel Monte Vista in Flagstaff, Arizona, opened in 1927 and remains as the oldest continuously operated hotel in that city.
Joe Sonderman

The origins of the Hopi House Trading Post, at the intersection of U.S. 66 and State Highway 99, Leupp Corner, are unique in the fact the founders were Ray Meaney, a Hawaiian bandleader, and his wife, Ella Blackwell. *Joe Sonderman*

HOPI HOUSE TRADING POST

Former Hawaiian band leader Ray Meany, and his wife, Ella Blackwell, opened the Hopi House Trading Post at the intersection of U.S. Highway 66 and Highway 99 in Arizona, an area known as Leupp Corner, in about 1941. Jack Rittenhouse in his 1946 travel guide listed the property as the Hopi House Service Station. He noted that it was " . . . the only building here, with a few Navajo hogans near it. The trader here is an affable, experienced man with a fairly extensive stock."

In 1955, Meany and his wife, Ella, divorced. As per the terms of the settlement, he retained ownership of the Hopi House Trading Post, a property he later traded for a motel in California, and Ella obtained San Diego's Old Frontier Trading Post near Joseph City, Arizona, their second trading post.

The Hopi House Trading Post remained operational until completion of the interstate highway that bypassed this segment of Route 66 in the late 1970s. Ruins mark the site today.

HORN OIL COMPANY

The Horn brothers, Calvin and Hosier, opened their first station in Albuquerque, New Mexico, along Route 66 in 1938. The station served as the cornerstone for establishment of the Horn Oil Company that would eventually number twenty-eight stations.

The zenith for the company was an abbreviated expansion into the establishment of auto court complexes, coupled with a service station and garage. The only such complex, Horn Motor Lodge, was built in 1946 at 1720 West Central Avenue in Albuquerque. Demolition of the motor lodge portion of the complex occurred in 2006. As of late 2011, the rest of the facility remained.

HOUCK, ARIZONA

The namesake for this small community is James D. Houck, a colorful figure in Arizona history who served as a territorial mail carrier, Apache County representative in the Thirteenth Territorial Legislature, and deputy for Apache County Sheriff Commodore Perry Owens, and who was a key participant in the event now known as the Pleasant Valley War. Houck established a trading post at this point on the road between Fort Wingate and Horsehead Crossing in 1877.

In 1881, the Atlantic & Pacific Railroad established a siding, station, and water stop here. This and the trading post served as the catalyst for development of a small community with Indian trade and sheep herding being the primary economic foundation.

Automotive traffic resulting from the National Old Trails Highway, later Route 66, had little effect on the small frontier-era town. In his 1946 guidebook, Jack Rittenhouse provided a surprisingly lengthy entry about Houck: "Two establishments here: the White Mountain Trading Post (which includes a post office) and a small curio shop. Gas and groceries here. Navajos are nearly always lounging around the trading post, drinking the soda pop they enjoy."

In the early 1960s, a faux frontier-era military fort constructed of logs opened at Houck under the name Fort Courage. Purportedly, this fort served as an occasional on-site location for the filming of some scenes for the 1960 television program *F Troop*. The fort remained operational as a tourist draw until 2010, but as of this writing, only the gift shop and café remain operational.

The Horn Motor Lodge at 1720 West Central Avenue was the sole attempt by the Horn Oil Company to diversify into motels. Razing of the lodge occurred in 2006, but as of 2011, the remainder of the complex was still standing. *Mike Ward*

HOWARD MOTOR COMPANY

The Howard Motor Company building, 1285 East Colorado Boulevard in Pasadena, California, retains its original façade in an architectural style deemed as Churrigueresque. This heavily ornate baroque styling mimics a type popularized in Spain during the late seventeenth century and revived for many structures at the 1915 Panama California Exposition held in San Diego's Balboa Park.

Because the facility originally opened as a Packard dealership in 1927, the shape of the front showroom window under the ornate façade emulated the trademark shape of the radiator grille on automobiles built by this manufacturer. These unique architectural details remained as of 2011.

The exceptional state of preservation in the details of the façade played an important role in inclusion of the property in the National Register of Historic Places in 1996.

HULL'S MOTEL INN

Hull's Motel Inn, Williams, Arizona, dates to the late 1930s. The 1940 edition of the *Directory of Motor Courts and Cottages* published by AAA notes, "14 cottages with baths, $2 up. 6 house keeping cottages. Air conditioned."

After acquisition of the property by John and Myrtle Smart in about 1947, expansion that included the connecting of the cabins created a seventeen-unit complex with enclosed garages. The motel, at 128 Bill Williams Avenue, still exists and operates under the name Historic Route 66 Inn.

The 1955 edition of the *Western Accommodations Directory* published by AAA lists the property as a complex of "one to three room units" with "central heat and tiled shower or combination baths; 2 housekeeping units; 8 closed garages." Rates listed range from $6.00 to $8.00 per night with lower off-season rates.

HYDRO, OKLAHOMA

The abundance of good well water at this site is purported to be the source for the name. Establishment of a post office under this name occurred on September 23, 1901.

The town remained a small agricultural community until certification of Route 66 in 1926, at which time the development of service industries diversified the economy. One of these businesses—known as Lucille's to enthusiasts of Route 66, a reference to Lucille Hamons who owned and operated the property for almost sixty years—is located immediately east of the town.

This station with living quarters overhead is a near perfect example of roadside service facilities built before 1930 and is now one of the most photographed locations on Route 66 in Oklahoma. Carl Ditmore of Hydro built the facility in 1927 at the Provine intersection, which resulted in it being initially referred to

as Provine Station, a name utilized in the listing of the National Register of Historic Places in 1997.

The prime location led other entrepreneurs to locate businesses here as well. To the west was the Hilltop Café and opposite Provine Station was a Texaco station. Kirk's Court and Café was also located near this location. This court is listed as recommended lodging in the 1940 edition of the *Directory of Motor Courts and Cottages* published by AAA.

In 1941, Carl and Lucille Hamons purchased the property that had expanded to include a store and motel. Hamon's Court, as the property was renamed, survived into the modern era as an almost complete time capsule in spite of numerous setbacks, including closure of the motel in 1962, the death of Carl Hamons in 1971, and the completion of I-40 that resulted in the bypass of Route 66 here in 1962.

In 1974, after the main sign blew down in a storm, Lucille Hamons renamed the property Lucille's. Shortly after decertification of Route 66 in 1985, a resurgent interest in the highway began to develop, resulting in the recognition of properties such as this as tangible links to the storied road's history.

Lucille Hamons died shortly after, in 1999, at age eighty-four. Months later, the Hamons Court sign was accepted by the Smithsonian Institution for inclusion in a developing exhibit chronicling the evolution of Route 66 and its role in American history. As of this writing, a full exterior restoration is completed, but the facility is closed. Additionally, the new owners have built a replica, Lucille's Roadhouse, a restaurant and lounge near exit 84 on I-40.

In June 1948, extensive flooding and a resulting tragedy on Route 66 placed Hydro at the center of national media attention. The *Daily Capital News* on June 25, 1948, reported: "All the deaths so far are at Hydro, in the west central section, where Deer Creek rose in a flash flood Tuesday night and sprang a five mile death trap along U.S. 66 transcontinental highway. A Greyhound bus and more than 50 cars and trucks were trapped in a wall of water that rose swiftly to 12 feet where the creek winds across the highway four times." The article continued by noting the recovery of six dead. It also noted the recovery of seven vehicles without occupants and that three truck drivers were still missing.

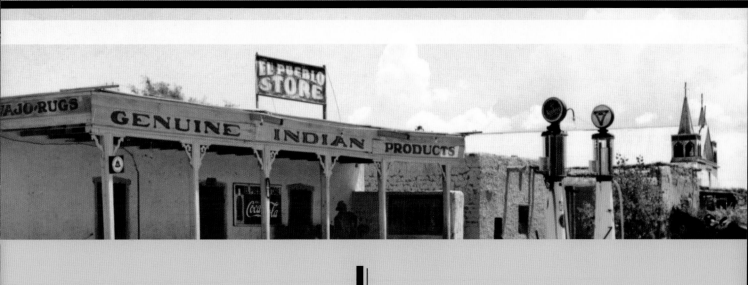

ILLINOIS STATE POLICE OFFICE

The District 6 Illinois State Police Office in Pontiac, Illinois, dates to 1941 and remains an excellent example of an architectural style known as Art Moderne. Indicative of this style is the extensive use of curved corners, smooth surfaces, and glass bricks. These details enabled the building to receive recognition

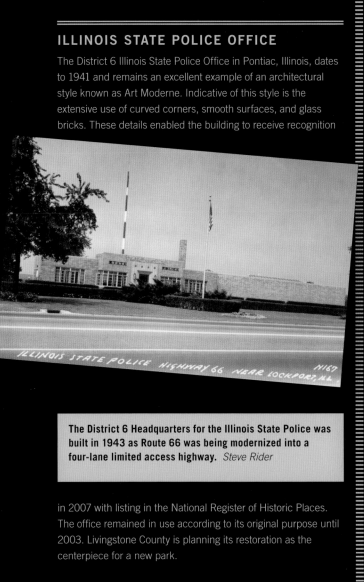

The District 6 Headquarters for the Illinois State Police was built in 1943 as Route 66 was being modernized into a four-lane limited access highway. *Steve Rider*

in 2007 with listing in the National Register of Historic Places. The office remained in use according to its original purpose until 2003. Livingstone County is planning its restoration as the centerpiece for a new park.

INTERNATIONAL FIBERGLASS

In late 1960, Steve Dashew established International Fiberglass to create figures for use as promotional pieces to supplement income derived from his primary business, a small boatyard at the port of Los Angeles at San Pedro in California. To promote the new endeavor, Dashew hired a sales representative and had him drive east along Route 66 with a variety of fiberglass animals in various sizes.

In 1962, the Lumberjack Café on Route 66 in Flagstaff, Arizona, purchased a towering rendition of Paul Bunyan. This

While attending the National Restaurant Association convention in 1965, John and Bernice Korelec purchased an astronaut for $3,500 from International Fiberglass to promote the Launching Pad Drive-In in Wilmington, Illinois. *Judy Hinckley*

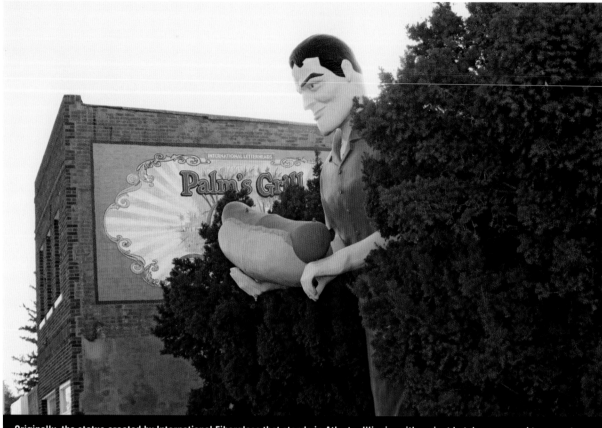

Originally, the statue created by International Fiberglass that stands in Atlanta, Illinois, with a giant hot dog was used to promote Bunyon's Restaurant in Cicero, Illinois. *Judy Hinckley*

INTERNATIONAL FIBERGLASS *continued*

statue now stands on the grounds of Northern Arizona University, whose sports team uses the Lumberjacks name.

American Oil in Las Vegas purchased another copy shortly after this date and indicated to the company that there was a dramatic increase in business after installation. Violet Winslow utilized this recommendation as the basis for an article published in the *National Petroleum News*. Requests for the Bunyan statue, but with slight variations, inundated the company.

To fill orders and defer the expense involved with molds and tooling, Dashew and his staff found creative ways to adapt existing molds, such as filling the beard portion with clay to give the finished product a clean-shaven appearance or adding plaster to the chest for a bare chest look. Additionally, Dashew began manufacturing accessories, such as axes, space helmets, pistols, and hats to personalize the statues. Ironically, the company never manufactured mufflers, even though many of the statues were later outfitted with these and as a result are now collectively known as muffler men. The identifying features for all of the figures were the hands: right palm up and left palm down. Later modifications included arms raised in greeting.

Mohawk Petroleum, a southern California service station chain, ordered several dozen Indians. These were of the bare chest iteration with greeting arms and a headdress. Produced for Phillips Petroleum were 120 cowboys and for Texaco 300 "Big Friends." The order from U.S. Rubber for a Miss Uniroyal with bikini and removable dress represented the first major investment in new molds and tooling. The company also supplied Sinclair with dinosaurs and made statues for A & W as well as Yogi Bear's Honey Fried Chicken.

The company manufactured figures until 1972. Dashew then founded a construction company and a yacht design firm. As a sailor, he set a world speed record under sail.

Numerous statues remain along Route 66. Among the most notable are the Gemini Giant at the Launching Pad Drive-In in Wilmington, Illinois; a Paul Bunyan statue in Atlanta, Illinois, relocated from Berwyn, Illinois; and a former Phillips Petroleum cowboy at a car lot in Gallup, New Mexico.

Documenting and locating the statues produced by this company became a quest for Gabriel Aldaz. His adventure of discovery on Route 66 and other roads became the subject of a book, *Right Palm Up, Left Palm Down: The Log of a Cross Country Scavenger Hunt.*

The first of the now iconic "muffler men" produced by International Fiberglass, and the one that sparked the quest by Gabriel Aldaz chronicled in *Right Palm Up, Left Palm Down*, was sold to the Lumberjack Café in Flagstaff in 1963. *Joe Sonderman*

ISLETTA PUEBLO, NEW MEXICO

Isletta Pueblo is located on the pre-1937 alignment of Route 66 south of Albuquerque. A U.S. post office opened here in 1882, closed in 1883, and after reopening in 1887 continued with uninterrupted operation.

The date of origination for this Tiwa pueblo is unknown, but in an expedition in 1540, Spanish explorers noted its location on an isletta (little island) in the Rio Grande. Additional reports pertaining to the pueblo from the period of Spanish colonization include Governor Antonio de Ortermin's dispatches on the Pueblo Revolt of 1680 and an atlas produced in 1700.

A Santa Fe mail train struck a Pickwick-Greyhound bus traveling from Los Angeles to Denver at the Isletta grade crossing north of the pueblo on April 19, 1930. The immediate death toll

of nineteen made this one of the worst tragedies on Route 66 to date. An inquiry determined the bus driver, F. D. Williams, was striving to make up for time lost because of mud east of Flagstaff. Initially, the driver had slowed for the crossing but then sped up either not seeing the train or misjudging its speed.

The Isletta Pueblo, and its historic plaza and church, remain as a tangible link to New Mexico's earliest history. However, Pueblo regulations require tribal permission before taking photos.

With the exception of the visible register gasoline pumps, this trading post located along the pre-1937 alignment of Route 66 at Isletta, New Mexico, appears to be as ancient as the church next door that was built in 1716. *Steve Rider*

IRWINDALE, CALIFORNIA

Irwindale is a creation of the modern era. Incorporation occurred in 1957, and Irwindale is, and was, primarily an industrial and commercial community. It receives little more than cursory mention in the leading Route 66 guidebooks for the area.

IYANBITO, NEW MEXICO

Iyanbito, a Navajo word meaning "buffalo springs," is located approximately fifteen miles east of Gallup. The date of origination is unknown, but its proximity to the railroad indicates settlement during the period between 1875 and 1880. The town's association with Route 66 appears to be negligible.

J

JACK RABBIT TRADING POST

The Jack Rabbit Trading Post near Joseph City, Arizona, dates to 1949. In that year, James Taylor purchased a small asphalt-shingled building formerly used as a snake farm, refurbished the building, and, to differentiate his business from similar ones along the highway, lined the roof with hopping jackrabbits. He also painted large dancing Indian chiefs on one exterior wall and a large rabbit on another.

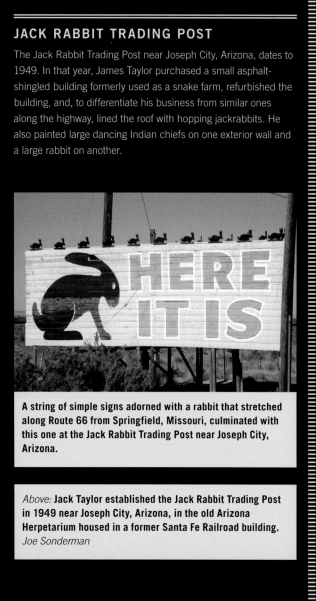

A string of simple signs adorned with a rabbit that stretched along Route 66 from Springfield, Missouri, culminated with this one at the Jack Rabbit Trading Post near Joseph City, Arizona.

Above: Jack Taylor established the Jack Rabbit Trading Post in 1949 near Joseph City, Arizona, in the old Arizona Herpetarium housed in a former Santa Fe Railroad building. *Joe Sonderman*

Additional promotion—developed with Wayne Troutner, owner of the For Men Only Store in Winslow— consisted of a simplistic advertising campaign of placing billboards and other signage showing a hopping rabbit and dancing cowgirl with very little verbiage along Route 66. Springfield, Missouri, was the eventual eastern reach of this campaign.

The final sign was a simple yellow billboard with the black silhouette of a jackrabbit and large red letters spelling out "Here It Is" placed in front of the trading post. Smaller rabbits lined the top.

Taylor profitably operated the facility for two decades before leasing it to Glen Blansett in 1961. In 1967, Blansett purchased the property. The trading post, still operated by this family, is now an internationally recognized icon resulting from the resurgent interest in Route 66 and the cursory appearance of a similar sign in the animated film *Cars*.

JEFFERSON HOTEL

Located at the corner of Twelfth and Locust Streets in St. Louis, the Jefferson Hotel, built to accommodate visitors to the 1904 world's fair, hosted the first meeting of federal officials to designate numbers to the new federal highway system. In the first draft, the highway between Chicago and Los Angeles, U.S. 66, was designated U.S. 60.

In later years, the hotel was adapted into the Hilton and Sheraton chains. As of 2010, it served as a senior citizen housing complex

JERICHO, TEXAS

Less than a dozen miles to the west of Alanreed are the forlorn remnants of Jericho, a small community with origins dating to 1902 and the establishment of a station on the Chicago, Rock Island & Gulf Railway. Ironically, traffic on Route 66 made the early days of the Great Depression the glory days for Jericho.

At its peak during the early 1930s, the town boasted three stores, a grain elevator, a tourist court, a garage, and a filling station. The realignment of the highway and changing face of agriculture in the Panhandle fueled the town's demise, and in 1955, the population no longer was sufficient to warrant a post office.

The original alignment of Route 66 from Jericho to Groom is notorious in the annuls of the highway's history. This section known as the Jericho Gap was infamous for mud, ruts, and enterprising farmers ready to rescue a motorist for a few dollars. The Texas Department of Transportation began work to close the gap with a paved bypass in 1928 and completed the project in late 1931.

For early motorists, Jericho, Texas, a ghost town on the pre-1932 alignment of Route 66, was spoke of with dread for its association with the often-muddy Jericho Gap.

JOLIET, ILLINOIS

Louis Jolliet, the French explorer who camped near this site in 1673, is the indirect namesake for this community. A map attributed to Joliet from 1674 designates a sixty-foot-high ridge, leveled through quarrying in the nineteenth century, along the Des Plaines River as Mont Joliet. The map, completed by cartographer Thomas Hutchinson in 1778, identifies this feature with the spelling of Juliet. As a result, the initial platting of the town site by James B. Campbell, treasurer of the board of commissioners of the Illinois & Michigan Canal, in 1834 utilized this name.

Conflicting use of both names occurred on maps and records into the mid-nineteenth century. However, in general the Juliet name referred to the community and Joliet to the geographical feature. Rectification of the discrepancy was the result of petitions filed with the state legislature in 1842. From 1845 forward, the date of the application for a post office, the official name for the community was Joliet.

Joliet has a unique history with regard to development of the marked trails period of automobile roads and the infancy of the U.S. highway system. Immediately south of Joliet, the section of highway now signed as State Route 59 and U.S. Highway 30 is the only place where the Lincoln Highway and U.S. Highway 66 utilized the same roadway. Additionally, the junction of two major east-west transcontinental U.S. highways is in Joliet. At the intersection of Cass and Chicago Street, U.S. Highway 6, originally connecting Cape Cod in Massachusetts with Long Beach in California, crosses U.S. 66.

Initially, the Route 66 association with the community was via Joliet Road. At some point around 1933, realignment though Plainfield bypassed Joliet with the former route becoming Alternate 66. Other roads in Joliet utilized by U.S. 66 include Chicago Street, Scott Street, Ottawa Street, Van Buren Street, and Washington Street. State Highway 53 in the city utilizes much of the original course of Route 66.

The *AAA Hotel Directory* published by AAA in 1929 contains four hotel recommendations for lodging: Oliver, Woodruff, Hobbs, and Walker. The service station directory published in the same year lists four recommended garages: Drifus Auto Service Company, A. C. Johnson & Son on the corner of Fourth and Eastern Avenue, Stoll's Garage at 109 Washington Street, and G. G. Garage at 1001 West Jefferson Street.

The 1955 edition of the *AAA Western Accommodations Directory* lists numerous motels but only one on Route 66: "Manor Motel at junction of U.S. 6 and U.S. 66. A fine court nicely situated back from highway. Attractively furnished rooms have central heat and tiled shower or combination baths; radios and TV available. Playground." Rates listed are $5.50 to $8.00 per night.

Attractions of note, including several with direct association to Route 66, are numerous. Some of the most notable are the building that housed the first Dairy Queen (501 Chicago Street), the Route 66 Experience and Visitor Center, the Joliet Area Historical Museum complex, and the jail built in 1858.

The museum, housed in a former church that dates to 1909, is located at the corner of Cass Street and Ottawa Street, the junction of Route 66 and the Lincoln Highway. The Route 66 Experience encapsulates travel on this storied road before the advent of the interstate highway system through a wide array of interactive exhibits, including a drive-in theater-modeled snack bar, a mock motel room with functioning Magic Fingers bed, and a ceiling mural that portrays the entire course of the highway.

The fully refurbished Rialto Square Theater, built in 1926 facing Chicago Street, Route 66, consistently receives inclusion in listings of the most beautiful theaters in the nation.

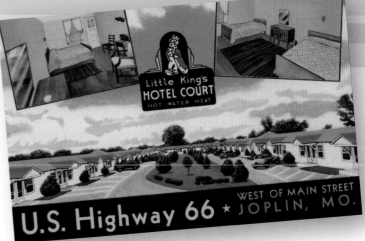

The Little King's Hotel Court was one of the largest complexes in Joplin during the early 1950s with sixty rooms and seventy-five double beds. *Steve Rider*

The architects utilized Italian Renaissance, Byzantine, Greek, Baroque, and Roman architectural elements. Interior accoutrements include a massive Barton Grande Organ that rises hydraulically from the floor and more than one hundred hand-cut crystal chandeliers. One of these, deemed the Duchess, is the largest of its kind in the United States.

Counted among the many unique ways in which this city utilizes its association with Route 66 to inspire walking tours of the city is through the placement of vintage gasoline pump replicas that serve as information kiosks at key locations. Another is Route 66 Park with a Rich & Creamy ice cream stand.

JONES MOTOR COMPANY

Ralph Jones was one of the most prominent businessmen in Albuquerque. Additionally, he was the president of the Route 66 Association and a leading member of that city's chamber of commerce.

In 1939, he hired architect Tom Danahay to design a building that would serve as an automobile dealership and service station on Central Avenue, Route 66. The attractive complex tastefully utilized white stucco and red brick trim to accentuate the decorative steeped tower and large display windows.

In 1957, Jones Motor Company relocated to a new, modern facility. The original property, listed in the National Register of Historic Places in 1993, changed hands numerous times.

In 1999, after extensive renovation that included the placement of vintage Texaco gasoline pumps and refurbishment of original service bay doors, the facility reopened as Kelly's Restaurant & Brew Pub. It remains a popular attraction for Route 66 enthusiasts as well as locals and received recommendation by the National Historic Route 66 Federation with a listing in the fifteenth edition of its *Route 66 Dining & Lodging Guide*, published in 2011.

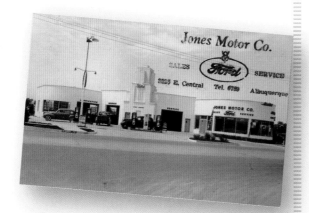

Listed in the National Register of Historical Places in 1993, the Jones Motor Company complex dates to 1939 and, after extensive renovation, reopened in 2000 as Kelly's Brew Pub. *Steve Rider*

JOPLIN, MISSOURI

The namesake for Joplin is Reverend Harris G. Joplin, who established the first Methodist congregation in Jasper County in about 1840. Until passage of a resolution by the state legislature unified them under one name, there were four communities here: East Joplin, West Joplin, Union City, and Murphysburg.

Overshadowing Joplin's importance as a terminus for several western frontier trails was the discovery of large deposits of lead and zinc in the area. The community sits at the western edge of a tristate belt of mineralization that includes the southwestern corner of Kansas and the northwestern corner of Oklahoma. During the years bracketing World War I, this constituted the largest lead mining district in the world. Additionally, several large quarries that produced limestone of exceptional quality were in the Joplin area.

Large estates, stately homes, and a substantial business district reflected this prosperity. The creation of the Ozarks Trails Highway System, and Route 66 after 1926, served as the foundational component in the development of an extensive service-related industry.

The travel guide written by Jack Rittenhouse in 1946 listed numerous hotels, motels, auto courts, and garages, including the hotels Connor (also listed in the *Hotel, Garage, Service Station and AAA Club Directory* for 1927) Yates, Keystone, and Virginia. Motels and auto courts listed included the Koronado Kourts, Trail Inn, Golden Glow, Castle, Mack's, Gateway, Star, Tivoli Park, Sunset, Joplin Courts, and Joy Vista. Of these facilities, the Koronado Kourts, 1717 West Seventeenth Street, received very high recommendations from AAA. This early chain operated additional facilities in San Antonio and Corpus Christi, Texas. The correct title for the properties was Koronado Hotel Courts.

The 1940 edition of the *AAA Directory of Motor Courts and Cottages* noted this was a " . . .thoroughly modern court of 60 cottages, all with bath, nicely furnished, steam and safety controlled gas heat." The 1954 edition of the *Western Accommodations Directory*, also published by AAA, expanded on the amenities available: "Rooms have air conditioning or fans, radios,

vented heat and tiled shower baths; 40 locked garages. Connecting rooms. Air conditioned coffee shop. Telephone and telegraph service. Reservations advised." As of 2011, a Walmart Supercenter occupies the site.

The Rittenhouse guide also noted a lengthy list of repair facilities. These included Rayl-Stanley, Reno Motor Company, Bob Smith's, and Bill's. The *Service Station Directory*, published by AAA in 1946, lists only Rayl-Stanley Motors.

The *AAA Western Accommodations Directory* for 1954 offers an indication that the postwar boom in tourism and travel on Route 66 further fueled a segment of the economy that was increasingly important to the community after the closure of area mines. In this directory are listed five motels—Castle Motel, The Elms Motel, The Madison Motel, Plaza Motel, and Rancho Motel—and two restaurants, Bob Miller's and Wilder's.

The 2011 tornado that devastated the city missed the Route 66 corridor that includes Main Street, Seventh Street, Broadway, St. Louis Street, and Euclid, Florida, Zora, and Madison Street. Numerous structures along this corridor have lengthy association with Route 66, including the building used by Dale's Barber Shop in 2010 at Utica and Euclid that was initially the Shamrock Inn, a DX gas station, and café complex that opened in 1930. The West Seventh Street Apartment complex is the recent incarnation of Little King's Hotel Court.

The Hotel Connor, right, opened in 1908. During demolition in the fall of 1978, the building collapsed, killing several workers. *Joe Sonderman*

JOSEPH CITY, ARIZONA

The initial settlement by Mormon pioneers on the Little Colorado River established in the spring of 1876 as Allen City was five miles north of the current town site. The establishment of a new town—St. Joseph, named for Joseph Smith—three miles to the south precipitated abandonment that fall.

In about 1900, a new town site established two miles to the southwest along the main line of the Atchison, Topeka & Santa Fe Railroad utilizing the name St. Joseph led to abandonment of the previous community. To avoid confusion with St. Joseph, Missouri, the railroad requested a name change to Joseph City before establishment of a station.

Agriculture remained the primary economic mainstay of the community, even with the increase in automotive tourism resulting from the National Old Trails Highway, Route 66 after 1926. An Arizona tourism guide from 1946 indicates the population was 308, and services available included two auto courts, Hopi Village and Oasis, a garage/gas station, and a general store. This corresponds with material provided by Jack Rittenhouse in the same year. The 1954–55 *AAA Western Accommodations Directory* lists only the Pacific Motel with rates ranging from $4.00 to $8.00. No listings or recommendations for service facilities are provided.

Joseph City, the oldest existing Mormon colony in Arizona, remains a small, active community even though the bypass of U.S. 66 by I-40 negated most traffic through town. To the west of town on a truncated section of the old highway are the ruins of San Diego Rawson's Frontier Days Trading Post, a favorite of tourists from the mid-1930s to the late 1940s.

JOSHUA MOTEL AND CAFÉ

The Joshua Motel and Café opened in Yucca, Arizona, in 1953, the year after completion of the realignment of Route 66 to bypass the grades and curves of Sitgreaves Pass in the Black Mountains. The motel remained in operation until the 1970s and the café until the early 1980s. After this date, the property served in a variety of capacities, including as offices and apartments. As of the fall of 2011, the complex was in ruins.

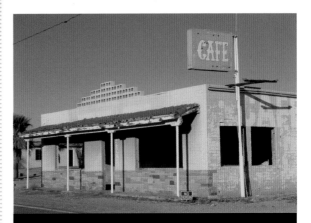

The empty shell of the Joshua Café in Yucca, Arizona, is but one of many faded vestiges from that brief moment between the realignment of Route 66 in 1952 and the dawn of the interstate highway.

KEL-LAKE MOTEL

Ernest J. Jackson served as proprietor of the Kel-Lake Motel, located across from Lake Kellogg at Carthage, Missouri, from 1955 to 1965, when the facility developed a reputation as a place where the less fortunate traveler was welcome. It also maintained a reputation for basic, clean lodging that earned it an AAA recommendation.

With the completion of Interstate 44, business plummeted, and Jackson sold the property. Surprisingly, the motel remained a viable enterprise and as of 2010 was still in business.

KELLYVILLE, OKLAHOMA

Named for James E. Kelly, a local merchant, the town established a post office under this name on November 27, 1893, which is the consensus for date of origination. Agriculture, primarily cotton, served as the economic foundation for the community. Diversification came with the establishment of Route 66 and the Devonian Oil Company refinery.

Jack Rittenhouse noted in 1946 that Kellyville was "a small community with about ten business establishments." With the completion of the Turner Turnpike, and subsequent bypass of the community in 1953, a number of these businesses closed.

A unique vestige of Route 66 is found on a loop road designated Old Highway 66 near Kellyville. For almost two miles, a concrete section of the original 66 alignment dating to the mid-1920s passes through an old tank farm.

KENTWOOD ARMS HOTEL

John Woodruff, a Springfield, Missouri–based property developer and the first president of the U.S. Highway 66 Association, built the Kentwood Arms Hotel in 1926. The *Hotel, Garage, Service Station, and AAA Directory*, published by AAA in 1927, provided an extended entry describing the property: "100 rooms, each with private bath or in connection. European plan $2–$4 single, $3–$6 double. Main dining room and grill with a la carte and table d'hote service. In the heart of the city. With 3 acres of lawn shaded by giant forest trees. 18 hole golf course, roof garden and concerts."

Built in 1926 by John T. Woodruff, first president of the U.S. Highway 66 Association, the Kentwood Arms Hotel received AAA recommendation every year from 1927 through 1958. It is now the Kentwood Hall dormitory at Missouri State University. *Mike Ward*

The property retained its status as a premier hotel for more than twenty years. The *Western Accommodations Directory*, published by AAA in 1955, noted that the Kentwood Arms Hotel was "a very good, modern, completely air conditioned hotel on attractive spacious lawns. Nicely furnished guest rooms, some connecting. Free radios. Suites $12 up. Dining room serves delicious food; grill and cocktail lounge."

In 1984, Southwest Missouri State, now Missouri State University, acquired the property. It now serves as Kentwood Hall Dormitory.

KIMO CAFÉ

Name selection for the Kimo Café, and adjoining Shell station, was a blending of "Ki" from Kingman and "Mo" from Mohave County. The property located directly across from the Desert Power and Water House, now the Powerhouse Visitor Center, opened in late 1938.

It remained open until the 1980s. After acquisition by the Dunton family during this period, enclosure of the station island was completed, the facility was brightly painted, and it was renamed Mr. D'z Route 66 Diner. In this capacity, it continues in operation at 105 East Andy Devine Avenue in Kingman, Arizona.

In May 2006, Oprah Winfrey filmed a segment for her television program here and declared the root beer to be the world's best. She purchased several cases of the restaurant's signature product and shared it with her audience on a future program.

With origins dating to 1938, Mr. D'z Route 66 Diner in Kingman, Arizona, is a Route 66 time capsule preserving remnants of more than seventy years of the highway's evolution. *Mike Ward*

KIMO THEATER

Built by the Boller Brothers for a cost of $150,000 for Oreste Bachechi in 1927, the KiMo Theater utilizes steel framing and brick facing with design trim that presents a unique blending of Pueblo Revival and art deco styling in its construction. Modernization in the early 1950s resulted in a replaced marquee and redesigned entrance.

The interior featured extensive use of Native American themes, including a ceiling that imitated a ceremonial kiva decorated with murals, vents painted to appear as Navajo rugs, light fixtures in the shapes of war drums, and buffalo skulls with amber eyes. Oil murals painted by renowned artist Carl Von Hassler depicted the legendary Seven Cites of Cibola.

In 1961, a fire destroyed the center stage and other aspects of the theater. These were replaced with modern elements, and in 1968, the theater closed.

An intervention by concerned citizens of Albuquerque in the mid-1970s prevented the structure from being razed. Listing on the National Register of Historic Places occurred in 1977, and renovation commenced in 1981. Completion of the restoration occurred in time for extensive celebrations of the seventy-fifth anniversary of Route 66 in 2001, and in the summer of 2011, replacement of neon signage served as the centerpiece of a major celebration.

KINGMAN, ARIZONA

There is evidence to suggest the first European association with the oasis at Beale Springs northwest of present-day Kingman occurred during the explorations of Father Francisco Garces in 1776. The namesake for the springs, Lieutenant Edward Beale, camped here in 1857 during the survey expedition made famous for its use of camels.

The springs were an important stop for travelers on the Beale Wagon Road, as well as the Mohave Prescott Toll Road, that linked the Colorado River port of Hardyville with Fort Whipple near present-day Prescott. The importance of these roads to the development of northwestern Arizona led to the establishment of Fort Beale at this location in 1871.

During the wars with the Hualapai Indians during this period, the fort played a key role in concluding the hostilities. Before relocation of the subjugated Hualapai Indians to the reservation along the Colorado River, the fort served as the headquarters for the temporary reservation.

In 1883, Conrad Shenfield, a railroad contractor, established a construction camp southwest of Beale Springs at the present town site. Beale Springs and Cottonwood Springs in nearby Johnson Canyon were the primary sources of water for Shenfield Railroad Camp.

With completion of the Atlantic & Pacific Railroad through the camp, and establishment of a station and siding, the town

CASA LINDA CAFE — KINGMAN, ARIZONA

Clara Boyd, a former Harvey Girl, and her husband, Jimmy, opened the Casa Linda Café at 511 East Andy Devine Avenue in Kingman, Arizona, in 1933. *Joe Sonderman*

site was renamed Kingman in reference to Lewis Kingman, the railroad location engineer. Its central location to the mining camps of the Cerbat Mountains, as well as the vast cattle ranches in the Hualapai and Sacramento Valleys and access to the railroad made Kingman a key supply and shipping center in northwest Arizona. This prominence played a key role in the decision of the Arizona Territorial Legislature to make Kingman the Mohave County seat in 1887. Growth remained steady even through economic periods of duress in the 1890s and in 1907.

Automobile tourism was added to the economic importance of mining, ranching, and the railroad with designation of the National Old Trails Highway. Kingman played a pivotal role in the final selection of the route for this road, which became Route 66 after 1926.

Initially, the National Old Trails Road Association and the Ocean-to-Ocean Highway Association joined forces as the National Old Roads Ocean-to-Ocean Highway Association to avoid wasted resources of finances and time. The common link in their endeavor was the agreement to use the section of the Trail to Sunset that followed the route from Santa Fe to Springerville in Arizona and then south to Phoenix with a crossing of the Colorado River at Yuma.

While this association promoted its route as the southwest link in the proposed national transcontinental highway, a new organization composed of business leaders from Kingman and Needles, California, and later from Barstow and Victorville, initiated a concerted effort for consideration of an alternative route. Their proposal was that the highway should follow the tracks of the Santa Fe Railroad from Albuquerque, across northern Arizona and the deserts of California.

Bolstering the proponents' claims of this being a more practical route were the availability of services provided by the Fred Harvey Company along the railway and the proximity of attractions, such as the Grand Canyon, that would foster development of tourism-related service industries. To solidify their position, the Mohave County Good Roads Boosters gathered in Needles in the fall of 1912 to develop a cohesive list of benefits for presentation at the second convention of the National Old Trails Road Ocean-to-Ocean Highway Association scheduled for April 1913.

The primary spokesmen at the convention were G. D. Hutchison, vice president of the California contingent, and John R. Whiteside, vice president of the Arizona contingent from Kingman, a city that had hosted several leading national candidates as well as representatives from the Arizona Good Roads Association. The arguments made were persuasive, and when coupled with volumes of evidence attesting to the quality of the roads on the northern route, the constitution was amended to adopt the northern path as the official route of the National Old Trails Highway west from Santa Fe.

Promotion of the route commenced immediately. Additional publicity came with events such as the Desert Classic "Cactus

Derby" automobile race that followed this course in 1914 with Kingman designated as a stop.

The National Old Trails Highway, and later Route 66, led to the creation of an extensive tourism-related service industry in Kingman. The 1927 edition of the *Hotel, Garage, Service Station, and AAA Directory* lists the Beale and Brunswick Hotels as recommended lodging. Both structures still exist, although they are closed as of this writing.

The *AAA Directory of Motor Courts and Cottages* for 1940 lists five auto courts: Akron Hotel Cottages, Arcadia Court, El Trovatore, Gypsy Garden, and Wal-A-Pai. In the guidebook by Jack Rittenhouse published in 1946, additional auto courts are listed: Williams, Kit Carson Motel, Stony Wold, Bungalow, White Rock, Lambert's, Gateway Village, Bell's, Stratton's, Kingman, and Challenger.

The *AAA Western Accommodations Directory* for 1954–55 adds to these the Branding Iron, Hillcrest Motel, and the Loma Vista Motel, just north of the junction of U.S. 66 and U.S. 466, now U.S. 93. Not listed in these guides are the Siesta, Coronado Court, Harvey House, or Commercial Hotel.

Surprisingly, a number of the facilities listed in these directories, and others with association to Route 66, still exist, even though they are closed, serve as weekly or monthly

A string of parks and museums dominate the roadside along Route 66 at the west end of Kingman, Arizona. The centerpiece of Locomotive Park is a massive 1920s Baldwin mountain locomotive and caboose. *Steve Rider*

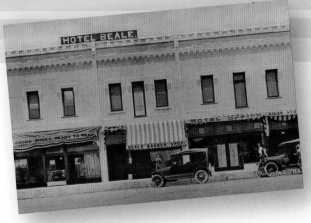

The proprietor of the Hotel Beale in Kingman, Arizona, during the mid-teens was Tom Devine, father of character actor Andy Devine. Route 66 in front of the hotel is signed Andy Devine Avenue. *Steve Rider*

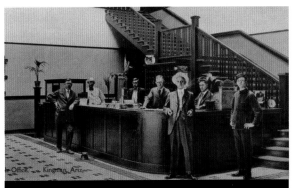

Surprisingly, even after years as serving as a flophouse and longtime abandonment, the lobby of the Hotel Beale has changed little from this view in about 1920. *Steve Rider*

apartments, or have been converted for other uses. Among these are the Siesta, 1929; Allen Bell's Flying A service station, now Lomeli's Garden Arts; and the Pony Soldier Motel, now the Route 66 Motel. Others include the Hillcrest Motel and Hill Top Motel, 1954; El Trovatore, 1939; TraveLodge and Barandin Iron Motel, 1953; Arcadia Lodge, 1938; Jade Restaurant, 1951; Lockwood Café and Casa Linda Café, 1933; White Rock Court, 1935; and Old Trails Garage, 1914.

During World War II, establishment of the Kingman Army Airfield east of Kingman along Route 66, and supportive infrastructure as well as auxiliary bases, effectively doubled the population. At its peak, this airfield became the largest flexible gunnery school in the nation.

Celebrity association with Route 66 in Kingman is lengthy. In 1914, Louis Chevrolet and Barney Oldfield made a pit stop here during the grueling Desert Classic "Cactus Derby" race.

Tom Devine, father to the character actor Andy Devine, owned the Beale Hotel. Front Street became Andy Devine Avenue in the late 1950s during a commemorative celebration that commenced with an episode of the television program, *This Is Your Life*.

Clark Gable and Carole Lombard married at the Methodist church in Kingman in 1938. They drove Route 66 to Oatman, where they spent their first night as husband and wife.

Charles Lindbergh selected Kingman as the first stop between Los Angeles and Winslow for his fledgling airline service in 1928. He frequently stayed at the Beale Hotel during construction of the airfield, and Amelia Earhart joined him for the ribbon-cutting ceremony.

Bob "Boze" Bell, acclaimed artist and executive editor for *True West* magazine, grew up in Kingman. His father, Allen Bell, managed several businesses here with the most notable being the Flying A station, a facility where Bob Bell worked as a young man.

On July 6, 1973, a railroad tank car filled with propane on a siding that parallels Route 66 caught fire, exploded, killed four firemen, and injured seventy individuals. The explosion caused extensive damage in the area, including to the Hobb's Truck Stop and Whiting Brothers station. The resulting fires caused the closure of the highway and the railroad for several hours. A memorial dominates Fireman Park about one mile north of Route

66 in Kingman. The tragedy became the subject of a training course for fireman throughout the nation.

Route 66 continues to play a key role in the tourism industry in Kingman. Most notable is the annual Route 66 Fun Run, hosted by the Route 66 Association of Arizona that attracts thousands of international automotive enthusiasts every May.

KINGMAN ARMY AIRFIELD

Initial plans for the Kingman Army Airfield, established May 27, 1942, as the Army Air Force Flexible Gunnery School and renamed in May 1943, were to utilize the facility as a training center for gun crews of B-17 heavy bombers. Expansion of training programs commenced shortly after activation of the first class on August 10, 1942.

These additional classes included a full range of gunnery: ground to air, air to ground, and air to air. Additionally, there were also bomber copilot transitional classes and classes for Women Air Service Pilots (WASP).

Through an arrangement with Warner Brothers Studios and the Department of Defense, Bugs Bunny became the airfield's official mascot. USO tours arrived by air and rail.

On January 7, 1944, a bus transporting air cadets from the gunnery range on the north side of Route 66 was struck by a freight train at the entrance to the airfield. The death toll of twenty-seven made this the worst bus and train collision in Arizona history to date.

On February 25, 1946, after training more than thirty-six thousand gunners, Kingman Army Airfield was deactivated and on February 26, 1946, was designated Storage Depot 41. Shortly after this designation, the former airfield became the largest storage facility for military aircraft in the world. The depot processed aircraft as scrap, as complete units sold wholesale, and as parts. In this manner, more than 5,600 aircraft were liquidated before closure of the facility on July 1, 1948—the date the airfield became the Mohave County Airport.

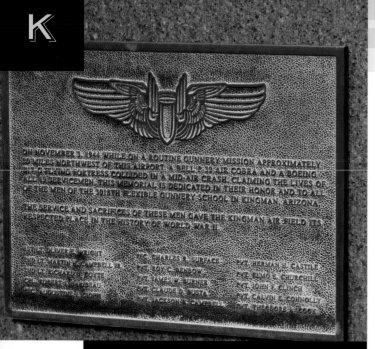

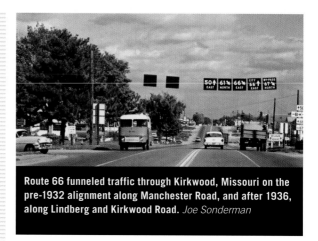

Route 66 funneled traffic through Kirkwood, Missouri on the pre-1932 alignment along Manchester Road, and after 1936, along Lindberg and Kirkwood Road. *Joe Sonderman*

The collision between a train and bus at the entrance of the Kingman Army Airfield along Route 66 in 1944 spurred the construction of an underpass. This commemorative plaque and the original airfield control tower are located at the airport terminal building. *Steve Rider*

KINGMAN ARMY AIRFIELD *continued*

With closure of the base, most structures—including the barracks, the base hospital, the headquarters, and the officers club—sold at auction, were dismantled, and then were utilized for other purposes in Kingman, including as the chamber of commerce offices and Arizona Department of Transportation offices. Development of the former base as an industrial park obliterated other traces of it.

As of 2011, two large hangars, a former machine shop that serves as the temporary home for the Kingman Army Airfield Museum, and the control tower, one of two in the nation, existed as remnants from the airfield. To the north of Route 66, across from the airport entrance, there are extensive vestiges from the primary gunnery range.

KIRKWOOD, MISSOURI

Kirkwood, named for James Pugh Kirkwood (chief engineer of the Pacific Railroad responsible for the establishment of the railroad's route), is purportedly the first planned residential community west of the Mississippi River in Missouri. The Kirkwood name dates to 1852, but names used before this date were Dry Ridge and Collins Station.

By the late nineteenth century, the city of St. Louis had become a gritty industrial community. Hoping to capitalize on this, developers initiated promotion of Kirkwood, thirteen miles to the west, as a haven. The railroad played a primary role in this promotion, and a modern depot opened in 1893. The depot still serves its original purpose, since it is a stop for Amtrak.

In the guidebook by Jack Rittenhouse published in 1946, Kirkwood received notation as a point of reference. "Your first speedometer reading is at a 'cloverleaf' intersection on the west side of St. Louis, where City 66 meets Bypass 66. If you have driven over Bypass 66, you will make a right turn at this intersection 2 miles south of Kirkwood," it noted. The *Service Station Directory*, published by AAA in the same year, lists Kirkwood Motor Service for repairs.

This cloverleaf interchange, opened in 1931, was the first of its kind west of the Mississippi River. Trimmed in pink granite, the bridge remained in use until completion of its replacement in 1980.

The fifteenth edition of the *Route 66 Dining & Lodging Guide*, published by the National Historic Route 66 Federation in 2011, lists Spencer's Grill at 223 South Kirkwood Road, Bypass 66, for dining. This diner dates to 1947.

KORONADO HOTEL KOURTS

The 1955 edition of the *Western Accommodations Directory* published by AAA notes that the Koronado Hotel Kourts at 1717 West Seventh Street in Joplin, Missouri, featured all modern amenities and had radios available upon request. After the demolition of the complex, a Walmart Supercenter was built on the site.

In 1940, as "a thoroughly modern court," the Koranado Kourts (a pioneering lodging chain) in Joplin at 1717 West Seventh Street warranted an extensive entry in AAA lodging guides. *Mike Ward*

LA BAJADA HILL

The initial road down the face of La Bajada Mesa dates to the establishment of the Camino Real de Tierra Adenerto in about 1640. Later improvements to the road through the nineteenth century reflected the increasing traffic that came as a result of Spanish colonization, American acquisition of New Mexico, and subsequent settlement, as well as the needs of the military.

Contractors using convict laborers and Cochiti Indians for improving the road for motorists commenced in 1909. The January 27, 1911, issue of the *Santa Fe New Mexican* featured a special "Good Roads" section profiling territorial-wide road improvement projects: "Construction work was begun in November, 1909, and the road built from La Bajada to Algodones, a distance of 19.5 miles. At La Bajada Hill was found the hardest work on the road and for most part of this distance was solid lava rock. This work was done by a force of convicts from the Penitentiary and by Cochiti Indians. The Good Roads Commission was assisted by the Indian Service to the extent of $1,000.00 used to hire Indians to work on the hill."

Even with these improvements, the road dropped eight hundred feet in 1.6 miles through a series of twenty-three switchbacks. Still, early motorists saw the improvements as evidence that New Mexico was at the forefront of building a modern highway system.

In the early spring of 1912, William Randolph Hearst, the managing editor for the *Los Angeles Examiner* and publishing magnate, sent Charles Lawrence, the automotive editor, and his driver, Harvery Herrick, to evaluate road conditions on the Ocean-to-Ocean Highway and other roads in the Southwest. The Santa Fe Automobile Club met them at the crest of La Bajada Hill and escorted them to the city for a gala reception.

In an interview with the *Santa Fe New Mexican* on April 12, 1912, Lawrence said, "The roads of this state are far better than

those of Arizona and the latter are far better than any we encountered in California. It seems that the further east we go the better the highways are cared for."

Comments about La Bajada Hill by Emily Post in *By Motor to the Golden Gate*, published in 1916, present an interesting picture of road conditions on the hill during this period. She wrote, "The best commentary on the road between Santa Fe and Albuquerque is that it took us less than three hours to make the sixty-six miles, whereas the seventy three from Las Vegas to Santa Fe took us nearly *six*. The Bajada Hill, which for days Celia and I dreaded so much that we did not dare speak of it for fear of making E.M. nervous, was magnificently built. There is no difficulty in going down it, even in a very long car that has to back and fill at corner; there are low stone curbs at bad elbows, and the turns are all well banked so that you feel no tendency to plunge off. A medium length car with a good wheel cut under would run down the dread Bajada as easily as through the driveways of a park!"

Emily Post's trip took place in the same year that the *Santa Fe New Mexican* featured several articles on road improvements in the area. One article begins with the following caption: "Spectacular Pass Over Famous La Bajada Hill on Ocean to Ocean Highway Now Made Safe for Amateur Motorists."

A front-page article detailing a drive from Albuquerque to Pecos (over a somewhat improved road that was utilized by Route 66) in the *Albuquerque Journal* on August 4, 1929, presents a similar picture. It said, "Leave Albuquerque going north on Highway 66 out past the Bernalillo County Court House and the Oden Buick Garage. Continuing on this highway to Santa Fe in the beautiful Oakland Landau sedan, La Bajada Hill turned into a delightful boulevard that wound away behind the car as though it were a level road. The driver did not shift into second until almost to the top."

LA BAJADA HILL *continued*

This "improved" road was used from November 1926 to late summer of 1931 for Route 66. The *El Paso Herald Post*, on July 25, 1931, featured an article about improving road conditions and highway development in New Mexico that stated, "The new highway eliminating La Bajada Hill will be opened to traffic within the next two or three weeks, Frank Butt, chairman of the state highway commission, said."

LA CITA

The first La Cita restaurant opened at the corner of Highway 66 and First Street in Tucumcari, New Mexico, in 1940. In 1961, a new building with an entrance capped by a large, neon-trimmed sombrero replaced the older facility at 812 First Street.

The restaurant closed in 2004. With new ownership and renovation, it reopened in 2006. As of early 2011, it remained operational.

LA FONDA

The La Fonda at the southeast corner of the plaza in Santa Fe, New Mexico, dates to 1922. However, an inn has stood at this corner since 1610.

In 1926, the Atchison, Topeka & Santa Fe Railroad, the owning company, leased the property to the Fred Harvey Company, and it became one of the Harvey Houses. The La Fonda remains as one of the city's premier historic hotels.

The *Western Accommodations Directory*, published by AAA in 1954, provided an extensive review of the property. It noted, "Unique furnishings and atmosphere. Most guest rooms have Spanish style furnishings. Living room suites, $25 to $40. Dinner dancing in New Mexico Room; outdoor dining in summer. Spanish cocktail lounge. Curio shop. Hotel parking lot. A Fred Harvey hotel."

The *Route 66 Dining & Lodging Guide*, fifteenth edition, published by the National Historic Route 66 Federation in 2011, also provides an extensive but concise recommendation. Rates listed range from $219 to $339.

LA GRANGE, ILLINOIS

Originally platted as Hazel Glen, the name used on the first application for a post office approved on May 31, 1866, an amended application, approved on December 16, 1868, changed the name to West Lyons. However, locals referred to it as Kensington Heights, a reference to a development in the area.

The name change to La Grange occurred after the site's purchase by Franklin D. Cossitt, a native of La Grange, Tennessee,

The 1939 edition of the AAA, published *Directory of Motor Courts and Cottages* lists the Orchard Rest in La Grange as a tourist camp consisting of 15 cabins with public baths and cooking facilities. *Steve Rider*

a community named for the estate of the Marquis de Lafayette, in 1871. Approval of the amended postal application that made the name change official occurred on January 21, 1876.

The 1940 edition of the *Directory of Motor Courts and Cottages* published by AAA lists two recommended lodging establishments: Groves Camp three miles south on U.S. 66 and Wolf Road Tourist Camp with fifteen cabins. A service station and garage directory for the same years lists Boswell Service & Towing and Loomis Brothers.

The 1955 edition of the *Western Accommodations Directory* published by AAA lists three recommended motels on Route 66: La Grange Motor Hotel, Redwood Motor Lodge, and Wishing Well Motor Court. All three properties garnered extensive but concise reviews.

LAGUNA, LAGUNA PUEBLO, NEW LAGUNA, NEW MEXICO

The tradition of the Keresan-speaking Pueblo Indians is that their people have lived at the site of Laguna Pueblo for at least seven hundred years. The location was selected because of a natural

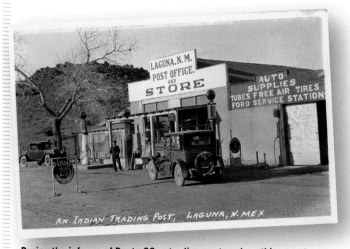

During the infancy of Route 66, a trading post such as this one at Laguna was more than a tourist trap; it was a veritable oasis offering repairs, supplies, gasoline, and oil. *Steve Rider*

dam on the Rio San Jose that created a lake. The Keresan word for lake is *kawaik*. The Spanish word for pond or marsh is *laguna*.

The first European references to the lake and the people here are contained in reports from the Coronado expedition of 1540. The lake existed well into the late nineteenth century.

Construction of the current pueblo dates to 1698. The following year, the governor, Pedro Rodriguez Cubero, stopped at the pueblo for a ceremony that resulted in the naming of the community as Laguna.

The creation of numerous satellite villages was the result of increasing population. Among these were Laguna, originally Cuba, and New Laguna. A U.S. post office has operated at Laguna Pueblo since 1879. The post office in New Laguna dates to 1900.

Laguna dates to the establishment of a village named Nacimiento that appears on maps of the Dominguez-Escalante expedition of 1776. The site for this settlement is just to the east of present-day Laguna.

Persistent Navajo raids led to abandonment in the first years of the nineteenth century. Resettlement commenced in about 1878 under the name Cuba. Shortly after this date, establishment of a suburb at the present site eclipsed the original community, resulting in a second abandonment. For reasons unknown, the Cuba name was not continued. Establishment of a post office in 1887 was under the name Laguna.

Jack Rittenhouse in his guidebook, published in 1946, provided a lengthy overview of Laguna Pueblo and Laguna. He noted that services were limited to a small grocery store and service station.

Route 66 through the area of Laguna and the pueblo is a scenic drive full of twists and turns past rocky outcroppings and stone buildings of indeterminate age. The San Jose Mission, best viewed from a pullout on Interstate 40 south of town, dates to 1699, and is a favorite photo stop.

LAKE OVERHOLSER BRIDGE

The Lake Overholser Bridge in Oklahoma City, listed in the National Register of Historic Places in 2004, is of historic importance for a number of reasons. One of these is the engineering that utilized a blending of Parker through-truss and pony-truss construction for the 784-foot span over the Canadian River at its confluence with Lake Overholser.

Construction of the bridge was resultant of an ambitious plan by the state highway commission to transform select postal roads and other roads into a five thousand–mile state highway system. One of these was Highway 3, that would link Fort Smith in Arkansas with Texola at the Texas border with Oklahoma.

The Lake Overholser Brige was a key component in the development of Highway 3. It would replace the ferry crossing of the Canadian River at this point necessitated by extensive flooding in 1923 that had washed out numerous bridges.

Construction commenced in 1924, and the bridge opened to traffic, with appropriate ceremony, in August of 1925. Incorporation of the bridge and segments of Highway 3 into the Route 66 corridor occurred in 1926.

Resultant of the dramatic increase in traffic during the postwar era, the bridge became a bottleneck. As part of the interstate highway program, a modern four-lane bridge built immediately to the north in 1958 replaced the historic structure.

The historic bridge remained in use for local traffic, and then pedestrian and bicycle usage only, until 2010. The resurgent interest in Route 66 has contributed to its recognition, and after extensive refurbishment, it reopened in 2011.

LA LOMA MOTEL

The La Loma Motel in Santa Rosa, New Mexico, opened in 1949 with Jose and Carmen Campos as proprietors. The motel was a basic auto court that promoted the use of "Franciscan furniture" and "Free Swimming Privileges."

As of 2010, the motel remained operational and in the hands of the original family. This makes it a unique Route 66 property.

LANDERGIN, TEXAS

John and Pat Landergin, first-generation Irish immigrants, relocated from New York City to the Indian Territory in the mid-1870s, studied ranching, and established a ranch on the Red River. Driving a herd of more than one thousand cattle over the Chisholm Trail, they relocated to Kansas.

In the closing years of the nineteenth century, they established another ranch in the Panhandle of Texas. In 1908, the completion of the Chicago, Rock Island & Gulf Railway to a point at their ranch, and establishment of a siding, led to the platting of a small community under the name Landergin.

The Landergin brothers were also instrumental in the development of Vega, another Panhandle community that would have association with Route 66. John Landergin established the First State Bank in that community.

Landergin remained a very small community. In 1936, the population stood at fifteen. John Rittenhouse noted in 1946 that even though it was "listed on many maps as a town," it actually consisted of "a few railroad homes across the railroad tracks, but offering no tourist facilities—not even gas."

In spite of its diminutive size, Landergin played an important role in Route 66 history. On October 11, 1997, the National Historic Route 66 Federation hosted the first John Steinbeck Award Banquet in a rented circus tent here. This event became an annual event known as the International Route 66 Festival.

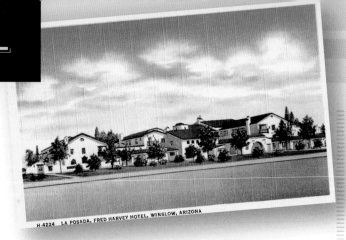

As late as 1955, the La Posada Hotel in Winslow, Arizona, garnered favorable reviews by AAA. It noted, "Very good accommodations in an attractive Spanish style hotel. Rates - $3.50 to $12.00." *Joe Sonderman*

LA POSADA

Nestled between Route 66, Second Street in Winslow, and the railroad, La Posada remains a premier example of the quality of facilities known as Harvey Houses built by the Fred Harvey Company. Built in 1929 and listed in the National Register of Historic Places in 1992, the recently refurbished La Posada consistently receives superb reviews from leading travel authorities.

Famed architect Mary Colter designed the entire complex, including grounds, to present the illusion it was a Spanish colonial estate. With this concept as the foundational element, she chose to use a Mission Revival style for the façades and in the construction made extensive use of adobe, stucco, red terra cotta tiles for the roof, flagstone for the floors, and rough-hewn wood for exposed ceiling beams. To enhance the illusion, great attention to detail was given to the trim, decorative components, and accessories. Sand-blasted planks were used for doors and wooden window shutters, iron rajas adorned the windows, wrought-iron railings bordered the flowing stairways, a stone-built wishing well served as the focal point of the gardens, and the

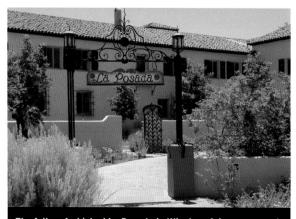

The fully refurbished La Posada in Winslow, Arizona, opened in 1930 as a Harvey House facility. It consistently receives favorable reviews in publications as diverse as *Lonely Planet* and *Arizona Highways*. *Judy Hinckley*

re-created weathered adobe ruins of a Spanish fortress that predated the establishment of the ranchero hinted of age.

The Great Depression, the supplanting of rail traffic by private automobile usage, and the rise in airline development in the postwar era eroded business through the 1950s. Only the extensive movement of troops via the railroad during World War II stemmed the slide.

The 1954 edition of the *Western Accommodations Directory* published by AAA gave the facility a very high rating: "Very good accommodations in an attractive Spanish style hotel. Large guest rooms have baths or toilets. Suites with living room, $25. Radios available. Lunchroom and bar."

Extensive renovation for use as an office complex for the Santa Fe Railroad followed closure of the restaurant in 1956 and the hotel in 1959. Shortly before La Posada's inclusion in the National Register of Historic Places, the Santa Fe Railroad closed the building and scheduled it for demolition.

Restoration to its original appearance commenced after acquisition of the property by Allan Affeldt, and his wife, Tina, in 1997. The hotel and restaurant are today a primary destination for travelers in northern Arizona.

The *Route 66 Dining & Lodging Guide*, fifteenth edition, published by the National Historic Route 66 Federation in 2011, lists the property as a "very special must stop." This entry also proclaims the La Posada as "one of America's treasures."

LA PUERTA

Modeled after the Palace of the Governors in Santa Fe, the La Puerta Motor Lodge opened at 9710 East Central Avenue (Route 66) in Albuquerque, New Mexico, in 1949. As of 2010, the Hill family that purchased it in 1956 still operated and owned the facility.

LAQUEY, MISSOURI

Joseph Laquey established a post office in Parsons' Store at this location in 1898. The primary association with U.S. 66 was Buffalo Lick Camp, a complex that consisted of a small general store and souvenir stand, and a few cabins.

The area of Buffalo Lick Camp near Laquey, Missouri, is rich in history, from the tavern in Buckhorn established along a stagecoach line to the exploits of Joseph Laquey, a political opportunist. *Steve Rider*

The Lariat Lodge at 1105 East Highway 66 opened on July 4, 1952, with great fanfare proclaiming, "Howdy Pardner! Welcome to one of the Indian Capital's newest and finest lodges." *Judy Hinckley*

LARIAT LODGE

The eleven-unit Lariat Lodge, as of 2010 the Lariat Motel, opened in Gallup, New Mexico, in early 1954. The *AAA Western Accommodations Directory* for that year promoted the facility by noting, "Well furnished rooms have TV, central heat and shower baths. Four air cooled rooms. Free radio and evening paper. Lower off season rates. Restaurant one block."

LAUNCHING PAD DRIVE-IN

Located at 121 South Main Street, in Wilmington, Illinois, the Launching Pad Drive-In opened in 1960 as a Dari-Delight franchise specializing in simple fare, such as hot dogs and ice cream. Shortly after this date, expansion transformed this small enterprise into a restaurant offering full service and brought about the change to the current name.

The Gemini Giant, poorly suited for space travel with short-sleeved shirt and open helmet, at the Launching Pad Drive-In has cast his shadow over Route 66 since 1965. *Judy Hinckley*

The proprietors, John and Bernice Korelc, discovered the promotional wares of International Fiberglass at the annual National Restaurant Association convention, paid $3,500, and placed an order for a five hundred–pound astronaut outfitted with helmet and rocket.

The Launching Pad Drive-In with its promotional Gemini Giant, listed for sale as of late 2011, is recognized internationally as a Route 66 landmark. As of fall 2010, the restaurant had closed, but it reopened for the tourism season in the spring of 2011.

LA VERNE, CALIFORNIA

I. W. Lord completed initial platting of the town site named Lordsburg in 1886, and the founding of the town occurred the following year. Hopes were that with its location along the Santa Fe Railroad, the community would experience rapid growth.

As a result of anemic growth, however, the bankrupt hotel, and most of the vacant land in the surveyed town site, sold to the Church of the Brethren for the sum of $15,000 in 1889. Establishment of a college in 1891 initiated resurgent interest in the community. The name change to La Verne occurred in 1919, in reference to La Verne Heights to the west.

Route 66 followed Foothill Boulevard through La Verne, which remained an agricultural community into the immediate postwar years. Indicative of this is the lack of lodging recommendations by AAA during the 1940s or 1950s.

Surviving businesses associated with Route 66 are few. The most notable exception is La Paloma, dating to 1966.

LAWNDALE, ILLINOIS

The platting of Lawndale by surveyor Thomas Esten in 1854 took place one year after completion of the Alton & Sangamon Railroad to this point. Esten relocated to Illinois from Massachusetts as an agent for a land development company and established a mill and store on Kickapoo Creek near the present site of Lawndale.

The initial town site consisted of twelve blocks. The addition of seventeen blocks followed in 1864.

In 1946, a guidebook noted, "Really not a town at all, since it consists of a couple of red railroad shacks, a few houses, and a pair of grain elevators. No facilities at all on US 66." This served as an apt descriptor in 2011 as well.

Lawndale is the setting for a persistent modern urban legend. In 1977, the Lowe family made claims that two giant birds, casting shadows large enough to cover a pickup truck, attempted to carry off their son, Marlon, who weighed fifty-six pounds. In 1997, Marlon told his story on the Discovery Channel program, *Into the Unknown*.

LEBANON, MISSOURI

Since many early residents had relocated from Lebanon, Tennessee, this community created in 1849 as the county seat of Laclede County utilized that name. Almost from its inception, the community has profited from its location on primary transportation corridors.

During the second decade of the twentieth century, the city developed a reputation as an aggressive promoter of good roads. Held here in 1916 was the Ozark Trails Highway convention. The establishment of Route 66 served as the catalyst for the development of an extensive service industry. The town's association with Route 66 has not dimmed with decertification or bypass, and numerous structures, as well as businesses, provide tangible links.

The 4 Acre Court opened by Ray Coleman and Blackie Waters in 1939 was described as "family units and campground." Fire destroyed one cabin in 2003, but the others remain as apartments rented by the month.

In partnership with his parents, Emis Spears and his wife, Lois, opened Camp Joy in 1927 and operated the facility until 1971. The camp served as a stop for Bonnie and Clyde as well as other gangsters of the early Depression. The 1940 *AAA Directory of Motor Courts and Cottages* noted, "Located on shady, well kept grounds. 30 exceptionally clean and well maintained cottages; 21 with hot and cold running water, 20 with shower baths; 15 with kitchenettes, with electric plates for cooking; all heated by wood stoves. Rates $1.25 to $2.25 per day for two persons. Private garages. 4 public baths and flush toilets. Community building; porter and maid service; night watchman. Filling station. Laundry facilities. Children's playground. Café near by. Accommodations for 15 trailers at 50¢ to $1 per day."

In addition to this station in Lebanon, O. E. Carter and Ed Lawson established the Underpass Café and service station at Phillipsburg, Missouri, west of the Frisco Railroad overpass. *Steve Rider*

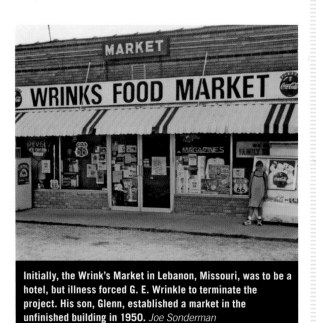

Initially, the Wrink's Market in Lebanon, Missouri, was to be a hotel, but illness forced G. E. Wrinkle to terminate the project. His son, Glenn, established a market in the unfinished building in 1950. *Joe Sonderman*

Wrink's Market opened in 1950 and was operated by Glenn Wrinkle, son of the original owner, G. E. Wrinkle, until the summer of 2009. Construction on the building planned as a two-story hotel commenced in 1946, but illness forced Wrinkle to modify the building and business plan. In the summer of 2011, the former market reopened as D. C. Decker's Cowboy Emporium. The business includes a restaurant, western museum, art gallery, and chuck wagon barbecue.

O. E. Carter and Ed Lawson opened a service station at the intersection of U.S. 66 and Washington Street in 1935. The building still exists and as of 2009 operated as a convenience store.

Arthur T. Nelson established several businesses in Lebanon. Initially, he donated the right of way for Missouri Route 614, U.S. 66, after 1926. On July 3, 1926, he established a small tourist camp and a Texaco station with landscaped grounds along this alignment. His second endeavor was the Top O' the Ozarks Inn. The facility consisted of eight cabins named for each state through which U.S. 66 passed. The Missouri cabin still remains.

The Nelson Tavern opened in January 1930. The centerpiece and primary draw of this nonalcoholic restaurant and hotel were gardens filled with exotic flowers and birds. Demolition occurred in 1958. But Nelson's Dream Village may have been his crowning creation. A dream inspired by the musical fountain at the Chicago world's fair was the catalyst. The V-shaped, stone-faced tourist court faced a large fountain lit by colored lights. Records played over a loud speaker as background music. The facility received AAA recommendation in 1946 and 1954 and remained operational until 1977.

After the sale of the Munger Moss Sandwich Shop in Devil's Elbow, Jessie and Pete Hudson purchased the Chicken Shanty Café in 1945. It was renamed the Munger Moss Barbeque, and a motel was added in 1946, subsequently renovated as well as expanded during the 1950s and early 1960s. The well-maintained motel, with Bob and Ramona Lehman as

proprietors for more than thirty years, with its refurbished neon signage is now a primary destination for travelers seeking Route 66 landmarks and vintage lodging.

The first contract issued under the Interstate Highway Act on August 2, 1956, was for a 4.6-mile section to bypass Lebanon. This bypass opened on August 8, 1957.

In 2007, a Route 66 museum featuring a re-creation of a vintage motel room, diner, and soda fountain from the 1950s and (as of 2011) a detailed diorama of Nelson's Dream Village created by Willem Bor of the Netherlands (a gifted artist and Route 66 enthusiast) opened as part of the Laclede County Library complex. It is now a primary attraction for Route 66 enthusiasts traveling through Lebanon.

LELA, TEXAS

Lela was initially established as a station called Story on the Chicago, Rock Island & Gulf Railway in 1902. Story grew to include a post office, a school, numerous businesses, and a weekly newspaper, *Wheeler County Texan*, within one year. In 1904, Bedford F. Bowers, the postmaster, filed an application requesting a name change to Lela in deference to his sister-in-law, Lela Smith.

By 1906, Shamrock had supplanted Lela's primary role as a trade center. As a result, many businesses relocated, as did the newspaper. The high school closed in 1931, and students began attending school in Shamrock.

Jack Rittenhouse, in 1946, noted Lela was "a small settlement, consisting of five gas stations, a café, and post office. No tourist accommodations." Discontinuance of the post office occurred in 1976 with mail subsequently rerouted to Shamrock.

LENWOOD, CALIFORNIA

The name Lenwood was derived from the pet name for Ellen Woods, whose husband initially subdivided the land here in the 1920s. Jack Rittenhouse in 1946 noted there were three auto courts: West Barstow, Lenwood, and Radio, as well as the Lenwood Garage and two cafés.

Numerous maps and promotional material for Route 66 in California list Lenwood as West Barstow, a name indicative of its proximity to Barstow.

Johnny Ozimek, a Swedish immigrant and specialist in the rebabbit of engine bearings, managed the garage at Radio Auto Camp during the late 1920s and 1930s.
Steve Rider

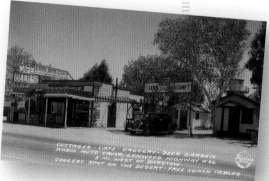

LEXINGTON, ILLINOIS

According to the *Historical Encyclopedia of Illinois and History of McLean County*, the founders of Lexington chose the name because both men, Asahel Gridley and James Brown, had associations with towns named Lexington. Gridley's father was a veteran of the Battle of Lexington fought in 1775, and Brown was from Lexington, Kentucky. Platting for the town site occurred in 1836. The application for a post office received approval on May 10, 1837.

This restored sign at Lexington, Illinois, dates to the 1940s when, as Jack Ritenhouse noted in 1946, "the freeway, by skirting these smaller towns, is affecting the portion of their income formerly received from tourists." *Judy Hinckley*

One of the gems associated with Lexington, Illinois, is Memory Lane, a pre-1930 segment of Route 66 lined with vintage billboards and Burma Shave signs that has been turned into a walking trail coursing through a rural area. *Judy Hinckley*

As an interesting Route 66 footnote, in 1946., Jack Rittenhouse in referring to Lexington commented, "The new freeway, by skirting these smaller towns, is affecting the portion of their income formerly received from tourists."

A unique attraction here is Memory Lane, a one-mile segment of the original alignment of Route 66, refurbished as an authentic circa-1940s time capsule that includes vintage

billboards, Burma Shave signs, benches, and a small park at the terminus near the later four-lane alignment. With the exception of special events, such as the annual Taste of Country Fair Festival & Route 66 Reunion, vehicular traffic is prohibited, but the trail can be walked at any time.

LINCOLN, ILLINOIS

Pottsville, founded by Russell Post in 1834, located less than a mile from present-day Lincoln, served as the first county seat of Logan County from 1839 until 1847, and it was incorporated into the community of Lincoln in 1865. The actual founding of Lincoln occurred in 1853 as the culmination of efforts from several area business leaders, including John G. Gilbert and the Logan County sheriff, Robert B. Latham.

The attorney assigned the task of initial platting and the corresponding filing with the state was Abraham Lincoln. This is purported to be the only community named for Abraham Lincoln before his assumption of the presidency.

Local legend has it that as namesake for the community, Abraham Lincoln attended the dedication, cut a watermelon, and then christened the site with the juice from that melon. At the corner of Broadway and Chicago Street stands a small monument commemorating this event.

Services and lodging for travelers on U.S. 66 evolved with the highway. The *Hotel, Garage, Service Station, and AAA Club Directory* for 1927 lists only the Commercial Hotel, whereas the guidebook written by Jack Rittenhouse in 1946, *A Guide Book to Highway 66*, lists three hotels: the Commercial, Western, and Lincoln, and the Elm Grove auto court.

In 1853, Abraham Lincoln, at the time a lawyer in Springfield, completed the legal documents for the platting of Lincoln, Illinois. This is the only community to be named for Lincoln before he became president.

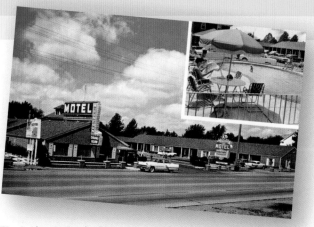

The A. Lincoln Tourist Court, later the A. Lincoln Motel, was located at 2927 South Sixth Street. The Cozy Dog Drive In stands on this site today. *Mike Ward*

The 1954 edition of the *AAA Western Accommodations Directory* also lists the Lincoln Motel. It noted the following: "A brick motel one block east of U.S. 66. Large rooms are centrally heated and have fans or air conditioning and tiled shower baths. $6.50 to $7.50." Listed as well is a second facility, The Pioneer's Rest, but this complex was actually seven miles to the south, closer to Broadwell. The entry for this motel indicates a restaurant was next door.

The *Service Station Directory*, published by AAA in 1947, lists two recommended repair facilities: Hoelscher Brothers and Sheer Repair Shop. Addresses for these facilities are not provided.

On October 22, 1956, Lincoln garnered headlines throughout the nation with the shooting of two highway patrolman, Glen Nichols and Robert Golightly. The officers initiated pursuit after a car raced through a red light in Lincoln, and the gunfight culminated in a restaurant parking lot at the edge of that city.

Of particular interest to travelers on Route 66 today is the Redwood Motel. When opened in 1956, the motel, located at the junction with U.S. 66, Highway 10, and Highway 21, marked a twenty-two year association with Route 66 for Wilfred and Dorothy Werth. In 1934, Werth opened a Standard Oil Station at this corner. He claimed that his station was the first in the state to offer modern pumps where the price, as well as number of gallons, appeared in small windows. The motel was sold in 1963, the station in 1991. There are plans for the refurbishment of the motel.

LINDY'S

Lindy's, located at 500 Central Avenue Southwest in Albuquerque, New Mexico, opened in 1929. As of 2010, the restaurant remained a popular local eatery specializing in authentic Greek and Mexican dishes.

The *Route 66 Dining & Lodging Guide*, fifteenth edition, published by the National Historic Route 66 Federation in 2011, contains a recommendation for this restaurant.

The 1939 edition of the *AAA Directory of Motor Courts and Cottages* contains a cursory entry for Rut's Corner: "Some units with cold water only, some without running water. Public showers, café. $1.50 to $2.50." *Steve Rider*

LITCHFIELD, ILLINOIS

Electus Bachus Litchfield established the Litchfield Town Company, a consortium of businessmen, for the sole purpose of establishing a town site along the proposed route of the Terre Haute & Alton Railroad. Platting occurred in the fall of 1849, and the official date of origination, under the name Hadinsburg, is July 27, 1850, the date of establishment for the post office. Shortly after acquisition of the company by Litchfield, an application was submitted for a name change. With acceptance, the community became Litchfield on March 23, 1855.

In the years immediately following the American Civil War, the town moved more toward an industrial rather than agricultural economic base. In 1867, a blind, sash, and door factory commenced operations. In the same year, the first coal mining company on nearby Rocky Branch opened, and organization of the Litchfield Mining Company occurred in February 1869.

The Wabash Railroad ran a main line through Litchfield in 1870, heralding an era of prosperity, but a series of fires hindered growth. In the early spring of 1867, three stores burned, and in 1870 the McPherson Mill burned. In 1871, five buildings at the center of the business district were destroyed by fire, and in 1873, the Boxberger Mill was leveled by fire.

The founding of the Litchfield Car and Machine Company in 1876 transformed the community. Formed from the reorganization of the Litchfield Car Manufacturing Company and H. H. Beach & Company, a machine shop and foundry, the new company quickly became an industry leader in the manufacture of railroad freight cars, coaches, locomotives, and stationary steam engines.

In 1878, oil discoveries, and in 1885, the discovery of large deposits of natural gas, spurred increased development in the area. With piping and establishment of gas mains, Litchfield became the first community in the state to have gas lighting.

Steady growth and development continued into the first years of the twentieth century, in spite of a major disaster in 1893. In that year, the Planet Mill, one of the largest flour mills in the nation, exploded and burned.

Tragedy of a large enough scale to garner national media attention struck the community in 1904. According to the *Moberly Evening Democrat* of Moberly, Missouri, on July 5, 1904, "Rushing along at 39 miles per hour, the Exposition Limited on the Wabash, due in St. Louis at 7:03 Sunday night, plunged into an open switch one mile from the Litchfield, Illinois, station at 5:25 Sunday night and in an instant almost its entire train was completely demolished. Twenty-two persons are known to be killed and thirty-seven injured."

Indicative of the town's progressive spirit was the receipt of a $15,000 gift from Andrew Carnegie to build and stock a library in 1903. Completion occurred the following year.

Litchfield's association with Route 66 commenced after the realignment of 1930. This added a new dimension to the town and its economy.

AAA consistently found places to recommend in Litchfield. The service station directory published in 1927 lists Brubaker's Garage for repairs. The 1946 directory also lists this garage. The 1940 edition of the *Directory of Motor Courts and Cottages* lists Rut's Corner with public showers and a café. The 1954 edition of the *Western Accommodations Directory* contains an entry for the Varner Motel three miles north of town.

Jack Rittenhouse, in 1946, noted that the town was just a short distance off the highway and that amenities for the traveler included gas stations, cafés, tourist cabins, and garages. He also noted, "This is an old mining town, and was the locale of early oil production."

Numerous historic structures remain from the mining era. The most notable would be the Wabash Depot and the Carnegie Public Library built in 1904. For the modern traveler on Route 66, many businesses have lengthy association with that highway. The most notable are the Ariston Café, owned by the same family since opening at its current location in 1931, and the Sky View Drive-In that opened in the spring of 1951 and remains as the last original drive-in theater operational on Route 66 in Illinois.

Alton Evening Telegraph, **August 20, 1943, dateline Edwardsville, Illinois: "Stolen early Thursday morning by burglars who broke into a service station adjoining Rut's Corner tavern at Litchfield, Montgomery County, a 300-pound steel safe was recovered later in the day on a farm east of here, off Route 43, where it had been blasted open and abandoned. Approximately $700 worth of liquor, stored in the service station, was hauled away by the thieves, whose only reward for transporting the safe thirty miles and blasting it open was a meager $45 in cash the strongbox contained."** *Steve Rider*

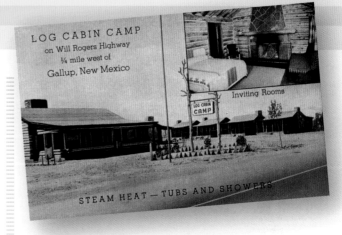

LIVES ON THE ROAD BY JON ROBINSON, MBI PUBLISHING COMPANY, 2001

Lives on the Road, a six-chapter compilation of interviews written by Jon Robinson, remains an important repository of Route 66 history. Each chapter covers a specific area of interest with interviews of individuals who played a key role in that segment of the highway's development. Since many of these people are now deceased, the book is an irreplaceable chronicle of Route 66 as well as the societal evolution it mirrored.

LIVINGSTONE, ILLINOIS

David Livingston, the first president of the village board serving from 1905 to 1911, is this town's namesake. The post office has operated without interruption since its opening in December 1904. Though the community was surrounded by farmlands, the primary economic component for Livingstone was coal mining. Many of the homes for mine employees were built from materials salvaged from the demolition of the buildings of the St. Louis world's fair.

Realignment of Route 66 around the southeast corner of Livingstone in 1940 fueled the development of a well-established service industry. Available services included Dave Bononi's gas station, the Livingstone Cooperative Store, Mitchelar Hardware, Warlock's, Busker's Store, and Bike's Garage, which also offered gasoline.

The Route 66 association with Livingstone, and direct access to Livingston Avenue from the limited-access four-lane highway, was from the period of 1940 to 1977. In 2000, placement of Historic Route 66 signs marked this corridor.

LOG CABIN LODGE

The Log Cabin Lodge built in 1938 in Gallup, New Mexico, foreshadowed the rise and development of the modern motel that would dominate lodging after the mid-1950s. The *Directory of Motor Courts and Cottages,* published by AAA in 1940, provides an expansive listing that stands in stark contrast to the usually concise ones: "Log Cabin Lodge, one-fourth mile west of the business center, on U.S. 66. Considered the southwest's most unique tourist lodge, 12 new, rustic, log cottages of one and two rooms; steam heated for winter comfort; excellent ventilation for summer comfort. Furnished in pioneer style or with Monterrey furniture, something new and different in cottage accommodations. One-room cottages, with closed garages, with or without kitchenette, for two persons. Some kitchenettes have electric refrigeration; some with beautiful stone fireplaces. Equipped with shower or with combination tub and shower bath. Studio couches and many unique appointments for extra comfort. Also two-room cottages, accommodating four or five persons; with tile bath or

Tony and Francis Leone established the Log Cabin Lodge in Gallup New Mexico, in the summer of 1938. AAA provided an extensive and detailed entry for it in the 1940 edition of the *Directory of Motor Courts and Cottages.* *Mike Ward*

combination tub and shower; with or without kitchen. Rates, $2.50 to $3 for two persons, $4 to $5 for four persons. Tony Leone, owner."

During the late 1940s, the Log Cabin Lodge became part of the fledgling Best Western chain of motels. In the 1955 edition of the *Western Accommodations Directory,* it again received AAA recognition.

Completed through 1959 were numerous additions and renovations, including the building of two double log cabins and a new wing in an adobe mission style, and the elimination of kitchenettes. The late sixties initiated a period of decline that resulted in the facility developing an unsavory reputation by 1980.

In 1993, the historic lodge received recognition with a listing on the National Register of Historic Places. The prestigious recognition did little to stop the continuing decline of the property, however, and on May 14, 2004, it was razed.

The Log Cabin Lodge in Gallup, New Mexico, evolved from the initial six-cabin complex into a twenty-four-unit motel by the 1950s. It closed in the mid-1990s, suffered extensive fire damage in 2004, and was demolished shortly after this date. *Steve Rider*

LOG CITY CAMP

The certification of U.S. Highway 66 and the subsequent increase in traffic flow led Carl Stansbury to clear a section of his property that faced the highway near Avilla, Missouri, and utilize the logs to construct Log City in 1926. The property continued to evolve through the mid-1950s.

By 1938, it had expanded from a service station and several cabins into a full-service facility that included a liquor store, restaurant, gas station, and fourteen cottages. The entry for Log City Camp in the *Directory of Motor Courts and Cottages*, published by AAA in 1940, listed "14 cottages with shower baths; rates $1.50 to $3 per day. Trailers 50c; public baths and flush toilets. Café and dining room." Following this sterile listing was a photo of the property and an expanded entry: "14 modern cottages with all conveniences. Every cottage with bath. Dining room and coffee shop air conditioned by washed air—serving excellent food at popular prices—Trailer accommodations."

With the bypass of Route 66, Log City Camp entered a period of steep decline. As of 2010, a body shop operated out of the former service station, and only three of the cabins remained standing.

LONGHORN RANCH

The Longhorn Ranch, a trading post, gas station, and café, opened at a point on Route 66 forty-eight miles east of Albuquerque in late 1940. The owner—Captain Bill Ehret, a former police officer from Endicott, New York who also served as a deputy in Lincoln County, New Mexico—initiated expansion projects in late 1945 in an effort to capitalize on expected growth in tourism-related travel.

In 1946, Jack Rittenhouse noted in *A Guide Book to Highway 66*, " . . . Longhorn Ranch Café and gas station. This is

The Longhorn Ranch Motel is the last remnant of a complex that Jack Rittenhouse, in 1946, described as " . . . a popular stop for travelers, offering a 'museum,' café, gas, and other accommodations." *Steve Rider*

Longhorn Ranch, 48 mi. east of Albuquerque, N. M., on Highway 66

The Longhorn Ranch began as a trading post, café, and gas station, established in 1940. Before closure in 1977, it had morphed into a full Old West complex with stagecoach rides and a Texas longhorn steer named Babe. *Steve Rider*

a popular stop for travelers, offering a 'museum,' café, gas and other accommodations."

By the late 1950s, the facility had morphed into a full-fledged Old West–themed resort that included a motel, restaurants, a garage, and curio shops. Entertainment included Native American Indians performing traditional dances, a tame longhorn steer, and stagecoach rides.

Bypass by the interstate highway drastically curtailed business, resulting in closure in 1977. The razing of most structures, with the exception of the motel, has left few discernable remnants aside from the towering signage on the south side of former Route 66.

LOS ANGELES, CALIFORNIA

European settlement in Los Angeles dates to the Portola expedition of 1769 that camped on the banks of the river at this site and the establishment of a rancheria shortly after. The first reference to a settlement here is from a report dated December 27, 1779: " . . . the founding of a town with the name Queen of the Angels on the river of the Porciuncula."

On August 26, 1781, Governor Felip de Neve issued the final decree for establishment, and the founding took place on September 4, 1781. After the American occupation, confusion regarding pronunciation and spelling of the name resulted in numerous variations. A report dated January 11, 1847, refers to the community as Ciudad de los Angelos. Another report from the same period uses the English equivalent, City of Angels. Sketches prepared in August 1849 show the name as City of Los Angeles. Use of the abbreviated version, Los Angeles, dates to organization of the county on February 18, 1850, and incorporation of the city on April 4, 1850.

Throughout the late nineteenth century, the city experienced slow but steady growth that resulted in the absorption of several neighboring communities through annexation, including Highland Park, Eagle Rock, and Garvanza most notably with regard to Route 66. The acceleration of growth during the twentieth

LOS ANGELES, CALIFORNIA *continued*

century necessitated numerous realignments of Route 66 and, eventually, its replacement.

From 1926 to 1936, the western terminus for Route 66 was the corner of Seventh Street and Broadway in Los Angeles, just as it had been for the National Old Trails Highway. Extension of the terminus to the corner of Olympic and Lincoln Boulevards in Santa Monica occurred in late 1936.

The geography of the area between the original community of Pasadena and Los Angeles, known as the Lower Arroyo Seco, was a valley of stunning natural landscapes that became a haven for artists and a key component in the development of Route 66 in the area. President Theodore Roosevelt, in 1911, suggested the area be set aside as a park. The City of Los Angeles preserved sixty acres for this purpose in 1923.

There would eventually be five different alignments of Route 66 here. The earliest, used from 1926 to 1931, followed Fair Oaks Avenue from Pasadena into South Pasadena, and then went southwest onto Huntington Drive, a road that began as the Old Adobe Road in the late eighteenth century. From Huntington Drive, Route 66 continued on Mission Road and then Broadway Avenue through the Lincoln Heights district of Los Angeles. Historians often refer to the second Route 66 alignment utilized between 1931 and 1934 as a transitional alignment. This alignment also utilized Fair Oaks Avenue but only to Mission Street. At Arroyo Drive, the highway turned south and then west on Pasadena Avenue. In Garazana, it curved southwest on what is now Figueroa Street, Pasadena Avenue, through Highland Park until 1936. It then continued south on Pasadena Avenue to Broadway Avenue.

Historians refer to the next version of Route 66, utilized for approximately one year, as a construction alignment. This alignment followed Colorado Boulevard west out of Pasadena and across the Colorado Street Bridge, built in 1913, and then into Eagle Rock, a community annexed by Los Angeles in 1923. Then Route 66 went south on what is now Eagle Rock Boulevard, a road that followed the 1906 Los Angeles Railway street car line. Route 66 then continued south on San Fernando Road, joining U.S. 6 and U.S. 99. At this point, the highways continued south to Pasadena Avenue and then onto Broadway Avenue. After January 1, 1936, this alignment was linked with Santa Monica Boulevard and Lincoln Boulevard in Santa Monica, to terminate at the intersection of Olympic Boulevard, U.S. 101A.

The next alteration to the alignment of Route 66 occurred in June 1936. This "alternate alignment" would remain signed as U.S. 66A until 1960. This alignment followed Colorado Boulevard out of Pasadena before turning south on Figueroa Street. Near the central business section of the Highland Park district, Figueroa Street merged with Pasadena Avenue. From 1936 to 1937, Route 66 crossed the Los Angeles River here, but in 1937, completion of a new bridge resulted in relocation of Figueroa Street and Route 66 to the southeast. The tunnels built between 1931 and 1935 connected Figueroa Street to Broadway Avenue.

At this point, this alignment turned west on Sunset Boulevard before reaching downtown Los Angeles and continued to join Santa Monica Boulevard.

The final alignment of Route 66 opened on December 30, 1940. Now the highway followed Colorado Boulevard out of Pasadena and onto the Arroyo Parkway, which in turn transitioned into the Arroyo Seco Parkway, a historic roadway innovative in its design that was the first modern limited-access freeway constructed west of the Mississippi River. Through 1942, the highway then followed Figueroa Street to Sunset Boulevard, which connected with Santa Monica Boulevard. With completion of a second bridge over the Los Angeles River that year, Route 66 travelers skipped the Figueroa Street section.

The completion of the Hollywood Freeway, with its four-level interchange at the junction of the Arroyo Seco Parkway and Hollywood Freeway, the first of its kind in the United States, resulted in the continuation of Route 66 on this path to Santa Monica.

From January 1936 to its decertification in Los Angeles County in 1964, Route 66 followed Santa Monica Boulevard west through Hollywood. Additionally, the terminus at Lincoln and Olympic Boulevards in Santa Monica remained consistent.

Landmarks associated with this highway, as well as others that predate it, abound along the various alignments in Los Angeles. That lengthy list would include Clifton's Cafeteria in a building that dates to 1904 (refurbishment commenced in February 2012); the *Los Angeles Times* building; Sycamore Grove Park; the Arroyo Seco Parkway; Jensen's Theatorium, 1912; Jensen Recreation Center, 1924; and the Highland Theater.

In 2003, historian Scott Piotrowski published *Finding the End of the Mother Road: Route 66 in Los Angeles County*. It remains the definitive source for tracing the various alignments of Route 66 in Los Angeles.

LOS LUNAS, NEW MEXICO

Los Lunas is located on the pre-1937 alignment of Route 66 south of Albuquerque. The post office opened in 1855, closed in 1857, and after reopening in 1865, continued in operation without interruption.

The town site initially was part of the San Clemente Land Grant issued in 1716 to Felix Candelaria. Initial partition of the lands contained in the grant commenced with the sale of properties to Baltazar Baca, who in turn sold the section containing the town site to Domingo Luna in about 1750. A son— Antonio Jose Luna, born in 1808—who ranched in the area established the settlement. In 1876, Los Lunas became the seat for Valencia County.

The 1927 edition of the *Hotel, Garage, Service Station, and AAA Directory* lists the St. Morris Garage for repairs or service. This guide also lists the population as one thousand.

Attractions of note include the Luna-Otero Mansion. Built in 1881, and listed on the Register of Historic Places, the mansion now houses a fine-dining establishment.

Even though Tome Hill is located six miles south of the city and Route 66, it has played a pivotal role in the development of this transportation corridor. It served as a landmark and dependable source of water for travelers on the Spanish colonial–era El Camino Real.

LOU MITCHELL'S

With the resurgent interest in Route 66, Lou Mitchell's at 565 West Jackson Boulevard in Chicago often is the first stop for westbound travelers on that highway. Relocated to its current location in 1926, this restaurant originally opened on this block in 1923.

A tradition initiated shortly after opening was the presentation of a box of Milk Duds to female customers. This link to the past is just one of the many enduring features of this family-owned restaurant.

The historic neon sign that proclaims "Lou Mitchell's Serving the World's Best Coffee" dates to 1949. Additionally, many of the interior appointments and architectural details, from booths and tables to coat racks and the aluminum and glass storefront, date to the remodel that took place in that year and were instrumental in the listing of the restaurant in the National Register of Historic Places in 2006.

LUCCA GRILL

The Lucca Grill, established by Fred and John Baldini at 116 East Market Street (now Business 51 and formerly U.S. Highway 66) in Bloomington, Illinois, opened in 1936. Current advertisement promotes it as the oldest continuously operated pizzeria in the Midwest. The fifteenth edition of the *Route 66 Dining & Lodging Guide*, published by the National Historic Route 66 Federation in 2011, lists the property as a very special, "must stop."

LUDLOW, CALIFORNIA

The namesake for this community is William Ludlow of the western division of the Southern Pacific Railroad. Though initial settlement under this name dates to the 1870s, the post office operated under the name Stagg from 1902 to 1906.

Lack of a dependable water supply necessitated the shipping of water by rail from Newberry Springs to the west. With resolution of this obstacle through the drilling of deep wells in 1900, Ludlow began to prosper as a supply center for area mines.

Further fueling growth and the town's prominence was the establishment of the Tonopah & Tidewater Railroad in the summer of 1905 that linked the main line with the mining boom in the area of Tonopah, Rhyolite, and Beatty in Nevada. Following this was the

This early view of Main Street in Ludlow provides stark contrast to the ghost town of today. Lee Yim, a Chinese immigrant, operated an ice cream shop in the Desert Inn building. *Steve Rider*

establishment of another spur line, the Ludlow & Southern Railroad, that connected the main east–west line of the Santa Fe Railroad with the Buckeye Mining District eight miles to the south.

The boom fueled by the railroad spurs was beginning to ebb when motorists traveling on the National Old Trails Highway created the need for service-related industries. This escalated with certification of Route 66 in 1926.

In his 1946 guidebook, Jack Rittenhouse noted, "Although quite small, Ludlow appears to be a real town in comparison to the one establishment places on the way here from Needles."

While most remnants and ruins in Ludlow date to the glory days of Route 66, roughly 1946 through the 1960s, there are a few notable exceptions. Among these would be the ruins of the 1908 Ludlow Mercantile on Main Street, severely damaged in a 2008 earthquake; a few old homes; and a haunting desert cemetery.

There are several existing businesses in Ludlow as of the summer of 2011, including a service station, Dairy Queen, the Ludlow Café, and Ludlow Motel. The fifteenth edition of the *Route 66 Dining & Lodging Guide*, published by the National Historic Route 66 Federation in 2011, notes that this motel offers "no frills but very clean, comfortable rooms."

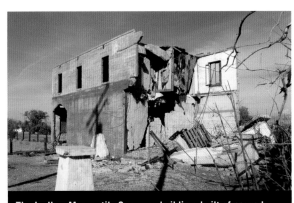

The Ludlow Mercantile Company building, built of poured concrete, was the centerpiece of a prosperous and thriving business district in Ludlow, California, during the era of the National Old Trails Highway. *Steve Rider*

LUNA CAFÉ

The Luna Café in Mitchell, Illinois, at 201 East Chain of Rocks Road, Route 66, opened in 1929. As of the summer of 2011, it remained an operational business.

Unverified legends associated with the café abound and are now part of Route 66 folklore. These include association with Al Capone, a casino that operated in the basement, and prostitution that operated on the second floor when the red cherry in the martini glass on the neon sign was lit.

In the late summer of 2011, restoration of the historic sign commenced. With completion, the sign, with its red cherry, was relit with great fanfare in October 2011.

LUNA LODGE

Built in 1949 at 9019 East Central Avenue in Albuquerque, New Mexico, the Luna Lodge, listed in the National Register of Historic Places in 1998, still exists as apartments. Contributing to the property's historic significance is the fact that as of 2010, less than half of the motels on the Route 66 corridor in this city built before 1955 remain.

Recognized as one of the best examples of an unaltered pre-1955 motel in Albuquerque, the Luna Lodge was the subject of an extensive evaluation and survey for the Historic American Engineering Record in 2006. The resulting collection of photographs, notes, and drawings are now archived at the Library of Congress.

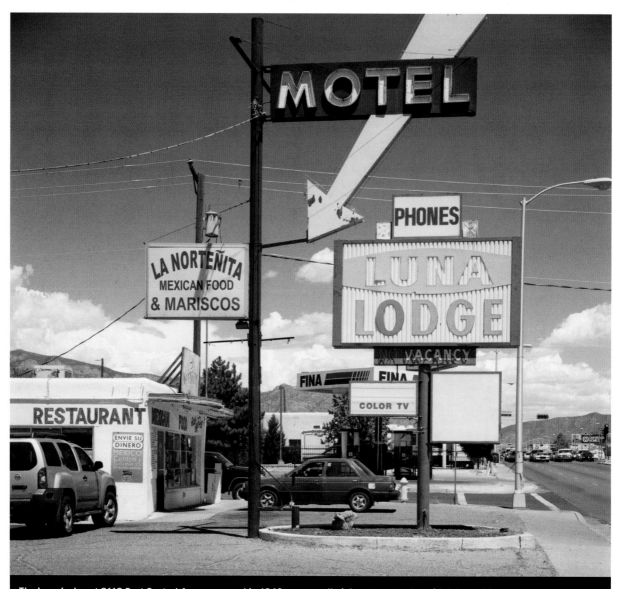

The Luna Lodge at 9119 East Central Avenue opened in 1949, as a small eight-room complex with John and Dorothy Jelso as owners.

Expansion into a 26-unit complex in 1952, and the addition of a swimming pool in 1954, enabled the Luna Lodge to remain competitive with the more modern auto courts built along Central Avenue during this period.

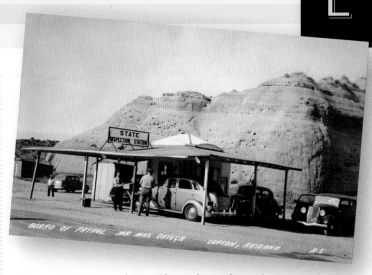

During the 1930s, the agricultural inspection stations at Lupton and Topock, Arizona, were a dreaded stop for the destitute immigrants fleeing toward California from the Dust Bowl.
Steve Rider

Initially, the property, with John and Dorothy Jelso as proprietors, consisted of eight units built in a blending of pueblo and Spanish Revival styling. Extensive remodeling in 1952 resulted in expansion to twenty-six units. A swimming pool added in 1954 ensured the motel remained competitive.

The *Western Accommodations Directory*, published by AAA in 1955, contains an entry for the Luna Lodge. It states, "One and two room air cooled units have TV, radios, telephones, tiled combination or shower baths and central heat; five car shelters. Coffee shop, TV in lobby. Free ice and newspaper. Heated swimming pool; playground."

LUPTON, ARIZONA

Lupton is the site of the first station established by the Atchison, Topeka & Santa Fe Railroad in Arizona west of the New Mexico state line. G. W. Lupton, train master in Winslow, was the

namesake of the town. The post office opened in May 1917, with Joseph D. Gorman as postmaster.

Tourism from the National Old Trails Highway, Route 66 after 1926, led to the establishment of numerous service industry businesses. In the guidebook by Jack Rittenhouse, services listed are several gas stations and a store. The primary facility during this period was the Indian Trails Trading Post established by Max and Amelia Ortega in the summer of 1946. The site of this trading post, demolished in 1965, is now a service road for Interstate 40.

LUTHER, OKLAHOMA

Named for Luther Jones, an Oklahoma City businessman, the post office opened with a town name of Luther in July 1898. In spite of its association with Route 66, it remained a small farming community.

Jack Rittenhouse, in 1946, noted a population of 425 and a gas station as the sole business on Route 66. Historian Jim Ross—in his seminal work *Oklahoma Route 66*, published 2001—lists the points of interest as a pecan grove and the Engle's Grocery that at one time housed a huge collection of Coca-Cola signs and related promotional material.

A heinous crime that commenced near Luther put the small community on the front pages of newspapers throughout the nation. On December 30, 1950, Bill Cook surprised Carl Moser, who was changing a tire along the highway near Luther, and for the next three days, Cook forced Moser's family of five to drive, at gunpoint, to various points in the Southwest. After an intense manhunt, the bodies of all five members of the Moser family were found in an abandoned mine shaft near Joplin, Missouri, on January 15, 1951. The state of Oklahoma sentenced Cook to three hundred years in the state penitentiary, but the sentence was cut short with Cook's execution in California for a murder committed in that state.

MADISON, ILLINOIS

In 1877, the Vaca Valley & Clear Lake Railroad extended its main line one mile beyond the trading center of Cottonwood. Platting of a town site commenced at this terminus under the name Madison in deference to Madison, Wisconsin, hometown of Bradley Hubert, a railroad executive.

The Route 66 association with the community commenced with the highway following Nameoki Road through Granite City and into Madison before passing through Venice to cross the Mississippi River on the McKinley Bridge. After 1929, it followed Highway 3.

Madison was largely an industrial community. AAA directories from 1927 to 1960 do not contain listings for recommended lodging.

MADONNA OF THE TRAIL

The initial concept to create a memorial to pioneering mothers who traversed the nation during the days of westward expansion dates to a meeting of members of the Missouri chapter of the Daughters of the American Revolution (DAR) in 1909. The result of this meeting was the formation of a committee to secure appropriations from the state of Missouri to mark the Old Santa Fe Trail with monuments.

The initial idea coalesced into the National Old Trails Road Association in 1911 with the goal of establishing the proposed Old Trails Road as a memorial highway. In this year, Elizabeth Butler Gentry of the DAR published a booklet entitled *The Old Trails Road, The National Highway.*

In addition to explaining the origins of the burgeoning movement, the booklet provided estimates of construction derived from reports submitted by leading engineers and outlined a goal of submitting a bill to Congress for federal

construction of the road. It culminated with a section chronicling a "D.A.R. Motor Trip to Panama Exposition in 1915," in which Mr. and Mrs. Thomas Wilby completed a ten thousand–mile trip to evaluate the proposed road.

In 1912, the National Old Trails Road Association stated in its bylaws that " . . . the Association shall be to assist the Daughters of the American Revolution in marking Old Trails and to promote the construction of an Ocean-to-Ocean Highway of modern type worthy of its memorial character." Additionally, the organization agreed to fund the erection and creation of the proposed cast-iron markers.

In 1924, Mrs. John Trigg Moss, chair of the DAR national committee, submitted plans for a larger monument that included a statue designed by August Leimbach of St. Louis. These plans called for the erection of these monuments in each of the twelve states through which the National Old Trails Road passed.

In 1927, the Daughters of the American Revolution of the Continental Congress accepted the design for the sculpture entitled *Madonna of the Trail.* This sculpture is of a pioneer woman clasping an infant in her arms with a child clinging to her skirt. The figure of the woman was to be ten feet tall and mounted on a six-foot base and two-foot foundation.

At Bethesda, Maryland, on April 19, 1929, three years after the federal highway system supplanted the National Old Trails Road, dedication of the twelfth and final monument took place. Restoration and rededication occurred in 1988.

Two of the monuments stand along Route 66: one in Albuquerque, New Mexico, dedicated on September 27, 1928, and the second in Upland, California, dedicated on February 1, 1929. Existing evidence indicates that the monument erected in Springerville, Arizona, was the subject of intense debate, since there was a contingent that wanted placement in Kingman, Arizona, but for reasons unknown, Senator Harry Truman, former president of the National Old Trails Road Association, intervened

MAGIC LAMP INN

Lucy and John's Café, owned by the Nosenzo family, opened in 1940 at 8189 Foothill Boulevard in Ranch Cucamonga, California. Renovation commenced in 1955 after the sale of the property to Frank and Edith Penn, who reopened the restaurant as the Magic Lamp Inn.

From its now famous neon sign to its unaltered façade, stained-glass windows, and Chinese cherry wood beams, this restaurant serves as a near perfect example of the classic roadhouse with California touches from the 1950s. The fifteenth edition of the *Route 66 Dining & Lodging Guide*, published in 2011 by the National Historic Route 66 Federation, gives this restaurant a very high rating. It lists the property as a "must stop."

MAISEL'S INDIAN TRADING POST

Located on Central Avenue in the heart of Albuquerque, New Mexico, one block from the historic KiMo Theater, Maisel's Indian Trading Post opened in 1939. Designed with a distinctive façade that served as an advertisement in itself, the trading post received recognition in 1993 with its listing on the National Register of Historic Places.

After the realignment of Route 66 along Central Avenue in 1937, Maurice Maisel selected this location for his trading post and retained the services of John Meem, the leading proponent of Pueblo Revival styling in the area, as the architect. One of the unique features of the structure is the deeply recessed entry flanked with display windows and floored with glazed terra cotta tiles containing American Indian designs. Maisel also hired Olive Rush, a leading Albuquerque artist, to design murals that would depict the ceremonial life of various Indian tribes. To execute the murals, he employed Navajo and Pueblo artists.

By 1950, the trading post was the largest found on Route 66, and more than three hundred Native American artisans worked on site. Shortly after Maisel's death in the early 1960s, however, the store closed.

Refurbishment commenced in the late 1980s, and shortly after this date, it reopened under the proprietorship of Skip Maisel, Maurice Maisel's grandson. The trading post is again a preeminent outlet for the work of Native American craftsman.

MANCHESTER, MISSOURI

Located on the pre-1932 alignment of Route 66, this community has an unknown date of origination. However, the use of this name for a town originally named Hoardstown, in reference to Jesse Hoard, on this site dates to 1824.

Unsubstantiated claims state that the Manchester name is derived from a settler, an English immigrant, who proposed use of the name in 1835 in reference to his hometown in England.

This was the year of completion for the Manchester Road, the first state-funded road in Missouri, which linked the community with St. Louis. This road served as the course for the original alignment of Route 66 west from St. Louis. Realignment in 1932 severed that link with the community of Manchester.

Incorporation occurred in 1950, and commencing in the late 1950s, subdivisions and suburban commercial development transformed Manchester and Manchester Road, now State Highway 100. Vestiges of the community's early history remain, including the city hall built in 1894.

MANOR MOTEL

In 1946, Walt Anderson, a masonry contractor, purchased land along Route 66 with the intention of opening a motel to profit from the nearly endless traffic stream along that highway. Construction continued piecemeal until the completion of the complex in 1954. In addition, he built the Manor Inn restaurant near the motel in 1953 and a Sinclair service station and liquor store across the street.

The 1954 edition of the *AAA Western Accommodations Directory* noted that the Manor Motel, located at the junction of U.S. 6 and U.S. 66 southwest of Joliet, was a modern complex with a wide array of modern amenities. It noted: "A fine court nicely situated back from highway. Attractively furnished rooms have central heat and tiled shower or combination baths; radios and TV available. Playground. Restaurant and filling station convenient."

Current renovations strive to maintain the historical integrity of the complex as well as provide modern amenities. The facility remains as a unique Route 66 time capsule.

Manor Motel - U. S. 6 and 66 - Joliet, Ill.

"A fine court nicely situated back from highway" begins a 1953 advertisement for the Manor Motel located eight miles from the junction of U.S. 66 and U.S. 6. Amenities offered included radio and television. *Mike Ward*

MANUELITO, NEW MEXICO

The namesake for this community is Manuelito, a famous nineteenth-century Navajo leader and diplomat. The post office operated under this name from 1881 to 1974.

Initial settlement here was as the headquarters for Cooks Ranch. With establishment of the railroad to this point and a siding in 1881, this became an important trading center and communication link for Fort Defiance.

Jack Rittenhouse noted in 1946 that Manuelito was a " . . . small community of homes, church, and school just off U.S. 66." The ruins of Mike Kirk's Trading Post are the primary link associated with Route 66.

MAPLEWOOD, MISSOURI

Maplewood, Missouri, the first community west of St. Louis on Manchester Road (the pre-1932 alignment of Route 66), initially was a subdivision on the former farm of James Sutton. The development commenced in the teens as a planned community with planted maple trees lining principal streets.

During the period of the community's association with Route 66, Maplewood developed into a major retail center. The era of suburban development in the 1960s and 1970s, however, initiated a precipitous slide and resultant deterioration.

Fueled by the resurgent interest in Route 66, Maplewood has entered a period of renaissance. As of 2011, the city has installed Route 66 sidewalk plaques and banners on light posts in front of historic storefronts.

By 1950, the traffic congestion resultant of routing Route 66 through the central districts of communities such as Maplewood, Missouri, was fueling the growing support for construction of limited-access highways and bypasses. *Joe Sonderman*

MARSHFIELD, MISSOURI

Marshfield, hometown of the noted astronomer Dr. Edwin Hubble, is the seat for Webster County. (A quarter-scale model of the Hubble Space Telescope is on display in the town square.) Platting of the town site named for the Massachusetts home of Daniel Webster commenced in 1855.

A series of tornados in the period 1878 to 1880 caused extensive damage and resulted in the deaths of eight citizens. The Works Progress Adminstration (WPA) booklet *Missouri*, published in 1941, notes that since these tornados ". . . things have gone fairly quiet, with only the rise and fall of farm prices to affect the town's tranquility."

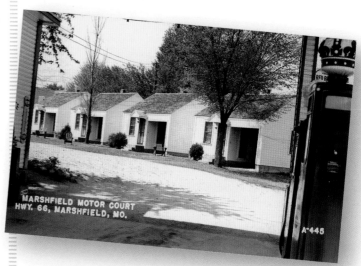

H. P. Highfill established a service station in 1930 and later expanded the property to include four cabins signed as the Marshfield Auto Court. In 1946, Edward Petersdorf purchased the facility and changed the name to Marshfield Motor Court. *Steve Rider*

Located midway between Marshfield and Conway, Missouri, the Garbage Can Café opened in 1952 with Kermit and Letha Lowery as the owners. *Steve Rider*

In 1946, Jack Rittenhouse listed services as "Tarr's Garage [also listed in the 1927 service station directory published by AAA], Webster Hotel; stores; few cabins." He also noted that "the town of Marshfield is a short distance off U.S. 66. At the intersection of U.S. 66 and the road into town, there are several small cafés, gas stations, and a few tourist cabins." The *AAA Service Station Directory* published in the same year lists Marshfield Motor Company for repairs.

The Marshfield Country Club building sits on the site of the Main Course Filling Station and Café, later the Skyline Café, and Trask's Place, promoted as the highest point on Route 66 for nine hundred miles. The house and café for the former Oak Vale Park complex remain as a private residence.

To the west of town, on State Highway OO (former U.S. 66), the Animal Paradise Family Fun Park, a drive-thru wildlife park, dominates a large tract of the former Sam Holman Ranch. The hotel on the ranch served travelers and catered to wealthy hunters until it burned in 1961.

This unimposing little gallery at 306 Manvel Street in Chandler, Oklahoma, houses the work of acclaimed artist Jerry McClanahan, the author of the best-selling *EZ 66 Guide for Travelers. Judy Hinckley*

MART BUILDING

Built by the Terminal Railroad Association in 1931, the Mart Building at Twelfth and Spruce Streets in St. Louis housed the KMOX radio studios from 1932 to 1959. The building—now known as the Robert Young Federal Building, in honor of Robert Young, Missouri congressman from 1977 to 1987—houses numerous agencies of the federal government.

MAZONIA, ILLINOIS

Purportedly, Mazonia derives its name for the Algonquin word for the wild hemp plant. Much of the site of this former mining town is, as of 2011, incorporated into the Mazonia-Braidwood State Fish and Wildlife Area.

MCCLANAHAN, JERRY

Jerry McClanahan, an internationally acclaimed artist and historian, is also the author of *EZ 66 Guide for Travelers*, published by the National Historic Route 66 Federation. For enthusiasts of Route 66, this guidebook consistently remains one of the most popular. Additionally, a website maintained by McClanahan provides travelers with near-constant updates about the highway.

In Chandler, Oklahoma, the McJerry Route 66 Gallery at 306 Manvel is a primary attraction. In addition to displaying his highly praised work, McClanahan welcomes all visitors who stop to have their copies of *EZ 66 Guide for Travelers* autographed.

During the 1990s, McClanahan served as a staff artist and writer for *Route 66 Magazine,* and in 1994, he collaborated with Oklahoma author and historian Jim Ross to create the

best-selling Route 66 map series *Bones of the Old Road*, as well as the video of the same name.

In addition to his artistry that graces numerous galleries, private collections, and buildings with murals, McClanahan writes regular features for the *Federation News*, the official publication of the National Historic Route 66 Federation, as well as *American Road*, a publication for which he serves as a department editor.

In October 2011, McClanahan, in conjunction with Shellee Graham and Jim Ross, released *Route 66 Sightings*. This compilation of interviews, informative text, and the photographic work of these three artists through a thirty-year period of Route 66 documentation debuted to critical acclaim.

MCCONNICO, ARIZONA

Established as a station at the junction with the main line of the Atchison, Topeka & Santa Fe Railroad and the Arizona & Utah Railroad line to Chloride, Arizona, in 1898, the namesake of this town was the railroad contractor who built the spur. Its location on the National Old Trails Highway, later Route 66, and access to the railroad, resulted in the establishment of numerous businesses, including a Whiting Brothers station, now Dan's Auto Salvage; a lumberyard and mill; and Crazy Fred's Truck Stop, still an existing business.

Complete erasure of the earliest alignment of Route 66, the course of the National Old Trails Highway, directly between Dan's Auto Salvage and the railroad tracks, with numerous remnants of businesses, occurred with development in 2010 and 2011. Additional transformational development in the area includes a steel mill.

MCHAT INN

Built in the late teens or early 1920s, this two-story log structure, located east of Williams, Arizona, expanded under the ownership of Gordon and Juanita McDowell to include cabins, a small store, and a gas station signed as the Wagon Wheel Lodge. With the Elmo Dance Hall located directly across the highway, the lodge quickly developed a reputation for illicit activity.

The dance hall is gone, as are the station and most of the cabins. However, as of 2011 the lodge remained as a private residence.

Built in 1910 and named for Congressman William B. McKinley, the McKinley Bridge served as the original Mississippi River crossing for Route 66. *Steve Rider*

MCKINLEY BRIDGE

The McKinley Bridge over the Mississippi River at St. Louis—named for Congressman William B. McKinley, who was also president of the interurban railroad company that constructed the bridge—dates to 1910. At the time of construction, it was purportedly the largest electric bridge in the world.

Initially used for the railroad, the bridge received additional lanes for automobile traffic a few years after it opened. With certification of U.S. 66 in 1926, the bridge became the crossing point on the Mississippi River for that highway and served in this capacity through 1928. From that date until 1937, it carried Route 66 traffic as Optional 66.

Age- and stress-related deterioration resulted in closure in 2001. After extensive upgrades and renovation, the bridge reopened in December 2007 and now includes a pedestrian and bicycle path for passage across the Mississippi River. It remains one of the oldest existing bridges still in use on Route 66.

MCLEAN, ILLINOIS

McLean County and the town of McLean in Illinois were named for John McLean, the first U.S. representative from the state, serving from 1818 to 1819, and the state's U.S. Senator from 1824 to 1825 and again from 1829 to 1830. Initially, the namesake suggested was William Hendricks, a U.S. senator from Indiana, but the consensus was that naming it for a living person would be inappropriate.

In 1946, Jack Rittenhouse noted, "Another small community, but it provides a gas station and café." No mention was made of the Dixie Truckers Home, now the Dixie Travel Plaza, which opened in 1928 as one of the nation's first truck stops. However, the service station directory published by AAA in that year lists the facility as an approved service facility.

An attraction that links the lure of Route 66 to more recent history located at 107 South Hamilton Street is America's Playable Arcade Museum. Located in a renovated historic structure, this museum replicates an arcade circa 1984 with playable games.

The modern incarnation of the historic Dixie Truckers Home in McLean, Illinois, features another classic from the preinterstate highway era, Stuckey's. *Judy Hinckley*

HINDMAN HOTEL — M. G. MULLANAX (Owner) — McLEAN, TEXAS

J. R. and Mary Hindman launched their business endeavors that would eventually include the Hindman Hotel and O'Dell Hotel in McLean with a small boarding house and café in their dugout home in 1904. *Steve Rider*

MCLEAN PERMANENT ALIEN INTERNMENT CAMP

Authorized in September 1942, the McLean Permanent Alien Internment Camp, 1871st Service Command Unit at McLean, Texas, closed July 1, 1945. The facility, designed in the then-standard layout to accommodate three thousand prisoners, initially housed German troops captured during the battles in North Africa.

A Texas State Historical Marker on site provides a concise summary of the camp. Directions to this site are available at the McLean/Alanreed Area Museum, 116 Main Street, McLean, Texas.

MCLEAN, TEXAS

McLean—the last Route 66 town bypassed in Texas, fifteen miles to the west of Lela—is another town that stretches the definition of the term "ghost town" with a population numbered at 782 in 2006. This number is almost half of the peak reached in 1950. Classic elements that make McLean look like a ghost town include nearly empty main streets; Route 66 is a four-lane road with east- and westbound lanes divided by one block, abandoned service stations, and equally empty motels.

The town's story begins with Alfred Rowe, master of the two hundred thousand–acre RO Ranch and a multifaceted entrepreneur with a very diverse background that included a Peruvian birth and English education. Rowe believed in learning a business from the ground up, which meant that his introduction to Texas ranching came as a lowly cowboy employed by Charles Goodnight.

He was also a master at sensing opportunity, and that was what he saw in a well, a switchyard, and a section house built by the Choctaw, Oklahoma & Texas Railroad, later the Rock Island Railroad, in 1901. Rowe donated adjoining properties for a cattle-loading facility, and on December 3, 1902, a plat for the town of McLean—named for William Pinkney McLean, a hero of the war for Texas independence and the state's first railroad commissioner—was recorded in the Gray County Courthouse.

Within two years, the town was a thriving hub of commerce with three general stores, livery stables, a bank, and even a newspaper. During the early 1920s, the discovery of oil in the area and burgeoning traffic on Route 66 kicked growth into high gear.

In 1929, Phillips Petroleum opened one of its first stations in Texas here. Built in a style to mimic a Tudor cottage, the station remained operational through 1977. Restoration of the property makes it a favored photographic stop for travelers on Route 66.

By 1940, there were six churches, a population in excess of 1,500, and more than fifty businesses. McLean was also an economically diverse community with petroleum, agriculture, and Route 66 businesses, as well as a factory, now the Devil's Rope/Old Route 66 Museum, that originally produced ladies undergarments.

Drought, the emergence of Pampa as the county's industrial center, the collapse of the oil industry, and the replacement of Route 66 with the interstate highway sent the town into a slow-motion downward spiral, similar to that experienced by many bypassed communities. Today, the resurgent interest in Route 66 has helped stem the decline and serves as the primary catalyst for the resurrection or preservation of some remaining roadside and historic relics.

In 2004, a large portion of the central business district with commercial structures dating to the early twentieth century received recognition with a listing in the National Register of Historic Places. Though not located in the historic district, the Cactus Inn Motel continues to offer clean, quiet lodging as it has for more than a half century. The *Route 66 Dining & Lodging Guide*, fifteenth edition, published by the National Historic Route 66 Federation, lists the Cactus Inn as recommended lodging.

A second establishment, Red River Steak House, also received recommendation as a special "must stop" rating in the *Route 66 Dining & Lodging Guide*, fifteenth edition. The restaurant catered the awards dinner at the 2011 International Route 66 Festival in Amarillo.

The long afternoon shadows on empty streets mirror the sunset of McLean, Texas, a town whose population has slipped from 1,521 in 1940 to 830 in 2000. *Steve Rider*

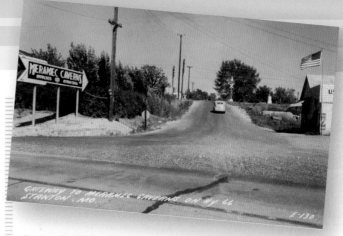

MERAMEC CAVERNS

The earliest recorded history of Meramec Caverns dates to its discovery by Jacques Renault, a French explorer, in 1720. Extensive deposits of saltpeter, used for making gunpowder, led to the initiation of mining in the cave and naming it Salt Peter Cave.

Stories persist that the cavern served as a stop on the Underground Railroad as escaped slaves moved north. Historic documentation for the cave indicates that during the American Civil War, it served as a saltpeter mine and munitions mill for the U.S. Army. Legend has it that William Quantrill, leader of a band of Confederate guerillas that may or may not have included Jesse James, destroyed the mill.

During the 1890s, installation of a wooden dance floor and bar transformed a portion of the cave into a popular ballroom, especially during the summer months. In 1901, expansion of the facility resulted in the discovery of other levels and rooms. Various attempts to profit from the cavern as a tourist attraction, however, met with limited success until its acquisition by Lester Dill in 1933. Dill had extensive experience in the area of utilizing caverns as draws for tourists. He claimed that at age ten, he began leading tourists from St. Louis into Fisher's Cave.

In 1927, the state of Missouri established Meramec State Park, with Dill's father as superintendent. Lester negotiated with the state for the development of Mushroom and Fisher's Cave. On May 1, 1933, Dill signed a five-year lease, with option to buy, for Salt Peter Cave from Charley Rueppele. He changed the name to Meramec Caverns, had a road to the cave entrance built, and utilized the saltpeter mine portion of the cave as a cool parking facility with promotions that heralded the facility as the "World's First Drive In Cave."

In 1934, Dill resurrected the ballroom idea, purchased the caverns from the estate of Charley Rueppele, sold one-half interest in the property to Vivian Peterson, and initiated extensive advertising along Route 66. Emulating the successful "See Rock

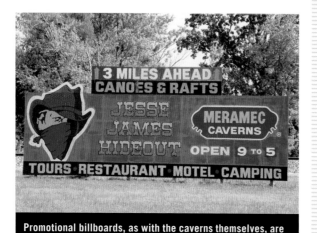

Promotional billboards, as with the caverns themselves, are near perfect time capsules from the golden era of Route 66 roadside attractions. *Steve Rider*

By the mid-1960s, the popularity of Meramec Caverns resulted in massive traffic jams at this intersection, especially if the flow was interrupted because of a train at the Frisco Railroad crossing. *Steve Rider*

City" barn advertisements, Dill chose a yellow and red theme for enhanced visibility. He hired local kids to wire cardboard advertisements to car bumpers in the parking lot.

As Dill developed and promoted the caverns as a tourist attraction during the 1930s, 1940s, and into the 1950s, fabrication and exaggeration blurred the actual history. Additionally, he became a master at using current events for promotional purposes.

With the increasing tensions of the postwar era and rise in fears about nuclear war, Dill stocked one room with rations and gallons of water and promoted the caverns as the world's first atomic refuge. To enhance the value of this promotion, cards indicating reservations inside the fallout shelter in case of nuclear war accompanied admission tickets.

In December 1941, exploration in the cavern led to the discovery of additional passages. Dill immediately claimed that relics in the passage had links to Jesse James. Building on this claim, in 1949 Dill relocated one hundred–year-old J. Frank Dalton, who claimed to be Jesse James living under an assumed name, to a cabin on the property. Following this was the dismantling of an old log cabin and its reconstruction in the cavern as a Jesse James hideout.

In 1960, he created the Honeymoon Room, an attraction that featured a newlywed couple posing as cave dwellers who had ten days to live in the room and find a hidden key for a free trip to the Bahamas. This stunt generated national attention with a feature on *The Art Linkletter Show*.

The caverns remain a major attraction in the area with extensive promotion along the interstate highway. Their preservation as a tangible link to travel on Route 66 during the 1950s has resulted in their iconic status and their inclusion in the documentary *Billy Connolly's Route 66*, produced in 2011.

MESITA, NEW MEXICO

Located within the confines of the Laguna Indian Reservation, the community of Mesita has an accepted founding date of 1870, the year a conservative faction of the pueblo relocated to this site. The namesake is a small mesa that is a dominant landscape feature here.

In 1946, Jack Rittenhouse noted in his travel guide that Messita was a cluster of homes with no facilities for travelers. He also noted that there was a garage three miles to the west. This description remains appropriate for the community.

METEOR CITY, ARIZONA

During the 1930s, Winslow, Arizona, billed itself as Meteor City. Joseph Sharber utilized this name recognition for a service station established at the junction of the road to Meteor Crater and Route 66 in 1938.

Shortly after acquisition of the property by Jack Newsum in 1941, expansion of the facility included the addition of a trading post. Jack Rittenhouse noted in his 1946 travel guide that Meteor City consisted of "one building, offering gas, groceries, and curios. For many years, a roadside sign here said 'Population 1,' but early in 1946, the operator of the 'town' married, and the sign now says, 'Population 2.'"

Gloria, Newsum's wife, served as a justice of the peace in the area and developed a reputation that earned her the nickname "The Witch of Route 66" for the harsh speeding fines levied on motorists. Jack passed away in 1960, and the trading post burned shortly after that date.

In 1979, a new trading post built as a geodesic dome opened on the site, and after it burned in 1990, another geodesic dome was constructed. This facility appeared in the 1984 film *Starman,* starring Jeff Bridges. Dan and Judi Kempton operated the facility from 1989 to 2001. In 2002, Emelia and Richard Benton purchased the property. After its refurbishment, it again became a landmark on Route 66 known for the world's longest map of that highway, a mural painted by acclaimed artist Bob Waldmire.

As of summer 2011, it remained operational. However, there were extensive indications the property was in need of repair, including the repainting of the now-famous map mural.

Meteor City in Arizona is a Route 66 landmark with origins dating to 1938. The world's longest map of Route 66 is the handiwork of renowned artist Bob Waldmire. *Joe Sonderman*

The curator of the American Meteorite Museum, Dr. Harvey Nininger, claimed that in its first year of operation, thirty-three thousand visitors came to see or study the five thousand–meteorite collection. *Joe Sonderman*

METEOR CRATER OBSERVATORY

Henry Locke opened the Meteor Crater Observatory, a beautiful stone structure with three-story observation tower built on a knoll of weathered red rock above Route 66, in the late 1930s as a trading post with mineralogical display. Shortly after opening, Locke lost the property through foreclosure. (Locke would later develop a comic strip titled *Desert Cuties* and serve as a deputy with the Winslow Police Department. While on duty, at age fifty-six, he suffered a fatal heart attack.)

In 1946, Dr. Harvey Nininger acquired the observatory and opened the American Meteorite Museum on October 19. In its first year of operation, the museum attracted a reported thirty-three thousand visitors, and with a collection of almost five thousand meteorites, it became an acclaimed research center.

In the guidebook published by Jack Rittenhouse in 1946, the author noted that the Meteor Crater Observatory was ". . . a castle like stone structure on a hill. Admission is free, and a stock of curios is for sale. The building houses a model of Meteor Crater, which lies a few miles to the south and is visible from the observatory."

The realignment of Route 66 to the north of the facility in 1949 severed the museum from its primary revenue source. It closed in 1953, and only towering, picturesque stone ruins remain to mark the site today.

MIAMI MARATHON OIL COMPANY STATION

Located at 331 South Main Street in Miami, Oklahoma, the Miami Marathon Oil Company Service Station, listed in the National Register of Historic Places in 1995, dates to 1929. Initially the station sold Transcontinental Oil products but became a part of Marathon Oil shortly after.

Recent renovation has restored the building to its appearance in 1930. As of 2010, it served as a beauty parlor.

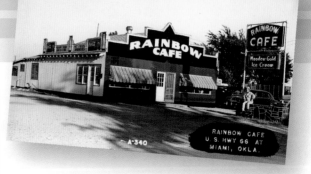

MIAMI, OKLAHOMA

According to George H. Shirk, author of *Oklahoma Place Names*, selection of the name for the community of Miami was in honor of Thomas Richardville, a Miami chief instrumental in the legislative process that resulted in acquisition of the town site. However, other sources claim Wayland C. Lykins, son of a missionary to the Peoria Indians and local rancher, selected the name as part of the application for a town site filed in Washington D.C. Though there may be conflict about the origin of the name, the accepted date of origination is March 2, 1891, and the filing of the town charter, the first in Indian Territory. A post office established on April 13, 1891, soon followed. Before statehood, Miami served as record town for Recording District 1, Indian Territory.

The discovery of extensive deposits of lead and zinc in 1905 transformed the community from a small rural town into a mining boomtown. Indicative of the town's prosperity and prominence were the opening of the Northeastern School of Mines, later the Northeastern Oklahoma Junior College, in 1919, and the Spanish Mission Revival–style Coleman Theater in 1929, established by George L. Coleman Sr. The latter, recently renovated, remains one of the city's crown jewels. From its inception, it has been heralded as one of the most beautiful theaters in Oklahoma.

The development of tourism-related services sheds light on the role Route 66 played in the economy of Miami. The *Hotel, Garage, Service Station, and AAA Club Directory* for 1927 lists only the Miami Hotel for approved lodging, while the 1954 edition of the *AAA Western Accommodations Directory* lists the Hotel Miami, Cherokee Motel, Frontier Motel, and Sooner State Motor Kourt.

The city has an extensive association with celebrities and artists, including Charles Banks Williams, the artist who painted the dome pictures in the Oklahoma State Capitol Building; Mickey Mantle; Jim Thorpe; and Steve Owens, the 1969 Heisman Trophy winner.

The Rainbow Café in Miami, Oklahoma, was but one of the restaurant enterprises initiated by the family of Art Tucker. From 1928 to 1952, a chain of Tucker's Lunch restaurants operated in Miami, Vinita, Picher, and Disney, Oklahoma. *Steve Rider*

Miami also has several important associations with Route 66. Until 1997, a steel truss bridge built in 1937 spanned the Neosho River south of town. Completion of this bridge served as the final link in the complete paving of that highway in the state of Oklahoma.

The original alignment of Route 66, a segment of which remains to the south of Miami, predates certification of the highway by four years and represents a rare and unusual moment in highway engineering evolution. Paved from its inception in 1922, this portion of roadway that connected Miami with Afton is only nine feet wide, including its original concrete edging. Amazingly, this roadway served as Route 66 until completion of the Neosho River Bridge. In the fall of 2011, the state of Oklahoma dedicated an historic monument at the south end segment of this highway.

A landmark on Route 66, with its unique neon signage that dates to 1965, is Waylan's Ku-Ku, a restaurant that specializes in simple American fare, such as hamburgers. Enhancing the time capsule feel are cruise nights held on the fourth Saturday of the month from April to October. This restaurant garnered a recommendation in the *Route 66 Dining & Lodging Guide*, fifteenth edition, published by the National Historic Route 66 Federation in 2011.

MIDWAY CAFÉ

The exact date of origin for the structure that became the Midway Café in Cuba, Missouri, is unknown. However, in the late 1920s, the complex consisted of a small restaurant in front with large garage that doubled as an automotive showroom in the rear.

In the early 1930s, Allyne Earls leased the small restaurant from the owner, William Mullen. A few years later, Earls purchased the property, and by catering to the needs of the motoring public passing by the door on Route 66, she developed a reputation for good food and hospitality that spread far beyond Cuba.

With the construction of, and subsequent staffing of, nearby Fort Leonard Wood during the 1940s, the café prospered, and Earls expanded the facility to include a second-floor hotel consisting of twenty-four rooms with four bathrooms that were consistently rented by the wives and families of soldiers stationed at the fort. This was in addition to restaurant expansions.

During this period, the Midway Café also received designation as an official stop for the Greyhound bus line. This and the

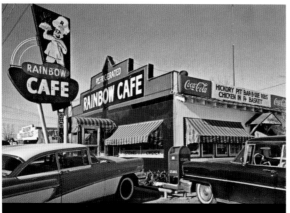

Located at 1214 North Main Street in Miami, Oklahoma, Art Tucker's Rainbow Café was, as the name implied, painted with all of the colors of the rainbow. *Steve Rider*

increasing flow of traffic on Route 66 during the postwar period ensured the café would remain a profitable venture.

The café stayed open twenty-four hours a day, seven days a week and, according to Earls, often served six hundred meals in a day. Legend has it that when Earls sold the facility in 1972, she had no key for the new owners, since the restaurant had not closed in decades.

However, the café was more than just a roadhouse. It also served the local community by providing jobs, as a favored location for special events, and as a hangout during the after-school hours.

After Earls sold the property in 1972, it changed hands several times before its acquisition by Noel Picard, a former member of the St. Louis Blues hockey team, in 1976. Picard and his family managed the facility until 1983.

After this date, the building served numerous purposes before its complete abandonment. Recently, truckloads of debris were removed from the property, and the Cuba Fire Department used the structure for various training purposes. Demolition occurred in late 2011 after careful evaluation of the projected cost of renovation.

MILAGRO, NEW MEXICO

The selection of the name Milagro, Spanish for miracle, is in reference to a legend that claims lost Spanish colonists miraculously discovered a spring near this site. The original village was located 2.5 miles south of its current location on Route 66, and a post office operated intermittently here from 1916 to 1935.

There is little to indicate the community had more than a passing association with Route 66. It does not appear on the 1929 edition of the Rand McNally *Auto Road Atlas of the United States and Eastern Canada*. In the classic guidebook written by Jack Rittenhouse in 1946, he notes several locations between Santa Rosa and Clines Corner with limited services but does not mention Milagro.

MILAN, NEW MEXICO

Before the uranium mining boom of the 1950s, a small cluster of service-related business existed here. The boom resulted in dramatic expansion, culminating with incorporation in 1957.

The namesake was Salvador Milan, a major landholder in the area who, with his sister Mary, was exiled from Mexico during the revolution of 1913. Milan served as the town's mayor from 1957 until his death in 1970.

Jerry McClanahan, in his book, *EZ 66 Guide for Travelers*, second edition (published by the National Historic Route 66 Federation in 2008), noted that "Milan is usually a good place to fill up your tank. Numerous remnants of old motels, garages, and trading posts line the west side of old 66."

MILK BOTTLE BUILDING

Completed in 1930, this unique 392-square-foot triangular building on Classen Street, an alignment of Route 66 in Oklahoma City from 1926 to 1930, was designed to fit a lot of similar geometry created by the Belle Isle streetcar line and Northwest Twenty-Third Street. Initially, the Triangle Grocery and Market, a business that also served as a stop on the streetcar line, utilized the structure.

The name Milk Bottle Grocery comes from the addition of an eight-foot-wide, eleven-foot-high metal sign shaped like a milk bottle in 1948. Originally, the sign was leased independently from the building, and the primary lessees were local dairies, including Steffen's and Townley's.

In addition to serving as a grocery, the building has housed a florist, a package liquor store, various restaurants, and a real estate office. As of 2010, the tenant operated a Vietnamese restaurant in the building now listed on the National Register of Historical Places.

MITCHELL, ILLINOIS

The initial postal application filed in February 1869 for this community was under the name Long Lake, but an amendment in March of 1892 changed this to Mitchell. The namesake for this change remains a matter of conjecture, however. Edward Callary, in *Place Names of Illinois,* 2009, quotes *A New Geography of Illinois: Madison County* and claims the namesake is John J. Mitchell of the Alton & St. Louis Railroad. However, regional historians claim the name is in reference to the Mitchell brothers: John, Jay, and William, who donated lands here for a school and church.

The community's association with Route 66 is equally confusing. The original alignment followed present-day Route 203 south through Mitchell into Granite City, where it followed Broadway through Madison to Venice. On January 1, 1936, U.S. 66 followed what is now Chain of Rocks Road to the Chain of Rocks Bridge. In 1955, with realignment to the new expressway that utilized the Veteran's Bridge, Chain of Rocks Road became Bypass 66, a branch of the highway eliminated in 1965.

The *Hotel, Garage, Service Station, and AAA Club Directory* published in 1927 lists Mitchell Service Company for approved service. Jack Rittenhouse noted in 1946 that available services included Paul's Garage, gas stations, and a café. The *Service Station Directory*, published by AAA in 1946, lists Paul's Mitchell Garage; presumably this is the Paul's Garage, alluded to by Rittenhouse and Tri-City, for approved repairs and service.

Because U.S. 66 and U.S. 40 passed through Mitchell and crossed the Mississippi River on the Chain of Rocks Bridge, motels were a lucrative business, especially in the period between 1946 and 1960. Three existing properties that provide links to this period are the Economy Inn, formerly the Chain of Rocks Motel; Land of Lincoln Motel; and Canal Motel.

A directory for motor courts and cottages published in 1940 notes that Nelson Cabin Camp was a ten-unit complex that offered basic amenities for the traveler. *Steve Rider*

MITCHELL, ILLINOIS *continued*

Of primary interest to Route 66 enthusiasts is the Luna Café, built in 1929. Unsubstantiated stories link the café with nefarious activity including prostitution and gambling, as well as historic figures involved with these trades (such as Al Capone). The café today serves as a neighborhood tavern. Inducted into the Illinois Route 66 Hall of Fame in June 2004, the Luna Café with its vintage neon sign is a Route 66 landmark.

MITLA CAFÉ

Located at 602 North Mount Vernon Avenue, Route 66, in San Bernardino, California, the Mitla Café opened in 1937. As of 2011, it remained operational. Both the popular *EZ 66 Guide for Travelers* written by Jerry McClanahan in 2008 and the *Route 66 Dining & Lodging Guide*, fifteenth edition (published by the National Historic Route 66 Federation in 2011), recommend this restaurant.

MIZ ZIP'S

Joe and Lila Lockhard, with her sons, Howard and Bob Leonard, and Bob's wife, Norma, as partners, purchased a motel, service station, and Trixie's Diner at 2924 East Route 66 in Flagstaff, Arizona, in 1942. The motel was re-signed as L and L, and plans called for changing this to Let's Eat.

According to family legend, Bob's uncle suggested they reconsider and find a name with more zip. The compromise resulted in the restaurant signed as Miz Zip's with "Let's Eat" emblazoned in neon on the façade.

As of 2011, it remained operational. The fifteenth edition of the *Route 66 Dining & Lodging Guide*, published by the National Historic Route 66 Federation in 2011, gave it an "exceptional" rating.

MODERN AUTO COURT

Built at 3712 East Central Avenue in the Nob Hill section, Albuquerque's first suburb where development commenced in

1916, the Modern Auto Court opened in 1936. It later became the Nob Hill Motel, closed in 2006, and with renovation became a complex of offices and retail stores retaining much of the original external historical integrity, which included renovation of the neon sign.

MONROVIA, CALIFORNIA

The namesake for Monrovia is William Monroe, who initially purchased thirty acres from Elias Jackson "Lucky" Baldwin. Baldwin was selling parcels of the Rancho Santa Anita in 1884. In conjunction with business associates, Monroe purchased an additional thirty acres from Rancho Santa Anita and Azusa de Duarte in 1886 and had a town site platted.

The earliest alignment of Route 66 utilized Shamrock Avenue. At the intersection of Shamrock Avenue and Royal Oaks survives a vintage service station that dates to approximately 1930. This well-maintained structure with refurbished gas pumps is now a prized location for film and photo shoots.

A second site of particular note, the Aztec Hotel, is located on Foothill Boulevard. Designed by renowned architect Robert Stacy-Judd, the hotel opened on September 5, 1925, and warranted a listing in the 1927 AAA lodging directory. The ornate façade inspired by both Mayan and Aztec glyphs, and equally unique interior styling, made it an immediate sensation, and the hotel bar was a favorite for celebrities. Renovations, including of the towering neon sign and a listing on the National Register of Historic Places, have not translated into this being a profitable enterprise. As of the winter of 2011, the property remained open but was in foreclosure.

The *Directory of Motor Courts and Cottages* published in 1940 lists four establishments for approved lodging: Motel 66, Orange Grove Trailer Park, Torco Motor Court, and Vista Sierra Lodge. Of these, the Motel 66 warranted a lengthy entry: "Motel 66, 913 E. Huntington Drive, east city limits on U.S. 66. A new, very clean and well maintained motel of 12 units, each with private shower; 6 with completely equipped kitchens, with Magic Chef Ranges and electric refrigerators; 2 units with twin beds; 1 with two double beds. Beautifully furnished with Monterrey furniture. All heated by gas. Open garages. 8 units are air conditioned; 8 with radios." The rates listed were $2.50 to $3.00 per day with weekly rates available. This directory lists R. L. Thompson and W. W. Hunter as managing owners.

The Motel 66 does not appear in the *Western Accommodations Directory*, published by AAA in 1955. However, this directory does list seven motels: 'Leven Oaks Hotel; Mon-Arc Motel, 917 West Huntington Drive with a notation of "High Class"; Monrovia Motor Lodge, 715 East Huntington Drive; New Salem Motor Court, 741 East Huntington Drive; Oak Park Motel, 925 East Huntington Drive; Pacific Motel, 721 West Huntington Drive; and Wagon Wheel Lodge, 926 South Fifth Avenue;

"A new, very clean, and well maintained motel of 12 units, each with private shower" opens an AAA lodging guide entry for the Motel 66. Rates listed as ranging from $2.00 to $2.50. *Mike Ward*

MONTEREY COURT

The Monterey Non Smokers Motel at 2402 West Central Avenue in Albuquerque, New Mexico, opened in mid-1946 as David Court. By 1954, the year it received recognition with inclusion in the *Western Accommodations Directory* published by AAA, it had been renamed the Monterey Court. The directory noted its "air cooled one and two room units have individually controlled vented heat and tiled shower or combination baths; radios available. Family units; 1 housekeeping unit; 10 car ports. Playground. $4.00–$6.00."

The property continues to receive recommendation from Route 66 enthusiasts. Jerry McClanahan, in his *EZ 66 Guide for Travelers*, second edition, noted that ". . . the only one I have had recent (repeated) experience of is the Monterey Non Smokers Motel."

The *Route 66 Dining & Lodging Guide*, fifteenth edition, published by the National Historic Route 66 Federation in 2011, also gives the property a high recommendation: " . . . Exceptional—$58–$90—value—a very special 'must stop'— classic Route 66 motel in beautiful condition—new room interiors—outdoor heated pool."

MONTOYA, NEW MEXICO

Initial establishment of the post office in this isolated New Mexico ranching community was under the name Rountree in reference to Henry Rountree, the postmaster, in 1902. That same year, the arrival of the Chicago, Rock Island & Pacific (CRI & P) railroad spurred growth, and an amended postal application changed the name to Montoya, in honor of Bartolome de Montoya, a historian. A post office operated here under this name until 1972.

Jack Rittenhouse noted in 1946 that Montoya was " . . . once a busy town, but it is now merely a loading point for the railroad." He also noted that available services included two gas stations and a store. He incorrectly identified the stone structure to the north of the railroad tracks as a hotel. In actuality, this two-story stone structure was a home, Casa Alta, built by Sylvan and Maria Hendren in 1900. The store referred to by Rittenhouse was the Richardson Store that operated from 1925 into the 1970s. Established by G. W. Richardson of Missouri, this was his

second venture in Montoya. His first store to the north of the tracks opened in 1908. During the 1930s, 1940s, and early 1950s, the store met the needs of travelers, as well as locals, by selling gasoline, food, auto parts, and ranch supplies. Its historic significance resulted in placement on the National Register of Historic Places in 1978.

MORIARTY, NEW MEXICO

Michael Moriarty of Iowa established a sheep ranch in the Estancia Valley near the present town site of Moriarity in about 1887. Development of a railroad construction camp at this location spurred growth that resulted in a town large enough to warrant a post office by 1902.

Route 66 served as a catalyst for continued growth and economic development. Extensive vestiges from this association remain, and the resurgent interest in this highway has resulted in the preservation or restoration of numerous properties.

The Lariat Lodge opened in late 1953, and, recently renovated, it is still in business as the Lariat Motel. The entry for this property in the *Western Accommodations Directory*, published by AAA in 1954, notes, "Well furnished rooms have TV, central heat and shower baths. Four air-cooled rooms. Free radio and evening paper."

The last operational Whiting Brothers station utilizing original signage is on Route 66 at the eastern edge of town. The Cactus Motel opened in 1952 and as of 2011 served as the Cactus Mall. The Pogue family still owns the Sunset Motel originally established by Bill and Elaine Pogue in the early 1950s. Renovation is currently underway.

Mike Anaya's store, Mike's Friendly Store, opened in 1949 and remained in operation until the summer of 2011. Still in operation is the El Comedor restaurant, with its period furnishings and recently renovated Roto-Sphere sign.

MOTEL ROYAL

The Motel Royal at 9282 Watson Road in St. Louis, Missouri, was one of the premier auto courts in the area during the early 1950s. The St. Louis Chamber of Commerce used a photograph of the motel and property in promotional material during this period.

The *Western Accommodations Directory*, published by AAA in 1954, included an extensive entry for the sixty-unit facility. It noted, "1 1/2 miles east of U.S. 66 By-pass, U.S. 61 & 67 junction. A very good colonial style brick court on spacious grounds. Attractive air conditioned units have one or two rooms, telephones, free radios, TV, radiant heat, tiled combination or shower baths and heated garages; 6 housekeeping units. Lower off season rates. Playground. Restaurant next door. Drive in theater convenient." The rates ranged, in season, from $6.00 to $8.00 per night. The facility no longer exists.

The fully refurbished Motel Safari in Tucumcari that dates to 1959 exemplifies how the resurgent interest in Route 66 is transforming communities all along its course. *Judy Hinckley*

MOTEL SAFARI

Built and operated by Chester Doer of Chicago, the Best Western Motel Safari in Tucumcari, New Mexico, opened at 722 East Highway 66 in late 1959. The second owner, Ron Frey, acquired the property shortly after this date, renamed it Motel Safari, and replaced the Best Western crown on the neon sign with a camel. This recently refurbished sign still exists.

In 2007, Richard Talley, a leading proponent of refurbishment of historic properties in the city and in association with Smalltown America Inns-Lodges-Motels, acquired the property. Refurbishment with attention toward preservation of unique and original architectural features commenced shortly after. This refurbishment included many of the original furnishings that were custom built on site. The patio at the site of the former swimming pool also underwent renovation.

The motel, now a favored lodging choice for Route 66 enthusiasts staying in Tucumcari because it offers a blending of historic authenticity with modern amenities (such as WiFi and flat-panel televisions), exemplifies the economic viability of historic property restoration along the Route 66 corridor.

Colorful wall murals produced by Doug and Sharon Quarles, local artists, enhance the time capsule feel while commemorating the importance of Route 66 to the community of Tucumcari. Additionally, in the summer of 2011, Michael Ward, a renowned Route 66 postcard collector, transformed items in his collection pertaining to Tucumcari into framed posters that were added to the rooms.

MOTEL WESTWARD

The Motel Westward, located at 1580 South Kirkwood Road, at Watson Road and Lindbergh Boulevard, opened in the early 1950s. The 1954 edition of the *Western Accommodations Directory* published by AAA gave the St. Louis property a favorable review: "A very good new brick motor hotel on U.S. 66 at junction of U.S. 61 & 67 By-pass. Attractive rooms are centrally air conditioned and heated and have tiled baths. TV available. Free continental breakfast, ice, and newspaper. Recreation room with TV. Restaurants adjoining." Rates listed ranged from $5.00 to $8.00.

The motel no longer exists. However, its sign, now fully restored, is on display at the Museum of Transportation in St. Louis.

MOUNT OLIVE, ILLINOIS

The initial date of origination for Mount Olive is unknown. However, a community on this site variously known as Rising Sun and Niemann's Settlement predate the accepted date of founding, 1874, by at least twenty years. The name Mount Olive is a translation of the German name, Oelburg, bestowed by Fred and Henry Niemann, immigrants from Germany. The reference is to the biblical Mount of Olives.

Jack Rittenhouse noted that Mount Olive was a small mining and farming town with services that included a garage, gas station, and hotel. He also referred to the Mount Olive Union Miners Cemetery, a site now listed in the National Register of Historic Places.

The creation of the cemetery stems from an incident known as the Virden Riot that occurred during the United Mine Workers of America strike of 1898. The riot started when mine owners attempted to break the strike with 180 African American miners recruited in the South.

Alexander Bradley—often referred to as General Bradley because of his role in Coxley's Army that led a march of unemployed workers down Pennsylvania Avenue in Washington, D.C. in May 1894—became the self-appointed organizer for the United Mine Workers of America in central Illinois. Operating from his home in Mount Olive, Bradley called a secret meeting in the nearby woods where it was resolved that area miners would join in a nationwide strike set for July 4, 1897.

To elicit further support for their cause, local miners (with Bradley, in his signature Prince Albert coat, top hat, and umbrella, leading them), marched to coal mines in Glen Carbon, Collinsville, Edwardsville, and Bellville, and petitioned miners to join the strike.

The labor tensions culminated with a clash between mine guards and miners in Virden on October 12, 1897, that left seven

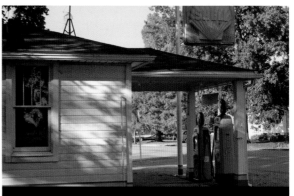

The Soulsby Service Station in Mount Olive, Illinois, is a favorite stop for Route 66 enthusiasts and an example of how the resurgent interest in this highway is creating a passion for the preservation of twentieth-century commercial architecture. *Judy Hinckley*

The centerpiece of the Union Miners Cemetery in Mount Olive, Illinois, is a monument with obelisk featuring a cameo of Mother Jones (Mary Harris Jones), a pioneering union miner organizer. *Judy Hinckley*

After divesting themselves of the Munger Moss Sandwich Shop in Devil's Elbow, Missouri, Jesse and Pete Hudson purchased the Chicken Shanty Café in Lebanon. They renamed it Munger Moss Barbeque and established a motel in 1946. *Joe Sonderman*

miners dead, including four men from Mount Olive. In addition, five guards were killed, and forty-four others wounded. Initially, the men from Mount Olive were buried in the town cemetery, but the owner objected to the ceremonies. The denouncement of the miners as murderers by the Lutheran minister prohibited their burial in the Lutheran cemetery.

The local union purchased an acre and established the Union Miners Cemetery in 1899, and the four men from Mount Olive were the first interred. This is also the final resting place of legendary union activist Mary "Mother" Jones.

For Route 66 enthusiasts, Soulsby Service Station, a fully refurbished service station dating to 1926, is the primary association with Mount Olive. The original station, built by Henry Soulsby, and his son, Russell, measured thirteen-by-twenty feet, but additions made during the 1930s resulted in the station as it appears today. Managed by Russell and his sister, Ola, the station was operational until 1991. It remains as one of the oldest filling stations standing on Route 66.

MUNGER MOSS MOTEL

In 1929, Howard and Nelle Munger built a sandwich shop on Route 66 to the east of the Devil's Elbow Bridge. After Howard's death in 1936, Nelle married Emmett Moss, and the business became the Munger Moss Sandwich Shop.

In about 1940, the property was sold to Jessie and Pete Hudson, who relocated to Lebanon after completion of the Hooker's Cut to bypass the Devil's Elbow Bridge in 1943. In 1946, the facility reopened as the Elbow Inn under the ownership of Paul and Nadine Thompson. From the date of its second closure in 1960, the facility has operated intermittently, and as of the summer of 2011, it was open as the Elbow Inn.

After relocating to Lebanon, Jessie and Pete Hudson purchased the Chicken Shanty Café, a service station restaurant complex, and renamed it Munger Moss Barbeque in late 1945. In 1946, addition of a motel soon replaced the restaurant.

Purchased in 1971 by Bob and Ramona Lehman, the current owners, the Munger Moss Motel remains a unique time capsule with rooms decorated in Route 66 themes featuring the work of various artists and photographers, including Shellee Graham and Jerry McClanahan. In the fall of 2010, the historic neon signage was completely refurbished and relit.

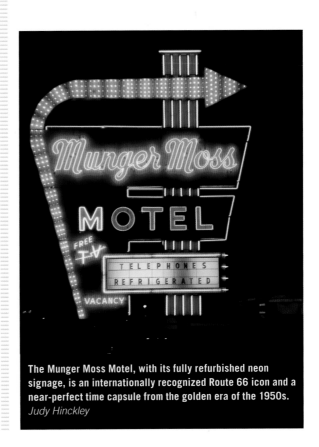

The Munger Moss Motel, with its fully refurbished neon signage, is an internationally recognized Route 66 icon and a near-perfect time capsule from the golden era of the 1950s. *Judy Hinckley*

MURRAY'S DUDE RANCH

Murray's Dude Ranch, sometimes referred to as the Overall Wearing Dude Ranch and billed as "The World's Only Negro Dude Ranch" in the 1950s, was the brain child of Nollie B. Murray, a prominent African American businessman from Los Angeles. Murray purchased the original forty-acre site near Apple Valley and Victorville, California, in 1926.

During the following twenty years, he expanded the property to include several small cottages, a swimming pool, tennis courts, and a riding stable. Though it was not a segregated establishment (Clark Gable was a frequent guest), through publications like *The Negro Motorist Green Book* and association with Joe Louis, it became a favorite vacation destination for affluent African Americans.

During the 1930s, the ranch served as the setting for four western films with all African American casts. Herbert Jeffries starred in them as a singing cowboy. These films were *Harlem on the Prairie* (1937), *Two-Gun Man from Harlem* (1938), *The Bronze Buckaroo* (1939), and *Harlem Rides the Range* (1939).

During World War II, the ranch became an oasis for African American National Guardsman assigned to guard locations deemed vital to national security in the Victorville area. It was with a USO tour that performed at the ranch in 1943 that Pearl Bailey became acquainted with the Murrays. In 1955, Pearl Bailey and her husband Louis Bellson, a drummer who had played with the Benny Goodman, Tommy Dorsey, Harry James, and Duke Ellington bands, purchased the property. After its sale again in 1964, it served a variety of purposes before succumbing to abandonment. In 1988, the remaining structures were burned as a training exercise for the Apple Valley Fire Department.

MUSEUM CLUB

Dean Eldredge, a sportsman and taxidermist, built a large, two-story log cabin around five large ponderosa pines along Route 66 east of downtown Flagstaff, Arizona, to house his collection of more than three thousand mounts and related curiosities. Locals referred to it as the zoo, even though it opened as the Dean Eldredge Museum and Taxidermist on June 20, 1931.

Doc Williams acquired the property after the death of Eldredge in 1936, sold most of the collection, and transformed the facility into a roadhouse. The next incarnation occurred when Don Scott, a former member of Bob Wills's band, the Texas Playboys, made it a country music honky-tonk in 1960. In 1973, Scott's wife, Thorna, died after falling on the stairs at the Museum Club. Two years later, he committed suicide.

The Museum Club remains a popular local hangout. It is also one of the most famous historic roadhouses in existence on the Arizona segment of Route 66.

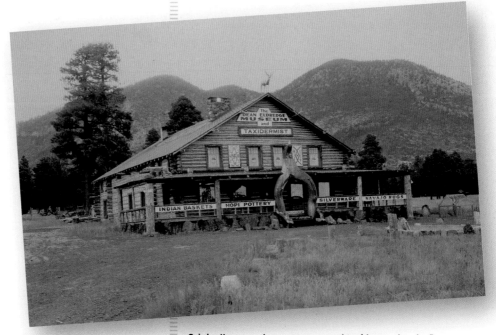

Originally opened as a museum and taxidermy shop by Dean Eldredge in 1931, the Museum Club in Flagstaff, Arizona, remains as one of the best-preserved classic roadhouses along Route 66 in Arizona. *Steve Rider*

N

NACKARD INN MOTEL

To capitalize on the increasing flow of traffic on Beaver Street, a segment of the pre-1934 alignment of Route 66 in Flagstaff, Arizona, Khatter Joseph Nackard built the Downtowner Auto Court one block south of Santa Fe Avenue in 1929. In 1933, the property underwent extensive renovation that included the connection of cabins through elimination of the garages to increase the number of available units. To reflect this modernization, the name became Nackard Inn.

Additional upgrades occurred in the early 1950s, and the name changed to Nackard Inn Motel. The AAA-published *Western Accommodations Directory* for 1955 contains a brief entry that notes the motel was "in town. Centrally heated rooms have radios and tiled shower or tub baths. Two two-room units. $5.50 to $6.50."

The Downtowner Auto Court in Flagstaff, Arizona, established by Khatter Joseph Nackard in 1929 was transformed through extensive remodeling into the Nackard Inn in 1933. In 1950, new ownership led to a name change, Downtowner Motel. *Mike Ward*

The place became the Downtowner Motel in late 1959, and as of winter 2010, the buildings served as an apartment complex. The towering Downtowner Motel sign remained as of the winter of 2011.

NARCISSA, OKLAHOMA

Narcissa, a former farming community named by Narcissa Walker in 1902, was the proverbial wide spot in the road when Jack Rittenhouse passed through in 1946. He noted, "Only one establishment on US 66: a gas station with a grocery and small garage."

The community's population warranted a post office from January 15, 1902, to November 15, 1916. The shell of the establishment alluded to by Rittenhouse remains, but there is little to indicate this was ever a town.

The towering promotional sign for the Downtowner Motel still dominates the skyline of Flagstaff, Arizona, even though the motel is now an apartment complex. *Mike Ward*

NATIONAL HISTORIC ROUTE 66 FEDERATION

The National Historic Route 66 Federation is a nonprofit organization dedicated to increasing public awareness about Route 66 and its historical significance and assisting in the acquisition of grant monies to preserve landmarks along the route. To accomplish this, the federation implements public education, advocacy, and membership programs as well as publishing a number of guidebooks.

In the late 1990s, the federation initiated efforts that culminated with passage of the National Route 66 Corridor Preservation Act in 1999. The act provides $10 million in matching funds grants for the preservation or restoration of historic properties and landmarks.

The Adopt-A-Hundred Program proved to be another successful federation program. This unique endeavor has twenty-seven volunteers that assume responsibility for a one hundred–mile section of the highway. Their task is to serve as an early warning system for potential problems pertaining to landmarks or historic properties.

The federation—in addition to publishing a quarterly magazine, presenting the Cyrus Avery Award for state preservation projects, giving the Steinbeck Award for preservation, and lending assistance to the development of groups organizing special events and to the media—also publishes travel guides, two of which are now widely recognized as the best available.

The *Route 66 Dining & Lodging Guide* is a self-explanatory work. To ensure relevancy and accuracy for updated editions, the volunteers of the Adopt-A-Hundred Program provide details and updates on a regular basis.

The *EZ 66 Guide for Travelers*, written and illustrated by iconic Route 66 artist Jerry McClanahan, remains one of the most popular and accurate travel guides available. Updates are available online.

The origins of the federation date to a drive made from Chicago to Los Angeles on Route 66 by David and Mary Lou Knudson in 1994. The trip inspired David and Mary Lou to liquidate business interests and dedicate their resources of time and money to Route 66 preservation.

NATIONAL OLD TRAILS HIGHWAY

The origin of the National Old Trails Highway, predecessor to Route 66 in the West and the Southwest, is tied to the development of other pre–federal highway road systems and the Federal Aid Road Act of 1916. The primary foundational element was a series of proposals by General Roy Stone, head of the U.S. Department of Agriculture's Office of Road Inquiry, in the late 1890s. Specifically, Stone proposed a transcontinental highway composed by linking existing roads and trails. Additionally, his

The National Old Trails Arch Bridge served as the primary Colorado River crossing for Route 66 traffic until May of 1947. It currently supports the pipelines of Pacific Gas & Electric.
Steve Rider

suggestion was to link this highway to existing north and south roads on both coasts.

His successor, Martin Dodge, endorsed this idea as well and expounded on the initial proposals. However, both men acknowledged the idea was premature.

On March 4, 1902, nine auto clubs met in Chicago, combined forces as the American Automobile Association, and immediately instructed the directors to initiate serious study for the development of a transcontinental highway. Segments of the proposed route from New York City to Sacramento in California would become the Lincoln Highway and later U.S. 6.

The creation of numerous associations, the publication of magazines (including *Good Roads*), and extensive meetings failed to create a cohesive plan or manifest in the envisioned road system. Instead, local organizations, chambers of commerce, good roads associations, and representatives of automobile manufacturers began creating road systems that best benefited local needs.

It was the Daughters of the American Revolution (DAR), Missouri chapter, that substantively began organizing resources to create the National Old Trails Road utilizing the path of the historic Santa Fe Trail. Fueling national support for this road was the 1911 publication of *The Old Trails Road, The National Highway* by Elizabeth Butler Gentry, a DAR member. The proposed project would use the historic trails like the "old National or Cumberland Road, which includes the Braddock's or Washington Road; the Boon's Lick Road; Santa Fe Trail; Kearney's Road; Oregon Trail." However, the goal of

The dedication of the National Old Trails Arch Bridge on February 20, 1916, was a momentous occasion and a milestone in the development of a highway system designed for automobiles in the Southwest.
Steve Rider

This guide to the National Old Trails Highway would have been crucial for motorists traversing this road in the late teens, as roadside signage was often inconsistent. *Steve Rider*

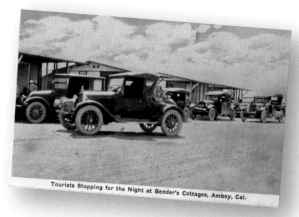

In the 1927 edition of the *Hotel, Garage, Service Station, and AAA Club Directory,* the only facility listed between Barstow and Needles in California was the Bender complex, consisting of a café, cabins, and a garage in Amboy. *Steve Rider*

Located immediately below the pre-1952 alignment of Route 66 on the west side of Sitgreaves Pass in the Black Mountains of Arizona is an early segment of the National Old Trails Highway, complete with bridges and guardrail system. *Steve Rider*

creating a bill for submission to Congress for construction as a federal roadway was even more ambitious.

The well-organized plan—coupled with endeavors such as the 105-day, double transcontinental automobile tour by Mr. and Mrs. Thomas Wilby in 1911—resulted in the movement being designated The Woman's National Old Trails Association. This was the title for an article in the December 1911 issue of *Southern Good Roads.*

The year previously, A. L. Westgard, a special agent of the Office of Public Roads and independent agent for various motoring organizations, mapped a Trail to Sunset Transcontinental Route for a 1911 AAA booklet of strip maps. Eventually, sections of this route were incorporated into the National Old Trails Highway, and both served as the foundation for portions of Route 66. The eastern terminus of the Trail to Sunset was at Jackson and Michigan Boulevards in Chicago, later utilized by Route 66. The route joined the future National Old Trails Highway at Lyons, Kansas, separated at McCarty's, New Mexico, and joined the future Ocean-to-Ocean Highway near Phoenix.

For a brief period, the Trail to Sunset received serious consideration as the route for the portion of the National Old Trails Highway that connected Chicago to California. However, a very active and well-organized good roads association in the territory of Arizona aligned itself with the fledgling Automobile Club of Southern California to advocate a shorter route from Albuquerque to Los Angeles.

This proposed route had several major advantages, including ready access to a main railroad line that allowed motorists to ship their vehicles in the case of mechanical failure or a change in plans. Additionally, this provided motorists with access to quality lodging and dining at the Harvey establishments. The October 1917 edition of *The Road Maker* included an AAA summary of national tourist roads that included details about this route.

NATIONAL OLD TRAILS HIGHWAY *continued*

It stated, " . . . but more lately there has been developed a new and shorter connection from Albuquerque through Holbrook, Flagstaff, Williams, Needles, and San Bernardino to Los Angeles."

The first concerted effort to have this roadway designated the National Old Trails Road occurred at the second national convention of the National Old Trails Road Ocean-to-Ocean Highway Association in 1913. Delegates representing the Santa Fe–Grand Canyon–Needles National Highway Association felt that the lack of population along this route could be negated by the fact that "the greatest advantage we have is that most of our road is built."

An amendment to the association's constitution during this convention established an official National Old Trails Road west from Santa Fe. This route would connect Santa Fe, Albuquerque, Gallup, Holbrook, Winslow, Flagstaff, Williams, Ash Fork, Seligman, Kingman, Yucca, Topeka (Topock), Needles, Goffs, Bagdad, Barstow, San Bernardino, Upland, San Gabriel, and Los Angeles. As the road in western New Mexico was deemed unsuitable for automobile traffic, a detour was approved. This route was from Santa Fe to Albuquerque through Magdalena, to Springerville in Arizona via Socorro and then to Holbrook.

In the March 1915 issue of *Motor*, an article written by A. L. Westgard entitled "Motor Routes to the California Expositions" noted, "Though assured by the State Engineer that the new road from Albuquerque to Gallup will be open for traffic this spring, I think it might be well, in case of possible delay of the opening of that route, to state here that a fair road leads from Albuquerque to Socorro, crossing a new bridge over the Rio Grande near the latter town, and thence on good to fair road via Magdalena across the Augustine Plains and the Datil Mountains to Springerville, Arizona, thence via St. Johns to Holbrook, where it joins the regular Old Trails Route as described in the next paragraph."

The initial interest of the DAR was to use historic trails as a bridge from the past to the future. As a result, this organization's support for the National Old Trails Road from Santa Fe to Los Angeles wavered in the beginning. However, this was rectified with a booklet entitled *The Old Santa Fe Trail Across Arizona*, written in part by Father Cypriano, the Arizona representative of the National Old Trails Association. In the forward, he succinctly outlined the roads historic roots from the Spanish explorations of 1540 to 1776. He then detailed the preliminary development of the Beale Road that served as the foundation for the construction of a transcontinental railroad.

As the efforts to finalize the official route were being debated, the Automobile Club of Southern California was signing the proposed route. In May 1914, *Touring Topics*, the association's magazine, reported that most of the National Old Trails Road in California "was signed," and by October, signage was complete to the New Mexico–Arizona border.

During the same period, the Automobile Club of Southern California turned its attention to a primary obstacle in the creation of a modern highway designed for automotive traffic: the crossing of the Colorado River. During this period, crossing of the river between Topock and Needles required the use of intermittent ferry service or, further to the south, the Santa Fe Railroad Bridge planked for automobile usage in between trains. The increasing influence of this organization is manifest in the subsequent appropriation of $75,000 from the states of California and Arizona and the federal government for the construction of an automobile bridge. The resultant Old Trails Arch Bridge, an engineering marvel of the time, opened on February 20, 1916.

In spite of its limitations, including a load limit of eleven tons, the bridge served as the Colorado River crossing for the National Old Trails Highway, and later Route 66, until 1947. With the transformation of the Red Rock Railroad Bridge into a highway bridge completed in May of that year, the Old Trails Arch Bridge closed to traffic. The bridge underwent conversion and currently serves as the support for natural gas pipelines of the Pacific Gas and Electric Company. (As a historic footnote, this bridge appears in the scene of the Joad family crossing into California in the 1940 film adaptation of John Steinbeck's novel *The Grapes of Wrath*.)

With very little adaptation, the first incarnation of Route 66 between Santa Fe and Los Angeles utilized the course of the National Old Trails Highway. In western Arizona, Route 66 followed both the main course of the National Old Trails Highway and the suggested alternate. From Kingman to Topock, both roads followed a course through the Black Mountains. However, in 1952, realignment of Route 66 bypassed this section of the highway and instead followed the alternate, or Valley Bypass, route of 1914 through Yucca. This later became the course for Interstate 40.

Immediately east of Goldroad, Arizona, directly below the pre-1952 alignment of Route 66, is a well-preserved section of the early alignment of the National Old Trails Highway that features numerous aspects of highway engineering from the early teens, including bridge abutments, guardrails, and banked curves.

NAVAJO, ARIZONA

Route 66 enthusiasts often miss Navajo, accessed via exit 325 on I-40, because it is located on a section of the old highway that is truncated and that one of the leading travel guides indicates is "inaccessible or unadvisable, due to roughness and washouts." However, an extensive history here belies its size or ease of access.

The initial settlement here was a trading station on the Atchison, Topeka & Santa Fe Railroad in 1883 named Navajo Springs. This was shortened to Navajo to increase telegraphy speed. In actuality, Navajo Springs is located three miles southeast of this station. Inaugurated here on December 29, 1863, it was the first government of the Arizona Territory. The springs were selected for the site of the ceremony because they

were the first point at which the members of the governmental party under military escort were sure they were within the geographical confines of the new territory.

The rush to consummate the proclamation was the result of a stipulation that required that oaths of office be taken in calendar year 1863. In Governor John Noble Goodwin's initial proclamation, he noted, "The seat of government will for the present be at or near Fort Whipple."

In 1946, Jack Rittenhouse noted that Navajo consisted of Marty's Trading Post, with gas and groceries. He also indicated a small café behind the trading post and five cabins.

NEEDLES, CALIFORNIA

The survey reports of the Whipple-Ives expedition of 1854 label the jagged peaks on both sides of the Colorado River near the site of present-day Topock "The Needles," likewise with the initial Pacific Railroad Survey. The Atlantic & Pacific Railroad established a station and small construction community on what is now the Arizona side of the river at this crossing in 1883.

A post office under the name Needles opened here in February of that year. In conjunction with plans for construction of a division point, the railroad relocated the community to the California side of the river on October 11, 1883.

The original alignment of Route 66 and the National Old Trails Highway utilized Front Street, parallel to the railroad tracks and then around the square, as well as Santa Fe Park, in front of El Garces, a Harvey House hotel and restaurant. The later alignment followed Broadway.

El Garces Harvey House dates to 1908 and was the replacement for an older wooden structure that burned. The namesake for the establishment was Father Francisco Garces, a Franciscan priest who led several expeditions in the area during 1775 and 1776. The hotel closed in 1949, and shortly after, the Santa Fe Railroad tore down the north wing and converted the

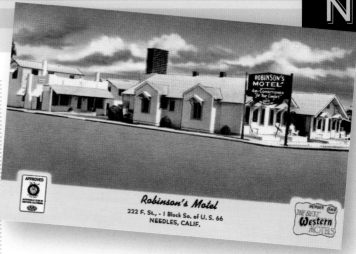

The 1940 edition of the *AAA Directory of Motor Courts and Cottages* lists Robinson's Bungalow Hotel & Motor Inn, later Robinson's Motel, as having eleven units with private bath. *Mike Ward*

remaining structure into offices. Only extensive lobbying from the city of Needles saved it from the wrecker's ball after centralization of operations by the railroad led to its abandonment and scheduled demolition. Part of the campaign was to have the building placed on the National Register of Historic Places. The owners of La Posada in Winslow recently purchased this property, and renovation is currently underway. A scheduled date for completion has yet to be announced.

In addition to the El Garces, the *Directory of Motor Courts and Cottages*, an AAA publication from 1940, lists the Robinson's Bungalow Hotel & Motor Inn as recommended lodging. In *A Guide Book to Highway 66*, however, Jack Rittenhouse presents a clearer picture of the importance of this desert oasis to travelers on Route 66. In addition to El Garces, he lists three other hotels: the California, Gateway, and Monarch. Auto courts and motels listed include West End, Gray's, Swain's, The Palms, Havasu Court & Trailer Camp, Motor Inn Motel. He also notes three garages, numerous cafés, and stores.

A surprising number of early motels still exist, although they now serve as apartments with rooms rented by the week or the month. The two most notable are the 66 Motel and The Palms, a facility with origins dating to the late 1920s.

Another historic location with association to Route 66, now closed but with a few of the original cabins utilized for storage, is Carty's Camp. Bill Carty established the facility in 1925 with tent cabins similar to ones he had stayed in at the Grand Canyon. Expansion during the 1930s included a gas station, garage, campground, and cottages advertised as Havasu Court.

Another noteworthy moment in the history of Route 66 in this area occurred in August 1959, when a monsoon downpour resulted in extensive flooding in Needles and damaged highways, bridges, and the railroad east and west of town. U.S. 66 and Highway 95 closed for more than twelve hours while detours around damaged bridges were made. A railroad worker drowned in the flooding, and eight cars were swept from the highway.

The dependence of communities like Needles on Route 66 and later the interstate highway is encapsulated in a statement

The earliest alignment of Route 66, as well as the National Old Trails Highway, followed Front Street in front of the El Garces Hotel on its course through Needles.

NEEDLES, CALIFORNIA *continued*

given by Bill Claypool, a community leader and owner of the city's largest department store, in 1965 when it was announced that the routing for I-40 might bypass Needles and Yucca to cross the Colorado River near Searchlight, Nevada. In this statement, he noted that the community had compiled a one hundred–page study on the effects of a bypass by the interstate highway. The immediate damage would be to service industry business. Of the twenty-nine service stations, twenty-five would close within six months. Additionally, ten of the nineteen cafés and ten of fourteen wholesalers would close, resulting in a loss of one-third of the jobs in the community.

Even though Interstate 40 still runs through part of Needles, the community entered a period of decline that escalated with the establishment of Laughlin, Nevada, and expansive development of Bullhead City, Arizona, a few miles north of the city. The small community of Needles continues to languish. Indicative of this are population figures that indicate a growth of about 1,200 residents in forty years, while neighboring communities have witnessed exponential development, as well as population growth of more than 150 percent, in less than twenty years.

NELSON, ARTHUR

Born in Buffalo, New York, on December 14, 1864, Arthur Nelson relocated to Lebanon, Missouri, with his father, Absalom Nelson, and family in 1882. Initially, the younger Nelson endeavored to establish his own business presence with a newsstand that sold cigars and books in the Lebanon post office, but within a few years, he joined his father who had established one of the largest apple orchards in the state of Missouri.

Before the turn of the century, the orchard was producing thousands of bushels of apples. With an eye for promotion, Absalom Nelson displayed seventy-five barrels of apples at the Paris Exposition of 1900, where his produce received a gold medal. This accolade resulted in a standing order from the British royal family for Nelson's apples.

At the 1904 world's fair in St. Louis, the apples received thirty-two of a possible forty awards, and the Nelson farms'

The centerpiece of the Nelson Dream Village was a delightful fountain lit at night by colorful lights accompanied by classical music played over a loudspeaker. *Joe Sonderman*

strawberry exhibit received a gold medal. Additionally, the Nelson farms supplied the blue corn for the Missouri exhibit at that fair.

During the same period, Arthur Nelson expanded his family's business interests to include real estate development and establishment of a telephone company. In 1901, Governor Alexander Dockery appointed him to the Missouri State Board of Agriculture. This would be the first of numerous political appointments and awards, including the appointment to the rank of honorary colonel by Governor Herbert S. Hadley.

A visionary thinker and entrepreneur, Arthur Nelson initiated the transport of produce from his family's orchards by truck in 1913. In turn, this necessitated his involvement, and the use of political connections, in the fledgling good roads movement. From an association with this group, he played a role in the development of the state's first cross-country highway designed specifically for automotive use, a road later largely incorporated into U.S. Highway 40.

The good roads movement was pivotal in the establishment of privatized trail organizations, and in 1915, W. H. Harvey initiated the Ozark Trails Association with the goal of developing a highway connecting St. Louis, Missouri, with Las Vegas, New Mexico. A convention of five thousand representatives from the various communities along the route met in Amarillo, Texas, on June 27, 1917, to finalize the course of disputed routes with the result being a routing through Lebanon.

In the same year, the Hawes Law enacted by the Missouri General Assembly transferred responsibility for primary road construction and development from the counties to the state. Building on this, a $60 million bond issue for road improvements received approval in 1920, and in 1921, the passage of the Centennial Law authorized the state to initiate a program of all-weather road construction that would connect population centers.

On April 12, 1922, Arthur Nelson and other interested parties representing communities located along the Frisco Railroad met at the opera house in Lebanon to capitalize on the recent statewide initiatives by forming the St. Louis–Springfield–Joplin Highway Association. On July 12, the efforts put forth by the association culminated in the announcement by the state highway commission that the route of the Ozark Trail through Lebanon was the approved course of the St. Louis–Joplin state highway.

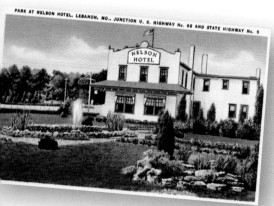

The *Directory of Motor Courts and Cottages*, published by AAA in 1940, listed Nelson Dream Village as a complex of "12 attractive, new, stone cottages with private baths; fireplaces." Rates ranged from $2.00 to $3.00 per night. *Joe Sonderman*

After donating the right of way for Missouri Route 14 (Route 66 after 1926) through his apple orchard, Colonel Arthur T. Nelson opened this Texaco station in July of 1926.
Joe Sonderman

Nelson donated forty acres of his orchard as a right of way. Incorporation into the new federal highway system occurred before completion of the projected state highway, and it received the designation of U.S. 60, soon amended to U.S. 66.

Shortly before the highway's absorption into the federal system, Nelson constructed a stylish service station on his family's property, making extensive use of carefully selected native stones. Accentuating the natural beauty of the area, and making full use of his membership in the state horticultural society, Nelson also added extensive flowerbeds.

The facility opened on July 3, 1926, with great fanfare and extensive publicity. In direct correlation to the increase in traffic, Nelson developed the property as he sought to expand on services made available to travelers.

The first expansion consisted of a small hamburger stand, followed by six tent-roofed cabins built around a central bathhouse. Eight cabins, each named for a state, built on the corner of Elm Street and Jefferson Avenue signed as Top O' the Ozarks Camp came next.

In 1929, Nelson added a two-story stucco building with a mission-styled façade accentuated with green trim to the end of the service station. The Nelson Tavern, later the Nelson Hotel—a twenty-five-room hotel featuring the latest in Beauty Rest mattresses, as well as amenities such as hot and cold running water—opened on January 21, 1930.

Promoted as "A Place for Those Who Care," the Nelson Tavern was a unique establishment. A full-time gardener tended the stylish grounds that included a gladiolus garden featuring numerous varieties imported from throughout the world. The interior with parrots and colorful macaws in cages displayed in a botanical garden of palm trees and exotic plants helped to make this, as one review stated, the "best known spot on Highway 66 between Chicago and Los Angeles."

In 1933, Nelson accepted an appointment by Governor Guy Park to the state highway commission with his primary task being to assist with the design, as well as the installation, of the Missouri display for the Century of Progress Exposition in Chicago. While there, an exhibit at the exposition that featured a fountain with synchronized colored lights and music entranced Nelson, inspiring him to create Nelson's Dream Village.

This motel complex, built directly across Route 66 from the Nelson Hotel, consisted of twelve stone cabins set in a semicircle built in a parklike setting. The centerpiece of the property was a fountain, twenty-six feet in diameter, which utilized a mechanism similar to that on display at the expo. The show commenced each evening at dusk to the accompaniment of music carefully selected by Nelson. The fountain became an attraction unto itself and the motel prospered.

On October 3, 1936, Colonel Arthur Nelson died, but the family maintained the properties. The *Directory of Motor Courts and Cottages*, published by AAA in 1940, gave the motel a favorable rating but a surprisingly cursory entry: "Nelson Dream Village, at the intersection of U.S. 66 and state highway 5. 12 attractive, new stone cottages with private baths; fireplaces. Rates, single $2, double $3, tavern and café near by."

In 1944, Nelson's son, Frank, leased the Nelson Hotel to C. Lynn West and his wife. West would later serve as city councilman and mayor of Lebanon and president of the Highway 66 Association.

Interestingly, the *Western Accommodations Directory*, published by AAA, in 1954 lists the hotel but not Nelson's Dream Village. It stated the following about the hotel: "Junction U.S. 66, State 5, 32 & 64. Some connecting rooms. Radios available. Air Cooled dining room and coffee shop serve good food at moderate prices. Free parking; garages near by."

On November 7, 1955, a contract to build a 4.6-mile four-lane, access-controlled highway bypass to Elm Street and Jefferson Avenue received approval. On August 2, 1956, the state of Missouri became the first state to award a contract funded with monies from the new federal interstate highway program.

The resulting 13.3-mile highway, with interchanges at each end of Lebanon, as well as for the junctions of State Highway 5 and State Highway 32, resulted in this being the first community bypassed by the new interstate highway system on December 4, 1957. This proved disastrous for Nelson's Dream Village.

On July 29, 1958, the Nelson family sold the hotel and service station to the Wheeler Market Company, a Springfield, Missouri–based company. Construction of a supermarket on the site erased all remnants of the Nelson Hotel. The motel remained operational and family owned through the early 1970s, mostly with long-term weekly or monthly renters. Demolition occurred in 1977.

An intricate diorama of the complex is on display at the Route 66 Museum in the Laclede County Library building. Crafted and gifted to the museum by Willem Bor, a Route 66 enthusiast and artisan from Holland, the detailed diorama portrays the beauty of the complex.

In 1946, Jack Rittenhouse said of the Cliff House that it "nestles at the foot of the cliffs of Newberry Mountain." He also noted that the complex's signature swimming pool closed during the war would soon reopen. *Steve Rider*

NEWBERRY SPRINGS, CALIFORNIA

In *California Place Names*, subtitled *The Origin and Etymology of Current Geographical Names*, by Erwin G. Gudde, Newberry Springs is given an almost sterile entry: "The Southern Pacific named the station Newberry in 1883. In 1919, the Santa Fe changed the name to Water because for a long period the springs there supplied the Santa Fe with all the water it needed. In 1922, the name Newberry was restored."

The guidebook written by Jack Rittenhouse and published in 1946 presents an even starker picture. It notes, "Nestling at the foot of the cliffs of Newberry Mountain is the single establishment which comprises this town: a gas station with a café, grocery, several tourist cabins, and a post office. Behind the café is a small swimming pool, closed during the war but now to be reopened."

In light of the historical significance of Newberry Springs, both entries are rather surprising. Archaeological evidence indicates the springs served as an oasis for travelers on an early trade route, later the Mojave Trail, for more than one thousand years. Additional evidence indicates settlement here may predate this period by several thousand years.

Found in the reports of the Father Francisco Garces, expeditions of 1776 are the first modern notations pertaining to the springs. The first known American association was with the expeditions of Jedediah Smith in the 1820s.

The importance, and population, of the community that developed here after establishment of the railroad in the early 1880s fluctuated through the years, but its proximity to Ludlow and Daggett stifled serious growth. Rittenhouse indicated the population in 1946 was fifty-two.

As early as 1929, the Cliff House in Newberry Springs, California, was a full-service oasis for motorists with cabins, garage, store, and café. *Steve Rider*

Numerous relics in various states of disrepair or abandonment attest to the importance of Route 66 for this community during the postwar period. Perhaps the most notable of these former businesses is an abandoned Whiting Brothers station with original signage.

Of the existing businesses in Newberry Springs, the Bagdad Café is the most famous. The original Bagdad Café was located in the ghost town of Bagdad to the east, but with the popularity of the film by this name, the owners of the Sidewinder Café changed the name in the hopes of capitalizing on the notoriety.

NEW CORRAL MOTEL

Located on Seventh Street, Route 66, in Victorville, California, the New Corral Motel opened in 1953. The *Western Accommodations Directory*, published by AAA in 1954, gave the property a succinct but favorable review: "A new motel within easy access to San Bernardino mountain resorts. Individually controlled air coolers; free radios; vented heat; tiled shower baths. Restaurants near by. $6.00 to $7.00."

As of 2011, the property remained in operation. It reflects a state of exceptional preservation, and its neon sign with a rearing stallion has become a favored photographic opportunity for Route 66 enthusiasts. The fifteenth edition of the *Route 66 Dining & Lodging Guide*, published by the National Historic Route 66 Federation, gives the motel a favorable rating.

NEWKIRK, NEW MEXICO

The initial settlement along the Chicago, Rock Island & Pacific Railroad established here in 1901 bore the name Conant in reference to James P. Conant, an early rancher in this area. The consensus is that the name change to Newkirk (on the application

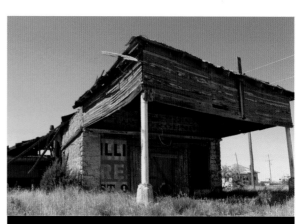

This former store, service station, and blacksmith shop is one of the oldest commercial structures along Route 66 in Newkirk, New Mexico.

for a post office in 1910) was driven by a resident with association to Newkirk, Oklahoma.

The 1946 guidebook published by Jack Rittenhouse lists Newkirk as having a population of 115 and a business district that included four gas stations, two "lunchrooms," a few cabins, and DeBaca's Trading Post. What remains today are mostly ruins, including an older auto court and Wilkerson's Gulf gas station.

NIANGUA, MISSOURI

Sources conflict about the date of origination for this community. However, there is indication of settlement here before the advent of the Civil War and Native American settlement in the area along the Niangua River before this.

A large number of the existing structures have a relationship with Route 66. The Niangua Junction Store, at the junction of Highway CC, Route 66, and Highway M, opened in 1935. One mile to the west is the Rockhaven Roadhouse & Cabins, now a private residence. The pony truss bridge over the Niangua River dates to 1924.

NILWOOD, ILLINOIS

Nilwood is a small agricultural community with origins dating to the late nineteenth century. It remains a small community with one of the oldest nonresidential structures being the school, now closed, built in 1927.

Immediately south of Nilwood, an original section of the 1926 to 1930 alignment of Route 66 (a portion of concrete roadway poured when this was Route 4 in approximately 1920), runs parallel to State Highway 4. The roadway is a favored "secret" location for Route 66 enthusiasts, as there are a series of turkey tracks in the concrete from the date of origination.

NOB HILL SHOPPING CENTER

A waiver of the minimum fifty-year criteria for inclusion in the National Register of Historic Places was granted in 1994 because of the historic significance and outstanding original condition of the Nob Hill Shopping Center in Albuquerque. The strip mall built in U configuration, the first major commercial development away from the traditional business district of the city, features extensive architectural details of the Moderne style of the 1940s.

The developer, DKB Sellers, built the facility, the first of its kind in New Mexico, in 1946, at the corner of Central Avenue (Route 66) and Carlisle Boulevard. Renovation in the 1980s preserved a number of the architectural attributes of the original property designed by Louis Hesselden. With an eclectic mix of shops, restaurants, and galleries, the shopping center was at the center of one of the city's trendiest districts as of 2010.

NOD-A-WHILE MOTOR LODGE

The Nod-A-While Motor Lodge, 5508 East Central Avenue in Albuquerque, New Mexico, opened in 1946 with E. C. Grober as proprietor. Renovation and new owners resulted in a name change to Silver Spur Motel in 1952.

The complex underwent additional upgrades in the late 1950s and 1960s. As of 2010, it remained operational as the Lazy M Motel.

NORMAL, ILLINOIS

Established as a siding and station at the junction of the Illinois Central Railroad and the Chicago & Alton Railroad, the initial name for this community was North Bloomington. The name change to Normal occurred in 1857, shortly after establishment of the Illinois State Normal University, now Illinois State University. The name Normal became the official one with the approval of a post office application on June 27, 1861. The post office remains in operation.

Route 66 followed several streets through the city: Shelbourne, Pine, Linden, Willow, Main, and Kingsley. Veteran's Parkway, now the Interstate 55 business loop, has served the primary flow of traffic since its construction in 1941.

Sites of particular note associated with Route 66 are many. At 1219 South Main Street, a pizza parlor is housed in the original Steak 'n Shake that opened in 1934, and the Sprague Super Service from the same period is being renovated as a Route 66 visitor information site.

The *Directory of Motor Courts and Cottages*, published by AAA in 1940, lists two properties but without addresses: Big Bill Cabins and Diamond Camp. The guide also notes that the Diamond Camp had a trailer camp and café.

A special postmark commemorating the 150th anniversary of the post office in Normal was introduced in November 2011. The initial date of release was November 11, the eighty-fifth anniversary of the U.S. 66 designation.

NORTHVIEW, MISSOURI

At the Northview, Missouri, junction was a collection of roadside businesses near Marshfield at the top of a winding grade loosely known as Red Top.

The Red Top Store and Café opened here in about 1928, and eleven cabins were added to the complex during the 1930s. On the opposite side of the highway were Otto's Steak House, a feed store, and a tavern with dance hall.

OAKHURST, OKLAHOMA

Oakhurst, Oklahoma, is a small community in Tulsa County. Establishment of a post office occurred on December 12, 1918.

Of Oakhurst and the road between Tulsa and Sapulpa, Jack Rittenhouse wrote in 1946 that "from this point until you reach Sapulpa, Oklahoma, about 10 miles from here you will scarcely realize you have left Tulsa, since the highway is flanked with a constant succession of business establishments, tourist courts, garages, gas stations, etc. . . . [Y]ou pass the Crystal City Amusement Park. Soon afterwards you enter the suburb of Red Fork, an industrial suburb of Tulsa containing many factories."

The next community on the drive west was Oakhurst, but Rittenhouse does not give it mention, since he apparently saw little to differentiate it from the string of communities that blended seamlessly along this section of highway. Jim Ross, historian and author of *Oklahoma Route 66*, did only slightly better: "Here, it is easy to imagine encountering a string of bulky 1940s sedans, or pulling over for a bite at a greasy spoon, maybe in Oakhurst or Bowden."

OATMAN, ARIZONA

The consensus is that Olive Oatman, a young girl captured by Indians during a raid on her family's wagon train near Gila Bend in 1851, is the community's namesake. Evidence indicates that shortly after being traded to the Mojave Indians, she was rescued at a location near the town site.

The origins of the town, initially named Vivian after the mining company that developed the rich ore body discovered by Ben Taddock in 1902, mark the beginning of the last major gold rush in Arizona. For reasons unknown, in spite of historic association, the name change to Oatman occurred in 1909.

In 1910, a second major discovery that became the Tom Reed Mine ignited explosive growth in the area. Further fueling growth during the teens was the establishment of the National Old Trails Highway and the Mohave & Milltown Railroad, a short-lived venture that connected Oatman with the main Santa Fe Railroad line near Topock. The rail bed for this short line is now a hiking and bicycle trail.

At its peak during the 1920s, the population has been estimated in excess of three thousand. The curtailing of production

By the late 1930s, Oatman, Arizona was a town on the wane with the primary source of income being Route 66, which served as the former mining towns' main street. *Steve Rider*

Above: The resurgent interest in Route 66 has transformed Oatman, Arizona, into a tourism boomtown that presents the romanticized image of a frontier-era mining community. *Judy Hinckley*

as a result of ore body exhaustion, a major fire that decimated several blocks in the business district in 1936, government-ordered closure of certain mines during World War II, and the bypass of Route 66 in 1952 transformed Oatman into a ghost town with a population of less than one hundred by 1960.

Jack Rittenhouse, in 1946, described Oatman as " . . . a mining boom town whose day has passed. US 66 passes through the town's one main street." He also noted available service facilities as Everett Hotel, two small tourist courts, Bill's Garage, and other "limited facilities."

Today, the resurgent interest in Route 66 has sparked a renaissance in Oatman, and much of the historic district, through recreation and restoration, reflects the romanticized version of a mining boomtown. Of the remaining original structures, the Oatman Hotel, the largest prestatehood adobe structure in Mohave County, is the most famous, as it is where Clark Gable and Carol Lombard stayed after marrying in Kingman in 1939.

Celebrity associations with Oatman are numerous. In 1914, famous drivers Louis Chevrolet and Barney Oldfield drove through town, since the route for the last of the Desert Classic series races followed the National Old Trails Highway.

Oatman has also served as a set or background for numerous movies, including *Edge of Eternity* (1959), *Foxfire* (1955), and some scenes for *How the West Was Won*.

ODELL, ILLINOIS

Land developer S. S. Morgan commenced initial platting for Odell in 1856. The namesake is William H. Odell, a chief engineer with the Chicago & Mississippi Railroad.

Initially, Route 66 utilized Odell Road and West Street through the village. The bypass of Odell occurred with the transformation of Route 66 into a limited-access, four-lane highway through Illinois that commenced in 1941.

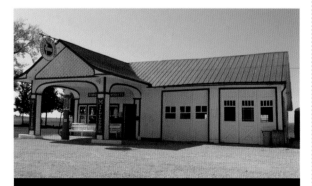

The fully refurbished 1932 Standard Oil filling station in Odell, Illinois, is a monument to the preservationist passions of authors John and Lenore Weiss, who initiated the Save Odell Station (SOS) project in 1996. *Judy Hinckley*

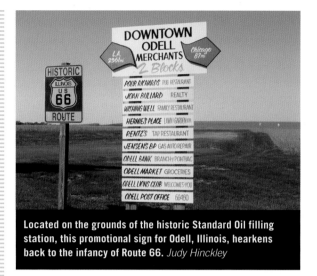

Located on the grounds of the historic Standard Oil filling station, this promotional sign for Odell, Illinois, hearkens back to the infancy of Route 66. *Judy Hinckley*

Because of its location on Illinois State 4, Odell has a history of providing services to travelers that predate the 1926 designation of Route 66. The *Hotel, Garage, Service Station, and AAA Club Directory* for 1927 lists the garage and service station of C. C. DeLong for recommended service.

The restoration of a 1932 Standard Oil Company service station and garage, listed on the National Register of Historic Places and now utilized as a visitor center, preserves this association. A second Route 66–related attraction of note is the refurbished barn with an advertisement for Meramec Caverns emblazoned on the side, one of two such barns remaining along Route 66 in Illinois.

OLD SPANISH TRAIL

Initial exploration for this trade route that linked Santa Fe in New Mexico with Los Angeles in California occurred in 1776. However, its primary period of usage was roughly from 1830 to 1855, and its name first appeared in the journal of John C. Fremont, who, with Kit Carson as his guide, followed this trail in 1844 while on assignment with the U.S. Topographical Corps.

The primary associations with Route 66 are in the section from near the present site of Barstow, along the Mojave River, and over the Cajon Pass into Los Angeles. The historic nature of the trail figured prominently in the decision to include the road here in the National Old Trails Highway system in 1913.

OKLAHOMA CITY, OKLAHOMA

The Oklahoma County seat and capital of Oklahoma since June 11, 1910, did not adopt the name Oklahoma City until approval of a postal application on July 1, 1923. The initial postal application and establishment of a post office was under the name Oklahoma Station on December 30, 1887. An amendment resulted in a change to the name Oklahoma on December 18, 1888.

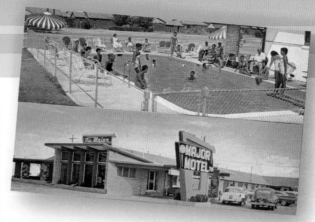

The entry for the Major Auto Courts, later The Major Court, in the 1941 *AAA Directory of Motor Courts and Cottages*, noted this was "an excellent court, one of Oklahoma City's finest." *Mike Ward*

In Oklahoma City, Twenty-Third Street served as the Route 66 corridor from 1933 to 1954, but the segment east of Pennsylvania Avenue was the original alignment. *Steve Rider*

OKLAHOMA CITY, OKLAHOMA *continued*

In Oklahoma City, as with most metropolitan areas through which Route 66 passed, the highway was realigned numerous times to accommodate changing traffic patterns and urban development. Primarily, there is the main line utilized from 1926 through 1954 with various adjustments and Alternate 66 that served as a beltline option between 1931 and 1953. Numerous surface streets were utilized, including Twenty-Third Street, Western Avenue, Britton Road, Kelly Avenue, May Avenue, Classen Boulevard, and Lincoln Boulevard. In 1954, realignment placed Route 66 on the current path of I-35 and I-44.

The *AAA Hotel, Garage, & Service Station Directory,* 1927 edition, lists three hotels: Huckins, Kingkade, and Skirvin. The *AAA Directory of Motor Courts and Cottages* for 1940 hints at the changes wrought by Route 66, listing only a small portion of the auto courts and motels available. In this directory, there are no listings for hotels.

However, there are extensive details provided for three auto courts and a tourist camp: Hutchinson Motor Court on "belt line U.S. 66" at 2114 Northwest Thirty-Ninth Street, Lakeview Courts (actually west of the city itself), Major Auto Courts at the 3400 block Northwest Thirty-Ninth Street, and Ritz Tourist Camp. Additionally, there are eighteen recommended service facilities listed in the *AAA Service Station Directory* from the same year.

The 1954 edition of the *AAA Western Accommodations Directory* provides additional evidence of the important role played by Route 66 with regard to the service sector in Oklahoma City. This directory, again representing a limited segment of the industry, lists four hotels, eight motels and auto courts, and five restaurants.

The hotels listed are the Biltmore, Hotel Black, Hockins, and Roberts. The motels, auto courts, and "motor hotel" recommendations include Park-O-Tell at 2615 North Lincoln Boulevard, Alamo Plaza Hotel Courts at 4407 South Robinson, Boyer Hotel Courts at 5120 Northwest Thirty-Ninth Street, Carlyle Motel at

3600 Northwest Thirty-Ninth Street, Dream House Motel, Major Court at 3200 Northwest Thirty-Ninth Street, Matlyn Court at 3250 Northwest Thirty-Ninth Street, and Royal Motel at 3100 North Lincoln Boulevard.

In spite of extensive urbanization during the postwar era, numerous historic structures remain along the various alignments of Route 66 within the city. Many of these predate certification of that highway in 1926.

Locations of particular note in Oklahoma City are numerous and include the Grateful Bean Café at 1030 North Walker, a building that dates to 1921 and that has served as a restaurant for most of that time. Across the street is the Mid Town Plaza, 1926, and, to the rear, the Boulevard Cafeteria, listed in the 1954 edition of the *AAA Western Accommodations Directory.* There is also the now-iconic milk bottle building on Classen Avenue; the Will Rogers Theater, 1946; and Citizen State Bank Building, with its distinctive gold geodesic dome that opened in 1958; the old Owls Court Motel; and Western Trail Trading Post.

At the corner of Northwest Twenty-Third and Hudson Avenue stands Cheever's Café. This building, built in 1907, initially was a private residence, but with extensive renovation, including an art deco façade, it served as a florist shop. The current incarnation occurred in 1997 after acquisition of the property by Keith and Heather Paul.

With its location on Route 66 and proximity to the capitol, Dolores Sandwich Mill, later Dolores Steak House, was a popular restaurant for the movers and shakers of the city. *Mike Ward*

OLD SMOKEY'S PANCAKE HOUSE AND RESTAURANT

Rodney Graves, also the founder of Rod's Steak House, opened Old Smokey's Pancake House and Restaurant in Williams, Arizona, in 1946. Stone facing with extensive use of neon to promote "Barbeque-Quick Lunch-Malts-Breakfast" made the business noticeable.

Purportedly a number of celebrities, including Elvis Presley, ate here. As of 2011, the restaurant was not in operation, but the structure remained.

ORO GRANDE, CALIFORNIA

Initial settlement of Oro Grande dates to 1878, but the community did not have a population sizable enough to warrant a post office until January 1881. The initial post office application used the name Halleck, in honor of the chemist at the stamp mill. An amended application approved on May 1, 1925, changed the name to Oro Grande, also the name of the largest mine operating in the area.

Mining and farming along the Mojave River served as the primary underpinnings of the community's economy before establishment of the National Old Trails Highway in 1913 and Route 66 after 1926. Jack Rittenhouse noted in 1946 that Oro Grande " . . . had a population seven times its present size (population 305) when the nearby gold mines were busy, about seventy years ago. Today its only major industry is a large cement plant, which you pass. Across from the cement plant are the 'company' homes of drab yellow. The town contains about ten stores, but offers no tourist facilities except one trailer camp with a few cabins."

As of early 2011, the primary artifacts consisted of a row of century-old storefronts with colorfully painted brick façades, and a 1950s motel turned private residence. A fire in 2010 damaged the motel.

The business district along Route 66 in Oro Grande, California, consists of a market, an old service station, and a row of stores with colorful brick façades that predate Route 66.
Steve Rider

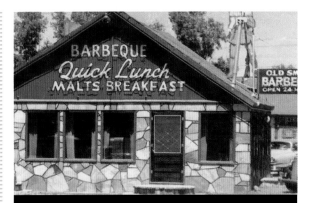

Currently closed, Old Smoky's Pancake House in Williams, Arizona, opened in 1946. The original owner was Rodney Graves, the founder of legendary Rod's Steak House.
Joe Sonderman

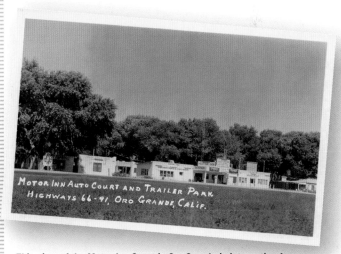

This view of the Motor Inn Court in Oro Grande is interesting for a number of reasons. Jack Rittenhouse in 1946 noted that the only lodging was a trailer camp with a few cabins. The second issue pertains to how lush the setting is, which is quite different from the Oro Grande of today. *Steve Rider*

OTTO'S MOTEL COURT

Otto's Motel Court, with Wallace Otto as proprietor, opened three miles east of the junction of U.S. 65 on U.S. 66 in Springfield, Missouri, in 1939. The 1940 edition of the *Directory of Motor Courts and Cottages*, published by AAA in 1940, noted the court was " . . . a modern, steam heated, complex of one room cottages of stone construction; all with tile showers; nicely furnished; enclosed garages; hot and cold water and lavatory. In a quiet location back from the noisy highway. Rates $2 per day for two persons, $2.50 for three persons. Each cottage has two full, double beds. One of the newer courts in this area and has all the modern facilities usually found in larger cities. Filling station. Café. 10 minute drive to downtown Springfield."

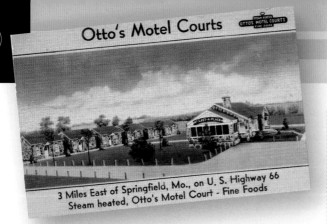

Otto's Motel Courts

3 Miles East of Springfield, Mo., on U. S. Highway 66
Steam heated, Otto's Motel Court - Fine Foods

In 1940, AAA promoted Otto's Motel Court, located three miles east of the U.S. 66 and U.S. 65 junction, as "one of the newer courts in this area and has all of the modern facilities usually found in larger cities." *Mike Ward*

OTTO'S MOTEL COURT *continued*

In 1947, the property sold to the Bell family, and it was remodeled and renamed Bell's Motel Courts. It sold again in 1952 to Lee and Jerome Carroll, who operated the motel until the early 1990s.

The office that also served as the proprietor's home still existed as of 2010. At that time, it housed the Truck Store.

OZARK TRAILS ASSOCIATION

In the years before establishment of a U.S. highway system, associations that usually consisted of municipal and business interests developed the maintenance and construction of interstate highway systems. The primary route devised by the Ozark Trails Association was from St. Louis, Missouri, to Las Vegas, New Mexico, with a secondary route to El Paso, Texas.

In addition to the primary route, the association also promoted connecting roads established by similar associations. This loose confederation resulted in the creation of a road system that, in conjunction with the RFD (rural free delivery road),

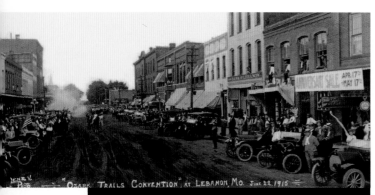

Ozark Trails supporters, as well as members of the good roads movement from throughout the United States, converged on Lebanon, Missouri, in June of 1915 for the annual Ozark Trails convention. *Lacolade Historical Society*

OFFICIAL OZARK TRAILS CAR

Floyd Thompson, formerly of this county, Chairman of the Oklahoma City Ozark Trails Committee, at the wheel; Col. W. H. Harvey, Dr. Frank Roach and J. L. Pope, who will attend the Ozark Trails meeting to be held at Lebanon Saturday night, May 5th. Come out to the meeting.

Many segments of the Ozark Trails system were incorporated into U.S. 66 after 1926. As an historic side note, the vehicle in this photo is a Case, built by the same company famous for tractor manufacturing. *Lacolade Historical Society*

composed the primary highway system in the area where Arkansas, Oklahoma, Missouri, and Kansas intersect.

The first federal highway project in Oklahoma was construction of a bridge over the South Canadian River between New Castle and Oklahoma City in Oklahoma, a bridge utilized in the early alignment of Route 66. Incorporated into the initial routing of U.S. 66 were numerous segments of this trail system between St. Louis and Lebanon, site of the 1916 convention, in Missouri and between Springfield and Joplin in Missouri; between Vinita and Tulsa in Oklahoma; and the sections between Amarillo, Texas, and Romeroville in New Mexico. The western terminus of the northern segment of the Ozark Trails system is Romeroville, where it met the National Old Trails Highway and the original Santa Fe Trail.

Initially, the trail system was marked with a green "OT" between green stripes on a white background painted on telephone poles, boulders, and barn sides. In 1913, organization founder William Harvey proposed the erection of concrete obelisks with the Ozark Trails inscription.

At that organization's 1918 convention, he expanded on his proposal with designs for a four-cornered shaft topped by a pyramid and the suggestion to place these obelisks at junctions and intersections with major roadways. In 1919, the organization reached an agreement on a standard design, a tall tapering illuminated shaft mounted on a square base with names of towns and distances painted on the sides, and a large fifty-foot version in Romeroville, New Mexico, to commemorate the intersection with the historic Santa Fe Trail.

The exact number of obelisks erected is unknown. However, seven still exist. One of these, listed in the National Register of Historic Places, is near Stroud in Oklahoma on a section of the Ozark Trail that served as the route of U.S. 66 from 1926 to 1930.

Historical evidence indicates completion of the large commemorative marker in Romeroville, New Mexico. The date of demolition or removal is unknown.

P

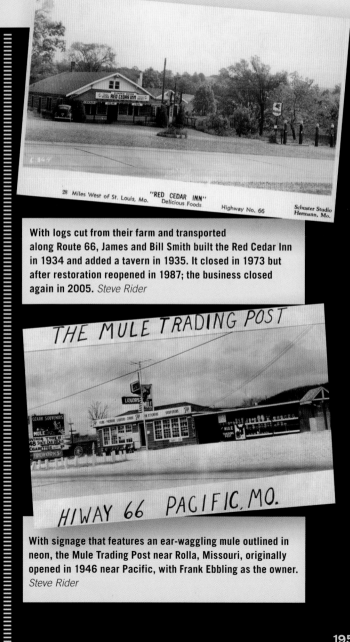

With logs cut from their farm and transported
along Route 66, James and Bill Smith built the Red Cedar Inn
in 1934 and added a tavern in 1935. It closed in 1973 but
after restoration reopened in 1987; the business closed
again in 2005. *Steve Rider*

PACIFIC, MISSOURI

An ambitious and optimistic group of investors created the
Pacific Railroad Company with plans to link the Mississippi River
to the pacific coast. In 1852, the platting of a community named
Franklin marked the western terminus of the project. Financial
shortcomings and other issues stalled the railroad at this point for
several years. In an effort to attract new investors, the railroad,
with support of residents, renamed the community Pacific in
1854. In October 1864, the railroad and the steep bluffs
overlooking the valley became key military targets. As a result,
Confederate troops burned most of the community and
destroyed area bridges.

The small community's association with Route 66
commenced with realignment in 1932. James and William Smith
capitalized on the resultant traffic with construction of the Red

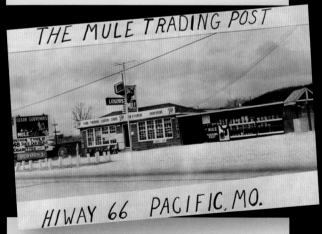

With signage that features an ear-waggling mule outlined in
neon, the Mule Trading Post near Rolla, Missouri, originally
opened in 1946 near Pacific, with Frank Ebbling as the owner.
Steve Rider

Named for Peter Lars Jensen, founder of the Henry Shaw
Gardenway Association, Jensen Point on the cliffs above
Pacific, Missouri, opened in 1939. *Steve Rider*

The restored sign from the Beacon Court that opened in 1946 now adorns the Beacon Car Wash in Pacific, Missouri. As of 2010, part of the original complex housed a towing company. *Mike Ward*

Herbert D. Lore utilized petrified wood in the construction of the Stone Tree House that opened in 1924. After acquisition by the federal government in 1936 and renovation, the Fred Harvey Company operated it under the Painted Desert Inn name. *Joe Sonderman*

PACIFIC, MISSOURI *continued*

Cedar Inn in 1934. Expansion of the complex included the addition of a restaurant, bar, and filling station. The facility still exists and as of 2010 served as a car lot.

Another landmark associated with Route 66 is a scenic overview, Jensen Point, named for Peter Jensen, the first president of the Henry Shaw Gardenway Association. This roadside park, constructed under the auspices of the Civilian Conservation Corps in 1939, after years of neglect, is again a favorite stop for travelers on Route 66 after extensive renovation that includes the addition of a replica Civil War–era cannon and informative kiosk about the battle of Pacific during that conflict, on the bluff overlooking the valley.

PADILLAS, NEW MEXICO

Padillas, or Los Padillas, a small community located south of Albuquerque along the Rio Grande River on the pre-1937 alignment of Route 66, has also been known as San Andres de los Padillas and San Andres. The date of origination is unknown; however, the earliest historic references date to 1803. More than three centuries of urban sprawl and development along the Rio Grande River south of Albuquerque has created a patchwork of farms, dusty adobe homes, and historic sites along this early alignment of Route 66. Jerry McClanahan, in *EZ 66 Guide for Travelers*, succinctly describes this with a simple statement: "The towns south of Albuquerque blend together, a succession of walled houses among the trees, small farms, and a few old roadside remnants."

PAINTED DESERT INN

Built in 1924 by Herbert Lore, who made extensive use of petrified wood in the construction, the Painted Desert Inn, originally the Stone Tree House, was sold to the National Park

Service in 1935. At that time, construction crews of the Civilian Conservation Corps transformed the structure through extensive remodeling into a Pueblo style, utilizing the plans drafted by Lyle Bennett, a leading architect of the period.

The Fred Harvey Company leased the property in 1940 and reopened the hotel, and it remained operational through 1942. In 1947, the company retained the services of renowned architect and interior designer Mary Jane Colter for further renovation.

Under her supervision, numerous changes made to the interior included the installation of windows that framed the stunning western landscapes surrounding the property. She retained Fred Kabotie, a noted Hopi artist, to create murals for the dining room that portrayed scenes of traditional Hopi tribal life.

In the spring of 1963, the Fred Harvey Company closed the inn and chose not to renew its lease. An initial order for demolition issued in 1975 was suspended. The property received recognition for its historical significance with registration as a National Historic Landmark in 1987, and in 2006, a full restoration to its 1949 appearance commenced. It now serves as a museum and visitor center. The Kabotie murals and numerous items, such as sconces and chandeliers, designed and created specifically for the hotel remain.

PAINTED DESERT TRADING POST, ARIZONA

Construction of the Painted Desert Trading Post commenced in late 1940 or early 1941 in a location to the east of the Petrified Forest National Park on a knoll above the Dead River Bridge. The site was so remote that there was no electricity or telephone service, necessitating the use of antique gravity-fed, visible register gasoline pumps. In addition to gasoline, the proprietors, Dotch and Alberta Windsor, sold sandwiches, curios, and a wide variety of products produced by Navajo artisans, including rugs and jewelry.

In early April 1947, the death of Alma Shelnutt briefly gave the trading post national attention when newspapers picked up the story

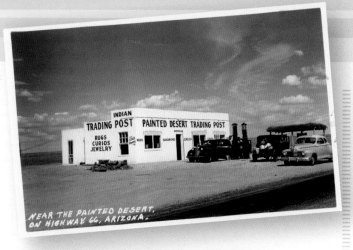

The Painted Desert Trading Post was located in such a remote location that it never had electricity, and when a customer collapsed from a heart attack, it took more than an hour to get assistance. *Steve Rider*

to use as filler. Shelnutt of Colorado Springs, who was traveling with her husband to Pasadena, California, collapsed with heart failure, but the remote location and lack of a telephone prevented her from receiving medical attention for more than one hour.

Dotch Windsor continued to operate the trading post after his divorce from Alberta, married Joy Nevin (a Holbrook veterinary supply business owner) in 1951, then continued to operate the facility with Joy. An August 1956 advertisement, shortly before the business closed, in the *Gallup Daily Independent* read, "Howdy! Drive Down Highway 66 to Dotch and Joys Painted Desert Trading Post. 5 miles east of the Painted Desert. Complete service station, curios, petrified wood, Indian craft. 65 miles west of Gallup."

The facility has remained empty since its closure and is today a hollow shell framed by quintessential western landscapes. As of summer 2011, this abandoned alignment of Route 66 is inaccessible.

PALM'S GRILL CAFÉ

James Adams opened the Palm's Grill Café at 110 Southwest Arch Street in Atlanta, Illinois, in 1934. Adams chose the name in deference to a favorite restaurant in Los Angeles, California.

Locally known simply as "the Grill," the café expanded to include a small dance hall and to serve as the Greyhound bus depot by 1940. The café continued to be an integral component of Atlanta until completion of the Route 66 bypass in the early 1960s.

After its closure, the owner, John Hawkins, transformed the facility, originally built in 1867 and listed on the National Register of Historic Places in 2004, into living quarters with office space. Upon his death in 2002, the Downey Building, which had housed the former café, became the property of the Atlanta Public Library and Museum through donation.

Extensive refurbishment restored the café to its 1935 appearance. The café reopened in 2009 and was featured in the first installment of Billy Connolly's 2011 *Route 66* series.

PALOMINO MOTEL

Opened in 1953 by James and Gladys Hyde, the thirty-unit Palomino Motel at 1215 East Highway 66 in Tucumcari, New Mexico, remained as an existing motel as of 2010. Promotional postcards proclaimed, "Why pay more? Please inspect our rooms. You will stay."

The 1954 edition of the *AAA Western Accommodations Directory* noted, "Large attractive rooms are air conditioned or air cooled and have vented heat and tiled shower or combination baths; radios available. Some connecting rooms. $6-$8."

PARAJE, NEW MEXICO

Paraje was established by a small group of Laguna Indian farmers, but it soon became a favored stop for the adventurers who called themselves motorists during the teens. The small town had a population large enough to warrant a post office from 1867 to 1910, but by 1946, Jack Rittenhouse noted only a small trading post remained. With exception of a map notation, the community does not warrant mention even in the *EZ 66 Guide for Travelers* by Jerry McClanahan.

PARAJITO, NEW MEXICO

Parajito is a small farming community located south of Albuquerque on the pre-1937 alignment of Route 66. Extensive research has not resulted in definitive information about its origins. As for a Route 66 association, it was too small to warrant indication on leading maps between the period 1926 and 1937, so it is unlikely that more than basic services, if any, were available to motorists.

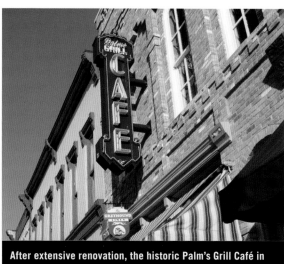

After extensive renovation, the historic Palm's Grill Café in Atlanta, Illinois, reopened in 2009. The café is indicative of the economic viability in refurbishing historic businesses on Route 66.

PARIS SPRINGS JUNCTION, MISSOURI

The stunning time capsule that is the refurbished Gay Parita Garage and Sinclair station dominates Paris Springs Junction in Missouri. Many maps inadvertently list this as Paris Springs, even though the site of the town by that name founded in 1870 is actually a half mile north of this intersection.

At Paris Springs, name changes and confusion over them are merely a part of the colorful history. The first settlement, called Chalybeate Springs, became Johnson Mills after O. P. Johnson of Cherry & Johnson established a mill to grind flour and cornmeal, as well as a chair factory, sawmill, and wool mill, on Clover Creek.

By 1872, when Eli Paris opened a spa and hotel to capitalize on the purported healing powers of the mineral-rich springs, the town also sported a wagon manufacturing enterprise and a profitable blacksmith shop. Paris's business venture led to the next and final name change.

When Route 66 bypassed the fading little community by one half mile, a number of entrepreneurial-minded citizens opened businesses at the junction, and Paris Springs Junction was born. Among the first buildings here was a cobblestone-faced garage, followed four years later by a Sinclair station.

Business was brisk, and in the years that followed, the owners, Gay and Fred Mason, added a small café and several cabins. For Paris Springs Junction, the end came in 1953 with the death of Gay and, two years later, the destruction of the Sinclair station by fire.

The decommissioning of Route 66 and bypass by I-44 sounded a death knell. However, unlike many properties along Route 66 in this section of Missouri, the Gay Parita Garage, and even the old Sinclair station, received a new lease on life with acquisition by Gary and Lena Turner. Under their careful stewardship, the store and café are now a residence, with the front façade appearing as it did during the 1930s. The garage and resurrected Sinclair station provide a rare opportunity to step back into the world of motoring and Route 66, circa 1930.

PARKS, ARIZONA

Initial settlement in the parklike meadow along the railroad in this area predates establishment of a post office under the name Rhoades on March 28, 1898. Unofficially, the name became Maine—in honor of the battleship *Maine* sunk in the harbor at Havana, Cuba, that year—a few

The Parks store has provided service to travelers on the National Old Trails Highway and Route 66 and still caters to Route 66 enthusiasts today.
Steve Rider

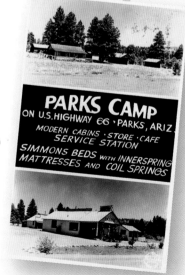

months later. With approval of an amended post office application in 1907, the name became official.

With establishment of the National Old Trails Highway in 1913, the "town" that consisted of a store and a post office housed in an old boxcar received competition with the opening of a store at the highway junction. The original site became Old Maine, while the new store received the designation Maine.

Interestingly, the name change to Parks, Arizona, occurred in 1921, when Art Anderson and Don McMillan acquired the store, but as late as 1929, most maps still used the name Maine. The small store and gas station at the junction of the National Old Trails Highway and the road to the Grand Canyon proved a profitable venture.

A similar facility, incorporating parts of that original building, operates here today under the name Parks in the Pines General Store. The *Route 66 Dining & Lodging Guide*, fifteenth edition, published by the National Route 66 Federation in 2011, recommends the facility for light meals of "pizza & sandwiches."

In 1946, Jack Rittenhouse described Parks as "another of those 'one-establishment towns,' offers gas and a few cabins."

PASADENA, CALIFORNIA

Pasadena, California, founded as Indiana Colony, a reference indicative of the origins of the initial promoters, is rather unique among the communities that constitute the greater Los Angeles area in that the name selection for the post office application of 1874 derives from an Ojibwa word: *tapedaegunpasadena* or *weoquanpasadena*. These are expanded descriptors of the word *passadina*, meaning "there is a valley."

In 1886, Pasadena incorporated, and within a decade, a modern community of sewers and paved streets illuminated with electric lights had formed. On January 1, 1890, the Valley Hunt Club initiated a festival that centered on a procession of flower-bedecked horses and carriages. In 1898, the Tournament of Roses Association sponsored the festival.

During the following twenty years, Pasadena developed a reputation as a winter resort for the wealthy and, with an increase in automotive travel during the teens, a center of tourism. Initially, Route 66 fueled this sector of the economy, but the onslaught of the Great Depression forced the community to diversify. The opening of the Arroyo Seco Parkway that linked Pasadena with Los Angeles enabled the city to become a popular residential area, and this dramatically escalated with the postwar migration to California.

A wide array of historic structures associated with Route 66 and the city's early history line Route 66, primarily Colorado Boulevard. Likewise with all five of the realignments in the Pasadena area.

The original alignment utilized from 1926 to 1931 turned south on Fair Oaks Avenue into South

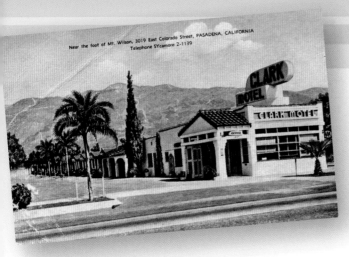

The 1941 edition of the *AAA Directory of Motor Courts and Cottages* promoted Clark's Motel as a large 21-unit complex, 15 with kitchenettes. Rates ranged from $2.50 to $7.50. *Mike Ward*

"Convenient to golf course and points of interest, 20 units each with tiled shower; 8 with kitchenettes, several with living rooms." This was the promotional entry for Monterrey Lodge in the AAA lodging guide for Southern California published in 1939. *Mike Ward*

Pasadena. Historic structures of particular interest are the refurbished Fair Oaks Pharmacy, with soda fountain, originally opened in 1915, and the Rialto Theater that opened in 1925. This theater remains one of the few single-screen theaters operating in Los Angeles County. Indicative of the theater's historic importance was its inclusion into the National Register of Historic Places in 1978.

From Fair Oaks Avenue, this original alignment utilized Huntington Drive. This road served as the primary connector between Los Angeles and Pasadena before Route 66 and had origins dating to the establishment of the Old Adobe Road in about 1790.

The second incarnation of Route 66, utilized between 1931 and 1934, was a transitional alignment. This alignment followed Fair Oaks Avenue before turning west onto Mission Street. Then it turned onto Arroyo Drive and Pasadena Avenue. Of particular note on this alignment is the El Centro Market, listed in the National Register of Historic Places. This property served as a

market only from 1931 to 1935, but it represents a transitional stage in the evolution toward a one-stop shopping supermarket.

The next realignment of Route 66 served for little more than twelve months in 1935 and 1936. This alignment followed Colorado Boulevard through Pasadena and utilized the Colorado Street Bridge built in 1913. This beautiful bridge remained in use until 1989. It reopened in 1993 after a $27.4 million renovation.

The next alignment of Route 66, signed as U.S. 66 Alternate until 1960, also utilized Colorado Boulevard. After 1940, this alignment utilized the Arroyo Parkway and the Arroyo Seco Parkway to connect with Los Angeles.

PEACH SPRINGS, ARIZONA

The various clans of the Hualapai people utilized these springs for centuries before the arrival of Father Francisco Garces, a Franciscan explorer, in 1775. He designated the springs Pozos de San Basilo, St. Basil's Wells. Obviously, other explorers encamped here after this date, but the next recorded visitation was the survey expedition of Lieutenant Edward Beale on September 17, 1858. His mapping party designated the waters as Indian Springs. Interestingly, he noted that nonnative peach trees were growing near the springs, a factor that led to its current designation as Peach Springs.

Establishment of a siding, station, and water tank at the springs by the Atlantic & Pacific Railroad, later the Atchison, Topeka & Santa Fe Railroad, gave rise to a community at the site. Reports from 1883 indicate a town large enough to support ten saloons.

Peach Springs figures prominently in an obscure event in western history, the last hanging on Prescott's courthouse square in 1898. The man convicted was Fleming Parker, a cowboy incensed by the railroad's compensation for the death of two of his horses and who retaliated by robbing the train at Peach Springs.

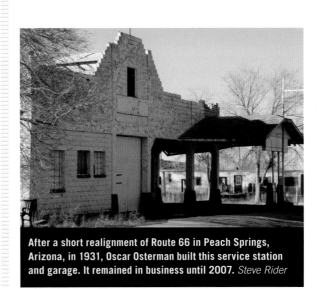

After a short realignment of Route 66 in Peach Springs, Arizona, in 1931, Oscar Osterman built this service station and garage. It remained in business until 2007. *Steve Rider*

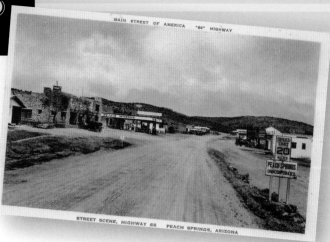

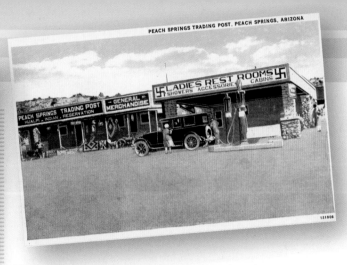

The stone building on the left opened as the Hualapai Trading Post in 1929 and currently houses the offices for the Hualapai Forestry Department. *Steve Rider*

This is the original Peach Springs Trading Post along the National Old Trails Highway and the first alignment of Route 66. A new, larger trading post that currently houses the Hualapai Forestry Department replaced this structure in 1929. *Joe Sonderman*

PEACH SPRINGS, ARIZONA *continued*

The town's location on the National Old Trails Highway spurred development of service-related business that included a trading post opened in 1917 by E. H. Carpenter. In 1921, he sold half interest in the business to Ancel Taylor and in 1924, the remainder. In 1926, Taylor razed the wood-framed facility and built a two-story cobblestone structure, a building that now houses the offices of the Hualapai Forestry Department.

Swedish immigrant John Osterman played a key role in the development of service-related industries in Peach Springs. Shortly after the armistice ending World War I, he built a station here that he sold to his brother, Oscar, in 1925. The realignment of Route 66 in 1931 necessitated construction of a larger station with garage. This business remained in operation until 2007, and the building still exists.

Oscar Osterman constructed an auto court immediately to the east of his station in 1936. With purchase of the property by Frank and Beatrice Boyd in 1938, the name changed to Peach Springs Auto Court. The Hualapai Lodge now stands on the site of this auto court.

Ethel Rutherford, later a state representative, operated a second auto court with café, the Qumacho, during the 1940s and early 1950s. This complex no longer remains.

The *Directory of Motor Courts and Cottages*, published by AAA in 1940, lists one facility, Peach Springs Motel. The listed rate was $2.50, and there was a notation of housekeeping facilities being available and a café nearby. In addition to these courts, Jack Rittenhouse listed other services available in 1946. These included "a few stores" and Milligan Garage.

With completion of the I-40 bypass in 1979, severance of the primary revenue source devastated the local economy. The isolation of Peach Springs after completion of this bypass served as an idea source for the creation of Radiator Springs in the 2006 animated film *Cars*.

Peach Springs is currently the tribal headquarters for the Hualapai Indian Reservation. The Hualapai Lodge, a post office, and grocery store are the only existing businesses.

PECOS, NEW MEXICO

Pecos, located on the pre-1937 alignment of Route 66, dates to the establishment of a small Spanish farming community here around 1700. For reasons unknown, the name at the time of American colonization was Levy, but the post office application filed in 1883 used the name Pecos, a reference to the river upon which the community is situated.

Immediately to the south of the town is Pecos National Historic Park, site of the ruins of the Pecos Pueblo. Reports from the Coronado expedition indicate this may have been the largest inhabited settlement north of Mexico City in the late sixteenth century.

Sporadic mining as well as tourism have diversified the town's economy. After 1937, in spite of the realignment of Route 66, tourism became the principal source of revenue.

The first span of the Pecos River in Santa Rosa, New Mexico, with an automobile highway bridge during the early 1920s would serve as the Route 66 crossing for more than a decade. *Steve Rider*

The National Old Trails Highway bridge across the Pecos River at the east end of San Jose, New Mexico, dates to 1921. *Judy Hinckley*

The ruins of the Pecos Pueblo leave many questions unanswered, but records from the Coronado expedition indicate this may have been the largest inhabited settlement north of Mexico City in the late sixteenth century. *Steve Rider*

PERALTA, NEW MEXICO

Located on a pre-1937 alignment of Route 66, Peralta has origins that date to an association with Andres and Manuel de Peralta, who arrived in the area at some point shortly before 1680. Initial establishment of a post office under the Peralta name occurred in 1861, was amended to Los Pinos in 1865, and then reverted to the original name in 1866.

Two incidents of historic significance are associated with Peralta. In 1862, a skirmish between Confederate and Union forces occurred near here, and in 1863, Colonel Kit Carson marshaled his forces here before initiating the military campaign to subdue the Navajos.

The associations with Route 66 were minimal, and few are aware of the town's link to that highway. Jerry McClanahan, in *EZ 66 Guide for Travelers*, says of the towns between Isletta Pueblo and Los Lunas, including Peralta, "old 66 passes thru a mix or residences and farms before briefly urbanizing in Los Lunas."

PHELPS, MISSOURI

The namesake for this small agricultural community is Colonel Bill Phelps, an attorney for the Missouri & Pacific Railroad and the lobbyist primarily responsible for approval of the post office application in 1857. Despite its association with the Ozark Trail Highway and Route 66, Phelps failed to experience substantial growth.

Jack Rittenhouse, in 1946, listed the assets of the town as gas stations, a café, a few homes, and two very old store buildings. In *The Missouri U.S. 66 Tour Book*, published in 1994, C. H. Curtis describes the remnants of Phelps as "what's left of Bill's Station, circa 1926, and the Henson Building, circa 1924, . . . now a residence, once with a café, store & barber shop, with rental rooms upstairs."

During the realignment of Route 66 in 1955, most structures on the south side of the highway were razed. Among the businesses decimated by this were the café and station operated by Mr. and Mrs. Harry Parkhurst. The relocation of their house to Albatross occurred shortly after.

PHILLIPSBURG, MISSOURI

Rufus Phillips, who built a store at this location shortly before the advent of the American Civil War, is the namesake for Phillipsburg, Missouri, a small, rural agricultural community that offered limited services for travelers on Route 66. The primary establishment through the early 1950s was the Underpass Café and Service Station, a reference to its location near the thirteen-foot, five-inch Frisco Railroad overpass.

This business dates to 1941, when O. E. Carter and Ed Lawson erected a prefabricated gas station here. By 1951, they had relocated business operations from Lebanon and expanded the property to include a café. The café building still remained as of 2010.

Having opened a service station in Lebanon, Missouri, in 1935, O. E. Carter and Ed Lawson were experienced businessmen by the time they established a prefabricated station at Phillipsburg in 1941. They added a café to that location in 1950. *Steve Rider*

PHILLIPS PETROLEUM COMPANY

The evolution of the Phillips Petroleum Company reflects the development of the American petroleum industry and the transformation of this country through the advent of the automobile industry. However, it is the association with U.S. 66 that makes the company unique.

The foundations of the company can be found in the Phillips brothers, Lee and Frank, and their entrance into the business of oil exploration in 1903 and their first productive well in September 1905 near Dewey in the Territory of Oklahoma. The brothers continued to develop wells but increasingly turned their resources toward banking.

The outbreak of World War I spiked petroleum prices, and the brothers again turned their full attention to the oil industry. In 1917, consolidation of oil holdings worth approximately $3 million served as the foundation for the formation of Phillips Petroleum Company.

In 1918, after the discovery of a large gas field in the Texas Panhandle, the company became a pioneer in the developing natural gas industry. Shortly after certification of Route 66 in 1926, the company entered the gasoline business on two fronts: in refining and in service stations. In 1927, Phillips opened its first refinery near Borger, Texas, in the Panhandle. On November 19, 1927, it opened the first service station in Wichita, Kansas. The first Phillips 66 service station in Texas opened in McLean in 1930, and this recently refurbished facility is now a widely recognized landmark on Route 66. Among the initial endeavors to establish recognition were standardized station designs that emulated small brick cottages. The McLean facility is a rare surviving example.

Searching for brand recognition, the company utilized the increasing popularity of U.S. 66, and the fact that many of its enterprises were near this highway corridor, by incorporating the number 66 in the name. Further assurance of brand association came with adoption of the U.S. highway shield for the company logo in 1930.

The Phillips Mansion remains as a monument to the oil company that, according to legend, decided to capitalize on the popularity of Route 66 by adapting the highway shield and numbers 66 to their marketing after the testing of a new fuel on U.S. 66.

Innovative attempts at developing customer loyalty also commenced during this period. One of the more notable endeavors was the hiring of registered nurses to serve as "highway hostesses" with the primary duty being inspection of Phillips 66 station restrooms to ensure cleanliness.

In spite of its developmental origins on Route 66, the company has yet to capitalize on the resurgent interest in the highway.

PIERCE PENNANT OIL COMPANY

Commencing in 1871, John D. Rockefeller initiated a systematic process of replacing independent agents and jobbers in certain fields of business with his employees or agents, one of which was the Waters Pierce Oil Company. The Waters Pierce Oil Company, founded in 1855, one of the nation's oldest oil companies, served as the distributor of Standard Oil Products in a district that included Kansas, Missouri, Arkansas, and Texas before 1910.

The Pierce Pennant Company derived its origins from the Supreme Court–mandated dissolution of the Standard Oil Trust in 1911 that resulted in the breakup of the Waters Pierce Oil Company. To a large degree, the business practices of the Waters Pierce Company in Texas served as the catalyst for the federal intervention that manifested in this "trust busting."

Reorganization in 1924 resulted in the creation of Pierce Petroleum Company, but William Clay Pierce also utilized the Pennant name, most specifically for the pioneering development of a chain of motor hotel complexes after the certification of Route 66 in 1926.

The bold plan called for establishment of travel plazas that consisted of Pierce Pennant service stations with hotels offering the latest in amenities and restaurants with standardized fare, as well as operations, in a manner similar to that developed by Fred Harvey in conjunction with the railroad. As envisioned, the locations for these facilities would be at 125-mile intervals between Chicago and Los Angeles along Route 66 and along Route 50 between St. Louis and Jefferson City in Missouri.

In July 1928, under the supervision of Edward D. Levy, the Pierce Pennant president, the first Pierce Pennant Motor Hotel, initially signed as the Pierce Pennant Petroleum Terminal,

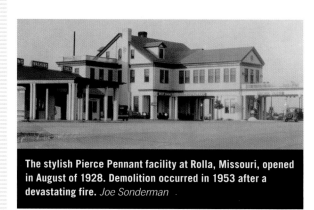

The stylish Pierce Pennant facility at Rolla, Missouri, opened in August of 1928. Demolition occurred in 1953 after a devastating fire. *Joe Sonderman*

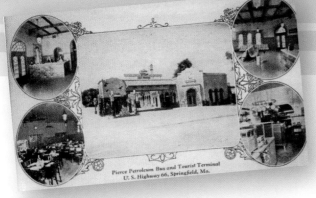

The first of the opulent and revolutionary Pierce Petroleum terminals offering a wide array of amenities, including a car wash, opened in Springfield, Missouri, on July 16, 1928. *Joe Sonderman*

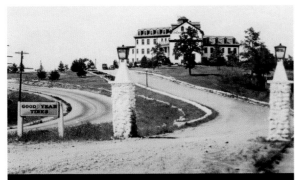

The Pierce Pennant Tavern in Rolla, Missouri, opened in August of 1928. Before its demolition by fire in 1953, the property had been renamed the Pennant Café and Hotel Martin in 1946. *Joe Sonderman*

opened in Springfield, Missouri. This initial complex featured a service station, bus terminal, soda fountain, restaurant, restrooms, repair facility, car wash, and hotel. (In 1936, the Greyhound bus company purchased this Springfield property. Demolition occurred in 1979.)

Before 1930, additional complexes opened near St. Louis, in Rolla and Columbia, Missouri, and in Miami and Tulsa, Oklahoma. In 1930, this subsidiary of Pierce Pennant Oil Company was sold to Henry Sinclair of the Sinclair Refining Company. He re-signed the properties as Sinclair-Pennant Hotels.

The realignment of Route 66 in the Meramec Valley of Missouri in 1933, coupled with the economic climate of the period, resulted in a precipitous decline in business. As a result, the remaining properties were sold to private parties, or were demolished, and the concept of a nationwide chain was abandoned.

An existing reminder of this pioneering endeavor on Route 66 is located at 17352 Manchester in Pond, Missouri. The Pierce Petroleum Company opened the Big Chief complex in 1929. As of 2010, it remained operational as Big Chief Roadhouse.

PINON LODGE

The Pinon Motel and Apartments at 8501 East Central Avenue in Albuquerque, New Mexico, opened in 1946 as the Pinon Lodge. Architectural details are a blending of art deco and pueblo

influences. As of late 2010, the facility remained in business as the Pinon Motel and Apartments.

PIONEER LUXURY COURT

The Pioneer Motel at 7600 East Central Avenue in Albuquerque, New Mexico, opened in 1949 as the Pioneer Luxury Court. As of 2010, it remained as an existing motel with signage that dates to its purchase and renovation by R. L. Porrata in 1958.

PLAINFIELD, ILLINOIS

James Walker, in partnership with Jesse Walker, an uncle, established a sawmill near the site of Plainfield, Illinois, in about 1830. The small community that developed around the mill became known as Walker's Grove. Chester Ingersoll platted the town site in 1834.

Establishment of a post office under the name Plainfield occurred on January 6, 1834. The community's association with Route 66 began in the late 1930s with realignment that resulted in the original alignment through Joliet being designated Alternate 66. The section of highway currently signed as Highway 59 and U.S. 30 to the south of town served as the path for the Lincoln Highway as well as Route 66.

The small historic business district houses an eclectic array of shops and restaurants. The Plainfield Historical Society Museum near the intersection of State Highway 59 is also an often overlooked attraction today.

PLAZA MOTEL

An AAA directory noted that the Plaza Motel, 2612 East Seventh Street in Joplin, Missouri, that opened in 1953 was a complex consisting of "twenty-one luxuriously furnished units, carpeting, tubs or showers, tile baths, refrigerated air panel ray heat."

The *Western Accommodations Directory*, published by AAA in 1955, noted that the motel offered a wide array of amenities, including the following: "Air conditioned rooms have radios, vented heat and tiled shower or combination baths; 4 open garages. $5.00 - $8.00."

As of 2010, the Plaza Motel remained open for business.

PLEW, MISSOURI

Plew, Missouri, originally Plewtite, dates to 1893 and purportedly is named for a pioneering family. It remained a small community, and there is no reference to the town's history or services available in any of the major guidebooks, including that written by Jack Rittenhouse in 1946 or Jerry McClanahan in 2008.

PONTIAC, ILLINOIS

The Kickapoo, Illini, and Pottawatomie tribes used the area at the present site of Pontiac, Illinois, as hunting grounds before initial settlement by American pioneers in the late 1820s. Establishment of Livingstone County by the Illinois Legislature in 1837 contained a provision requiring a suitable location for a county seat to be determined by a commission composed of landowners within the proposed county.

The site selected included lands owned by Lucius Young, Seth Young, and Henry Weed, three pioneers to the area. After the platting of a town site, the three men pledged to contribute $3,000 for the construction of public buildings and to donate lands for a public square.

Completion of the first courthouse was in 1842, with its replacement built in 1856. A fire in 1871 leveled the building and resulted in construction of the current courthouse in 1875. In 1891, there were extensive improvements made that included the addition of electricity and steam heat. The addition of the clocks in the spire occurred in 1892.

A diverse agricultural–based economy enabled Pontiac to grow and prosper into the closing years of the ninetenth century, at which time light industry, including the manufacture of shoes and candy, added a new element.

During this period, Pontiac became associated with the Chautuaqua Assemblies, a movement that began on the shores of a lake by this name in upstate New York in 1874 as a religious gathering. By the 1890s, the movement had expanded to include educational and entertainment programs. Using money derived from the sale of stock in the group's events, a section of land known locally as Buck's pasture was transformed into a beautiful park with a pavilion and roads. During the thirty years the Chautuaqua event was held in Pontiac, the list of notable celebrities who spoke here included William Jennings Bryant, Samuel Gompers, Billy Sunday, and Booker T. Washington. Additional events included pageants, plays, agricultural displays, and new car automobile shows. During its peak, estimates place the number of guests at sixty-five thousand in the two-week season.

Chautauqua Park remains a key component in the City of Pontiac park system. The pavilion serves as a home for the Vermillion Players.

Fueling prosperity during the first decades of the twentieth century were rail service provided by the Bloomington, Pontiac & Joliet Electric Railway and completion of the all-weather road between Chicago and St. Louis that became State Route 4, U.S. 66, after 1926. The development of an infrastructure to provide needed services for travelers on these routes further diversified the community's economy.

A unique survivor from the origination of Route 66 is the Old Log Cabin Restaurant. Built in 1924, it originally faced the highway as it ran beside the railroad tracks. With completion of the four-lane bypass to the rear of the establishment in the

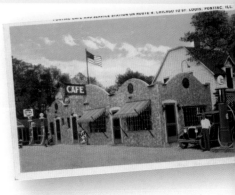

By the time of U.S. 66 certification in 1926, State Highway 4, (the original alignment of Route 66) was paved from Chicago to East St. Louis, and a well-developed infrastructure of roadside service lined that highway. *Steve Rider*

1940s, the building, lifted from its foundation, was spun 180 degrees to face the new highway.

The community of Pontiac was one of the first to capitalize on the resurgent interest in Route 66 in Illinois and to use this interest as a catalyst for development. *Time* magazine recognized the community as one of the ten best small towns in America. The article, in which this accolade was noted, applauded the unique character of the town with its historic district filled with restored buildings, parks, and well-maintained brick streets. Extensive murals that depict the city's history provide the historic district with a colorful vibrancy. In addition, the International Walldog Mural and Sign Museum chronicles the history of outdoor wall signs and promotional murals from the early nineteenth century to the present era.

The Route 66 Hall of Fame Museum—the first museum dedicated to the preservation of this highway in the state of Illinois and originally housed in the Dixie Truckers Home in McLean—is a multidimensional time capsule chronicling the evolution of the highway. Prized exhibits are the modified Volkswagen microbus that served as a traveling studio for Bob Waldmire, the school bus transformed into a motorized home by that iconic artist, and the Route 66 photo journal exhibit by Michael Campanelli.

Established in the summer of 2011, the Pontiac-Oakland Museum and Resource Center features the largest collection of

Colorful murals that reflect the rich history of Pontiac, Illinois, have been a catalyst in the transformation of the community into a destination for Route 66 enthusiasts from throughout the world. *Steve Rider*

these vehicles, memorabilia, design sketches, and documentation in existence. It is fast becoming a favored destination for automotive enthusiasts.

PONTIAC TRAIL

To a large degree, Illinois State Highway 4, the highway that served as the first alignment of Route 66, followed the historic Pontiac Trail. This trail predates European settlement and development, and it served as an important corridor for early colonists.

In the period of named roads, before establishment of the U.S. highway system in 1926, a highway designated the Pontiac Trail utilized portions of the historic trail system.

PONY SOLDIER MOTEL, FLAGSTAFF

Dating to 1963, the ninety-unit Pony Soldier Motel at 3030 East Santa Fe Avenue in Flagstaff, Arizona, advertised the largest pool in northern Arizona at the time of its opening. The motel remains in existence as the Best Western Pony Soldier Inn and Suites as of spring 2010.

PONY SOLDIER MOTEL, KINGMAN

In the 1960s, Mr. and Mrs. Tom White, the proprietors of the Pony Soldier Motel in Kingman, Arizona, at 2939 East Andy Devine Avenue offered the "Very Finest Accommodations" at the twenty-five-unit complex. It still exists as the Route 66 Motel, and the landmark, flashing arrow on the sign is still operational.

The property received a matching fund grant from the National Park Service Route 66 Corridor Preservation Program in the summer of 2011 for the refurbishment of the signature sign and the roof.

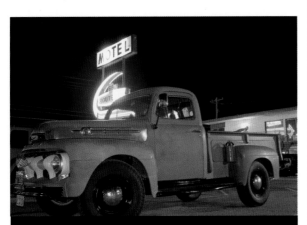

The Pony Soldier Motel at 2929 East Andy Devine Avenue in Kingman, Arizona, currently the Route 66 Motel, retains most of its original attributes, including the flashing arrow sign.

POWELLVILLE, MISSOURI

Even though it appeared on state maps, Powellville was never really a community. In actuality, it consisted of a service station manned twenty-four hours a day, a restaurant, a general store, and a ten-cabin motel complex.

Jewell, Harry, and Herman Powell, owners of a pioneering trucking firm that served the St. Louis and southwestern Missouri area, established Powellville in the mid-1930s. In *A Guide Book to Highway 66*, published by Jack Rittenhouse, the entry is succinct: "A gas station, café, and a few cabins."

For more than thirty years, the complex met the needs of travelers on Route 66. The construction of Interstate 44 in 1967, however, necessitated the demolition of the entire complex.

PREMIERE MOTEL

Located at 3820 East Central Avenue in Albuquerque, New Mexico, the Premiere Motel opened as a modern, thirty-unit complex in 1941. By 1954, the property had been sold to Manly and Dorothy Betts (former owners of the Conchas Motel in Tucumcari), and renovations (including enclosure of the garages) had transformed it into a thirty-five-unit motel.

The *Western Accommodations Directory*, published by AAA in 1955, gave the property favorable reviews. It noted the following: "Convenient to shopping center. Individually air cooled units have one or two bedrooms, TV, free radios, telephones, tiled shower or tub baths and vented or central heat; 4 housekeeping units. Free ice. Sun deck; patio. Restaurant next door. $5.00 - $7.00."

Shortly after its closure, fire decimated the complex in May 2009. Demolition occurred a few months later.

PREWITT, NEW MEXICO

The initial date of settlement of Prewitt is unknown, but references to a community at this site under the name Baca (the name of a local ranching family) date to 1890. In 1916, brothers Bob and Harold Prewitt moved to the area from Gunnison, Colorado, and established a trading post in a large tent along the National Old Trails Highway shortly thereafter.

A post office application name under the name Prewitt received approval in 1928. The reference to Baca remains with a Navajo chapter house that uses that name.

The association with Route 66 was minimal. The Jack Rittenhouse guidebook published in 1946 indicates the "town" consisted of little more than a trading post and railroad siding shacks. Jerry McClanahan in *EZ 66 Guide for Travelers* has even less to say. He noted, "Numerous remnants of old motels, garages, and trading posts line the west side of old Route 66 (4 lane for much of the way) thru Bluewater to Prewitt."

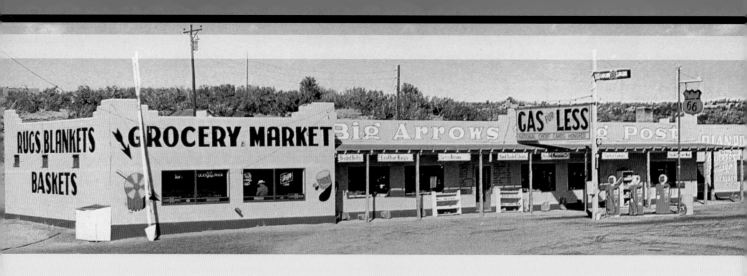

QUAPAW, OKLAHOMA

Settlement in Quapaw predates establishment of a post office in 1897. Mining and Route 66 served as the foundational elements of the economy, but development of the town was negated as a result of its proximity to the larger communities of Baxter Springs, Miami, and Commerce.

In the guidebook published by Jack Rittenhouse in 1946, the population is given as 1,054. Available services are listed as the Gateway Hotel, Lucy Garage, gas stations, and a few stores.

The guidebook penned by Jerry McClanahan, *EZ 66 Guide for Travelers*, second edition (published by the National Historic Route 66 Federation in 2008), contains a short descriptor of Quapaw. "Over the line, more 'chat

piles' [old mining tailings] greet you in Oklahoma. Several [deteriorating] murals decorate quaint Quapaw," it notes. McClanahan indicates Dallas Dairyette for "small town eats."

QUERINO, ARIZONA

The origin of the name Querino is unknown, but it appears on maps in relation to the canyon at this site as early as 1865. The railroad established a siding here and used this name as well. Interestingly, a map published in 1883 and another in 1885 use the name Quirini. A map prepared shortly before statehood in 1912 used the name Helena.

Querino was, in the words of Jack Rittenhouse written in 1946, "another one-structure 'town' consisting of the Querino Trading Post. Curios and gas." The trading post opened in about 1939. Realignment of Route 66 led to its abandonment in the mid-1950s.

The primary Route 66 association with the site today is its location on a post-1931 section of the Mother Road, now a gravel road, which stretches between exit 346 and exit 341 on Interstate 40. The 269-foot Querino Canyon Bridge built in 1930 is located here.

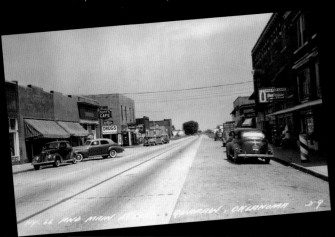

Quapaw chief Victor Griffin laid a commemorative zinc tablet in the middle of Main Street in Quapaw, Oklahoma, during the celebration that marked completion of pavement between Commerce and Baxter Springs, Kansas, on March 24, 1933. *Steve Rider*

Above: The ruins of the Querino Canyon Trading Post in Arizona are located along County Road 7250 (formerly Route 66) near the Querino Canyon Bridge built in 1930. The guidebook written by Jack Rittenhouse contains a cursory entry about the facility. *Joe Sonderman*

RAIL HAVEN

The Best Western Route 66 Rail Haven, at 203 South Glenstone Avenue in Springfield, Missouri, opened in 1938 as the Rail Haven Cottage Camp, with Lawrence and Elwyn Lippman as proprietors. The initial property consisted of eight stone cabins bordered by a split-rail fence.

The 1940 *Directory of Motor Courts and Cottages* published by AAA provided an extensive entry for this facility. It read: "Rail Haven Cottages on U.S. 65 and City Route 60 and 66, corner of St. Louis Street and Glenstone Boulevard, ten blocks east of the Public Square. 16 thoroughly modern stone cottages, all with showers; very nicely furnished; automatic safety controlled gas heat; well ventilated, insulated against heat and cold. Very good beds. Rates $2.50 to $4.00 per person. Porter and maid service.

Night Watchman. Laundry facilities. Children's playground. Service station in connection. Catering to select clientele. Beer, wines, and liquors are not sold on the premises. Café in connection, serving good food at moderate prices."

In 1954, after renovation and expansion of the facility, it became the Rail Haven Motel with rates ranging from $5.00 to $8.00. The *Western Accommodations Directory*, published by AAA in 1954, noted that it was situated on "attractive, spacious grounds." It was also noted that amenities included "beautifully furnished one and two room motel units with air conditioning and fans, central heat or thermostatically controlled floor furnaces and tiled showers or combination baths. TV and cribs available. Gift shop and filling station; 24 hour restaurant next door."

Ward Chrisman purchased the property in 1961 and opened a modernized Sycamore Restaurant. When acquired by Gordon Elliot in 1994, the restaurant was closed and motel well worn.

The razing of the restaurant and complete renovation of the property transformed the vintage motel into a favored destination for Route 66 enthusiasts. The motel, now listed in the National Register of Historic Places, has a Best Western affiliation.

The Best Western Route 66 Rail Haven at 203 South
Glenstone Avenue in Springfield, Missouri, opened in 1938 as
eight stone cabins owned by Lawrence and Elwyn Lippman.
Joe Sonderman

RANCHO CUCAMONGA, CALIFORNIA

By about AD 1200, a Kucamongan tribal village was located in the area known as Red Hill in Rancho Cucamonga, California. It was at this site in March 1839 that Tubercio Tapia built a well-fortified adobe home to serve as the headquarters for his vast Rancho de Cucamonga on his thirteen thousand–acre Cucamonga land grant issued by Governor Jaun Bautista Alvarado. A portion of his winery still remains as the Thomas Winery.

In 1846, a contingent of the U.S. Army arrived in the area, and four years later, in 1850, California became a state. In 1858, John Rains and his wife, Maria Merced Williams de Rains,

RANCHO CUCAMONGA, CALIFORNIA *continued*

purchased Rancho de Cucamonga from Tapia's daughter and immediately expanded on the vineyards as well as hired brick masons recently relocated from Ohio to replace the Tapia adobe with a masonry-constructed family home that is now listed on the National Register of Historic Places.

The pressing American influence fueled a resultant clash in cultures, as well as legal wrangling over the Spanish and Mexican land grants that dramatically altered the political and social landscape. Adding to these tensions were debates and lawsuits over water rights.

Three pioneering automobile collectors, Dr. Orris R. Myers, Purcell Ingram, and Orville Race, established an automotive museum along Route 66 in Cucamonga, California, in 1954 and named it after the book written by Ken Purdy, *Kings of the Road*. *Steve Rider*

The murder of John Rains in 1862, and the subsequent departure of his wife, resulted in foreclosure of the ranch, but not before a small community had developed at Red Hill. In 1864, an application for a post office received approval, the first U.S. post office in the western portion of San Bernardino County. In 1870, the ranch sold to Isaias Hellman, representative for a consortium of San Francisco investors that would later form the Cucamonga Company.

By 1887, with construction of irrigation tunnels from Cucamonga Canyon and completion of the Santa Fe Railroad through the area, the Cucamonga tract flourished. This would be the first of three communities carved from the former properties of the Rancho de Cucamonga, the other two being Alta Loma and Etiwanda.

Creation of a Tri-Community Incorporation Committee to evaluate the merits and possible benefits of bringing all three communities together under one unified government occurred in 1975. In November 1977, the plan went before voters, and with a 59 percent majority, the incorporated community of Rancho Cucamonga replaced the three prior entities.

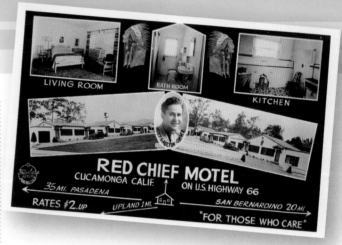

Nestled amongst groves of citrus trees, the Red Chief Motel was promoted as the finest facility between San Bernardino and Pasadena in 1936. *Steve Rider*

Surprisingly, the community of Cucamonga remained largely rural and agricultural into the 1950s. Route 66 utilized Foothill Boulevard for the transition across the town.

Capitalizing on the community's association with Route 66 has become an important part of the city's development in recent years with the resurgent interest in that highway. Indicative of this was inclusion of the city in the list of possible host communities in California for the 2012 International Route 66 Festival.

The Cucamonga Garage that opened in 1910, and a similarly designed service station in front that opened in about 1919, housed a variety of businesses before closure in the 1980s. *Steve Rider*

RED BALL CAFÉ

Listed in the National Register of Historic Places, the Red Ball Café at 1303 Fourth Street Southwest (the pre-1937 alignment of Route 66 in Albuquerque, New Mexico) opened in 1922. Recently refurbished, the café remains one of the oldest continuously operated businesses on Route 66 in this city.

The *Route 66 Dining & Lodging Guide*, fifteenth edition (published by the National Historic Route 66 Federation) contains a lengthy entry for this establishment. It is listed as a "very special must stop."

RED FORK, OKLAHOMA

Red Fork, Oklahoma, currently within the city limits of Tulsa, derives its name from the Red Fork of the Arkansas River. Before its absorption into Tulsa, Red Fork, as an independent community, had a post office that operated under this name from January 3, 1884, to July 31, 1928.

Jack Rittenhouse, in 1946, indicated that Red Fork was an "industrial suburb of Tulsa, containing many factories." In the second edition of *EZ 66 Guide for Travelers*, by Jerry McClanahan, he notes, "In Red Fork, the former 66 Motel is gone, but Ollie's Station Restaurant has toy trains running along the ceiling."

RED GARTER

The Red Garter Bed and Bakery, 137 West Railroad Avenue, Route 66, in Williams, Arizona, is a popular bed and breakfast that received an "exceptional" rating in the fifteenth edition of the *Route 66 Dining & Lodging Guide*, published by the National Route 66 Federation in 2011. Located on the westbound alignment of Route 66, the building built in 1897 by August Tetzlaff initially served as a tailor shop, saloon, and brothel. The saloon remained operational into the 1940s but closed after a particularly brutal murder. John Holst acquired the property in the 1990s and after extensive renovation reopened it in its current configuration.

RESCUE, MISSOURI

The late Skip Curtis—a member of the Route 66 Association of Missouri, the State Historical Society of Missouri, the Missouri Historical Society, and the National Trust for Historic Preservation, and author of *The Missouri U.S. 66 Tour Book*—claimed that the name for the town of Rescue came from a stranded family rescued by area pioneers. The name is the one initially supplied on the application for a post office in 1897.

Jack Rittenhouse, in 1946, noted that Rescue was "a small village with a few homes and a couple of groceries." Skip Curtis in his tour book noted that Route 66–related businesses consisted of a complex with a service station, cabins, and lodge, started by a Mr. and Mrs. Roy Rogers in the 1920s, that later became Reeds Cabins and Shady Side Camp.

Shady Side Camp, built by L. F. Arthur, dates to about 1927 and was expanded to include four stone cottages in 1935. Promotional material from the late 1930s noted that the camp offered "private cooking facilities, dishes not provided, and access to community toilets and showers." The property is now private with some cabins still in existence as of 2011.

REST HAVEN MOTOR COURT

The initial business on Route 66 at the site of the Rest Haven Motor Court in Springfield, Missouri, was a service station and four cabins owned by Richard Chapman. Hillary and Mary Brightwell purchased the property at 2000 East Kearny in 1947, added ten cottages in 1952, and another ten in 1955. Ed Waddell, a renowned area stonemason, faced the buildings and provided exquisite brick trim.

Harry and Mary Brightwell, the original owners of the Rest Haven Court, operated the motel until 1979. The current Rest Haven sign dates to 1953 and is favored as a photo stop by Route 66 enthusiasts. *Steve Rider*

The *Western Accommodations Directory*, published by AAA in 1954, listed the property with notes indicating it was "a very nice court, 1/4 mile east of U.S. 65 and U.S. 166. Nicely furnished stone cottages and attractive motel units have air conditioning or window fans, telephones, free radios, vented or central heat with thermostat control and tiled shower or combination baths. TV and cribs available. Gift shop and filling station; 24 hour restaurant next door."

The motel, recommended by the National Historic Route 66 Federation in the fifteenth edition of its dining and lodging guide published in 2011, remains operational. The sign, designed by Hillary Brightwell and dating to 1953, provides a time-capsule feel for the renovated facility and is a favored sight for Route 66 enthusiasts.

RIALTO, CALIFORNIA

Rialto was founded with establishment of a colony by Methodist pioneers from Halstead, Kansas, along the old El Camino Real in 1887. It remained an agricultural town well into the twentieth

Produce stalls and thematic-styled juice bars lined Route 66 between Rialto and Pasadena during the 1920s, 1930s, and 1940s. This stand at the corner of Foothill Boulevard and Eucalyptus survived into the early 1950s. *Steve Rider*

century, but postwar development and the service industry spawned by the traffic on Foothill Boulevard, Route 66, eventually transformed the community.

The primary attraction for Route 66 enthusiasts is the Wigwam Motel, a recently renovated property listed in the National Register of Historic Places, that dates to 1949 and is one of two such properties along U.S. 66.

The *Western Accommodations Directory*, published by AAA in 1955, lists one motel as recommended lodging: "Farm House Motel – 625 E. Foothill Boulevard." The rates were $3.50 to $5.00.

On November 19, 2011, the post office in Rialto commemorated its centennial with issuance of a pictorial postmark.

RICHARDSON STORE

G.W. Richardson of Missouri opened his first store in the town of Montoya, New Mexico, in 1908. With completion of extensive road improvements in 1918, he built a new store and relocated his business to the south side of the railroad tracks.

The construction of I-40 south of the store in 1976, and the subsequent bypass of Montoya, resulted in a precipitous decline in business. The store, listed on the National Register of Historic Places in 1978, has seen little change since the 1930s.

Currently, a chain-link fence protects the property from vandalism. However, exposure to the elements and lack of maintenance make its survival doubtful.

RIO PUERCO BRIDGE

With federal government funding, construction of the Rio Puerco Bridge over the Rio Puerco River west of Albuquerque, New Mexico, commenced in 1933, and the bridge opened one year later. Its completion allowed for the Laguna cutoff to be built, and in 1937, with additional road projects in the area, it resulted in the bypass of the southern loop of Route 66 through Isletta Pueblo and Los Lunas.

The bridge, a Parker through truss type that eliminated the need for a center pier, received a number of updates in 1957. At 250 feet, it is one of the longest single-span steel truss bridges in New Mexico. It continued to carry Route 66 traffic until completion of Interstate 40, at which time it became part of a frontage road. In 1999, two years after the structure received recognition with a listing in the National Register of Historic Places, the New Mexico State Highway and Transportation Department bypassed the bridge and closed it to vehicular traffic.

As a result of its historic significance, the Rio Puerco Bridge still exists as a pedestrian bridge, providing a unique opportunity to experience early Route 66 in western New Mexico.

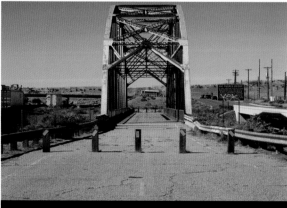

Completion of the Rio Puerco Bridge in 1933 represented one of the first stages in the realignment of Route 66 that would bypass the loop south from Albuquerque through Isletta and Los Lunas.

RIVERSIDE, ILLINOIS

The original alignment of Route 66 west of Chicago between 1926 and 1928 utilized Lawndale Avenue, Joliet Road, and Ogden Avenue along the village limit lines of Riverside and Lyons, with the north side of the highway lying within the limits of Riverside.

The community of Riverside dates to the construction of the Chicago, Burlington & Quincy Railroad in 1863, which opened the area to development as a suburb of Chicago with establishment of commuter passenger service. Envisioned as a planned community for upper middle-class families by the Riverside Improvement Corporation, the developers hired Frederick Law Olmstead, designer of Central Park in New York City, to assist in platting.

Riverside, one of the first planned railroad-connected suburbs in the nation, opened to residents in 1868, and a post office opened in November 1870. Incorporation as a village occurred in 1875.

The central village of Riverside received recognition for the extensive array of historic architectural elements preserved there with designation as a National Historic Landmark. Architectural tour planners are attracted to Riverside because of the wide array of periods represented by Victorian-era mansions, well-preserved bungalows from the 1920s, and modest homes built between the years 1940 and 1960.

RIVERTON, KANSAS

During the postdecertification period and the modern era of resurgent interest in Route 66, the primary association with the Mother Road in Riverton, Kansas, has been the Eisler Brothers Store. The history of this property, listed in the National Register of Historic Places in 2003, dates to the late teens and the establishment of a small diner and garage by Leo Williams. After

the destruction of this original business by a tornado in 1923, Williams built the current store, with living quarters, on an adjoining lot. It opened in 1925.

The certification of Route 66 in 1926, and inclusion of the property as a recommended stop on a map series in the early 1930s, ensured Williams would have a steady business. To generate additional income, Williams constructed a regulation-sized croquet court in the lot to the east of the store, which made it the focal point for area recreation during summer evenings.

In 1973, the store sold to Joe and Isabell Eisler. As of 2010, their nephew, Scott Nelson, served as proprietor. The building retains a number of original features and appointments, including the glass-enclosed porch, pressed tin ceiling, shelving, and deli counter at the rear of the store. The store is a favored stop for Route 66 enthusiasts. It consistently receives accolades from travel guides, including the fifteenth edition of the *Route 66 Dining & Lodging Guide* published by the National Historic Route 66 Federation in 2011.

Initially built as the private residence of B. F. Steward in 1902, the Spring River Inn in Riverton, Kansas, served as the focal point for social affairs in the area under various names. A fire on October 20, 1998, decimated the structure. *Steve Rider*

ROCK CAFÉ

Listed on the National Register of Historic Places in 2001, the Rock Café in Stroud, Oklahoma, epitomizes the entrepreneurial spirit unleashed by the seemingly unlimited potential for success that manifested in the flow of traffic on Route 66. The owner, Roy Rives, opened the facility in August 1939 after three years of intermittent construction that included the pouring of the concrete foundation one wheelbarrow of cement at a time.

Shortly after opening, the café began to double as a stop for the Greyhound bus lines, a boon for business during World War II. In late 1946 or early 1947, the dramatic increase of traffic on Route 66 prompted institution of a twenty-four-hour schedule at the café.

Though the café remained in operation, by the early 1990s it was in need of extensive renovation and repair. In 1993, the café

was sold, and the new owners initiated a program of repair that culminated with its placement on the National Register of Historic Places in 2001 and earning a cost-share grant from the National Park Service Route 66 Corridor Preservation Program.

Utilizing original floor plans, renovation transformed the property, but in 2008, a major fire gutted the entire structure. This was shortly after the filming of an episode of the Food Channel's program *Diners, Drive-Ins & Dives*. With funding from the National Park Service and the National Trust Southwest Office, reconstruction allowed for a 2009 reopening.

The proprietor Dawn Welch served as the inspiration for the character Sally Carrera in the 2006 animated film *Cars*. Welch and the Rock Café have come to symbolize the modern era on Route 66 that has again made it economically viable to refurbish historic properties.

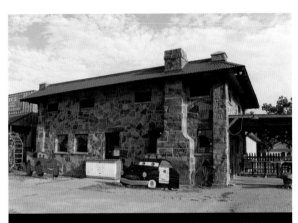

Dawn Welch, the owner of the Rock Café in Stroud, Oklahoma, served as the inspiration behind development of the Sally Carrera character in the animated film *Cars*.

The Rock Café in Stroud, Oklahoma, survived the decertification of Route 66 and, with Dawn Welch as proprietor, rose from the ashes of a devastating fire to become an icon of the resurgence movement.

ROCK FOUNTAIN COURT

The Rock Fountain Court, 2400 West College Street in Springfield, Missouri, now the Melinda Court Apartments, dates to 1945. Built by local developer "Mac" MacCandless, the cabins are another stunning manifestation of master stonemason Ed Waddell's work.

An interesting note about the original structures: the cabin most visible from the road was sheathed entirely in stone while the other eight cabins utilize stone for the front façades only. The namesake stone fountain at the center of the courtyard was another unique feature.

The *Western Accommodations Directory*, published by AAA in 1954, mentions Rock Fountain Courts, listed in the National Register of Historic Places in 2003, as being on the "west edge of U.S. 60, 66, 166 city routes & state 13. Stone cottages have one or two rooms, air conditioning or fans, radios, tiled shower baths and vented heat; 6 units have TV; 1 kitchenette; 5 closed garages."

ROGERS, WILLIAM PENN ADAIR

Born in 1879, on his father's ranch near Oolagah in the Indian Territory, later the state of Oklahoma, William Penn Adair Rogers attained international fame as an American humorist using the abbreviated name of Will Rogers. His career in the entertainment industry commenced in 1902, the year he joined Texas Jack's Circus & Wild West Show as a bronco rider and trick roper.

His debut occurred on the show circuit in South Africa, where he used the name Cherokee Kid. A master of trick roping, he joined Colonel Zach Mullhall's Wild West show for a performance at the St. Louis world's fair in 1904 and at the Cleveland Theater in Chicago as a headliner for a popular vaudeville bill.

In 1905, Rogers garnered international attention through press reports about his capture of a bull that had leapt into the stands at a horse fair in New York City's Madison Square Gardens. An additional change in his career occurred during this period when he began adding homespun witticisms and jokes to his display of mastery with a rope.

In 1916, he gave the first of several presidential performances before President Woodrow Wilson. He also joined the Ziegfeld Follies as a comedian in the same year, and in 1918, he starred in his first motion picture, *Laughing Bill Hyde*. The popularity of the film resulted in Rogers accepting a contract with Goldwyn Studio. In 1919; he relocated his family to California.

During the 1920s, Will Rogers became one of the most recognized American stars in the world, and by 1933, he was the highest paid film star in Hollywood. In 1922, he began producing his own films, initiated a weekly syndicated column for McNaught Syndicate, and embarked on a lecture circuit that, by 1925, would be international in scope. In 1926, he accepted the honorary title of mayor of Beverly Hills. Three years later, he

Unveiled in Los Angeles in 1937 was the first signage designating Route 66 as the Will Rogers Highway. Formal dedication occurred the following year. *Steve Rider*

starred in his first movie with a soundtrack, a film that would be the first of twenty-one films produced by Fox Film Corporation.

The decade of the 1930s commenced with Rogers performing in a series of radio broadcasts for E. R. Squibb and Sons, and working as a fund-raiser for Nicaraguan earthquake relief. His career ended abruptly in August 1935 when the plane in which he was riding with a friend, Wiley Post, crashed near Point Barrow, Alaska, and both died.

In January 1936, representatives from seven California communities gathered in a meeting with the Los Angeles County Board of Supervisors to discuss the proposal to designate U.S. Highway 66 as the Will Rogers Highway. The idea languished until 1952; the year after Warner Brothers Studios released *The Story of Will Rogers*, starring Jane Wyman and Will Rogers Jr. with a world premiere in Claremore, Oklahoma, site of the Rogers ranch and nearest community to his birthplace.

The U.S. Highway 66 Association saw this as an excellent opportunity for garnering support for designating U.S. 66 as the Will Rogers Highway and for promoting the highway. With acceptance of the designation, a caravan was organized to travel

Established in 1941 at 5727 East Eleventh Street in Tulsa, Oklahoma, the Will Rogers Motor Court was promoted as "a spacious air-conditioned court with television available in most units" by AAA in 1955. *Mike Ward*

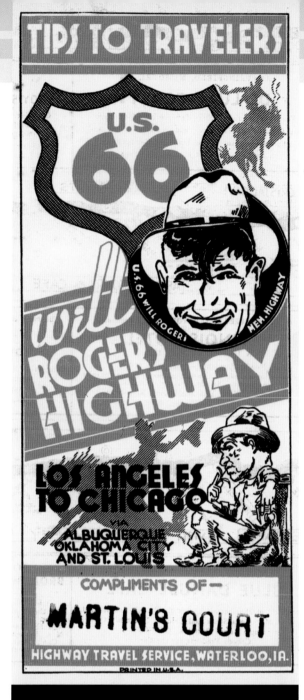

Promotional material for Route 66 utilizing Will Rogers played a pivotal role in the development of the concept that this was the Main Street of America. *Steve Rider*

Claremore, Oklahoma, retains strong ties to Will Rogers. The Will Rogers Memorial—where he, his wife Betty, and a son are buried—as well as an extensive collection of Rogers's memorabilia, is located one mile west of Route 66 on a twenty-acre site once owned by the celebrity. The Hotel Will Rogers—built in 1930 as a

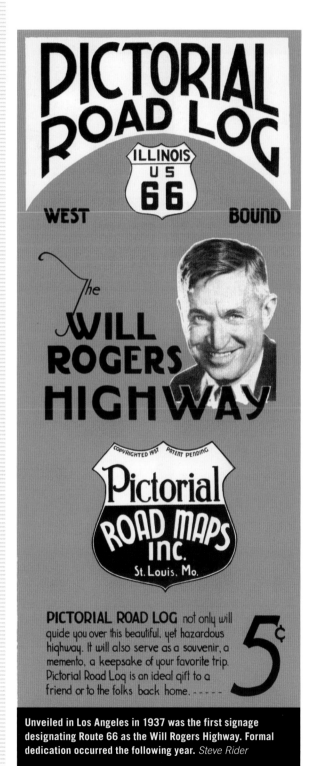

Unveiled in Los Angeles in 1937 was the first signage designating Route 66 as the Will Rogers Highway. Formal dedication occurred the following year. *Steve Rider*

from Oklahoma to Palisades Park in Santa Monica, California, where a bronze plaque was commemorated.

The plaque reads: "Will Rogers Highway dedicated in 1952 to Will Rogers—humorist, world traveler, good neighbor. This Main Street of America, Highway 66, was the first road he traveled in a career that led him straight to the hearts of his countrymen." Additional plaques with this wording were placed at the borders of each state through which the highway passed. The plaque fueled the myth that Route 66 ended at the park rather than at Santa Monica Boulevard and Lincoln Boulevard several blocks to the east. That myth continues to this day.

ROGERS, WILLIAM PENN ADAIR *continued*

luxury hotel, now the Will Rogers Center and Apartments—and Will Rogers Boulevard are also indicative of the star's association with the community.

This plaque in Santa Monica's Palisades Park fueled the myth that Route 66 ended here rather than at the corner of Olympic and Lincoln Boulevards several blocks to the east. *Mike Ward*

ROLLA, MISSOURI

Legend has it that the naming of Rolla, Missouri, involved establishment of a Pacific Railroad construction at the site in 1858 and a suggestion from George Coppedge, a local farmer, that his native Raleigh, North Carolina, be the namesake. Because of his thick accent, the town became known as Rolla.

During the American Civil War, the town served as headquarters for Union forces. Its association with the railroad, its central location in Missouri, and its control of the strategically and geographically important Wire Road all were pivotal in the decision to use Rolla as a primary base.

From its inception, Route 66 in Rolla, utilizing Bishop Avenue and Kings Highway, as well as a City 66 that followed Pine Street, has been an integral component of this community's economy. With the resurgent interest in this highway, that historical relationship continues unabated.

On March 15, 1931, the city turned out to celebrate completion of the highway's paving in the area. In attendance were Cyrus Avery, president of the U.S. Highway 66 Association, and Governor Henry S. Caulfield. Caulfield used the event to pressure the legislature to pass a bill that would create a highway patrol.

The *Hotel, Garage, Service Station, and AAA Club Directory*, published by AAA in 1927, recommended Ozark Garage for service or repair. The *Service Station Directory*, published by AAA in 1947, recommends Ramsey's Garage. Jack Rittenhouse, in 1946, suggested Vance Motor Company.

The *Directory of Motor Courts and Cottages*, published by AAA in 1940, provides an unusually lengthy listing for recommended lodging in a town with a population of, according to 1946 statistics, just over five thousand residents. Listed properties are Colonial Village, Phelp's Modern Cottages, and Schuman's Tourist City, a facility also noted by Jack Rittenhouse in 1946.

Richard Schuman opened his establishment in June 1929 as a complex of several cabins. According to the *AAA Directory of Motor Courts and Cottages*, by 1940, it had expanded to a "Modern Hotel and 24 cottages, 13 with private baths, many with combination tub and shower, and steam heat, the rest with private toilet and lavatory; all modern conveniences, including radio and telephone. Accommodations for 100 guests. Rates, $1.50 to $3.50 per day. Under personal supervision of R.E. Schuman, owner. Member United Motor Courts, Inc."

The 1955 edition of *Western Accommodations Directory* published by AAA also lists this property, but there is no mention of the hotel, and the entry utilizes the name Schuman's Motor City. It states, "On U.S. 63 & 66 city route, at east entrance to U.S. 66 Bypass. One and two room cottages have air conditioning or window fans, vented or central heat, some with thermostat control, and shower, tub or combination baths; some radios and telephones. TV in lobby. $3.50 to $8.00."

In *The Missouri U.S. 66 Tour Book*, by C. H. "Skip" Curtis, published in 1994, the author notes that a Denny's and Budget Apartments stood on the former site of Schuman's Tourist City. He also indicates a Lee's Fried Chicken occupied the site of the former Colonial Village Hotel at 1902 North Bishop Avenue.

Colonial Village, a property also noted by Jack Rittenhouse, opened in 1938 as "Rolla's newest and finest," a hotel, restaurant, and cabin complex. The *Directory of Motor Courts and Cottages* published in 1940 indicates that the property featured an "air conditioned main building of 13 rooms, each with bath. 15 cottages, most with showers; $2 to $3 per day for two persons, $3.50 for thee persons." Listed, as manager, is Lorene Lavery.

Phelp's Modern Cabins, at Bishop Avenue and Thirteenth Street, opened in late 1934, represented the Phelps Oil Corporation's first effort to diversify into lodging. The intricate mosaic-style stone façades, arched entryways, and porches with ornate balustrades made the slogan "one of the finest auto courts in the Ozarks" more than promotional hyperbole.

The 1940 edition of the *Directory of Motor Courts and Cottages* lists the property as "16 ultra-modern stone constructed cottages." Amenities included combination tub and shower, steam heat, radio, hardwood floors, fans, air conditioning by "Frigidaire," and "nice furnishings." Other interesting features included basement garages for six of the two-room units. Rates given were $2.00 to $6.00 per day.

With the Phelps Oil Corporation's divesture from the lodging industry, the new owners signed and promoted it as Grande Court. In the early 1960s, the beautiful complex was razed and a Dairy Queen was built on the site.

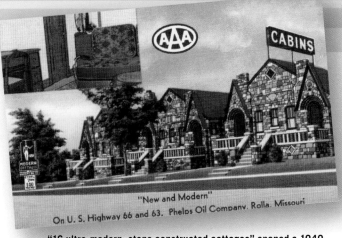

"16 ultra-modern, stone constructed cottages" opened a 1940 advertisement for Phelp's Modern Cottages that listed amenities including Frigidaire air conditioning, basement garage, steam heat, radio, and fan. *Mike Ward*

The pioneering efforts of the Pierce Petroleum Company to provide travelers with a uniform standard for lodging with a chain of quality full-service facilities manifested in Rolla as the Pennant Hotel that opened on November 4, 1929, and the Pierce Pennant Tavern that opened on August 1, 1928. The Pennant Hotel, after acquisition by George Carney, became the Carney Motel in 1956. The Drury Inn stands on this site as of 2010.

Robert and Margaret Martin divested themselves of the Wagon Wheel Motel in Cuba, Missouri, to purchase the Pierce Pennant Tavern in 1946. After remodeling, they opened the property as the Pennant Café and Hotel Martin. A devastating fire in 1953 resulted in demolition of the building and construction of a new Motel Martin, a property that no longer exists.

A tangible link with the era of Route 66 in Rolla lost in 2011 was Zeno's Motel & Steakhouse, a three-generation business that closed in October of that year. A rare survivor, the Mule Trading Post is located to the east of town.

Established in 1946 at Pacific, Missouri by Frank Ebbing, the Mule Trading Post opened at its current location in 1957. Completion of the interstate highway that bypassed Pacific, and the trading post, necessitated the relocation.

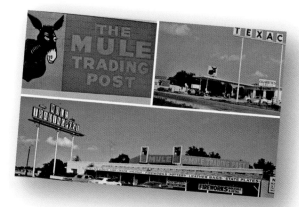

With signage that features an ear-waggling mule outlined in neon, the Mule Trading Post near Rolla, Missouri, originally opened in 1946 near Pacific, with Frank Ebbing as the owner. *Joe Sonderman*

ROMEOVILLE, ILLINOIS

Established as a port on the Illinois & Michigan Canal, Romeoville was first settled in 1833. The post office opened under the name Juliet on June 29, 1833, was amended to Romeo on October 29, 1833, and settled in 1845 at Romeoville.

For history buffs, Romeoville is associated with the Isle a la Cache Museum and nature preserve. Located on the Des Plaines River, the museum houses a wide array of exhibits chronicling the development of the Great Lakes fur trade, as well pre-European and Native American life in the area.

ROMEROVILLE, NEW MEXICO

The namesake for this community on the pre-1937 alignment of Route 66 is Don Trinidad Romero. Born in Santa Fe in June 1835, Romero established a freight company that operated on the Santa Fe Trail between Kansas City, Missouri, and Santa Fe, and built a ranch with its headquarters southwest of Las Vegas, New Mexico. He became a member of the Territory of New Mexico House of Representatives in 1863, the probate judge for San Miguel County, New Mexico, in 1869, and served as a representative of the Territory of New Mexico to the U.S. Congress from 1877 to 1879. He served as U.S. marshal from 1889 to 1893.

At his home in Romeroville, a ranching community established in 1877 and built at a cost of more than $100,000, he entertained many illustrious guests, including President Rutherford B. Hayes and General William Tecumseh Sherman. Anna Clark, in the book *Women Tell the Story of the Southwest* by M. L. Wooten, described the interior of the house as consisting of " . . . a dozen large, lofty, high ceiling rooms paneled in walnut. The downstairs rooms had sliding doors opening into the spacious ballroom. There was a low, wide, curving stairway." After serving as a sanatorium, the home, built in 1870, burned in January 1930.

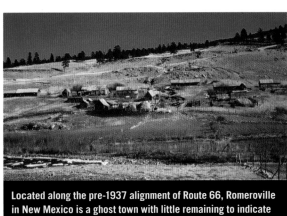

Located along the pre-1937 alignment of Route 66, Romeroville in New Mexico is a ghost town with little remaining to indicate that this was once a destination for kings and presidents.

At the 1918 convention of the Ozark Trail Association, William Hope Harvey, the organization's founder, proposed the construction of twelve large pyramids at important junctions to designate the trail system. He also proposed a larger, fifty-foot pyramid be placed in Romeroville to mark the location where the Ozark Trail met the historic Santa Fe Trail.

Initially, Route 66 followed the course of the Ozark Trail through Romeroville. The precipitous decline of the community during the period of the 1930s, fueled by drought and the realignment of Route 66 in late 1936, led to the temporary closure of the post office that year and permanent closure in 1953. The town remains as an almost complete ghost.

ROSATI, MISSOURI

From the summit of King's Hill, travelers on the Springfield Road had views of three distinct high hills or knobs. It was here that Italian immigrants, many of whom were former sharecroppers, established the community of Knobview in 1890.

Initial efforts to establish vineyards with cuttings from Italy failed. However, second attempts made using Concord grape plants obtained from French immigrants establishing vineyards in nearby Dillon were far more successful.

In honor of Bishop Joseph Rosati, the first American bishop of Italian descent, the community's name officially changed to Rosati with submission and approval of an amended post office application in 1930.

In season, grape stands were quite common along Route 66 here. The community remains the center of vineyards and wineries, and the historic Rosati winery has reopened.

ROSE CAFÉ

The Rose Café in St. James, Missouri, opened under the proprietorship of John and Mabel Rose in 1929. With a succession of owners, the café changed names numerous times, becoming the Commercial Café, Mary's Café, and, in 1960, Johnnie's Bar and Indian Relic Museum, with John Bullock as the owner.

During the late 1940s and early 1950s, the café also served as a stop for the Greyhound bus lines. As of 2010, the bar remained operational.

ROSS, JIM

Instrumental in the resurgent interest in Route 66, Jim Ross began extensive exploration of the road in the 1980s, chronicling the highway through photography and mapping. His book,

Oklahoma Route 66, published in 2001 and updated in 2011, remains the most preeminent work on that topic.

His work also includes the highly acclaimed *Here It Is! The Route 66 Map Series*; the 1998 documentary *Bones of the Old Road* that he coproduced with Jerry McClanahan; and *Route 66 Sightings*, a compilation of work by Ross, Shellee Graham, and Jerry McClanahan, released in 2011. Additionally, he has supplied photographs for a wide array of publications and books, including *Route 66 Magazine*, *Route 66 Backroads* by Jim Hinckley, and the AAA magazine *Home & Away*.

Ross cofounded *American Road* magazine and, because of his expertise, has been featured in numerous documentaries and productions.

ROUTE 66 (MOVIE)

On May 5, 1952, it was announced that work on a new film to be entitled *Route 66*, an epic about long-haul truck drivers featuring Burt Lancaster and Charlton Heston with direction by Hal Wallis, would commence in the fall. An *Albuquerque Journal* article dated May 6 reported that Charlton Heston was currently driving Route 66 to "pick up color."

The project never happened. Reasons for abandonment of the project are unknown.

ROUTE 66 (TELEVISION SERIES)

The television series *Route 66* debuted on October 7, 1960. It initially garnered little in the way of reviews or viewers. However, the drama soon received critical acclaim and an Emmy nomination. It ran for four seasons, featuring Martin Milner as Tod Stiles and George Maharis as Buz Murdock. In 1963, illness forced Maharis to leave the program, a factor that contributed to plummeting ratings and resulted in that being the final season.

The program is often credited for helping to make Route 66 a pop culture phenomenon and is now deemed a cult classic among Route 66 enthusiasts. Interestingly, Route 66 served as a location for very few episodes, even though this was the first television program filmed entirely on location. Filming occurred in twenty-five states and in Toronto, Canada.

In the fall of 2011, Shout! Factory acquired all rights to the series and immediately announced plans for a full release in packaged media, cable, broadcast, syndication, and video on demand. This was in stark contrast to the previous owner of rights to this program, Roxbury Entertainment, which received poor reviews for the subpar quality of limited-release episodes.

ROUTE 66 ASSOCIATION

The creation of the Arizona Route 66 Association, established in February 1987, stands as a cornerstone in the current era of

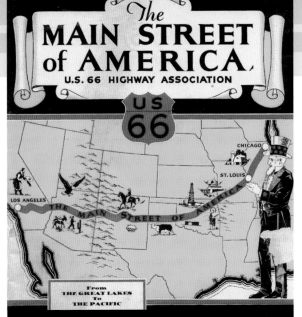

resurgent interest in this historic highway. The initial organizational meeting held at the Copper Cart Restaurant was the catalyst. Angel Degadillo, a barber in Seligman, Arizona, who was concerned about the precipitous decline in the community as a result of Route 66's bypass with completion of I-40, called the meeting.

In 1988, the association created the Route 66 Fun Run, a three-day event that utilized the longest uninterrupted section of Route 66 to celebrate that legendary highway as well as the American love affair with the automobile and the road trip. The annual event continues to grow in popularity, and the 2011 Route 66 Fun Run attracted participants from as far away as Australia. In fact, a tour company based in that country now coordinates its spring Route 66 tour with that event.

The formation of similar associations took place in Missouri, Illinois, and Oklahoma in 1989, in California and Kansas in 1990, and in Texas and New Mexico in 1991. Each association has played a pivotal role in the transformation of Route 66 into an internationally recognized icon through the acquisition of funding for refurbishment of signs and historically significant properties, placement of signage, publications, establishment of museums, and promotion of businesses along the route.

The Illinois association formed on March 5, 1989, to "preserve, promote, and enjoy the past and present of U.S. Highway 66." The Route 66 Association of Illinois has been instrumental in transforming this highway into one of the major attractions in the state. A study released in 2010 indicated that Route 66 was consistently the state's second or third most popular tourist attraction. Through the late 1990s, the association spearheaded an effort to have Route 66 designated a "state heritage tourism project." As a result of these efforts, the Heritage Project, Inc., a nonprofit organization, was created to manage the initiative. Through grants obtained from the State of Illinois, Illinois Department of Commerce and Economic Opportunity, and Illinois Bureau of Tourism, a corridor

management plan was developed, and the U.S. Department of Transportation, on September 22, 2005, designated Illinois Historic Route 66 as a National Scenic Byway.

ROUTE 66 DINER

Located one block from the post office in Sanders, Arizona, the Route 66 Diner is built around a Valentine Diner relocated from Holbrook, Arizona. The diner received a recommendation by the National Historic Route 66 Federation and inclusion in the fifteenth edition of that association's *Route 66 Dining & Lodging Guide*.

ROUTE 66 IN ARIZONA

Initially Route 66 in Arizona followed the final alignment of the National Old Trails Highway. Two of the most notable remnants from this early period are the beautiful concrete Padre Canyon Bridge east of Winona that dates to 1915 and the Canyon Diablo Bridge at Two Guns of similar vintage.

In the years that followed, there were numerous realignments and improvements, but the most extensive rerouting of the highway happened on the grades west of Williams on the western descent to Ash Fork and the 1952 bypass of the section through the Black Mountains. In eastern Arizona, Route 66 is largely a string of disconnected and truncated segments as a result of Interstate 40 that intersects, or overlays, the highway there. In western Arizona, between Seligman and Topock on the Colorado River, remains the longest uninterrupted portion of the highway, more than 180 miles, much of which has direct association with the predecessor National Old Trails Highway.

Numerous remnants have received recognition with listing in the National Register of Historic Places or National Scenic Byways. The earliest of these is the 0.35-mile segment at Parks that dates to 1921. This section of highway, bypassed in 1931, appears to be

The pre-1952 alignment of Route 66 in western Arizona follows the twisted course of the National Old Trails Highway through the Black Mountains over Sitgreaves Pass. *Joe Sonderman*

ROUTE 66 IN ARIZONA *continued*

paved, but in actuality, the surface consists of stones and cinders fused with sprayed road oil. An article published in *Arizona Highways* in 1931 noted that this section of Route 66 was dangerously narrow, as well as crooked and poorly surfaced.

In Williams, Arizona, the last community on Route 66 bypassed by the interstate highway on October 13, 1984, there are two sections of historic highway, both with surfaces of Portland cement. The west end was paved in 1928, the east end in 1938.

From Brannigan Park to Parks, there is a 6.5-mile section dating to 1931 that includes upgrades made in 1939. In addition to the tangible links to the evolution of highway engineering preserved here, there are several surviving examples of supportive infrastructure as well, including the two-story log building, now a private residence, that was the McHat Inn and the Pines General Store and post office that opened in 1933.

The Ash Fork Hill east of Ash Fork retains several historic alignments of Route 66, even though most are not accessible by motor vehicle. The earliest dates to construction in 1921 and 1922, and it was utilized by Route 66 until 1932. This early section remained a graded gravel road for the duration of its use. The sections built between 1932 and 1933 would be paved before the end of the decade. They remained in use until the realignment of 1950, which addressed the 1,700-foot grade (one of the steepest on Route 66) and the increasing demands of traffic. Interstate 40 now overlays or bisects this alignment.

Another well-preserved section of Route 66 that includes the Walnut Canyon steel truss bridge is the pre-1947 alignment between Winona and Flagstaff. Additionally, there is a segment of the post-1947 alignment in this area between exit numbers 201 and 204 on I-40 east of Flagstaff.

From Kingman to the Colorado River are numerous segments representing every era of Route 66 evolution and civil engineering as it pertained to highway construction. The first of these is a short section curving around El Trovatore Hill in Kingman that dates to the 1930s. It is signed as Chadwick Drive.

In 1946, Jack Rittenhouse noted that as you entered Arizona from New Mexico, " . . . you pass under an arch; you pass the 'State Line Station,' which maintains a good café, gas station, etc." *Joe Sonderman*

From the Colorado River, the pre-1952 alignment followed a twisted and steep course east across the desert and into the Black Mountains at Oatman, Arizona. *Joe Sonderman*

In the historic district, turning south on Fourth Street (the earliest alignment of Route 66 that also served as the path of the National Old Trails Highway) allows for an approximately five-mile drive along an almost perfectly preserved section of highway. On the opposite side of the canyon is the late 1930s alignment that replaced it and carried traffic until completion of the interstate highway.

Bypassed in 1952, Route 66 across the Sacramento Valley and over the Black Mountains through the mining towns of Goldroad and Oatman is also largely the path of the National Old Trails Highway. Reasons for bypass can be found an Arizona Highway Department report that stated almost five hundred thousand out-of-state vehicles traveled all or part of Route 66 in 1937.

Immediately to the east of the site of Goldroad, and below Route 66, is a section of the earliest alignment of the National Old Trails Highway that retains numerous engineering features of historical significance. These would include stone bridge abutments as well as cable and post guardrail systems. Historical evidence indicates initial construction of this road dates to 1907 and that significant improvements occurred between 1912 and 1914. Dates of abandonment and replacement are unknown.

The post-1952 alignment from Kingman to the Colorado River is largely the path utilized by Interstate 40. On early pre–Route 66 maps, this road appears as a valley bypass.

The Beale Wagon Road, the railroad, the National Old Trails Highway, and two different alignments of Route 66 utilized Truxton Canyon to access the Hualapai Valley to the west. *Joe Sonderman*

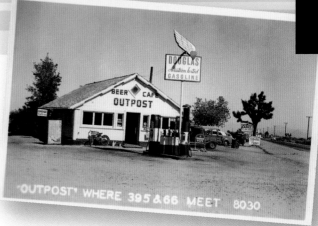

"OUTPOST" WHERE 395 & 66 MEET 8030

Located between Cajon Summit and Victorville, California, the Outpost was a favored stop for motorists whose radiators were boiling after making the long climb over Cajon Pass. *Steve Rider*

ROUTE 66 IN CALIFORNIA

Initially, Route 66 in California followed the National Old Trails Highway, a roadway established in 1913 that followed the railroad across the Mohave Desert from the Colorado River to Barstow, then south over the Cajon Pass to its terminus at Broadway and Seventh Street in Los Angeles. Bond issues and other measures to modernize and improve the road fell short before the 1914 Desert Classic race, dubbed the Cactus Derby and featuring Barney Oldfield and Louis Chevrolet. The race garnered international attention and fueled a growth in automotive tourism in the Southwest.

The first major improvements occurred in 1916 when San Bernardino County took responsibility for the road's maintenance from Needles to the Cajon Summit. Two years later, the state highway department assumed this responsibility. In 1923, E. Q. Sullivan, district engineer for district eight of the state highway department, noted that on some days there were more than three hundred vehicles westbound from Needles on this road.

Route 66 crossed the Colorado River into California south of Needles over the Old Trails Arch Bridge, built in 1916. It continued to serve this purpose until 1947, when the converted Red Rock Railroad Bridge replaced it. The current bridge serving Route 66, and now I-40, opened in 1966.

After crossing the river, the highway looped north along the water before turning west through Park Moabi and into Needles. The earliest alignment of Route 66 entered Needles on Front Street and followed K Street as well as Spruce Street. After 1929, it followed Broadway.

Before 1931, the highway route roughly followed the course of present-day I-40 west of Needles before turning north (largely the course of U.S. 95 today), then west through Goffs, and then south into Essex. After 1931, it followed the course of I-40 before turning southwest at the current Mountain Springs Road exit.

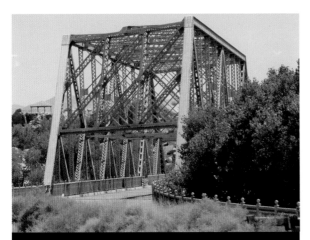

The Mojave River Bridge north of Victorville, California, dates to 1930. Extensive historic integrity, including the guardrails on the approach, makes this bridge a rarity. *Steve Rider*

In about 1928, completion of a realignment allowed Route 66 to head over Cadiz Summit to Amboy rather than following the railroad through Cadiz. With slight alterations, the road continued on its present course into Barstow through Ludlow, Newberry Springs, and Daggett.

The first major departure from the original alignment came with completion of a four-lane highway from Barstow to Victorville in 1958. This bypass had devastating results for the communities of Lenwood, Hodge, Helendale, and Oro Grande.

In the narrow confines of Cajon Pass, the highway, beginning with the National Old Trails Highway, was in a near-constant state of improvement, resulting in numerous alignments. The construction of I-15 truncated or obliterated most of these.

Route 66 initially followed Cajon Boulevard into San Bernardino, turned south on Mount Vernon, and then west on Foothill Boulevard (the primary route through communities to the west) until reaching San Dimas. By 1946, the San Bernardino leg, listed as City 66, was supplanted as the primary route by a more direct one to Los Angeles, roughly the course of I-15.

Initially, in San Dimas, the highway curved toward Glendora, utilizing present-day Cataract Avenue, Country Club Drive, and Amelia Avenue to connect two segments of Foothill Boulevard. The later incarnation of the highway followed Alosta Avenue, re-signed Route 66 after 2001, through Glendora before again joining with Foothill Boulevard. In Monrovia, Route 66 initially followed Huntington Drive before turning north on Shamrock to rejoin with Foothill Boulevard, the road used for later alignments.

From this point, and into Pasadena, Route 66 utilized Colorado Boulevard. From 1926 to 1931, Route 66 followed Fair Oaks Avenue south to Huntington before following Mission Road to Broadway, which ran to Seventh Street, the original western terminus. This was the first of five realignments that connected Pasadena with Los Angeles.

The second alignment utilized from 1931 to 1934 also utilized Fair Oaks Avenue south from Pasadena. It then turned west on Mission Street to Pasadena Avenue, now Figueroa Street, and then joined Broadway Avenue to Seventh Street.

The next alignment, referred to by historian Scott Piotrowski as a construction alignment, only saw service for a period

ROUTE 66 IN CALIFORNIA *continued*

between 1935 and 1936. This alignment followed Colorado Boulevard from Pasadena across the Colorado Street Bridge, built in 1913, and into Eagle Rock. Here, it turned south on Eagle Rock Boulevard and continued south after intersecting with San Fernando Road, joining with U.S. 6 and U.S. 99. At the intersection of Pasadena Avenue, the southward direction continued to Broadway Avenue.

After January 1, 1936, the western terminus for Route 66 moved from downtown Los Angeles at Seventh Street and Broadway to Olympic and Lincoln in Santa Monica. As a result, Route 66 continued west on Sunset Boulevard to Santa Monica Boulevard.

The next alignment of Route 66 dating to June 1936 remained signed as 66 A, or alternate, until 1960. The highway followed Colorado Boulevard through Pasadena to Figueroa Street and turned south. Figueroa Street, after 1936, utilized the four Figueroa Street tunnels, allowing this road to continue into downtown Los Angeles. At the intersection with Sunset Boulevard, Route 66 turned west to join with Santa Monica Boulevard.

On December 30, 1940, Route 66 followed Colorado Boulevard through Pasadena to Arroyo Parkway, which then joined the Arroyo Seco Parkway, the first limited-access freeway west of the Mississippi River. It then followed Sunset Boulevard to Santa Monica Boulevard.

In 1953, the first high-speed interchange in the nation opened with the Hollywood Freeway meeting the Arroyo Seco Parkway. From January 1, 1936, to decertification in Los Angeles County in 1964, Route 66 followed Santa Monica Boulevard west from this point to join with Lincoln, where it turned south to terminate with Olympic Boulevard.

ROUTE 66 IN ILLINOIS

By the year U.S. 66 was certified, 1926, the state of Illinois had one of the most developed highway systems in the nation. One of these highways was signed State Route 4, a paved route that used portions of the Pontiac Trail to connect Chicago with St. Louis. When this highway was adapted as the course of U.S. 66, Illinois became the only state in which the entire course of that newly designated highway was an all-weather road.

However, with an increase in traffic flow and expanding population centers, and as a result of military priorities during World War II, the highway remained in a near-constant state of evolution before its replacement with the interstate highway system. Shortly after its inception, highway engineers began development of roadways that would bypass central business districts of rural communities to expedite traffic flow, a system that would model the development of the interstate highway system.

Six segments preserving elements of the stages of development are listed in the National Register of Historic Places. In chronological order, the first would be a section between Girard and Nilwood that dates to 1919 and was utilized by Route 66 until 1931. This original portion of Illinois State Route 4 reflects numerous aspects of the development of highway engineering in the years immediately following World War I. The six-inch-thick, sixteen-foot-wide Portland cement surface is original as are five concrete box culverts and a single-span concrete bridge built in 1920.

North of Auburn is another section of Illinois State Route 4, but this section, utilized as Route 66 until 1932, dates to 1921. As with the Girard to Nilwood section, this portion of roadway is surfaced with Portland cement in the same dimensions, but there is also a 1.5-mile section overlaid with brick in 1932. Additionally, there are two original single-span concrete bridges.

The next alignment of note is in Carpenter Park, Springfield Township. Dating to 1922, and utilized by Route 66 until 1936, this roadway retains the four-inch concrete curbs that were eventually

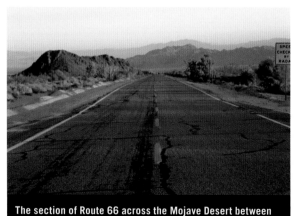

The section of Route 66 across the Mojave Desert between South Pass in the Sacramento Mountains and Barstow, California, presented one of the most formidable obstacles for early motorists, especially during the months of summer. *Steve Rider*

Near Lexington, Illinois, a pre-1930 segment of Route 66, complete with vintage billboards and Burma Shave signs, has been preserved as a hiking and bicycle trail aptly promoted as Memory Lane. *Steve Rider*

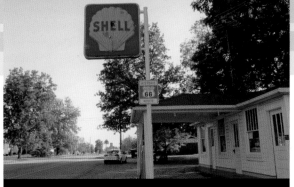

Lining Route 66 from Chicago to East St. Louis are a wide array of refurbished structures, such as Soulsby Service Station in Mount Olive that enhances the sense of time travel that comes with following this highway through Illinois. *Judy Hinckley*

The state of Illinois has joined with private enterprise and nonprofit organizations to ensure the Route 66 corridor is presented as a valued historic treasure, with the result being the highway consistently ranked as one of the top attractions in the state. *Judy Hinckley*

deemed a danger and removed from segments of the road that remained in use after this period through modernization.

Currently designated as Illinois Route 53 between Joliet and Wilmington, this section of Route 66 reflects the era between 1942 and 1956. With funding through the Defense Highway Act of 1941, the original 1920s-era highway—utilizing the latest in highway engineering developments, including a subbase of gravel and stone overlay topped by a ten-inch thick cement slab—was transformed into a four-lane divided highway of two twenty-four-foot wide roadbeds and became Alternate 66 around Joliet. The segment remained in use carrying Route 66 traffic until 1957, the year of its bypass by I-55. Period engineering attributes include a 1942 Union Pacific Railroad overpass and several concrete box culverts.

The section between Cayuga and Chenoa preserves the highway as it was in the period of 1943 to 1944 and 1954 to 1955. The original highway here reflected the height of highway engineering for the period and featured a width of eighteen feet with a surface of Portland cement. During 1943 and 1944, work commenced to transform this into a modern four-lane, divided highway with eleven-foot driving lanes. The project reached completion in 1954 and 1955. The southbound lanes built over

the original payment opened in 1944. The northbound lanes date to 1954 but have a modern macadam overlay.

Between Litchfield and Mount Olive is another section representing the same period. Preservation for this segment was derived through a cost-share grant from the National Park Service Route 66 Corridor Preservation Program in 2002.

ROUTE 66 IN KANSAS

Kansas with regard to Route 66 is unique. This state has the shortest association with that highway of all eight states through which Route 66 passes, just under thirteen miles. It is also the only state fully bypassed with completion of the interstate highway.

The primary adjustment to the highway in Kansas came with the bridges over Brush Creek north of Baxter Springs and the completion of a four-lane segment of road that crossed into Kansas from Missouri to enter Galena on Seventh Street rather than Route 66 Boulevard.

Initially, the highway crossed the river on Marsh Arch Bridge, built in 1923, a structure that remains a favored location for photographers. Completion of the new bypass bridge occurred in the late 1950s.

In 1935, angry miners, members of the United Mine Workers, blocked U.S. 66 in front of the Eagle Picher Lead Smelter and attacked "scabs" brought in from Missouri. Governor Alf Landon dispatched the National Guard to restore order. *Steve Rider*

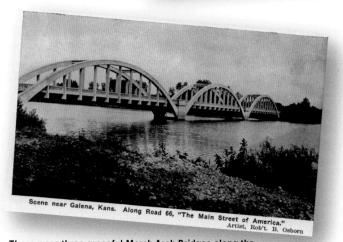

Scene near Galena, Kans. Along Road 66, "The Main Street of America." Artist, Rob't. B. Osborn

There were three graceful Marsh Arch Bridges along the thirteen-mile Route 66 corridor in Kansas. Built in 1922, and dismantled in 1986, was the Spring River Bridge. *Steve Rider*

The heavily mineralized tri-state area of southwestern Missouri, southeastern Kansas, and northeastern Oklahoma through which Route 66 passed spawned a staggering array of roadside mineral museums and rock shops. *Joe Sonderman*

ROUTE 66 IN MISSOURI

The course of Route 66 from the Mississippi River through St. Louis utilized a number of different streets and numerous bridges with all alignments converging at Gray Summit west of the city. Initially, the highway crossed the river on the McKinley Bridge, built in 1910, and then followed Ninth Street, Salisbury Street, Natural Bridge Avenue, Grand Avenue, Delmar Boulevard, Sarah Street, Lindell Boulevard, Boyle Avenue, Clayton Avenue, McCausland Avenue, and Manchester Road.

In 1929, realignment resulted in the Municipal Bridge becoming the primary river crossing and McKinley Bridge being utilized as Optional 66. After crossing the Municipal Bridge, the highway followed Seventh Street to Chouteau Avenue, and then Manchester Road, Boyle Avenue, Clayton Avenue, McCausland Avenue, and again onto Manchester Road. This remained the course of Route 66 until 1933, when the new highway from Valley Park to Gray Summit opened.

From 1933 to 1975, Route 66 underwent numerous realignments. With the original alignment maintained as Optional 66 until 1937, the highway variously utilized Chouteau Avenue, Twelfth Street, Gravois Avenue, Chippewa Street, and Watson Road.

On January 1, 1935, the Chain of Rocks Bridge became the primary river crossing. In 1955, this was designated Bypass 66 when the King Bridge became the primary crossing. With utilization of the Chain of Rocks Bridge, the highway followed Riverview Drive, Broadway Avenue, Calvary Avenue, Florissant Avenue, Herbert Street, Thirteenth Street, Twelfth Street, and Tucker Boulevard. This course remained City 66 until 1963.

In 1967, Route 66 utilized the Poplar Street Bridge as the primary crossing of the Mississippi River. Surface streets included Gravois Avenue, Chippewa Street, and Watson Road. In February 1975, Route 66 shared a roadway with Interstate 44 until decertification in 1977.

Before 1932, U.S. 66 followed Manchester Road west from the city through Des Peres to Gray Summit, now State Highway 100. After this date, it utilized Watson Road and roughly followed the present course of Interstate 44.

With slight variations, Route 66 maintained the same primary course west for the rest of its history with the exception of the area known as Hooker Cut, a four-lane bypass (completed in 1945) of the Big Piney River Bridge that dated to 1923. West of Lebanon, in the area of Phillipsburg and Marshfield, the four-lane segment of Route 66 absorbed by I-44 bypassed the earlier alignment that coursed through Conway and Niangua Junction.

In Springfield, the highway followed numerous streets variously signed as Bypass 66 and, after 1936, City 66. Originally, the highway entered the city from the east on Division Street, now Highway YY, but after 1936 utilized Kearney Street. Additionally, the highway followed St. Louis and College Streets, Park Central, Glenstone Avenue, and West Bypass. It continued west on what is now Highway 266.

The Mark Twain Expressway and Bypass 66–67 (Lindbergh Boulevard) in St. Louis, Missouri, was one of the first manifestations of the interstate highway system that would replace Route 66. *Joe Sonderman*

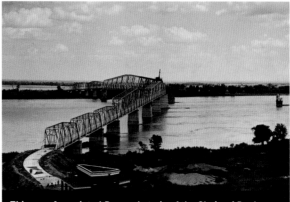

This rare Associated Press photo is of the Chain of Rocks Bridge shortly after its opening in 1929. The bridge with its unique midriver bend carried Route 66 traffic from 1936 to 1965. *Steve Rider*

Dedication of the National Highways Viaduct and two other bridges spanning the Spring River at Carthage, Missouri, occurred in June of 1930. *Steve Rider*

In Carthage, the highway used two primary corridors. Initially, it entered the city from the east on Oak Street and continued out of the city on Imperial Road. With the realignment to the road now signed as Old 66 Boulevard, the original alignment became City 66.

In Carterville, Webb City, and Joplin, several realignments of Route 66 resulted in the use of numerous streets. In Carterville, the primary streets were Pine and Main. In Webb City, it was Broadway and Madison before the final realignment to McArthur Road. In Joplin, the final alignment of Route 66 followed Madison Street, Rangeline Road, and Seventh Street. Previously, it utilized North Main Street Road as well as Euclid, Florida, and St. Louis Streets, and Broadway.

Shortly before the Kansas state line, Route 66 followed two distinct courses into Galena. The original alignment, now Old 66 Boulevard, paralleled the railroad tracks and entered town from the north on Front Street. The later alignment entered from the east on Seventh Street.

ROUTE 66 IN NEW MEXICO

Route 66 in New Mexico, as in other states through which the highway passes, initially followed existing roads and trails. However, in New Mexico, many of these were distinctly historic in nature, including the Santa Fe Trail and El Camino Real.

This state also holds the distinction of having the most dramatic realignments of the highway in its history. In 1926, Route 66 followed a 506-mile course across the state. By 1937, that had been reduced to 399 miles.

The early alignment followed the Ozark Trails Highway north from Santa Rosa to Romeroville, where it then roughly followed the course of the Santa Fe Trail into Santa Fe. From the capital to Albuquerque, it tracked the course of the Spanish Colonial–era El Camino Real. Continuing west from Albuquerque, the highway headed south to the Isletta Pueblo before crossing the Rio Grande for a third time at Los Lunas. There the westward course to Gallup resumed.

Segments of the road from Santa Rosa to Santa Fe, and the alignments down La Bajada Hill, remained gravel construction until after completion of the bypass in 1937. However, the segment from Albuquerque to Isletta and Los Lunas was an all-weather road by 1926.

The first adjustments to the earliest alignment occurred in 1931 with the elimination of two Rio Grande River crossings south of Albuquerque. The rural remnants from the pre-1931 period having the greatest deal of historical integrity are in the village of Pecos and the section from a point south of Algodones, across the Sandia Indian Reservation, and to North Fourth Street.

Urban sections in Santa Fe and Albuquerque are numerous. However, in Santa Fe commercial structures specifically built to serve the needs of travelers on Route 66 are almost nonexistent in original configurations and design. In Albuquerque, there are

The pre-1943 alignment of Route 66 that loops through Devil's Elbow and across this 1923 steel truss bridge that spans the Big Piney River retains the attributes that resulted in its designation as one of the seven beauty spots in Missouri by a state planning commission in 1941.

The segment of Route 66 in New Mexico from exit 96 on I-40 through San Fidel to Mesita provides an excellent sense of what it was like to travel Route 66 in the era of the Edsel and tailfin. *Judy Hinckley*

three tourist courts, two gas stations, and a café. These are located within the Barelas–South Fourth Street Historic District. In Los Lunas, three unaltered properties have been identified

Distributed by the

U.S.HIGHWAY 66 ASSOCIATION
of New Mexico

The U.S. Highway 66 Association established in February of 1927 to promote Route 66 as the Main Street of America played a primary role in the highway's development that has culminated in the modern, resurgent interest. *Steve Rider*

and inventoried. Two currently are listed in the State Register of Historic Places.

Completion of a bridge over the Rio Grande west of Albuquerque in 1931 and a bridge over the Rio Puerco in 1933 deemed the Laguna cutoff resulted in a dramatic reduction of Route 66 traffic through Isletta and Los Lunas.

In 1936, Governor Arthur Hannet, a former mayor of Gallup, issued orders for the highway department to cut a roadway west from Santa Rosa through the Estancia Valley to Albuquerque. Though the Santa Rosa road was not eligible for federal road funds, it quickly became a popular shortcut for westbound motorists.

Intense lobbying efforts and political infighting between factions vying to realign Route 66 over the cutoffs and those who wanted to keep the current route followed completion of these two state projects. In late 1937, abandonment of both the northern and southern loops occurred with the official realignment of Route 66.

Interestingly, Edgar Knight, the Albuquerque, New Mexico, representative at a special meeting held in Tulsa in February 1927, broached the subject of a direct route to Albuquerque from Santa Rosa via Moriarty. His primary argument was the mileage saved by eliminating a loop through Santa Fe.

In addition, during this period there were other alignment adjustments. The most notable was the elimination of several railroad crossings in the area of Grants and Gallup.

Completion of the 1937 realignments, resulting in the bypass of Santa Fe, marked a dramatic historic change in New Mexico. Previously, patterns of travel were primarily north and south.

The designation of the interstate highway system in 1956 with the Federal Aid Highway Act commenced a twenty-five year period that marked the final evolutionary stages of Route 66 in New Mexico. During this period, alignments of Route 66, and the communities along them, were bypassed in sections.

ROUTE 66 IN OKLAHOMA

There are five excellent remnants of Route 66 in the state of Oklahoma that chronicle that highway's evolution. The earliest provides a direct link between the era of named highway associations and the federal highway system.

Initially, Route 66 utilized existing roadways with the result being a knitting of unrelated roads designed for local needs. The surviving three-mile segment of the unique "sidewalk" highway south of Miami is a rare example of the highway's early course. Built between 1919 and 1921, as part of State Highway 7, this segment is only nine feet wide but continued to serve as U.S. 66 until 1937. In November 2011, a monument commemorating the road's role in the development of Route 66, and its historical importance, was dedicated near Afton.

Immediately to the west of Sapulpa is a 3.3-mile section that initially served as the course of the Ozark Trails, a named highway that predates the federal highway system. Built in 1924

through a partnership between federal, county, and state offices, to provide a paved, all-weather road to link Sapulpa and Bristow, this section of roadway represents the latest in highway engineering for that period. Utilized as Route 66 through 1952, this segment contains numerous features that are indicative of its original integrity, including a standard eighteen-foot roadbed of Portland cement, now with an overlay of asphalt; the Frisco Railroad underpass built after a lengthy legal battle; the Rock Creek Bridge with red brick decking; segments of original concrete guardrails; and original retaining walls.

To the west of Stroud is a section of the Ozark Trails utilized by Route 66 from 1926 to 1930. This 1.3-mile section has remained a graded, gravel track roughly eighteen feet wide since its inception in about 1915.

In 2004, the Dosie Creek Bridge, built in 1917 utilizing wood decking, was replaced, but there are still a number of features that preserve original integrity. These include a twenty-one-foot-tall stone obelisk that marked an intersection on the Ozark Trails and two culverts, one marked with a date of 1909 and the other 1917.

Approximately one mile east of Arcadia remains a one-mile section of Route 66 that stayed in use until 1952 but that originally dates to its construction in 1922 as part of State Highway 7. Paved in 1928 and 1929 utilizing Portland cement, this section is historically significant because it preserves evidence of two stages in highway evolution: the initial paving and a modified Bates-type surfacing that consists of asphalt over a concrete base with concrete edgings.

The eighteen-mile segment from Bridgeport Hill to Hydro served as Route 66 from 1934 to 1962 and represents a major development in highway engineering and in the evolution of highway standards. It also is a link to an important chapter in that highway's history. Generally, this segment is referred to as the El Reno Cutoff. Utilizing federal money the Oklahoma Highway Department, this project aimed to create a more direct

A bridge that predates certification of Route 66 carried traffic for that highway across the north fork of the Red River west of Sayre, Oklahoma, from 1926 to 1958. *Steve Rider*

alignment of Route 66 between El Reno and Hydro in 1930. Its completion in 1934 bypassed the initial alignment of Route 66 that followed sections of the old Postal Roads and Ozark Trails system through Calumet, Geary, and Bridgeport. Indicative of the evolving science of highway engineering and standards, the width is twenty feet rather than the eighteen-foot requirement of the 1920s. Additionally, this section of highway reflects other improvements of the period, including a parabolic curve with lips and gutters to facilitate drainage.

With the completion of the nearly one-mile-long Canadian River Bridge that utilized thirty-eight pony truss spans on this segment of Route 66, the toll bridge at Bridgeport was relegated to serving the needs of local traffic, and that community became a ghost town. Political manipulations delayed the opening of the bridge to traffic and subsequently this section of Route 66 by almost a year.

As an interesting historic footnote, at a meeting of representatives from cities along Route 66 held in Tulsa in February 1927, one of the contentious topics pertained to a protest from the chamber of commerce in Picher, Oklahoma. The protest centered on the current proposed alignment of Route 66 from Commerce to Baxter Springs in Kansas, a route that bypassed Picher.

Construction of the U.S. 66 and U.S. 77 Bypass in Oklahoma City in 1959 transformed the Lincoln Boulevard corridor and expanded the improvements that commenced with construction of the Urban Expressway in 1954. *Steve Rider*

The surviving segment of the "sidewalk highway" between Miami and Afton, Oklahoma, that opened on March 1, 1922, as Oklahoma Route 7 is an interesting evolutionary link in modern highway development, as it is only nine feet wide. *Steve Rider*

By the late 1950s, upgrades and realignment had moved Route 66 from City 66 (Sixth Avenue) to a four-lane segment of Amarillo Boulevard (West Sixty-Sixth Street). *Steve Rider*

ROUTE 66 IN TEXAS

To a large degree, Route 66 from the Oklahoma state line to McLean, the last town in Texas on Route 66 bypassed, still exists, though most of it reflects the latter incarnation rather than the earliest. Of the 178 miles of Route 66 in Texas, almost 150 miles, not including segments that are drivable but not recommended, remain paved with easy access.

Between McLean and Alanreed, south of Interstate 40, remains a segment of the early alignment of Route 66, now a graded gravel road signed as County Road B. This segment of roadway continues west of Alanreed, but this is now on private property. It represents the eastern end of a section of early Route 66 known as the Jericho Gap, an area with an infamous reputation for deep mud during periods of rain. Portions of this segment of the highway are again accessed via State Highway 70 and County Road B through the ghost town of Jericho.

In Amarillo, with the exception of the segment truncated by the airport, Route 66 remains largely intact. This includes West Amarillo Boulevard, the last incarnation of the highway represented by four lanes, and the earliest incarnation of it along Southwest Sixth Avenue.

From Amarillo to Adrian, it is possible to drive Route 66, and segments of an earlier alignment are visible to the north. The

In Glenrio, Texas, the four-lane segment of Route 66 that served as Main Street, and that is included in the National Register of Historic Places, fades into a rutted track at the New Mexico state line.

historic highway resumes at the ghost town of Glenrio on the New Mexico state line.

ROUTE 66 MAGAZINE

To capitalize on the resurgent interest in Route 66, as well as to preserve its history and provide a resource for international audiences interested in the iconic highway, Paul and Sandi Taylor launched *Route 66 Magazine* from their home in Laughlin, Nevada, a few miles north of Topock, Arizona, on Route 66. The magazine gained quickly in popularity, and in 1996, publishing offices were relocated to Williams, Arizona, and a gift shop was added.

As the magazines readership grew, publisher Bob Moore joined the staff. Additionally a wide array of acclaimed photographers and writers, such as Jerry McClanahan and Jim Hinckley, became contributors.

Paralleling the growing interest in Route 66, the international popularity of the magazine led to the development of a radio station as well as two satellite offices, one in Adrian, Texas, and another in Sapulpa, Oklahoma, and an international subscription office in Shrewsbury, Shropshire, England. In 2001, a limited partnership with Sport Truck Connection Television led to the establishment of national travel programs for cable television. *Route 66 Magazine* published program excerpts quarterly.

Paul Taylor says, "When we first began *Route 66 Magazine*, we were told by many that we would run out of stories and have to discontinue the magazine within seven years." With the winter of 2010/2011 issue, the magazine celebrated its eighteenth year of publication.

ROUTE 66 NEWS

Route 66 News is the creation of Ron Warnick, who saw the need for a news and events source for the Route 66 community that was updated on a daily basis. Utilizing his journalism background, he launched the blog format site in October 2005 and it continues to be a primary source of information for many enthusiasts.

As of 2011, the site was averaging thirty-thousand page views per month during the winter. During the popular travel months of spring and summer, the traffic often exceeds forty-thousand hits.

ROWE, NEW MEXICO

Rowe, New Mexico, a ghost town with few residents, is located on the pre-1937 alignment of Route 66 six miles south of Pecos. The initial date of settlement was 1876, with the establishment of a post office following in 1884. The post office continues in operation today.

S

Mt. Vernon Motel

"San Bernardino's Finest"
2140 Mt. Vernon Ave. (U. S. 66 - 395 - 91)
San Bernardino, Cal.

SAMPSON, MISSOURI

C. H. Curtis, in *The Missouri U.S. 66 Tour Book*, published in 1994, indicates Sampson, Missouri, was a small community with a post office that operated between 1904 and 1935. The Route 66 association with the community included the Abbylee Modern Court and the Timber Hill Camp, a small complex of three cabins.

SAN BERNARDINO, CALIFORNIA

The San Bernardino Valley was the primary location of Tongva Indian villages before initial European settlement in the late eighteenth century. The official date of origination for the City of San Bernardino is May 20, 1810, the date Padre Francisco Dumetz and an exploratory party from the mission at San Gabriel established a temporary chapel to celebrate the feast day for St. Bernardino of Sienna.

In June 1842, the name San Bernardino was used on a land grant, and in 1851, a company of pioneers representing the Church of Jesus Christ of Latter-day Saints purchased the rancho and established a colony. Brigham Young recalled many of these initial settlers to Utah in 1857, however. The primary catalyst for growth occurred with completion of the California Southern Railroad in 1883.

Route 66 entered the city from the north on Cajon Boulevard, continued south on Mount Vernon Avenue, and then turned west on Fifth Street to connect with Foothill Boulevard. Kendall Drive and E Street to Fifth Street served as City 66.

The city of San Bernardino remained the largest community on the western fringes of the greater Los Angeles area until the postwar boom. Records from 1927 indicate a population of 18,800.

> The *Directory of Motor Courts and Cottages*, published by AAA in 1939, contains an extensive listing for Mount Vernon Auto Motel. "40 very attractive and well furnished apartments, each with private tub or shower bath; 21 units are air conditioned; 8 with radio." *Mike Ward*

The *Hotel, Garage, Service Station and AAA Directory* published in 1927 lists three hotels: Antlers, Planet, and Stewart. Addresses are not given. The 1940 edition of the *Directory of Motor Courts and Cottages* published by AAA list three motels, two of which were on Mount Vernon Avenue. The third, Motel San Bernardino, has a short notation of being located "2 miles west on U.S. 66," but the *Western Accommodations Directory* for 1955 gives the address as 2528 Foothill Boulevard. The two other listed complexes were large—Mission Auto Court, 1150 Mount Vernon Avenue, sixty-five cottages, and Mount Vernon Auto Motel, 2140 Mount Vernon Avenue, forty units. Both also offered on-site dining as well as some units with complete kitchenettes and private garages.

The *Western Accommodation Directory*, published by AAA in 1954, lists a number of motels on Route 66: The Le Mae Motel, 1860 Mount Vernon Avenue, $4.00 to $7.00; Motel San Bernardino, $4.00 to $7.00; Motel 66, 1400 North Mount Vernon

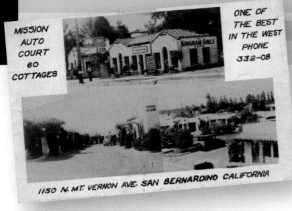

In 1939, the Mission Auto Court was a large complex that warranted an extensive entry in the *Directory of Motor Courts and Cottages* published by AAA and that offered a wide array of amenities. Rates ranged from seventy-five cents to $9.00 per night. *Mike Ward*

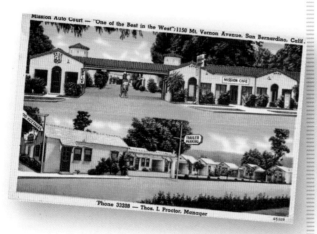

The list of amenities available to guests at the Mission Auto Court included kitchenettes, circulating ice water, radios, fans, water and electrical connections for trailers, tiled showers, laundry facilities, and a night watchman for security. *Mike Ward*

SAN BERNARDINO, CALIFORNIA *continued*

Avenue, $4.00 to $7.00; Orange Blossom Motel, 1551 North Mount Vernon Avenue, $4.00 to $7.00; Valley Motel, 1640 North Mount Vernon Avenue, $4.00 to $7.00; and the Wigwam Village, $5.00 to $6.00.

Numerous motels and other business with direct links to Route 66 remain today. However, the majority of motels along Mount Vernon now cater to weekly or monthly rentals. Of particular interest are the Milta Café on Mount Vernon Avenue, in business since 1937, and the McDonald's Museum on E Street at Fourteenth Street, the site of the first McDonald's that opened in 1948. The Wigwam Motel is actually in Rialto at the western city limit of San Bernardino.

San Bernardino is the site of the annual Stater Brothers Route 66 Rendezvous, the largest Route 66 celebration in the world. In 2011, the twenty-second annual event attracted more than five hundred thousand spectators to the thirty-five-block spectacle that included more than 1,600 custom and antique vehicles.

SANDERS, ARIZONA

Sanders was, and is, the first town of any size in Arizona for travelers headed west on Route 66. Jack Rittenhouse noted it had a population of eighty-eight and the Tipton Brothers Trading Post and two gas stations.

Surprisingly, this dusty little oasis has a number of unique and fascinating Route 66 vestiges often missed, including the bridge over the Rio Puerco River constructed in 1923 to the east of town and a classic Valentine Diner in the "business district." The little diner, relocated from Holbrook and ingenuously mated with a house trailer, is truly one of a kind. Even on Route 66 where ingenuity reigned supreme, this café is unique.

Travel notes from a 1921 tour guide describe Sanders as being "on the main A. T. & S. F. R. R. about 20 miles west of New Mexico line. First called Sanders, for C.W. Sanders, office engineer, A.T. & S. F. R. R. Changed to Cheto because of another Sanders station on Santa Fe." This did not keep Art Sanders, owner of the trading post, from claiming he was the town's namesake.

Al Berry bought the White Elephant Lodge (originally the Chamese Lodge) near Sanders, Arizona, after it went bankrupt and fire decimated the complex in the late 1950s. *Steve Rider*

As with Houck, the need for a post office in Sanders was not consistent. The post office opened in 1896 under the name Cheto and closed a few years later. It reopened in 1932 as Sanders.

Al Berry also operated the Log Cabin Trading Post at Sanders, Arizona. Primary attractions included the "Largest Free Zoo in the Southwest" and Indian ruins. *Steve Rider*

SAN DIMAS, CALIFORNIA

Indicative of the landscape at the site of San Dimas is the original name given the area in the early nineteenth century, Mud Springs. As with most communities in the sprawling and fertile San Gabriel Valley, citrus groves served as the primary economic foundation for San Dimas, and for a brief period, the San Dimas Lemon Association is believed to have been the largest packing facility in the world.

The actual City of San Dimas designation dates to a vote for certification on June 28, 1960, and receipt of certification on August 4 of that year. Route 66 utilized Country Club Drive and Foothill Boulevard.

SAN FELIPE, NEW MEXICO

The native peoples whose village was on this site when Francisco de Coronado arrived in 1540 called it Katishtya. A Spanish colonial outpost established here in about 1620 and the original pueblo were mostly abandoned after the Pueblo Revolt of 1680. Rebuilding commenced in 1693. Castano de Sosa gave the Spanish name for the settlement in 1591.

The village changed little with establishment of the Trail to Sunset or National Old Trails Highway. Route 66 also had a negligible affect, and the realignment of 1937 severed this association.

SAN FIDEL, NEW MEXICO

Ballejos was the initial name on this community's application for a post office filed in 1910. In 1919, an amendment changed this to San Fidel. However, initial settlement dates to the establishment of a farm at this location by the family of Baltazar Jaramillo in about 1868.

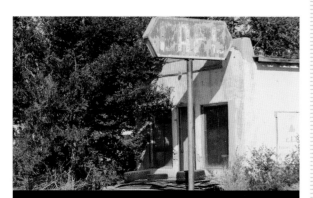

Jack Rittenhouse, in 1946, noted, "San Fidel [New Mexico] was originally a busy trading center; today it has declined somewhat." The slide has continued into the modern era, leaving little but faded remnants of better times.

Jack Rittenhouse, in 1946, noted, "San Fidel was originally a busy trading center; today it has declined somewhat." He also noted a café, a gas station, a small garage, a curio shop, and a small store constituted available services.

The town retains numerous vestiges associated with Route 66 and its earlier history, including a café (closed), the former Acoma store that served as an art gallery until 2010, an adobe church, and several other adobe structures. A bar in a former service station has a colorful sign that reads "San Fidel Geezerville."

SAN JON, NEW MEXICO

The first building in San Jon (pronounced San Hon) dates to 1902, but it was the railroad completed to this point in 1904 that led to San Jon's establishment as an important ranching and farming center in the area. The post office opened in 1906 and is still in operation.

San Jon, fifteen miles west of Glenrio on the Tucumcari & Memphis Railroad, was the largest town on the eastern plains of New Mexico before 1920. Jack Rittenhouse noted there were gas stations, garages, the San Jon Implement Company, two auto courts, several cafés, a hotel, and a variety of stores. Main Street, Route 66, was an endless stream of traffic every hour of the day, every day of the week. The primary operational business today is a small truck stop located at the I-40 exit and the San Jon Motel on Route 66.

The old Cap Rock Texaco station along Route 66 eight miles west of San Jon, New Mexico, warranted notation in the 1946 guidebook written by Jack Rittenhouse.

SAN JOSE, NEW MEXICO

San Jose, New Mexico—located along the pre-1937 alignment of Route 66, as well as the National Old Trails Highway and the Santa Fe Trail—remains as one of the oldest communities in San Miguel County. Farming at this site along the Pecos River in 1803

Built in 1826, this historic old church in San Jose, New Mexico, has cast its shadow across the Santa Fe Trail, the National Old Trails Highway, and Route 66.

by colonists from Santa Fe predates the actual settlement of the community.

The small adobe church in the square has cast its shadow across all three of these historic roadways. It dates to 1826. Of particular interest for Route 66 enthusiasts is the single-lane, steel truss bridge spanning the Pecos River at the east end of the community. This bridge opened to traffic in 1921.

SANTA FE, NEW MEXICO

Santa Fe, the state capital of New Mexico, is the oldest capital city in the United States. In 1609, one year after assuming the position of governor of New Mexico, Don Pedro de Peralta relocated the capital from San Gabriel to the current site of Santa Fe, dominated at that time by an abandoned pueblo of indeterminate age.

The new capital, established as La Villa Real de Santa Fe (the Royal Town of Santa Fe), remained the only official Spanish colonial settlement in New Mexico for almost one hundred years. The official date of settlement is 1610. Historical evidence indicates the survey for the plaza occurred in 1608.

The name selected was in reference to Santa Fe near Granada in Spain, site of the royal encampment that served as the base for King Ferdinand and Queen Isabella (the principal financiers behind the initial voyage of Christopher Columbus) during the final battles against the Moors in 1492. A French map dating to about 1670 lists the city in New Mexico as Santa Fe ou Granada.

Remnants from the city's earliest history abound, including the San Miguel Mission, the oldest continuously operating church in the United States that incorporated elements of a twelfth-century pueblo in its construction. The church, built between

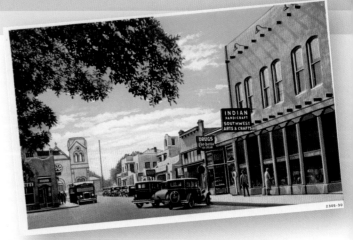

In Santa Fe, New Mexico, the earliest alignment of Route 66 followed the course of the old Santa Fe Trail to the historic plaza, the western terminus of that trail, before turning south on Shelby. *Steve Rider*

1610 and 1628, burned during the Pueblo Revolt of 1680 and was rebuilt in 1710.

Because the city was the northern terminus for the El Camino Real, and later the western terminus for the key trade route of the Santa Fe Trail, Santa Fe developed as a community, reflecting a wide array of influences. Early motorists traveling the National Old Trails Highway commented heavily about the city in journals, letters, and feature articles published internationally.

FORT MARCY AUTO CAMP, SANTA FE, N. M.

Fort Marcy Auto Camp along the pre-1937 alignment of Route 66 was located near Old Fort Marcy Park, site of the first American military encampment on a hill near the historic Santa Fe plaza. *Steve Rider*

The Sierra Vista Court along the pre-1937 alignment of Route 66 near Santa Fe, New Mexico, offered basic services and amenities for $2.50 to $3.00 per night in 1939. *Steve Rider*

Before the relocation of the western terminus of Route 66 to Santa Monica, California, the Santa Monica Boulevard corridor was already a major urban traffic artery. *Steve Rider*

Emily Post, in *By Motor to the Golden Gate*, published in 1916, wrote of Santa Fe, "Her alliance with the American Republic is what one might call a marriage of arrangement. Foreign in race, in sentiment, in understanding, she has never adopted the customs or manners of her new lord, but lives tranquilly, uneventfully, dreaming always of the long ago."

In her description of the city, she noted, "You might think yourself in the Orient or in a city of old Spain transported upon a magic carpet, but nothing less like the United States can be imagined. Along the narrow crooked streets, dwellings hundreds of years old stand shoulder to shoulder with modern houses that have wedged themselves between."

The narrow, ancient streets necessitated numerous realignments of Route 66 before the 1937 transition that severed Santa Fe from that highway. Initially, the highway followed the National Old Trails Highway into town on the course of the Santa Fe Trail, utilizing College Street and going past the plaza on Santa Fe Street. In late 1930, the highway bypassed the busy, constricted plaza using Water Street, and in the years that followed, other streets, such as Cerillos, Ortiz, Galisteo, and Shelby, served as Route 66.

Of particular interest for Route 66 enthusiasts are the El Rey Inn and the La Fonda Hotel. The refurbished El Rey Inn, originally the El Rey Court, dates to 1936, and the La Fonda has served as one of the city's premier hotels since opening in 1922.

AAA promotion for the Motel Santa Monica in 1941 proclaimed this was "a new, well-furnished motel, one minute from a public bathing beach, tennis courts, and the homes of motion picture stars." Rates ranged from $2.00 to $6.00 per night. *Steve Rider*

SANTA MONICA, CALIFORNIA

The Santa Monica name, referencing Saint Monica, the mother of Saint Augustine, is referenced in two land grants for the present site of the city of Santa Monica. The first of these, Boca de Santa Monica, dates to June 19, 1839, and the second, San Vincente y Santa Monica, to December 20, 1839.

For many Route 66 enthusiasts, the historic Santa Monica Pier serves as the end of the trail, even though the actual terminus was at Lincoln and Olympic Boulevards several blocks to the east. *Steve Rider*

Nevada Senator John P. Jones and Colonel Robert S. Baker, land developers, acquired large portions of the San Vincente y Santa Monica land grant and platted the community in 1875. Establishment of a post office under the name Santa Monica occurred in 1880.

Commencing on January 1, 1936, and ending with decertification of the highway in Los Angeles County in 1964, Route 66 utilized Santa Monica Boulevard from the intersection of the Hollywood Freeway through Hollywood, Beverly Hills, and Santa Monica. On January 13, 1962, a tragedy on Santa Monica Boulevard placed it at the forefront of national media attention.

According to the *Reno Evening Gazette* of January 13, 1962, "Ernie Kovacs, cigar chomping comedian who rose to fame in five brief years, was killed early today when his station wagon skidded on wet pavement and smashed into a utility pole. The 42-year-old Kovacs, reportedly on his way home alone from a party in honor of Mrs. Milton Berle, was thrown from his car, police said. The smashup occurred shortly before 2 a.m. on Santa Monica Boulevard in West Los Angeles."

Contrary to popular opinion, the western terminus for U.S. 66 was at the intersection of Lincoln Boulevard and Olympic

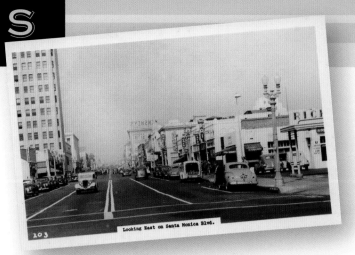

From January 1, 1936, to 1964, Route 66 followed Santa Monica Boulevard west through Hollywood and Beverly Hills to its western terminus at the intersection of Lincoln and Olympic Boulevards. *Steve Rider*

The Sun & Sand Motel and restaurant, in Santa Rosa, New Mexico, has provided service to Route 66 travelers for more than a half century. The restaurant garnered a favorable recommendation in the 2011 *Route 66 Dining & Lodging Guide*.

SANTA MONICA, NEW MEXICO *continued*

Boulevard, U.S. 101-A, not at Palisades Park—made famous by its Will Rogers Highway Memorial plaque—or at Santa Monica Pier.

Fostering the confusion about the western terminus are this memorial to Will Rogers, the Oklahoma-born celebrity who owned a horse ranch and polo field in Santa Monica (in Palisades Park), and Route 66 signs reading "End of the Trail," which were created for a movie and placed at Santa Monica Pier. Dan Rice, owner of 66-to-Cali, a T-shirt company, and a Route 66 souvenir store on the pier, spearheaded the efforts to ensure the pier remained the traditional, not official, terminus for the highway, a campaign that culminated with the re-creation of the Route 66 End of the Trail sign and its placement on the pier.

Built in 1909 to replace an earlier one built in 1893, the pier remains the final destination of choice for westbound Route 66 enthusiasts. Refurbished in the mid-1980s, the pier with its historic carousel and Pacific Palisades Amusement Park provides a suitable celebratory end for that journey.

SANTA ROSA, NEW MEXICO

Established as Agua Negra Chiquita in 1865, this town was formally established when its post office opened under the name Santa Rosa in 1873. Santa Rosa was on the west bank of the Pecos River, and a community on the east bank of the river opened its post office under the name Eden in 1885. With closure of the Santa Rosa post office in 1898, Eden changed its name to Santa Rosa and submitted an amended post office application.

Santa Rosa remained a small ranching community until the completion of the railroad to this point in 1901. From this date, the town entered a period of rapid growth and soon replaced Puerto de Luna as the Guadalupe County seat.

The service industry that developed to meet the needs of travelers on Route 66 added to the diversity of the economy. The *Directory of Motor Courts and Cottages*, published by AAA in

1940, lists two recommended properties, Santa Rosa Court and Yucca Court.

The entry for Santa Rosa Court contains an extensive listing of available amenities. These include "mountain spring water for drinking," oak floors with rugs, a Texaco station, Western Union service, and the use of celotex insulation for seasonal comfort.

Jack Rittenhouse noted in his 1946 travel guide that Santa Rosa had a population of 2,310 and that services available to travelers included the Central Motor Company, several garages, numerous auto courts and cafés, a hotel, and a trading post. Perhaps the most significant business related to Route 66 was the Club Café established in 1935.

Made famous by its billboards that sported a caricature of a grinning fat man, the café owned by Newt Epps survived the bypass of Route 66 in 1972 but closed its doors in 1991.

For the automobile enthusiast, the Route 66 Auto Museum in Santa Rosa, New Mexico, is a delightful gem with its colorful custom cars, vintage automobiles, and classically styled hot rods. *Judy Hinckley*

The building stood vacant for a number of years before being purchased by Joseph and Christina Campos, owners of Joseph's Bar & Grill. The building was razed after it was determined that it would be cost prohibitive to refurbish the property. Utilization of the fat man logo for the Campos Grill and

SANTA ROSA COURT
U. S. HIGHWAYS 84-54-66
EAST SIDE

The following is from a promotional piece for Santa Rosa Court dated 1940: " . . . 15 modern, clean cottages, each with private shower. All cottages equipped with celotex insulation, making them cool in summer and warm in winter; floor furnace heat." *Mike Ward*

The newest incarnation of Club Café in Santa Rosa, New Mexico, utilizes the smiling Fat Man signage that graced the original building and billboards along Route 66. *Judy Hinckley*

the Club Café sign that remains standing along Route 66 are the last vestiges of this famous restaurant.

The *Western Accommodations Directory*, published by AAA in 1954, lists two recommended properties, Tower Motel and Western Motel.

There are three notable existing establishments associated with Route 66 in Santa Rosa: the Comet II Restaurant, the historic Sun & Sand Motel (with restaurant), and the Route 66 Auto Museum. Additionally, there are several original motels lining the route, but most of these are now closed.

Local citizen groups have recently refurbished the Park Lake Historic District, listed in the National Register of Historic Places in 1996, after years of neglect. Park Lake, a Works Progress Administration (WPA) project, is a twenty-five acre park with the lake as its centerpiece. The park, with its picnic area, swimming dock, and baseball fields, was an oasis for travelers on Route 66 and the centerpiece of recreational activity in Santa Rosa. Utilizing guidelines established as "WPA Rustic," the park featured terraces, landscaping that blended with natural topography, groves of shade trees, masonry canals, and retaining walls built of locally quarried stone.

On December 15, 2011, the Santa Rosa tourism director, Richard Delgado, announced that the city was applying for a National Scenic Byways Program grant for the renovation of the historic Ilfield-Johnson Warehouse and its conversion into a nine thousand–square-foot New Mexico Route 66 Museum. In addition, plans call for the building to house the extensive petroliana collection of Johnnie Meier and exhibits chronicling the city's history from the pre–Spanish colonial era to the period of Route 66.

SAPULPA, OKLAHOMA

Initial listing of the town site of Sapulpa, Oklahoma, the seat of Creek County, was in Recording District Number 8, Indian Territory, and establishment of a post office occurred in 1889, three years after establishment of a station on the Atlantic & Pacific Railroad. The consensus is that the namesake is Sus-pul-ber, a leader of the Creek tribe.

In 1946, Jack Rittenhouse, in his seminal work, *A Guide Book to Highway 66*, abandoned his normally sterile entries to provide historical context for Sapulpa. He wrote, "Sapulpa's history goes back to 1886 and is rich in Indian and pioneer lore. It is the center of oil and gas production in the famous 'Glenn Pool' where fortunes were made in the early oil boom. One pair of investors started with $700 and ran their fortune up to $35 million in 11 years. Now oil is merely a routine business. Sapulpa also has glass factories (you pass the Liberty Glass Co. on the east side of town) and also has a large brickyard, which you pass as you leave town going west."

He indicates that available services included the St. James Hotel, two garages (Hendrix and Thompson), stores, and two auto courts (W-E and Elkins). The W-E Auto Court is the only

lodging recommendation in the 1940 edition of the *AAA Directory of Motor Courts and Cottages*, and the entry indicates the availability of housekeeping units and an onsite café. Listed rates are $1.00 to $2.00.

Surprisingly, Rittenhouse made no mention of Dixieland Park, a small amusement center that opened in 1927 and relied heavily on Route 66 traffic until its closure in 1951. The complex included a service station, a roller rink, a large swimming pool with bathhouses, a restaurant, and a bandstand.

The opening of the Turner Turnpike in 1953 resulted in the bypass of Sapulpa. From its inception in 1947, the Oklahoma Turnpike Authority and its first priority project, a turnpike connecting Tulsa with Oklahoma City, was the subject of heated debate. The catalyst for the planning of the road was, according to the group, to "eliminate the dangerous curves and hairpin turns between the two cities which are bottlenecking through traffic on US 66." Of primary concern were those "between Bristow and Kellyville and Kellyville and Sapulpa."

From 1938 to 2011, Frankoma Pottery produced its wares in Sapulpa. The innovative patterns and use of color has resulted in certain pieces becoming highly sought-after collectibles.

The resurgent interest in Route 66 has sparked a renaissance manifested in historic preservation and the repainting of "ghost signs," old advertisements, on numerous buildings in Sapulpa. Some key landmarks are of particular note: Happy Burger, 215 North Mission, dating to 1957 and listed in the *Route 66 Dining & Lodging Guide*, fifteenth edition (published by the National Historic Route 66 Federation), and the building that served as offices of the Tulsa–Sapulpa Union Railway Company, a railroad operation initiated in 1917 as an interurban line providing service to Tulsa.

SAYRE, OKLAHOMA

The namesake for Sayre, Oklahoma, the seat for Beckham County, is Robert H. Sayre, a railroad surveyor, investor, and developer. Establishment of a post office under this name occurred in October 1901.

During this period, Beckham County was an agricultural dynamo with farms producing a wide array of crops, including cotton, alfalfa, wheat, and maize. In the early 1920s, the discovery of oil and gas transformed the economic base of Sayre with five oil companies, and a gasoline plant, operating there.

A fledgling service industry that began in the teens grew dramatically after the certification of Route 66 in 1926, further diversifying the economy. Jack Rittenhouse in *A Guide Book to Highway 66*, published in 1946, noted, "US 66 enters this quiet town, drops down a slight hill and turns right in the business district whose one main street ends at the courthouse. Joseph Benton, who took the stage name of Guieppe Bentonelli when he

PARK AT SAYRE, OKLA.

Roadside parks constructed by the WPA, often with upgrades and amenities, served as campgrounds and stops for roadside repairs during the Great Depression. *Steve Rider*

became a Metropolitan Opera star in 1935, came here as a child and still has relatives here. Jess Williard, famous prize fighter, once drove a wagon freight line from here and also ran a lodging house."

The *Directory of Motor Courts and Cottages*, published by AAA in 1940, lists only the Red, White, and Blue Court, a facility also noted by Rittenhouse. The 1954 edition of the *AAA Western Accommodations Directory* also lists only one facility: "Sunset Motel—e. edge on U.S. 66. One and two bedroom brick units, each with picture window, air conditioning or air cooling, dressing room, tiled shower bath, vented heat and garage with direct entrance to room. Baby beds. Family rooms for four or six persons. Playground. Restaurant nearby."

The Beckham County Courthouse appears in a scene in the 1939 film *The Grapes of Wrath*. Other landmarks of particular note are the post office (201 North Fourth Street), with a land run mural commissioned by the WPA in the 1930s, and the historic Owl Drugs with its period soda fountain.

The courthouse, listed in the National Register of Historic Places in 1984, is the architectural crown jewel in Sayre. Built in 1911, the three-story structure, faced with brick and stone,

Because of its brief appearance in *The Grapes of Wrath*, Sayre, Oklahoma, the Beckham County seat, with its 1911 courthouse, will always be associated with the Great Depression and the westward migration of the "Okie." *Judy Hinckley*

replaced a smaller two-story structure, an indication of the growing prominence of Sayre and Beckham County in the years immediately following statehood. Designed by the architectural firm of Layton, Smith, and Hawk, the courthouse reflects extensive use of neoclassical design elements, including Doric columns and copper sheeting on the third-floor cornice.

SEABA STATION

In 1921, John Seaba established this station in Warwick, Oklahoma, along State Highway 7, a part of the Ozark Trails network incorporated into U.S. 66 in 1926. Expansion to the original facility through the early 1940s transformed it into Seaba's Filling Station and Seaba's Engine Rebuilding and Machine Shop.

Gas rationing during World War II and government contracts for the repair of military transport vehicles resulted in abandonment of the service station and that portion of the facility being reconstructed as an addition for the machine shop. The building continued as a machine shop until 1994.

From the date of closure, the building has served various purposes. In 2005, approval of a National Park Service Route 66 Corridor Preservation Cost-Share Grant served as the catalyst for commencement of the property's restoration. In the late summer of 2010, it reopened as a motorcycle museum.

Among the many unique attributes of this historic property are the restrooms at the rear of the main building. Built of stone, discarded bricks, and other materials, they were, in essence, outhouse, with flush toilets. These period toilets utilized a fluted cast iron base, wooden seat, and, instead of the traditional water reservoir tank, a valve system operated by pressure on the seat.

The historic Seaba Station in Warwick, Oklahoma, now houses a motorcycle museum. Initially, John and Alice Seaba opened it in 1921 as a DX service station.

SEA SHELL MOTEL

The Sea Shell Motel at 612 West Hopi Drive in Holbrook, Arizona, was part of an early motel chain with locations in Blythe, California; Lordsburg, New Mexico; Safford, Arizona; and Gila Bend, Arizona. The *Western Accommodations Directory*, published by AAA in 1955, described the property as "a very attractive western style court. Well kept, nicely furnished rooms in an air cooled main building and annex are centrally heated and have tiled shower baths."

The Whiting Brothers acquired the property in the late 1950s and after extensive upgrades and expansion opened the property as the Whiting Brothers Motor Hotel. It has also operated as the Golden Door Motor Hotel and, as of late 2010, served as the Economy Inn.

SELIGMAN, ARIZONA

In 1886, Tom Bullock successfully solicited $300,000 from investors in Prescott, Arizona, for the construction of a railroad that would connect the city with the main line of the Atlantic & Pacific Railroad at Prescott Junction, now Seligman. Known as one of the largest boondoggles in Arizona Territorial history to that date was the resultant Prescott & Central Arizona Railroad.

However, largely because of this endeavor, the Atlantic & Pacific Railroad relocated its roundhouse and supportive infrastructure from Williams to Prescott Junction. The community that arose around this facility was renamed Seligman in deference to the Seligman brothers, major shareholders in the railroad and part owners of the sprawling Aztec Land & Cattle Company known as the Hashknife outfit. A post office opened under the name Seligman in April 1895.

Ranching, railroad service, and shipping from this railroad junction served as the primary economic foundation until

During the annual Route 66 Fun Run, the old highway between Seligman, Arizona, and Topock on the Colorado River is transformed into a 180-mile living time capsule.

establishment of the National Old Trails Highway, Route 66, after 1926. Motels, cafés, service stations, a Harvey House, and supportive businesses provided the community with vibrancy.

Jack Rittenhouse, in 1946, listed four hotels—the Havasu (a Harvey House), Navajo, Central, and Seligman—and several garages, auto courts, and cafés. The completion of Interstate 40 and resultant bypass of Route 66 in 1978, and closure of Santa Fe Railroad operations in 1985, devastated the local economy.

The Havasu, one of six Harvey House properties in Arizona, opened in late 1905, closed in 1954, and then, after refurbishment, was utilized as offices for the Santa Fe Railroad. Demolition occurred in 2008.

To combat the community's decline, Angel Delgadillo, a barber whose family moved to Seligman in 1917, called a meeting of local business owners in February 1987. The resultant Arizona Route 66 Association became the first organization of its kind established to promote and preserve U.S. 66. Angel Delgadillo, his late brother Juan Delgadillo (founder of the Snow

With a degree of certainty, it can be said that the cornerstone for the modern interest in Route 66 is the barbershop and gift shop of Angel and Vilma Delgadillo in Seligman, Arizona. *Joe Sonderman*

The old Cottage Hotel in Seligman, Arizona, has in recent years served as the library and museum, but as of 2010, it was closed. *Joe Sonderman*

Cap Drive-In), and the community of Seligman are foundational elements of the resurgent interest in Route 66. This interest and the annual Route 66 Fun Run, a Route 66 Association of Arizona–sponsored event that begins in Seligman, have restored a great deal of vitality to the community.

As a result, several historic businesses have been renovated, including Seligman Sundries, a structure that dates to 1904; the Copper Cart Restaurant, 1950; and the Supai Motel, dating to 1952. The oldest existing and operational motel is the former Court De Luxe, now the De Luxe Inn, which opened in 1932.

This effort to preserve and promote its association with Route 66 has made Seligman the subject of international press coverage. Additionally, numerous individuals here, such as the Delgadillo brothers, have become celebrities, inspiring travelers on Route 66 to plan trips specifically to obtain their autographs, have photos taken with these people, and to get a hair cut from Angel.

In the early summer of 1961, the community received attention from the international press but for less positive reasons. The *Miami Daily News Record* on June 11, 1961, reported the following: "Police had reached a virtual dead end Saturday in their investigation of Friday's slaying of a vacationing Oklahoma couple as they slept in their car about 13 miles west of here [Seligman]." The murders, never solved, were linked to several similar crimes along Route 66 in the preceding months.

The remaining structures in the Seligman historic district reflect two distinct periods. The commercial buildings along Railroad Avenue and Chino, the pre-1933 alignment of Route 66, are generally of a type associated with the early twentieth century, as evidenced by recessed entries, single-story construction, and canopies over the front and false front façades. The structures built along the current course of Route 66 reflect a modern type of midcentury architecture. Excellent examples include the Snow Cap Drive-In, Copper Cart Restaurant, and the former Studebaker dealership building.

SELIGMAN SUNDRIES

From the date of construction in 1904, the Seligman Sundries building in Seligman, Arizona, has served variously as a theater, trading post, dance hall, and drug store with soda fountain. Extensive renovation has returned the interior to its original appearance, including a historic soda fountain.

Since its opening in 1904, the Seligman Sundries building has housed a trading post, soda fountain, theater, and dance hall. The building now houses a period soda fountain and gift shop. *Joe Sonderman*

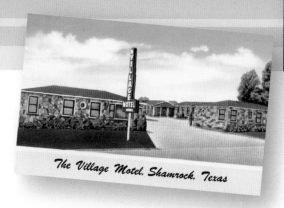

The Village Motel, Shamrock, Texas

In the mid-1950s, the Village Motel was a basic fourteen-unit auto court that offered combination baths, radios, and a playground for the children for $4.00 to $7.00 per night. *Mike Ward*

SEQUOYAH, OKLAHOMA

The namesake for Sequoyah, Oklahoma, is Sequoyah, inventor of the Cherokee alphabet. The post office under this name was established in August 1871, but the town's name changed to Beulah for a brief period in 1909 as a result of an amendment. (It changed back within that same year.)

Jack Rittenhouse, in 1946, succinctly presented a portrait of this community that has changed little since that date. He wrote, "Listed on the maps as a 'town,' but actually consisting of a coal ladder, a dozen homes, and one gas station and store."

SHAMROCK, TEXAS

Aptly, this town derives its name from the application for a post office submitted by George Nickel, an Irish immigrant, in 1890. Interestingly, the post office never opened, however, since Nickel's home/post office burned that same year.

Therefore, the official beginning for the town is given as 1902, the year for completion of the Chicago, Rock Island & Gulf Railway to this point and the selling of town lots that summer. When Frank Exum submitted an application for a post office, he named the town after himself, but the railroad designated the stop Shamrock in deference to the original post office application.

By 1911, Shamrock was an incorporated community with a promising future: two banks; a newspaper, *Wheeler County Texan*; numerous businesses; and the Cotton Oil Mill. Amazingly, the prosperous little town depended on hauled water until completion of a water line from the J. M. Porter Ranch in 1923.

With the discovery of oil in the area in 1926, and the designation of Route 66 in the same year, Shamrock became a modern, bustling community. However, in 1931, the town captured national attention for something other than its prosperity when a daring band of bandits began targeting buses traveling on Route 66. The *Helena Independent* of Helena, Montana, on June 8, 1931, provided a front-page headline that read, "Holdup Like Robbery Of Stage Coach."

It went on to describe the incident: "Rivaling in thrills of a stage coach holdup in the wild and wooly days of the old West seven unmasked highway men halted a Pickwick Greyhound westbound bus nine miles east of here [Shamrock, Texas] early this morning and robbed its passengers of cash and jewelry." What added interest to the story was the courtesy displayed by the robbers.

"Emulating the chivalry of the old time wild-west robbers, the highwayman asked each passenger from whom they had took money where he or she lived and refunded enough change for them to wire home for money and to buy their breakfast," the newspaper article added.

In May 1932, the city again garnered national headlines by hosting the annual meeting of the U.S. Highway 66 Association. The centerpiece of the event was a Progress of Transportation parade with Major Gordon Lillie—better known as Pawnee Bill, a contemporary of Buffalo Bill Cody—as grand marshal.

Jack Rittenhouse noted, in 1946, that the town contained a hotel, numerous auto courts, garages, and a wide array of cafés. One of these was Cross Roads Court, the only listing for recommended lodging in the 1940 edition of the *Directory of Motor Courts and Cottages*.

The 1955 edition of the *Western Accommodations Directory* published by AAA lists two recommended properties: Sun 'N

A surprising number of the structures seen in this circa-1960 view of Route 66 in Shamrock, Texas, remain existent, though many are empty or are being used for other purposes. *Steve Rider*

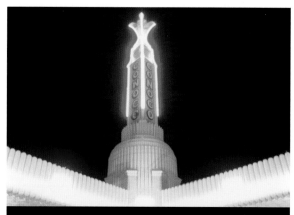

At the junction of Route 66 and U.S. 83, the refurbished neon of the U-Drop Inn—built in 1936 in Shamrock, Texas—again lights up the night. *Steve Rider*

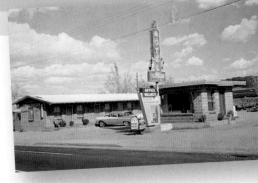

Sand Motel and The Village Motel. The entry for both reads "east edge on U.S. 66" and the rates listed are from $4.00 to $8.00.

The decline of the oil industry and the completion of I-40 that allowed travelers to bypass Shamrock have resulted in a slow downward spiral for the town, with the population decreasing from 3,113 in 1960 to 1,828 in 2006. Still, this little town takes great pride in its association with the legendary Route 66 as evidenced by the restoration of the iconic U-Drop Inn, an art deco masterpiece built in 1936, and the restored Magnolia gas station.

SHERMAN, ILLINOIS

Initial legislation in 1866 that created the township of Sherman, Illinois, called for the name Jackson in honor of President Andrew Jackson. For reasons unknown, an amendment changed it to Sherman in deference to General William Tecumseh Sherman, a leading commander of the Union Army during the American Civil War.

Local legend tells a different story. According to tradition, Cornelius Flagg, Joseph Ledie, David Sherman, and Virgil Hickox formed a partnership in 1858, purchased a section of land, and then platted the community. The name was selected with the drawing of one of their names from a hat.

Jack Rittenhouse, in 1946, noted that a five-mile segment of the new divided Route 66 highway began here. He also indicated that available services included a grocery store, gas station, and the Withrow Garage.

Initially, the town depended on coal mining and farming as a foundational economic base. However, growth for the community proved elusive until the 1970s. The village incorporated in 1959 and as of 2010 had a population of 3,500.

SHIRLEY, ILLINOIS

A small settlement existed here before establishment of the post office under the name Shirley in 1857. Jack Rittenhouse, in 1946, noted, "No tourist facilities in this small community, with its grain elevators surrounded by small cribs to hold extra grain. A few homes and a few stores."

SIBERIA, CALIFORNIA

Siberia, California, west of Bagdad, was one of the water stops and sidings established by the Southern Pacific Railroad, now the Burlington, Northern & Santa Fe Railroad, in 1883. Services and facilities were negligible as indicated by the lack of notation in guidebooks from 1914, 1927, 1940, 1946, and 1955. The faintest of foundational elements in the desert mark the site today.

The Siesta Motel, now utilized as apartments, opened in 1929 at 1926 East Andy Devine Avenue in Kingman, Arizona. The addition of a second wing occurred in about 1959. *Mike Ward*

SIESTA MOTEL

Located at 1926 East Andy Devine Avenue in Kingman, Arizona, the Siesta Motel was initially several miles east of that city in the unincorporated community of El Trovatore. The units on the west end of the property date to 1929 while those on the east, and the office building, date to the late 1950s.

The signage from the 1950s remains, but a flat, painted face has supplanted the neon. In 2011, the property still existed as the Siesta Apartments and Kitchenettes.

SILVER MOON CAFÉ

The Silver Moon Café located at the east end of Santa Rosa, New Mexico, opened on Route 66 in 1959. As of 2010, it remained operational.

66 DRIVE-IN

The 66 Drive-In Theatre near Carthage, Missouri, opened on September 22, 1949, and remained in operation through 1985. After its closure, the property became the site of an automotive wrecking yard.

Surprisingly, the facility retained a number of original features when renovation began in the mid-1990s. These included the steel-framed screen house that also served as a billboard on the Route 66 facing rear of the building, the concession stand and projection booth, and the ticket booth.

Renovation included the replacement of many period features, including a playground below the screen. In 2003, the property received recognition with inclusion in the National Register of Historic Places. Many Route 66 travelers that overnight in Carthage during the months of summer include the theater in their plans.

SOULSBY SERVICE STATION

The Soulsby Service Station in Mount Olive, Illinois, dates to 1926, the year Henry Soulsby designed and built the facility. The station remained a family-run operation with Soulsby's children,

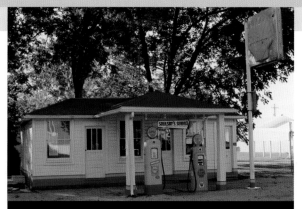

Henry Soulsby, with his son Russell, established this station in Mount Olive, Illinois, in 1926. Russell and his sister, Ola, continued to manage the station until 1991.

Russell and Ola, as proprietors until 1993. In 1997, Russell sold the property to Mike Dragovich.

With establishment of the Soulsby Preservation Society, Dragovich initiated renovation efforts in 2003. In 2004, the restoration received funding from a grant provided by the National Park Service. Recognition for the restoration occurred in 2004 with the property's listing on the National Register of Historic Places.

SPENCER, MISSOURI

The town of Spencer originated with the establishment of Johnson's Mill in about 1866 on Turnback Creek, a waterway now spanned by a pony truss bridge built in 1923. The community that developed around the mill warranted a post office by 1868, and the name utilized was that of the owner of the Spencer General Store that also housed the post office.

The community languished for the rest of the nineteenth century, but by the late teens, abandonment had made it a ghost town. In 1925, after learning the proposed U.S. highway system

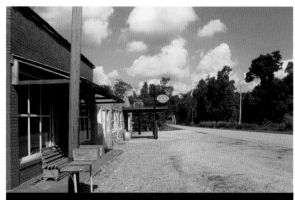

The town of Spencer, Missouri, predates the American Civil War, but the surviving vestiges along an early concrete alignment of Route 66 date to the 1920s.

would incorporate the state highway running through Spencer, Sidney Casey purchased the town site, two acres, and a vacant store for $400.

The rebirth of Spencer fueled by the traffic on Route 66 resulted in development of a complex that included a garage, service station, barbershop, and café. Realignment of Route 66 to bypass the narrow 1923 bridge over Turnback Creek and the 1926 steel truss bridge over Johnson Creek west of Spencer resulted in closure of the business.

The Francis Ryan family purchased the complex with plans for complete refurbishment. As of 2011, the façades of existing buildings are refurbished and vintage gasoline pumps are in place.

SPENCER'S GRILL

Opened by William and Irene Spencer in 1947, Spencer's Grill in Kirkwood, Missouri, remains as a restaurant called Spencer's. Numerous fixtures and landmark features, such as the neon sign and exterior clock, date to a 1948 remodeling of the property.

SPRINGFIELD, ILLINOIS

A political compromise that resulted in the site of Springfield, Illinois, being designated the temporary seat for Sangamon County in 1821 is the point of origination for this community. Formal planning for the town site on lands owned by John Kelly on Spring Creek commenced in 1823. The initial post office application approved in January 1822 utilized the name Sangamon Courthouse. An amendment approved on February 19, 1828, resulted in the current designation of Springfield. In 1836, the city became the state capital.

Springfield will always be associated with Abraham Lincoln. The only home he ever owned still stands at Eighth and Jackson Streets, two blocks from Route 66. His law office remains at Sixth and Adams Streets. The depot from which he departed to Washington D.C. as president elect, and to which he returned after his assassination, is located at Tenth and Monroe Streets. His presidential library is at 112 North Sixth Street, Route 66, and his tomb is at 1500 Monument Avenue.

From 1971 to 1987, the A. Lincoln Wax Museum, the only wax museum in the world dedicated to one man, operated at Ninth Street and Capital Avenue, an alignment of Route 66. The attention to detail by Hank Geving, the sculptor, received critical acclaim from Civil War–era scholars and historians who specialized in the presidency of Abraham Lincoln.

Arguably, the most famous attraction associated with Route 66 in Springfield would be the Cozy Dog Drive In. Established by Edwin Waldmire Jr., father of renowned artist Robert "Bob" Waldmire, the Cozy Dog Drive In opened in 1949 and was relocated to its current residence at 2935 South Sixth Street (the site of the former A. Lincoln Motel) on Route 66 in 1996.

SPRINGFIELD, ILLINOIS *continued*

Initially, Route 66 entered Springfield on Peoria Road and followed the course of State Highway 4, utilizing Ninth Street, Capitol Street, Second Street, S Grand Avenue, Macarthur Street, Wabash Street, Chatham Road, and Woodside Road. The final alignment, now Business Loop 55, followed Peoria Road, and traversed the city on Ninth Street, Fifth Street, Sixth Street, Spruce Street, and Myrtle Street.

As the state capital, and with association to the important State Highway 4 (and later Route 66) corridor that connected Chicago with St. Louis, Springfield developed an extensive service-related industry to meet the needs of travelers. The *Hotel, Garage, Service Station, and AAA Directory* published in 1927 lists three hotels—Abraham Lincoln, Leland, and St. Nicholas—and thirteen repair facilities. Curiously, the 1940 *Directory of Motor Courts and Cottages* published by AAA recommends only one facility for lodging: "Poland's Modern Cottages, on U.S. 66 (Peoria Road), one mile northeast of city limits."

In the guidebook by Jack Rittenhouse published in 1946, he provides an expanded picture of the service industry associated with Route 66. In addition to the hotels and garages listed in the 1927 hotel directory, he names numerous auto courts and motels, including Highway Hotel Court, Bedini's Lakeview Cabins, Johnny & Janey Camp, Capital Tourist Camp, Modern Court, Poland's Modern Cottages, and Sabattini's Cabins. The *Service Station Directory*, published by AAA in 1946, contains a lengthy list of repair facilities. No addresses are provided.

The 1949 edition of *The Negro Motorist Green Book* also contains an expansive listing. Included are the Hotel Dudley, 130 South Eleventh Street, and five tourist homes. The 1954 edition of the *Western Accommodations Directory* published by AAA also contains an extensive listing of lodging and dining recommendations. In addition to the three hotels listed in the 1927 hotel

For $5.00 to $7.00 per night, in 1954, guests at Little Chum's Lodge could enjoy a "brick motel with air conditioned rooms" and make use of the playground and barbeque. *Mike Ward*

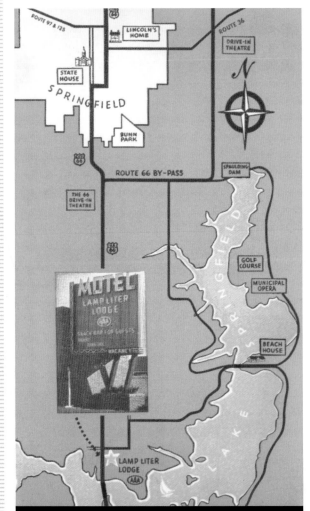

This promotion for the Lamp Liter Motel provides travelers with all the information they need: the course of Route 66, how to find Abraham Lincoln's home, and, of course, how to find the motel. *Mike Ward*

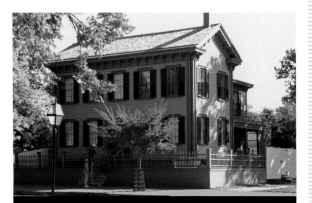

At Eighth and Jackson Streets in Springfield, Illinois (just a few blocks from Route 66), stands the Abraham Lincoln Home. The neighborhood is preserved and re-created to appear as it did in the 1850s.

directory, there are eleven motels, of which seven are located on Route 66, as well as six restaurants, of which four are related to Route 66.

A wide array of buildings and businesses with Route 66 association still exist. Some of the most notable are the Capital City Motel, 1620 North Ninth Street; a building at 4333 Peoria Road that was a portion of the Little Chum's Lodge; the Pioneer Motel at 4321 Peoria Road that opened in 1951; the Lazy A Motel, now apartments, at 2840 Peoria Road that opened in 1949; the former Ross Motel at 2127 Peoria Road; and Shea's Historic Route 66 Museum at 2075 Peoria Road.

An attraction directly related to the history of the highway, as well as the period of resurgent interest in Route 66, is Shea's Gas Station Museum. Housed in a vintage service station complex, the museum—the creation of Bill Shea—houses one of the largest existing collections of service station and oil company memorabilia, ranging from restored gas pumps and garage equipment to promotional material.

SPRINGFIELD, MISSOURI

The first historic association with the site of Springfield, Missouri, dates to the early years of the nineteenth century, shortly after American acquisition of the lands through the Louisiana Purchase of 1803. Relocated to the area in agreement with treaties negotiated with these tribes were the Delaware and Kickapoo Indians. Sequiota Park, southeast of the intersection of Glenstone Avenue and College Street (an early alignment of Route 66 that later became City 66), is a remnant of the Delaware lands given in that treaty. Kickapoo Prairie to the west was named in reference to the Kickapoo village that was once located there.

John Polk Campbell, a homesteader from Tennessee who made his claim on this site in 1829, is credited as the founder of Springfield. The origins of the Springfield name for the community are unknown, but the primary historical evidence is that it is in reference to either Springfield, Massachusetts, or Springfield, Tennessee.

Incorporation occurred in 1838—the same year the Cherokee were forcibly relocated from North Carolina and Tennessee to the Indian Territories in what is now Oklahoma. The Military Road used for this relocation, known as the Trail of Tears by the Cherokee, served as the primary connection between Springfield and Fort Smith, Arkansas, until the mid-1840s. This road would also serve as the course utilized by the Butterfield Overland Stage line in the late 1850s. In 1860, when telegraph lines were strung along the road east to St. Louis, it became known as the Wire Road, segments of which were utilized in the original alignment of Route 66.

Establishment of the railroad in late 1848 provided Springfield with expanded markets for agricultural products and spurred industrial development that would make the city an

After acquisition of a service station belonging to Richard Chapman in 1947, Hillary and Mary Brightwell added four cabins and established the Rest Haven Motor Court. By 1954, they had expanded it into an eighteen-unit complex. *Steve Rider*

important logistical point in the American Civil War. The railroad would also serve as a catalyst for the merger of Springfield and North Springfield in 1887.

On August 10, 1861, on the farm of James Wilson, 5,400 Union troops moving on Springfield clashed with an estimated 12,000 Confederate troops in an event now known as the Battle of Wilson's Creek, the first major land battle of the Civil War west of the Mississippi River. Overwhelmed by superior forces, the Union troops fell back to Lebanon, and then Rolla, along a course later followed, in part, by Route 66. Springfield would be the focus of several other battles before Union forces gained control of the city in January 1863. In 1867, the creation of Springfield National Cemetery provided internment for casualties of these conflicts, and in 1960, the National Park Service established Wilson's Creek National Battlefield.

On July 21, 1865, James Hickok, later given the moniker "Wild Bill," shot and killed Davis Tutt Jr. in the town square in what is claimed to be the first shootout on the western frontier. Two brass plaques inlaid in the pavement of Park Central Square, part of an alignment of Route 66, commemorate this incident.

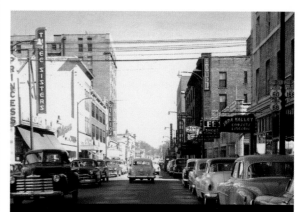

In Springfield, St. Louis Street served as the congested corridor for City 66. This circa-1953 view is looking west from Kimbrough Avenue toward the Woodruff Building. *Joe Sonderman*

13 Miles West of Springfield, Missouri
on U. S. Highway No. 66

SPRINGFIELD, MISSOURI *continued*

By the first decades of the twentieth century, Springfield was a modern, prosperous, and progressive community. As a result, the incident that occurred on April 14, 1906, a mob assault on the city jail and the hanging of two African American men, generated international headlines.

On April 30, 1926, Cyrus Avery and other interested parties met in the offices of John Woodruff, in the Woodruff Building, to discuss possible compromises about several conflicts pertaining to the assignment of numbers for the new federal highway system. It was because of this meeting that the highway between Chicago and Los Angeles received the designation of U.S. 66.

Route 66 became an integral part of the economic diversity of the city as evidenced by the evolution of roadside services chronicled in AAA directories. The 1927 *Hotel, Garage, Service Station and AAA Club Directory* lists four lodging recommendations: Kentwood Arms, Colonial, Ozarks, and Springfield, all hotels.

The 1940 edition of the *Directory of Motor Courts and Cottages* contains a lengthy list of properties on Route 66: Camp Rose Auto Court, Mack's Cottages, New Haven Courts, Ottos Motel Court, Ozark Tourist Court, Rail Haven Cottages, Snow White Lodge, Duggins Cottages, and Stuffed Pig Modern Cottages.

Rock Village Lodge was one of many motor courts in the rapidly growing Springfield area. *Mike Ward*

The *Western Accommodations Directory* of 1954 reflects a dramatic expansion of the lodging industry in Springfield as well as other service-related businesses, such as restaurants. Listed are three hotels— Colonial, Kentwood Arms, and Hotel Moran— all on Route 66. Motor courts listed on that highway include Motel Springfield, Rail Haven Motor Court, Rest Haven Motor Court, Rock Fountain Courts, Rock View Court, Rock Village Hotel Court, Ship & Anchor Motel, Skyline Terrace Court, Ted's Motor Court, Trail's End Motor Court, and Wishing Well Motel.

For Route 66 enthusiasts, the number of surviving motels and auto courts, with vintage neon signage, makes Springfield a

Established by Allan Rose, the Camp Rose Auto Court, in 1939, provided guests with "a quiet, refined place to stop" as well as ten sleeping rooms, eight with showers, for $2.00 to $3.50 per night. *Mike Ward*

destination of choice for lodging. Among these are the Rest Haven Court that opened in 1947 with signage that dates to 1953; the Satellite Motel, now the Raintree Inn, that dates to 1959; the Americana Motel, now the Flagship Motel, that dates to 1959; Glenstone Cottage Court that dates to 1947; Route 66 Rail Haven that dates to 1938; Wishing Well Motel that dates to 1947; and Rancho Motel that dates to 1955.

SPURS MOTEL

The Spurs Motel at 224 Mike's Pike in Flagstaff, Arizona, opened in 1956 with Mr. and Mrs. Dohr as proprietors. As of 2010, it remained operational as the Knight's Inn.

STANDARD OIL STATION, ODELL

Based on a 1916 Standard Oil of Ohio design, the Standard Oil Station in Odell, Illinois, dates to 1932, the year general contractor Patrick O'Donnell purchased property along Route 66 and built the station. Shortly after its construction, O'Donnell entered agreements with other oil companies, and as a result, the station has association with Sinclair as well as Phillips 66.

In 1940, O'Donnell added a two-bay garage to the original building. With completion of the four-lane bypass in 1946, the garage served as a primary revenue source, allowing the station to remain operational until 1967.

In 1952, O'Donnell leased the facility to Robert Close, who purchased the property from the O'Donnell estate in 1967. Close operated the property as a garage and then as a body shop until 1999.

Initial work by the Route 66 Association of Illinois Preservation Committee for the station's inclusion in the National Register of Historic Places commenced in 1995. Designation occurred in November 1997.

The Village of Odell acquired the property in 1999, and restoration began as a cooperative effort between the National Park Service Route 66 Corridor Preservation Program, Hampton Inn Landmarks, the Village of Odell, the Illinois Route 66 Association, and the Illinois State Historic Preservation Office.

The refurbished facility now serves as a welcome center for the Village of Odell. In 2002, the receipt of the National Historic Route

66 Federation Cyrus Avery Award for most outstanding Route 66 preservation project served as recognition of the effort involved in restoration as well as the property's historic significance.

STANLEY COUR-TEL

Stanley Williams built the stylish Stanley Cour-Tel at the intersection of Lindbergh Boulevard and Natural Bridge Avenue in St. Louis in 1950. Its proximity to the airport and McDonnell Aircraft ensured success, and it was here the *Apollo One* astronauts stayed while training at the aircraft company.

Razing of the facility occurred in 2001 at initiation of tunnel construction beneath a new runway, which resulted in a modernized Lindbergh Boulevard. The stylish neon sign was salvaged, and it is scheduled for restoration that will result in inclusion of the displays at Rich Henry's Rabbit Ranch in Staunton, Illinois.

STANTON, MISSOURI

Originally settled as Reedville, Stanton, Missouri, received its name from John Stanton and the Stanton Copper Mine, which spurred the town's initial prosperity. The primary Route 66 association is as the gateway to Meramec Caverns.

Because of this attraction, the community has a long association with tourism-related businesses that continues to this day with sites like the Jesse James Wax Museum, the Antique Toy Museum (housed in a former Stuckey's), and the historic Stanton Motel. This motel, dating to the 1940s, is a recommended facility in the fifteenth edition of the *Route 66 Dining & Lodging Guide*, published by the National Route 66 Federation in 2011.

One of the earliest motel complexes to cater to travelers was Benson's Tourist City three miles to the west, which received an extensive entry in the 1940 *Directory of Motor Courts and Cottages* published by AAA. Another was the Acacia Shady Rest Court, located just east of the turnoff to the caverns.

Route 66 swept past Shady Rest Court, an AAA-approved property, near Stanton, Missouri. By 1951, expansion of the facility included a restaurant and improved trailer park. *Steve Rider*

The guidebook written by Jack Rittenhouse in 1946 contains a detailed listing for Stanton with a list of available services, including an AAA garage and a notation that "a good café here is Wurzburgers," a café that is also listed in the 1955 edition of the *Western Accommodations Directory* published by AAA. The former noted: "Wurzburgers—on U.S. 66 at entrance to Meramec Caverns grounds. A well-known and popular restaurant, established forty years." For recommended lodging, this guide lists the El Rancho Motel, "a brick ranch style court on nice grounds." Rates listed range from $4.00 to $7.00 per night.

STARLITE LANES

The Starlite Lanes opened at 3406 East Santa Fe Avenue in Flagstaff, Arizona, on November 9, 1957. As of spring 2011, this business remained in operation.

STAUNTON, ILLINOIS

Sources conflict with regard to the naming of Staunton, Illinois, where initial settlement commenced in about 1817. Indications are that Hugh Staunton provided the funds for the platting of the town site and the requisite legal filings. However, Thomas and James Stanton were early settlers here, and local legend has it they filed the paperwork for the town site.

Establishment of a post office under the name Staunton occurred in April 1837. Agriculture and the opening of a trading post provided the initial economic foundations. However, the development of coal mines during the mid- to late nineteenth century became the primary catalyst for growth.

(As a historic side note, Staunton garnered national attention in 1923 for the most lopsided football score on record. Staunton High School suffered a humiliating defeat by Gillespie with a final score of 233–0.)

In 2002, Hampton Inns sponsored the Route 66 Caravan, an expansion of the company's landmarks program that signed specific properties as "a site worth seeing." *Judy Hinckley*

STAUNTON, ILLINOIS *continued*

In its association with Route 66, the community plays a unique role in the highway's history in Illinois. It is here that the pre-1930 alignment of the highway, Illinois Route 4, and the post-1930 alignment converge. In 1940, realignment through Livingston roughly along the course of present-day Interstate 55 bypassed the town.

The primary attraction for modern enthusiasts of Route 66 is Henry's Rabbit Ranch & Route 66 Emporium near Madison Street on the post-1930 alignment of the highway. With rabbits ranging from those manufactured by Volkswagen to giant fiberglass models to live specimens, as well as an extensive collection of vintage neon signage and even trucks emblazoned with the mascot for the now-defunct Campbell 66 Express, Henry's Rabbit Ranch captures the essence of the classic Route 66 attraction.

The eclectic collection of Route 66 memorabilia—ranging from historic tractor-trailer rigs to vintage neon signs and all things pertaining to rabbits—make Henry's Rabbit Ranch the primary attraction in Staunton, Illinois. *Judy Hinckley*

ST. CLAIR, MISSOURI

Initial settlement of the community here began with establishment of an inn and tavern named Traveler's Repose. As the town grew around the inn, a name change to St. Clair, in honor of an engineer with the Frisco Railroad, occurred in 1859.

Jack Rittenhouse, in 1946, noted that available facilities included a garage, the Commercial Hotel, and Johnson's Mo-Tel. He also noted, "US 66 passes town on the west edge. Over 100 years old, it is a peaceful town, full of old residences."

The attractions in St. Clair run the gamut from unusual to historic. There are two water towers in town, one signed hot and one signed cold. Listed on the National Register of Historic Places are the International Shoe Company Building and the Panhorst Feed Store.

Vestiges of the sixteen-unit Benson's Tourist City still exist. The complex operated under a number of names, including Del Crest and Sho-Me Courts. *Mike Ward*

SHARDY'S CAFE: Highway 66, St. Clair, Missouri

Bud & Roy's Place, also promoted as Oak Grove Café, opened as a tavern and store with cabins in about 1932. Four cabins converted to homes remain on the property. *Steve Rider*

STEAK 'N SHAKE

In an effort to maximize profits from his small service station in Normal, Illinois, Gus Belt added a small restaurant to the facility in 1932. The menu was limited to fried chicken, French fries, coleslaw, and beer.

Objections from the Illinois Normal State Teachers College pertaining to beer sales in such close proximity to the campus resulted in Belt obtaining a loan and transforming the Shell station into a restaurant. In February 1934, the new facility opened under the name Steak 'n Shake. The steak reference pertained to the use of T-bone and sirloin steak in the making of the signature sandwich, a steak burger. The shake referenced flavored milkshakes.

Utilizing sanitation as a marketing tool, Belt specifically designed the facility to represent cleanliness through a black and white décor with ample use of stainless steel. The food served received equal attention for ensured quality with precise ratios of lean to fat in the meat and a kitchen design that allowed customers to watch food preparation.

To maximize use of the facility, Belt initiated curb service to supplement regular seating. This proved to be a profitable decision as it allowed for the meeting of local customer needs with a

sit-down restaurant and the needs of travelers on Route 66 by offering food to go.

In 1936, a second facility mimicking the first opened in Bloomington, Illinois. By 1939, Belt had eight locations, including another in Bloomington; Decatur, East Peoria, and Danville, Illinois, each had one, and there were two in Champaign.

By 1943, Belt sold franchises but retained control of most of the fifteen restaurants. Between 1948 and 1954, an additional ten restaurants opened in the metropolitan St. Louis area. To a large degree, this expansion was a result of the public offering of stock in the company.

The company remained family managed until 1969, when Belt's wife, Edith, sold her interests to Longchamps, Inc.

In *A Guide Book to Route 66*, **written by Jack Rittenhouse in 1946, the author notes two auto courts in St. James, Missouri: American Way Camp and Kozy Kottage.** *Steve Rider*

STEVE'S CAFÉ

Steve Wilcox purchased the former Wahls Brothers building, built in 1918, at the intersection of City 66 and Highway 24 in Chenoa, Illinois, and opened Steve's Café in late 1937. Shortly after this date, the business expanded to include a Texaco gasoline station.

The facility underwent numerous transitions, including enclosure of the service station with the addition utilized as part of the restaurant, and then further use as the Red Bird Lounge after 1975. The restaurant closed in 1997, and the property has since served a variety of purposes, including as a used car lot and antique store.

ST. JAMES, MISSOURI

The first settlement of this town was under the name Big Prairie, but in 1860, Thomas James, owner of the Maramec Iron Works, petitioned for a change to a name honoring Saint James the

The Rose Café with John and Mable Rose as proprietors opened in 1929. It operated as the Commercial Café and Mary's Café before acquisition by John Bullock in 1960. From that date forward, it operated as Johnnie's Bar. *Joe Sonderman*

apostle. With designation of U.S. 66, James Boulevard was the route followed through town. It was also in St. James that the first divided section of that highway came into being.

Jack Rittenhouse, in 1946, noted that available services included a hospital, garage, gas stations, cafés, and auto courts. The *Directory of Motor Courts and Cottages*, published by AAA in 1940, lists the Parkway Inn for recommended lodging. It said the following about the inn: "Consisting of 14 sleeping rooms, most with hot and cold running water, 4 with tub bath, 10 showers. 1 with kitchenette with electric plate. 4 private garages. Rates $1 to $2 per day for two persons. All are heated by hot air and oil. 2 public baths and flush toilets. Porter and maid service. Night watchman. Filling station. Laundry facilities. Children's playground. Restaurant facilities."

U.S. Highway 66, now signed as Route KK in St. James, led to the creation of a number of service-related businesses, many of which still exist. Of particular interest to Route 66 enthusiasts are Johnnie's Bar, which opened in 1929 as Rose Café, and the former tire shop, the last remnant of the Atlasta complex that also opened in the same year. This complex initially consisted of a gas station, upstairs residence, coffee shop, and lunch counter, but a fire in 1964 destroyed everything but the tire shop.

In season, the 4M Vineyards & Farms store captures the very essence of the once-prolific roadside stands that lined Route 66 in Missouri. In addition to souvenirs, the store also offers a wide array of fresh fruit and fresh-fruit products, including pie.

STICKNEY, ILLINOIS

From 1928 to 1977, Route 66 followed Harlem Avenue, Illinois Route 43, between Ogden and Joliet Road with the north lanes of Joliet Road, to Pershing Road in the village of Stickney.

Prior to 1900, the two square miles of Stickney were a swamp area known locally as Mud Lake. The primary improvement to the area before this date was construction of a rail line in the early 1880s, which was purchased by the Santa Fe Railroad in 1888.

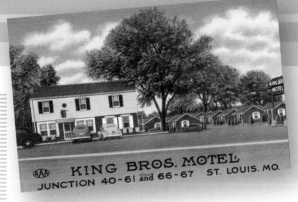

Initially established as the Smith Brothers Motel in the late 1930s, the King Brothers Motel, with its key location at the junction of four major highways, evolved into a major complex by the 1950s. *Joe Sonderman*

The completion of the Chicago Sanitary and Ship Canal immediately to the south of the area in 1900 resulted in the area's drainage. Development of the site commenced shortly after this date, and in 1913, the village of Stickney was incorporated. It was named after Alpheus Beede Stickney, the founder and first president of the Chicago Great Western Railway.

During the era of Prohibition, the small village had an unsavory association with Al Capone, who operated several houses of prostitution here. Today, the community has the dubious distinction of being the site of the Stickney Water Reclamation Plant, the world's largest waste water treatment facility.

ST. LOUIS, MISSOURI

In the twelfth century, the communities of the Mississippian culture loosely known today as the mound builders sat at the present site of St. Louis, as well as along the east bank of the Mississippi River. The Cahokia Mounds State Historic Park near Washington Park in Illinois remains as one of the last "mounds" that once dominated the area and that led to the initial settlement of St. Louis being dubbed "Mound City."

The period of European association with the site dates to the explorations of Louis Joliet and Jacques Marquette in 1673. In 1703, establishment of a small Catholic mission served as the cornerstone for establishment of the city of St. Louis. A drainage channel named River Des Peres, formerly a river, at the southern boundary of the city is the site for this mission. Actual settlement commenced in 1765, and in that year, St. Louis was designated the capital of Upper Louisiana.

In 1768, the city became part of a Spanish colony and in 1800 reverted to French control. Its transference to U.S. control occurred in 1804.

From 1812 to 1821, the year Missouri obtained statehood, St. Louis served as the capital for the Missouri Territory. Its location as the northernmost navigable port on the Mississippi River for large steamboats resulted in the community becoming a center of wealth.

A disastrous fire and a sweeping cholera epidemic in 1849 transformed the community. These disasters led to the establishment of a stringent building code that required extensive use of stone or brick and the development of a public water and sewage system. By the mid-1860, St. Louis, with a population of more than one hundred sixty thousand, was the largest city in the United States west of Pittsburgh and the second largest port in the nation.

During the closing years of the nineteenth century and the first years of the twentieth century, St. Louis developed as a center of industry and innovation. Ralston-Purina, Anheuser-Busch, the Desloge Consolidated Lead Company, International Shoe, and Brown Shoe Company all had headquarters here.

Indicative of this prosperity were the Wainwright Building, a ten-story structure recognized as one of the earliest steel-framed skyscrapers, which still stands at the corner of Chestnut and Seventh Streets, and the Jefferson Hotel, built in 1904 at the Twelfth and Locust Streets. Additionally, in 1904 the city hosted the Louisiana Purchase Exposition world's fair at Forest Park and the Olympics.

With the rise in personal ownership of automobiles that allowed for commuting from suburbs rather than living in the densely developed older neighborhoods built around factories, the city population began to decline. Between 1950 and 2000, the city lost almost one-half of its population.

The dense urban center, and a street grid that reflected a lack of mass transit development as well as a lengthy history, played a primary role in the development of Route 66 through St. Louis. It was also a primary factor in the road's numerous realignments. As a result, the city presents the most complex of challenges with regard to following that historic highway today. However, St. Louis retains a wide array of landmarks associated with Route 66 and its earlier history.

After crossing the Mississippi River on the McKinley Bridge, the initial alignment of Route 66 followed Ninth Street, Salisbury Street, Natural Bridge Avenue, Grand Avenue, Delmar Boulevard,

Before the Chain of Rocks Bridge was used as a Mississippi River crossing for Route 66 in 1936, the crush of traffic along Broadway, as well as the other narrow streets utilized for the U.S. 66 corridor in St. Louis, represented one of the most congested segments of that highway. *Joe Sonderman*

Sarah Street, Lindell Boulevard, Boyle Avenue, Clayton Avenue, and McCausland Avenue before following Manchester Road from the city. In 1929, the river crossing shifted to the Municipal Bridge, now MacArthur Bridge, and the highway snaked through the city on Seventh Street, Clayton Avenue, McCausland Avenue, and Manchester Road. The original alignment continued to be signed as Optional 66 until 1937.

In 1933, a rerouting of the highway utilized Choteau Avenue to Twelfth Street and then Gravois Avenue, Chippewa Street, and Watson Road. In 1936, this route received designation as City 66, and the main river crossing shifted north to the Chain of Rocks Bridge.

Further confusing issues during this period is another routing of City 66. This alignment utilized Riverview Drive from the Chain of Rocks Bridge to Broadway, and then Calvary Avenue, Florissant Avenue, Herbert Street, Thirteenth Street, Twelfth Street, and Tucker Boulevard.

The 1955 realignment utilized the Veteran's Memorial Bridge as the primary river crossing and the Third Street Expressway, later I-55, to City 66 at Gravois Avenue.

The City 66 designation was eliminated in 1963, but with the realignment of Route 66 to the Poplar Street Bridge in 1967, Gravois Avenue, Chippewa Street, and Watson Road became the main route for the highway.

In February 1975, U.S. 66 and I-44 utilized the same corridor. Decertification in St. Louis occurred in 1977.

Along the eastern border of the city, the bridges spanning the Mississippi River are the first landmarks encountered by westbound travelers. The McKinley Bridge built in 1910 served as the initial river crossing for Route 66. The Municipal Bridge that opened in 1916 served as the river crossing for Route 66 from 1929 to 1935, and City 66 from 1936 to 1955. From 1936 to 1955, the Chain of Rocks Bridge built in 1929 served as the primary river crossing. It also served as the crossing for Bypass 66 from 1955 to 1965. The Veteran's Memorial Bridge, now named the Dr. Martin Luther King Jr. Bridge, that opened in

1951 carried Route 66 traffic across the river from 1955 to 1967. The Poplar Street Bridge, currently the river crossing for Interstates 55, 70, and 64, served as the river crossing for Route 66 from 1967 to 1977.

The most noticeable initial landmark for westbound travelers on Route 66 today would be the Gateway Arch that towers over the Jefferson Expansion Memorial, visible from the Poplar Street Bridge. Completed in 1965, this engineering marvel has come to symbolize the city.

One of the oldest landmarks to cast its shadow over Route 66, the former Third Street Expressway that is now the depressed lanes of I-70, is the Basilica of St. Louis built in 1834. All other buildings in this area were cleared for construction of the Jefferson Expansion Memorial.

Other historic landmarks include the Jefferson Hotel (1904), transformed into the Jefferson Arms, a retirement community, before abandonment; the Missouri Pacific Building (1929); the Mart Building (1931); the St. Louis City Hall (1904); and St. Frances De Sales Church (1908).

Route 66 landmarks are also plentiful. These include Bauer's Ranch House at 5805 Chippewa Street, now a doctor's office; Joseph Mittino's at 6600 Chippewa Street that opened in 1940; the Ivy Motel, still operational at 10143 Olive Street; and the Airport Motel, 1936, still operational at 6221 Lindbergh Boulevard. Other locations of note include the Big Chief, now the Big Chief Roadhouse, opened by the Pierce Pennant Petroleum Company at 17352 Manchester Road in 1929; the oldest continuously operated tavern in St. Louis at 9243 Manchester Road (the Trainwreck Saloon); and the iconic Ted Drewes Frozen Custard on Chippewa Street.

STONEYDELL RESORT

Built by George Prewett in 1932 on the site of a campground on the Cherokee Trail of Tears, the Stoneydell complex consisted of a hotel, restaurant, ten cabins, large goldfish pond, and one hundred–foot swimming pool. Built utilizing area stone, the resort was a landmark on the highway for a number of years.

In 1967, construction on I-44 necessitated the razing of most of the complex. As of early 2010, the restaurant, goldfish pond, and a couple of cabins remained.

The MacArthur Bridge, formerly the Municipal Bridge, originally opened in 1916 and served as the primary Mississippi River crossing for Route 66 from 1929 to 1935 and for City 66 from 1936 to 1955. *Joe Sonderman*

George Prewett opened Stonydell Resort with its one hundred–foot swimming pool, hotel, cabins, restaurant, gold fish pond, and justice of the peace in 1932.
Steve Rider

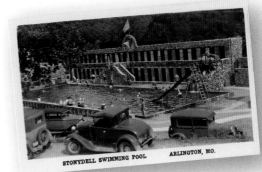

STONYDELL SWIMMING POOL ARLINGTON, MO.

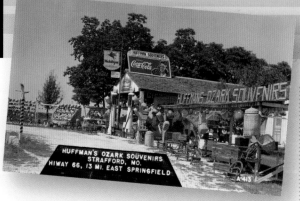

Route 66 provided a lucrative market for the artisans of the Ozarks who made baskets, pottery, and folk art. Stores such as Huffman's in Strafford, Missouri, lined Route 66 from Lebanon to Springfield. *Steve Rider*

STRAFFORD, MISSOURI

The platting of Strafford, Missouri, on lands once deeded to the Kickapoo Indians for a reservation coincided with completion of the railroad to this point in 1870. The developer was a J. Strafford, who claimed to be from Strafford, Connecticut.

The town's location on Missouri Route 14, Route 66 after 1926, transformed the community. The small town received international notoriety in the 1950s with its inclusion in *Ripley's Believe It or Not* for being the only town in the United States with two main streets and no alleys.

The original alignment of Route 66 ran through the north side of the community. Realignment in the early 1940s placed the highway between the railroad tracks and the backs of businesses. Owners resolved the problem by adding façades and entrances to the rear of their buildings, resulting in most businesses having two fronts and no rear.

Ripley's Believe It or Not noted that Strafford, Missouri, was the only town in the United States with no back alleys between its two main streets. *Joe Sonderman*

ST. ROBERT, MISSOURI

Settlement in the area known as Gospel Ridge dates to almost a century before establishment of the town of St. Robert, Missouri.

The community itself, incorporated in 1951, began with the opening of a Catholic church by Reverend Robert J. Arnold and a string of roadside service facilities built immediately outside the parameters of Fort Leonard Wood in the 1940s.

One of the earliest businesses here was the Scott Garage built in the late 1920s. During the 1940s, the building underwent a dramatic refurbishment that included an elaborate stone façade and transformation into a drug store, gift shop, general store, and dance hall with "dime a dance" girls. With construction of Interstate 44, the building was leveled.

Another casualty of the interstate highway construction was the Wagon Wheel Station and Café established by James Egan in about 1930. In the 1940s, the building became a nightclub, and the Ramada Inn Fort Wood occupied the site until 2010.

STROUD, OKLAHOMA

The initial settlement here was the result of James Stroud's trade with area tribes. With the addition of agriculture-related development, the community became large enough to warrant approval of a post office application in September 1892.

When Oklahoma achieved statehood in 1907, Stroud lost an integral component of its economy, the sale of whiskey and liquor, since the state was declared dry. As a result, agriculture, and shortly after, oil, fueled economic growth into the teens.

On March 27, 1915, legendary frontier-era outlaw Henry Starr resumed his career as a bank robber by robbing two banks in Stroud. The daring feat garnered national headlines and for a brief moment placed the community in the spotlight.

Additional economic diversification in the form of service industries catering to traffic on the Ozark Trail, and later Route 66, ensured relative stability even during the Great Depression. The postwar surge in travel on Route 66 fueled additional growth in this sector.

With its location on the Ozark Trails Highway System, Stroud, Oklahoma, began developing an infrastructure to meet the needs of motorist by the mid-teens. *Steve Rider*

The Sunrise Motel received inclusion in the AAA *Western Accommodations Directory* in 1954 and 1955 with rates ranging from $4.00 to $6.50 per night. Demolition occurred in 2007 during the construction of I-44 interchange. *Mike Ward*

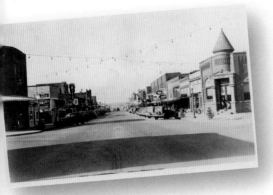

Main Street in Stroud, Oklahoma, was the course through town for the Ozark Trails Highway as well as the initial alignment of Route 66. *Steve Rider*

F. E. Dobbs contracted a gifted stonemason known locally as Grandpa Berti to build the stunning Shamrock Motel in 1945. As of 2011, the building still stands along Route 66. *Mike Ward*

Still, in 1946, a popular travel guide noted that the town offered all services but was short on lodging choices. For historic lodging choices, little has changed, as indicated by the fifteenth edition of the *Route 66 Dining & Lodging Guide*, published by the National Historic Route 66 Federation in 2011, which lists only the Skyliner Motel.

The bypass of Route 66 dealt a harsh blow to the economy of the community. The resurgent interest in that highway, however, has led to refurbishment of several historic properties, the most notable of which is the Rock Café built in 1939.

SULLIVAN, MISSOURI

There are references to a community named Mount Helicon near the site of Sullivan before 1856. The current community built adjacent to that area is named for Stephen Sullivan, a developer who platted the town site in 1858, donated land for the Frisco Railroad Depot, and had a station built.

The community remained largely agricultural and dependent on the railroad until the advent of automobile tourism after 1910, which gave rise to a supportive infrastructure. With the certification of Route 66 in 1926, and development of the nearby Meramec State Park, as well as Meramec Caverns, this segment of the economy grew exponentially.

The 1940 edition of the *Directory of Motor Courts and Cottages* published by AAA lists the Sullmo Hotel and Cabins with a $2.00 rate for a single. With public showers and café, the facility was also noted by Jack Rittenhouse in 1946. In *The Missouri U.S. 66 Tour Book*, published by C. H. Curtis in 1994, the author notes that at that time, the St. Anthony's School stood on the site.

The Sullmo Hotel began as a private residence, built at some point around 1900. Its conversion into a hotel took place around 1930 as a result of its location facing Route 66. In 1935, further expansion of the facility included the addition of cabins.

The *Western Accommodations Directory*, published by AAA in 1954, lists two motels, Sunrise Motel and Shamrock Motel. The Sunrise Motel remained in existance until late 2007, when it was razed to accommodate an improvement to the Interstate 44 interchange. The Shamrock Motel, opened as the Shamrock Court in 1945, still remains. The facility is rather striking, a result

of the extensive use of stone facing and the craftsmanship of an Italian immigrant stonemason known locally as Grandpa Berti.

Curtis, in his guidebook, also notes that at the four-way stop with Elmont Road stands Scott Welding. The building utilized by this company began as a Standard station and garage in 1927, with mechanics on duty twenty-four hours a day.

The Grande Courts, initially promoted as the "Pride of Sullivan," opened in the late 1940s. Extensive remodeling of the forty-room complex, with its landscaped courtyard and swimming pool, transformed it into a modern motel signed as the Hitching Post Motel. Adjacent was Snell's Café, promoted as the home of "Awful Good Food" with Mr. and Mrs. Fred Snell Sr. as owners. The Family Motor Inn now occupies the site of the motel, and the Snell's Café building housed an antique mall until 2010.

249

SUMMIT INN AND CAFÉ

The current incarnation of the Summit Inn and Café located at the summit of Cajon Pass in California opened in 1952. It is the replacement for the original Summit Inn on an earlier alignment of Route 66, at a site now located between the eastbound and westbound lanes on Interstate 15.

When the facility was built by Gordon Fields for Burton and Dorothy Riley, Route 66 remained a two-lane highway on the east side of the property. Extensive upgrades to the highway, including the transformation to four lanes, resulted in realignment to the west side of the property in 1955.

The construction of Interstate 15 in the late 1960s truncated or obliterated all alignments of Route 66, but the Summit Inn and Café remained a viable business with the service station portion of the complex relocated to the end of the property closest to the newly constructed off-ramp. The Summit Inn and Café still exists as of 2011 and is a poplar stop for Route 66 enthusiasts as well as local vintage car clubs.

The *Route 66 Dining & Lodging Guide*, fifteenth edition, published by the National Historic Route 66 Federation in 2011, gives the property a "must stop" recommendation.

Similar variations of the Summit Inn met the needs of Route 66 travelers before the construction of the four-lane alignment of Route 66 in 1955 necessitated relocation to the current site on the west side of the highway. *Steve Rider*

SUNSET MOTEL

Located west of St. Louis, Missouri, at the intersection of U.S. 66 and U.S. 50, the Sunset Motel dates to the mid-1940s. Renowned for its beautiful neon signage and buff brick façade, it remains operational.

From 1971 to 2006, Oliver Lee and Loleta Krueger served as proprietors. Their family currently manages the property. The unique neon sign underwent renovation in 2009, made possible by a matching funds grant provided by the Route 66 Corridor Preservation program and assistance from the Route 66 Association of Missouri.

The recently renovated Supai Motel in Seligman, Arizona, opened in 1952 and derived its name from the village of Supai, the only town on the Havasupai reservation.

SUPAI MOTEL

Located at 134 East Chino Avenue in Seligman, Arizona, the Supai Motel, drawing on the name of the Havasupai tribe located to the north of town, opened in 1952. At that time, promotional material billed it as "Seligman's newest and finest."

The resurgent interest in Route 66 led to a complete renovation of the fifteen-unit complex. Recently, refurbishment of the neon signage was completed.

SYCAMORE INN

Dating to 1848, the Sycamore Inn at 8318 Foothill Boulevard in Rancho Cucamonga, California, is purportedly the oldest restaurant on Route 66. Initially, it served as a stop for the Butterfield Overland Company.

A major fire followed by extensive expansion and modification by John Klusman in 1912 obliterated the original facility and resulted in its new look as a historic European inn. Additional renovations of the historic property occurred in 1939, and the Sycamore Inn is today renowned throughout the Los Angeles area for fine cuisine and unique ambiance.

T

TECOLATE, NEW MEXICO

Tecolate is located on the pre-1937 alignment of Route 66 southwest of Las Vegas, New Mexico. The origins of the community date to 1824, when the family of Salvadore Montoya established a small farm that later became a supply center at this location on the Santa Fe Trail.

It was in the plaza of Tecolate that General Stephen Kearny, in August 1846 during the Mexican–American War, announced that the citizens were no longer under Mexican sovereignty. In 1850, the U.S. Army established an outpost and supply center here during the campaigns against the Navajo and other warring tribes.

William Anderson Thornton, a member of a military expedition in the summer of 1855, noted in his diary, "The villages of Vegas and Tecolate made from unburnt clay and in appearances resemble unburnt brick kilns in the States. People poor and dirty. Flocks of sheep, goats, and cattle very numerous. Wheat and corn raised by irrigation."

The small community retains a feel for the pre-statehood era, and numerous vestiges provide tangible links to early history. Among these would be the small adobe church of indefinite origin and a Santa Fe Trail marker.

TEPEE CURIOS

Tepee Curios, 924 Highway 66, in Tucumcari, New Mexico, opened in 1944 as a Gulf service station owned by Leland Haynes. Shortly after acquisition by Jene Klaverweiden in late 1959, extensive alterations were made, including construction of a half tepee at the front entrance, enclosure of the service bay, removal of the gasoline pumps, and addition of neon trim and signage with the name Jene Klaverweiden's Trading Post. Recent refurbishment of the front façade and the neon sign allows visitors to see it as it was in the early 1960s.

Before its conversion into Jene Klaverweiden's Trading Post, Teepee Curios in Tucumcari, New Mexico, opened as a service station, curio store, and small grocery in 1944.

TEWA LODGE

Designed in a Pueblo style by architect S. V. Patrick, the Tewa Lodge opened at 5715 East Central Avenue in Albuquerque, New Mexico, in 1946 under the ownership and management of H. C. Harvey. The *AAA Western Accommodations Directory* for 1954 lists amenities as "air cooled units of one or two rooms, radios, telephones, tiled shower baths, vented heat and car ports; free TV in some units. Four housekeeping units. $6.50 to $9.50."

Now listed on the National Register of Historic Places, the Tewa Lodge remained operational as of 2010.

Listed on the National Register of Historic Places, the Tewa Lodge opened at 5715 East Central Avenue in 1946. Owners over the years have included Senator Edward Mechem, who purchased the property in an investment partnership. *Mike Ward*

TEXOLA, OKLAHOMA

Texola, as with Glenrio on the west end of the Panhandle, suffers from a case of conflicted identity. Straddling the Texas/Oklahoma border, the tiny hamlet founded in 1901 has been surveyed eight different times and, depending on the survey, has been listed as being in Texas or Oklahoma. However, it is currently listed as an Oklahoma community one-half mile east of the border.

The conflict of identity is also apparent in the different names the community has had. At various times, maps show it as Texokla, Texoma, or Texola.

In late October 1905, a fire nearly erased the community. The *Galveston Daily News* on October 26, reported the following: "A fire today at Texola [Oklahoma] destroyed two business blocks, making a clean sweep from the Boxley & Company's grocery store down Main Street. The Terrill hardware store, Boxley grocery, Howard drug store, a saloon, racket store, confectionary store, and butcher shop were burned as were also several unoccupied buildings."

In April 1908, another fire devastated the business district. The *Muskogee Times Democrat* reported on April 29, 1908 that "four buildings on the main street of this town have been destroyed by fire and the total loss of buildings and stocks is placed at $20,000. The fire is believed to have been of incendiary origin. The losses are as follows: Kukendall Bros. dry goods and groceries, $10,000, insurance, $5,000, W.T. Smith, vacant building, $1,000. Howard's Drug Store, $3,000, insurance, $3,000."

After a string of robberies in neighboring communities spanning two years, the national media began to follow the story. In January 1908, a violent robbery in Texola fueled the attention. According to *The Washington Post* of January 19, 1908, "After a hand to hand fight with Assistant Cashier Jones, two masked men tonight robbed the First National Bank of Texola of about $4,000. Jones was found bound, gagged, and insensible from a blow to the head."

Change came slowly to the western plains, and as late as the 1940s, the little village gave the appearance of suspension in a preterritorial time warp. Jack Rittenhouse noted this in his route guide: " . . . Gas, cafes; no courts; limited facilities. This sun-

baked small town has an old section of stores which truly savor of pioneer days. Notice them to your right on the town's one main cross street. They have sidewalk awnings of wood and metal, supported by posts."

Originally, the lands here were ceded to the Choctaw tribe by treaty, but an 1896 Supreme Court ruling designated them a part of the territory of Oklahoma. Settlement in the area began in earnest in the 1880s. Establishment of the railroad at the turn of the century provided the accoutrements of civilization necessary for the establishment of towns on these plains.

Texola today is almost a pure ghost town with a population counted in the double digits. This has kept the vandalism to a minimum, but the ravages of time are taking their toll. Still, a wide array of remnants from better days remain, and many of these bridge the gap between the days of the western frontier and the glory days of Route 66. Perhaps the most notable is the tiny stone jail dating to 1910.

In 1946, Jack Rittenhouse described Texola as being a "sun-baked small town." He also noted that available services were limited to a couple of cafes and gas stations. *Steve Rider*

Texola, Oklahoma, on the Texas and Oklahoma border, survived devastating fires and the Great Depression, but the bypass of Route 66 proved to be its undoing. *Steve Rider*

THAYER, ILLINOIS

Thayer is a small agricultural community that has faded to a residential district and several closed businesses. Date of origination is unknown.

THOREAU, NEW MEXICO

The first post office application filed in 1886 for this community was under the name Chavez, a reflection of the family that opened a store at this siding established by the Atlantic & Pacific Railroad in 1881. This name remained in effect until 1892.

In 1890, William and Austin Mitchell relocated their Michigan timber business to the Zuni Mountains near Chavez, hoping to capitalize on the proximity to the railroad siding. The survey of a town site and post office application filed for a name change to Mitchell commenced in 1891.

The third name change transpired in 1899, shortly after the Hyde Exploring Expedition established an extensive Indian trading network with Mitchell as the headquarters. Contrary to local legend, the namesake for the change to Thoreau was the naturalist Henry David Thoreau.

Route 66 travelers in the 1940s could avail themselves of the services offered by the Thoreau Trading Post or Beautiful Mountain Trading Post as well as a gas station and garage. The population as of 1940 was 375.

Listed on the National Register of Historic Places in 1993, Roy Herman's garage and service station survives as one of the oldest examples of a franchise-styled service station in western New Mexico. Initially, the building served as a Standard Oil Company station in Grants, New Mexico, opening in 1935.

In 1937, the steel panels over steel framework building was dismantled, relocated to Thoreau, and reopened as the first business along the new alignment of Route 66 that bypassed the business district of that community by a half mile. In 1963, the building was again relocated, this time to a new location on Route 66 several hundred yards to the west.

THREATT FILLING STATION

Built of locally quarried sandstone in a Bungalow-Craftsman style that originally included lodging for the proprietor, the Threatt Filling Station is located at the intersection of Historic Route 66 and North Pottawatomi Road three miles east of Luther, Oklahoma, and dates to at least 1915.

With the exception of a small addition built to the rear in the early 1960s, the building remains unchanged from its initial construction by Allen Threatt. The early date of construction is a result of the creation of State Highway 7, later U.S. 66, along the northern border of the Threatt farm.

The Threatt family immigrated to the area with other former slaves in 1899 and began homesteading after establishment of the federal system of land allotment for the Oklahoma Territory. In addition to farming, the Threatt family began a sandstone quarry and, after 1915, operated the service station.

The African American ownership, and the catering to travelers of similar ethnicity, made the property unique as well as profitable. This and the exceptional state of preservation led to its listing in the National Register of Historic Places in 1995.

As of 2011, the facility served as a private residence.

TIMES BEACH, MISSOURI

In an odd twist of irony, the idyllic Route 66 State Park on the Meramec River mirrors the vision of those who established a small resort community on this site seventeen miles west of St. Louis in 1925. It also masks the tragedy that claimed the community of Times Beach.

After acquiring a 480-acre site on a flood plain utilized for farming, the owners of the *St. Louis Star Times* initiated an unusual sales promotional campaign to increase the paper's circulation. For $67.50, a customer could purchase a twenty-by–one hundred-foot lot and receive a six-month subscription to the newspaper. There was a slight catch: to utilize the property and build a house required the purchase of a second adjoining lot.

Because this was largely a summer resort, and the area was prone to flooding, stilts were foundational elements of the

The Bridgehead Inn opened in 1935. It now houses the Route 66 State Park visitor's center and is the only building that remains from the community of Times Beach. *Steve Rider*

cottages built. By 1930, residents were building homes that were more substantial, a reflection of the move from resort to community. This and a growing business district to meet the needs of full-time residents, as well as travelers on Route 66, gave the town an atmosphere of stability.

Steiny's Inn, Famous for Fine Food

Overlooking the Meramec, Highway 66, Eureka, Mo.

Edward Steinberg purchased the Bridgehead Inn in Times Beach, Missouri, in 1947, remodeled the property, and changed the name to Steiny's Inn. He operated the complex until 1972. *Steve Rider*

TIMES BEACH, MISSOURI *continued*

This shift from resort to town marked the beginning of a new chapter in the history of Times Beach. The next chapter began with World War II, gas rationing, and the immediate postwar housing shortage that again transformed the character of "The Beach," as residents called it.

By 1970, 1,240 people called Times Beach home, and the community was slowly moving beyond its postwar image as a low-income collection of mobile homes and cracker-box houses. Perhaps the most notable manifestation of this change was the decision to address the town's 16.3 miles of dusty, unpaved streets.

With a budget insufficient to meet the projected cost of paving, city administrators instead turned to oiling the roads to control the dust. Contracted for this endeavor was Russell Bliss, owner of a small company that hauled waste oils and other materials. What city management did not know is that Bliss was also hauling waste for the Northeastern Pharmaceutical and Chemical Company of Verona, Missouri, a major producer of Agent Orange during the Vietnam War. As a result, for several years, Bliss sprayed the streets of Times Beach with material laden with deadly dioxins.

In the fall of 1982, an investigative reporter turned his attention to Times Beach after establishing a link between Russell Bliss and the deaths of dozens of horses at stables he had sprayed with waste oil. This investigation was quickly followed by one initiated by the Environmental Protection Agency.

On December 5 of that year, the worst flooding in the town's history forced an almost complete evacuation. Eighteen days later, the EPA notified residents and the community's administration that "if you are in town it is advisable for you to leave and if you are out of town do not return."

In an instant, the obscure little community of Times Beach dominated international headlines and became synonymous with deadly environmental degradation, the bane of the modern era. By 1985, mandatory evacuation was complete, negotiated buyouts were underway, and the town site quarantined.

In 1996 and 1997, the final chapter in Times Beach history began to unfold. An incinerator built on the site at a cost of $110 million dollars burned 265,000 tons of contaminated soil and materials. Upon completion of the project that included certification the site was clean, the property reverted to the state of Missouri, which reopened it as Route 66 State Park in 1999.

There are but two remnants of the little town on the banks of the Meramec River, one a monument to Times Beach, the other to Route 66. Steiny's Inn, a 1935 roadhouse, now serves as the park's visitor center, and a beautiful steel truss bridge, closed in 2009, stands in mute testimony to the forgotten town's ties to legendary Route 66.

TINNIN, EARL

Earl Tinnin had association with several enterprises along Route 66 in eastern Arizona before becoming the proprietor of Two Guns in 1933. In 1935, he opened the Toonerville Trading Post to the west of the Two Guns complex. He managed this enterprise until 1954, when he sold it to Daniel McAlister, who was killed in a robbery there in August 1971. The building is now a private residence.

Shortly before the sale of the Toonerville Trading Post, Tinnin acquired the Ben Franklin Motel at 1416 East Santa Fe Avenue in Flagstaff, Arizona. The *Western Accommodations Directory*, published by AAA in 1954, noted that this motel was "very good, nicely furnished one and two room units have radiant or hot water heat with thermostat control and tiled shower baths; radios available. 1 housekeeping unit. Some garages. Patio. $7.50 to $10.00."

TOPOCK, ARIZONA

Purportedly, the word *topock* is a corruption of the Mohave Indian word for bridge. Initially, the small community established along the river here used the name Lieutenant Amiel W. Whipple had used to describe the mountain peaks nearby: Needles. With completion of the railroad to this point in 1883, the approved application for a post office used this name, but during the same period, a community on the California side of the Colorado River also used the name Needles.

In late 1883, an amended post office application changed the name of Needles,

In 1946, about fifteen years after this photo was taken, Jack Rittenhouse noted that Topock consisted of a gas station, grocery store, garage, and cabins complex. *Steve Rider*

Topock Camp Calif-Ariz Line - Topock Arizona

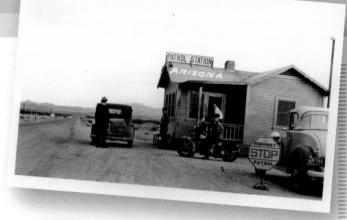

In the 1930s, the Arizona Port of Entry near the Arizona/California state line and similar border stations were the bane of westbound migrants fleeing the Dust Bowl. *Steve Rider*

The realignment of Route 66 in western Arizona in 1952 bypassed the steep grades and sharp curves of the Black Mountains, a course also followed by the National Old Trails Highway. *Steve Rider*

Arizona Territory, to Powell. With a decline in population, the post office closed but reopened in 1903. The new application listed the name as Mellon in deference to Captain Jack Mellon, a Colorado River steamboat captain of legendary acclaim.

In 1909, the post office again closed as a result of declining population. This trend reversed in 1915, but the new application for a post office using the name Needles was rejected, since the community on the California side of the river was using the same name. An amended application utilized the name of the station given by the Atchison, Topeka, & Santa Fe railroad: Topock.

Topock served as a primary river crossing. From 1890 to 1914, Joe and Nellie Bush operated a ferry, the *Nellie T*, here. The town supported a few small service businesses that met the needs of travelers on the National Old Trails Highway, as well as Route 66. Jack Rittenhouse, in 1946, noted the population as being fifty-two and available services included a gas station, store, cabins, and garage.

Topock and Golden Shores remain small communities that cater to recreational use of the Colorado River and are home to visitors from northern locations who winter here. Tangible links with Route 66 are negligible.

TOWANDA, ILLINOIS

Initial settlement here was with the name Money Creek used on the first post office application in 1843. Platting of a town site occurred in 1854 in conjunction with the construction of the Chicago & Mississippi Railroad. Peter Badeau and Jesse Fell—the founder of the Illinois State Normal University, now Illinois State University—were the surveyors. Fell selected the town's new name to reflect his birthplace, Towanda in Bradford County, Pennsylvania, unaware that the name was a Delaware word for burial place.

Approval of an amended post office application in 1855 made the new name selection official, and Towanda remained a small, rural agricultural community into the modern era. Jack Rittenhouse, in 1946, noted that "a small business district is off the highway."

Today, Towanda is a destination for Route 66 enthusiasts as a result of the community's creative use of an abandoned section of that highway. Entitled "Historic Route 66 Illinois—A Geographic Journey," this walking and bicycle trail features displays from all eight states through which the highway passes as well as re-created Burma Shave signs.

This creative use for an abandoned section of Route 66 is part of an initiative that, when completed, will constitute a three hundred–mile Route 66 bike trail. Where possible, such as with this section at Towanda, original bridges are being utilized on the trail.

The Del-Co Truckers Lodge near Towanda, Illinois represented an evolutionary step in the transition from complex dedicated to meeting the needs of the fledgling long haul truck drivers and the modern truck stop that is almost a fully self-contained city. *Steve Rider*

Located in Santa Rosa, New Mexico, on U.S. 54, U.S. 66, and U.S. 84 across from the Club Café, the Tower Motel, formerly Tower Courts, opened in 1950 and continues to provide lodging today. *Mike Ward*

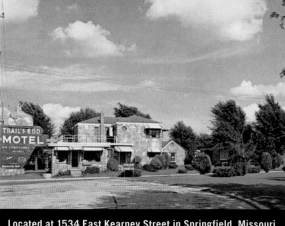

Located at 1534 East Kearney Street in Springfield, Missouri, the Trail's End Motel (formerly the Trail's End Motor Court) opened in 1949. It currently operates as the Rancho Court Apartments. *Mike Ward*

TOWER COURT

Built by Ben Shear in 1939, the Tower Court on Central Avenue in Albuquerque, New Mexico, utilized the typical 1930s auto court layout of a U shape with garages adjoining each unit. To differentiate his motel from others on this corridor along Route 66, Shear added a thirty-foot-tall tower containing the motel office and his living quarters at the front of the property.

Shortly after opening, a second story consisting of two units mirroring the lower units transformed the rear wing of the facility. Changes to the property since this addition include renaming it Tower Motel, enclosing the garages, and removing the trademark tower.

Added to the National Register of Historic Places in 1992, the Tower Motel remains as one of a handful of prewar auto courts on the Central Avenue alignment of Route 66 in Albuquerque. Currently, the facility serves as an apartment complex.

TOWER COURTS

In 1950, Ira Smith, who had opened the Pecos Theater in 1936, expanded his various business enterprises in Santa Rosa, New Mexico, by opening the thirty-two-unit Tower Courts. New ownership in late 1952 resulted in renaming the property Tower Motel.

The *Western Accommodations Directory*, published by AAA in 1955, noted the property featured "air cooled one to three room units with vented heat and tiled shower or combination baths. Twelve new units, 20 car ports. Radios available." As of mid-2011, it remained an operational motel.

TRAIL'S END MOTOR COURT

The Trail's End Motor Court—later Trail's End Motel and currently the Rancho Court Apartments at 1534 East Kearney Street in Springfield, Missouri—opened in 1949. Built with extensive use of Ozark stone, the property featured landscaped grounds, a two-story home for the owner, and a substantial sign with stone base topped by an American Indian on horseback trimmed in neon.

The 1955 edition of the *Western Accommodations Directory*, published in 1955, noted the facility located on "U.S. 66 & 166 By-pass" featured air-conditioned or air-cooled units with one or two rooms, radios, vented heat, shower or combination baths, television in some rooms, and a playground. Additionally, the entry notes a service station on site. Rates ranged from $4.50 to $8.00 per night.

TRANSCONTINENTAL AIR TRANSPORT

Transcontinental Air Transport, a pioneering airline founded by Clement Keys in 1928, utilized the concept of combining air and rail transport for rapid cross-country travel, and it was the first airline to offer in-flight meals. It played a key role in the modernizing of several communities along Route 66, especially in the Southwest.

Enlisting the aid of Charles Lindbergh for his expertise, as well as promotional potential, a series of airports was established and navigational beacons were developed. On July 7, 1929, a forty-eight-hour coast-to-coast trip served as the inauguration of the system.

The first leg was via the Pennsylvania Railroad from New York City to Columbus, Ohio, an overnight jaunt. Passengers then boarded a Ford Trimotor plane at the Port Columbus Airport for a flight to Waynoka, Oklahoma, with refueling and inspection stops in Indianapolis, St. Louis, Kansas City, and Wichita.

At Waynoka, Oklahoma, passengers boarded a Santa Fe Railroad train for an overnight run to Clovis, New Mexico, where they again boarded an aircraft. To meet the needs of passengers, and as refueling stops, airfields were established in Albuquerque, New Mexico; Winslow, Arizona; Kingman, Arizona; and Los Angeles, California. The trip from beginning to end took about forty-eight hours.

In 1929, Transcontinental Air Transport merged with Maddux Air Lines. In 1930, this company merged with Western Air Express and reorganized as Transcontinental & Western Air, a company that again reorganized shortly after as TWA.

The offices for the TAT airline in St. Louis were in the Jefferson Hotel at Twelfth and Locust Streets. This hotel served as the venue for the meeting of highway officials in 1925 at which the highway between Chicago and Los Angeles received the designation U.S. 60. *Joe Sonderman*

TROUP, ROBERT JR.

Robert William "Bobby" Troup Jr. was a moderately successful songwriter in the early 1940s, with his songs performed by Sammy Kaye and his orchestra, Frank Sinatra, Connie Haines, the Andrew Sisters, Glen Miller, and Tommy Dorsey. While driving to California with his wife, Cynthia, Troup developed the idea for a song entitled "Get Your Kicks on Route 66."

The song, first recorded by the Nat King Cole Trio in 1946, became a major hit for that group, topping the R & B, and popcharts. Troup had a lucrative and diverse show business career, but this single song overshadowed much of his work.

He continued to write a wide array of music for many leading recording artists, served as a panelist on the pioneering television program *Musical Chairs*, and provided much of the music for this trivia-based program. Additionally, he played host on the NBC program *Stars of Jazz*, starred in several movies (including *The Gene Krupa Story*, released in 1959), played himself in the television series *Acapulco*, and starred in the television program *Emergency*.

His signature piece, "Get Your Kicks on Route 66," became an anthem, an internationally recognized classic, and one of the most recorded songs of all time. Groups and singers as diverse as Bing Crosby and the Rolling Stones, Brad Paisley and Chuck Berry, Jerry Lee Lewis and Mel Torme have all recorded this song.

With the resurgent interest in Route 66, the song retains its popularity and association. The 2006 Disney-Pixar film *Cars* featured the song in its soundtrack.

TRUXTON, ARIZONA

Clyde McCune was a cofounder of the town of Truxton. In an interview with Jon Robinson for *Route 66 Lives on the Road*, McCune described the town's origins in this manner: "The Department of the Interior had been talking about building a dam across the Colorado River at Bridge Canyon, and the reasonable way to get to that from Highway 66 was the take off there from Truxton.

"The road would have gone up to the reservation and then taken what we call the Buck and Doe Road out to the canyon. That's the reason we set up our business there in 1950."

The dam never materialized, but the Truxton Garage opened by McCune and Don Dilts prospered. In fact, it proved so prosperous that Dilts soon opened a service station and restaurant next to the garage.

In rapid succession, other entrepreneurs followed suit, and other service stations, motels, restaurants, and garages crowded the shoulder of Route 66 in the wide valley at the head of Crozier Canyon. With the opening of Interstate 40 and the bypass of this section of Route 66 on September 22, 1978, Truxton rapidly began to regress to its pre-1960 origins.

Today, the little town dwarfed by boundless, cinematic western landscapes maintains the slightest of pulses with the Frontier Motel and Café, a bar, Cowgills Market, and a garage/service station still meeting the needs of travelers on Route 66, area ranchers, and residents of Peach Springs.

The historic association with the site of Truxton is a lengthy one, but the town itself is a relative newcomer in Western Arizona, as it dates to 1951. A garage, bar, and the Frontier Café and Motel are the only operating businesses.

The owners of Cowgills Market in Truxton, Arizona, proudly proclaim the market's location on Route 66 and provide several unique photo opportunities for Route 66 enthusiasts.

TUCUMCARI, NEW MEXICO

There is a colorful legend about the name Tucumcari that centers on the romance of two Indians, Tocom and Kari, but this is fiction. However, the consensus is that Oklahoma linguist Elliot Canonge is correct in asserting that the name derives from a Comanche word for lying in wait for someone to approach: *tukamukaru.*

Tucumcari Mountain, at 4,956 feet, is the dominant feature of the surrounding landscape. This mountain with its commanding views of the surrounding area was a popular lookout for the Comanche. A burial record from 1777 notes the capture of a Comanche woman at Cuchumcari.

Numerous early trails crossed the plains at this location, since Tucumcari Lake northeast of the present community

A 1954 promotion for the Tocom-Kari Motel heralded amenities like alarm clocks, locking garages, and radios for $4.00 to $7.00 per night. *Mike Ward*

This stunning sculpture that hints of the area's rich history from the pre–Spanish colonial period through the era of the chrome bedecked tailfin and Route 66 stands at the east end of Tucumcari, New Mexico. *Judy Hinckley*

The La Cita restaurant in Tucumcari, New Mexico, opened at its current location in 1961. The original restaurant opened in 1940 at 812 First Street. *Judy Hinckley*

offered one of the few dependable sources for water year-round. One of the most famous of these trails was that established by the Goodnight-Loving cattle drives.

In 1901, the Chicago, Rock Island & Pacific Railroad (CRI & P) Railroad extended its line to the site of the modern community of Tucumcari and established a siding. For reasons unknown, the initial post office for the village that formed around the siding was under the name Douglas, but in 1902, an amended application changed this to Tucumcari.

For most of the following decade, the railroad continued to serve as the primary catalyst for growth. An article in the *Santa Fe New Mexican*, dated September 3, 1903, provides insight into this development with details pertaining to the agreement between the Choctaw, Rock Island, Santa Fe and El Paso & Northeastern Railroads to make Tucumcari the division point: "Tucumcari will derive a great deal of benefit from this new deal. [I]t means that Tucumcari will have a population of six to eight thousand people within the next two or three years." The article also notes plans for immediate construction of railroad infrastructure. This included roundhouses, shops, and a joint depot.

Establishment of Route 66, and extensive irrigation systems after the completion of Conchas Dam, transformed the community and added diversity to the economy. The guidebook published by Jack Rittenhouse in 1946 contains an extended entry for Tucumcari, in which he lists three repair facilities (Waller Motor Company, Pelzer, and Tucumcari Motor Company), four hotels, and ten auto courts. One of the courts listed in that guide, Linns Golden Court, is also one of the recommended lodging choices for Tucumcari listed in the 1940 edition of the *Directory of Motor Courts and Cottages* published by AAA. The second is Camp Traveler on U.S. 54 rather than U.S. 66.

During the 1950s, the launching of a promotional campaign that included red billboards along Route 66 proclaiming "Tucumcari Tonight" and "2,000 Motel Rooms" further fueled development of the service industry. A New Mexico Department of Transportation study conducted in 1959 indicated an average of eight thousand vehicles per day traversed the city on Gaynell Boulevard, renamed Tucumcari Boulevard after 1970, and Route 66 Boulevard after 2004.

In the 1949 edition of *The Negro Motorist Green Book,* entries for New Mexico are quite sparse. Surprisingly, Tucumcari offered a number of facilities. These include Henry Jones Barber Shop, 211 North Fifth Street; Swift's Garage on Highway 66; and the Rocket Inn at 524 West Campbell Avenue.

The 1955 edition of the *Western Accommodations Directory* published by AAA lists nine motels: Blue Swallow Motel, now an icon visited by thousands of Route 66 enthusiasts annually; Buckaroo Motel; Cactus Motor Lodge; Circle S Motel; Conchas Motor Lodge; Palomino Motel; Rainbow's End Court; Tocom-Kari Motel; and Traveler's Paradise Motor Lodge.

The bypass by Interstate 40 devastated the community. However, a wide array of Route 66–related businesses and buildings still remain, and the resurgent interest in the highway has resulted in creative efforts to acquire and restore vintage businesses, as well as renovate empty properties by painting them to appear as time capsules representing Whiting Brothers and other period enterprises.

The Cactus Motor Lodge opened in 1941. It is now an RV park, but funding from the National Park Service Route 66 Corridor Preservation Program resulted in restoration of the vintage signage in 2008. The Palomino Motel opened in 1953 at 1215 East Highway 66 and as of 2010 remained an operational motel. The original signage is now on display at Neonopolis in Las Vegas, Nevada. The Apache Motel opened in 1964. As of 2010, it remained operational with renovations that include extensive Native American–themed murals. The Circle S Motel at 1010 East Highway 66 remained operational as the Relax Inn as of 2010. The 1954 *Western Accommodations Directory* published by AAA lists it as a new and modern property.

Tee Pee Curios, a recently renovated landmark at 924 Highway 66, opened as a service station in 1944. Extensive restoration of the façade, as well as neon signage and trim, has resulted in the building appearing exactly as it did in 1960 when it served as Jene Klaverweiden's Trading Post.

The Blue Swallow Motel, opened in late 1939, is one of the most photographed sites on Route 66. Under new ownership as of July 2011, the property remains an operational motel, and in the fall of 2011, extensive renovation commenced, including repainting the entire facility in original colors. The Motel Safari at 722 East Highway 66 opened in 1960 as a Best Western motel. Richard Talley acquired the property and renovated it in 2008. La Cita, a restaurant that opened initially in 1940, was relocated to its current spot at 812 First Street in 1961. Renovation of the unique façade and signage occurred in 2006.

Built in 1954 at 1502 West Highway 66, the Redwood Lodge still existed as of 2010. Also existent, as of 2010, are the Desert Air Motel, the Ranch House Café building, Paradise Motel, Buckaroo Motel, the former Ron-Dy-Voo Café building, and Hall's Restaurant, now the Golden Dragon Chinese restaurant.

Restoration of historic properties is not limited to those associated with Route 66, either. The historic train depot is also undergoing renovation as of this writing.

45 COTTAGES COOK'S COURT TULSA OKLA. TRAV-O-TEL

By the late 1950s, Cooks Court in Tulsa was beginning to look dated. As of 2011, a Paintmaster Collision Center stood on this site. *Mike Ward*

TULSA, OKLAHOMA

Initial settlement of the present site for the city of Tulsa was due to the relocation of eastern and southeastern Indian tribes to the Indian Territories during the 1820s and establishment of a fort at the confluence of the Grand River, Verdigris River, and Arkansas River, an area known as Three Forks. To separate the Creek, Osage, and Cherokee tribes in the area, establishment of a boundary, roughly Edison Street east to Choteau and south to Fort Gibson, occurred in 1833.

In 1836, the Lockapoka Creek Indians, under the leadership of Chief Achee Yahola, arrived after relocation from Alabama. Their initial settlement was in the area now bordered by Seventeenth, Eighteenth, Cheyenne, and Denver Streets. The Creek Council Oak, a towering tree near the Arkansas River listed in the National Register of Historic Places, marks the site of where the first Creek Council fire was lit.

According to Oklahoma historian George Shirk, the name Tulsa is a derivative of Tulsey, a Creek tribal community in Alabama. The postal application approved in March 1879 used the name Tulsa, eliminating the confusing variation of previous names used.

The racially diverse community proved to be a haven for former slaves, and Tulsa enjoyed steady growth through the closing years of the nineteenth century. With establishment of the Atlantic & Pacific Railroad to Tulsa in 1882, the core of the business district began to develop in the area of Main and Boston Streets, and for the first time, there was a sizable influx of European Americans.

The discovery of oil at Red Fork four miles to the west dramatically transformed the community and surrounding area. By 1907, the year Oklahoma became a state, the Glen Pool was recognized as the largest oil field in the world, and Tulsa proclaimed itself the Oil Capital of the World.

Indicative of the changes wrought as a result are census records that indicate a population increase from 7,298 in 1907 to more than 70,000 by 1920. Reflective of the prosperity are the solidity of numerous historic buildings and homes built during this period.

TULSA, OKLAHOMA *continued*

The early ethnicity of late nineteenth-century Tulsa was reflected in the Greenwood district with its predominately African American community. The prosperity of Tulsa was such that even in this district substantial homes were built and businesses established, resulting in news stories referring to the area as the Black Wall Street. In the late spring of 1921, however, the Greenwood area became the site of the worst manifestation of racial prejudice and intolerance in U.S. history. The incident marked the culmination of years in which there was an increase in crime as well as vigilante actions.

In 1920, a mob removed a teenager accused of murder from the jail and lynched him. Evidence that indicated there might have been complicity from the Tulsa Police Department sparked national outrage.

On May 30, 1921, Dick Rowland, an African American, and Sarah Page, a white elevator operator, had an altercation that evidence indicates was relatively minor in nature. Rumors and innuendos led to accusations of attempted rape and the arrest of Rowland.

At 7:30 that evening, an armed contingent of whites had gathered at the Tulsa County Courthouse to demand the release of Dick Rowland to them. The sheriff refused, and as the crowd grew, approximately twenty-five armed African American men, mostly veterans of World War I, arrived from the Greenwood district to support the sheriff. The offer of service was refused, but their presence incensed the mob, which then proceeded to the National Guard Armory where guardsmen prevented the group's entry.

Shortly after this, a rumor spread through the Greenwood District that a mob was storming the courthouse, and a larger group of armed African American men responded. An attempt to disarm them sparked a riot. More than forty African Americans—

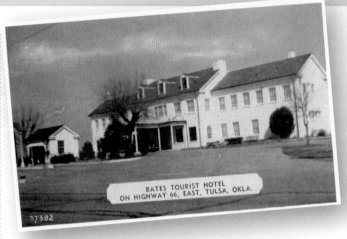

Located at 12100 East Eleventh Street in Tulsa, Oklahoma, Bates Tourist Hotel was originally one of six Pierce Pennant travel centers built in the 1920s. *Steve Rider*

including A. C. Jackson, a surgeon of international renown—were killed, and a full thirty-six blocks of businesses and residents were leveled by fire.

Surprisingly, the city entered a period of prosperity and development almost immediately after this event.

An argument can be made that Tulsa is the cornerstone for establishment and creation of U.S. 66. It was in this city that Cyrus Avery, the Oklahoma State Highway Commissioner and a pioneering advocate for good roads, developed his reputation and initiated the meetings that led to the creation of the highway.

This early association with U.S. 66 served as a catalyst for the development of an extensive service industry. The 1927 edition of the *Hotel, Garage, Service Station, and AAA Club Directory* lists the hotels Oklahoma, Ketchum, and Tulsa, as well as Brown Motor Company, Chalmers Electric Company, Southwestern Battery Company, Yellow Auto Wrecker, and Bob's Day & Night Garage for service.

The *Directory of Motor Courts and Cottages* published in 1940 gives five lodging recommendations, all accessed from Route 66. These are Beautyrest Modern Cabins, Blue Jay Court, Cooks Court, Park Plaza Courts, and Tulsa Motel.

Jack Rittenhouse, in his 1946 guidebook, presents an expanded picture of the service industry in Tulsa. He lists thirteen hotels, fifteen motels and auto courts, and indicates that there are "many more courts on both sides of Tulsa." He also names three garages.

The 1949 edition of *The Negro Motorist Green Book* lists a wide array of available services as well. These include six hotels, two tourist homes, a restaurant, a garage, and a service station.

The 1954 edition of the *Western Accommodations Directory* published by AAA lists five hotels, five motels (four of which are on Route 66), and four restaurants. The motels listed are Downtown Motel, 2719 East Eleventh Street; Park Plaza Motel; Tulsa Motel, 5715 East Eleventh Street; Tulsa Ranch-O-Tel, 7938 East Eleventh Street; and Will Rogers Motor Court, 5827 East Eleventh Street.

Cyrus Avery, heralded as the father of Route 66, established this complex at the intersection of Mingo Road and Admiral Place, the original alignment of Route 66. Demolition occurred in 1943. *Steve Rider*

There are two primary alignments of Route 66, roughly twenty-four miles, found in Tulsa. These include the early alignment that entered the city on Eleventh Street, turned on Mingo Road, and then again on Admiral Place before connecting with Southwest Boulevard via Lewis, Second, Detroit, Seventh, Cheyenne, and Eleventh Streets. The latter alignment utilized Eleventh and Tenth Streets before connecting with Southwest Boulevard.

Along both alignments are a number of sites associated with Route 66 and the city's early history. Among these are a circa-1954 Tastee Freez near Yale Street, the Rancho Grande with its original signage, the Tulsa Monument Building, the 1929 Warehouse Market Building, Lyons Indian Store, a 1925 Blue Dome gasoline station, the 1916 Eleventh Street Bridge, Cyrus Avery Centennial Plaza, and Talley's Café.

The benefits to the community as a result of the resurgent interest in Route 66 are exemplified in the restoration of a towering Meadow Gold sign with extensive neon and construction of an informational kiosk upon which it is mounted. The sign dates to the 1930s and originally stood on the Beatrice Foods building at Eleventh and Lewis along Route 66.

After more than thirty years of neglect, the two twenty-by-forty-foot panels were scheduled for demolition in 2004. In an unprecedented joint effort, the state historic preservation office, National Park Service, City of Tulsa, Tulsa Foundation for Architecture, and Oklahoma Route 66 Association raised the necessary funds to remove, restore, and relocate the sign, as well as design and build the small brick pavilion at Eleventh and Quaker for its mounting. Dedication for the restored sign, with functioning neon, and pavilion occurred on May 22, 2009. The success of the program led the Tulsa Foundation for Architecture to initiate an inventory of the city's historic neon signage.

TURMEL, KENNETH

After service to his country in the U.S. Air Force and the U.S. Postal Service for more than twenty years, Kenneth Turmel turned his attention toward establishing a recording studio. In 1993, introduction of the Cherokee Strip Land Run postage stamp by the U.S. Postal Service gave him a new idea.

The "Postmarkart" consists of mint postage stamps on colorful, hand-painted backgrounds within outlines of state borders. These large pieces were carried to carefully selected post offices for the acquisition of historically significant postmarks placed upon the artwork background. Because these postmarks commemorating specific historic events and celebrations are destroyed by the postal service, as per regulation, after expiration, the "Postmarkart" has become a historical document. More than one thousand postmasters, museums, artists, and collectors have endorsed the work as "original" and "the first of is kind."

Self-dubbed as the "landrunner," Turmel has traveled more than 150,000 miles in gathering postmarks, as well as

autographs. His Route 66–related projects have attracted the attention of collectors internationally. He has an extensive array of proposed versions of "Postmarkart" pending. Among these are the Arizona centennial, New Mexico centennial, and the California sesquicentennial.

TWIN ARROWS, ARIZONA

Built to capitalize on the postwar tourism boom along Route 66, the Canyon Padre Trading Post dates to about 1950. After its acquisition by Jean and William Troxell in 1954, it became the Twin Arrows Trading Post, with two giant arrows made from utility poles added to differentiate the establishment from other trading posts in the area.

The Troxells operated the trading post until 1985. It closed in the mid-1990s, but the Hopi tribe has plans for its renovation and reopening as a Native American marketplace.

TWO GUNS

Two Guns is an iconic Route 66 attraction in Arizona with a reputation carefully crafted to make it a favorite stop for tourists during the glory days of the old double six. The original establishment was built to capitalize on the stunning majesty of Canyon Diablo, still spanned by a beautiful concrete bridge built for the National Old Trails Highway. The legend of "Two Gun" Miller has evolved over the years to include a zoo with a variety of desert animals and a variety of ruins built into the canyon walls.

The cornerstone for the creation of this tourist attraction was the Apache Death Cave. Various reports, including work by Flagstaff historian Richard Mangum, claim that in the summer of 1878 Navajo pursuers killed a band of marauding Apache warriors at these caves.

The ruins of the Two Guns complex, and the historic National Old Trails Highway bridge over Canyon Diablo, nestled among the stark landscapes present a haunting image.
Joe Sonderman

TWO GUNS *continued*

The earliest endeavors to create an attraction that capitalized on the stunning scenery and colorful history occurred when Ed Randolph established a business near present-day Two Guns in 1915, shortly after completion of the concrete bridge for the National Old Trails Highway crossing of the canyon. In 1924, Earl Cundiff bought Randolph's homestead claim for $1,000 and built the Canyon Lodge, a store that provided tourists with supplies as well as a campground and several cottages. Establishment of a post office with Cundiff as postmaster occurred shortly after.

In 1925, Harry "Indian" Miller, a colorful local character who claimed to be half Apache, set up a small shop at the location after leasing a portion of the property from Cundiff, bestowed upon himself the name Chief Crazy Thunder, and called his facility Two Guns. By 1926, he had expanded his building into an extensive stone complex in a pueblo style that included a zoo featuring a wide array of animals native to the area, a small café, and a curio shop, and then added fake ruins in the caves.

Possibly as a result of Miller's success, Cundiff began contesting property boundaries. On March 3, 1926, the arguments took a violent turn when Miller shot and killed Cundiff. The resulting trial became a national sensation with the acquittal of Miller in spite of the fact that Cundiff was unarmed at the time of the shooting. Miller's freedom was short-lived, however; he was arrested shortly after the trial for defacing the grave of Cundiff after a fit of anger led him to erase the epitaph "Killed by Indian Miller."

The initial publicity generated by the trial and arrest of Miller fueled a growth in tourism at Two Guns, but by the late 1930s, business had plummeted precipitously. Miller sold the property and established the trading post complex signed as the Cave of the Seven Devils, now the Fort Chief Yellowhorse Trading Post near the New Mexico state line.

The initial complex at Two Guns—supplanted with the addition of modern amenities, including a new service station in the 1960s—never regained its prominence as an attraction, and

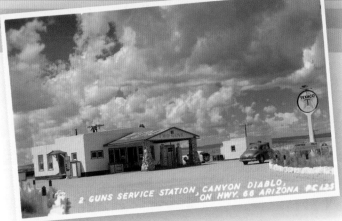

The realignment of Route 66 in 1938 led Louise Cundriff, Earl Cundriff's widow who was then married to Phillip Hesch, to build a new Two Guns store, station, and home (bottom/top).
Joe Sonderman

Canyon Diablo, the site of Two Guns, Arizona, presented the most formidable obstacle to the thirty-fifth parallel survey expedition of Lieutenant Amiel Whipple in 1853. Lieutenant Edward Beale, on his expedition in 1857, deemed the canyon impassable.
Joe Sonderman

in 1971, a fire destroyed numerous structures. Extensive ruins are the dominant feature of the site today.

Ironically, few tourists who stopped to see the Indian "ruins," Miller's cave, or the zoo realized that just to the north was a real western ghost town with a very violent history.

Canyon Diablo began life as a construction camp for the bridging of the chasm by the railroad in 1881. The camp grew into a small collection of bordellos and saloons with a well-deserved reputation for lawlessness in the years that followed. Not surprisingly, there were numerous gunfights, at least two train robberies, and the staging of an amazing three-week, six hundred–mile chase of robbery suspects led by Bucky O'Neill, a legendary western character who died during the assault on San Juan Hill during the Spanish–American War.

U

U-DROP INN CAFÉ

Built in 1936 by J. M. Tindall and R. C. Lewis at the junction of U.S. 66 and U.S. 83 in Shamrock, Texas, from designs created by owner John Nunn, the U-Drop Inn is a now an international icon of Route 66. The distinctive structure is one of the most recognizable landmarks of Route 66 in the mythical town of Radiator Springs made famous in the 2006 Pixar movie *Cars*.

Initially, the structure was designed and built to be a complex of three businesses: Tower Conoco Station, the U-Drop Inn Café, and a retail store. Shortly after opening on April 1, 1936, the retail section became an extension of the café.

Many of the original design features, such as brick construction with glazed tile accents of green and gold and towers built of wood framing with stucco covering, remained existent through the early 1970s. The current color scheme of light pink concrete with green accents dates to the refurbishment funded by a $1.7 million federal grant awarded after the property's listing on the National Register of Historic Places in September 1997.

John Nunn retained ownership for several years, sold the property, and then repurchased it in 1950. With the death of Nunn in 1957, his wife, Bebe, sold the café to Grace Brunner, who renamed it Tower Café and added a Greyhound bus terminal. In the mid-1970s, the property became a Fina station. As such, it was painted in a red, white, and blue theme during this period.

James Tindall Jr., son of the original financier for the building's construction, purchased the property in the early 1980s and reopened the café. In May 1999, the First National Bank of Shamrock purchased the property and gifted it to the city.

SHAMROCK, TEXAS

Legend has it that the initial plans for the nowiconic U-Drop Inn in Shamrock, Texas, that opened in 1936 were scratched out in the dirt with a nail by owner John Nunn. *Steve Rider*

After its refurbishment, including the neon trim, it reopened as the offices of the Shamrock Chamber of Commerce and visitor center. The building remains one of the most recognizable landmarks on Route 66.

Above: John Nunn initiated a contest to name his new café and station complex in 1936. The winner, a ten-year-old boy, pocketed $5.00 and had the privilege of seeing the name selected—U-Drop Inn—in neon lighting up the Shamrock, Texas night. *Steve Rider*

The refurbished U-Drop Inn in Shamrock, Texas, is one of the most famous locations on Route 66, largely because of its association to the animated film *Cars*.

UPLAND, CALIFORNIA

The origination of Upland lies in the creation of a development named Magnolia Villa by the Bedford brothers in 1887. Its proximity to Ontario led to initial designation as North Ontario. However, citizens interested in retaining individuality for the community petitioned the county board of supervisors to change the name to Upland, a reference to the town's elevation, which was higher than that of Ontario. Approval occurred in 1902.

Because the town has association with the National Old Trails Highway, the Daughters of the American Revolution selected it as a site for placement of a *Madonna of the Trail* statue. Route 66 followed the later course of this road along Foothill Boulevard but at various times also utilized Alosta Avenue, Amelia Avenue, and Citrus Avenue.

The near continuous flow of traffic sparked development of service industries in Upland, as with almost every community along this highway. The *Directory of Motor Courts and Cottages*, published by AAA in April 1940, lists one recommended property: Auto H Courts, a complex consisting of twelve housekeeping units. In keeping with the rural location of Upland, and the tendency of auto courts in rural areas to offer sparse

amenities during this period, this entry also notes that some units had baths but that public showers were available.

Jerry McClanahan, in *EZ 66 Guide for Travelers*, second edition (published by the National Historic Route 66 Federation in 2008), notes that Upland "has revitalized its section of '66 with retro décor added to spice up the strip malls, as in the Route 66 shopping center."

V

VALENCIA, NEW MEXICO

Located on the pre-1937 alignment of Route 66, Valencia occupies a site noted as a Tiwa Pueblo in the records of the Chamuscado-Rodriguez expedition of 1580. Blas Valencia, a soldier who served in the Onate expeditions of 1598, is the namesake of this town. His grandson, Juan de Valencia, had a rancheria here as early as 1660.

The first records using Valencia as a place name are from the Vargas expedition of 1692. For a short time just before the period of Americanization, the community of Valencia served as the county seat. A U.S. post office opened in 1884 and operated intermittently through 1939. With closure of the post office, mail for the community went to Los Lunas, on the west side of the Rio Grande.

The community's association with Route 66 spanned the period between 1926 and 1937.

VALENTINE, ARIZONA

Shortly after the establishment of a Hualapai Indian Reservation by President Chester A. Arthur in January 1883, members of the Hualapai Tribe, with assistance from the Massachusetts Indian Association (MIA), initiated efforts to end the practice of having children from the tribe sent to Fort Mohave on the Colorado River or to the Albuquerque Indian School. In 1894, the MIA established a day school at Hackberry, Arizona, with the goal to "give the rudiments of education to the youngsters, to teach self-sufficiency through agriculture to the older pupils."

During the second year of operation, a new site for the school was established east of Hackberry along the main line of the railroad in a valley at the foot of Truxton Canyon. In May 1895, the Office of Indian Affairs assumed control of the school.

In 1898, President William McKinley issued an executive order creating the Hualapai Indian School Reserve on properties adjacent to the day school. The following year, through acquisition of the MIA properties, this reserve expanded to almost 795 acres.

In 1899, a congressional appropriation for establishment and construction of the Truxton Canyon Training School received approval. Construction of the facility commenced in 1900. By 1903, the school complex consisted of a large dormitory, a two-story schoolhouse, housing for teachers, and an industrial arts building. Hualapai students under the direction of the industrial teacher fired the bricks for the construction of these buildings.

A post office, with the Indian agent acting as postmaster, opened under the name Truxton Canyon. The post office suspended operations within two years, but reestablishment in 1910 required use of a new name as per postal rules. In honor of Robert G. Valentine, Commissioner of Indian Affairs from 1908 to 1910, the new post opened under the name Valentine.

In 1913, the road between Peach Springs and Kingman received designation as the National Old Trails Highway, and the

The post office in Valentine, Arizona, opened in 1910. The town's namesake was Robert G. Valentine, the Commissioner of Indian Affairs from 1908 to 1910.

VALENTINE, ARIZONA *continued*

Truxton Canyon Indian School assumed a new importance as a stop for travelers in need of water. The complex continued to expand, but federal regulation pertaining to Indian school reserves prohibited the development of commercial enterprises. Because of this, service-related businesses built to profit from the increase of traffic after the certification of Route 66 in 1926 were to the west of the school complex.

The Truxton Canyon Indian School closed in 1937. Through 1960, the school served various purposes, including as a meeting hall, the site for community dances, and public school. Listed in the National Register of Historic Places in 2003, the school is currently empty and is in need of extensive repair. Other remaining vestiges include some teachers' houses, now homes for employees of the Truxton Canyon Indian Agency, and the former administration building, currently closed. In 1960, demolition of the massive dormitory commenced. The builder of the Mohave Museum of History and Arts in Kingman used some of the bricks in its construction.

Traffic on Route 66 initially ensured that the small community of Valentine thrived. There were several auto courts and service stations. The bypass of this segment of Route 66 in 1978, however, resulted in a dramatic decline in business and subsequent closure of the auto courts. The last service station, a Union 76 facility that doubled as the post office, closed after the murder of the post-mistress shortly after this date. The post office never reopened.

VEGA, TEXAS

For this community located on the Ozark Trails, a pre–U.S. highway system network of auto trails near the New Mexico state line, the development of service-related industries in Vega, Texas, predated establishment of Route 66 by almost a decade. Jack Rittenhouse, in 1946, noted that this town with a population of just over five hundred offered several gas stations, cafés, garages, and three small auto courts. These businesses augmented the agricultural economic base of the area.

Of primary interest to Route 66 enthusiasts today is the Vega Motel, listed in the National Register of Historic Places in 2006, originally Vega Court, which dates to 1947. The complex, with Ervin Pancoast as owner and proprietor, initially consisted of twelve units arranged as west and south wings with pairs of garages alternating with pairs of rooms and an office that served as Pancoast's home in the center courtyard. In 1953, an additional eight units were constructed as an east wing. In 1963, the property received a modernized facelift utilizing Perma-Stone.

As of early 2011, the renovation of the Vega Motel transformed a portion of the property into a mall of small shops. Renovation of some motel rooms is a part of the general plan.

Other landmarks of note in town include the refurbished Magnolia gas station, built in 1925 and located on the original

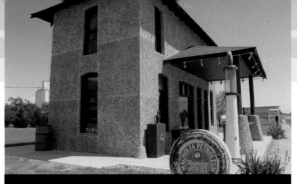

Located along the early alignment of Route 66, also the Ozark Trails Highway, in Vega, Texas, this refurbished Magnolia station dates to 1924.

alignment of Route 66 near the Oldham County Courthouse (dating to 1915), and Roark Hardware, the oldest continuously operated hardware store on Route 66. A more recent addition to Route 66–related attractions in Vega is Dot's Mini Museum at West Main and Twelfth Streets, the earliest alignment of the highway.

VENICE, ILLINOIS

Venice is associated with the earliest alignment of Route 66 and the McKinley Bridge crossing of the Mississippi River. The earliest references to a community by the name of Venice at this site date to the early 1840s and a river ferry owned by Dr. Cornelius Campbell of St. Louis.

The initial post office application approved on September 29, 1838, used the name Six Mile, but in March 1843, an amended application resulted in the change to Venice. The name is likely in deference to the famous city in Italy.

In 1958, the city of Venice, Illinois, purchased the McKinley Bridge from the Terminal Railroad Association. With a steady decline in revenues derived from tolls, repairs, and postpone-ment of repairs and maintenance resulted in extensive deteriora-tion and closure in 2001.

Legal issues prevented the state of Illinois for loaning money for repairs, since the city of Venice was in arrears to the city of St. Louis for taxes. As a result, the city of St. Louis foreclosed, and then the states of Illinois and Missouri assumed joint control of the bridge.

After extensive repair, the bridge reopened in 2007. Upgrades included the addition of bicycle and pedestrian paths.

VERDIGRIS, OKLAHOMA

Settlement near the site of Verdigris, Oklahoma, predated establishment of a post office on March 12, 1880. The post office remained operational through November 1954.

In the Jack Rittenhouse guidebook published in 1946, he notes a population of sixty-four and limited services that included a garage, gas station, and small store. He also adds the historical footnote that this community is near the site of the Civil War–era Fort Spunky.

A primary attraction associated with Verdigris is the Nut House. Established more than forty years ago, this classic roadside stop began by selling products made from pecans grown locally. Today, the store sells all manner of nuts and nut products.

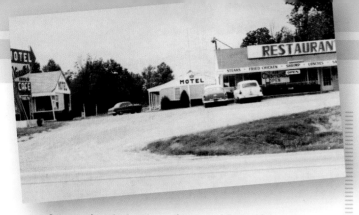

Construction of a four-lane alignment of Route 66 forced the relocation of the restaurant at the Vernelle's Motel complex in 1957, and the construction of I-44 in 1968 necessitated its demolition. *Joe Sonderman*

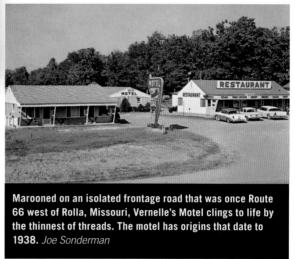

Marooned on an isolated frontage road that was once Route 66 west of Rolla, Missouri, Vernelle's Motel clings to life by the thinnest of threads. The motel has origins that date to 1938. *Joe Sonderman*

VERNELLE'S MOTEL

Originally called Gasser Tourist Court, Vernelle's Motel opened on Route 66 west of Rolla in 1938 with E. P. Gasser as the proprietor. In its initial configuration, the complex consisted of six cabins, a filling station, and a small gift shop. Expansions after acquisition by Gasser's nephew, Fred, and his wife, Vernelle, in 1952 transformed the property. In addition to establishment of a restaurant, the renovation created a modern motel complex.

Construction of the four-lane alignment of Route 66 necessitated relocation of the restaurant in 1957. The construction of I-44 in 1968 resulted in its demolition.

Nye Goodridge purchased the property in 1960, and his son, Ed, continued to operate what remains of the complex as of late 2010. A 2005 realignment of I-44 left the motel invisible from the highway, but surprisingly, as of fall 2011, it remained an operational facility.

VICKERY PHILLIPS 66 STATION

The designation of Second Street and Elgin Street as U.S. 66 in Tulsa, Oklahoma, in 1926, a section bypassed with realignment in 1932, served as the catalyst for the transformation of the former residential district into a corridor lined with highway service businesses, including service stations and restaurants. In late 1930, the Phillips Petroleum Company purchased a property at the corner of Elgin and Sixth Street, razed the two-story house at that location, and built a service station that opened in 1931.

Built in the then-company-approved design known as Cotswold Cottage to facilitate corporate recognition, the station featured a tapered brick chimney with an inset for a backlit Phillips 66 sign. For seven years, Phillips Petroleum retained corporate management before leasing the property to independent operators under contract to the company.

In 1946, reflecting the name of the lessee, V. W. Vickery, the station began utilizing the name Vickery Phillips 66 Station, the name under which the property was listed in the National Register of Historic Places in 2004. During the period of Vickery's management, a second, detached building, built in the original design, was added to the facility to provide service bays.

In 1973, Phillips Petroleum Company sold the property. The station was used for a wide array of purposes and was vacant often. In 2006 and 2008, a new owner utilizing cost-share grants from the National Park Service Route 66 Corridor Preservation Program, and federal tax credits for the renovation of historic properties, refurbished the complex. In 2009, the buildings served as offices for a rental car facility.

VICTORVILLE, CALIFORNIA

Initial settlement at the site of Victorville, California, dates to the establishment of a store and inn by Aaron G. Lane in 1858 along the Mojave River. The small settlement that developed around this enterprise, roughly at a point near where I-15 crosses the Mojave River today, became known as Lane's Crossing.

With establishment of a siding and station in 1885, the community was renamed Victor in honor of J. N. Victor, construction superintendent of the California Southern Railroad. The postal application was amended to Victorville in 1901 in an effort to avoid confusion with Victor, Colorado.

The railroad—and after 1910, the Arrowhead Highway and the National Old Trails Highway—led to the development of an extensive service industry. With the designation of Route 66 in 1926, and the establishment of numerous resorts that capitalized on the dry desert air, as well as dramatic scenery in the immediate area, Victorville also became a haven for celebrities and a favored location for film companies.

The *Directory of Motor Courts and Cottages*, published by AAA in 1940, lists three recommended motels for lodging: Green Spot Motel, Kleen Spot Auto Court, and Orange and Black Auto Court. Of these, the still-existent Green Spot Motel has the most interesting history.

Located near the corner of Seventh Street and C Street, the Green Spot Motel complex afforded a great deal of privacy, since the U-shaped court with ten gabled roof cabins with adjoining

In promotional material published by AAA in 1939, the Kleen Spot Auto Court was one of three auto courts recommended in Victorville. The other two were Orange and Black Auto Court and Green Spot Motel. *Steve Rider*

VICTORVILLE, CALIFORNIA *continued*

garages composed the rear of the property, and five similar cottages formed the sides with all units facing a central courtyard. The entrance consisted of a central office flanked by two arches with Spanish-tiled roofs. During the 1930s and 1940s, the motel served as a haven for weary celebrities escaping the city or in Victorville for filming. In 1940, Herman Mankiewicz and John Houseman wrote the first drafts of the script for *Citizen Kane* here.

Dramatic transformation of the community came when the Victorville Army Airfield was established in 1941 (the George Air Force Base after 1947). The base remained operational until 1992.

The guidebook published by Jack Rittenhouse in 1946 contains a lengthy entry about the town and its history as well other notations. He does not list specific properties but notes all tourist facilities are available.

Surprisingly, the 1954 edition of the *Western Accommodations Directory* published by AAA contains only two listings, New Corral Motel and Voyager Motel. Of these, the recently refurbished New Corral Motel remains and is listed as recommended lodging in the *Route 66 Dining & Lodging Guide*, fifteenth, published by the National Historic Route 66 Federation in 2011.

In Victorville, California, Route 66 entered the east side of the community on D Street and then followed Seventh Street through the business district. *Steve Rider*

Three attractions of particular interest to Route 66 enthusiasts are the Mojave River Bridge with its original, ornate guardrails built in 1930; the California Route 66 Museum on D Street between Fifth and Sixth Streets; and Emma Jean's Holland Burger on the north end of town. The latter is a roadside diner that remains almost unchanged since its opening in 1947, resulting in its inclusion in the Food Channel's Route 66 edition of *Diners, Drive-Ins & Dives* in 2007.

The community was also designated the host city for the 2012 International Route 66 Festival.

VILLA RIDGE, MISSOURI

A supervisor named Emerson decided to call the railroad siding and station built here in the early 1880s Villa Ridge, referencing the ridge that divides the Meramec and Missouri River watershed.

In *The Missouri U.S. 66 Tour Book*, published by C. H. Curtis in 1994, the scant businesses associated with Route 66 are detailed. These are Guffey's Store, Stropman's Camp, Hobbleburger's Tavern, Keys Twin Bridge Café, and the Pin Oak Motel.

Of particular interest to Route 66 history here are the business endeavors of Spencer Groff, who opened a fruit stand at the junction of the Ozark Trail (later State Highway 100) and the Old Springfield Road (later Route 66) in 1919. In 1927, he opened a luxurious and modern complex, The Diamonds, at this location. The property evolved in the following decades and offered a wide array of amenities to travelers, including what Groff promoted as the "World's Largest Roadside Restaurant," two swimming pools that held a combined total of 180,000 gallons of water, and cabins (later the Mission Bell Motel).

In 1948, a devastating fire leveled the restaurant, but Groff rebuilt. In 1950, a modern, streamlined restaurant opened. In 1967, a new facility opened at a location along Interstate 44 and the former property became the Tri County Truck Stop, a facility that operated until 2006. The final manifestation of

Located near the crest of a rise above the Bourbeuse River Valley, the Hilltop Café and station was operated by Max and Laverta Pracht. *Steve Rider*

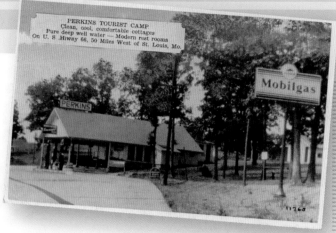

Many businesses near Villa Ridge, Missouri, utilized The Diamonds, a facility promoted as the "World's Largest Roadside Restaurant" that opened in 1927, as a point of location reference. *Steve Rider*

The Diamonds grew to include a 162-unit motel. Razing of the restaurant occurred in 2007.

Also associated with Route 66 in the area of Villa Ridge were several other notable properties. Among these would be the Gardenway Motel, an existing motel that opened in the 1940s and that was built by Louis Eckelcamp, co-owner of The Diamonds.

VINITA, OKLAHOMA

Downingville (Vinita after 1871) is the county seat of Craig County and location of the Eastern Trails Museum. Initial development came as a result of the community's location at the junction of two major rail lines: the Missouri, Kansas & Topeka and the Atlantic & Pacific.

In Oklahoma history, this small community is recognized for two milestones. It is the oldest incorporated town in the state and the first to have electricity. The namesake for the town is Vinita Ream, who lived from 1850 to 1914. This renowned sculptress is best known for her life-sized sculpture of Abraham Lincoln that stands in the rotunda of the capitol building in Washington, D.C.

In the 1946 guidebook published by Jack Rittenhouse, listed amenities include the hotels Vinita and Cobb and the auto courts DeLuxe, Ranch Motel, Meek's, 66 Court, and Texaco Cabins. Of these, only the 66 Court receives mention in the *Directory of Motor Courts and Cottages*, published by AAA in 1940.

The Ranch Motel, the Hotel Vinita, Lynn Motel, Motel Vinita, and Jim's Restaurant all receive recommendation in the 1954 edition of the *Western Accommodations Directory* published by AAA. There are numerous restaurants and motels still existing in

Vinita that have either historic association with Route 66 or that are able to capture the essence of travel on that highway in the preinterstate highway era.

The most notable are the Western Motel, Clanton's Café at 319 E. Illinois (Route 66) owned by the same family since 1927, and the Chuck Wagon Restaurant. All are recommended by the National Historic Route 66 Federation in its fifteenth edition of *Route 66 Dining & Lodging Guide* published in 2011.

In 1931, for $1.50 per night, the traveler could enjoy the luxury of a kitchenette with gas hot plate, ice water, electric lights, and fresh linens at Shell Camp. *Steve Rider*

VIRDEN, ILLINOIS

The namesake for this community is John Virden, owner of a hotel and tavern at this location. Establishment of a post office under the name Virden occurred on February 10, 1852.

In 1898, the tensions between workers, the fledgling miners union, and mine owners erupted in a series of confrontations that culminated in a bloody event remembered as the Virden Miner's Riot. A monument to the event and those killed was dedicated in Central Park in October 2006.

Because Virden is located on State Highway 4, the course of Route 66 before 1930, the small town has an extensive history associated with that highway and the early development of roadside services. The *Hotel, Garage, Service Station, and AAA Club Directory* published in 1927 lists Royston Motor Sales at 219 North Springfield Street for repairs.

Counted among the primary attractions for Route 66 enthusiasts today is a stylish mural painted on the brick wall of a historic building that is adorned with a banner stating, "Welcome to Virden—Established 1852." A unique attraction is the memorial to Officer Mike, a dog, in Central Park.

Dating to 1930, the Hotel Vinita, left, is listed in the *AAA Western Accommodations Directory* for 1954. Rates ranged from $2.00 to $7.00 per night. *Steve Rider*

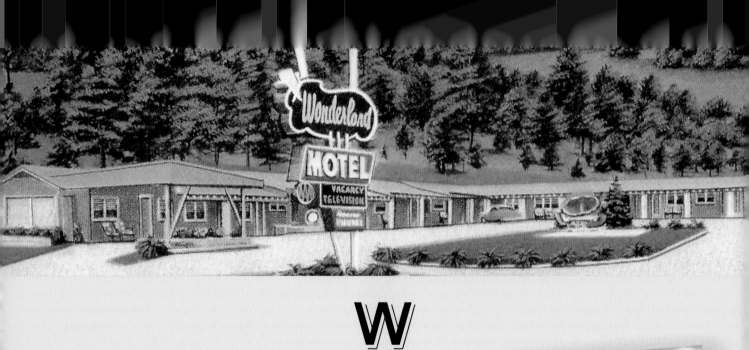

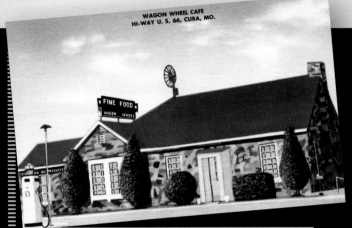

WAGGONER, ILLINOIS

Located on the post-1930 alignment of Route 66, Waggoner is named for George Waggoner, an early pioneer in the area who relocated from Kentucky. A post office under this name opened in December 1886.

Jack Rittenhouse noted in 1946 that "the town of Waggoner is about a half mile west of here. At 191 miles (five miles west) is a gas station, café, and five tourist cabins, with a First Aid Station."

As of 2010, the population was 245, and there was one operational restaurant, Country Town.

WAGON WHEEL MOTEL

The Wagon Wheel Motel in Cuba, Missouri, listed in the National Register of Historic Places in 2003, dates to 1935. That year, Robert and Margaret Martin purchased the property and made plans to build a complex that featured a service station, cabins, and café. Contracted to construct the buildings was master stonemason Leo Friesenhan, and in March 1936, the café and service station opened. The cabins opened shortly after.

Even though the stone cabins built in a Tudor Revival style invoked an image of historic lodging, the complex was actually futuristic in design. While most motels and auto courts of the period featured either separate cabins or rooms adjoined by carports or garages, the Wagon Wheel Cabins complex consisted of three stone cabins with each building housing three rooms with garages.

Business from traffic on Route 66 fueled rapid growth, and the property continued to evolve. The 1940 *AAA Directory of Motor Courts and Cottages* notes, "10 new, well-built stone cottages, each with private tub or shower bath, hot and cold running water. Well-furnished and maintained; hot water heat; fans in summer; 7 private garages. This is a home away from

The Wagon Wheel Motel complex consisted of a café, service station, and duplex cabins. Today, the café serves as a gift shop, and the fully renovated motel is a destination for Route 66 enthusiasts. *Mike Ward*

The Wagon Wheel Motel, a crown jewel in the era of resurgent interest in Route 66, received AAA recommendations for more than fifteen years. *Mike Ward*

Above: The Wonderland Motel that opened at 2000 East Santa Fe Avenue in 1956 with advertisement proclaiming it was the "Motel with the VIEW" continues to provide weary travelers a restful night. *Mike Ward*

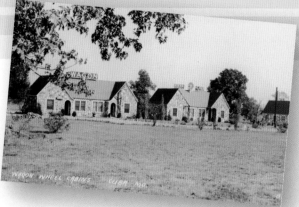

With the exception of landscaping and rooftop signage, the Wagon Wheel Motel remains remarkably unchanged from this late 1930s view. *Steve Rider*

home. Splendid surroundings. Porter and maid service; night watchman. Café; laundry facilities; filling station. A very nice place to stop." Curiously, the 1955 edition of the *AAA Western Accommodations Directory* does not mention the motel. However, the Wagon Wheel Café is given very favorable recommendations.

The property was sold to Winifred and John Mathis in 1947. Under new ownership, the complex underwent numerous modifications. The name changed to Wagon Wheel Motel, the now classic and recently refurbished neon sign designed by John in the early 1950s was added, and another lodging building and laundry room were added.

The 1950s and 1960s were a time of great transition for the property. In 1956, the gas station and café closed. In the 1960s, the City of Cuba built a garage around the former service station to service vehicles and equipment. Then, in 1963, Pauline and Wayne Roberts purchased the motel. A few years later in 1969, they bought the former café and service station building, uniting the complex under one ownership for the first time since the 1940s.

The property continued meeting the needs of travelers and maintained a relatively high standard well into the 1980s. By 2000, however, the motel had begun showing its age, and low-cost weekly rentals were the primary source of income.

Connie Echols acquired the property in 2009 and initiated extensive renovation, commencing with the former café that she

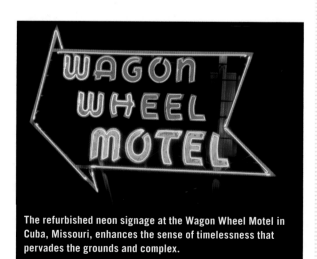

The refurbished neon signage at the Wagon Wheel Motel in Cuba, Missouri, enhances the sense of timelessness that pervades the grounds and complex.

planned to transform into a retail store, Connie's Shoppe. This shop opened in December 2010.

The garage was stripped from the former service station, with the facility utilized as a workshop, and in January 2010, restoration of the motel complex commenced. As of this writing, the renovations continue, even though the grounds, the former café, the laundry room, and most of the motel rooms have already been refurbished to original appearance with the tasteful addition of modern amenities.

The complex consistently garners praise and accolades, is fast becoming a favored lodging choice for Route 66 enthusiasts, and is a foundational element in the refurbishment of Cuba. The property exemplifies the new era of Route 66 history.

A delightful book, *The Wagon Wheel Motel on Route 66*, by Riva Echols, Connie's sister, is available through Connie's Shoppe. The well-researched book chronicles the history of this Route 66 landmark.

WALDMIRE, ROBERT

Robert "Bob" Waldmire, who lived from April 19, 1945, to December 6, 2009, was an artist of exceptional and unique talents who played a pivotal role in the development of a resurgent interest in Route 66, as well as the preservation of significant properties along that highway. His intricate pen-and-ink drawings transformed into postcards and posters that became internationally recognized Route 66 souvenirs. Additionally, his murals in various communities along that highway are popular photographic stops for travelers.

Bob Venners in *Desert Exposure* noted, "Bob Waldmire is the most prolific and best known artist specializing in Route 66 themed work." While Route 66 themes are what Waldmire is best known for, they actually represent only a small portion of his diverse portfolio.

Additionally, he produced city and state posters, wildlife portraits, maps, and even a series on World War II aircraft as well as a fortieth anniversary of the Ford Mustang poster. Original works by Waldmire are highly prized among collectors.

The vast body of work produced by Waldmire was reflective of his unique lifestyle and diverse interests. As an example, his large, nineteen-by-twenty-five-inch state posters are filled with intricate miniature scenes of scenic or historic locations, wildlife, and plant life, as well as philosophical comments and quotes from historic figures pertaining to the quest for world peace, the importance of ecological preservation, and the importance of nonviolent protests.

Waldmire—the son of Edwin Waldmire Jr., founder of the iconic Cozy Dog Drive In in Springfield, Illinois, and Virginia Waldmire, designer of Cozy Dog logo consisting of two hot dogs in a blissful embrace—traveled Route 66 extensively in a modified 1972 Volkswagen micro bus that also served as his home and studio while on the road. This bus, and Waldmire himself, became popular icons of the highway. Indicative of this is the fact that Waldmire and his bus were the inspiration for the

WALDMIRE, ROBERT *continued*

character Fillmore in the animated film *Cars*. The van is now a primary attraction at the Route 66 Hall of Fame in Pontiac, Illinois, as is the 1966 Chevrolet bus that he modified into a two-story home.

Waldmire's formal education included studies at Springfield Junior College in Springfield, Illinois, in 1966, and classes in art and zoology at Southern Illinois University at Carbondale. In the late 1960s, his career as an itinerant freelance artist commenced with a map of Springfield, Illinois.

In an interview for "Art Seen" that appeared in the *Illinois Times* on December 9, 2004, Waldmire reflected on this endeavor. "Before I dropped out for the last time, a fellow student made a poster of Carbondale. That was the only town poster he ever made, but I liked the idea, brought it home, and made a map of Springfield using my own ideas," he said. "I did most of the

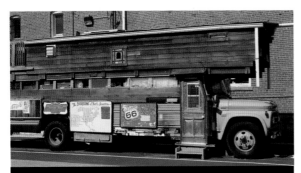

The converted bus that often served as a home on the road and workshop for iconic Route 66 artist Bob Waldmire is a primary attraction at the Route 66 Hall of Fame Museum in Pontiac, Illinois. *Judy Hinckley*

Among the many colorful and vibrant murals that line the streets and alleys of Pontiac, Illinois, is this portrait of Bob Waldmire, the iconic artist known for his intricate pen and ink work as well as murals. *Judy Hinckley*

artwork on it in the backroom at the old Cozy Dog. The merchants that sponsored it paid me to draw their businesses on the poster."

For five years during the 1990s, Waldmire lived at the Hackberry General Store in Hackberry, Arizona. During his tenure, the old store became the Route 66 Visitor Center with extensive trails and signage that explained the biodiversity of the region.

In the years shortly before his death, Waldmire garnered numerous accolades in recognition of his artwork and preservation efforts on Route 66. These included the prestigious John Steinbeck Award, awarded in 2004. The winners of this award are chosen from nominations presented to the John Steinbeck Foundation and the National Historic Route 66 Federation. Selection of the recipient is based upon the criteria of contributions made to preserve, promote, or restore Route 66 properties, as well as the highway itself.

WALLIS, MICHAEL

Michael Wallis is an award-winning author, journalist, historian, and biographer. His landmark book, *Route 66: The Mother Road*, first published in 1990, is considered a foundational element in the resurgent interest in this historic highway. Published again in 2001 and released to coincide with Route 66's seventy-fifth anniversary, an updated edition of the book continues to be a bestseller.

In large part because of the book, Wallis has received the John Steinbeck Award, been nominated for the Pulitzer Prize three times, was the first inductee into the Oklahoma Route 66 Hall of Fame, and is an inductee in the Oklahoma Historians Hall of Fame, as well as the Writers Hall of Fame of America and the Oklahoma Writers Hall of Fame. Other accolades include the Arell Gibson Lifetime Achievement Award from the Oklahoma Center for the Book, the Will Rogers Spirit Award, and the Western Heritage Award from the National Cowboy & Western Heritage Museum.

Wallis often volunteers on projects related to the restoration or preservation of historic properties along Route 66. Additionally, Wallis was instrumental in the development of the Pixar movie *Cars*, a 2006 film that introduced a new generation to the charms of Route 66 in which he provided the voice for the sheriff. He is also a founding member of the Route 66 Alliance, an organization conceived to provide a unified voice of representation to businesses along the highway and to coordinate its promotion.

WALNUT CANYON BRIDGE

Built in 1922 by the U.S. Bureau of Public Roads, as part of project to modernize the highway between Winslow and Flagstaff, the Walnut Canyon Bridge, a steel truss structure, was the largest and most expensive part of the twenty-three-mile improvement corridor. The bridge opened in the summer of 1924.

Currently closed to traffic, the bridge is located on an abandoned section of Route 66, alongside the Townsend-Winona

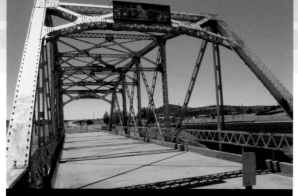

Located along the segment of pre-1947 alignment of Route 66 between Winona and Flagstaff, Arizona, the Walnut Canyon Bridge now serves as a favorite photo stop for Route 66 enthusiasts. *Judy Hinckley*

Road that is the pre-1947 alignment of that highway, which connects Flagstaff at U.S. 89 with Winona, Arizona. Its listing in the National Register of Historic Places in 1998 is indicative of its importance. Fledgling discussions to transform old alignments of Route 66 into a bicycle trail include this bridge.

WARR ACRES, OKLAHOMA

Initially platted by real estate developer C. B. Warr to profit from the post–World War II rush to suburbia, Warr Acres today merges almost seamlessly with Oklahoma City. Of particular interest to Route 66 enthusiasts is the fact that Warr Acres, at the corner of Thirty-Ninth Expressway and MacArthur Boulevard, is the site of installation of the first state-sanctioned historic U.S. 66 Highway sign.

WARWICK, OKLAHOMA

The well-watered lands along Deep Fork River were what led David and Norah Hugh to homestead a farm, in 1891, on the site that would become Warwick. A collective of similar-minded farmers provided ample reason for the establishment of a post office in 1892.

In the early fall of 1896, the St. Louis & San Francisco Railroad purchased a right of way from Hugh. In 1903, a second right of way was deeded to the Fort Smith & Western Railway Company, and in the same year, a town site was platted and lots sold.

Indicative of the nature of the people who settled here, a solid, modern stone building built in 1909 replaced the little log school that also served as a church. The business district during this period consisted of a blacksmith shop, veterinarian, general merchandise store, sawmill, and saloon. These all reflected the town's agricultural underpinnings.

By the late teens, and through the 1930s, meeting the needs of motorists enabled the small town to diversify its economic base. It could be said with a degree of certainty that the year 1940 was the best of times and the worst of times in Warwick.

A new school that reflected the optimism of the town's residents was built, the railroads that gave rise to the community went bust, and the Burlington Northern Railroad picked up the pieces but discontinued passenger service. During the immediate

postwar years, nearby Wellston began siphoning an increasing share of Route 66–related business, and by 1968, the Warwick school was consolidated with the Wellston school. In December 1972, the post office closed, and little Warwick was on the fast track to becoming a ghost town. Surprisingly, a few remnants survived into the modern era and with the resurgent interest in Route 66 are now treasured souvenirs.

Topping the list is the historic Seaba Station, a former machine shop built in 1924 that expanded into providing other services, such as gasoline and automotive repair, after the certification of Route 66 in 1926. Currently listed on the National Register of Historic Places, the refurbished property opened in 2010 as a motorcycle museum.

WASHBURN, TEXAS

The origins of Washburn stem from the division of the JA Ranch in 1887 and acquisition of section ninety-eight by Robert Montgomery. Montgomery platted a town site at the terminus of the Fort Worth & Denver City Railroad. The namesake is D. W. Washburn, a railroad official and a friend of Montgomery's father-in-law, Greenville Dodge.

The catalyst for development was two wells drilled by the railroad and establishment of a depot, section house, coal chute, and stockyard. Construction of a spur line to connect with the Southern & Kansas Railroad main line at Panhandle in 1888 provided additional incentive for growth. In March of that year, a post office was established.

By the early 1890s, amenities included a newspaper, the *Armstrong County Accord*; three hotels; a hardware store; school; and church. In 1896, telephone service became available. For a brief period, Washburn served as the county seat, and in 1907, James Logue, the first postmaster, opened a bank.

Abandonment of plans for extensive railroad development centered in Washburn, and the rising prominence of Amarillo initiated a period of decline not stemmed by development of a small service industry meeting the needs of Route 66 and predecessor highways. During the decades of the 1920s, 1930s, and 1940s, the population fluctuated between twenty-five and one hundred residents.

The association with Route 66 terminated with realignment in about 1930. Closure of the post office occurred in 1956.

WAYNESVILLE, MISSOURI

The namesake for Waynesville, Missouri, where the post office was established in 1834, is General Anthony Wayne, an American Revolutionary War hero dubbed "Mad Anthony" for his disregard for personal safety during the Battle of Stony Point. Waynesville remained a small agricultural community with a diversified economy from tourism on Route 66 into the early 1940s. The WPA Missouri guide published in 1941 noted that

Waynesville had a "leisurely atmosphere, unmarred by the smoke of industry." Shortly after the date of this publication, the construction of Fort Leonard Wood nearby transformed the community. Additionally, realignment of Route 66 to the south of town as a four-lane highway, the current course of I-44, during the 1940s brought further changes, leaving the original path of the highway as City 66.

Jack Rittenhouse, in his 1946 guidebook, alluded to the dramatic transformation of the town during World War II. He wrote, "Pop. 468 in 1940, much higher now."

Waynesville figures prominently in Route 66 history. In 1990, at the Pulaski County Courthouse built in 1903 that now serves as a museum, Missouri Governor John Ashcroft signed a bill designating Route 66 as a historic highway in the state.

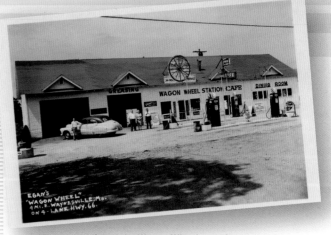

James Egan established the Wagon Wheel complex near Waynesville, Missouri, in the late 1920s. Until recently, the Ramada Inn Fort Wood occupied the site. *Steve Rider*

Built in 1903, the Pulaski County Courthouse in Waynesville, Missouri, is where Governor John Ashcroft signed the bill designating Route 66 as a historic highway in 1990. *Joe Sonderman*

WAYSIDE AUTO COURT

Located across the highway from the site of the Coral Court Motel in the village of Marlborough, Missouri, the Wayside Auto Court at 7800 Watson Road predates the more famous establishment by several years. Built in late 1938, the court consisted of thirty-three brick cottages set among well-kept and landscaped grounds.

The *Directory of Motor Courts and Cottages*, published by AAA in 1941, gave the property an unusually long and descriptive entry as well as a display advertisement. It said the following: " . . . On U.S. 66 City Route, one mile west of St. Louis city limits, four and one fourth miles east of the intersection of U.S. 66, 61, and 67 By Pass. 33 ultra modern, fireproof brick cottages; tiled showers and lavatories; hot and cold city water; central hot water heat, new method circulating fans; exceptionally well furnished including Simmons Beautyrest mattresses on every bed. Very clean and well kept. Maid and Porter service. Office and telephone service 24 hours daily. Laundry facilities and service. Café near by. Rates, single $2.50 per day, double $3.00."

The property also received mention in the Jack Rittenhouse guide published in 1946. As of late 2010, the auto court that once advertised "Commercial Men Welcome" still existed.

WEATHERFORD, OKLAHOMA

The early history of Weatherford is somewhat confusing. Initial settlement at a site near the present-day community preceded establishment of a post office in August 1893. By 1898, the town had withered to the point that a post office was no longer warranted, and in October of that year, the nearby community of Dewey amended its post office application, changing the name to Weatherford.

The namesake for the original community, as well as the current one, was William J. Weatherford, an early settler in the area and a deputy U.S. marshal. The town's most famous resident is astronaut Thomas P. Stafford, the namesake for the airport as well as an aeronautical museum.

Service-related industries established to meet the needs of motorists traveling Route 66 provided diversity to the largely agricultural economy. The 1955 edition of the *Western Accommodations Directory* published by AAA lists Moore's Court for recommended lodging.

Of primary interest to Route 66 enthusiasts today are the 66 West Twin Drive-In, the Mark Motor Hotel with its accompanying restaurant, and a period Sinclair station.

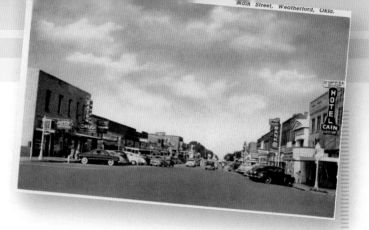

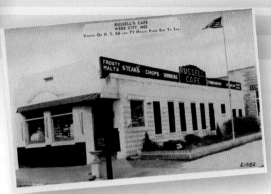

Weatherford, Oklahoma, is the hometown of astronaut Thomas Stafford. This early 1950s view is looking east on Broadway Avenue, Route 66. *Steve Rider*

Indicative of the impact Route 66 had on communities like Webb City, Missouri, Russell's Café purportedly served an average of one hundred thousand people per year during the 1940s. *Steve Rider*

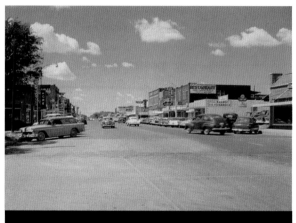

In Weatherford, Oklahoma, during the 1950s, Route 66 lived up to the slogan of being the Main Street of America. *Steve Rider*

WEBB CITY, MISSOURI

The foundational events for establishment of Webb City, Missouri, occurred in 1873 when John C. Webb discovered lead ore on his corn farm, established a mine, and then platted a town site. By the first years of the twentieth century, the extensive deposits of lead and zinc mined in Webb City, as well as in the area of Galena in Kansas and Miami in Oklahoma, made this one of the largest mining districts in the world for this ore.

The mining boom in Webb City peaked during the years of World War I. During this period, the population reached twenty-eight thousand, and there were fifty mines operating on three shifts.

The certification of Route 66 in 1926 and development of light industry served as a brake on the community's economic decline. The highway followed Broadway through town initially, but realignment moved it to the south of town on McArthur Drive. In spite of this association, Jack Rittenhouse in 1946 noted that there were "no major tourist accommodations here." However, there were several notable cafés and, after 1950, a couple of motels in addition to the Midwest Hotel. The Civic Drive-In Café—designed by Larry Larsen, a theater architect who designed the Fox Theater in Joplin—opened in the late 1930s,

and Russell's Café opened shortly after. Mr. and Mrs. Harold Fenix opened the Ozark Motel at 410 South Madison Avenue in 1951. The motel remained operational through 1968.

Manifestations of the city's interest in capitalizing on its association with Route 66, and the resurgent interest in that highway, are found at a former service station on Broadway. It has been transformed into a Route 66 visitor center. Among the unique attributes of the complex is a large mural depicting Route 66 during the 1940s painted by Mayor John Biggs in 2010.

WEBSTER GROVES, MISSOURI

Proclaimed the queen of St. Louis suburbs, Webster Groves, Missouri, resulted from the merger of the Webster, Tuxedo Park, Selma, Old Orchard, and Webster Park tracts in 1896. It remains a community known for stately older homes and deeply shaded streets lined with towering trees.

In addition to its Route 66 association, Webster Groves has had two brushes with fame. In 1965, CBS produced a controversial documentary entitled *16 in Webster Groves*, and there was also a reference to the community in the NBC television series *Lucas Tanner* that only ran from 1974 to 1975.

WELLSTON, OKLAHOMA

Named for Christopher T. Wells, a licensed Indian trader, Wellston (with a post office established in September 1884) was the focus of a bitter political power struggle in 1932. This dispute marked the first time federal funds were withheld from a roads project.

At the heart of the dispute between the U.S. Bureau of Public Roads and the state of Oklahoma was a demand from the federal government that paved alignment of Route 66 bypass the heart of Wellston by almost one mile. As part of an irrevocable bond issue, the state had assured the residents of Lincoln County that the highway would be threaded through the center of Wellston, and to that end, Route 66 from Chandler to the Wellston city limit was paved in 1928. Deemed a cost-saving efficiency by the federal government, the bypass was to

WELLSTON, OKLAHOMA *continued*

commence at the point where the road curved northward into Wellston. Failure to abide by this proposal would result in suspension of all federal highway dollars currently held in reserve until resolution.

In the end, the bypass, unpaved during the dispute, was completed as per federal recommendations, and the loop through Wellston was paved with expenses paid by the state of Oklahoma. As a result of the bypass, the loop was designated State Highway 66, the earliest such designation in the state, and when U.S. 66 was decertified in 1985, the loop through became State Highway 66 B.

Jack Rittenhouse noted, in 1946, that Wellston was a small community located about one mile north of the highway. He also noted that at the crossroads there was a gas station and the Pioneer Tourist Court. In the book *Oklahoma Route 66*, written by Jim Ross and published by Ghost Town Press in 2001, he notes that "a couple of buildings and a frail, somewhat disenfranchised totem pole remain at what was once a motor court called Pioneer Camp."

WESTERN HILLS MOTEL

Built by Harold Melville at 1580 East Santa Fe Avenue in Flagstaff, the Western Hills Motel opened in 1953. The *Western Accommodations Directory*, published by the AAA in 1954, noted the property offered the following: "Very Good accommodations in an attractive new motel on a knoll above the highway. Well decorated rooms are centrally heated and have tiled shower or combination baths. Lower off season rates. Restaurant, patio."

As of late 2010, the facility remained operational, and the animated neon sign is the oldest of its kind in Flagstaff. The restaurant specialized in Vietnamese cuisine.

The Western Hills Motel, with its classic animated neon signage, opened at 1580 East Santa Fe Avenue in Flagstaff, Arizona, in 1953 with Charles Greening as the owner. *Mike Ward*

WESTERN MOTEL

The Western Motel opened at 860 Will Rogers Drive, U.S. 66, in Santa Rosa, New Mexico, in 1952. The listing for the property in the *Western Accommodations Directory*, published by AAA in 1954, noted it was "an attractive court back from the highway. Colorfully decorated, air cooled one and two room units have vented heat and tiled shower or combination baths."

Renovation of the property, then renamed Milner Western Motel, resulted in the forty-eight-unit complex receiving a notation by AAA in its 1971 guidebook that said the following: " . . . Unusually well maintained very tastefully appointed rooms." As of 2010, the motel was abandoned and in a state of collapse with demolition imminent.

The Western Motel in Santa Rosa, New Mexico, opened in 1952. The *Western Accommodations Directory*, published by AAA in 1954, featured a descriptive entry as well as a display advertisement.

WEST WINDS MOTEL

Built in 1948, and listed in the National Register of Historic Places in 2004, the West Winds Motel in Erick, Oklahoma, is a unique time capsule in that it reflects the evolution of motel development during the period of the 1940s and 1950s, retaining numerous attributes of each stage. The building on the north side of the property retains the original configuration motel units separated by open garage bays, a feature most motel owners eliminated during the 1950s. The building on the east side of the property reflects the modern approach. This building is devoid of the garages and has a canopy stretched along the length of the front façade.

The faded and nonfunctional existing sign that features the name of the motel framed in neon, with a bucking bronco and cowboy appearing above, dates to the 1950s. The future status of the property is uncertain.

WHIRLA-WHIP

Whirla-Whip, located one block south of Route 66 on State Highway 4 in Girard, Illinois, opened in 1957. It remains as a near-perfect vestige from the era preceding the dominance of franchises with its specialty of one thousand flavors of soft-serve ice cream. It also serves hamburgers.

WHITE OAK, OKLAHOMA

Settlement of this small agricultural community predates establishment of a post office in October 1898 by at least one year. White Oak has remained a small agricultural town with a fluctuating population into the modern era.

The post office closed in October 1957. The White Oak Mill, now closed, is the most prominent landmark remaining.

WHITE ROCK COURT

Built by Conrad Minka, purportedly an immigrant Russian hard rock miner, in 1935, the White Rock Court in Kingman, Arizona, incorporated a number of unique features. Most notably, the entire complex, including the two-story owner's home and office over a full basement, utilized a series of tunnels and airshafts transformed into evaporative coolers with the use of water tanks and hanging sheets of burlap to beat the summer heat. Using locally quarried volcanic tufa stone as the primary building material provided excellent insulation properties.

Tunnels under the parking lot connecting the main house with the motel units served as utility corridors as well for the ducting from a central heat source. Persistent rumors suggest the extensive tunnel complex also served a number of illicit purposes, including the housing of a still for the manufacture of liquor.

The 1952 *American Motel Association Guide* describes the property as having fifteen modern cottages in a convenient location. Mr. and Mrs. Conrad Minka are listed as the owners and managers.

As of 2010, the complex remained still existed and was being used as a private residence and apartments. The primary changes from date of origination are the painting of the native stone in white and enclosure of several of the attached garages.

Built in 1935 by Conrad Minka, a former hard rock miner, the White Rock Court is now utilized as a private residence and apartments. *Joe Sonderman*

WHITE ROCK COURT - ON HIWAY 66 - EAST END OF KINGMAN, ARIZ.

WHITE'S COURT

The White's Court complex in Carthage, Missouri, dates to the establishment of a café and gas station on the site in 1927. Eight cabins added during the 1930s evolved into a modern auto court of cottages with attached garages, modified into a motel by enclosure of the garages in 1957. Promotional material from the latter period noted the modern cottages as well as a café and service station. As of 2010, the facility served as the Red Rock Apartments.

WHITING BROTHERS

The patriarch of the diverse Whiting Brothers businesses was Edwin Whiting, who established a lumber mill near St. Johns, Arizona, in 1901. The Whiting Brothers chain of gas stations, and later motels, began with Art and Ernest Whiting, Edwin's sons, selling gasoline at their Ford dealership in St. Johns, Arizona, in 1917. They opened a second, modern station in 1927, in Holbrook on Route 66.

Initially, they sold gasoline and petroleum products produced by Pathfinder, a small Los Angeles–based oil company. In later years, they sold products produced by Shell and Phillips Petroleum.

As the Whiting brothers expanded their operations into Winslow and Flagstaff, they also began developing a standardized station design that would ensure recognition and association. The initial step in this standardization was to paint the stations a bright white with bands of the company colors, yellow and red, along the top of the buildings and the bottom of the pump islands. An elevated signboard with red letters on a yellow background evolved with the development of the trademarked Whiting Brothers shield. Likewise, the brothers created attention by placing one hundred–foot signboards painted yellow with red lettering running somewhat perpendicular to the highway.

Whiting Brothers stations were a common sight on Route 66 in the Southwest through the 1960s, a primary factor of consideration when the city of Tucumcari, New Mexico, made the decision to renovate empty properties by painting them to appear as vintage facilities in 2010. There were locations on Route 66 in Lenwood, Barstow, Newberry Springs, Needles, Cadiz Summit, Yucca, Topock, Kingman, Truxton, Seligman, Ash Fork, Williams, Flagstaff, Winslow, Holbrook, Lupton, Gallup, Continental Divide in New Mexico, Grants, San Fidel, Albuquerque, Moriarty, Santa Rosa, Newkirk, Tucumcari, San Jon, Vega, Amarillo, Groom, and Shamrock.

At its peak, the Whiting Brothers chain numbered more than one hundred stations. The only existing station operating with original signage is in Moriarty, New Mexico, along Route 66.

In 1955, Whiting Brothers diversified into the motel business. The first property, the Whiting Brothers Deluxe Motel, opened at 902 West Hopi Drive in Holbrook, Arizona. The business empire was dealt a setback from which it would never

By the early 1960s, there were Whiting Brothers service stations and motels all along Route 66 from Amarillo to Barstow. *Joe Sonderman*

WHITING BROTHERS *continued*

recover in March 1961 when Virgil and Farr Whiting, the sons of Ernest Whiting, died in a private plane crash. *The Arizona Republic* on March 31, 1961, reported, "The plane, piloted by Virgil, 44, took off from St. Johns shortly after 1 PM Wednesday. The men were headed for a business engagement in Phoenix."

Virgil, the pilot and general manager of the sawmill at Eager, Arizona, was described as "experienced" with training that including service in the U.S. Army Air Corps as a bomber pilot during World War II. The article also noted that Farr was the manager at Whiting headquarters in St. Johns.

WHITING BROTHERS DELUXE MOTEL

The Whiting Brothers Deluxe Motel at 902 West Hopi Drive in Holbrook, Arizona, was the first manifestation of the Whiting Brothers diversification from service stations to motels. Expansion of the property and a name change to Whiting Motor Hotel occurred in late 1956.

In the mid-1960s, Al and Helene Frycek purchased the property and renamed it the Sun N' Sand Motel. The facility closed in 2001 but has been reopened as the Globetrotter Lodge.

Established in 1956, the Whiting Motel, later the Whiting Motor Hotel, was a fifty-seven-unit complex that offered a wide array of amenities, including individually controlled "hi-fi music." *Joe Sonderman*

WIGWAM VILLAGE MOTEL

The initial wigwam village constructed in Cave City, Kentucky, in 1936 was the creation of Frank Redford, who patented the design in the same year. Chester E. Lewis purchased copies of the plans, negotiated a royalty agreement with Redford, and opened Wigwam Village Motel Number Six in Holbrook, Arizona, in 1950. Terms of the royalty agreement included the stipulation that a coin-operated radio be placed in each unit. Redford was to receive a dime for every half hour of play.

The complex consists of fifteen concrete and steel freestanding teepees, twenty-one feet wide at the base and twenty-eight feet in height, arranged in a semicircle around the main office. The large central teepee, with attached complex, served as the owner's home, the motel office, and a Texaco service station.

The motel closed in 1974, but the service station remained operational. The motel remained vacant until completion of its restoration in 1988. With the exception of the central teepee replaced with a conventional building as per orders from Texaco, the motel is a near-perfect time capsule circa 1955, enhanced by the gravel parking lot, period furniture, and vintage cars

The Wigwam Motel in Rialto, California, opened in 1950, was expanded in 1954, and in January of 2012, after extensive renovation by the family of Kumar Patel, was listed in the National Register of Historic Places.

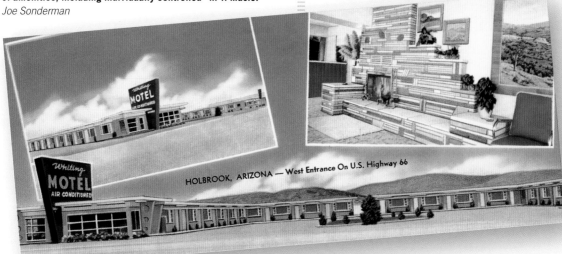

HOLBROOK, ARIZONA — West Entrance On U.S. Highway 66

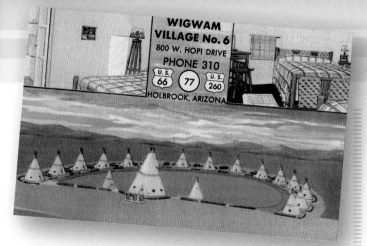

The Wigwam Motel (originally Wigwam Village Number Six) in Holbrook, Arizona, opened on June 1, 1950, closed in 1974, and reopened in 1989. *Joe Sonderman*

parked around the motel. One, a weathered Studebaker, actually belonged to Chester Lewis.

The property, listed on the National Register of Historic Places in 2002, has become an icon of the modern era on Route 66. Occupancy is often 100 percent, especially during the months of spring, summer, and fall.

Wigwam Village Motel Number Seven opened in Rialto, California, in 1950. With the bypass of Route 66, the motel and the surrounding neighborhood rapidly deteriorated.

The Patel family saved the Wigwam Village Motel from the wreckers' ball by purchasing the property and performing extensive renovation. Like its twin in Holbrook, the Wigwam Village Motel in Rialto is now an internationally recognized landmark on Route 66 that rates highly as a destination among enthusiasts. It received inclusion in the National Register of Historic Places in late 2012.

WILDORADO, TEXAS

Eugene Binford and John Goodman established a ranch here on Wildorado Creek shortly before 1900. With completion of a survey by the Amarillo division of the Chicago, Rock Island & Gulf Railway, and its decision to establish a siding here, the ranchers platted a town site at the location.

Establishment of a post office in 1904, with Goodman as postmaster, indicates growth of the community, even though the railroad would not reach the town site until 1908. Goodman continued to be instrumental in the growth of Wildorado; in 1908, he built the Wildorado Hotel and organized the Wildorado State Bank.

The following year the *Progress*, a newspaper, began publication, and by 1915, the town had a telephone exchange and a business district that included a general store, grocer, lumber company, blacksmith, and hardware store. The development of the Ozark Trail, Route 66 after 1926, led to the development of a service industry, including the Wildorado Garage, a distributor of Pennant Motor Oils. In 1946, it was noted that travelers could avail themselves of a garage, café, gas station, and grocery store.

During the 1920s and early 1930s, Wildorado developed a reputation for lawlessness that attracted national attention. The *Syracuse Herald* addressed the issue on January 29, 1928, with an article entitled "Wildorado—Texas Town Plundered So Many Times that Six Shooters No Longer Terrorize." The article continues by saying the following: "Wildorado, Texas, the most plundered town in the United States, has an itching trigger finger." It then states, "The Wildorado State Bank has been robbed eight times in the last three years, and the general store next door has been visited by bandits so frequently that the proprietors have lost count of the number of times they have looked down revolver muzzles."

Toward the end of the article, it is noted that "the latest robbery of the bank occurred when two youths, armed to the teeth, entered the building. Sharp shooting citizens of the town had gathered quickly and captured one of the bandits. They were forced to release him when his partner threatened to kill O'Neal, the bank president.

"One of the men participating in the attempted capture of these bandits was the night watchman who killed one robber and wounded another in a recent gun battle during an attempt to rob the Wildorado Grain and Mercantile Store. Although somewhat discouraged by all these bandit raids, Wildorado is armed and ready."

The article ends, as it later turned out prophetically, by noting "the town is 22 miles west of here and some day soon Amarillo expects to hear that robbers of the stores or bank have been captured or killed."

The dawn of a new decade did little to alleviate the violence. From the *San Antonio Light* on May 21, 1933: "Burglars hauled off a one ton safe containing more than $500 after breaking into the State Bank here [Wildorado] sometime Friday night, it was learned today. Most of the bank fixtures were torn down by the burglars in getting the heavy safe out the front door."

Willdorado, today, is less than a shadow of its former self. A large cattle feed lot east of town is the principal landmark.

WILLIAMS, ARIZONA

The namesake for the town, and mountain to the southwest, was Bill Williams, an early trapper and mountain man known for his legendary exploits. Initial settlement in the Williams area commenced with the establishment of a ranch and homestead by Charles T. Rogers in 1876. Rogers also served as the first postmaster in 1881.

With the rails of the Atlantic & Pacific Railroad laid through Williams in September 1881, the town became an important cattle and lumber shipping center. The proximity to the Grand Canyon fueled a burgeoning tourism industry that manifested in construction of a spur line to the canyon by the Atchison, Topeka & Santa Fe Railroad in 1901 and the construction of the Fray Marcos Hotel, a Harvey House.

WILLIAMS, ARIZONA *continued*

Further fueling the development of tourism-related businesses was the establishment of the National Old Trails Highway in 1914, Route 66 after 1926. A 1946 guidebook lists three hotels, nine auto courts, four garages, and several cafés.

The dramatic surge in traffic during the postwar period necessitated sweeping changes. In Williams, in 1956, these changes included construction of an overpass at the east end of the city and institution of one-way traffic eastbound on Bill Williams and west bound on Railroad Avenue.

Fueling this surge in traffic was a near-constant barrage of press and publicity. As an example, the May 1955 issue of *Arizona Highways* included a special feature, with full-color photographs by Norman Wallace entitled "The Scenic Wonderland," a profile of the stunning landscapes through which Route 66 passed in the state.

With completion of Interstate 40 north of town on October 13, 1984, Williams became the last community on Route 66 bypassed. With the resurgent interest in Route 66, the town has undergone a renaissance that has led to the preservation of numerous historic buildings, including the circa-1897 Red Garter Bed and Bakery, a former bordello; Rod's Steak House, 1946, a classic roadside restaurant from the early 1960s; Old Smoky's Pancake House and Restaurant, 1946; and re-creations such as Twisters 50's Soda Fountain.

Additional surviving businesses include numerous motels, such as the Kaibab Motor Lodge, now the Canyon Hotel and RV Park; the Thunderbird Inn, 1957; El Rancho Motel, 1958; El Coronado Motel; Williams Motel; Gateway Motel, 1936, now an office plaza; and the Del Sue Motel, 1936. Others are the Downtowner Motel, now the Rodeway Inn; Sun Dial Motel, now The Lodge; Bethel's Tourist Court, now the Royal American Inn; Hull's Motel Inn, now the Historic Route 66 Inn; Westerner Motel; Highlander Motel; and Norris Motel, 1953, now the Best Value Inn.

The Fray Marcos de Niza Hotel in Williams, Arizona, opened in 1908 primarily to serve the clientele that traveled to the Grand Canyon on the Santa Fe Railroad spur line. It closed in 1954, and reopened in 1989 as the depot for the Grand Canyon Railway. *Joe Sonderman*

Sun Dial Court, U. S. 66 - Williams, Arizona
"Gateway to the Grand Canyon"

Currently The Lodge, the Sun Dial Motel at 200 East Bill Williams Avenue utilized promotion during the early 1950s that noted it was "nicely furnished" and was located in "the tall pine country of Northern Arizona." *Mike Ward*

Currently the Best Value Inn, the Norris Motel at 1001 West Highway 66 opened in 1953 with Marion and Reese Morgan as proprietors. Rates, in 1954, ranged from $6.50 to $8.00 per night. *Joe Sonderman*

Williams, Arizona, the last bypassed community on Route 66, is filled with treasures large and small that reflect its colorful history and association with America's most famous highway. *Joe Sonderman*

WILLIAMSVILLE, ILLINOIS

Thomas Hart Benton, a U.S. senator from Missouri, is the namesake for the community founded as Benton in 1853 and changed to Williamsville in 1854 as homage to Colonel John Williams. Established of a post office under the name Williamsville took place in April 1854.

Jack Rittenhouse noted in 1946 that "the town is a quarter mile off U.S. 66. There is a garage in town, but no gas station or other facilities on the highway." Until quite recently, the primary point of interest was the 1930s-era service station that recently housed the Dream Car Museum and Die Cast Auto Sales.

Made famous in the Route 66 anthem penned by Bobby Troup, the Winona, Arizona, associated with the highway was, and is, little more than a wide spot in the road. *Joe Sonderman*

WILLOWBROOK, ILLINOIS

The primary attraction in Willowbrook with lengthy ties to Route 66 is Dell Rhea's Chicken Basket at 645 Joliet Road. Established in the mid-1940s, the restaurant served as a stop on the Blue Bird bus line.

WILMINGTON, ILLINOIS

Thomas Cox platted the town site for this community as Winchester and built a sawmill on the Kankakee River in 1836. To avoid duplication of post office names, the community was renamed Wilmington the following year. With the discovery of coal seams in the area during the 1860s, mining quickly replaced agriculture as the main economic foundation.

The primary point of interest for Route 66 enthusiasts today is the Launching Pad Drive-In, dating to 1960, with its towering fiberglass Gemini Giant. The restaurant closed in late 2010, and the property was listed for sale.

Other historic properties of note include the Eagle Hotel, 100 Water Street. Built in 1836 as a stage station and hotel by David Lizer, the property has been utilized as a warehouse, tavern, bank, and store. The Mar Theater, 121 South Main Street, dates to 1937 and features an original marquee. The facility still serves its original purpose.

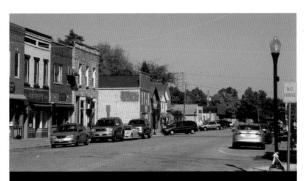

The historic district in Wilmington, Illinois, is a treasure trove of architectural delights built between the 1840s and 1920s that now house a wide array of specialty shops.

WINONA, ARIZONA

Bobby Troup's now classic song about Route 66 immortalized Winona, a railroad siding and lumber camp established in about 1882 as Walnut. A duplication of names resulted in the change to Winona in 1886.

By 1912, the camp had become a small community, and with the establishment of the National Old Trails Highway in 1913, a small service industry supplanted the logging-based economy. Billy Adams opened a tourist camp for motorists during this period that is purported to have been the first of its kind in the state.

With Route 66 realigned to the south, the original community withered as businesses relocated. The most notable Route 66–related artifacts today are the Winona Trading Post and an iron truss bridge to the west on the pre-1947 alignment of the highway signed as Townsend-Winona Road.

Troup's anthem elevated tiny Winona to levels far higher than its importance or size warranted, since it never did cast a very large shadow on the historic highway. Jack Rittenhouse listed the Winona Trading Post, with a café, gas station, grocery store, and cabins, as the lion's share of the town. It was here in 1924 that the post office was established.

WINSLOW, ARIZONA

With the exception of Sunset Crossing, near present-day Winslow, there are few places to safely ford the Little Colorado River. As a result, the crossing became an important location for most explorers, including Lieutenant Edward Beale, who mapped the Beale Wagon Road along the thirty-fifth parallel in northern Arizona.

The importance of the crossing and availability of water led Lot Smith and a party of Mormon settlers to establish a small fortification at the site in 1876. The crossing and fortification became less important, however, with the successful bridging of the river by the Atlantic & Pacific Railroad and establishment of a siding at a location to the north in 1880.

The namesake for the community is General Edward F. Winslow, president of the St. Louis & San Francisco Railroad, a partner company with the Atlantic & Pacific Railroad.

Next to the Winslow Walgreen Agency Drugs building was J. C. Penney, a building that burned in October of 2004. The world famous Standin' on the Corner Park occupies this corner today. *Steve Rider*

Winslow and the other communities that lined Route 66 on its course across Arizona during the 1920s were still firmly rooted in a pre-territorial heritage as evidenced by the buildings that lined their main streets. *Joe Sonderman*

Initially, most businesses and residents were in tents, but in 1881, J. H. Breed relocated his trading post from Sunset Crossing and built a stone building in Winslow.

As an important rail center, Winslow quickly became a hub for the development of ranching and trade with the Navajo and Hopi tribes. The railroad also served as a catalyst for the development of tourism. The development of the National Old Trails Highway after 1913, and Route 66 after 1926, further fueled this industry, and vestiges from each era of the evolution of tourism-related services still exist.

The La Posada—designed by Mary Jane Colter in a Spanish Mission style and one of the last Harvey Houses built—opened in 1930. After closure in 1959, the Santa Fe Railroad gutted the facility and remodeled it as an office complex. Consolidation and other restructuring of the company resulted in the building's closure and a subsequent order for demolition in the early 1990s. Allan Affeldt and Tina Mion later acquired the property, and restoration commenced in 1997. Today, La Posada consistently receives the highest recommendations for dining or lodging from the most prestigious travel publications.

Numerous motels from the postwar-era tourism boom on Route 66 remain, including the Desert Sun Motel, 1953; L-Z Budget Motel, closed as of this writing; and the Marble Motel, circa 1947.

To combat the decline precipitated by the completion of I-40 and resultant bypass of Route 66, a park was created in downtown Winslow to capitalize on its association with that storied highway as well as the song "Take It Easy" recorded by the Eagles in 1973. The Standin' on the Corner in Winslow, Arizona Park—dedicated in 1999 with its bronze sculpture created by Ron Adamson and trompe l'oeil murals by John Pugh—has transformed the almost forgotten historic district into a destination.

On December 7, 1928, Charles Bolling, manager of the Square Deal Garage, was to discuss transforming the garage into a Hupp agency, but an accident near Winslow injured that company's representative. The following day a fire damaged the café.
Joe Sonderman

WOLFE'S MARKET

Originally opened on Indian Hill Boulevard in 1917, and relocated to its current location along Foothill Boulevard, Route 66, in Claremont, California, Wolfe's Market is still operational. As of 2010, it remained a one family–owned business.

WONDERLAND MOTEL

Opened by Waldo and Adelyne Spelta in 1956 as a twenty-unit complex, the Wonderland Motel, 2000 East Santa Fe Avenue in Flagstaff, Arizona, still provides lodging for travelers. Initial promotion, through AAA and postcards, proclaimed the motel was "Flagstaff's Newest and Finest" and that in the months of summer it was cooled by "Nature's air conditioning."

WOOLEY, SHELBY

Shelby "Sheb" Wooley, born April 10, 1921, is one of two celebrities from Erick, Oklahoma, immortalized by having a street named after him in that community. The second is Roger Miller, an award-winning songwriter and singer during the 1950s and 1960s.

Following in the footsteps of his father, Bill Wooley, a talented fiddle player and singer, Sheb formed a band, the Plainview Melody Boys, at age fifteen that played for a broadcast at radio station KASA in Elk City, Oklahoma. In 1940, Wooley married Melva Miller, a cousin to Roger Miller.

In 1945, Wooley relocated to Nashville, Tennessee, where his music captured the attention of Ernest Tubb, a star of the Grand Ole Opry. In December of that year, he made his first recordings, "I Can't Live Without You" and "Oklahoma Honky Tonk Girl."

He relocated to Hollywood, California, in 1950, where he continued to perform and write music and began a career in movies that would span more than thirty years and eighty motion pictures. Film credits include roles in *Rocky Mountain* (1950), *High Noon* (1952), *Giant* (1956), *War Wagon* (1967), *The Outlaw Josey Wales* (1976), and *Hoosiers* (1986).

Wooley recorded his biggest hit to date in late 1955, a song entitled "Purple People Eater" that was certified gold in three weeks. Three years later, Wooley was cast as Pete Nolan for a new television program, *Rawhide*. He would play this part for eight years.

In 1962, Wooley began recording humorous parody songs under the name Ben Colder before becoming an original cast member for the television program *Hee Haw* the next year, a program for which he wrote the theme song.

In addition to numerous gold records, Wooley won the Country Music Association's Comedian of the Year award in 1968. Other accolades include the 1992 Songwriter of the Year award, the Western Heritage Award for nine consecutive years, and two Golden Boot awards.

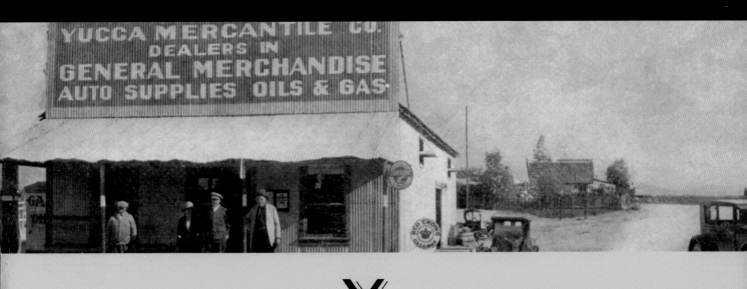

Y

Y SERVICE STATION AND CAFÉ

The Y Service Station and Café, built in 1937, utilized a strategically located triangular lot at the intersection of U.S. 66 and U.S. 183 in Clinton, Oklahoma, for maximum exposure. Shortly after completion of the station and café, cabins under the name Y Modern Cabins opened, completing the profitable complex.

The station and cabins remained a busy enterprise until realignment bypassed the property in 1956. Listed on the National Register of Historic Places in 2004, the building that housed the original café and service station (the cabins no longer exist) served as an automobile dealership in late 2010.

YUCCA, ARIZONA

The name for this community derives from the prolific growth of yucca that early pioneers found in the area. The Atchison, Topeka & Santa Fe Railroad chose the site as a siding to serve area ranching and mining interests shortly after 1901, and establishment of a post office followed in August 1905.

Early maps of the National Old Trails Highway indicate the primary route was through Oatman and over Sitgreaves Pass, the same followed by Route 66 after 1926; however, a secondary route to avoid the grades went through Yucca. The primary road from Kingman to Phoenix during this period ran through Yucca before crossing the Bill Williams River at Alamo Crossing, a small mining mill town on the north bank of the river. This resulted in Yucca being at an important crossroads. The rerouting of Route 66 through Yucca in 1952 bypassed the Black Mountains and Oatman. This is the current path of Interstate 40.

An auxiliary field for the Kingman Army Airfield established here during World War II, acquired by Ford Motor Company in

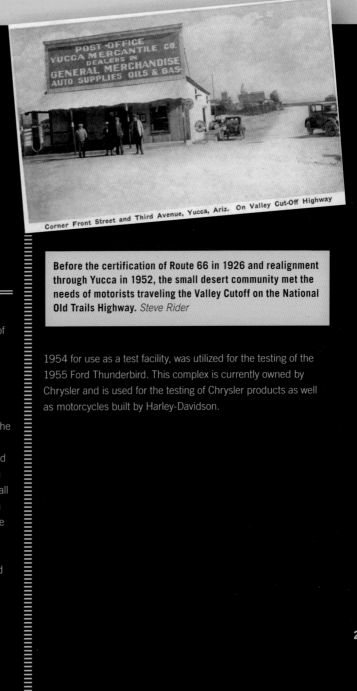

Corner Front Street and Third Avenue, Yucca, Ariz. On Valley Cut-Off Highway

Before the certification of Route 66 in 1926 and realignment through Yucca in 1952, the small desert community met the needs of motorists traveling the Valley Cutoff on the National Old Trails Highway. *Steve Rider*

1954 for use as a test facility, was utilized for the testing of the 1955 Ford Thunderbird. This complex is currently owned by Chrysler and is used for the testing of Chrysler products as well as motorcycles built by Harley-Davidson.

YUKON, OKLAHOMA

Platted in 1891 as part of a business partnership between A. N. Spencer of the Choctaw, Oklahoma, & Gulf Railroad and Minnie Taylor and Luther Morrison, who had homesteaded the property, Yukon was named after the Yukon River in Alaska for reasons unknown. The routing of the railroad through the town site at a former junction on the Chisholm Trail resulted in the almost complete abandonment of the nearby town of Frisco, as businesses and residents relocated.

With a population of 830 in 1907 at the time of statehood, the city that had incorporated in 1901 continued to prosper and grow at a relatively steady pace. The 1960s initiated a period of steep growth as Yukon became a bedroom community for Oklahoma City.

Extensive advertisement aimed at farmers and labors in Bohemia resulted in a large number of immigrants settling in the Yukon area. With the creation of Czechoslovakia and the resulting absorption of Bohemia, these immigrants began to be referred to as Czechs, a heritage now manifested in Yukon being proclaimed the Czech capital of Oklahoma. Since 1966, the city of Yukon has hosted an annual Czech day each October, an event that has become one of the nation's largest celebrations for this ethnic group. A further indication of the Bohemian role in Yukon's development is the Jan Zizka Lodge Number Sixty-Seven, listed in the National Register of Historic Places.

The railroad served as the catalyst for the city's founding, but agriculture fueled its growth. Indicative of this is the Yukon Mill and Grain Company, initially founded as an elevator. In 1903, three partners, Frank Kroutil, John Kroutil, and A.F. Dobry, acquired the property and expanded the mill. By 1930, it was the largest flour mill in the Southwest, capable of producing more than two thousand barrels per day. Dissolution of the family partnership in 1933 resulted in the construction of a second mill, the Dobry Mills, directly across the street. A large conglomerate, Mid-Continent, acquired the properties in 1972, and the Yukon Mill and Grain Company remains operational as of 2010.

In 1939, the twenty-six-unit Lakeview Courts provided guests with tiled showers, private garages, telephone and telegraph service, and a twenty-four-hour porter for $2.00 to $5.00 per night. *Mike Ward*

Numerous historic structures remain, providing tangible links to the community's early history, including the Mulvey Mercantile building dating to 1904 and listed in the National Register of Historic Places and a beautiful Chisholm Trail mural at the corner of Fourth and Main Streets.

Route 66–era landmarks are also relatively plentiful. These include the towering Yukon's Best Flour grain elevators with the company's massive illuminated sign, several vintage service stations, and the Yukon Motel.

Yukon is the home of Garth Brooks. In the 1990s, a former access road to Route 66 that served as a commercial strip was renamed Garth Brooks Boulevard.

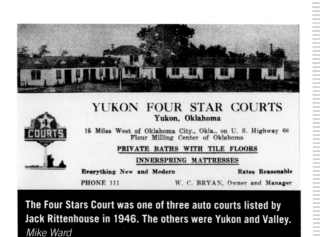

The Four Stars Court was one of three auto courts listed by Jack Rittenhouse in 1946. The others were Yukon and Valley. *Mike Ward*

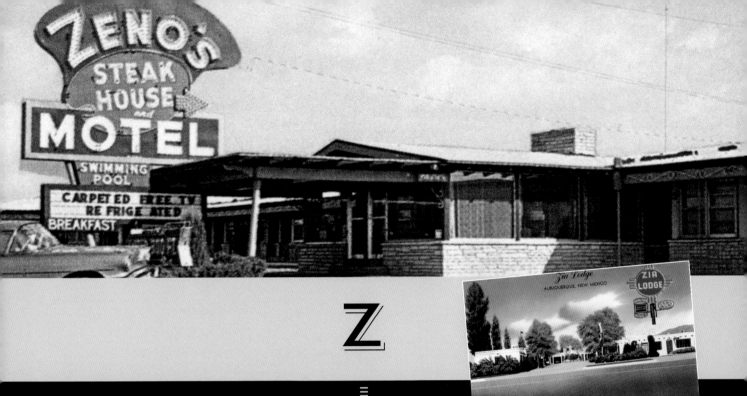

Z

ZENO'S

Zeno's Motel and Steakhouse opened in 1957 under the proprietorship of Zeno and Loretta Scheffer. Initially, it featured thirty-two units, and promotion noted modern amenities, such as wired music and a swimming pool, as well as a lounge.

Expansion of the facility resulted, by 2011, in fifty rooms, as well as a full-service restaurant and banquet facilities. Zeno's, located near Martin Springs Road and I-44 in Rolla, Missouri, closed on October 22, 2011.

The renewed interest in Route 66 was not enough to keep the doors open at Zeno's, a steak house and motel opened by Zeno and Loretta Scheffer in Rolla, Missouri, in 1957. The complex closed in October 2011. *Judy Hinckley*

Above: Initially, Zeno's Motel featured thirty-two units, but with expansion and improvement during the 1960s, the complex offered fifty units as well as a swimming pool and lounge. *Joe Sonderman*

ZIA LODGE

The Zia Lodge, 4611 East Central Avenue in Albuquerque, New Mexico, opened in mid-1938 as a modern court that featured amenities like "steam heat" and "tiled baths." The *Western Accommodations Directory*, published by AAA in 1954, noted

The Zia Lodge, razed in 2005, opened in 1938 at 4611 East Central Avenue. Promotional material from 1954 lists combination baths, radios, and telephones as amenities. Rates ranged from $4.50 to $9.00 per night. *Mike Ward*

The Zia Lodge remained operational through 2002. Demolition occurred in 2005, two years after a fire devastated the complex.

ZIA MOTEL

Dating to the late 1940s, Zia Motel at 915 East Highway 66 in Gallup, New Mexico, remained an operational business as of 2010. Early promotion for the motel by AAA in 1954 proclaimed it was a "modern motel consisting of 26 units, 13 with kitchens, that are comfortable and quiet."

ZUZAX

Zuzax, east of Albuquerque, was the creation of Herman Ardans, who derived the name to ensure his curio shop on U.S. 66 in New Mexico had recognition among travelers. Ardans' stock answer to questions about the name was that it was in reference to the Zuzax Indians, a colorful manifestation of his creative imagination.

Construction of the buildings in the curio shop complex in 1954 utilized materials obtained from surplus military barracks. With merchandise that included stuffed rattlesnakes, cider, postcards, arrowheads, and mineral specimens, the Zuzax trading post was typical of those found along Route 66 in the Southwest during this period.

Shortly before the bypass of Route 66, the Zuzax trading post closed. Today, the Zuzax name refers to an exit and cluster of fast-food franchises on I-40 east of Albuquerque near Tijeras.

INDEX

288